JEWISH ART
an illustrated history

CECIL ROTH

JEWISH ART

AN ILLUSTRATED HISTORY

Revised Edition by
BEZALEL NARKISS

NEW YORK GRAPHIC SOCIETY LTD.
Greenwich, Connecticut

THE ORIGINAL EDITION OF JEWISH ART WAS FIRST PUBLISHED IN THE
UNITED STATES OF AMERICA IN 1961.

THIS BOOK IS A REVISED AND ENLARGED EDITION PUBLISHED IN THE
UNITED STATES OF AMERICA IN 1971
BY NEW YORK GRAPHIC SOCIETY LTD., GREENWICH, CONNECTICUT.

STANDARD BOOK NUMBER 8212–0391–6.
LIBRARY OF CONGRESS CATALOG CARD NUMBER 70–148668.
©1971 IN ISRAEL BY MASSADA PRESS LTD.

DESIGN BY J. SCHWARZWALD
PRINTED IN ISRAEL BY PELI PRINTING WORKS LTD., RAMAT GAN

CONTRIBUTORS

Appelbaum, Simon, Israel. Archaeologist. Excavated Early Iron Age and Roman sites in Britain, and Hellenistic and Roman sites in Israel. Formerly supervised the antiquities of Cyrenaica. Lecturer in Classics (archaeology) at Tel Aviv University. Contributor on ancient history and archaeology to professional periodicals.

Avi-Yonah, Michael, Israel. Archaeologist. Associate Professor of Archaeology at the Hebrew University, Jerusalem. Director of Archives, Department of Antiquities, Government of Israel. Formerly assistant librarian and archives director, Rockefeller Archaeological Museum, Jerusalem. Author of *Mosaic Pavements in Palestine; Map of Roman Palestine; Abbreviations in Greek Inscriptions; Oriental Elements in the Art of Palestine; In the Days of Rome and Byzantium* (Hebrew); *Historical Geography of Palestine* (Hebrew).

George, Waldemar, France. Art critic. Author of monographs on Matisse, Picasso, Rouault, Gris, Leger, Chagall, Chirico, Soutine, and of *Le Dessin Français au XXᵉ Siècle; Humanisme et Universalité;* and *Les Artistes Juifs et l'Ecole de Paris.*

Goodman, Percival, U.S.A. Architect. Professor, School of Architecture, Columbia University, New York. Leading synagogue architect in the U.S.A. Contributor to architectural journals. Author of *Communitas.*

Habermann, Abraham M., Israel. Bibliographer. Director of the Schocken Library, Jerusalem. Formerly librarian, Jewish Community of Berlin. Author of numerous studies on Hebrew poetry, bibliography, and the history of Jewish printing.

Isserlin, Benedict S. J., Gt. Britain. Archaeologist. Head, Department of Semitics, University of Leeds, England. Author of monographs on archaeology and Semitic Studies.

Jamilly, Edward, Gt. Britain. Architect. Former member of Government of India Planning Team. Author of published reports on building and planning in India, France, and Cyprus. Associate of the Royal Institute of British Architects. Author of monographs on Anglo-Jewish architects and architecture, George Basevi, and English synagogues.

Kashtan, Aharon, Israel. Architect. Senior lecturer, Faculty of Architecture, Israel Institute of Technology, Haifa. Designer of the Hebrew Language Academy building in Jerusalem. Author of studies on the Mediterranean and Palestinian dwellings; the history of synagogue architecture; Jerusalem architecture.

Kon, Maximilian, Israel. Architect and art critic. Author of *The Tombs of the Kings; The Menorah of the Arch of Titus; The Stone Capitals of Ramat Rachel.* Contributing editor to Encyclopaedia Hebraica.

Landsberger, Franz (deceased), U.S.A. Art historian. Curator, Jewish Museum, Hebrew Union College, Cincinnati, Ohio. Formerly Associate Professor, History of Art, Breslau University, and Director, Jewish Museum, Berlin. Author of *Die Kuenstlerischen Probleme der Italienischen*

Renaissance; Die Kunst der Goethezeit; Einfuehrung in die Juedische Kunst; A History of Jewish Art; Rembrandt, the Jews and the Bible.

Mayer, Leo Ary (deceased), Israel. Archaeologist and educator. Professor of Archaeology and Near Eastern Art, Hebrew University, Jerusalem. Rector, Hebrew University 1943–1945. Authority on Moslem art and architecture. Adviser on Moslem buildings, Israel Ministry for Religious Affairs. Author of *Saracenic Heraldry; The Rise and Progress of Moslem Archaeology; The Buildings of Quaytbay; Bibliography of Moslem Numismatics; Mamluk Costume; L'art Juif en Terre d'Islam. Bibliography of Jewish Art* (posthumously).

Namenyi, Ernest M. (deceased), France. Art critic. Formerly curator, Jewish Museum, Budapest, Hungary. Contributor on Jewish art to professional publications. Author of *L'esprit de l'art Juif.*

Narkiss, Bezalel, Israel. Art historian. Senior lecturer, Department of Art History, Hebrew University, Jerusalem. Formerly fellow of the Warburg Institute, University of London. Editor and adviser on Jewish art, Encyclopaedia Judaica. Author of introductions to facsimiles of *Mahsor Lipsiae, The Bird's Head Hagada, The Golden Haggadah,* and a monumental volume of *Hebrew Illuminated Manuscripts.*

Perrot, Jean, France. Archaeologist. Head of French Archaeological Mission to Israel. Conducted excavations at Beersheba, Yazur, Ascalon, Abu Gosh, Ein Mellaha. Published numerous papers in scientific and professional journals, especially on prehistoric Palestine.

Roditi, Edouard D'Israeli, American poet and art historian living in Paris. Author of *Dialogues on Art* and other works in English, French, and German.

Roth, Cecil (deceased), Israel. Historian and author. Lecturer in Jewish Studies, University of Oxford, England. Editor-in-chief, Standard Jewish Encyclopedia and Encyclopaedia Judaica. Contributor to Encyclopaedia Britannica, Encyclopaedia Judaica, Cambridge Medieval History. Author of numerous works on Jewish historical subjects, including *A Short History of the Jewish People; The Jewish Contribution to Civilization; The Jews in the Renaissance.*

Schwarz, Karl (deceased), Israel. Art critic. Formerly custodian of the art collection, Jewish Community Museum, Berlin. Contributor to literary and scientific periodicals on art and sculpture. Author of *Augustin Hirschvogel, Ein Deutscher Meister der Renaissance; Graphischen Werkes von Lovis Corinth; Die Juden in der Kunst; Jewish Sculptors.*

Werner, Alfred, U.S.A. Art critic. Author of *Alexander Watin und Die Juedische Volkskunst; Utrillo; Dufy;* and prefaces and introductions to artists' biographies.

Wischnitzer, Rachel, U.S.A. Art historian. Professor of Fine Arts, Stern College, Yeshiva University. Formerly art curator, Jewish Museum, Berlin. Art editor, Universal Jewish Encyclopaedia and Encyclopaedia Judaica. Contributor and editor of magazines on art. Author of *Symbole und Gestalten der Juedischen Kunst; The Messianic Themes in the Paintings of the Dura Synagogue; Synagogue Architecture in the United States. The Architecture of the European Synagogue, and many articles on Jewish Art.*

CONTENTS

PREFACE TO THE SECOND EDITION

I believe that there is no exaggeration when I say that the publication of the first edition of this work in 1961 marked an epoch in the study of what has been termed, for the sake of convenience, JEWISH ART. In this work, which appeared in Hebrew in 1957, with the editorship of Z. Efron and myself, material on the subject had been gathered for the first time in a systematic and exhaustive way, supplemented by a wealth of illustrations covering every aspect of the subject.

Many people informed me subsequently that the work was an eye-opener. Never before had they realized the scope and wealth of our Jewish cultural history. The discussions and criticisms in themselves advanced the study of the subject. The interest of the public at large was aroused. And at the Fourth and Fifth World Congresses for Jewish Studies — held in Jerusalem in 1965 and 1969, respectively, — a special committee dealt with this topic in a comprehensive way.

The conclusions reached in the first edition of 1961 have not been invalidated by recent research. However, in some areas, for example that of the Hebrew Illuminated Manuscripts of the Middle Ages, our horizons have been widened by more recent publications. In 1967 there appeared posthumously a monumental Bibliography of Jewish Art by L.A. Mayer — one of the distinguished collaborators in this publication — which besides indicating the magnitude of the subject, provides also, for the first time, a guide to the literature written upon it.

In this new edition of Jewish Art, errors and omissions have been rectified. I wish to thank Dr. Bezalel Narkiss who is responsible for preparing the second edition for press. Special credit is due to him for an excellent selection of illustrations.

Cecil Roth

(During the later phases of preparing the book for publication Professor Roth passed away, on 22nd June, 1970).

INTRODUCTION

The conception of Jewish Art may appear to some a contradiction in terms: for there is a widespread impression that in the past visual art was made impossible among conforming Jews by the uncompromising prohibition in the Ten Commandments — *"Thou shalt not make unto thee a graven image, nor any manner of likeness, of anything that is in the heaven above or that is in the water under the earth."* More sweeping still, though perhaps somewhat less familiar, is the condemnation in Deuteronomy IV, 17–8, which in the prohibition of graven images particularizes in terms that leave no place for ambiguity: *"the likeness of male or female, the likeness of any beast that is on the earth, the likeness of any winged fowl that flieth in the heaven, the likeness of any thing that creepeth upon the ground, the likeness of any fish that is in the water under the earth."*

It may be observed that to regard this interdict, however rigidly interpreted, as antagonistic to all artistic development would imply a very narrow view of the scope and functions of art: for not all art is representational, and even in representational art there are subjects which do not imply the delineation of a human or animal figure. Hence, even had these Biblical verses been interpreted in the most literal fashion, and commanded at all times the most unquestioning obedience, there could nevertheless be some scope for our subject. But in point of fact the premise is incorrect. Whether the passages in question were intended as an outright prohibition of the representation of any human or animal form in any circumstances is questionable. But what is certain is that it was not always so interpreted, even among Jews of the most rigid and unswerving loyalty. Indeed, the Pentateuchal code itself, with its detailed instructions regarding the Cherubim which were to be placed in the Ark, suggests the logical conclusion that the stern negative of the Ten Commandments was intended to be read in conjunction with the following verse: *"Thou shalt not bow down to them and shalt not serve them"* — that is, that no image must be made for the purpose of worship, either as representing or as substituting the Divinity.

In all Jewish history, attitudes and interpretations varied from land to land and from generation to generation. Sometimes the application of the prohibition was absolute, and no representation whatsoever, of man or beast or bird, was admitted even in relatively "liberal" Jewish circles. Sometimes men went to the other extreme, and great latitude was shown, human figures being incorporated freely even in objects associated with

Divine worship. The inhibition was maintained only as regards three-dimensional "graven images" of human beings — i.e., busts and statues. These do not begin to make a general appearance in Jewish circles until the seventeenth or perhaps the eighteenth century — though even in the classical period there were some significant exceptions to this generalization as well.

II

It may be suggested that the Jewish attitude was conditioned by two opposing forces — on the one hand by revulsion and on the other by attraction. In antiquity, the former was normally the stronger. In a pagan environment, where images were objects of worship, the Biblical prohibition was automatically strengthened and confirmed, and the Jew became a passionate iconoclast. This was so, it seems, at the time of the First Temple. However, a few inconsiderable specimens of representational art originating in this period have been found (e.g., the ivory plaques of Samaria or the "Lion Seal" of one of the ministers of King Jeroboam), though they emanate from areas of questionable orthodoxy. In the period of the Second Temple, the Greek attempt to introduce pagan rites and symbols into the Temple inevitably led to reaction, and a period of intense iconoclastic sentiment resulted. Under the Romans, for whom religious symbols had a political significance, this was naturally intensified.

But it is not quite certain even now whether the implementation of the traditional prejudice was as sweeping and as consistent as is generally believed. All manner of images (*Parsufin:* i.e., "visages," from the Greek πρόσωπον) were to be found in Jerusalem before its destruction in the year 70, other than those of human beings, we are informed by a scholar of a later generation (Jerusalem Talmud *Avodah Zarah* 42c). The mass of the people seems to have tolerated decorative representations of animals, such as were to be found in the Herodian palaces. They presumably did not emphatically resent human representations made by their Gentile neighbors if they were not intended for religious veneration. But as the harsh, hated Roman rule with its all-pervasive iconic symbolism tightened its hold, so the objection against images of every sort became more and more intense, political disloyalty finding incontrovertible justification in the more rigid interpretation of the Biblical law. It was now that young Jews dared martyrdom, with the encouragement of patriotic Rabbis, by pulling down the golden eagle — symbol of Rome's majesty — set up by Herod above the Temple Gate, and hitherto undisturbed. Public sentiment forced the Romans to remove the Imperial images from their standards before they marched into Jewish territory, and (we are told by the Church Father Hippolytus) the Zealots refused to pass under a city gate decorated with statues, lest they should be suspected of venerating them, or even to handle a coin on which a human form was depicted. (This was, of course, equivalent to the imposition of a ban, on plausible religious grounds, on the use of currency minted by the oppressor.) The same standard was adopted late in the 3rd century by Rabbi Nahum ben Sinai (Jerusalem Talmud *Avodah Zarah* 42b), but a famous New Testament episode (Matthew XXIII, 15–22: "Render unto Caesar") suggests that such rigidity, if not unknown, was at least far from general at the time of Jesus. There is reason to believe that the patriotic extremists ultimately succeeded in having their views officially adopted. At a representative gathering in the Temple Court after the triumphant expulsion of the Romans in the year 66, among other Revolutionary legislation, a ban was imposed on all representations, of

animals as well as of human beings, even for purely decorative purposes, and anything of the sort within reach was destroyed by Governmental order. This is the attitude reflected in the strongly orthodox writings of Josephus, who at the outset had been one of the leaders of the Revolt.

That this development was political, as much as religious, in origin became apparent not long after the destruction of Jerusalem, at a period when the Roman rule seemed to be finally and permanently established and the Pharisaic spokesmen were to some extent reconciled with it. Now greater latitude again appeared in practice. The *Mishnah* contains elaborate regulations concerning the proper and very rigid attitude to adopt as regards pagan images. Nevertheless, even a leader of Judaism such as the Patriarch Rabbi Gamaliel himself used a signet ring engraved with a human head, depicted the heavenly bodies for demonstration purposes notwithstanding the specific Biblical disapproval, and did not refrain from frequenting public baths embellished by a quasi-religious pagan statue. "The Aphrodite is intended as an adornment to the baths, not vice versa," he informed his critics. Caius Caligula's attempt to have his statue introduced into the synagogues of the Empire in 37 had encountered such universal and profound, or even pathetic, opposition that even the Imperial representatives hesitated to implement it. But, in the third century, a royal statue set up without any malevolent object was to be found in a synagogue in Nehardea at which scholars of the most extreme piety such as "Rav" and Samuel did not hesitate to worship *(Rosh Hashana* 24b). This might perhaps have been a question of yielding to circumstances. But the Talmud (B. Kama 97b) imaginatively describes a fictitious series of coin-medallions embodying the likeness of the patriarchs and heroes of the Bible, without any suggestion of disapproval. At about this period, the Aramaic paraphrase of the Pentateuch known as *Targum Jonathan* expressed the current outlook in its rendering of Leviticus, XXVI, 1, which prohibits idols and graven images: *"A figured red stone ye shall not put upon the ground to worship thereto, but a colonnade with pictures and likenesses ye may have in your synagogues, but not to worship thereto."*
It would seem that the change in attitude came about so far as the places of worship were concerned (on this point there will be more ample details below, in chapters IV and V) in the third and fourth centuries, when as we read in a passage of the Palestinian Talmud (*Avodah Zarah* 41a: partly omitted in the standard text, owing to a scribal error): "In the days of Rabbi Johanan they began to paint on the walls, and he did not prevent them. In the days of Rabbi Abun they began to make designs on mosaics, and he did not prevent them."

If representational art was admitted to the synagogue in the fourth century, it seems to have been barred from other public places and from the home for some generations further. Of course, some pietists vociferously objected to pictures in the synagogues. Indeed, if we were to interpret opinions embodied in the Talmudical literature, we would imagine that nothing of the sort could have happened. But, clearly, the iconoclastic ideal which the Rabbis voiced was to some extent out of touch with reality. The fact that eminent teachers objected to the figurative arts no more demonstrates that they did not exist than the objections against gluttony prove that all Jews were abstemious, or the objections against talking in synagogue demonstrate that perfect decorum was at all times maintained. A more satisfactory parallel, for it concerns the actual organization of worship, could be drawn from the fact that objections against the interruption of the statutory services by new accretions did not prevent the development of synagogal hymnology.

III

This iconopathic interlude (as we venture to call it) seems to have come to an end in the sixth or seventh century. This was due to two factors. One was the iconoclastic movement in the Byzantine Empire, which could not fail to affect the Jews; the other was the birth and expansion of Islam, with its profound iconoclastic tendency. The Jews were compelled by force of logic to follow suit. It is manifestly impossible for the traditional leaders of the protest against image-worship to allow their neighbors to be more zealous in this respect than they were themselves. For a prolonged period, therefore, the iconoclastic tendency triumphed in Jewish life, and in the Orient, the south of Europe, and the Mediterranean area generally; it continued as long as Moslem domination and influence lasted.

The result was in certain respects paradoxical. It is currently believed, and with some reason, that the aesthetic sense was more widely developed among the Sephardim than among the Ashkenazim. But it was among the latter that representational art re-emerged. In Spain, even after the Moslem hegemony was broken, the Jews remained influenced by Arab propinquity and example. Under Catholic rule, too, they could not very well afford to show themselves less fervent in this respect than another minority. In France and Germany, on the other hand, they could succumb to the attraction of the environment with fewer qualms — all the more so since the "images" of the Madonna or the Saints used in Catholic worship were not such as a Jew — while remaining a Jew — might be tempted to revere. Though in the twelfth century Eliakim ben Joseph of Mainz ordered the removal of the stained glass windows with pictures of lions and snakes from the synagogue, his younger colleague Ephraim ben Isaac of Regensburg permitted the painting of figures of animals and birds on the walls. And Isaac ben Moses of Vienna — though he himself disapproved — recalled that as a boy he had seen similar embellishments in the place of worship he had frequented at Meissen. Meir of Rothenburg (d. 1293) did indeed object to the presence of illuminations in the prayer book, but only on the grounds that the worshiper's attention might thereby be distracted from his devotions. In the twelfth century, the North French Tosaphists discussed and permitted even the representation of the human form in the round, provided that it was incomplete. We are specially informed that the Jews of England at this time used signet rings which bore a human likeness. Rashi, too, knew of, and did not apparently object to, wall frescoes illustrating Biblical scenes, such as the fight between David and Goliath, with descriptive wording below (Babylonian Talmud *Shabbat* 149a). On the surface, it certainly seems as though he is referring to a practice current among the well-to-do Jews of his personal environment in North France and the Rhineland.

The author of the *Sepher Ḥassidim*, or Book of the Pious (par. 1625), categorically expressed his disapproval of pictures of animate beings in the synagogue, especially before the Torah-shrine; but this work notoriously reflected the most exacting standards of twelfth century German pietism, and his language suggests that the practice was not unusual, even so, in the place of worship, and *a fortiori* in the home. On the other hand, the scholars of the Spanish school consistently maintained an extreme attitude. The *Sepher ha-Ḥinnukh*, ascribed to Aaron of Barcelona (13th century), emphasizes that it was forbidden to make likenesses of a human being out of any material even for ornament (XXXIX, 12). Moses Maimonides, on the other hand, adopted an intermediate position

(*Mishneh Torah, Hilkhoth Avodat Kokhavim*, III, 10–11) forbidding only the human (not animal) form in the round, while permitting it in painting and tapestries.

In the post-medieval period, the Jewish attitude towards art was fluid, varying from age to age and from country to country. Generally speaking, it may be said that in the Moslem countries a strong feeling of opposition persisted, as will be shown in Chapter IX of this work. As late as the middle of the nineteenth century, the Rabbi of Smyrna, Abraham Palagi, refused to admit to the synagogue a portrait that had been sent by Moses Montefiore. Yet even so, it remains impossible to generalize, for richly illuminated Hebrew manuscripts were executed in Persia (see below, pages 370/71 and color plate). In the European environment, standards varied. In the Latin and Catholic countries, the iconoclastic tradition tended to be strong, and in certain respects became stronger in the course of time. In the Protestant world, and in Central Europe generally, it was weak, human representations being admitted even on ritual objects. Western Europe (e.g. Holland and England) normally banned representations of the human likeness on ritual objects but admitted them domestically. In Italy, we are informed how the Ark of the synagogue at Ascoli, removed to Pesaro in 1569, rested on two roaring lions. On the other hand, Rabbi David ibn Zimra (16th cent.) objected even to a family crest embodying a lion over the Torah-shrine at Candia, then under Venetian rule. Rabbi Samuel Aboab of Venice (1610–94: Responsa, 247) expressed his disapproval of illustrated Bibles, but only apparently because he considered it improper for the angels to be delineated according to the inadequate human imagination.

In some respects, the revulsion from extreme iconoclasm in religious art went further in certain parts of northern Europe in the seventeenth and eighteenth centuries than in any other epoch in Jewish history before or after. It now became common, if not usual, in Ashkenazi communities to have figures in relief (i.e., three-dimensional) of Moses and Aaron on the breastplates which adorned the Torah Scroll, the central object of the synagogal ritual and a focus of adoration so far as that can be said of any synagogue appurtenance. (It is hardly worthwhile to mention less remarkable instances, of which there are many.) At this time, decorations in some Polish synagogues began to include human figures, in at least one case even inside the hallowed Torah-shrine. Now it was that, as we shall see, the Sephardim in Amsterdam habitually adorned their tombstones with elaborate reliefs depicting Bible scenes. Moreover, in one at least, erected to mark the grave of Samuel Senior Texeira in 1717, this Biblical representation comprises what can best be interpreted as a representation of the Almighty Father appearing to Samuel. This was in utter contravention of the Ten Commandments as Jews have always interpreted them. The Hand of God had indeed figured in the frescoes of Dura-Europos but this went very much further. What is remarkable is not merely the fact that the carving should have been made, but that it should apparently have escaped adverse comment and should have remained *in situ,* an incident that assuredly could not happen in our own more easy-going day. By *a priori* reasoning, it is possible to interpret this figure as representing an angel rather than the Deity. But this is not the case in connection with the amazing frontispiece of Jacob ben Asher's *Arba'ah Tourim,* printed in Augsburg in 1540. In the bottom part of the page are depicted two representations of God creating the animals, and the creation of Eve. The same appears in the very scholarly Biblical edition entitled *Minhat Shai,* edited by Solomon Jedidiah Norsa, which appeared under devout auspices in the learned city of Mantua in 1742. This picture contains half a dozen vignettes,

one of which shows Ezekiel's Vision of the Dead Bones. Presiding over the miracle from above a cloud, at the summit of the picture, appears the bearded semblance of the Heavenly Father. This same engraving is later repeated twice, before the Prophets and before the Hagiographa. Once again, the amazing fact is not only that it should have been executed, but that no objections were apparently raised against it.

IV

Art thus having been admitted to the synagogue, naturally found admission on a more generous scale into the home. Some of this development was apparently due to the influence of the ex-Marranos, who had been establishing their communities, especially in Western Europe, from the end of the sixteenth century. Here a curious paradox emerges. These highly assimilated persons, acclimatized in their former lives to European aesthetic standards, maintained the strongest possible iconoclastic ban in their synagogues while mitigating it in an exceptional degree outside. The reason for this may lie in the fact that the *raison d'être* of their lives hitherto, under the semblance of Christianity, had been their protest against image worship in the churches, and—especially in a Protestant environment—they could hardly afford to tolerate even an ornamental likeness of the human form in anything connected with their religious worship. Yet, they had clearly realized up to this point that there was no relation between the paintings and portraits in their houses and the "images" in the churches. Hence at home they perpetuated their former aesthetic standards, and domestic appreciation made rapid progress under their auspices. This could not fail to have its influence on their neighbors, and the Ashkenazim, too, soon followed suit.

In the Italian ghettos, the Jewish houses are said to have been decorated with frescoes representing Biblical scenes. Leone Modena (d. 1648) informs us in his *Riti Ebraici* that in Venice of his day "many take the liberty of having pictures and images in their houses, especially if they are not in relief or embossed, nor have the bodies at full length." In the early 18th century, J.J. Schudt wrote in his *Jüdische Merkwürdigkeiten* (Frankfort on the Main 1714–17): "There can be no question about Jews allowing their portraits to be painted, I myself having seen here in Frankfort in some of their rooms not only Bible stories depicted on the walls, but also portraits of their parents. Indeed, as keen picture-lovers, they spend a great deal of money on pictures and portraits."

Portraits commissioned by Jews begin to appear here and there in the sixteenth century on three or four medallions of Italian origin. Curiously enough, no painted or engraved Jewish portrait of quite the same antiquity is known, though an Italian moralist of about 1600 recommended that a man should have his mother's likeness by him continually, so as to save him from temptation. Nevertheless, by the close of the seventeenth century it was commonplace in Central and Western Europe, even for Rabbis, both Sephardi and Ashkenazi, to have their likenesses painted and engraved, presumably for distribution among their admirers. Thus, they obviously set an example to their flocks to do the same, and at the same time gave a helping hand to the Jewish portrait-painters who were now beginning to emerge. In one case (that of Eleazar Brody, when he became Rabbi in Amsterdam in 1735) a crude portrait-medal was even struck, though this aroused some disapproval (see below, chapter VIII). However, the eminent Haham Zevi Ashkenazi refused to have his portrait painted, when he visited London in 1712, and the artist

commissioned by his admirers to execute it had to sit in an adjoining room and sketch him unawares.

What is most remarkable is that in Eastern Europe—perhaps as part of the reaction against the Reform movement in Judaism—a revulsion seems to have taken place even as late as the nineteenth century, some persons of particular piety now refusing to have their likeness taken by the new method of photography, the religious objections to which must assuredly have been relatively slight. This fact illustrates the constant ebb and flow in the Jewish attitude towards representational art, concerning which one can say only that generalization is impossible.*

V

The data assembled above have made it abundantly clear that the conception of representational art for both domestic and synagogal purposes had become fully familiar in Jewish circles long before the beginning of the age of Emancipation. Inevitably, Jewish artists also began to emerge at much the same time. The reader will find at a later stage of this work (chapter VIII) some account of them, so far as this is possible. In many cases, no more than the names are preserved, and there does not appear to be any instance at this period that rises above mediocrity. At the close of the eighteenth century—not as might have been expected in the Sephardi world but rather in the circle of the Court Jews and their associates among the Ashkenazim in Germany, Holland, and England—a few academic painters of local reputation began to emerge. These were weakened rather than reinforced by one or two persons (Mengs, perhaps Zoffany) who left the Jewish community and made a considerable mark in the world of art generally in their day. The early nineteenth century saw the number of such artists increase, without however producing a single name now remembered outside a very limited circle, or artists whose works are prized by collectors. But we must remember that this was also the fate of the great majority of their non-Jewish contemporaries whose style of painting, choice of subject, and indeed scale of work as well as aesthetic approach are now hopelessly out of fashion. Nevertheless, in their day, some of them were considered eminent and enjoyed a very great reputation, as indeed their technical competence fully justified. It is not unlikely that in the course of the next generation or so their style of painting may be appreciated again, much as that of the painters of the Regency period who have become fashionable in England during the past few years. If that should happen, the names of Veit, Bendemann, Oppenheim, and Magnus, whose work is described below in the chapter devoted to the Jewish Artists of the period of Emancipation, may perhaps regain their former distinction.

In the second half of the nineteenth century a handful of Jewish artists of the first rank make their appearance led by Pissarro and Israels. Then, in the twentieth century, a sudden outpouring of genius from the Eastern European ghettos storms the studios of Paris, with dazzling results.

The phenomenon is noteworthy. There is obviously a dramatic value as well as logical sequence in the traditional story that meticulous obedience to the literal interpretation of

* It may be remarked that Solomon Hirschell, chief Rabbi in England from 1802 to 1842, although of profound orthodoxy in the pre-Emancipation sense, had his likeness executed time after time in painting, engraving, medallion, and bust, a portrait even being prefixed to an edition of the prayer-book produced under his auspices.

the Bible long kept the Jews from all artistic manifestations, and that when the ban was lifted they took advantage of it to the full, with prodigious results. But we have seen that the premise is incorrect, for Jews did not eschew the visual arts even in the Middle Ages and the Ghetto period. Under the circumstances it is remarkable that so few did in fact embrace the career of art (as they did for example that of medicine). Social prejudice may indeed explain this in some degree. But we must then explain the phenomenon that for fully one hundred years after the penetration began on a fairly large scale — that is until the second half of the nineteenth century — hardly a single figure of more than mediocre importance emerged, whereas afterwards there is a prodigal outpouring of artistic ability. Nor can one explain the changed atmosphere by saying that this was due to the opening of the gates of the Eastern European ghetto, with its stronger inhibitions and with its extraordinary store of pent-up genius; Pissarro, Israels, Liebermann, Modigliani, all came from wholly different environments in Occidental lands. The problem is one to which no solution readily suggests itself, except perhaps that the artistic career had to become economically possible for persons without social connections and without the possibility of executing ecclesiastical commissions before Jews could afford to embrace it.

That there is little or no superficial relationship in the vast majority of cases between the productions of the numerous artists of Jewish birth or extraction, with whom this work will be concerned, is of course obvious and indisputable. To what extent may their production, nevertheless, be characterized as "Jewish"? And to what extent is it proper to speak of them as "Jewish" artists?

These are questions that need not be answered at the present stage. For, obviously, this volume cannot concern itself with Jewish Art, in the sense that a companion volume might concern itself with Italian or French or Spanish or Israeli art. Yet it may be observed that one might question the validity even of those common terms that have just been set down; for it is only by postulating an artificial unity, based on geographical and similar considerations, that one is able to regard the art of any country in all periods as a whole. French or English art does have an obvious homogeneity in certain of its phases, the homogeneity inevitable in persons living in the same area, with the same standards, and under similar social conditions. On the other hand, there was no common factor between Cimabue and Titian, or between Fouquet and Cézanne, other than the fact that they were born in the same land. What one terms "English Art" is in fact simply the sum of the artistic production of persons, however influenced, born or active in England, so that it is legitimate to include in the category of "Jewish Art" the artistic production of persons, however influenced, professing the Jewish religion or of Jewish stock.

Whatever may be the final conclusion, one thing must necessarily impress the student. Irrespective of the spiritual or psychological bond between them, the Jewish artists, generally speaking, reflect faithfully the fashions of their countries and their age, and it is difficult to find any superficial element in their work that can be designated as "Jewish." In every case, the national feeling and atmosphere are uppermost. The Anglo-Jewish artists of the nineteenth century were as profoundly Victorian as Max Liebermann was German. It is possible to distinguish between the work of a Jewish and a Christian manuscript illuminator of the Middle Ages only by such inconclusive trivialities as fidelity in depicting Jewish rites, or other special Jewish motifs. A bond of union may perhaps be discerned among the Jewish painters of the Paris school, but this is due more to the common physical background of the Eastern European ghetto, from which so many of

them emerged, than to the essential Jewish heritage, which they shared with their more tranquil Occidental colleagues.

VI

It is proposed then to describe in this volume the artistic achievements in every medium of Jews and persons of Jewish birth, from the earliest times down to the present day, together with objects and buildings of specific Jewish ritual use, whether their authorship was provably Jewish or not. The term "Jewish" thus applies here to authorship and to object; it is not intended to apply to the content. Because the Jewish people and the land of Israel cannot be considered separately, a preliminary chapter is devoted to pre-Israelite Canaanite art, which must necessarily have affected the artistic production of the early Israelites and is integral to the past culture of Palestine.

The variety of Jewish religious art in the Middle Ages and the subsequent centuries will become manifest in reading these pages (chapters VII–VIII in particular). It must be admitted, nevertheless, that except perhaps in one or two isolated cases, it does not bear comparison with the extraordinary achievements of European religious art in general of the period. There are many reasons for this. Poverty, tension, and destruction must all be taken into account. But there is a more fundamental point. The synagogue was essentially a place of intimate prayer; it was not a place of assembly for a dramatic public function. Public worship among the Jews had as its focal point the Scroll of the Pentateuch, not the altar at which the perpetual miracle of the Mass was performed. The Scroll demanded indeed meticulous penmanship and received deferential treatment. But the appurtenances of public worship, not being associated as among the Christians with the conception of human salvation and the perpetual manifestation of the actual Divine presence, did not impose such elaborate treatment. Scholarship, or charity, was the highest form of service. It was more meritorious to provide bread for the poor, or books for the student, than adornments for the synagogue. The centrality of cult-objects, which was almost fundamental to Christianity and was thus responsible for the finest artistic achievements of the Middle Ages, was hence absent in Judaism. Jewish life gained in warmth what the synagogue lost in artistic beauty.

VII

Recent investigations and theories have suggested that the place of "Jewish Art" in art history may be far greater than the slender relics would imply when taken in themselves. The discovery of the great series of synagogue frescoes at Dura-Europos suggests the possibility that Christian ecclesiastical art — on which medieval and eventually modern European art ultimately depend — may have developed out of an anterior synagogal art, in much the same way as church music is believed to have developed out of that of the Temple and the Jewish liturgical chant. Obviously, the sparse instances of Jewish artistic productivity that have survived from this period do not stand alone, and we have to imagine that the Dura-Europos ruins represent not the exception, but the norm of the place of worship of a well-to-do Jewish community in that environment. It has been pointed out that the frescoed scenes necessarily present a continuous story, not a number of disjointed episodes, since the intention was to illustrate and emphasize the moral teachings of the Biblical accounts. This style, which was carried over into early Christian art, has been described as an original Jewish contribution to pictorial art.

The collaborators on this volume — all experts in their fields — are drawn from half a dozen different countries and have as many different backgrounds. Each has been left to deal with his subject in the way that appeals to him. The reader will note considerable difference of approach and of interpretation. This has been deliberately allowed to stand, and will be a perpetual reminder that we are still working a new field, where the hypotheses are not yet sufficiently established. The Rabbis of old said that there were a hundred ways to approach the study of the *Torah*. It is not beside the point to emphasize that the same applies to the study of Jewish Art.

PART ONE:
JEWISH ART IN ANTIQUITY

PALESTINIAN ART BEFORE
THE ISRAELITE CONQUEST

by JEAN PERROT

It is said that the history of origins is always the easiest to write because it has no documents. This might well apply to the study of the first Palestinian art; works worthy of consideration are so few during a period which is reckoned in millennia that we cannot in our present state of knowledge trace continuity of artistic evolution or attempt to isolate common features. At most, we may endeavor to determine the origin and degree of alien influences — Egyptian, Mesopotamian, Aegean, and Syrian, which successively distinguish Palestinian art and give it its essentially composite character; for the most part, and predominantly so in the remotest periods, we have only isolated works.

Nevertheless, a common origin is shared by all the works of art produced on Palestinian soil; a subtle bond links them through the centuries. A study of Jewish and ancient Hebrew art cannot be disassociated from that of its Canaanite predecessors, and in the same way, if to a lesser degree, a knowledge of pre-Canaanite art must necessarily contribute to a better understanding of the art of historic times.

The rapid sketch which it is our intention to trace here has as its geographical framework Palestine on both sides of the Jordan. In all periods it is possible to isolate a zone south of the Dead Sea on the fringe of the Arabian and African deserts. All the civilizations which follow one another in this semi-arid region are essentially pastoral, whereas to the north more favorable conditions permitted a settled population and the development of an agricultural civilization.

This is, on the whole, a poor country, where the conditions favorable to artistic achievement seldom converged throughout the historic period; while the geographical situation on the frontiers of the Egyptian and Syro-Mesopotamian empires frequently made it a battlefield.

This was not so, however, at the end of the Stone Age. The country's slight agricultural possibilities did not then constitute a handicap to the sparse population, which found natural shelter in caves throughout the mountainous zone. Palestine was not yet the corridor of invasion which it was to become in the second millennium, but a closed region protected by the deserts encompassing it on the south and east. It is not until Neolithic times that we find in the south of the country the first traces of penetration from Africa or contacts with it. During the preceding millennia, the country offered to Middle East men optimal conditions of life — wheat, it should not be forgotten, grows wild here — and it is possible that Palestine was a first focus of the new civilization at its beginning.

These considerations compel us to divide our study into two main parts. The first will be

devoted to the art of the late Stone Age beginning with the Natufian—the oldest Palestinian art known to us at present, whose first manifestations may be placed in the 6th or 7th millennium before the Common era. In the second part, we shall review briefly the art of the successive phases of the Bronze Age down to the Phoenician art of the thirteenth or twelfth centuries B.C.E., when the invasion of the maritime peoples, on the one hand, and the Israelite conquest, on the other, put an end to the history of Canaanite Palestine.

II

Art does not make its appearance in Palestine till the Natufian phase of the Mesolithic period. No work of art accompanied the Palestinian industries of the Upper Paleolithic, although the same period in Europe evinced an unusual artistic flowering. The engravings which it was thought could be detected on the walls of Umm Qatafa cave in the desert of Judea, representing a fantastic procession of elephants, hippopotamuses and horned rhinoceroses, have not satisfied specialists, to the great relief of paleontologists faced with a fauna which has long disappeared.

The Natufians of Palestine, whose original culture has been revealed for us chiefly by recent excavations—"Natufian" being derived from Wadi Natuf, in Western Judea, where the culture was encountered for the first time—dwelt in the caves of Carmel and Judea. Like their Paleolithic predecessors, they still lived by hunting, but their existence was already semi-sedentary; they harvested cereals, winnowed grain, and ground it in querns. They tamed the dog and perhaps other animals as well. The Natufians had their cult of the dead, as testified by the numerous decorated skeletons found in the Carmel *Fig. 1* caves; they had a taste for self-adornment, as proved by beads and pendants; and tools which they decorated with carvings in high relief reveal them as highly skilled artists.

The Paleolithic tradition is represented by some carved calcite pebbles found in the caves of El-Wad, in the Carmel, and Ain-Sakhri, in Wadi Khareitoon. A small statuette found in Sha'ar Hagolan is of the same tradition, though may be of a slightly later date. This small very schematic human figurine, only 65 mm. in height, is characterized by considerable development of the buttocks, while the trunk ends above the waist, which is indicated by an incised line, without any sign of the head and arms. The lower part is merely a rough cylindroconical peg with a median furrow to show the legs. This figurine is an exact replica of a Late Magdalenian figurine from Mauern in Bavaria, and of another, probably of the Grimaldian epoch, found in Tuscany. These representations are also related to the schematic images of Petersfels in the Jura and to the curious late Paleolithic stylizations of Mezine in the Ukraine. All repeat the same symbolism, which seems to have been common to the entire European Paleolithic world. Although signposts are lacking between the plain of Russia and Palestine, the possibility of a relationship should not be discounted. This would be further confirmed by the resemblance to be observed between another fragmentary figurine found at Sha'ar Hagolan—a woman's body whose modeling is not ungraceful—and an Aurignacian figurine from Linsenberg in the Rhineland, a site where the presence of bilobate pendants like those of the El-Wad cave (Carmel) have been reported.

The masterpiece of Natufian art is unquestionably a small animal statuette in gray *Fig. 2* limestone, 15 cm. in length, from the Judean cave of Um ez-Zuweitina. It represents a crouching gazelle, its neck outstretched as if to drink; the head, unfortunately, is

broken. The legs, very slender, are flexed under the body, the tail is short and fine, while a light relief separating the back from the belly appears to indicate a difference in the color of the hair. Traces of red paint can still be made out on the belly and hind quarters. Quiet and graceful, and perfectly executed, this work, despite its mutilation, bears witness to the Natufian sculptor's love of full forms and beautiful shapes; without losing the feeling of life and movement, by intelligent simplification and the elimination of the accidental, it attained a purity of line and a balance of masses which is the mark of all naturalistic art at its apogee.

The interest of the Natufian artist in animal forms found further expression in the decoration in high relief of several reaping-hook hafts found at El-Wad, at Kabarah, and in Wadi Fallah. That from El-Wad represents a fawn, its head drawn backward as if to suckle, in a *Fig. 3* graceful movement, all the more remarkable because it is imposed on the sculptor by the shape of the epiphysis. The body and head of the animal are worked in high relief at the end of the bone, while the feet stretch along the stock. They are marked at the knee, shoulder, and breast by parallel incisions, doubtless indicating folds of skin, much as on the figure of a wild goat of Magdalenian IV from Mas d'Azil. With the same felicity as the European artists of this period, those of Natufian Palestine understood how to adapt figure to material. These decorated sickles may be compared with the more recent and less beautiful examples found in the lower levels of Tépé Sialk on the Iranian plateau. They are decorated in the same fashion with animal motifs and, in one instance, with a human figure. This relationship is emphasized by a comparison of the bone-remains of the earliest inhabitants of Sialk with those of Byblos and Megiddo who belong to an ethnic group showing sufficient affinity with Natufian man to support the assumption that there was racial affinity. While not venturing a hasty conclusion on the immediate origins of Natufian art and culture, we may say that apparently there may have been contacts between the Middle East and the northern regions, where the artistic tradition of the European Upper Paleolithic survived fairly late. We encounter it still vigorous in the Mesolithic age in the Baltic lands, on a horizon chronologically not very remote from that of the Palestinian Natufian. It should above all be remembered that as far back as we can go in history, Palestine appears linked to Eurasia, and the ancient Palestinian industries were, in Neuville's words, "nearer to those of la Vézère than to those of the Nile." This remote dependence of Natufian art does not deprive it of any of its originality, for the sculptors of Mount Carmel understood how to renew the ancient formulae and to apply the old decorative subjects to new types of tools such as reaping hooks or basalt pestles, which were also often adorned with some animal motif. They were the first artists of the Middle East.

Some scholars attribute the rock engravings of Kilwa in the southern Transjordanian desert to Natufian art. This suggestion, however, encounters considerable difficulties of an archaeological, aesthetic, and cultural character.

These engravings were discovered in 1932 on the sandstone rocks of Jebel Tubaïk, a mountainous massif of S. Transjordania, at the crossroads of the natural routes leading from Palestine to Hejaz and Arabia and from the Gulf of Aqaba towards Lower Mesopotamia.

The oldest engravings, of which only a few will occupy us here, generally represent wild goats, but a bovine, a dromedary, a hare, and other animals are also seen. Men appear only rarely. The animals are shown life-size (the bovine is 2 m. 35 cm. long). The technique

used is that of a broad deeply cut line, which obviously did not allow for much refinement of drawing: the surface, framed by the lines, is never worked. These engravings are often clumsy and schematic, but in some cases the accuracy of the outlines testifies to careful observation and a sure sense of form and movement. The very coarseness of the line vibrating in the light imbues these images with a surprising animation.

One fine beast has been caught at full gallop, his nose to the wind, his long horns descending gracefully behind, his forelegs gathered under his outstretched neck. Others, pierced by arrows, have halted motionless, already seized by death. One, coughing out his lifeblood, is almost a prototype of the wounded animals which the Assyrian sculptors were later to represent with such forcefulness. Only hunters, by daily experience which enabled them to accumulate powerful and dynamic visual impressions, could possess such familiarity with animal forms. We are here in a true hunter's world with arrow-pierced animals, figures bearing marks of blows, and mating beasts. This is huntsman's magic. These are rites to ensure the success of hunting-parties, a magic for reproduction, since it is vital that the game multiply and procreate, that there should be enough to kill in abundance.

Some of the goats seem to be dragging hobbles, or to be wearing a sort of halter, and may be domestic animals or animals recently caught to increase the livestock. At least some of these engravings — which are somewhat cruder and are perhaps of a later period — may be the work of the first pastoral people. But the tendency of prehistoric artists to portray animals at the height of their physical development should not be forgotten, and what we have described as hobbles may in fact be traps which are often pictured in this way. The Kilwa engravings have been related, as mentioned above, to Natufian art — in particular to the statuette at Ain-Sakhri, described above, of an enlaced couple. The interest of this comparison is primarily ethnographical; for this as a mode of coitus is not uncommon even today among the Bedouin of Israel and Jordan and the Kilwa engravings may be compared to the modern schematic engravings recently discovered on the rocks of the Central Negev. The Kilwa and Judean representations arise from the same symbolism and the same fertility cult, but they are not enough to prove the existence of a cultural link. Even if it were to be established that the inhabitants of the two regions belonged to the same ethnic group, the fact would remain that their arts are quite different from one another. While the Natufian artist who prolonged and renewed the European Paleolithic tradition was primarily a sculptor, the Kilwa artist was an engraver whose source of inspiration and models have to be sought in quite a different direction, namely, southward — on the sandstone rocks of Libya, of Fezzan, the Saharan Atlas, and as far as Morocco. It is from this far-flung school of rock art that the Transjordanian engravers borrowed their taste for life-size figures, their technique, and even some of their themes. There are obvious African parallels to a scene at Kilwa showing a man with raised arms before a tethered bovine. This man, whether suppliant or hunter, whom we find a little later in Palestine on an engraved pavement at Megiddo, proves with the other Kilwa engravings the artistic and cultural relations which existed between south Palestine and the African world at the close of the Mesolithic and at the dawn of the Neolithic age. The engravings of Kilwa and those with hammered surfaces in the region of Aqaba and the Negev are to be compared with the predynastic Egyptian rock drawings, and confirm both the continuity and intensification of relations established during the fourth millennium.

III

Northern Palestine was at this time in full Neolithic evolution. Along the entire coast from Byblos to Ascalon, inland in the mountains of Galilee and Samaria and in the Jordan Valley, the population became settled and increased in numbers as the development of agriculture and the domestication of animals transformed the economy. The control of these means of existence secured new leisure, technology made rapid progress, and weaving and pottery appeared simultaneously with the first industrial specialization. This material progress was linked with a profound modification of society, now organized on a broader basis, and the first villages were founded.

These changes took place slowly, perhaps under the influence of the north Mesopotamian regions, which were richer in agricultural resources and therefore achieved the speediest progress. But in Palestine a break with the past cannot be recorded. The figurines of Sha'ar Hagolan described above evidence the survival in the Neolithic period of certain religious and aesthetic conceptions of the preceding epoch.

On the other hand, the cultural evolution was conditioned by physical conditions, whose diversity resulted in a well-marked cultural particularism. While the population of the Judean hills led an existence not essentially different from that of its Mesolithic predecessors, in the Jordan Valley, the brilliant Jericho culture, the most original of the Palestinian Neolithic cultures, was flowering, and gave testimony to new religious and aesthetic conceptions. These found their expression in those astonishing clay statues, discovered in the lower levels of the mound, whose remains must be placed among the chief works of ancient art in the Middle East. A strange flat head, evidently only meant *Fig. 4* to be seen from the front, is of nearly natural size, measuring 20 cm. in height. The face is a rounded oval, the eyes, made of seashells inserted in the clay, are set very low under prominent brows. The chin is flat, the cheekbones are projecting, the nose is small and upturned. The mouth is slightly pouted, fine and thin. Stiff straight hair, painted in dark brown-red, escapes and falls to the eyebrows from below a sort of cap, indicated above the forehead by a light pad. The beard is represented in the same fashion, by lines radiating around the face. We do not know whether this artist of Jericho aimed at portraying divinity, as has been suggested, but in any event he succeeded in spiritualizing his vision and in leaving us a somewhat mysterious and solemn image, not lacking in grandeur. The head belonged to a body — one leg slightly flexed — modeled full-figure on a reed framework, whose fragments surprised us by the skill they display. This statue was the largest of a group of three found together; of the smallest, which may have represented a woman and child, only fragments remain.

Seven decorated craniums recently discovered in the same levels at Jericho suggest an analogous aesthetic approach, but here the skulls themselves served as supports on which the outlines of faces were modeled, the eyes being encrusted with shells. These decorated skulls may feasibly be related, as Miss K. M. Kenyon suggests, to ancestor worship.

The "Munhata phase" of Neolithic culture (circa 5000 B.C.E.*) has provided a large number of human figurines, mostly done in terra-cotta, and excavated in the Jordan Valley at Jericho and at Ḥurvat Minḥa (Khirbet Munḥata) and in Sha'ar Hagolan. The statuette of a seated woman found in Ḥurvat Minḥa probably represents a fertility goddess. The terra-cotta figurine, 11 cm. in height, is a wonderful achievement of the Neolithic artist. It is made of several pieces of clay attached together and incised in order to distinguish the head, the buttocks, and thighs. Finer pieces of clay were stuck on to the

* Before Common Era.

figure to represent the nose, eyes, ears, breasts, and arms. It is a very subtle and regal statuette, with very pleasing proportions and attractive in composition.

IV

In the second half of the fourth millennium, new progress was made in Palestine. The discovery and growing use of metal marked the opening of a new economic era, which continued without great changes till the end of the third millennium. Two great hearts of civilization were kindled now in Mesopotamia and Egypt; but Palestine, remote from these centers, knew only their reflections. If Neolithic particularism began to blur, the fundamental cultural duality between the north and south persisted and is well illustrated by the emergence in the southern areas of an original culture, that of Beersheba and Ghassoul.

Its origins are still unknown; it is possible that they are to be found in the marginal area of the south Transjordanian plateau, in the country later to be known as Edom and Moab. At any rate, the newcomers — for the appearance of the new culture in Palestine seemed linked with an ethnic intrusion — maintained close commercial relations with southern Transjordania, best explained by an emigration from those parts. The very highly developed copper industry of Beersheba could hardly have originated except southeast of the Dead Sea in the neighborhood of the rich copper-sites in the Wadi Feinan, which were to be subsequently exploited throughout the historic period. The Transjordanian plateau probably provided also the basalt in which the craftsmen of Beersheba were able to carve large thin-walled bowls decorated with lines and incised chevrons and delicate cups with hollow feet and four openings.

The northern and eastern Negev, hitherto uninhabited, now experiences a phase of fixed settlement. Side-by-side with stock-raising, agriculture developed in the valleys wherever the meager water supplies allowed. Surprising underground villages hollowed in the loess and alluvial soils afforded the settlers effective shelter against the extremes of the climate. From these dark dens have emerged the remains of a brilliant culture and genuine art. These remote inhabitants had a taste for adornment, which manifested itself in pendants of mother-of-pearl, turquoise and bone, stone and ivory bracelets, copper rings, necklaces, and palettes for cosmetics. That they loved beautiful shapes is revealed by their often elegant stone and earthenware crockery. Above all, they possessed a deep aesthetic feeling, as shown by the extraordinary ivory statuettes found at As-Safadi.

Fig. 5 One of these, measuring 12 cm. in height, is known as the "Venus of Beersheba." It represents a headless naked pregnant woman holding her hands under her swollen belly which like her upright breasts has holes in its middle. These may have contained colored stones. Smaller holes on her wide triangular waist may have had strands of wool or actual hair woven through them. The arms are set apart along the neatly shaped body and the shoulders are rounded, forming a convincingly natural impression of the upper part of the chest. The legs, which are very long, are set apart, round and slender, with slightly protruding knees. The thigh, set very high, projects backwards in a way which satisfies the eye, imparting an equilibrium and sense of movement, which rids the figure of some of its hieratic character.

Fig. 6 This statuette is not alone. The small ivory head of a woman from Beersheba complements this figure. It is treated with particular care, and the skull, which is very short, shows a

pronouncedly flat occiput, perhaps corresponding to some aesthetic canon or technical need, but harmonizing with skeletal remains that have been found. The head is hollow and reminds us of the cup-mark on the head of some statuettes from Négada, but the hollow may have contained the knot of the wig which the statuette wore. The eyes were filled with black material and originally encrusted with mother-of-pearl representing the pupils. The nose is long, straight, and prominent. The ears are marked by a perforated circular swelling. Unlike other figures, the head has no holes for a beard, which may mean that it is the portrait of a woman, possibly a goddess.

Another head of a woman may have been a large pendant figurine, the face together with the headgear measuring 8 cm. The face is a highly elongated oval, the nose very long, and one of the eyes preserves encrustation. The mouth is only slightly indicated, while a simple bulge represents the ears. The figure's headgear was perforated for a necklace, so that this figure could have been an amulet of some sort. A bone pin from the same culture is decorated with the figure of a pelican, lively and vigorous in style despite the small dimensions of the object (45 mm.) *Fig. 7*

Fig. 8

Much rougher work is an ivory hippopotamus head, meant to be attached to a support. The eyes and nostrils are indicated. Hippopotamus incisors as well as elephant tusks furnished the Beersheba ivory workers with their raw material; they could have seen the former animal in the swamps of the coastal plain where it was to be found down to the last centuries before the Common era, while the elephant, who may then have lived in the Jordan Valley, was still abundant in Syria long after.

The affinities of the Beersheba culture with those of pre-dynastic Egypt are probably to be explained by the earlier penetration of African influence into southern Transjordan alluded to above in reference to the engravings. But it is still too early to define the mechanism of the formation of the culture. It is otherwise with those elements of the culture which invite search in a direction other than Egypt, this being particularly the case with the painted and engraved pebbles, linked with the Neolithic examples from Sha'ar Hagolan and farther afield. A small schematic figurine in gray stone, representing a man seated on his heels with his knees on the ground and with flexed thighs, recalls the Aegean world. Finally, it seems that in some of its aspects, this southern culture was not uninfluenced by Mesopotamia.

Contemporary with Beersheba and representing the same southern culture, Ghassoul has preserved for us, above all, large painted compositions adorning individual houses and representing people, animals, birds, and geometric motifs. One of these paintings measuring 4.5 m. in length, unfortunately survives only in part, in bad condition. A series of colored spots which can be distinguished inside a yellow frame has been interpreted as representing successively red and yellow rays, and then the feet of several persons. Two, in the center, of large size, are painted in brown-red. Their contour has been drawn twice over, then streaked down to the ankles with slanting white lines. These feet are resting on a sort of brown elevation, very distinct over the ground line. Then, on the right, comes a shapeless yellow blob, probably a chair, then again, also on an elevation, legs slightly smaller than the preceding, also followed by a yellow blob. To the rear, but this time on the ground, appears a series of feet much smaller than the preceding. We have here, according to the excavator, the picture of a princely family with the children standing behind, while in front a small naked brown person, preserved to breast level, is a servant. The rays would have belonged to a solar disc or to a star.

Another painting at Ghassoul, better preserved, represents a large star with five rays of red and black, measuring not less than 1.84 m. in diameter. Around it appear various motifs, hard to identify, which have been thought to be monsters and mythological beasts. The large star appears like other motifs encountered at Ghassoul to embody aesthetic interests analogous to those of the Beersheba sculptors. It is the same taste for abstract expression carried beyond realism to the point of being geometric. From a technical point of view, the Ghassoul paintings are less isolated since the discovery of the Mesopotamian mural paintings of Tepe Gawra and of the later (Protolithic) examples at the temple of Tell Uqair. The techniques, if not the themes, are comparable.

It may be said of the southern culture that it marks a particularly fruitful period in Palestine. Its artistic features are of astonishing originality and boldness, and it will be interesting to determine, when it becomes possible, its ethnic connections. The northern area has nothing comparable to offer in this period, although its material progress follows a parallel course, and there we already find the image of what Palestine was to become in the third millennium.

V

The transition to the Bronze Age took place without apparent upheavals.

It is true that Palestinian art of the third millennium is virtually unknown to us and new researches may reveal it, but at present the only finds which can hold our attention are cylinder-stamped jars, some engravings at Megiddo, and a few objects of bone and ivory.

The cylinder-stamps and seals found at Megiddo, Farah, Jericho, Et-Tell, Beth Yerah, and other sites of northern Palestine comprise, like the well-known examples from Byblos, floral or animal motifs and four-legged beasts in continuous friezes or animal heads in irregular order. These belong to a group of Egyptian and Mesopotamian affinity whose center of diffusion seems to have been southern Syria.

It is also to an influence from the north that we must attribute two small ivory bulls' heads, nearly identical, discovered respectively at Jericho and Beth Yerah, in levels of the second half of the third millennium. Technically these objects are less surprising since the discovery of the Beersheba ivories, among which we have noted a hippo-potamus' head attached with the help of two lateral perforations at the base of the neck to a body of different material. The Jericho and Beth Yerah heads show similar arrange-ments for attachment. But if we do not have to regard them as important (it may in fact be imagined that the tradition of the ivory-sculptors did not disappear with the Beersheba culture), they nevertheless testify indisputably to foreign influence. Both actually have a triangle cut on their foreheads certainly designed to take an encrustation. These, though recalling the white triangle on the forehead of the Egyptian Apis bull in later represen-tations, have prototypes in the animal heads with triangle on forehead from the Diyala and Middle Tigris regions. The eye is executed in the same manner (encrusted and surmounted by concentric arcs) on the heads from Jericho and Beth Yerah, and on the copper examples that adorn the lyres of the royal tombs at Ur. In Palestine, the Early Bronze Age is characterized too by the intrusion of a new ceramic technique (Khirbet Kerak ware) whose fine black and red products, carefully polished, are well-known in Syria and as far as Anatolia, where, it seems, their origin must be sought.

If Palestine was not the principal route of commercial exchanges between Syria and

Egypt, it, nevertheless, established direct trade relations with Egypt, as is evidenced by Palestinian pottery in the tombs of the Pharaohs of the first dynasties and even in some proto-dynastic tombs. In Palestine, a rectangular schist palette from Jericho and objects of attire such as the hippopotamus head in carnelian from the tomb of Assawir may be considered as resulting from trade contacts with Egypt. The alabaster cups of the Ai sanctuary, identical with those of the tombs of the second and third dynasties, are another example of these imports. A curious zoomorphic vase imitates a pig whose legs are bound to its body by cords, as if the animal were prepared for sacrifice. A fine object also coming from the Ai sanctuary is an ivory knife handle of very fine workmanship decorated by small incised triangles perhaps intended to receive an encrustation.

In the deep levels at Megiddo, potsherds have been found bearing representations of persons or animals incised with a flint point in a naïve style comparable to that of the pre-dynastic engravers in Egypt. These African analogies recur at Megiddo in the engravings on the pavements forming the floor of a building at level XIX. One of these engravings represents a giraffe; the animal's body is covered with hatching, doubtless to express his coat, as in the African rock engravings. Another engraving represents a bull with long hatched horns, also of African type, but the drawing has a new interest in the treatment of the anatomy in separate masses, much as in certain Egyptian proto-dynastic representations influenced by Mesopotamian art. The drawing of the animal's forefoot, withdrawn against the body, is characteristic of this style too. A third engraving shows a man walking to the right with raised arms; a cord hung from his neck holds an amulet, and he wears a broad oblique striped belt. The man's attitude, well-known from the rocks of North Africa, is that of prayer or of a hunter raising his bow with one hand and his arrows in the other; but at Megiddo it is difficult to see a bow in the many-stringed instrument, a sort of harp, which the man holds in his left hand.

It has been suggested that the steles at Shihan and Baluah in Transjordan should be attributed to this same period. The Shihan stele (now in the Louvre), unfortunately very mutilated, shows a helmeted man with naked torso, the loins girded with an apron of Egyptian style. From a projection on the helmet hangs an appendage which passes behind his shoulder and ends in a coil. The man is brandishing in both hands a spear whose point is turned towards the ground. Near him stands an animal, considered by some to be a lion and by others a bird. The general shape of the stele, the position of the figure, the head in profile, the shoulder and chest seen frontally, and the legs again in profile certainly show Egyptian influence, contemporary with the Pyramid age. Such dating is not entirely without its difficulties, for it makes it hard to explain the additional object falling from the helmet. This is a Hittite attribute of which we know no parallel older than that of the Guardian at the royal gate of Boghaz Keuy, whose general stance is also not dissimilar. A date for the Shihan stele as late as the end of the Bronze Age is not therefore to be wholly excluded.

VI

At the end of the third millennium Palestine seems to have been in a state of upheaval, Beth Yerah, Ai, and Jericho being destroyed. At this time, the Amorite nomads of the Syrian desert began to invade the neighboring districts and to become settled. This movement was accompanied by one in Palestine which disturbed Egypt. This troubled period is marked by a decline of civilized standards; its art is known to us but its pottery

testifies to new influence by the appearance of elegantly profiled wares known as calciform.

Under the Pharaohs of the 12th dynasty, Egypt recovered and reestablished its influence in Asia; by binding the kinglets of Palestine and Syria with a system of alliances and friendships, they reinforced their Asiatic frontier, simultaneously securing their own communications with the lands whence they drew indispensable raw materials, such as timber. The monuments of Ugarit and Qatna and the tombs of Byblos give some idea of the degree of Egyptian influence on the artists and craftsmen of the Syrian coast. The royal and princely tombs of the Phoenician city contain exquisite works of art, royal sphinxes, weapons, jewels, and scarabs inscribed with the names of Pharaoh, most of which were imported from Egypt, but whose presence stimulated local artists, especially the goldsmiths and jewelers, who copied foreign motifs solely for their decorative value, without paying attention to their significance.

The revival of Egyptian power was of brief duration; divided by dynastic rivalries, Egypt was soon too weak to maintain her imperial power over the Asiatic provinces, where new ethnic elements, Hurrian and Indo-Aryan, made their appearance. From the second half of the 18th century Syria and Palestine were particularly independent and slowly developed their economies and military power. Even before the end of the 18th century, the first Semites, forerunners of the Hyksos, crossed from Palestine to Egypt. This is the age of the Patriarchs, and at this time may be set Jacob's migration within the framework of the great Hyksos invasion. The latter, bearers of a superior armament and mounted on swift chariots, rolled in successive waves across Palestine and conquered Egypt. In the 17th century, Palestine was thus at the geographical center of a vast empire controlled from the Hyksos capital of Avaris in the Delta which stretched from Nubia to the Euphrates. The Palestinian tombs of the period have yielded, besides numerous weapons, thousands of scarabs, gold and silver jewels, pins, necklaces, bracelets, buckles with pendants, and other forms consisting of stamped metal discs with granulated decoration and two ear-like projections for suspension. A fine example of this technique at Tell Ajjul represents a bird with outstretched wings. There are also diadems and frontlets worked in repoussé on beaten gold leaf, and amulets of the same technique representing the naked goddess are sometimes grouped in necklace form; these amulets, found along the entire coast from Tell Ajjul to Ras Shamra, are a fair indication of the cultural unity which then permeated the Near East.

Among the pottery there are, besides numerous calcite and alabaster vases, some graceful and well proportioned forms which often imitate metallic prototypes. This is the golden age of Palestinian ceramics in which the polishing of vases, their finish and execution, and, at the end of the period, their paint and plastic decoration reflect true *Fig. 10* aesthetic feeling. A vase with human head from a tomb at Jericho shows a face with a fine prominent nose and eyes framed by brows which, like the ears, are somewhat over-emphasized, the ears serving as jug handles. The beard and coiffure are represented by stippling of the head encrusted in white material. This human type recalls the fine silver statuettes plated with gold found at Ras Shamra, which are, together with two other statuettes likewise representing a divine pair, the best illustration of the Canaanite bronze-smith's art of this period. In Palestine some good examples have been found at Megiddo, among them a bronze figurine representing a man with extended forearms wearing a necklace and high headdress which recalls the Egyptian crown. A fine modern figurine

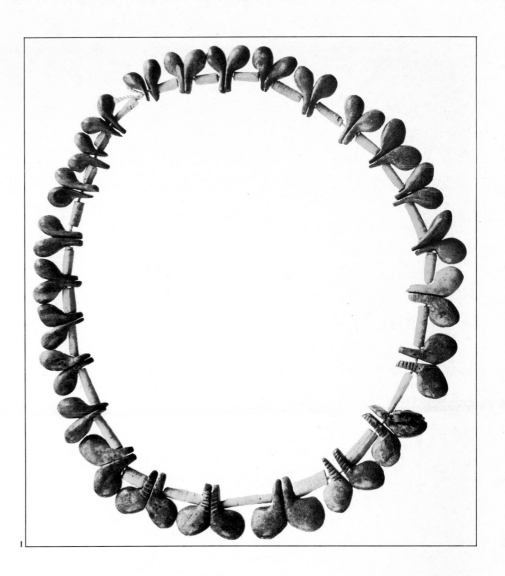

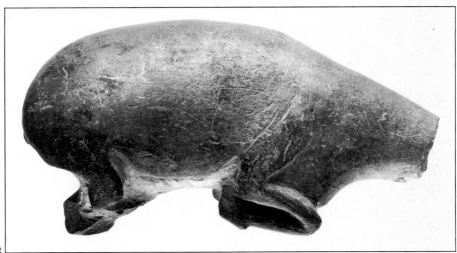

1. Bone necklace. Cave of El-Wad, Carmel. Natufian art.
 Department of Antiquities and Museums, Jerusalem.

2. Crouching gazelle, stone. Cave of Um ez-Zúweitina,
 Wilderness of Judah. Natufian art. Department of Antiquities
 and Museums, Jerusalem.

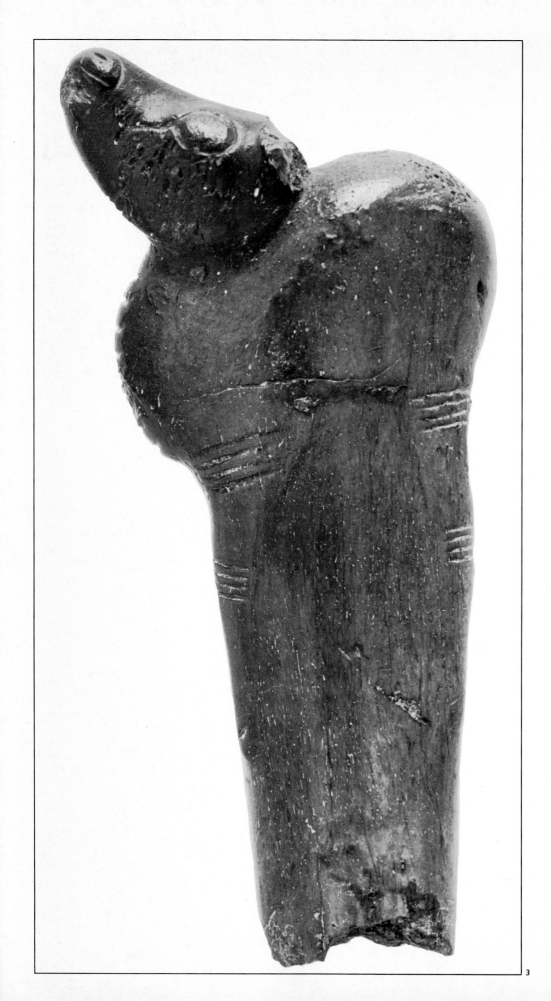

3

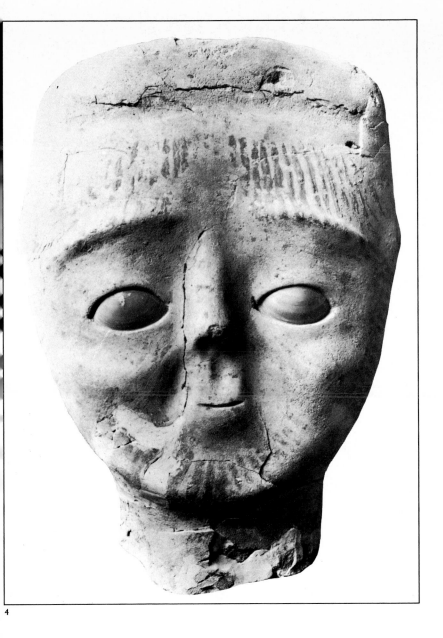

4

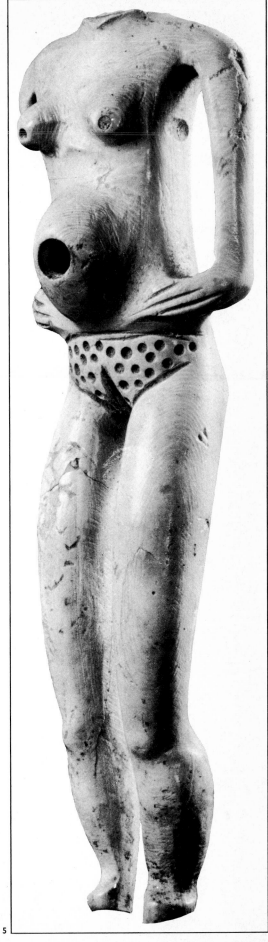

3. Head of gazelle (reaping-hook haft), bone. Cave of El-Wad, Carmel. Natufian Art. Department of Antiquities and Museums, Jerusalem.

4. Human head, clay. Found at Jericho. Neolithic art. Department of Antiquities and Museums, Jerusalem.

5. "Venus of Beersheba". Ivory figurine of a pregnant woman. As-Safadi. Beersheba Culture. French Archaeological Mission in Israel.

5

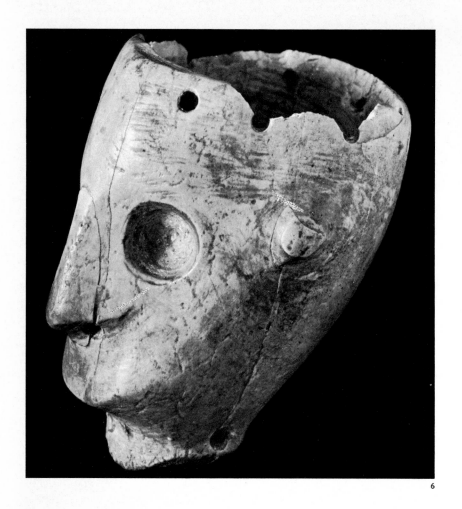

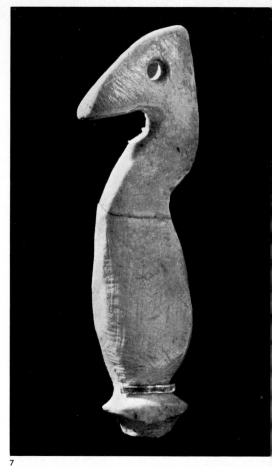

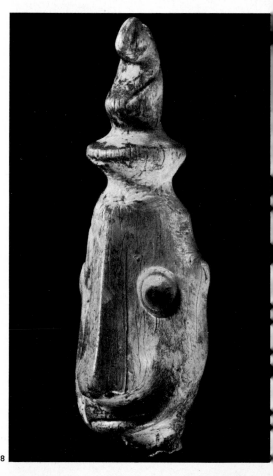

6. *Ivory head of a goddess. As-Safadi, Beersheba culture. Department of Antiquities and Museums, Jerusalem.*

7. *Pelican pinhead ornament. Bone, from Abu-Matar, Beer-Sheba culture. French Archaeological Mission in Israel.*

8. *Ivory head of a pendant figurine. Ivory. As-Safadi, Beersheba culture. French Archaeological Mission in Israel.*

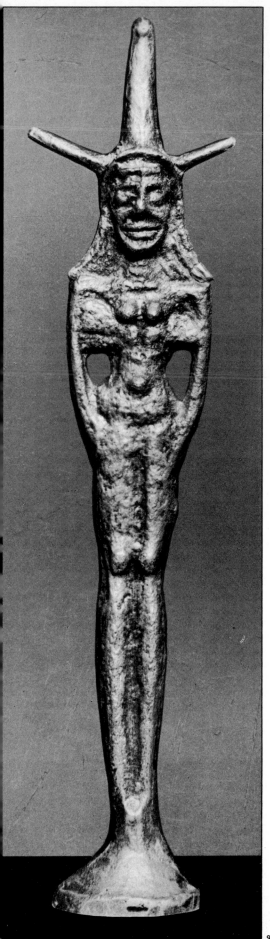

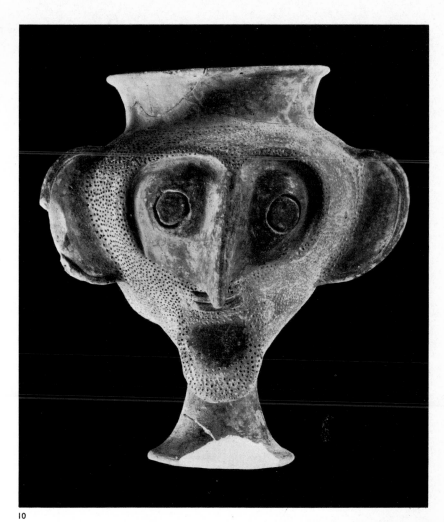

10

9

9. *Canaanite Goddess. Modern bronze cast, made from a stone mold found at Nahariyah. Department of Antiquities and Museums, Jerusalem.*

10. *Anthropomorphic jug from Jericho, 17th century B.C.E. Department of Antiquities and Museums, Jerusalem.*

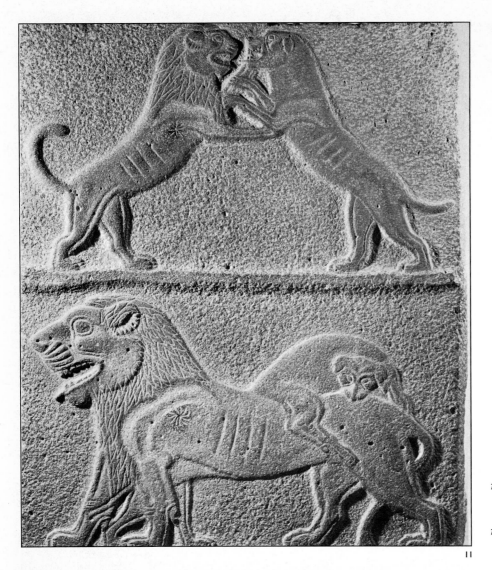

11. *Fight between a lion and a mastiff. Basalt tablet from Beth Shean. 14th century B.C.E. Department of Antiquities and Museums, Jerusalem.*

12. *Basalt deity and steli from a Canaanite shrine at Hazor. 18th century B.C.E.*

11

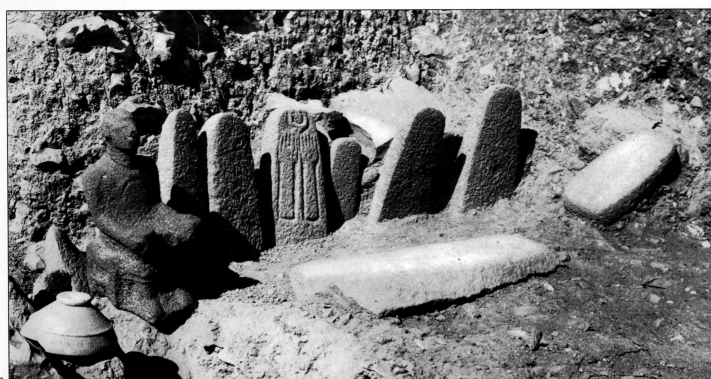

12

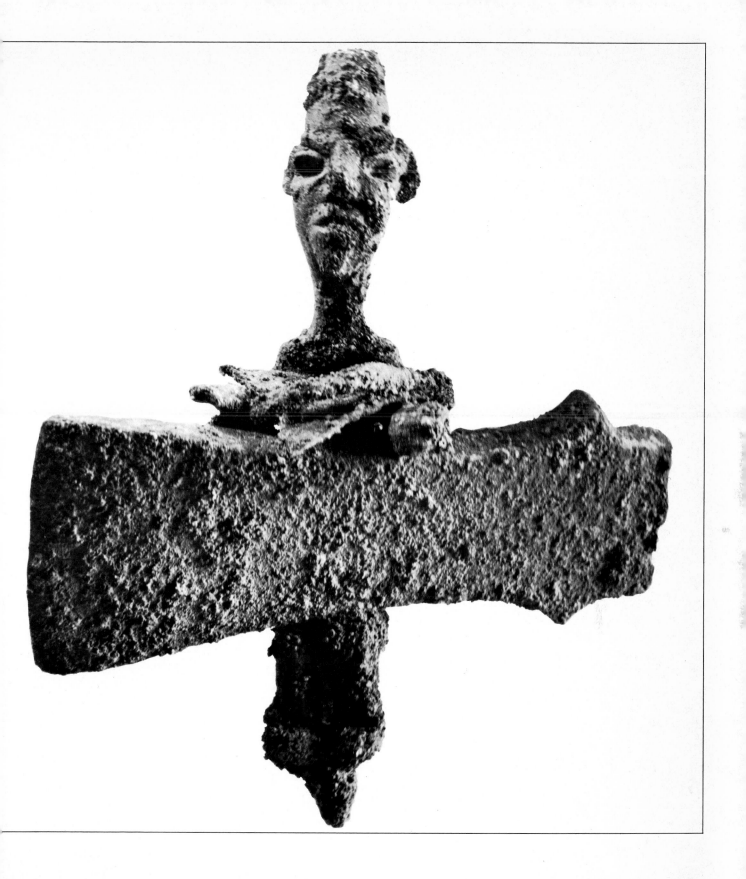

3. *Bronze figurine of war god; ax head from early Israelite High Place at Ḥazor. Courtesy of Prof. Yadin, Jerusalem, Head of the Ḥazor Archaeological Mission.*

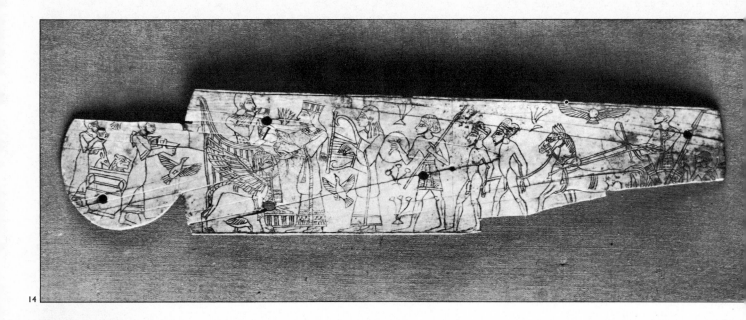

14. *A victory procession. Engraved ivory tablet, from Megiddo,
 12th century B.C.E. Department of Antiquities and Museums,
 Jerusalem.*

15. *Pottery model of shrine, found in Transjordan. Period of the
 Hebrew Monarchy. Department of Antiquities and Museums,
 Jerusalem.*

of the naked goddess, was cast from a stone mold found at Nahariyah; she wears a *Fig. 9*
high conical headdress on her long hair, and from it in front a pair of horns emerges. Her
forehead is adorned by a diadem and her neck by a triple row of pearls. Monumental art
hardly appears in Palestine; the incessant conflicts between petty princes scarcely favored
conditions conducive to a real artistic flowering. The only work we can record is the broken
stele of the "Snake Goddess" found at Beth Mirsim, where we see the Egyptian giving
place to a northern, possibly Hurrian, influence.

By the beginning of the 16th century, the Hyksos Empire broke up. The Pharaohs of the
18th dynasty reconquered the country, expelled the invader, and chased him into Asia;
after fierce battles the fortresses of southern Palestine were retaken one after the. other;
Beth Mirsim, Megiddo, and Jericho were utterly destroyed. The Pharaohs were not
content this time to acquire the precarious alliance of the country's princes, but hence-
forth based their Asiatic policy on effective conquest.

The wealth brought by the new development of commercial relations produced luxury
and stimulated the arts. The artistic influence of Egypt, which had never been completely
eclipsed during the Hyksos interregnum, now reasserted itself; jewelers and ivory-workers
emulated the models of the Nile valley. But new influences, too, can be traced at this
time; with the settlement in the coastal harbors of traders and craftsmen from the islands,
the artistic influence of the Aegean develops to the point where it sometimes becomes
difficult to distinguish between local products and imports.

VII

Palestine has yielded indeed nothing of the highest quality, comparable with the objects
found at Ras Shamra and elsewhere. The country, naturally poor and subject to constant
exactions by Egyptian military governors, was disturbed by frequent rebellions, its
civilization declined rapidly between the 15th and 13th centuries, and the little originality
retained by its art it owed to Syrian influence, as evidenced by two bronze figurines
covered with gold found at Megiddo.

Nothing illustrates this decline of Palestinian civilization better than the evolution of the
painted decoration on pottery in the same period. The end of the 16th century had been
marked by the appearance of a fine ware whose painted decoration still belonged by
origin to the great tradition of the Middle Bronze Age. The vase's shoulders are adorned
by polychrome geometric designs dividing the surface into metopes separated from one
another by fields of checkers, bands of color alternating with wavy lines, chevrons, orna-
mentation in the form of stylized palm leaves, triangles opposed at the apex, and motifs
consisting of two superimposed crosses. In the panels so framed, simple volutes some-
times appear whose centers are taken up by many-colored Maltese crosses. More often,
there are naturalistic motifs such as stags and goats, wild goats facing one another or a
palm tree, and, most frequently, birds and fish, isolated or sometimes grouped in small
living tableaux; cranes preen themselves, dolphins swim in groups, birds peck the backs
of fishes.

These themes persist in the following centuries, but the drawing becomes poor and
schematic, the color uniform. A single example, a small cup with internal decoration
from Ain Shems, may serve as illustration. Here we find the inevitable goats placed on
each side of three sacred trees. The animals, indicated merely by two triangles joined at
the apex in the center of the composition, appear to be looking back at the trees which

they are leaving, a classic movement among Aegean beasts. The free spaces are taken up by a frisking fawn and birds and the center of the cup by a small elliptical figure whose center line is picked out in small dots. We have evidently traveled far from the superb golden bowl found at Ras Shamra — it is true, a public object. Of the same period are the imported luxury vases such as the great rhytons and faience goblets discovered at Tell Abu Hawam. These vessels were imported from Cyprus in the 13th century. Whereas at the end of the 16th, the current was still flowing from the east, as evidenced by the bichrome pottery exported from Palestine as far as Ras Shamra and the islands — at the end of the Bronze Age the current had been reversed, and the products of the island workshops were flooding the coastal ports. The flourishing towns of northern Syria, grown wealthy on trade, profited from these external influences which also stimulated local artists. But Palestine, impoverished by the Egyptian occupation, not only did not benefit from these exchanges but saw its own culture in danger of suffocation.

In 1360 the Hittites conquered Mitanni. With the disappearance of this buffer state the tension between Egypt and the Hittite Empire became critical, the Amarna letters illustrating the political situation during the period. Syria and Palestine now passed under Hittite control. Egypt did not begin to react before the end of 1320 under the Pharaohs of the 19th dynasty, Seti I and Rameses II. Palestine and its ports were reconquered. But the indecisive battle of Kadesh on the Orontes left the Hittites in occupation of the rest of their Syrian conquests, a situation acknowledged subsequently by treaty. This established a compromise peace under the stabilizing influence of which the cities of the Mediterranean coast experienced a new period of relative prosperity.

An interesting monument dated at about this troubled period in Palestine is the Beth Shean orthostat, representing in two registers a fight between a mastiff and a lion. Its entire subject is obscure. It has been suggested that the struggle should be symbolically interpreted, the two animals representing two peoples or their gods, in combat, but nowhere else in the East do we see simple animals without attributes in such a symbolical role. The style of the monument is, however, so reminiscent of Syrian representations — the lion has been compared to a similar beast on the gold bowl from Ras Shamra — that the work has been ascribed to Syrian art, perhaps an import which came into Palestine as war booty at the end of the 14th or at the beginning of the 13th century. However, the recent discoveries at Hazor may lead us to consider this monument, hitherto isolated, not as local work. The small sanctuary uncovered at the foot of the rampart surrounding Hazor contained a unique collection, arranged in a niche of the wall, which will interest us here solely from an artistic point of view. The niche was decked with a row of seven basalt steles of different sizes, uninscribed except for the central one, which bore a cutting of two hands outstretched towards an astronomical symbol (the disc of the sun and the crescent of the moon) in a gesture of prayer. In front of the steles, to the left, was a small basalt statue of a bareheaded god in a long garment seated on a stool and holding a goblet in his right hand. The execution is rough, but the work, which is well proportioned, is by a good artist, and the head in particular has an air of lofty pride. On the right extremity of the niche was the figurine of a lion cut in a basalt slab, its head and forepaws only being free-sculpted at the end of the slab, while the animal's body is prolonged in shallow relief on one of the faces of the stone. The northern influence is here dominant; the man's dress and the stool on which he is seated are of Syrian type. It is moreover in North Syrian sculpture that the best analogies of the lion are to be found.

Fig. 11

Fig. 12

The stylistic homogeneity of the Hazor objects can only be explained by their local production; they reveal an unexpected angle of Canaanite art, which was revived by northern influence and may well be explained by the town's geographical situation and political independence.

VIII

From the same period in Palestine there have come to us a large number of ivory objects found at Farah, Beth Shean, Tell Duweir, and, above all, at Megiddo. The Megiddo ivories, more than 380 pieces and fragments, constitute an extraordinary collection, such as no other site has afforded. The oldest of them go back to the 14th century, the most recent to the middle of the 12th; but they all show the same artistic tradition which continues elsewhere into the succeeding century. These ivories illustrate better than any other monument the syncretistic tendencies of the period. We shall briefly describe the most typical among them.

A small plaque of quite exceptional character should be set apart from the rest. It represents several ranks of people, bull-headed men, helmeted gods and monsters, who on the upper register support a Hittite king clad in his characteristic garment and protected by the Hittite winged disc. The panel composition and accumulation of figures are obviously Hittite. Although the Canaanite ivory workers usually displayed a remarkable versatility of technique, it seems improbable that this plaque, which is unique of its type at Megiddo, is the work of a local craftsman. It is undoubtedly preferable to regard it as having been made for a Hittite king or for some northern prince and brought to Megiddo as war booty during the time of Egyptian domination.

Four small ivory plaques which possibly belong to the same furnishing are of particular interest; they show the king of Megiddo leaving for war with his chariots and footmen; the chariots are each drawn by two horses and ridden by one man. Battle is joined, and the chariots thrown into a gallop destroy the enemy. Victorious in the fight, the king accepts the homage of his vassals and subjects, who bring him an offering of ducks; finally, the king is seen seated on a festal throne, a cup in his right hand, and a lotus in his left, in the presence of his wives who sit before him. Although all the scenes are shown according to Egyptian convention, the objects are Asiatic. The throne is a simple stool, like that of the Hazor statue and those which appear later on the Assyrian reliefs.

The subject of the king's victory is treated with much freedom. We find it again on an ivory at Farah, but here the king is seated on a throne of Egyptian style, the queen is pouring him a beverage, while a servant stands behind the throne and a naked woman dances to the sound of a double flute. On another plaque from Megiddo the king first *Fig. 14* appears on his chariot bringing back naked circumcized prisoners preceded by a warrior. Behind the chariot marches an officer carrying the royal harp. The king is protected by a somewhat confusing winged motif typical of the oriental manner, and imitating some Egyptian prototype. To the left, the same king appears on a throne composed of a winged sphinx of a type unknown in Egypt but found again at Byblos on the sarcophagus of Ahiram. The king is served by the queen in Syrian dress wearing a low cylindrical crown. She proffers him a lotus flower and a napkin to wipe his lips, while a harpist plays before him. Behind the throne, two servants stand near a big basin and a plate, on which are two cups in the form of animal heads. Birds in the field of the composition have no parallels in scenes of this type shown in Egypt, and must be an addition by the artist,

who thus shows the same *horror vacui* so frequent among primitive people. Of this we have seen numerous examples above.

The same concern to fill out the composition, but with much greater skill, is found again on a remarkable comb whose decoration, this time of Mycenaean influence, portrays fighting animals. A mastiff is attacking an ibex by slipping under its body. The position is unnatural, but one must admire the skillful composition of the scene and the ability with which the artist uses to the utmost the field at his disposal. With the slenderest means, by the simple entwining of the bodies, he imparts an astonishing intensity to the fight. Beside this lively scene, the Beth Shean orthostat looks quite clumsy. To the same group also belong four rectangular plaques showing recumbent griffons with out-stretched wings. The execution shows a similar mastery and reveals the same Mycenaean influence.

These objects give but a feeble notion of the variety of the Megiddo ivories. More detailed description should be devoted to the remarkable bulls' heads, the elegant gaming tables, and numerous decorative fragments, among which ducks' heads abound, as at Tell Duweir; to the female figurines with rounded bosoms, to the astonishingly modeled back of a naked woman, or to the perfume bottle from Duweir in the form of a woman with outstretched arms holding a bowl which serves as a spoon. To the same type of rep-resentations also belong a Hazor head or cone-shaped objects from Megiddo ending in women's heads, their eyes encrusted with glass pearls. What should be emphasized, above all, is that these small works of art are perfect reflections of the complex play of Asiatic, Egyptian, and Aegean influences brought to bear on the Syro-Palestinian coast at the end of the Bronze Age. With consummate skill these craftsmen move into their compositions elements borrowed usually simply for their decorative value, from various repertoires, and often succeed in producing works of striking force and originality.

At the end of the 12th century, the invasion of the Peoples of the Sea rolled upon the coasts of Asia Minor, Syria, and Palestine and reached the Egyptian frontier. As early as the end of the preceding century the Israelites had begun to settle in the mountainous areas on both sides of the Jordan. The history of Canaanite Palestine comes to an end. But this is not the end of the composite art whose birth and development we have followed over the course of the second millennium, and whose tradition continued in the subsequent period, now having as its protagonists Philistines and Israelites.

ISRAELITE ART DURING THE PERIOD OF THE MONARCHY

by BENEDICT S. J. ISSERLIN

Israel entered into the full light of history with her immigration into Canaan; and the history of Israelite art must take the same period for its starting point. Present perhaps since the fifteenth century B.C.E., Israelite tribal elements seem definitely to have established themselves in the uplands of Canaan in the thirteenth and early twelfth. Locally sweeping everything before them with fire and sword, they could, nevertheless, not make good any theoretical claims to ownership of the whole of Palestine; and the Canaanite cities in the plains, such as Megiddo, Taanach, Beth Shean, or Gezer, remained independent. As a result, the warlike invaders, politically grouped in a tribal confederacy, soon settled down to peasant agriculture, and remained in juxtaposition with the older inhabitants.

These latter (whom we shall hereafter simply refer to as the Canaanites, neglecting any finer ethnic divisions) were people possessed of a long-established and highly developed material civilization. Politically they were grouped into city-states ruled by petty kings, who in turn owed allegiance to the Egyptian empire. This latter, enfeebled during the late thirteenth century B.C.E., had apparently by the twelfth shrunk to the control of a few important centers in the Palestinian plain belt, and in the eleventh century it flickered out. The whole picture of a dying empire invaded by warlike outsiders recalls in some ways the final stages of the Roman Empire and the rise of medieval Europe.

Yet, while the art of Europe of the Dark Ages can be studied from plentiful finds related both to the invaders and the invaded, the historian of early Israelite art is much less fortunately placed. There is, indeed, material giving a fair idea of the culture of the original Canaanite inhabitants, as has been seen in the previous chapter. However, archaeology has up to now been unable to point out any objects (weapons, pottery, etc.) which can be assigned to the newly arrived nomad Israelites. (The attempt might indeed be made to close this gap to a certain extent by drawing conclusions from a study of the art known among the other nomads of Asia, both ancient and modern; an art which to some extent seems to lean on that of the settled countries nearby. However, to what extent deductions from such a study could legitimately be applied to the ancient Israelites is rather doubtful; they are, after all, described as an escaped Egyptian proletariat of semi-nomad ancestry.) We are thus reduced to reviewing the development of Canaanite art under the Israelite impact, and to trying to see whether Canaanite art can be said to undergo any significant deviation from its earlier course, when faced with the shock administered by the invasion.

From the dimness which thus veils Israelite art before the settlement in the Promised Land, only the textual description of the Tent of Meeting and its appurtenances, as given in the Scriptures (Exodus XXXVI–VIII), stands out in some detail. As for the tent, we hear of curtains of "fine twined linen, blue, purple, and scarlet, adorned with cherubim" (Exodus XXXVI: 8); these curtains were joined by loops and clasps, and placed below an outer tent of goat-hair and skins. There is mention also of acacia boards or frames covered with gold (XXXVI: 20,34), and of a veil of blue, purple, and scarlet, and fine twined linen, adorned with cherubim, the work of "the cunning workman" (XXXVI: 35). It is not easy to visualize always just what is intended, and, indeed, the whole description of the Tent of Meeting has not passed unassailed. Critics have been inclined to regard the present text as the blending of several strands of tradition, and to find in it a much later and theoretical reconstruction giving body to what would otherwise have been vague. It may, however, be permissible to recall that the statement about the cherub decoration need not be an anachronism. Cherubs (by which may be intended sphinxes, or kindred fabulous beasts) go back to types well-known in the decorative arts of Syria and Egypt during the second half of the second millennium B.C.E. That the carpet weavings of a nomad population may closely follow the decorative motifs in use among their settled neighbors has recently been demonstrated by the findings of carpets executed among the nomads of ancient northern Asia which are clearly derived from the art of ancient Persia. There would thus be no *prima facie* objection to the occurrence of the cherub motif, as developed in ancient Egypt, among the nomad Israelites sojourning in the deserts bordering on those two countries.

Cherubs (of pure beaten gold) are also mentioned as flanking the "mercy seat" of the ark, which latter is described as a box-shaped object provided with a molding (Exodus XXXVII: 1–9). Again parallels from contemporary art both sacred and profane can be quoted. Winged guardian figures sheltering a sacred object are developed in Egyptian art, while (if the "mercy seat" is regarded as the symbolic resting point of the Godhead) the throne drawn on the Megiddo ivory gives a good idea of the contemporary Canaanite type of throne flanked by sphinxes.

Fig. 14

A tent sanctuary centering around a movable palladium (a thing not without parallels among other Semitic peoples), employing to some extent the artistic conventions in use among the neighboring nations, seems not impossible; but the details elude us.

Whereas the art of the most ancient Israelites remains largely unknown to us, that of the ancient Canaanites is well documented, and has been dealt with in the preceding chapter. It seems useful to note down, summarily, a few facts which will be relevant when we come to discuss the art of the period to follow.

1) Egyptian political sovereignty brought in its train the transplantation into Canaan of some Egyptian art. This comprised official buildings, statues, commemorative relief slabs, religious sculpture, and *objets d'art*; besides this, Egyptian artistic features were apt to affect the local tradition.

2) Canaanite art shows a strongly mixed character conditioned by the incorporation of foreign influence from many quarters. Sometimes a certain subject will tend to be treated in a certain tradition. Thus, cattle may be rendered in the Aegean manner; lions may recall Egyptian or Hittite North Syrian models.

3) Canaanite art had developed a certain number of decoration motifs which formed a part of the commonly employed stock. These include the "tree of life" with its compli-

cated scroll work; the lotus and lotus chain of Egyptian origin; griffins and sphinxes. These motifs were not peculiar to ancient Palestine, but formed part of the cultural heritage of Syria and Mesopotamia.

4) Besides the "great art" supported by the leisured classes and connoisseurs, there was a popular art at home among the villagers and simple craftsmen. This is well illustrated by the paintings placed on ordinary pottery. Typical of these is a tendency to simplification and abstract geometric form; there is little attempt to achieve realistic representation. Occasionally, there is evidence of a good sense of spacing and line, perhaps also of a certain humorous feeling.

We have, in what preceded, tried to summarize what is known about the art of Israelites and Canaanites before they came into hostile contact. Let us now see how things developed when they met during the period of the Judges (ca. 1250–1050). Politically this was a complicated epoch. Egyptian rule was weakening and disappearing. The Israelites and Canaanite city-states fought each other to a standstill; as a result, the former were restricted mainly to the upland zone, the latter to the lowland belt. Then the *status quo* was further upset by the invasion of the Philistines. These latter came from the Aegean world and made themselves at home in the coastal plain, reducing the hills to their sphere of influence. For a moment they were very near to establishing an empire over all Western Palestine, but in the end they went down before the superior military and political skill of David.

The history of art to some extent mirrors this confused state of things. We witness at first, in the Egyptian-dominated zone, the existence of occasional Egyptian influence in building, some Egyptian statuary, and frequently the continued existence of Egyptian *objets d'art* at the courts of Canaanite subject kinglets. The latter also continued to treasure ivory carvings in the local tradition, where Egyptian, Aegean, and Syro-Palestinian traditions were blended. However, while this is true for seats of the fairly opulent rulers in the richer part of Palestine away from the Israelite thrust, in the more exposed and naturally less favored parts of the country, the level of achievement seems to have been much lower. Furthermore, the standard reached in the applied arts connected with everyday things seems generally to have been poor. Pot-making and pot painting alike are decadent. The terra-cotta representations of women in labor, intended as charms, are without artistic skill or merit. The products of the art of the sealmaker also show a much lower level than had been achieved some centuries earlier. Both scarabs and stamp seals tend to be satisfied with a simple "blob" style, or the most basic geometrization. Vigorous but crude, these seals employ motifs partly derived from Egypt, like falcons, monkeys, snakes, or Asiatic motifs, often of great antiquity, such as scorpions, animals represented tête bêche, ostriches, men. This simple style was to remain in vogue for some time. It seemed to be linked with the general decline of civilization in the Near East between 1200 and 900 B.C.E.; and similar seals of roughly the same period as those in Palestine have come to light in Cyprus and Syria.

As for the Philistines who made the Canaanite lowland regions their home, it is difficult to say much about any artistic traditions of their own. About their architecture, both sacred and profane, we know next to nothing; the brief notices about Dagon temples contained in Judges XVI, 24ff, and I Samuel V, 2-5, are insufficient to enlighten us about their architectural character. The only sphere in which an artistic tradition, different from that of the Canaanites in general, might be ascribed to them is that of vase painting. Here

a special Philistine style of polychrome painting, employing such motifs as the spiral, the lozenge, and the swan preening its plumage, has been recognized. However, it must be said that the so-called Philistine style is apparently to be attributed to local potters working in the territory under Philistine domination. It is an eclectic style developed from vague memories of the motifs current before the time of troubles in the Aegean world of the thirteenth century B.C.E., and with special links to Cyprus, and, to a lesser extent, the Dodecanese. Occasionally, local Palestinian influence makes itself felt. Thus, the "Orpheus vase" from Megiddo, showing a musician with a lyre leading along a motley crowd of animals, seems to represent a cross-breeding between Philistine and local peasant art; a decadent lotus pattern on a Philistine vase from Tel el Farah seems to go back to Egyptian inspiration.

As for the art of the Israelites during the period of the Judges, our Biblical texts hint that a certain amount of sacred and profane art was to be found among them. There were temples, orthodox (at Shilo) and schismatic (as at Dan); individuals might provide themselves with ephods and idols (cf. Judges VIII, 27; XVII, 1—8). Such works might be in traditional Canaanite manner; idols of well-established Canaanite types have been found in strata at Gezer and Megiddo dating roughly from this period, and a little idol of a war-god from Israelite Hazor, dating apparently from a time shortly after the Israelite conquest, *Fig. 13* belongs to the same Canaanite tradition with North-Syrian analogies. The coming of the monarchy under Saul provided, for the first time, a central ruler endowed with wealth and prestige, who might be expected to express his standing also by bounty towards the arts. We have, however, no evidence that this happened at this stage; Saul's residence at Gibea, so far as it has been excavated, has proved to have been a purely utilitarian stronghold without pretensions to comfort or the graces of life. Things probably improved under his successor David, but concrete details still fail us; what we hear about his "house of cedar" (II. Samuel VII, 2) and general building program is best taken with the better documented work of his son Solomon.

Solomon's reign seems, in fact, to mark a period in the artistic development of Palestine. His father's rule had seen the effective union of Israelites and Canaanites within one state, and the building up of a Southern Syrian empire in close commercial alliance with Phoenicia, and in active contact with Egypt. This political structure, reorganized by the new king, was now made to furnish the means for an immense building program at the behest of a rich and luxurious court. All this must have brought in its train ample opportunities for artists and technicians, both local and foreign, in the new capital, Jerusalem, but also at many other points throughout the realm.

As befits the situation, the artistic remains of this time point to the continued existence of local Palestinian (Canaanite) traditions, but also to a strong infusion of features to be ascribed to Phoenicia and to a lesser degree, to Egyptian inspiration. Thus the Canaanite tradition in building is exemplified by the small "northern" temple found in Beth Shean, layer V, which is very similar in plan to the pre-Israelite "fosse temple" at Lachish. Egyptian architectural features also still occur at various places, and Egyptian tradition remains dominant, now and later, where amulets and similar little faience figurines are concerned.

The main interest of this period, however, is naturally centered in the works of art and architecture connected with Solomon's great building program.

Outstanding among these for general interest is Solomon's Temple. Not a stone of the

present temple platform can be ascribed to it with certainty, though it is indeed quite possible that architectural members of the structure are still hidden in the accumulated masses of later filling. Yet, while visible archaeological evidence is lacking, reconstruction is, nevertheless, possible to a fair extent on the basis of written accounts: 1. Kings VI–VIII, and to some extent Ezekiel XLI–III, when these texts are studied in the light available from archaeological evidence obtained in Israel and elsewhere. Much of the detail, however, must still remain questionable.

Solomon's Temple, an oblong building orientated east-west, consisted essentially of three divisions: a porch *(ulam),* a main hall *(hekhal),* and a Holy of Holies *(devir).* The porch was 20 cubits wide and 10 deep (ca. 10 x 5m.); according to II Chronicles III, 4, it may have been overtopped by tower-like structures. From the porch one entered through a double door of cypress wood into the Temple hall proper, 40 cubits long and 20 wide, and 30 in height. It was provided with a ceiling of cedar wood, possibly coffered. The Holy of Holies behind the main hall was 20 cubits square and 20 high; it may have been raised in level above the main hall. The Temple was surrounded to the north, west, and south by store chambers, three stories in height. Light was admitted to the main Temple hall by clerestory windows placed above the store chambers. The whole Temple structure was built of ashlar and internally paneled with cedar wood, carved with cherubs, palm trees, and floral ornaments, and heightened with gold. The doors were carved with similar elaboration. The internal furniture of the house included (besides a golden altar, the table of the shewbread, and 10 lamps) the Ark of Covenant which was placed in the Holy of Holies and guarded by two huge winged cherubs carved in olive wood and gilded. On the outside, the porch was preceded by two tall brass columns 18 cubits high. These were provided with complicated composite capitals 5 cubits in height, involving such elements as chain and checker work, and pomegranates. The Temple may have been placed on a raised platform; it was surrounded by a court delimited by ashlar walling founded on three courses of hewn stone and one row of cedar beams. (The gates to this, if Ezekiel's description can be applied, were of composite type involving a succession of lateral chambers between the jutting-out door jambs). Within the court there were, besides the altar, a great water container called the "molten sea," placed on twelve oxen, and ten movable lavers on wheels.

This somewhat bald outline receives considerable amplification and interest if use is made of archaeological parallels. Basically, Solomon's Temple comes within the category of the "long house" temple; this is to be found, in various forms, in ancient Canaan (as at Megiddo, Shechem, Ugarit) and even at Assur, *inter alia.* Within this wider category, the evolution of the temple type divided into porch, main hall, and Holy of Holies can now be followed in the Canaanite zone from its early adumbration at Byblos *via* the impressive pre-Israelite temple at Hazor to the 9th century B.C.E. temple at Tel Tainat in Syria. The latter comes very close indeed to the place of Solomon's main building, while the lateral store chambers of Solomon's Temple can be paralleled at the nearly contemporary "southern" temple of Beth Shean, level V. Various individual features of Solomon's building can likewise be paralleled in the "long house" temples of the ancient Palestine-Syria and nearby countries. If there was a raised sacral end, parallels can be quoted again at Beth Shean, Tel Tainat, and rather earlier, at Tel Atchana in Northern Syria. If there was a tower-like porch, parallels could be adduced from Egypt, but perhaps also, in a different variety, at ancient Assur and much later still, at Paphos in Cyprus.

Coming to constructional methods, we find that ashlar walling, but also ashlar with courses of cedar beams, was known already during the second millennium in Syria, Anatolia, and the Aegean area; in Palestine, the method is illustrated at the contemporary level V of Beth Shean, and at Megiddo, stratum IV (Megiddo IV also provides what seems to be a very close approximation to the gates described by Ezekiel). Dealing next with internal decoration, we have to remember that cedar paneling, and especially cedar paneling inlaid with ivory and heightened with gold, was at home in Phoenicia and in the sphere affected by her. Proceeding now to external fittings, we have to remember that the two gigantic free-standing columns Yakhin and Bo'az are paralleled by similar free-standing twin pillars before Phoenician temples at Tyre and Gades. For the gigantic laver, *Plate 1* a stone laver from Amathus in Cyprus has been adduced as a parallel; the portable lavers are in the same tradition as one from Enkomi in Cyprus, which is itself related to vase *Fig. 16* supports from that island, and the vase support from Megiddo mentioned before. All told, there is not much which looks like direct borrowing from the powerful southern neighbor, Egypt; much is of Canaanite-Syrian derivation, and there is a strong Phoenician influence embracing perhaps the overseas connections with Cyprus. Ornamental detail is best reconstructed on such considerations. Thus, the composite capitals of Yakhin and Bo'az with their lily work may have been something like the capital imitated by a somewhat later stone brazier from Megiddo. The cherubs facing palm trees may have been like those of the later Phoenician-inspired ivories. The difference in age must, however, be remembered.

With all its finery, the varied colors of the different kinds of wood, the carvings and gilding showing strongly where a beam of light from the highly placed windows penetrated into the otherwise semi-dark interior, Solomon's Temple must certainly have been impressive; even though the time, like ours, was free with the word "unique" as Mr. Parrot reminds us.

Of Solomon's public and domestic buildings in Jerusalem, we know much less. The one about which most detail is given is the "house of the forest of Lebanon," a long hall, 50 cubits by 100, provided with four rows of internal columns; this building was, in later times, used as an armory, and it has been compared with such military buildings as the stables at Megiddo, stratum IV, with their rows of internal pillars and certain naval armory buildings in later Greece. The portico of pillars and the porch of the throne of judgment hall may have been analogous to porticos known from Zenjirli (ancient Sham'al), in Northern Syria at a somewhat later date. The king's private apartments may (or may not) have conformed to the type of residence called "bit hilani" known at that latter site and elsewhere in Syria; we know nothing of the plans, though the details given about ashlar masonry of large dimensions and hewn stone mixed with cedar beams sound like Phoenician work. What the house of Pharaoh's daughter or the heterodox cult buildings erected by the king in his later years may have been like we have at present no means of knowing.

The collapse of Solomon's empire after his death and the split of the united monarchy into the two warring sister-states of Israel and Judah meant the end of an imperial epoch and the opportunities it presented. The two new monarchies were, nevertheless, not inferior in territory and resources to other petty Syrian states, like Sham'al or Damascus, and like them could act as patrons for art both sacred and profane. Furthermore, a rising mercantile aristocracy was soon to join the courts as possible clients for those supplying

the embellishments and graces of a refined life. Around Judah and Israel, the former subject kingdoms of Transjordan (Ammon, Moab, Edom) and the city-states in the coastal plain provided other possible centers of patronage for the arts, if of a less impressive kind.

We are much better placed to judge the artistic activity of this period; descriptions on paper are now superseded by actual finds.

In architecture, the methods characteristic of the great public buildings of the time of Solomon still persist. There is ashlar masonry, and ashlar mixed with cedar beam work. Both methods of construction can now be studied in detail from the surviving examples uncovered by excavation. Splendid examples of ashlar construction have been uncovered at Megiddo, stratum IV (which is best attributed to the period of the House of Omri), in the remainders of the royal palace at Samaria, and, more recently, at Ramat Rachel, south of Jerusalem, where the ruins of what seems to have been a royal residence have been partly excavated. Construction is extremely careful; it consists of well-laid layers of headers and stretchers, the foundation courses left with rough quarry bosses, but the visible work carefully smoothed. Megiddo IV has also furnished examples of the method of mixing ashlar and beam work. Occasionally, the cost of some less important buildings was lowered by mixing short stretches of ashlar with intervening cheap dry walling, as at Megiddo; even this kind of masonry is in sharp contrast to the type of poor rubble walling employed for the houses of commoners. The ashlar of the public buildings is vastly superior to it, and may sometimes have been the work of Tyrian masons, as in the case of Samaria.

Of the royal palaces at Samaria and Ramat Rachel only the casemated enclosure walls are at present sufficiently known. What the plans and architectural features of the palaces proper may have been we cannot yet tell; perhaps they conformed to the Syrian "bit hilani" type; a residence at Megiddo, stratum III (probably of the time of Jeroboam II in the eighth century B.C.E.), pretty definitely resembles the types of residence in vogue in Northern Syria and Mesopotamia. Gates, as at Megiddo, also tend to resemble those found in Syria and Mesopotamia during the same general period. They are monumental, but give no indications of any other distinguishing architectural features. Of the art and architecture of the great schismatic cult centers inveighed against by Amos, such as those of Bethel and Dan, we have at present no real knowledge. We do, however, possess a little information concerning the small local shrines, regarded as heretical by the Bible. This knowledge is based on the existence of pottery models such as have been found at Gezer, Tel el Farah (perhaps the ancient Tirzah) near Nablus, and in Transjordan. The *Fig. 15* latter in particular, with its small porch supported by columns, in front of the chapel proper with its pitched roof, is not so very different from rural sanctuaries known to us from pottery models in early Greece about this time.

What helps such and other buildings to achieve the quality of a work of art are structural proportions and additional ornamental features such as moldings, carvings, etc. About the structural side we usually know very little, since buildings are often ruined almost down to floor level. Of the details of architectural ornamentation, on the other hand, sufficient evidence has survived for us to form some ideas.

Egyptian architectural influence seems largely to have faded out in Israel during the ninth and eighth centuries B.C.E. The last piece of evidence to be quoted in this direction is a pottery shrine model from Megiddo, stratum IV. It shows at the top what looks rather

like a vague imitation of an Egyptian cavetto cornice above a torus roll molding. This type of ornamentation had been traditional in Egypt for several centuries. The importation from there of such features in Palestine at this time is quite possible. In Judah, to the south, the influence of the great civilization by the Nile was more apt to be felt; and here we have, in fact, a fairly complete monument in the Egyptian manner, namely the so-called Tomb of Pharaoh's Daughter, a rock-cut-out monumental structure in the village of Silwan (ancient Siloam). It is basically a rectangular building crowned by a cavetto cornice which was formerly topped by a pyramid; a type of monumental tomb which was fully established in Egypt by the New Kingdom. The dating of this tomb has been disputed. It may be possible, however, to assign it to the eighth-seventh century B.C.E., in which case it might have something to do with the renewed artistic as well as political influence which Egypt was exercising at that time over the neighbor countries, during the rule of the active Ethiopian dynasty and after the restoration of her political independence under the Saitic Kings.

Fig. 17

While Egyptian architectural influence was thus at best limited, architectural ornamental features ultimately derived from the common Syro-Palestinian tradition are widely met and deserve some discussion.

We had occasion on an earlier page to refer to the "tree of life" motif as one of the stock features in pre-Israelite decorative tradition. This ancient motif is now developed and applied to architectural ornamentation. The scroll work going with this feature in particular is turned to use in various ways. Thus the above-mentioned rural shrine model from Tel el Farah near Nablus shows columns topped by what look like inverted primitive Ionic capitals; the shrine model from Transjordan shows the columns supporting the pediment ending in two pairs of volutes back to back, one pointing upwards and the other downwards. A capital made up of similar volutes is also shown on the head of a little clay model of an hermaphrodite caryatid found in Transjordan. The mutilated wall pilasters found at Tel el Hesy and re-employed in later work may belong to the same general tradition which can be linked with the evolution of kindred if somewhat different architectural features in the neighboring lands.

One special derivation from this general ancestral stock seems to be the so-called proto-Aeolic pilaster capital which is attested, with little basic variation, from Mesopotamia to Cyprus. Basically this form of capital consists of a central triangle flanked by volutes. Simple or florid, plain or painted in various colors, these capitals have turned up at various Palestinian sites: at Megiddo and Samaria, from buildings of the time when the House of Omri held sway; at Hazor and Ramat Rachel in Judah, probably about a century later; and also in Transjordan as at Medeibi. They seem to have served for a variety of purposes; they might adorn the entrances of public or religious buildings, as at Megiddo, or help to beautify porches, as at Samaria.

Fig. 18

There is evidence, also, concerning other types of capitals in use for topping free-standing columns. A brazier from Megiddo referred to earlier seems to imitate a composite capital consisting essentially of two rows of pendant leaves topped by a bowl element. Attention has been drawn to other objects imitating similar columns and capitals, such as a pottery stand from Gezer. A more recent find from Ramat Rachel near Jerusalem, a stone plaque which may once have formed part of a decorative screen, features dwarf columns, again with two superimposed rows of pendant leaves. This family of columns is well-known in the ancient Near East during the first millennium B.C.E. On ivory carvings it is shown

supporting a railing across an open window; it is imitated on contemporary furniture, as at Zenjirli-Sham'al; a mutilated full-size example has turned up at Assur. But relations are particularly close with the type of capital represented in Anatolia at Neandria and elsewhere. Again our evidence thus points to the close links existing between the artistic traditions of Israel and Judah and those of North Syria, traditions which were carried to the West and influenced nascent Greek architecture. Again also, the style of architecture in vogue during the period of the monarchy seems to rest on the earlier tradition of pre-Israelite Canaan. The capital with drooping leaves seems derived from a simpler type represented among the Megiddo ivories, and this is again an adaptation of an old established Egyptian type of capital. Architectural traditions which seem mainly at home outside the Syrian sphere are rarer; part of a crowstep battlement from Megiddo might perhaps go back to a more properly Assyrian style of building.

Architectural sculpture did definitely occur in the peripheral regions of the Israelite monarchy. In the disputed borderland between Israel and Damascus, at Sheikh Sa'd (ancient Qarnaim), there was found a lion, which must have served to defend a gate entry. It recalls North Syrian gate lions of the ''Syro-Hittite'' type, but is already under some Assyrian influence in the treatment of the mane; it might belong to the latter part of the ninth, or the early eighth century B.C.E. In the central region of Israel such things must have been rare; enough cities have been excavated by now to give significance to the absence of even mutilated fragments of monumental sculpture at such places as Megiddo. Yet while rare, something of the kind must nevertheless have existed. This is proved by the occurrence of pottery models of buildings adorned with human or animal figures; for these figures show such definite stylistic traits that they cannot be the products of mere fantasy, but must rather imitate things actually known to their makers. One of these models is the example already quoted from Megiddo. It shows at the corners replicas of colossal architectural sculpture as known in Northern Syria and Mesopotamia. The high cap and long curls of the sphinx on the left seem particularly significant, for they are in the Syro-Hittite tradition. A brazier from nearby Tel Taanach adorned with lions and sphinxes in poor execution may be contemporary or rather earlier. Again the general style of the figures seems to point to a Syrian tradition underlying the local work. No similar objects seem to have come to light in layers dating from the time definitely after the *coup d'état* of Jehu; perhaps the prophetic revolution did away with this as with other ''abominations.'' In Judah also, the feeling against this kind of thing seems to have grown. Solomon's Temple had possessed plentiful representations of cherubs in the interior, though on the outer precincts sculpture seems to have been used sparingly: Ezekiel (XL, 22; 26; 31; 34; 37) mentions only palm-tree decoration on the gates. And it seems that architectural sculpture and allied arts after the time of Solomon were rare, and fell under very strong theological opprobrium; witness what Ezekiel has to say about what probably were paintings or reliefs in the Assyrian manner (VIII, 10; XXIII, 14). The only piece of Judean sculpture known which might be taken to illustrate the traditions of architectural sculpture is the sphinx from the ''grottos of the kings.'' With its high pointed cap, this animal again comes within the Syro-Hittite tradition; it may be worthwhile recalling that a similar sphinx is already featured on a Hittite-inspired ivory from Megiddo, and that this type had thus been know in the country for some considerable time.

Minor architectural sculpture is known, but apparently it never developed to any great

extent. We might point to the bird (eagle?) on the pediment of the shrine model from Transjordan; perhaps also to a stone with a female in relief from Megiddo. This latter shows extreme simplification and reduction of body to a few plain surfaces; the exaggeratedly large head recalls the "Aramaean" tradition of northern Syria.

There is, however, on the present evidence, one type of representational art which seems to have been totally absent in the Land of Israel. This is statuary representing kings or deified rulers. Such statues were part of the common Syrian heritage; and at the time of the Hebrew monarchy they were being placed in the gates of Sham'al and Malatia. No Israelite gate has up to now given indication of ever having been similarly provided. This seems significant, for statues of rulers or persons of standing were known in contemporary Ammon (as might have been expected, they come within the Syrian and Phoenician tradition). As for other statuary representing human features there is hardly anything which deserves mentioning. One might perhaps refer to a head from Megiddo, strictly frontal, with large staring eyes and a small beard; it seems Mesopotamian rather than Syrian in derivation, but is, in any case, quite isolated. Of direct foreign influences there is otherwise little evidence. A statuette in the Egyptian style was left unfinished by its maker at Gezer; Tel es-Safi has furnished remnants of reliefs in the Assyrian manner, which may have been due to the field artists of the Great King on campaign.

Of plastic work in more precious media little has remained. This is quite understandable, for statues were often idolatrous (and thus an object for attack during times of cultic reforms) and their precious composition (involving gold and ivory) would have rendered them desirable plunder in any case. We know a little about them from the denunciations of the prophets (cf. Isaiah XL, 19ff; XLIV, 9ff; Jeremiah, X, 3ff); the method of manufacture apparently referred to — a wooden core overlaid by sheet-gold fastened down with nails — is known from archaic Greece, but went out of fashion there after the seventh century B.C.E. Of chryselephantine statues one or two fragments have survived, as at Gezer; they seem very near in style to the older, pre-Israelite cult statuary of the Canaanites, as found, e.g., in the "fosse temple" at Lachish.

Fig. 19

More has come down to us of the small domestic idols which were of little intrinsic value. Chief among these are the so-called Pillar Astarte figures in pottery. These consist of a tubular body, thrown on the wheel or handmade, splaying at the base with rolls of clay attached as arms to support the very prominent breasts, and a head which was made separately in a mold and fitted on. Typical of these heads are a "Greek profile," large almond-shaped eyes, and hair or wigs arranged neatly in rows of little curls. The type, widely distributed with little variation, goes back to the old traditions of Canaanite sacred imagery with Egyptian affinities; it was to influence early Greece (Rhodes, Cyprus) during the archaic period. Other small plastic items include crude little figures of men supporting tri-cornered hats on the heads (such as have also been found in the faraway Phoenician settlement of Ibiza); various animals and little figurines of horsemen. These latter are frequent and usually reduced to simple basic forms without much attempt at rendering detail. Some may have been toys, but occurrences in what were apparently the

Fig. 20

burials of adults speak against their always having served as such. On the whole, the standards of workmanship are low; occasionally work with more pretension to naturalistic representation can be found, as in a seated figure of a male with high cap and long hair and very strongly "Semitic" features from Tel es-Safi.

These terra-cotta objects are the common man's art. Better things can be expected from

orders executed to embellish the abodes of the wealthy and discriminating. The latter could also go in for more precious materials. They could, in particular, call in the ivory carver, whose works, as we have seen, had some centuries earlier served to beautify the homes of the wealthier Canaanite princes. Now there were two royal courts, Jerusalem and Samaria, both of which had come under the political influence of Tyre and thus might be expected to have developed likings for Phoenician-style luxury. Ahab is reported to have made an "ivory house" (I Kings XXII, 39). The art of the ivory carver must also have been appreciated at the Judean court, for Sennacherib somewhat later reports that the tribute paid to him by Hezekiah included ivory objects. The wealthy classes shared the luxurious tastes of their royal masters; Amos found cause to upbraid the idle rich who were sprawling on ivory couches (Amos VI, 4) or inhabiting ivory houses (III, 15). The reference in both these cases, and in that of Ahab's "house of ivory" mentioned earlier, are to buildings, the internal paneling and furniture of which were adorned with ivory inlays and carvings.

Of the extravagant works which aroused such intense feelings, a representative selection has come to light in the excavations at Samaria. Some of the pieces in question possibly originated in Ahab's ivory pavilion, though a later origin of some items, nearer the fall of the city in 722 B.C.E., cannot be excluded. Most of the material consists of flat plaques meant to be applied as inlays either to cedar wall paneling or to furniture; carving in the round is rather rare. The flat pieces are usually carved in low relief; there are also items decorated with insets of colored glass or paste to heighten the effect of the carving; in other cases these colored inlays make up the decorative patterns themselves. The most spectacular pieces were adorned both with polychrome insets and gold leaf.

The artists who produced these ivories worked from a fixed repertory of types which they were fond of repeating and applying over and over again. Such motifs are the lotus chain, the palmette, the "woman at the window" (perhaps intended for Astarte), Isis and Nephthys, the infant Horus on a lotus flower, winged genii and sphinxes. Work in the round includes lions intended as armrests for a miniature chair or throne, and a lion-head which once tipped the handle of a dagger or similar object.

Fig. 21, 22

Stylistically, these ivories belong to a well-known school, and many of them can be duplicated at the former royal Assyrian palace at Nimrud (some of the ivories found there might indeed have been loot transferred to Assyria on the fall of Samaria). Other ivories fairly similar to those found in Samaria have come to light at Arslan Tash, ancient Hadatta, in Syria; some of these are presumably booty which the Assyrians captured when campaigning against Hazael of Damascus. All these ivories tend to repeat similar standard motifs, and the better ones vary little in execution. Many of the patterns are obviously of Egyptian origin; the idea of inlaying ivory with colored substances may also go back to Egyptian *cloisonné* work. In details, however, the execution does not conform to Egyptian idiosyncrasy. Other rarer pieces are originally of an Asiatic derivation; thus a lion-headed handle recalls a stone lion-head from Nimrud to which it does not, however, conform in all particulars.

With this mixture of derived Egyptian and Asiatic motifs, the ivories fall naturally within the mixed artistic tradition of the Phoenicians, to which they have, in fact, been ascribed. Motifs encountered on the ivories can be matched, in very similar execution, on works in other media from the output of Phoenician workshops. Phoenician trade also carried these patterns into early Greece; both the lotus chain and the palmette occur in very

similar shapes on painted pottery vases from Rhodes. In origin, this art is closely allied to the general, pre-Israelite artistic tradition of Canaan. On the other hand, only the earlier stage of Phoenician art seems to be represented here; there is no hint of the *genre* scenes much in fashion on the later Phoenician metal bowls.

The inspiration of the Samarian ivories belonged thus to a school of craftsmen trained in the Phoenician school. These ivory workers apparently went to ply their trade wherever required; part of an unworked elephant tusk found at Samaria proves that some of the carving was done locally. It is quite possible that some other craftsmen were local, Israelite in descent or associations. For the existence of a local school of ivory carvers trained on somewhat different artistic canons can be deduced from a consideration of certain ivory and bone carvings found at sites other than Samaria. These include a lion-shaped handle from Tel el Farah in the coastal plain; a bone wand with a charging bull from Tel en-Nasbeh north of Jerusalem; an ivory box with a sphinx, a kneeling figure *Plate 2* from Hazor by the upper Jordan, and a bone handle showing a winged genius and sacred tree from the same site.

The common factor with these pieces seems to be that they are not only technically inferior to the Samarian ivories, but also more in the line of the North Syrian tradition in art than the latter; they can be matched in stylistic detail among the works of art found in the north during the ninth and eighth centuries, to which they belong. The lion on the handle from Tel el Farah in particular shows Hittite North Syrian traits; the kneeling figure on the ivory from Hazor has the exaggeratedly large head often found among "Aramaean" sculptures. The crude genius and sacred tree on the bone handle from the same site recall the crude simplifications in vogue at Tel Halaf. In themselves, the pieces are artistically unimportant; together they strongly suggest that in addition to the Western art imported by the Tyrian-dominated court, the country also knew a school of ivory carvers who were inspired by North Syrian art, the existence and prevalence of which we had occasion to notice in other spheres. It seems certain that those Syrian-influenced artists did not care much for any restraints on executing "graven images," as indeed can be seen in a battle-ax from an early Israelite High Place at Hazor. It contains the image of *Fig. 13* a Northern war god, wearing a helmet surrounded by spikes.

We must lastly refer to another sphere of applied art in which a good deal of work was produced during the period of the Israelite and Judean monarchy, namely the craft of the seal-cutter and engraver. The early days of the divided monarchy still witnessed the continued production of much rough and crude work in the "blob" and geometric style of the "dark ages." By the time of the House of Omri, however, there had come a remarkable revival. A new type of seal (scarab or scarabaeus) was coming into use in Southern Syria and in Israel-Judah especially. It gave the owner's name and often also his patronymic, and frequently, too, some decorative motifs. The inspiration for these latter seems to have come from two directions.

We can learn something about one of these by a consideration of the well-known seal of "Shema the Servant of Jeroboam," for this seal is no isolated invention *de novo*. It forms part of a larger class of contemporary seals, including technically less successfully executed signets from Israel and Phoenicia, and stretching down to such crude simplifications as the stamp seals whose imprints on pottery have been found at Tel en-Nasbeh and Ramat Rachel. This type of seal goes back in its details (the treatment of the mane and belly hair, the open mouth and body muscles) to a type found among the North Syrian

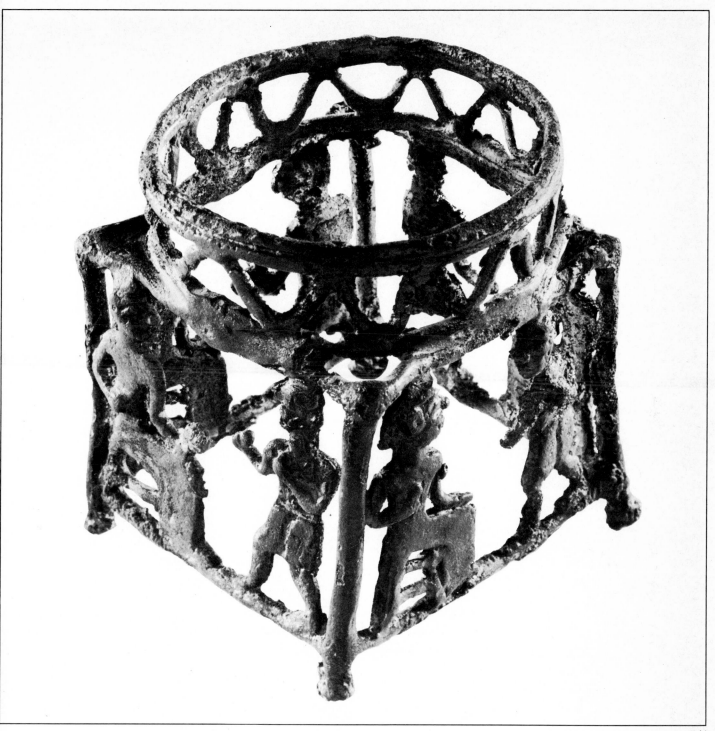

16. *Vase support from Megiddo. Department of Antiquities and Museums, Jerusalem.*

17. The so-called "Tomb of Pharaoh's Daughter", a rock-cut
 monument in Siloam Village. Period of the Hebrew Monarchy.

18. Stone slab with imitation of proto-Aeolic column capitals
 from Ramat-Rachel. Department of Antiquities and Museums
 Jerusalem.

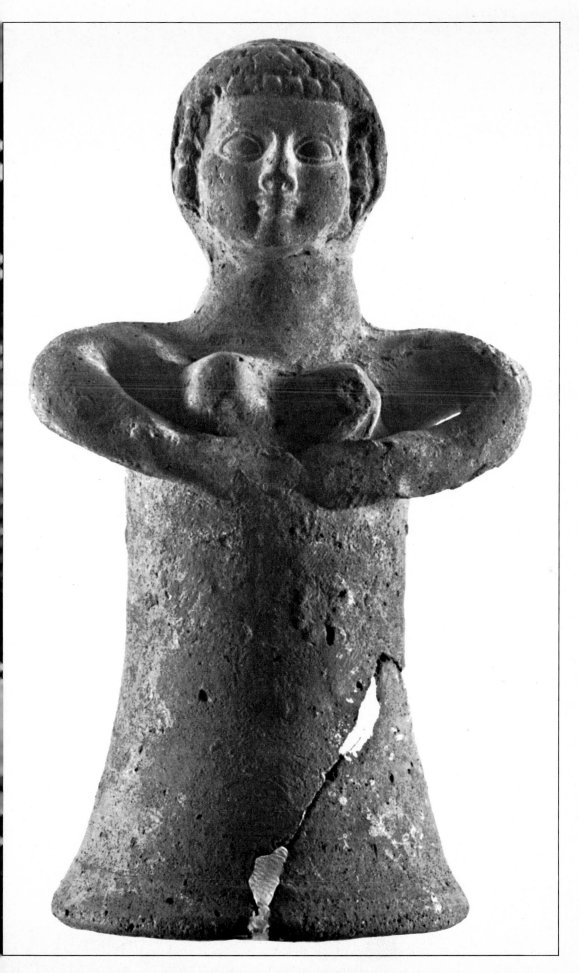

19. "Pillar Astarte" of pottery from Lachish. Department of Antiquities and Museums, Jerusalem.

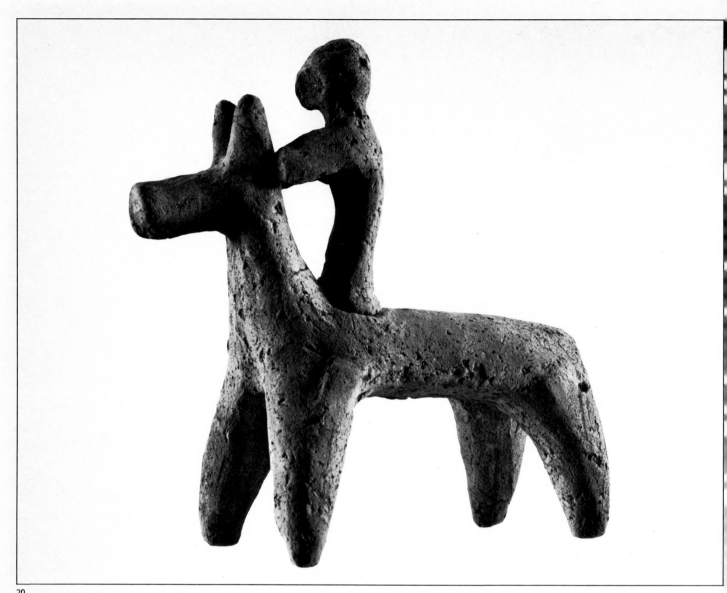

20. Pottery model of horseman from Lachish. Department of
Antiquities and Museums, Jerusalem.

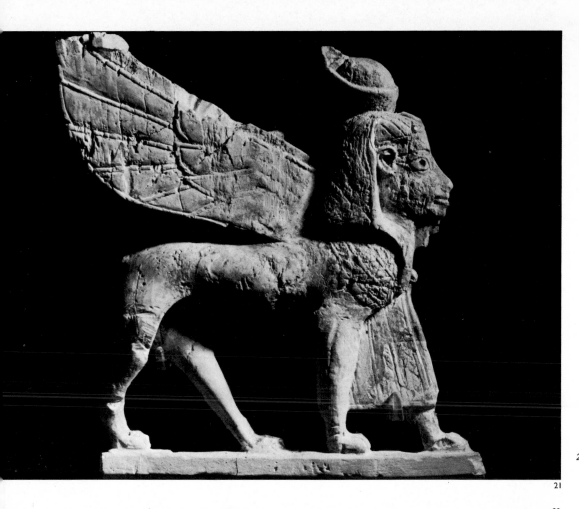

21

22

21. Winged Sphinx. Ivory panel from Arslan-Tash (Hadatta). Elie Borowski Collection. Department of Antiquities and Museums, Jerusalem.

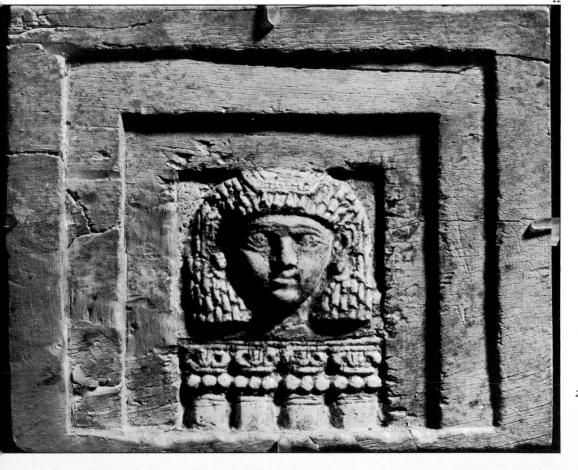

22. A woman in the window. Ivory from Arslan-Tash (Hadatta). Elie Borowski Collection. Department of Antiquities and Museums, Jerusalem.

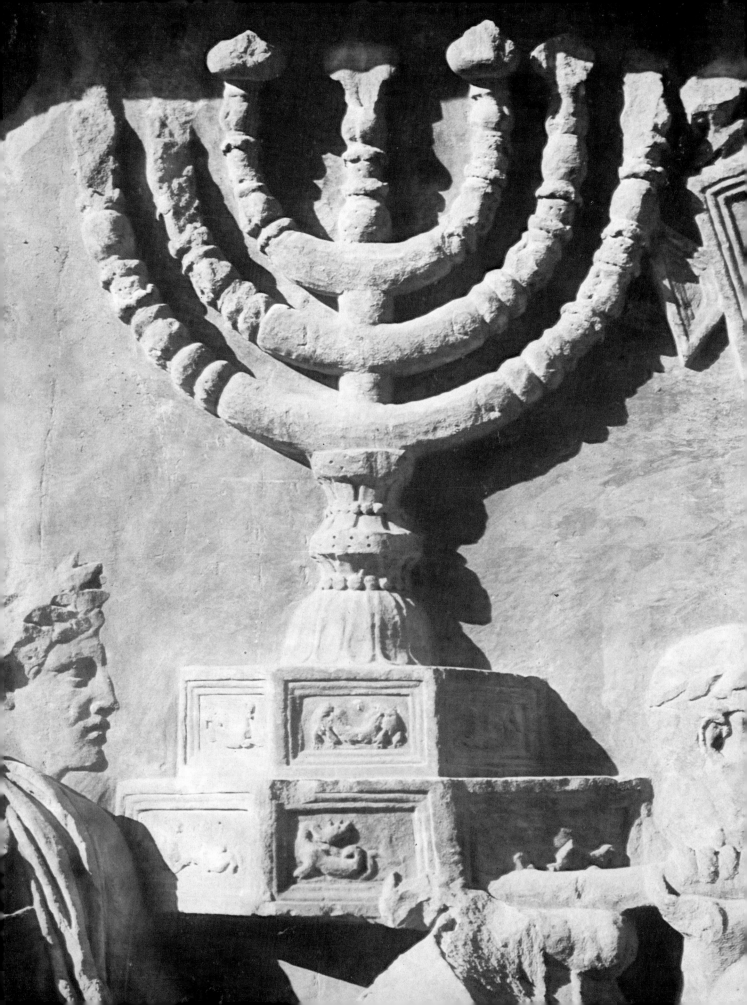

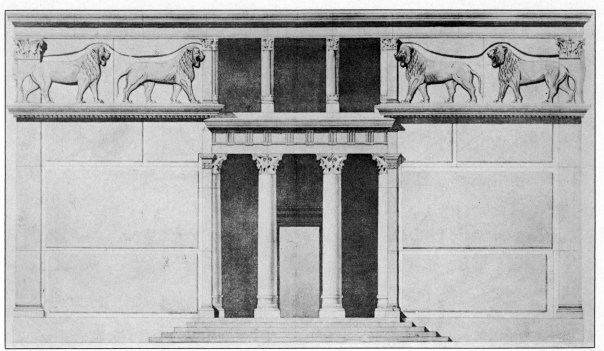

24

3. The Golden Candelabrum from the Temple in Jerusalem,
 as it is represented on the Arch of Titus, Rome.

4. Reconstruction of the Tobiad Palace at Iraq-el-Amir,
 Transjordan.

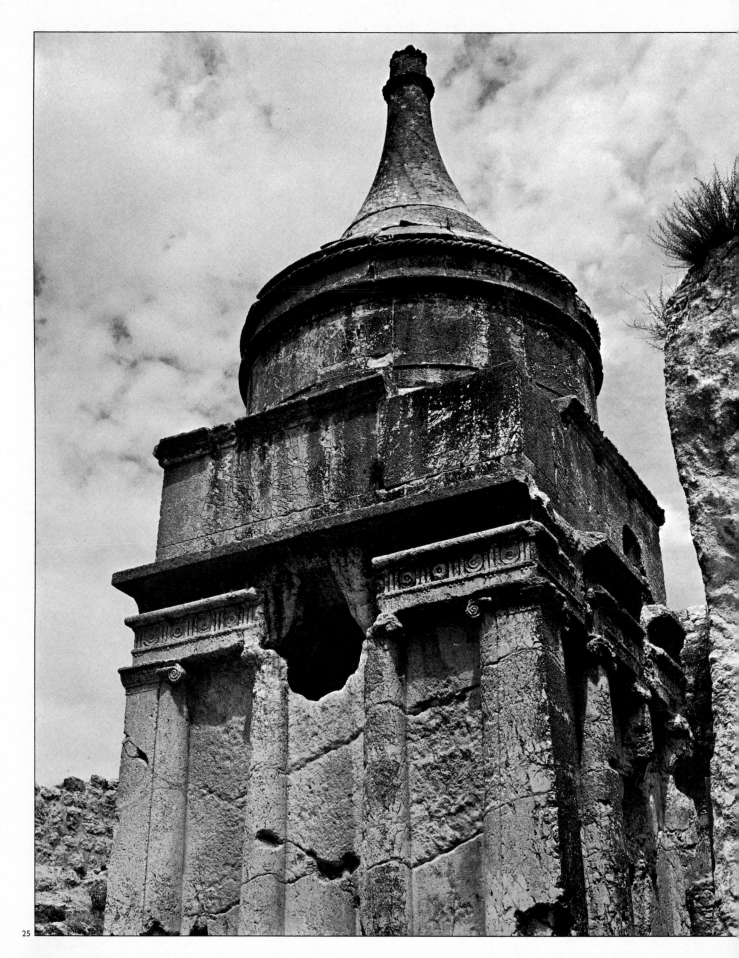

25

25. *The so-called "Tomb of Absalom," Kidron Valley, Jerusalem.*

glyptic art of the late second millennium B.C.E., which is itself derived from the old and detailed Babylonian seal-maker's art. Direct Assyrian artistic influence in Palestine can, of course, not be ruled out; Israel had been in contact with Assyria since the ninth century; and immediately after Jeroboam's death, Assyria began the advance which was to lead to the extinction of the Israelite state.

There is, however, a second strain of inspiration of which the seals give evidence. This is Phoenician both as to its motifs and as to treatment, and includes much Egyptian heritage, as is common with Phoenician art in general. Such motifs were used by Phoenician craftsmen irrespective of the medium employed on metal, ivory, seals, and presumably textiles. The Israelite seal-cutters may well have derived their stock of patterns from them. We know from the Biblical record that Phoenician trade reached Israel (Ezekiel XXVII, 17), and a fragment of a Phoenician-type metal bowl has, in fact, turned up at Megiddo. Other sources of inspiration are less important. Mesopotamian in origin are probably the crescent and star, the symbols of Sin and Ishtar. The cockerel, a motif which seems to appear first on seals of the imperial period in Assyria, is represented in Judea on the splendid seal of Ya'azanyahu.

These seals of the Israelite and Judean kingdoms are, by the mere frequency of their occurrence, an important source for the history of applied art in those two countries. Their stylistic derivation, as we saw, is mixed; however, the better examples have everywhere developed a style marked by good arrangement, a feeling for line and ornament, though without any special tendency towards naturalistic detail. The Judean seals are often marked by elegance both in the drawing and style of script, while the seals from the petty monarchies across the Jordan are apt to be stiff and uninspired. On the whole, the treatment is purely linear; the official Judean "la-melekh" stamps differ from the general run of private seals by going in for a design consisting essentially of simple surfaces surrounded by curving border lines.

On the art of mural painting, much in favor in Assyrian royal palaces, no significant example has survived in Israelite territory, though Ezekiel seems to have thundered against this impious abomination (XXIII, 14–15). Our ignorance of Israelite painting is all the more complete because Israelite pottery, unlike that of the preceding Canaanites, was hardly ever given painted ornamentation during the period of the monarchy. The patterns show a sense for clear simple functional lines, but make little attempt at other embellishments. This is all the more striking when we compare the frequency of painting of the most varied kind on the pottery of contemporary Cyprus, or the immense popularity of painted pottery in Greece during the Orientalizing period. For in both cases the motifs of decoration were largely borrowed from Phoenician and other Western Asian textiles, metal goods, etc.: these motifs were known in Israel, but for some reason they entirely failed to evoke the same response. There are indeed a few exceptions to the general rule. A vase from Tel Qasileh figures a spirited if extremely shaggy horse; and a pot from Tel-ed-Duweir (ancient Lachish) bears an incised drawing of two graceful gazelles nibbling at a lotus flower. (In the latter case, we have a new and entirely unconventional application of an old Canaanite motif: the two antithetically placed goats flanking the "sacred tree." Yet the general rule stands.) That painting should as a whole have been avoided during the later period of the monarchy is perhaps understandable; it was a time when religious reform was in the air, and the plastic arts also apparently tended to fall into disfavor in the strict mental climate engendered by the prophetic revolution and successive cultic

reformations. But why the potter should have shunned representational art when the seal-cutter did not is less understood; on purely religious grounds the making of "graven images" might have caused more offense than representation in two dimensions only. Perhaps the ranks of seal-cutters included among their members a greater number of foreigners, while the members of the potters' guilds were mainly of local village stock. We can only state the existence of this divergence, which is indeed to some extent an illustration of the mixed tendencies at work in the Judean state and capital during the later days of the monarchy.

The end of the political independence of Israel and Judah marks a decisive break also in the history of their art. The remaining rump of the northern monarchy fell to the Assyrians as early as 722 B.C.E., and in 586 Judah succumbed to the Babylonians. The further development of the lands which had made up the Northern kingdom passes out of the purview of these pages. The limited revival of the Southern state in the shape of the province of Judah within the body politic of the Persian Empire, however, is of direct interest to us. A few words must, accordingly, be said about the artistic progress of the Jews between the "Return," and the time when Alexander the Great put an end to the Persian Empire and opened up the East to Hellenism and Hellenistic art.

Too little is known about the post-exile Temple to define its position in the history of art. To some extent, the architecture may have followed the old model: the Decree of Cyrus (Ezra VI, 4) lays down a method of construction (three rows of great stones and a row of timber) analogous to the building technique familiar from the Solomonic sanctuary. In detail there may have been significant differences: the decoration involving cherubs was apparently not repeated. Josephus, writing some centuries later, had no memory of what cherubs looked like (Antiquities VIII, 73). The main impression achieved by the building must have been due to proportions, material, and perhaps decorative motifs of a non-representative kind. We know too little about them, however, to say more. Other buildings in the country offer little worthy of comment. The "residency" at Lachish develops the old-established "bit hilani" by the addition of vaulting, an innovation perhaps imported from the East. The building has furnished no architectural details or ornaments worth noticing. The decline is marked also in other fields. The special art of the Judean seal-cutter died out in the fifth century, killed perhaps by the use of Babylonian models, or religious scruples. Almost the only manifestations of Palestinian art belonging to this time, that are known to us, are the scratched drawings on little limestone altars, such as have been discovered at Lachish, Gezer, Samaria, and elsewhere, both in Palestine and outside. It suffices to compare these scribblings with earlier work to see how deep the regression into rusticity and childlike drawing had become. Even in its utter decay this "art" still kept some very Oriental features: the lion on one of the altars is decorated with a star on its shoulder, thus continuing an extremely ancient Near Eastern tradition.

The most important feature in the history of art in Palestine during the Persian period (only a small part of which was at that time occupied by Jews), however, is the arrival of new traditions from abroad (the older Phoenician connections in the coastal plain, largely non-Jewish, continued, as Phoenician graves at Athlit and elsewhere prove; but they do not seem to have exercised much influence otherwise). Cypriote statuary now appears, as at Tel es-Safi; it seems, however, not to have evoked any local copies. As against this, the first humble indications of Greek artistic influence in the country

are of considerable interest. There is no visible impact of Greek art in Palestine before the post-exile period. Then things began to change. Greek vases, and also Greek coins, were entering the country. The official provincial coinage of Judah was modeled on a Greek prototype: it imitated the Attic coins featuring the owl. Another coin, found in Hebron and probably also Jewish, is based on Arabo-Philistine types which are likewise derived from Greek models. In such small ways did Greek art first make an impact in Palestine.

This coming of Greek art provides, in fact, a natural limit to our brief account of the history of art in Israel and Judah. Let us now review the field we have covered as a whole, and try to see what special features (if any) separate this art from the artistic output of the neighboring countries.

That Israelite and Judean art, during the period dealt with, was not overmuch pre-occupied by matters of a religious nature should be clear; and Israelite art cannot thus be singled out for any special contents. Similarly, it seems difficult to establish, among the common motifs employed, the occurrence of common Jewish religious symbols as known to any significant degree later. The horsemen, frequently found as a pottery figure, might conceivably then as later have had religious significance, but there is no proof that this was so. The cherub, found in Solomon's Temple and elsewhere, is not by derivation or distribution especially Israelite. Essentially, however, the motifs employed are foreign, and often originally connected with the cults of other nations (especially Egypt), though the religious nature of the ornamental details may not always have been remembered. In this connection, it seems worth recalling that the majority of Jews at this time found it possible to accept together with the adherence to the Jewish cult, elements which later generations would have felt to be heretical. This is, in fact, the time when there existed in Egypt the schismatic temple at Elephantine, where an aberrant Judaism was clothed in art forms, the details of which may one day be revealed to us by excavations.

Just as Israelite and Judean art are thus not in any way dominated by their dedication to the Yahwistic cult, so they do not differ in origin from the art of the neighboring nations. They are, like the latter, based on the Canaanite-North-Syrian tradition, strongly shot through with Phoenician traits. A negative religious influence can perhaps be postulated to explain the apparent absence of monumental sculpture, and of painting on pottery, after the time of the House of Omri. In these matters Israel and Judah were parting company with the more progressive countries of the eighth, seventh, and sixth centuries, to the west. The Egyptian influence, felt in Cyprus and productive of a special class of sculpture, and the forces behind the rise of Orientalizing art in Greece were apparently not felt, or resisted. One receives the impression of intentional restriction to certain fields of activity.

Within the limits thus set, Israelite art does seem to have developed certain attitudes which to some extent distinguish it from the art of the neighboring nations, and also from that of the Canaanites during the preceding period.

Israelite plastic art seems to like a reduction of bodies to simple geometric forms; and in the case of relief, the juxtaposition of simple plain surfaces. There is little attempt made at anatomical correctness, naturalistic detail, or any evidence of a canon of attitudes or proportions. The results may sometimes look strangely modernistic; they differ from the work of Egyptian or Phoenician artists, though North Syrian ("Aramaic") analogies might to some extent be found.

Israelite drawing, as shown by seals or designs scratched on pottery, etc., is likewise not interested in the representation of naturalistic detail. In this respect it is closely linked with the pot paintings of the preceding Canaanite popular art, but is in sharp opposition to the better work of Semitic Mesopotamian glyptic art. It shows, on the other hand, a fairly strong sense for flowing and elegant line, a tendency also exemplified in the Judean script, as found during the later period of the monarchy, from ca. 700 B.C.E. onwards. At the same time, there is occasionally a surprising feeling for movement, seen as it were in a split second and rendered with a few brief strokes. A consideration of two drawings which we have referred to earlier may make our meaning clear.

Let us look at the two gazelles nibbling at a lotus scratched by some unknown small-town potter on a vessel from Lachish. There is no attempt to give depth to the picture; it is purely two-dimensional, and in fact the horns of the gazelles consist of one single line only. The outlines of legs and body cross in a way which a novice in Greece would not have been guilty of; in fact, the Mesopotamian seal-cutters centuries earlier did much better. Yet, in spite of all this, the drawing possesses a freshness, a truth of observation, and a sense of graceful line, which lift it into the realm of genuine art.

Naturalism achieved not through the accumulation of detail, but by "split-second" observation, reproduced in a few outlines only, is thus the basic feature of this seal as of the Lachish pot drawing just discussed. The horse from Tel Qasileh, while earlier and more primitive, seems to belong to the same school of vision. Such pieces are rare among the mass of mediocrity of Judean art, but they seem to have no parallel at all in the neighboring countries. It may possibly be permissible to recall here that Judean poetry at times seems similar, evoking split-second impressions by a few rapid strokes without further detail. Take, for instance, Nahum III, 2–3: "The noise of a whip, and the noise of the rattling of the wheels, and of the prancing horses, and of the jumping chariots. The horseman lifteth up both the bright sword and the glittering spear: and there is a multitude a slain, and a great number of carcasses…"

This is very different from the detailed description of slaughter in Homer, or in the Assyrian royal annals. Occasionally, at least, Judean art shows signs of a vision and of an approach peculiar to itself.

A sense for elegance, and a sharp gift for observation, combined with a liking for simple but gracious form; these things seem somehow not out of place in Judah and particularly in Jerusalem which we can sense from the very strictures of the prophets. Their words seem to evoke a city, active, noisy, alert, and curious of things foreign; skeptical and witty; brilliant, gay, and profoundly worldly. It seems in some ways a little Athens rather than a Heavenly Jerusalem; and, indeed, our study has repeatedly brought us up against strong links with pre-classical Greece. Prophetic teaching and religious reform were to deflect the mind of the nation into different channels, and the catastrophe of 586 B.C.E. sealed the doom of the old spirit. It is, nevertheless, valuable to search out what it was, and to re-create the background of Israel's religious evolution from the scraps of evidence that yet remain to us.

JEWISH ART AT THE TIME OF THE SECOND TEMPLE

by MAXIMILIAN KON

Jewish art at the time of the Second Temple was born and grew against the background of Hellenistic influence on the spiritual life of the Jewish people. The Greek conception of the nature of beauty now began to penetrate among the educated strata of the nation; even under the Hasmoneans, notwithstanding the struggle for liberation from Hellenistic oppression and tyranny, there was a growing understanding of the essence and principles of Greek art, which were adopted and integrated within the compass of Jewish national values. Among the militant group which stood at the head of the nation and which raised the banner of national-religious and spiritual revival, there was an ever-growing understanding of the nature of art and of its function in national life. However, the acclimatization of Hellenistic art to Jewish life resulted from the need for artistic expression alone; it by no means signified a functional connection with or dependence on the Hellenistic *Weltanschauung*. The understanding of this basic truth spread increasingly among the educated, and reached its height during the reign of Herod.

The return to Palestine of a generation of exiles who had grown up under Persian culture, as well as the direct influence of that culture, which was encouraged by the Persian rulers and administrators of Judea, could not but impress their stamp on the first developments of Jewish culture at the beginning of the Second Temple period. Historical descriptions and archaeological excavations enable us to reconstruct fragments of this culture, and thus to draw conclusions as to its influence on the development of Jewish art in later times.

The characteristic plan of a Palestine house of the Persian period is evident in the remains of a residence discovered during the Lachish excavations. On the southern section of a large courtyard surrounded on all sides by buildings, stands a hall, raised on three steps and open across its whole length. On the western side of the courtyard, a portal with two columns leads to a long hall and a small room bordering upon it; on the north and east sides are the living quarters. The capitals of the columns and all remnants of architectonic decoration are missing, so that reconstruction of the front is virtually impossible. But we may assume that its decoration and the structure of its columns followed the Persian pattern.

Ezekiel's account of the Temple (XLI, 18–19) describes the frieze in high relief, which ran around the whole building, in the following terms: "And it was made with cherubim

and palm trees, so that a palm tree was between a cherub and a cherub; and every cherub had two faces; so that the face of a man was toward the palm tree on the one side, and the face of a young lion... on the other side; it was made through all the house round about." This type of front is common in the decorative treatment of the Persian building of these days — e.g., on Darius' palace at Persepolis. Again, Josephus describes the "Babylonian curtain" which covered the doors of the Temple: "Before them there was a Babylonian curtain, craftily wrought in sky-blue and white and purple and royal purple; and the work of the curtain was marvelous, for these colors had not been applied artlessly, but so as to show the picture of the whole world."

In other words, the entrance to the inner Temple, which had an area of about 40 sq.m., was completely covered by a colored curtain hung at a height of 9 m. The use of curtains instead of doors inside the building was common throughout the Middle East. In palaces and temples they were made in a style befitting the situation, richly covered with colored *appliqué* work and decorated with a fringe of gold-thread tassels. Presumably such heavy curtains could not have been hung from the lintel of the Temple door if they had been made in one piece, for it would then have been virtually impossible to draw them aside on days of public adoration. Hence, we must assume that the Temple curtain consisted of two parts hung separately from the lintel, but forming one single composition unit. The method of hanging such curtains has already been investigated in all details in the course of the excavations of the Persian royal palaces of Persepolis and Susa. They are shown on stone reliefs from the time Darius or Xerxes, where we may study the hanging arrangements and the decorative composition.

Fig. 23 The shape of the seven-armed Temple candelabrum, preserved on the well-known relief of the Arch of Titus in Rome, is an interesting and instructive instance of Persian influence on the decoration of the sacral implements of the Temple. The lower part of the stem, shaped like a bunch of leaves hanging downwards, is characteristic of the bases of Persian columns and the decorations of Persian furniture and other objects of handicraft of the period.

The comparatively short duration of the Persian hegemony explains why most of the spare remains of the period appear to be mere imitations of Persian art, with no attempt at artistic adaptation to the new conditions of different surroundings.

II

Alexander the Great's conquest of the East closes the first chapter of the titanic struggle between the cultures of the Orient and the Occident. It is not only the time of the penetration of Greek culture throughout the conquered territories, but also the period of extensive Graeco-Macedonian colonization, which now for the first time was carried out on a large scale. It must, however, be pointed out that as early as the beginning of the 5th century B.C.E., the first signs of Attic influence in Palestine may be discerned. Attic pottery of the black-and-red figurine style has not only been found in the Hellenized South of the country, but even in the North. But the decisive factor in the acclimatization and continuity of Hellenistic influences in Palestine were no doubt the Graeco-Macedonian colonies in the Middle East in general, and in Palestine in particular. Except for Jerusalem and the surrounding area, the whole country underwent a rapid process of Hellenization. The new Greek settlers began to build their towns systematically, following the principles of classical town-planning (first formulated by Hippodamus of Milatus).

Maresha may be taken as an instance of a town in Palestine built strictly according to the Hippotamic scheme. This little town, only 23,000 sq.m. in area, had two main streets running at right angles north-south and east-west. The regular grid-pattern of the building blocks includes the Agora (the central square of the Greek city, corresponding to the Roman Forum), which is surrounded on all sides by roofed colonnades, as well as the city wall with its towers at the four corners.

The century of Ptolemaic rule over Palestine had a considerable influence on the de- *Fig. 24* velopment of the art of the Jewish population. The ruins of the Tobiad Palace at Iraq-el-Amir display all the characteristics of Alexandrine architecture and decoration. The excavation of the building is incomplete, so that we are not yet able to study the nature of its internal architecture and decoration. On the north are the remains of a large entrance hall with a two-column portal; on either side there are small rooms, one of which contains a staircase. A large opening flanked by two small ones leads from the hall to the inside of the building. Along the wall we discern the remains of pilasters. The decorative treatment of the Corinthian capitals of this building is closely related to the Alexandrine style, with the characteristic lack of the central volutes of the classical Graeco-Roman capital. At Iraq-el-Amir we find, instead, a plant motif consisting of a stem surrounded by a small ring of dividing leaves, ending at the top in two flower-and-leaf patterns pointing in opposite directions surmounted by tendrils. The front of the building was decorated by a wide frieze, showing two pairs of lions approaching each other, flanking the upper window. Instead of the stiff schematic character of Persian decoration, we have here a much freer treatment. The artist does not hesitate to allow the upper ends of the outer pilasters to disappear behind the lion's tails, and to cover the pilasters flanking the central upper window by their heads.

Of the tomb of the Hasmoneans in Modi'in we know nothing except the data given by Josephus and the Book of Maccabees: it was a mausoleum with seven pyramids arising from its upper part.

The latter source provides us with the following description: "Now Simon built a monument on the grave of his father and brothers and raised it high and embellished it with polished stones inside and at the rear. And he built seven pyramids, one opposite the other, for his father, mother, and his four brothers. And he decorated them artfully, and around them he set large pillars. And on top of the pillars he wrought the shapes of all manner of weapons for a memory forever, and beside them he sculpted ships, that those who go down to the sea might see them." This description allows us to reconstruct the Hasmonean mausoleum. It was apparently a very high rectangular structure built from ashlars which served as a base for the upper story of the monument, consisting of seven base structures in the form of towers surrounded by pilasters and crowned by pyramidal or conical tops. The wall-surfaces between the pilasters were decorated with reliefs of weapons and ships. A similar instance of a sepulchral monument dating from the first century B.C.E. may still be seen at Sueida in Transjordan.

Typically, the influence of Syrian-Hellenistic art at the time of the Hasmoneans may be seen even in the decorations of such Temple implements as the base of the seven-armed candelabrum and the table of shewbread, as depicted on the Arch of Titus in Rome. The candelabrum, made by order of Judah the Maccabee, was a replica of the one robbed from the Temple by Antiochus Epiphanes and taken to Syria. The new candelabrum was placed on a base resembling the bases of the columns in the temple of Apollo at Didyma,

the front of which was just then being finished. In one detail the Jewish base differs from its Hellenistic prototype: while the dragons on the reliefs of the Didymian bases have human faces, those on the base of the candelabrum intended for the Jerusalem Temple bear the faces of animals. The table of shewbread resembles, according to the testimony of Josephus, "those at Delphi." It stood on legs "whose lower halves resembled the legs which the Dorians make for their couches." It is well-known, in fact, that the legs of Greek beds were shaped like lions' paws.

The coins of the age of Persian domination at the beginning of the Second Temple period followed Greek patterns, and lacked originality in their decorative treatment. The first coins of this period (fourth century B.C.E.) bear figures from the Greek pantheon and are only distinguished by the inscription YHD—the Aramaic name of the Judea district in Persian times. On a coin of this period found at Gaza, we see the head of a man wearing a Greek copper helmet. The reverse bears the picture of a bearded god sitting on a winged chariot and holding an eagle in the left hand. Technically and artistically, the coin comes close to Attic standards. A completely different coin was found at Bet-Zur. It shows the profile of a shaven man with smoothly combed hair held together in front by something like a diadem in the shape of a ribbon. The reverse shows a woman's head, depicting Astarte, over the inscription "beqa" (=half). Around her neck the goddess wears a pearl necklace. On both coins the eyes appear *en face,* though the whole head is shown *en profil.* The faces bear an archaic, expressionless smile.

A fundamental change in the choice of numismatic subject occurs on the coins of the Hasmonean kings. The newly awakened spirit of national consciousness is first of all reflected in the discontinuation of the use of human likenesses on coins, and the substitution of ritual symbols and plant or fruit motifs. The influence of the Syrian coinage may, however, be discerned in the cornucopias on the coins of John Hyrcanus and the anchors on some coins struck by Alexander Jannaeus.

III

Notwithstanding the rich descriptive material relating to the Second Temple period found in Gentile as well as in Jewish sources, there is little general awareness of the cultural tendencies of these times.

The Jerusalem of Herod's days was not only the seat of the glorious Temple, rebuilt and enlarged by the king at the height of his impetuous energy; it was no less the city of the resplendent stadium, of the amphitheater, the gymnasium, and the *bouleuterion* (council-house)—a city receptive to the Hellenistic spirit whose symbol, the golden eagle of Rome, perched above the Temple gates. The new trends of Hellenistic mentality, which began to gain currency among the Jews of those days, developed in course of time into an attempt to reconcile two conflicting *Weltanschauungen.* In the field of creative art this new spirit expressed itself in the introduction of the human shape, and even in the use of figures and scenes from the Graeco-Roman pantheon. It would be wrong to regard these ideas as resulting only from the assimilatory tendencies of certain circles. While evidence from rabbinic sources relating to this period is scanty, it is known that the patriarchal house which continued and transmitted the tradition of Hillel the Elder had a keen aesthetic sense and did not object to representations of the human figure for ornamental purposes.

A vast graveyard stretches for several miles on both sides of the road which enters

Jerusalem from the north, as though to delay the wayfarer on his journey to the capital. On both sides rise sepulchral monuments, hewn out of the living rock. These are quarried out of the flank of the mountains. Their slanting sides serve as a tectonic element of the tomb, while the entrance to the sepulchral chamber leads down beneath ground level. In some instances the monument is crowned by a structure of ashlars, such as the so-called Tomb of Absalom. Other memorials form a single architectonical unit, hewn out of the rock in one complete piece, like the Tomb of Zechariah; these are family mausoleums. Pausanias, the author of the ''Description of Greece'' (2nd century C.E.), admiringly compared the monument built by Queen Helena of Adiabene as a mausoleum for her dynasty (now known as the Tombs of the Kings in Jerusalem) with the mausoleum of Halicarnassus, which was reckoned among the seven wonders of the world. In their architectonical and decorative execution, these graves often recall the fronts of temples and palaces.

Fig. 25
Fig. 26

Some idea of the structure and decoration of these tombs may be gained from a fuller description of one of them—the mausoleum of the Queen of Adiabene, just mentioned, which dates from the end of the Second Temple period. The lower part of this enormous monument was hewn from the rock and is comparatively well preserved, while the upper part, which has been destroyed, was built from ashlars. Originally, the whole structure reached a height of about 30 m. Steps hewn in the rock, 9 m. wide, led to the funeral courtyard, which was dug 10 m. deep into the hillside. In order to make room for this and for the inner part of the tomb, some 10,000 cu. m. of rock had to be quarried and removed. Surmounting the upper part, which was built from ashlar, rose three sepulchral monuments topped by pyramids.

The gateway of the tomb, which is raised on three steps and has two monolithic columns in the middle and two pilasters at the sides, is hewn out of the rock. Below the triglyphs, we find a wide decorative frieze surmounting the entrance, composed of pine cones surrounded by leaves and other leaves and fruits. This combination within one composition of elements of different plants and fruits, or of various naturalistic, stylized and geometrical units, is characteristic of Palestine art in this period. The naturalistic approach and the freedom of execution evident on this frieze exemplify the high level attained by decorative art in Palestine at the close of the period of the Second Temple. The leaves do not conform to any strict decorative pattern, but freely overlap and are shown in an interesting foreshortening. The strongly sculptured relief of the frieze resolves the decorated surface into patches of light and shadow, which fill the whole area with decoration. As against this, the new trends in Jewish art towards the end of the Second Temple period are reflected in the discontinuation of the frieze above the entrance and its accentuation by unconnected bunches of grapes, garlands, and acanthus leaves on a bare, undecorated surface. The cornices and capitals of the pilasters are remarkable for their lack of decoration, in contrast with the rich decorative treatment of these areas in the Hasmonean era.

Fig. 28

The famous monument in the Kidron Valley, commonly called Absalom's Tomb, is another characteristic instance of the monumental architecture of the Jerusalem tombs of this time. The lower part of the monument is in the form of a cube standing on a large postament, ending in an Egyptian cavetto cornice. The upper story is shaped as a concave conical roof, ending in a flower with six petals. A round drum decorated with a rope-like raised ring (terus) provides the transition from cube to cone. Each of the four sides of the

Fig. 25

cube is decorated with two Ionic half-columns touching the wall, while the corners have pilasters with quarter-columns attached to them. The Doric-Greek triglyph, the bases of the columns with their *cyma reversa* which recall Persian patterns, and the compositional principle of a *tholus* superimposed on a cubic body add up to a *mixtum compositum* characteristic of the late Hellenistic and Roman period.

Fig. 26 The Tomb of Zachariah must be regarded as belonging to the same kind of family sepulcher. Situated near Absalom's Tomb, it is also among the most interesting funerary monuments of the Kidron Valley. Its architectonical construction resembles that of Absalom's Tomb, from which it is distinguished only by the heavily stressed Egyptian-style cornice and by the pyramid which crowns the composition. Another such monument,

Fig. 27 outside the Kidron Valley, is the Tomb of Jason, west of Jerusalem. It was, perhaps, built for a family who came from abroad. The surmounting of sepulchral monuments by a geometrical pyramid is a usual motif all over the Eastern Mediterranean at the end of the Hellenistic period.

Even the walls and turrets of the cities of this time were objects for architectonic decora-

Fig. 29 tion. The remnants of the southwest part of the Temple wall, which has recently been excavated, and particularly parts of the wall built by Herod to surround the Graves of the

Fig. 30 Patriarchs in Hebron, which are still extant and in good condition, allow us to study the architectonic treatment of this type of structure. The front of the structure was divided horizontally into two areas. The lower part was smooth, constructed of enormous ashlars. The upper part, slightly set back, was divided into closely placed vertical strips, alternately recessed and protruding so that a pattern of closely set pilasters was created. The contrast between the severity of the base with its heavy ashlar masonry and the decorative airiness of the upper part of the wall produces an impression of remarkable monumentality and grace. This building style shows marked Hellenistic influences.

Particular care was devoted to the architectonic decoration of the inside of the royal towers and palaces. The towers were constructed as fortresses, combining the functions of royal residences and defense works; containing a complex of living rooms, halls, baths, armories, and observation posts for the garrison, they were equally capable of serving as residences or as fortresses. According to Josephus, the Tower of Phasael in Jerusalem was "like unto a royal palace" in richness of decoration and beauty of internal architecture. Of the Hippicus Tower, Josephus says that the splendor of its structure and the beauty of its decoration "sought its like among the towers of the whole world." Both were surpassed by the Antonia fortress, built by Herod to guard the northern approach to the Temple. In its monumentality and the richness of its internal decoration, this was the prototype of the Roman fortified palace, such as we find, for instance, in the palaces of Gallienus at Antioch and of Diocletian at Spalate. Occasionally, the upper story of the front of these tower-forts was inlaid with small colored stones set into cement, so that a mosaic-like effect was achieved. This accounts, obviously, for the name of "Psephinus" ("Mosaic Tower") given to the tower on the northern side of the wall of Jerusalem.

IV

Archaeological excavations in Palestine have thus far produced but few examples of architecture and decoration of the beginning of Herod's reign; but they are sufficient to give us some impression of the art of this period. They confirm what Josephus Flavius had to say about the monumentality, the artistic level, and the originality of the archi-

tecture of the time. The conflict between the opposing influences of East and West is the factor which gave Herodian art its characteristic quality. The rapid development of architecture, which within a short period of time completely changed the appearance of the towns of Palestine, must be attributed to Herod's febrile activity. His work in this field was not confined to Jerusalem, though he enriched the capital by a wealth of magnificent buildings.

Jerusalem was built on four hills. The Upper City, or Upper Market, was connected with the Temple by means of two bridges spanning the Central Valley (the Tyropoeon, or Cheesemakers' Valley). From the Lower City, or City of David, two tunnels led to the southern part of the Temple Square on the Temple Hill. One of these tunnels, still comparatively well preserved, is mentioned in the Talmud by the name of Hulda Gate, and is nowadays called the Double Gate. The entrance to this tunnel may be regarded as a fair example of Herodian art and of the main elements of the Jewish art of those times. The entrance hall, which has a square ground plan, is covered by four stone cupolas, supported in the middle by a monolithic column. The Corinthian capital of the monolith, with long, smooth leaves alternating with acanthus, but without volutes or tripartition of the leaves, is a Hellenistic adaptation of an Egyptian capital. On two of the four cupolas we still find interesting remains of the stucco plaster work which once covered them completely. The central circular area of one of these cupolas is smooth, except for a protuberance in the middle. The rim of the cupola consists of a triple wreath of leaves, interrupted by four rosettes. The middle space is decorated with eight squares, symmetrically arranged. A leafy vine bearing bunches of grapes completely surrounds the squares, which are filled with geometrical designs and box-like patterns. The general character of this composition, of which the pure, stylized geometrical pattern is the main subject, is characteristic of the Jewish decorative art of the period. The composition of the second cupola of the Hulda Gate recalls the classical monocentric style of cupola treatment. The rich and complicated basket-weaving motif on the upper part of the cupola is essentially Greek. The decorative element common to both cupolas is the vine. The pendentives at the corners of these cupolas prove that this principle of construction, which was used in building the Byzantine churches, had already been known in Herod's period. Characteristic of this period, too, are pilasters with a narrow cornice, quite unlike the rich cornices of the Hasmonean period. Of the terminal gate of the tunnel nothing remains. At the end of the tunnel there was doubtless a building which architectonically and decoratively harmonized with the royal basilica and the colonnades of the Temple square.

The Temple itself, in its impressive monumentality, set the pattern for many buildings, of which we still find traces in some of the contemporary Jerusalem tombs. In his description of the Temple, Josephus mentions the royal basilica built by Herod as a monumental entrance to the Temple square. This basilica, actually a basilica-like stoa with two stories of columns, was directly connected with the bridge over the Central Valley which led from the Upper City to the Temple Hill. One hundred sixty-two monolithic columns, thirty feet tall, hewn of white limestone, with Attic pediments, had been set on bases and aligned in four parallel rows. They formed a long perspective of a stoa constructed in basilica form along the whole southern part of the Temple square. The rich decoration of the Corinthian capitals aroused general admiration. The high and lofty central nave with its two-story rows of columns evenly illuminated the inside of the stoa

Stucco plaster work,
vault of Hulda Gate, Jerusalem.

Fig. 30a

and reinforced the play of light and shadow on the deep relief-work of the cedar roofing and the ceilings of the wings. The thousand-foot-long stoa was open across the whole length of the southern area of the Temple square; its entrance was on the narrower side. The monumental impulse of the planning of this building made it one of the finest examples of stoal architecture in those days.

Josephus' description of the Temple, as well as that of the Talmud, mainly relates its measurements; consequently, they enable us at best to form only a general impression of its structure and plan. About the decoration of the Temple itself we know nothing. The great opening which gave access to the Temple hall allowed the masses assembled in the court before the building to look inside and witness its splendor: "For it was directed towards the reaches of the heavens and the vastnesses of the world, which have no limit" (Josephus, Wars 5.V.4.). The walls of the Temple were covered with gold; presumably, the metal decoration was in the general style of Herodian art. Of particular interest is the description of the "golden vine which stood at the entrance of the Temple hall and which was trained on supports" (Mishnah Middot III, 2, 8). Its bunches of grapes were as tall as a man: "Whosoever offered a leaf or grape or bunch of grapes (of gold) would bring it and hang it on the vine" (ibid). In the Jerusalem Temple we find the purely architectonical theme of the doorway combined with a supporting structure mainly intended to carry the golden vine with its branches and grapes—a favorite motif of Jewish art. A similar decorative principle already occurs in the pillars of Yakhin and Bo'az, which were placed before the doorway of Solomon's Temple. It is probable that the resplendent development of Jewish architecture in Herod's time had its echo in the neighboring countries. This is proved by the remains of the small temple of Ba'al Sha'amin discovered in the course of the excavations at Siah in Syria. The construction of this was begun shortly after Herod's death, though it was not completed before the second half of the first century C.E. The capitals here are exactly similar to those in the portal of the Hulda Gate. In the decoration of the entrance to the Siah Temple—an ornamental frieze crowned by a vine with an eagle in the center—we also discern, notwithstanding the primitive execution, the influence of the Jerusalem Temple.

As already stated, the royal basilica was connected with the bridge which led from it to the Upper City. The remains of this bridge, which have been preserved, enable us to establish its dimensions and to form an impression of the monumental conception of the town-planners of Jerusalem in those days. The bridge, which was more than 50 feet wide and rose more than 70 feet above the Central Valley, formed the final section of Jerusalem's main street, which connected the Temple with Herod's palace. The bridge was a continuation of the royal basilica; they had a common axis and formed a connected architectonical unit, linked by the entrance gate. The decoration of the gate corresponded in style with that of the basilica and of the colonnades on the Temple square. At its western end the bridge led to the central square of the Upper City, the Xystus. As the level of the bridge lay below that of the Upper City, stairs were constructed to lead directly from the Xystus to the bridge; the top was surmounted by an arched gateway, which formed the east front of the Xystus.

The Xystus, corresponding in function to a Greek Agora, or marketplace, was, together with Jerusalem's main street—which was parallel to it, connecting Herod's palace with the Temple—the most populous part of the city and the favorite meeting place of the Jerusalemites. Josephus has nothing to say about the architectonical structure of this

square; but its name justifies the assumption that it was surrounded on all sides by a roofed colonnade.

The layout of Jerusalem's streets in Herod's time is closely connected with the city's topography and history. The street plan of the Judean capital was unlike that of the other great Hellenistic cities of the Near East. It was only after the time of the Hasmoneans that the new quarters of the Upper City began to show some signs of planning. As in all contemporary Hellenistic cities, the external aspect of Jerusalem's streets was monotonous. The fronts of the houses were devoid of all architectonic decoration; on the side of the street, the walls of the ground floor were practically without windows; the entrances to the houses were hardly indicated by any architectonic device. Only the doorposts and lintels of the houses of the rich bore a modest sculptured relief. The steep and closely built slope of the Upper City, which stretched down towards the Central Valley, appeared like a mosaic in which the white patches formed by the crowded houses were interrupted by the green of trees and plants in the courtyards, and by the flowers cultivated on the flat roofs and in the gardens of the rich.

V

The philosophies of life of the East and the West, which met and fused at the different levels of the Jewish population, inevitably found their expression in the architecture of the houses. The house-plan either conformed to the spirit of the Hellenistic trends which had obtained currency in the country, or reflected the continuous Oriental tradition. Together with the basic principles of Greek architecture, the Jewish builder adopted also the Greek terminology. Terms such as *traklin* (triclinium), *akhsadra* (exedra; the exedra in Greek building was a recess, with raised seat, where the disputations of the learned took place), *stoe* (stoa), etc., frequently occur in Talmudic sources.

Yet we know virtually nothing about the palaces of the Jewish aristocracy of the period. Lack of data prevents any attempts at reconstructing their type or structure. We cannot even say whether they were essentially large dwelling-houses, or whether they followed the old Assyrian-Persian tradition and formed a harmonious composition of separate buildings with different functions. Josephus mentions the palaces of Queen Helena of Adiabene and so on, only in passing. In the one instance where he speaks of the Hasmonean palace, he only remarks that it was situated at the end of the slope of the Upper City, and had been modernized under Agrippa. We possess, however, interesting information about Herod's royal palaces, based on Josephus' descriptions and on the results of archaeological research carried out at Massada and from the partial excavation of Herod's palace at Jericho. The former consisted, it appears, of three separate buildings, combined within one single architectural unit, each with its own function within the general purpose of the palace. Each building formed a separate independent unit with its own internal courtyard. Herod's private living quarters were in the southern sector of the palace; the representative and administrative sections in the northern part. Long halls with small rooms on each side, so characteristic of Oriental architecture, surrounded the courtyard of the palace on three sides. Two long halls, placed opposite each other, served as ceremonial rooms of the private wing. According to Josephus, this palace which was built "on the western slope... below the wall which closes off the summit of the mountain," had a northern aspect. It was of the fortress type and was surrounded by a wall "high and heavily fortified, and on its four corners were towers sixty cubits high.

The arrangement of the rooms inside and of the halls and the baths was ample and rich, and everywhere there arose pillars made of one single stone, and the walls and floors were covered with colored stones."

On the second of the two peaks below the top of Mount Massada, where, according to Josephus, Herod's palace stood, the remains of a large hall, surrounded by a row of columns, have been uncovered. The mountainside itself served as its south wall, having half-columns sunk into it. The capitals were characteristic of the Corinthian order of the late Hellenistic period. The steep sides of the peak below the wall were covered with ashlars. The northern wall was presumably also decorated inside and outside with half-columns. Those on the outside must have recalled the way in which the upper part of Herod's palace at Jericho was decorated with pilasters.

The lack of archaeological data on Herod's palace in Jerusalem is to some extent compensated by Josephus' description. It was built with legendary splendor and with the architectonic *élan* characteristic of its builder. The richness of its execution overshadowed the Temple itself. We must assume that this palace resembled the instances of Oriental palace architecture known to us. Two of its representative parts were given special names in honor of the king's Roman protectors: the "Caesareum" and the "Agrippae-um." Josephus describes the palace as follows:

"No building in the world is comparable to this palace, which was in every way exceptional. It was surrounded by a wall thirty cubits high, from which towers arose at equal distances, and which contained banquet halls for hundreds of guests. Who shall describe the rare stones of all kinds used in building it; the ceilings with their beams which in size and ornament exceeded anything which the human eye had ever seen; the countless halls and rooms of all manner of shapes, each with its own conveniences and mostly furnished in silver and gold. Rows of colonnades intersected, and each colonnade had columns of a different order. The palace was surrounded by gardens as by a sea of greenery; wide avenues of trees crossed, and near them there were ponds and water basins from which jets of water spouted through copper ornaments" (Wars 5.IV.4).

The architecture of Herod's palaces reflects in an interesting way the interaction of Oriental and Hellenistic art.

Fig. 31 An instance of the treatment of archways in the streets of the towns may be found in an arched gate still preserved in Jerusalem, the so-called Ecce Homo Gate in the fortress of Antonia. Its construction is a characteristic instance of the architecture of its time. It stood within the Antonia fortress, and served as an architectonic-decorative element in the fort's internal structure. The lower part of the gate has been well preserved, and from it we can reconstruct the whole. It was a gate with three arches, with two rounded niches above the lateral openings. The smooth surface of its wall, without any protruding basis or decorative pillars, and with its straight, barely raised cornice, has all the characteristic qualities of the architectonic style of Herod's days. In its quiet and simple approach, this architecture is completely different from the over-rich decorations of the Hellenistic style.

VI

The nature of the new style which establishes the autonomous character of the Jewish art that began in Herod's reign reveals itself in the surviving examples of decoration of this period. The remains of decorations on the front and inside of Jewish tombs of the

time, as well as on sarcophagi and ossuaries, give us the opportunity of determining the basic principles which characterize the original elements in the art of the Herodian period.

Characteristic of the new style is the triangular tympanum of the funeral cave known as the "Cave of Jehoshaphat." The connecting constructive element of the decorated area is provided by a wavy line of vine tendrils which becomes narrower towards the corners of the tympanum. In the center is an acanthus surrounded by tendrils. In its execution it differs both from the Jewish and the non-Jewish treatment customary at the time. The lateral leaves, rounded at the bottom, unite the whole into one organic pattern, while the central leaf is stylized to such an extent that it no longer resembles the plant which it is supposed to portray. The acanthus rests on a basis of three leaves which supports it and raises it somewhat. Fruits, leaves, or flowers appear within each of the near-circles formed by the vine tendrils. The free treatment of the details combines agreeably with the symmetrical composition of the tympanum as a whole. In its general nature the decorative treatment of this tympanum shows all the characteristics of Hellenistic-Alexandrine art; but the composition of the acanthus indicates a new approach to the execution of the decorative subject — the combination of stylized and naturalistic details within one single element.

Different again is the gable of the so-called Tombs of the Sanhedrin in Jerusalem. *Fig. 32* The selection of decorative subjects on this tympanum, which is composed of both stylized and naturalistic patterns, is also typical of the Hellenistic-Alexandrine school. But the composition fills the whole area without leaving any undecorated space and betrays its Oriental nature by a notable *horror-vacui*. This tympanum is noteworthy for its excellent technical execution. Its technique differs considerably from the Hellenistic relief, which protrudes plastically from its background; the decorations of the Sanhedrin Tombs' tympanum are carried out in a sharply carved recessed high-relief, the highest points of which lie level with the surface of the area. This method of treating stone is an adaptation of the contemporary technique of wood decoration. This new type of stone treatment is found exclusively in Judea at the end of the Second Temple period. The metamorphosis of structural fragments of timber architecture into decorative elements of stone architecture is familiar from the development of Greek decorative art. But the adaptation of the decorative treatment of wood to the decorative treatment of stone is the first instance in history of this form of artistic expression.

On several ossuaries* attributed to the first century B.C.E. we find decorations evidencing the full development of the new style, technically as well as compositionally. The stone ossuaries give the impression of wooden chests. Their lids are of widely differing shapes. Usually they are provided with a recessed area which serves as the background on which the decorations are carved. The favorite subjects for the decoration of ossuaries are geometrical patterns, the acanthus, the rosette, and leaves. In several cases remains of paint have been found. One ossuary found in the neighborhood of Jerusalem has a semi-cylindrical lid decorated with a row of twin columns resting on a single base and terminating in a single capital. The colonnade is closed at the top by arches in a repeating rhythm. It should be noted that in Romanesque and Gothic monasteries the cloisters were generally surrounded by colonnades of this kind. Notwithstanding the Oriental

*　An ossuary is a small chest (usually about 30″ × 15″ × 15″) in which the bones of the dead were kept after the remainder of the body had decomposed.

trend of the decoration, this ossuary is remarkable for the outstanding clarity of its compositional structure. A broad frame of leaves surrounds the whole recessed and decorated area. The two pillars in the center, which are flanked by two large rosettes, lend the decorative pattern balance and compositional clarity. While these columns have Attic bases, their stems are fluted and their capitals are of the Corinthian order and resemble those of the Hulda Gate. The perforated structure of the central rosette, which is composed of eight triple leaves, appears to provide the archetypal model for the later rosettes of the Gothic cathedrals.

Fig. 33 One of the best instances of the decorative style at the end of the Second Temple period occurs on another ossuary, also found in Jerusalem. The composition consists of two rosettes flanking a stylized acanthus, the outline of which, engraved in a light, wavy line, fuses with the outer circles of the rosettes. In general, we may say that one of the basic principles in the decoration of the Jewish ossuary is the use of stylized geometrical or naturalistic motifs in a way which ensures the artist's freedom of movement in their application.

In order to demonstrate the basic differences between the old geometrical elements and the new decorative patterns, the reader is invited to consider an instance of this treatment, characteristic of Jewish art at the end of the Second Temple period. The decorative geometrical element known as the "whirling wheel" and consisting of intertwined circle segments is of Oriental origin and may be found throughout the Middle East. Under Herod, this element, which originally was strictly geometrical, underwent a change. Its geometrical lines became the structural skeleton for a free imaginative flower motif with curved petals all pointing in the same direction. While the appearance of the old geometrical elements is thus changed, its original dynamism is retained. Archaeological excavations have uncovered this pattern on the fronts of Jewish tombs and on ossuaries as a decoration on doors, etc. The fact that ossuaries so widely differing in execution and in decorative pattern were made at the same time must be attributed to the differences in the artistic talent and technical accomplishment of their sculptors.

The creative imagination which produced these new and original trends in Jewish art unfortunately had no opportunity of developing to the full. Its growth was cut short by the tragic climax of the Jewish War in 70 C.E. The end of Jewish political independence marks the beginning of the slow disappearance of this original style, which had derived its vitality from a Jewish art deeply conscious of the direction of its already fully established way.

VII

Fig. 34, 35, 36, 37 Numismatic art before Herod, under him, and later is characterized by the absence of portraits or human figures; exceptions are the decorative motifs of the coins struck by Herod, Philip II (whose territory was inhabited mainly by non-Jews), and by Agrippa I and Agrippa II. Herod himself and his successors were most careful not to offend the religious sensitivities of the majority of their subjects, and therefore systematically refrained from using human or animal motifs on their coins. For while in enlightened Jewish circles the use of human images in art became more and more accepted, the multitudes were yet far from ready for a more liberal interpretation of the Second Commandment,

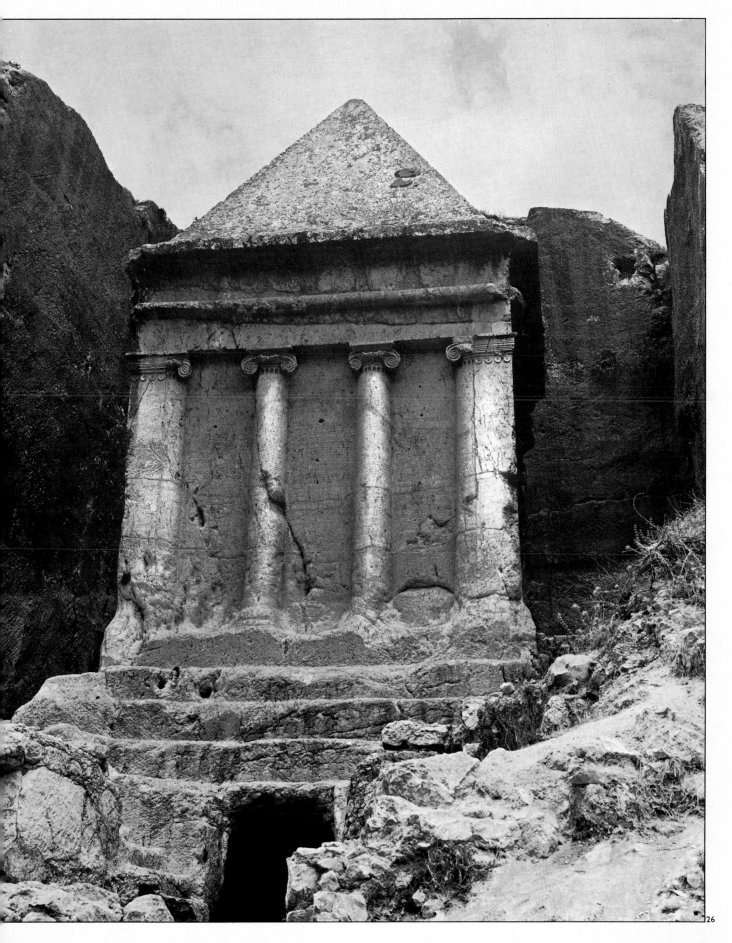

26. Tomb of Zechariah, Kidron Valley, Jerusalem.

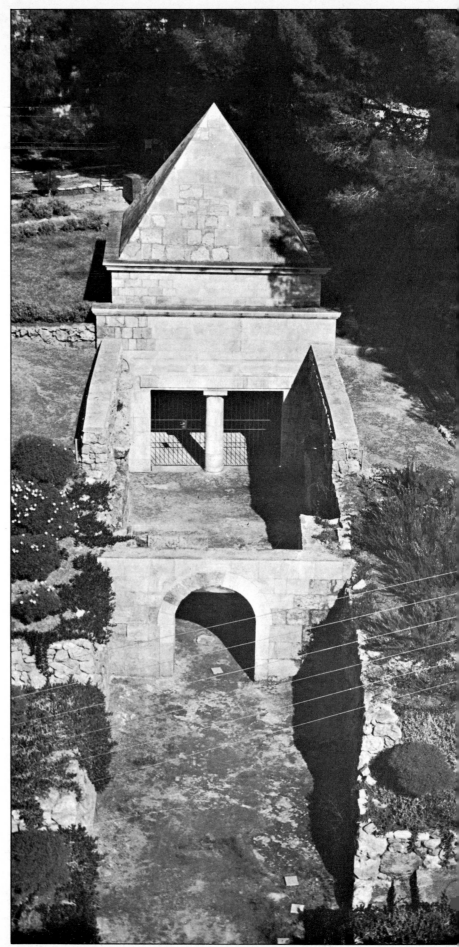

27. *Jason's Tomb, Jerusalem. Department of Antiquities and Museums, Jerusalem.*

28. *Part of Frieze, Tombs of the Kings, Jerusalem.*

29. *South-western corner of the wall which surrounded Herod's Temple, showing part of the so-called Robinson Arch, which may have been the beginning of the upper bridge road connecting the Temple with the Upper City. During excavations in the Tyropeon Valley, 1968.*

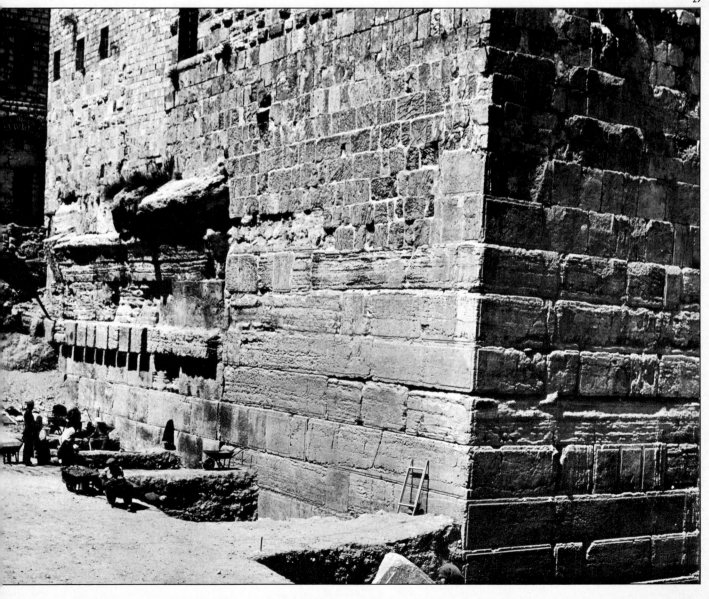

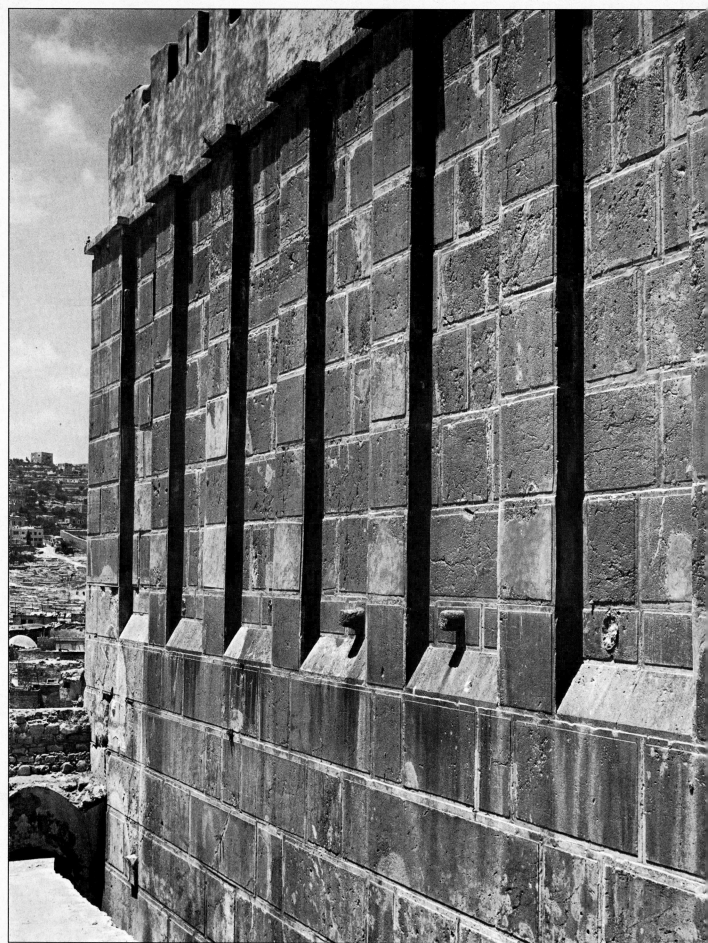

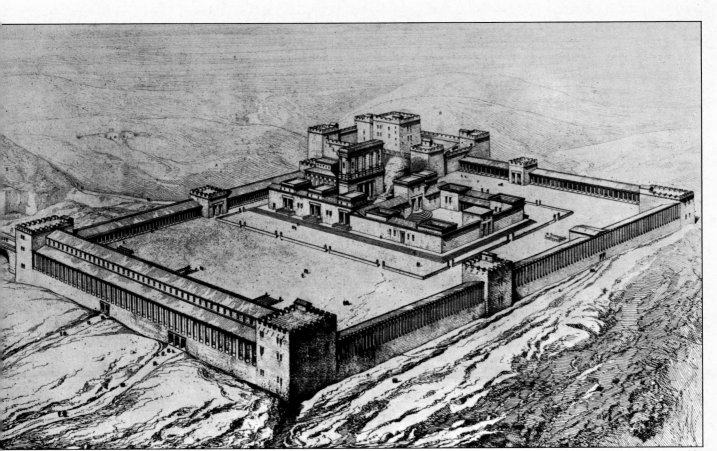

30a.

30. Herodian Wall of the Tombs of the Patriarchs, Hebron.

30a. Reconstruction of Herod's Temple (after De Vogue).

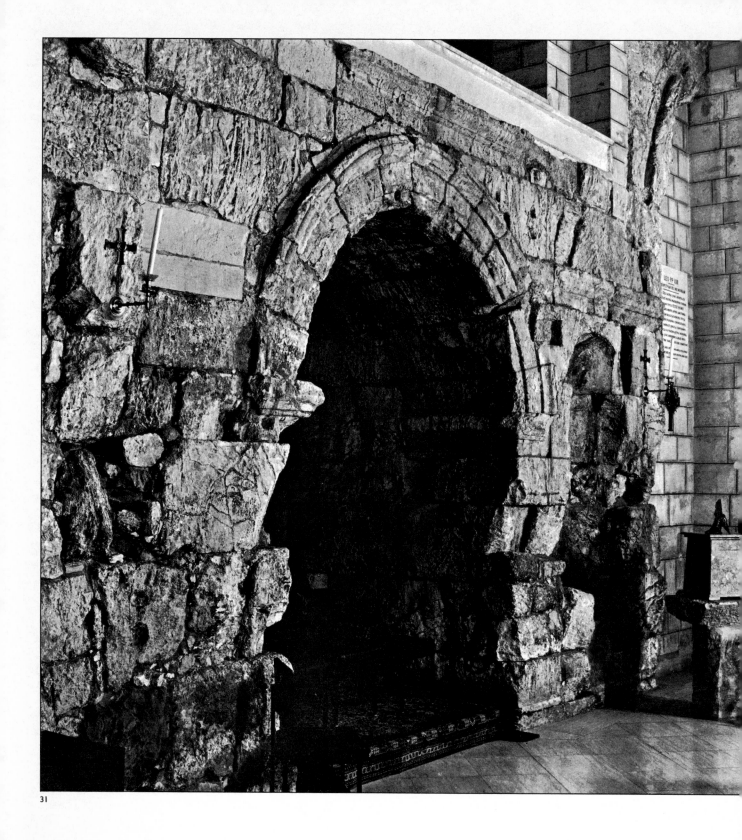

31

31. One of the three arches of the so-called "Ecce Homo Gate"
 from the fortress of Antonia in Jerusalem, now part of the
 church of the Sisters of Zion.

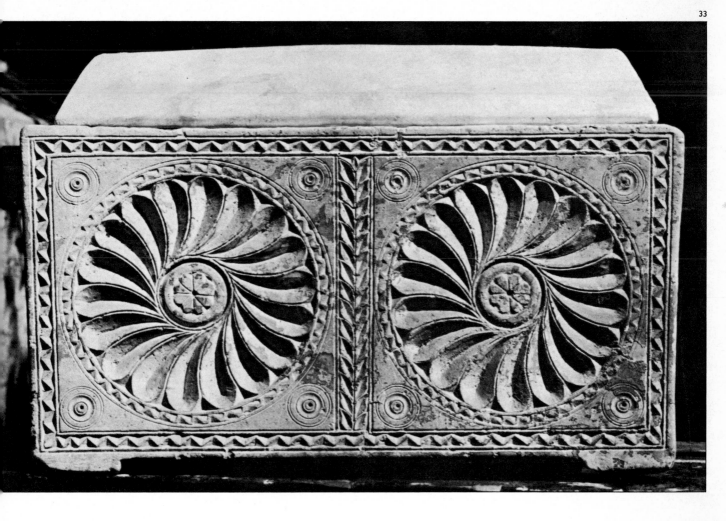

32. *Decorated gable of a portal of the so-called "Tombs of the Sanhedrin," Jerusalem.*

33. *Stone ossuary of Herodian period, from near Jerusalem, Department of Antiquities and Museums, Jerusalem.*

34

35

36

34. *Coin from Judea as a Persian province (ca. 375 B.C.E.)*
 Reverse: owl standing. Incribed: Yehud.

35. *Jewish coin of Judah Aristobulos (104–103 B.C.E.)*
 Obverse: Judah the High Priest and Hever (Community) of
 the Jews.

36. *Jewish coin of John Hyrcanus (1st century B.C.E.) Obverse:*
 Yehohanan the High Priest and Hever of the Jews.

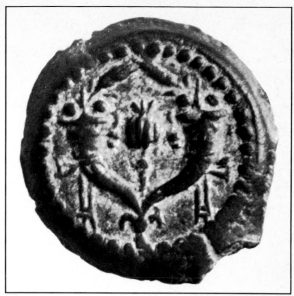

37

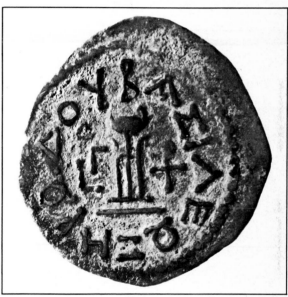

38

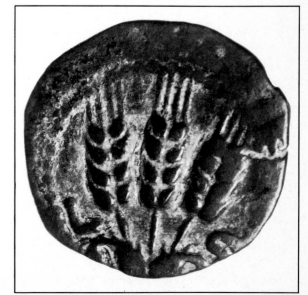

37. *Jewish coin of John Hyrcanus (1st century B.C.E.) Reverse:
Double Cornucopiae and poppy-head.*

38. *Coin of Herod I (28 B.C.E.). Obverse: Tripod with lebes
(bowl) for offering. Inscribed: King Herod.*

39. *Coin of Herod Agrippa I (42 C.E.). Reverse: Three ears of
corm. Inscribed: L.S.*

39

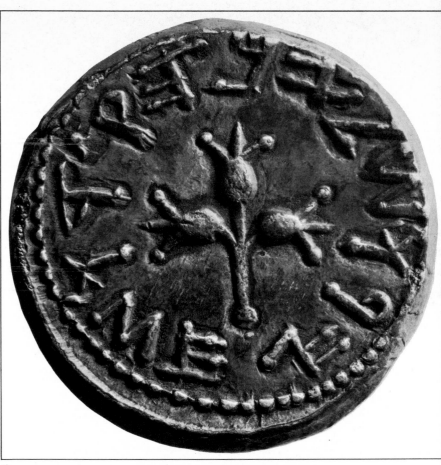

40

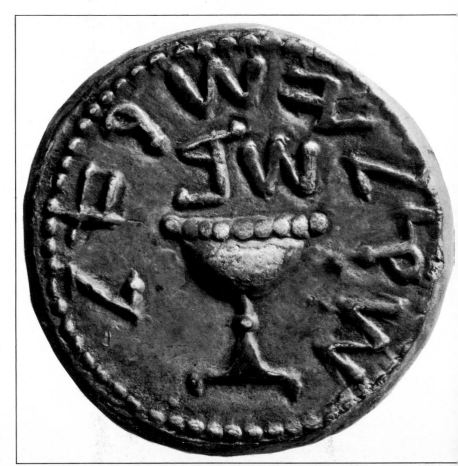

40. Shekel of the First Revolt — Second Year (68/69).
Obverse: Stem with three pomegranates. Inscribed:
Jerusalem the Holy. Department of Antiquities and
Museums, Jerusalem.

41. Shekel of the First Revolt — Second year (68/69).
Reverse: Chalice. Inscribed: Shekel Israel. Depart-
ment of Antiquities and Museums, Jerusalem.

and even the Roman governors of Judea respected the religious-conservative scruples of the Jewish masses.

The coinage of the Herodian period is a continuation of that of the Hasmonean dynasty, both in pattern and in method of execution. The latter suffers from inadequate understanding and characterization of the subjects shown, and from lack of technical skill in miniature drawing. Only as from Agrippa II and the Roman governors, and more particularly during the Great Insurrection, some understanding of the art of coining becomes apparent. The crossed cornucopias (Agrippa II), the palm and the three ears of corn (Agrippa II and Roman procurators), the branch with three pomegranates and the chalice (period of the war against Rome), the vine leaves and the wreaths of leaves begin to be more freely composed and drawn. The narrow-necked amphoras and the goblets with a large square foot faithfully express the character of objects which were in general use at the time.

Fig. 38, 39

Fig. 40, 41

The almost complete lack of remains of decorative murals prevents us, at least for the present, from studying the development of this branch of art in Jewish Palestine. Nevertheless, there are good grounds for the assumption — fully confirmed by the latest excavations — that decorative mural painting was adequately represented in the Herodian period. In general, we may postulate, that in style the decorative mural in Palestine did not deviate from the Roman fashion generally current at the time, the so-called third style of Roman mural painting. Large surfaces, framed by simple geometrical patterns and suitably divided, were filled with decorations which also included miniature frescoes of human figures and mythological scenes, thus conforming to the general character of architecture under Herod. We may further assume that in the course of its development the decorative mural of the late Second Temple period continued to follow the Roman line. Strzygowsky (in "Orient oder Rom") and many recent art historians hold that early Christianity — which came into existence on Jewish soil, originated from the spirit of Judaism, and was spread by Jews — took over the decorative art of the Jewish synagogue of those times. Only this hypothesis, he feels, can explain the fact that the murals in the early Christian catacombs of Rome invariably depict Old Testament scenes, scenes from the New Testament only beginning to occur at a later date. There is reason to believe that drawings of humans and animals were not unfamiliar to Jewish art at the time of the Second Temple. As will be seen, in the second century C.E. their use had become common and it would appear probable that *halakhic* sanction only acknowledged what for a long time had been customary.

The decorative elements of Jewish art, which have their origin in both the Eastern and the Western tradition, occasionally reflect the characteristic changes which distinguish them from their prototypes. However, the approach of the new Jewish art of this period cannot be defined in terms of its decorative elements, of their artistic-constructive application and of the technique of their execution alone; it is in no less degree determined by the principle of their combination into groups which form a single compositional unit. It is this principle which lends Jewish decorative art of the Second Temple period its specific character. In Oriental art the geometrical element does not exist as an independent unit, but is merely a repetitive auxiliary motif in the complicated web of ornament which covers the whole decorated surface. Not without justice is this art, by reason of its emotive effect on the spectator, sometimes qualified as a kind of expressionism, in contrast with the cold, clear, and logical composition of Western art. In the composition

scheme of Western art the geometrical element is almost completely absent. In the rare cases where it is used, such as in the "astragal" and "meander" patterns, it appears exclusively as the basic element of a ribbon pattern. But even in these cases the continuous ribbon of repetitive geometrical elements retains the structural clarity which permits each single elementary unit to be clearly discerned, unlike the visually complicated web of Oriental art. In this respect as well, we may note in Jewish art of the time the attempt to combine the structure logic of the Occidental composition with the visual-emotional tendency of the Orient. Although in the compositional conception of Herodian art the desire for light-and-shade effects is occasionally gratified at the expense of the lines of the element itself, we always remain aware of a tendency to leave a plain and unadorned surface as background for the outline of the element or combination of elements. Jewish art during the period of the Second Temple had all the characteristic qualities of autonomous creation, and we are justified in defining it as a separate style within the art of the Near East. At first, it remained faithful to the basic principles of Alexandrine art in its combination of geometrical and stylized ornamental elements, but in the course of its development, Jewish art found new ways of expressing these principles and discovered original methods of compositional combination. The development of the new independent style was obviously the expression of the artistic spirit of the Jewish architects and artists of the period—a spirit reflecting the changed Jewish attitude to new trends and the attempt to achieve a fusion between the Eastern and Western cultures on Jewish soil, which was being undertaken in many fields during the first century B.C.E.

With the establishment of Aelia Capitolina on the site of the destroyed capital of Judea a new era began.

SYNAGOGUE ARCHITECTURE IN THE LATE CLASSICAL PERIOD

by MICHAEL AVI-YONAH

The "House of Assembly" (Hebrew: *Beth ha-Knesseth*, Greek: *Synagôgé* from *synagô*—"get together") was in its beginnings a revolutionary conception. The ancient world knew places of worship from its earliest days: i.e. temples, which were supposed to be the dwelling places of the living god. These consisted normally of a relatively small shrine, the house of the god, accessible only to the priests (as regards it holy of holies, the *adyton,* sometimes inaccessible even to these). Such a shrine, whether it contained the visible symbol of the god (a statue or a holy stone), or the throne of the invisible deity, or even nothing at all (as was the case of the Temple in Jerusalem), was surrounded by a spacious court in which the faithful could gather around the altar and worship while the sacrifices ascended to heaven. This court was surrounded by porticoes, dwellings of the priests, etc. This was the classical design of the temple, common to the ancient Orient and Classical and post-Classical Greece and Rome.

Side by side with the temple, another kind of public building existed in the East: the royal throne room, called *basilica*, hall of justice, or the like. This was paralleled in the Greek democracies by assembly-halls, called *bouleutéria,* for the civic council and law-courts which judged the citizens. Such halls became the universal feature of the market-place in Greek and Roman cities. They consisted of a hall of assembly, with a small place set aside for the transaction of judicial business. It was these basilicas that in due course became the model for the synagogue.

The origin of the synagogue has been much disputed; it seems most probably to have originated in the Babylonian exile. Separated from the traditional center of their worship, yet unwilling to admit the supremacy of the apparently victorious gods of Babylon, the leaders of the Jewish community established, "by the waters of Babylon," meeting-houses for prayer and exhortation, turning their eyes towards the Jerusalem they could not forget. The days of the joyous First Return to Zion now dawned, and the Temple rose from its ashes; but the habit of communal meetings was probably by now in-grained, and was found so useful, that it spread before long to the gradually growing Jewish Diaspora in the Persian Empire and then in the Hellenistic kingdoms. There seems good reason to believe that, after the re-erection of the Temple, synagogues were established even in the various towns and villages of Judah; such places of assembly would certainly have been of the greatest value for the reshaping of Jewish religious life which was undertaken by Ezra and Nehemiah. A hint of the existence of such rural synagogues has been inferred from the apparent reference in Psalm LXXIV, 8, to "the synagogues of God" (in Hebrew *mo'adei El*) which were "burned up in the land" by

God's enemies. In any case, synagogues were most probably established last of all in the Holy City of Jerusalem itself; for there the Temple served as the natural center of Jewish worship.

In view of the historical development sketched above, we need not wonder that the earliest epigraphical and archaeological evidences of the existence of synagogues should come to us from outside Israel. The spiritual content of these places of worship always remained Jewish; but their external form was to a large extent adapted from the gentile world. The problem of the synagogue architect was to express in foreign elements (architectural and ornamental) the spirit of the Jewish congregation. If we remember that the synagogue was the spiritual mother both of the church and the mosque, we begin to understand the immense and worldwide implications of the attempt of the Jews of the Persian and Hellenistic period to create, for the first time in history, a place of worship which would have to contain *all* the worshipers and not only a handful of priests; and which instead of being turned outwards, from the shrine of the god towards the pious, was turned inwards, towards the center of prayer inside the building. In the following pages we shall trace the long history of the evolution of the synagogue from its beginnings (as evidenced by archaeological remains) to the fully developed style in the Byzantine period, at the threshold of the Middle Ages.

II

The earliest evidence for the existence of a synagogue comes from Egypt: it is the dedicatory inscription of a *proseuché* (place of prayer) found in the Schedia quarter of Alexandria and dated to the time of King Ptolemy III Euergetes, who reigned from 247 to 221 B.C.E. Unfortunately, this inscription is the only part of the synagogue left. Yet some idea of the magnificence of the early synagogues in the Diaspora may be gathered from the Talmudic description of the synagogue of the community of Alexandria. Said Rabbi Judah (Tosephta *Succa,* IV): "He who never saw the *diplostoon* (i.e. double stoa: see below) never saw the great glory of Israel. It was like a kind of great basilica, a stoa within a stoa, and sometimes there were inside twice the number of those who left Egypt (at the time of the Exodus). Seventy-one golden chairs were there, one for each elder... In the middle was a wooden podium (*bimah*) and the *hazan* of the synagogue stood in a corner of it with a *sudarium* (piece of cloth) in his hand" with which he gave signals for the people to cry 'Amen'; for the synagogue was so big that signals were necessary. Although, of course, we have here the usual *Aggadic* exaggeration, it is obvious that the great synagogue of Alexandria had several halls supported by columns; that the elders sat in seats of honor, probably facing the public; and that in the middle there was a wooden construction, i.e., one which would leave no clear archaeological traces. All these points will be of significance when we come to discuss the extant remains of the Galilean synagogues.

In connection with the description of the great synagogue in Alexandria, another point should be mentioned — such a splendid building was undoubtedly built on a site free of other buildings and visible from afar. This is in accord with our information from other sources to the effect that Jewish synagogues in the Diaspora were built in public places and enjoyed the protection of the authorities, despite the growth in anti-Jewish feeling which took place throughout the ancient world after the two wars against the Romans (135–132 and 73–66 B.C.E.). However, the synagogues in Dura-Europos and in Naro

(Hammam Lif) were hidden among private houses, which were no doubt occupied only by Jews.

After the inscriptions from Schedia and some other places in Egypt, the next remnant of a synagogue (chronologically speaking) is particularly tantalizing because it is also the earliest archaeological evidence for the existence of a synagogue in Judea*, certainly dating to before 70 C.E. We refer to the Theodotus inscription, found in Jerusalem in 1914. Of this building nothing remained but the inscription and the foundations of a few plastered underground rooms, which may have served as cisterns. The inscription refers to the dedication of a synagogue (this very term is used instead of the more literary *proseuché*) for the reading of the law and the teaching of the commandments, together with the hospice, chambers, and the water installation for the lodging of needy strangers. In the digs at Massada in 1963–65, the remains of a synagogue were discovered which is undoubtedly the oldest to be revealed so far. The building is connected with the northwest wall, and its dimensions are 12x15 m. Two stages of construction are discernible: in the first stage it consisted of two rooms, a corridor, and a hall; the ceiling was supported by five pillars, four of which formed two rows, the fifth being between the rows, an arrangement which brings to mind the crosswise pillars of the Galilean synagogues (see below). The doorways of the corridor and the hall were on the southeast side, so that the rear wall of the building faced Jerusalem. The archaeologist Y. Yadin suggests that this building was a synagogue which served those members of Herod's family and court who wished to pray. During the period of Massada's occupation by a Roman garrison, the building was used as a stable, but in the time of the Zealots it was refurbished. The wall between the corridor and the hall was done away with, and it was replaced by two pillars made from links taken from the northern corner of the original building. This corner was cut off by walls and separated from the rest of the hall. In the hall itself, plastered benches were installed along the walls, and benches made of unhewn stones and splinters of cut stones from dismantled Herodian palaces. Naturally, in the days of the Zealots greater use was made of the building (the benches testify to this), and a special room was built to preserve ritual objects; during the excavations, a kind of *geniza* pit (for the storage of disused sacred books and ritual articles) was found. The shape of the synagogue in its final form recalls the Hellenistic buildings, the *Ecclesiastéria*, in which the citizens of the cities gathered for general meetings. We may have here an important hint as to the source of the type of the synagogue.

In the Caesarea excavations of 1956–62, the foundations of a square building (9 sq. m.) were discovered. This, too, may once have been a synagogue during the Second Commonwealth, since capitals decorated with candelabra were found there; but it cannot be reconstructed today.

Fig. 42

III

The first synagogues in Galilee appeared at the time of the concentrated settlement of Jews there, after the relaxing of the persecution by Hadrian, i.e., from the end of the second century C.E. and after.

Synagogue buildings continued to be constructed in Palestine till early in the eighth

* The first-century remains found at Delos, formerly attributed to a synagogue, are now considered part of a secular building.

century (over sixty remains of such have been found so far). These remains may be divided into three types: the early (second to fourth centuries), the transitional (late third to fifth), and the late (fifth to eighth).

The dating of the early type of synagogue has to be based on stylistic considerations, as only one dedicatory inscription has been found—that at Qisyon—prayers for the peace and prosperity of the Emperor Septimius Severus and his family (192–211). Some scholars, however, believe that this inscription is from a secular building. The distinguishing mark of this group of synagogues is the direction of their façades, which face towards Jerusalem (i.e., south in Galilee, west beyond the Jordan). As we shall see, this was the direction in which the worshipers turned in prayer. Most of the synagogues found in Galilee and the adjacent area belong to this type, including some of the best known.

The site of these synagogues was chosen in accordance with the Talmudic prescription according to which the synagogue must be situated on the highest point in the town. That is why synagogues were built in mountainous Galilee, affording marvelous views from the terraces in front of most of the buildings. The selection of such high places also had its architectural consequences: it required the construction of a platform (usually paved with stones) in front of the synagogue, and often of staircases leading up to it; these, in turn, increased the dignity of the edifice, which was visible at a distance and could be approached only with some difficulty. The desire to have an impressive architectural ensemble led to the construction of platforms even in front of synagogues which were not built on mountain slopes, as at Capernaum.

Another position for the location of a synagogue which was apparently allowed, although there is no express mention of it in our ancient sources, was on the shores of the sea (or lake, as at Capernaum) or near brooks and springs (i.e., the second synagogue at Gischala or the one near Umm el-Qanatir in the Golan). The selection of such sites rested apparently on ancient tradition, which is referred to by Josephus (Antiquities XIV, 258) who writes concerning the privileges of the Jews of Halicarnassus who were allowed ''to build places of prayer near the sea in accordance with their native custom.'' According to the Acts of the Apostles (XVI, 13), Paul went on the Sabbath ''out of the gate [of the city of Philippi in Macedonia] by a riverside, where there was a place of prayer.''

The ground plan of the earlier group of synagogues is fairly uniform, although, of course, considerable differences exist between the buildings erected in the various places, *Fig. 43, 44* depending on the economic status of the community and the generosity of the local benefactors. The largest is the Synagogue of Capernaum; it measures 360 sq. m. (although *Fig. 45* its length is exceeded by that of Meron, with its interior length of 24 m.). The fact that one of its columns was presented by one Herod, the son of Mokimos, is testimony to the Hellenized character of the donor whom the architect had to satisfy. Conversely, the small Golanite villages now called Khirbet ed Dikke and Umm el-Qanatir could apparently only afford synagogues with a floor expanse covering no more than 130 sq. m.

In discussing the plans, elevations, and details of these Galilean synagogues, we must consider separately three different groups: the donors and their spiritual advisers, the synagogue elders; the architects who drew up the plans; and lastly, the stonecutters and masons who actually executed the work. Obviously, the plans of the buildings were adapted to the needs of the first group. They decided on the size of the synagogue, and on its arrangements, so that it should conform to ritual purposes and, in general, to their idea of what was fitting for a place of Jewish worship. The architect who drew up the

plans and elevations, and who in some cases may have prepared the detailed drawings of the ornament, of course, had to satisfy the desires of the donors, but he naturally drew upon his experience and observation of other (usually non-Jewish) constructions. On the other hand, the workmen who carried out the architect's plans were almost certainly local masons, steeped in the traditions of the country. They would carry their mannerisms even into the carving of decorations originally derived from the Greek ornament. In addition to their inherited tendencies towards stylization and geometric repetitions, it would be difficult for them to render in the hard basalt of the Galilean hills the supple Hellenic shapes originally conceived for cutting in marble. The local workmen seem to have had some say in the selection of the motifs chosen to decorate the synagogues; we notice, for instance, a high proportion of good-luck symbols in this ornament. The average proportions of length and width in the synagogues of the first category are 11:10, i.e., they are almost square in plan. The principal part of the building is, of course, the hall of assembly and prayer. This hall was modeled on the basilica of the Graeco-Roman period, although closer to the Greek type: that is to say, its roof was supported by rows of columns, which subdivided the interior. However, unlike the usual type of Christian basilica, there was, in addition to the two lengthwise rows of columns, a third, which ran crosswise, parallel to the facade of the building. Indeed, this third colonnade and the absence of an apse are the distinguishing marks of the early type of synagogue. As a result of the existence of this third colonnade, the central space of the earlier synagogues is surrounded by aisles on three sides. The earlier type has also no narthex; the open court adjoining the synagogue or the porch in front of the building fulfilled the functions of an ante-room. The court is, in fact, an almost invariable feature of these synagogues. Such courts are sometimes surrounded by a colonnaded porch on the three sides not adjoining the prayer hall; they must have served as protection against inclement weather and provided accommodation for strangers or for the local poor.

Inside the hall, we have to assume the existence of a gallery resting on the columns running around the three sides and leaving the front wall free. The existence of such a gallery is confirmed partly by remnants of steps actually found, as at Capernaum. Secondly, some synagogues contain among their débris columns smaller than those of the main colonnade in the hall; these presumably must have formed part of a secondary colonnade supporting the roof from the gallery. In the absence of any evidence of a screen on the ground floor, the finding of screen slabs also suggests the existence of an upper gallery protected by a balustrade. The separation of men and women dates back to the Second Temple where the Court of Women (*'Ezrath Nashim)* was originally used by both sexes till the rabbis ordered an upper gallery to be set up for the women only. This arrangement seems to have become ultimately the normal usage in Palestine synagogues.

Only one of the Galilean synagogues — that of Kfar Bar'am — has its façades preserved up to the second story; nevertheless, enough remains have been found at Capernaum and Chorazin to furnish us with a general idea of the typical frontal aspect. The façade was in two stories and was surmounted by what is known as the "Syrian gable." This is a peculiar variation of the common Greek triangular pediment surmounting the front of the temples; it consisted of the curving out of the basis of the pedimental triangle into the shape of an arch. The reason for this variation may be the need to provide better lighting for the interior of synagogues. Temples accessible to a few priests familiar with their surroundings could remain in semi-darkness; but places of prayer in which the Scriptures

Fig. 46

69

were read had to have more light. Apart from three small windows high up in the façade, the synagogues were lit by a big central window, the three doors of which will be discussed below. To provide architectural space for this window, surmounted by an arch, the basis of the gable was made to follow the arch. The façade of the Syrian temples further influenced the synagogue architects in their choice of three doors in the façade, with the middle one higher than the two side doors. The façade was divided by pilasters which supported a cornice; above it was the big semi-circular window surmounted by a richly sculptured arch. In the upper story there seems to have been a window over each of the doors. Each window had a triangular pediment and was sometimes flanked by colonnettes; here again the central window was the more richly decorated and was surmounted by a conch-shaped ornament. Of course, there is much deviation from this generalized description in the case of each particular synagogue. The most interesting of these is the construction of a porch with a separate gable in front of the Kfar Bar'am Synagogue.

The typical synagogue column stands on a high square pedestal which usually rests on a low stylobate. The columns are not fluted as a rule. The bases are of the Attic type. A peculiarity of the synagogue construction are the double columns in the corners of the stylobate which have a heart-shaped section. The capitals are mostly of Corinthian type, but they deviate strongly from the classical type, especially owing to the usual absence of the chalices and the inner spirals. The formation of the acanthus leaves on these Corinthian capitals is of particular interest for the history of Jewish art, because in their sharply cut edges and geometrical interstices, they antedate by at least two centuries the typical Byzantine capital; in fact, if we did not know the approximate date of these synagogues, we would assign them, on the basis of their architectural decoration, to the Byzantine period. This particular transformation of the classic acanthus leaf is founded on a preference for an ornament based on optic principles, i.e., the alternation of sharply defined light and dark surfaces, as opposed to the gently molded surfaces of classical art. The earliest evidence for such optic treatment of ornament is to be found in the ossuaries from the time of the Second Temple.* We have here, therefore, what is in all appearance a native Jewish element used in the decoration of the synagogues. The few capitals of the Ionic order substitute circular plaques for the classic spirals. We also find some capitals of the plainest type, consisting of a simple bulge over the columns. At Umm el-Qanatir another very interesting type of capital has been preserved, viz., a basket capital. This type, very unusual for that period, has some connection with Assyrian capitals, and might even reflect the capitals used in the First Temple. The colonnettes flanking the windows of the façade were mostly fluted; their capitals have an entirely unorthodox garland of leaves and fruits. In all these details we can see the hand of the native workman, with his own traditions, transforming the classical design of the city-trained architect.

The interior of the synagogue halls was in strong contrast to the richly ornamented façade, which was of startling plainness. This again was apparently deliberate. The place of worship was meant to attract and impress the faithful by its richly ornamented exterior, but once inside, attention was to be kept concentrated on prayer. The only exception to this internal plainness was apparently the back-wall of the upper gallery, which was

* See above, pp. 61–62.

surmounted by a richly carved frieze. In the lower hall, two plain rows of stone benches, one above the other, went around the side-walls (and occasionally also along the back-wall). The only exception to their plainness was a decorated stone seat. The most perfect specimen, with its back ornamented by a rosette, sculptured hand-rests, and an Aramaic inscription in front, was found at Chorazin; fragments of a similar chair were discovered at Hammath by Tiberias. There seems to be a general agreement that this was the so-called "Seat of Moses" which is mentioned in Matthew XXIII, 2, and by a fourth century scholar Rabbi Aha (*Pesiqta d'Rav Kahana*, p. 12). Opinions differ as to its use: some scholars consider it the seat of honor; others hold the opinion that it served as the stand for the scroll of the Law during the service.

Fig. 47

All the synagogues of the early type so far discovered are paved with plain stone flags. The walls of the synagogues were plastered and painted, but there is no direct evidence as to the nature of the paintings; in view of the discoveries at Dura-Europos, to be described below, the possibility is not altogether to be excluded that they comprised frescoes illustrating Biblical history.*

Apart from the general structural outline, the most interesting feature of the architecture of these earlier synagogues is their ornament in relief. At the time of their discovery, this was a revelation. It proved that despite the narrow interpretation of the Biblical pro-hibition: "Thou shalt not make unto thee any graven image," the Jews of Galilee in the time of the Mishna and the Talmud made rich use not only of vegetal and animal forms, but even sometimes of human shapes. The scholars who first studied these synagogues were driven to assume either that they were erected by Jewish "heretics," or that they were ordered in all their details by Roman emperors favoring the Jews. However, the subsequent discoveries of the synagogues of the later period with their figured mosaic pavements, and of the Dura-Europos Synagogue with its rich, storied frescoes, have proved beyond doubt that the Jewish orthodoxy of the early centuries of the Common Era did not wholly exclude the use of such images. Later on, there was indeed a reaction which came from among the Jews themselves—witness the carefully cutaway images of living things in the Galilean synagogues.

The ornament of the earlier group of synagogues—as far as it is extant—consists of reliefs, rather sparingly applied in the classical manner on lintels of doors and windows, along arches, and in the balustrade and frieze of the upper gallery. The latter is usually the most richly decorated part of the synagogue. At Capernaum it is ornamented by a scroll of acanthus leaves, within the circles of which appear various floral and symbolic ornaments such as the hexagram and pentagram (the "Shield of David" and the "Seal of Solomon" of later ages). Above the acanthus scroll is an egg-and-dart ornament and above it *lonicera* leaves. At Chorazin the same type of frieze (with more naturalistic leaves) contains a still more varied ornament: besides garlands and geometric ornaments, there appear the images of living beings derived either from Greek mythology (Hercules, the Medusa, a centaur) or from daily life (a soldier, vintage scenes, etc.). Two flying angels holding garlands are represented on lintels in Capernaum, Kfar Bar'am, and Rama.**

Fig. 48, 50

Fig. 49

It should be noted, however, that even in that relatively liberal period, no sculptures in the round were employed in synagogue ornament with the exception of figures of lions

Fig. 82

* See chapter VI; also the general discussion in the preface.

** For a more detailed account of the manner of ornament used in the Galilean synagogues, see chapter VI.

(clearly symbolic) which seem—on the evidence of the representations in the Beth Alpha mosaic—to have flanked the (later) Torah-shrine. Fragments of such stone lions have been found in the synagogues of Chorazin and Kfar Neburaiya (Nabratein), where a dedicatory lintel was also found. The degree of naturalism of such representations is difficult to establish, owing to their fragmentary condition. In any case, the frieze is stylized in an Oriental fashion recalling the Assyrian and earlier representation of lions, and the curls or strands of the hair are reduced to geometrical patterns. Another piece of sculpture in the round is the stone candlestick found at Hammath by Tiberias, which has a surface decorated with the traditional "knops" and "flowers" (cf. Exodus XXV, 31–6).

Fig. 49, 50

Fig. 82

Fig. 74

The inscriptions in the Galilean synagogues are not properly part of the ornament or architecture, but they should be mentioned in as far as they throw some light on the cultural environment of those responsible for the erection of these buildings. We should thus note that with the exception of two dedicatory inscriptions in Greek (Capernaum and Qisyon), all of them are in Aramaic; there are none at all in Hebrew. We should also note that there was apparently no single individual rich enough to donate a whole synagogue building, but that the different parts (columns, stairs, etc.) were donated by separate donors; obviously, however, the plans of the synagogues were drawn as a harmonious whole, not being influenced even in detail by the plethora of donors.

In concluding the part of this study devoted to the earlier type of synagogue, we should mention the problem of their orientation. As we have noted before, the earlier type of synagogue, wherever situated, was built with its façade, i.e., with its principal entrances, facing towards Jerusalem. Thus if the entrances in the façade were used at all, the worshipers must have turned around before beginning to pray (assuming, of course, that they prayed towards Jerusalem, as is directed in the Talmud). Some scholars assumed that they used the side entrances found in almost all synagogues, as this implied only a partial turn in the direction of Jerusalem. Others believe (taking into account the synagogue of Sardis) that the worshipers were seated on both sides of the building, so that the elders sat facing Jerusalem. If this was so, the ornamental façade with its huge semicircular window served only as a permanent reminder of the direction of the Holy City. In any case, this diametrical opposition of the direction of worship to the orientation of the building is an architectural paradox which remains inexplicable; unless we assume a deliberate breach with the pagan usage which orientated its temples towards the rising sun.

The problem of the orientation of the earlier synagogue is further bound up with that of the position of the Torah-shrine. So far, no evidence has been found in all the earlier synagogues of a permanent construction intended to hold the sacred scrolls. The excavators of the Capernaum Synagogue noticed traces of a secondary construction, at a certain distance from the main door, parallel to the ornamental façade of the synagogue. They have assigned to this construction certain remains of colonnettes and conches found on the site. The signs, however, are few and indistinct, and the place of this supposed Torah-shrine would be most awkward; for it stood athwart the main entrance, leaving only a narrow passage. A more likely solution seems suggested by the remains of the Eshtemoa Synagogue (see below); the existence there of a niche (most likely intended for the Torah-scrolls) at some distance above the ground raises the possibility that similar niches existed in the other synagogues, none of which has been preserved to a sufficient height to leave traces of such a niche. However, there was obviously no place for such a shrine

in the façade wall of the synagogue which was broken by doors and windows. If we assume its existence in one of the side walls not directed towards Jerusalem, its evidence as regards the direction of prayer becomes worthless.

The most probable solution seems to be that in the early synagogues the shrine for the scrolls of the Torah was a wooden movable construction, which was normally, perhaps, kept in a side-room of the synagogue and was wheeled or carried out for the service. Side-rooms which might have served such a purpose were found at Capernaum, Chorazin, and other synagogues, near the north wall. Such a movable shrine could be placed against the main door facing towards Jerusalem after the congregation had entered and taken its place. The prayers might well have been said from a wooden tribune, or *bimah*, in the center of the synagogue, such as is reported from the great Synagogue of Alexandria. The position of the structural *bimah* in the Beth She'arim Synagogue (see below) would seem to support this view. A wooden structure of this kind would, of course, leave no trace in the pavement.

IV

It is obvious from the above that the changeable position of the Torah-shrine must have been the cause of some inconvenience in the synagogal service, especially if the synagogue façade was directed towards Jerusalem. We need not wonder, therefore, that from the third century onwards synagogue architects began to look a solution which would obviate these inconveniences. We are now entering, therefore, a period of experimentation with various architectural forms. As a result, no two synagogues of that period are entirely similar. The period of experimentation ends with the sixth century and the stabilization of the later type of synagogue.

The new principles which emerged finally, and henceforth guided the construction of synagogues in Palestine and occasionally also abroad were three: (a) the shrine was fixed in the wall in the direction of Jerusalem, and the congregation prayed towards it; (b) the synagogue entrances (or at least the principal ones) were transferred to the opposite wall; though in this detail there was a return to the type of synagogue found at Massada (see above); (c) the style of ornament was changed, and the sculpture in relief was replaced to a large extent by frescoes and mosaics.

The largest as well as the most interesting of the synagogues of the transitory type is that discovered in 1938, in the excavations at Beth She'arim. In its original shape it dates from the first half of the third century. Already then the architect had adopted the purely basilical form with two rows of columns dividing the hall into a central nave and two side aisles, the whole measuring 31 m. x 15 m. The entrance was by three gates in the wall facing Jerusalem; there is no evidence for a fixed place for the Torah-shrine, but a reading platform surrounded by a chancel screen with posts stood in the north-west (i.e., the corner opposite Jerusalem), so that at least part of the ritual was rendered there. The walls of the synagogue were plastered and painted; here and there marble plaques bearing inscriptions were fixed in the walls. In the fourth century, there occurred a complete change in this synagogue. A stone Torah-shrine was apparently put up in the direction facing Jerusalem and the central door of the ealier synagogue was consequently blocked. The evidence from Beth She'arim is the more important because, since it was one of the seats of the Patriarch and Sanhedrin, the local architect must have been strictly orthodox; and its example must have been widely followed, as Jews from all over the Diaspora

Synagogue at Beth She'arim, ground plan (after Mazar).

visited the place. We have here the clearest possible evidence of the transition and its natural consequences.

The Synagogue of Eshtemoa, excavated in 1936, is interesting from two points of view: it is the only synagogue so far excavated in southern Judea; and its width exceeds its length, the Torah-shrine being apparently in the long north side of the rectangular plan.* This synagogue measured 21.30 m. x 13.33 m.; it was entered by three doors in the short east side, so that here the worshipers had certainly to make a half-turn towards Jerusalem. The entrances were screened by a small porch. Owing to a fortunate chance, the north wall of this synagogue (facing Jerusalem) was preserved to a sufficient height to prove existence of a wall niche which (as indicated above) almost certainly contained the Torah-scrolls. The two niches flanking it might have been destined for the seven-branched candlesticks, if we are to regard the Beth Alpha mosaic (see below) as representing the common arrangement. It is interesting to note that if the Eshtemoa Synagogue had been destroyed to its foundations, as were so many of the Galilean synagogues, we would have lost this most important piece of evidence. A rock-cut wall niche was also discovered in the Galilean synagogue of Arbel. There, however, this apse-like construction is evidently of a much later period than the other parts of the synagogue, which was built according to the usual plan of the earlier type. The addition of the niche in the south wall, facing Jerusalem, is evidence of a change of plan at a later date, which also involved a change in the arrangement for entrance.

Fig. 54

The three synagogues of Hammath by Tiberias (discovered in 1922), Husifa (Isfiya), and Yafia, which we may assign to the fourth-fifth centuries, represent yet another stage in the transition from the earlier to the later type. All three are basilican in form, with a central nave and two aisles, separated by rows of columns. The entrance doors are in the wall opposite to the direction of prayer. All three of them are paved with mosaics. An important distinction between the synagogues of this transitional type and those in which the later type appears fully developed is that the former lack an apse pointing towards Jerusalem. At Hammath by Tiberias four marble colonnettes and a carved lintel were found in the debris on the side facing Jerusalem; this naturally suggests that they once formed part of a Torah-shrine fixed in the wall, therefore leaving no trace in the ground plan. The same arrangement must necessarily have been adopted at Husifa, where the east wall has been excavated beyond its center without a trace of apse.

Two synagogues built alongside one another, which were discovered in Caesarea in 1956–62 belong to this type. The older of the two, which was destroyed in the middle of the fourth century, was in the shape of a hall, 18 m. wide x 9 m. long, the entrance being from the narrow side. The hall was paved with mosaics with geometric patterns. In about 459 another hall was built on top of it, its plan similar to that of a basilica, and which was entered from the northern side. The inscriptions in the two synagogues were in Greek, except for the fragment of an inscription which specified the 24 groups of watchmen formed by the priests.

The most important synagogue of the transition type was discovered in Hammath by Tiberias (excavated by Dr. M. Dotan on behalf of the Antiquities Department in 1961–64). The first building was a hall 14.5 m. wide, with two columns of pillars. The entrance was from the north. The wall facing Jerusalem was south at first, with a small platform in

* This arrangement was common in Renaissance Italy: see below, page 116.

front; later on a square room was added in the middle, a kind of an apse. The mosaics, which are the work of an Antiochian craftsman (who may have not been a Jew), *Fig. 51* indicate that the building was constructed in the beginning of the fourth century. The dedicatory inscriptions mention various donors, including one Severus, the *"trefos"* of the *Nessi'im* (presidents, leaders, apparently an official of the *Nassi* [prince] who then had his seat in nearby Tiberias). Of special importance in the mosaic is the portrayal of the zodiac with the figure of the sun god, Helios, in the center; between the planets are figures from Greek mythology. In the sixth century another building was built on top of this synagogue. It belongs to the later, pure basilican, type of synagogue (see below). The early synagogue in Hammath by Tiberias represents the closest approach to non-Jewish art in an early Jewish house of worship.

V

A group of synagogues abroad which are connected with this type are of the utmost importance, for they are the earliest archaeological (as distinct from epigraphical) evidence for the existence of synagogues outside Palestine. The most famous of these is the Synagogue of Dura-Europos on the Euphrates. The frescoes which are its principal title to fame in the annals of Jewish art will be discussed in another chapter; but the architecture of the synagogue (or rather, the two super-imposed synagogues, for the remains of the later building of 245–246 C.E. hid the remains of an earlier one) is also highly instructive. We should note that in both its phases the Dura-Europos Synagogue was hidden away among other houses, being thus as inconspicuous as possible. Access to the earlier synagogue was from the street on the west through a long and narrow corridor with descending steps. From this corridor the worshiper entered a court through a portico on two of its sides (north and east). In the northeastern corner of the court was a pool, probably intended for ritual ablutions. On the east side of the court was a room surrounded by benches, apparently a school room. Two other siderooms adjacent to the court were probably the sacristan's dwelling. Another room, connected with the court by a wide opening, and with the prayer hall by a side door, was surrounded with benches and probably served as the women's section. The prayer hall was small (10.85 m. x 4.60m.) and bore much resemblance to the synagogues at Eshtemoa and Caesarea, i.e., its main axis extended in width and not in length; it had a niche (assumed) in the west wall facing Jerusalem. However, it differed from similar synagogues in Palestine in that the doors were in the long wall facing the niche. Benches, occasionally doubled, ran along the whole of the walls except at the doors. A patch in the stone pavement in the center of the room seems to indicate the presence of a wooden *bimah* there.

The later building at Dura-Europos is dated fairly exactly to the middle of the third *Fig. 52* century C.E.; this is the construction decorated by the celebrated frescoes. This second synagogue is somewhat larger than the first (its hall measures 13.65 m. x 7.68 m.) The court has also been much enlarged, and the colonnade extended to three instead of two of its sides, including the one along the wall of the synagogue. The old entrance from the west has been entirely abandoned and a new one arranged in the opposite direction. Entering from the street, one faced a long blind corridor; but a door on the left led to another passage. Here a door to the right led through two rooms into the fore-court of the synagogue. The various rooms attached to the synagogue, including the school,

were now lodged in a separate building which was probably acquired at the time when the synagogue was enlarged. The general arrangement of the synagogue hall was not changed, except that there seems to have been no separate room for women. It is possible that this was a sign of the more liberal attitude, also evidenced by the mural paintings; the side door which may have served the women was, however, preserved. In the second synagogue there is clear architectural evidence for the niche surmounted by a conch which protruded from the wall. It had a seat (perhaps identical with "The Seat of Moses") and was flanked by two columns surmounted by an arch. Adjoining it on the north were four steps leading to a small raised platform, which must have been the *bimah* from which the Law was read and the services performed. The removal of this *bimah* from the center of the prayer hall to the back-wall is parallel to the development witnessed in Palestine. This can be seen by a comparison of the plans of the fourth century synagogues, the back-walls of which are straight, with those of the sixth, which have a conspicuous *bimah* and apse at one end.

In recent years two synagogues have been discovered in the Diaspora, which are extremely important in that they represent a transition type. The larger of the two was found in Sardis, in Asia Minor. Two stages of construction are discernible in it, and possibly it was begun as early as the first half of the third century, but most of the find belongs to the fourth century and later. This synagogue was part of a marble-paved forum and was surrounded by other public buildings: the large and wealthy Jewish community of Sardis was not at all worried about concealing its place of worship. The building itself consists of a yard and a long and narrow (18.5 m.) hall with art work along the walls; the hall is completed with an apse. The front of the building faced Jerusalem. Near the walls, between the three doorways, two *bimot* were found. A bench went along the apse, this apparently being the place for the elders of the community. In front of the chord of the apse were found remnants of a table which once consisted of a marble plate resting on the backs of two eagles. In the apse, remnants of a mosaic were found, with a dedicatory inscription from the fourth century, and with designs of an amphora and a vine twisting out of it. Included in this find were a number of Jewish inscriptions and remains of a seven-branched candelabrum, made of marble and very nicely ornamented. A row of shops, owned by Jews, was strung along the southern wall of the synagogue. From the plan of this synagogue, it transpires that during services the elders of the community sat facing Jerusalem, while the cantor stood with his back to them. As for the rest of the congregation, unless they faced the elders (with their backs to Jerusalem), it can only be assumed that they had places along the two sides of the chamber. The synagogue at Sardis testifies to the attitude towards art displayed by the large and wealthy Jewish communities of the Diaspora — the ornamental work of the building was ordered from gentile craftsmen or from Jews who worked according to the existing style, and those who ordered it had no fear of using animal figures or apprehension about fitting a synagogue into the plan of a gentile city; on the contrary, they proudly emphasized the Jewish symbols which indicate the nature of the building.

At Ostia, the ancient port of Rome, a fourth century synagogue (built on much earlier foundations) has been discovered, which testifies to a change in the manner of worship. At first, the plan of the Ostia Synagogue was in line with that followed in Sardis — the entrance was through a court and the seats of the elders were along the wall opposite the front and facing Jerusalem. But in the course of time a special structure was

installed in the hall; it was a sort of ark, with pillars and a border decorated with Jewish *Fig. 53*
symbols, alongside which the congregation stood and prayed as it faced the Holy City.
The finds of another Syrian synagogue, that of Apamea, have not yet been published in
all details, and we cannot therefore study its plan. The layout of the mosaic pavement with
its inscriptions seems to indicate a nave entered from a fore-room and surrounded by
aisles. The Apamea Synagogue was built in c. 391 C.E.

Two more synagogues in the Diaspora, the plans of which have been published, belong
to this period of transition. The earlier of the two (to judge from the absence of an apse)
seems to be the one found at Miletus. It was entered through a fore-court surrounded by
a porch on three sides (as at Dura-Europos). A bench ran around the walls of the court.
The prayer hall itself was entered from the fore-court, with a side entrance on the north.
It was a fairly large basilica (18.51m. x 11.06m.) with two rows of columns ending in
pilasters at the end-walls. There is no evidence of an apse. The women's gallery may have
been above the aisles, but there is no trace of steps. The synagogue and its court are
connected separately with a large courtyard surrounded by walls, with a porch on its
west side (20.83m. x 28.51m.).

The synagogue at Priene may be ascribed to the same period, but the construction of a
projecting square niche in the center of the back-wall indicates a slightly later type of
building. There is the usual fore-court, with a well in the corner. The building is again
of the basilican type, with two rows of columns, a door in the center and another in the
north side; a row of benches is built along the wall on that side.

VI

The evidence both from Palestine and from the Diaspora points to the fourth–fifth
century as the date of the transition from the earlier to the later type of synagogue. The
beginning of the transition can already be noted at Dura in the third century C.E., whereas
as we shall see, the basilican type appears fully developed (i.e., with an apse) at Sardis in
the beginning of the third century. We are, therefore, inclined to assume that in the de-
velopment of the later type the Diaspora took the lead and was followed by architects
in Palestine. Proof of this is that the hall with the niche at one side and the entrance
facing the niche appear first in the Diaspora; the conditions of existence of the Jewish
communities in the dispersion, far away from the Holy Land, would naturally make the
direction of prayer a matter of prime importance.

The later type of synagogue—which is in this sense comparable to the earlier type—
is a well-defined class of structure. The synagogues of the earlier group were solid
constructions of dressed stone, with heavy architectural ornament in their facades.
Their remains, even when in ruins (viz., columns, pedestals, bases, lintels, fragments of
friezes) thus remained conspicuous on or above the ground. On the other hand, the later
synagogues were comparatively flimsy structures, built of dressed stone on the outside
only, while their walls were filled with rubble and plastered on the inside. They reflect
the impoverished state of the Jewish communities in the Byzantine period. The finest
part of their decoration, the mosaic pavements, easily disappeared underground. The
first remains of the later type of synagogue to be noted were in fact isolated fragments of
mosaic inscriptions in the synagogues of Sepphoris and Kefar Kenna. Their unusual
character led the earlier excavators to believe that they must have been made by Judeo-
Christians, especially in view of their late date. However, the discovery of the synagogue

pavement and inscription at Na'aran (at present 'Ein Duk, north of Jericho) and the discovery of the Beth Alpha Synagogue in 1928 have broadened our knowledge. Earlier discoveries in the Diaspora (at Aegina and Naro [Hammam Lif]: see below) were now seen in their true context.

Fig. 55 If the synagogue at Stobi (near Monastir in Yugoslavia) is correctly ascribed to the end of the fourth century, it is the earliest known building of the later type. It is described as a basilican construction measuring 19.20m. x 14.20m. divided by two rows of pillars into a nave (7.40m. wide) and two aisles. An apse projected from the eastern wall of the nave. A vestibule, 3.75 m. wide, preceded the main hall. In accordance with the basilical tradition, it was connected with the hall by three doors, the central one wider than the rest. On the other side, the vestibule was connected with an atrium surrounded by a colonnade, while there was a marble basin in the south-east corner.

The Palestinian examples of the later type may be dated to the fifth to eighth centuries. The earliest seems to have been that at Gerasa in Transjordan, over which a church was erected already in 530–531; the synagogue must in consequence date at the latest to the beginning of the sixth or more likely to the end of the fifth century. The Beth Alpha

Fig. 54 Synagogue is dated by an inscription to the reign of the "King" (i.e. emperor) Justinius. This inscription in all probability refers to Justin I, who reigned from 518 to 527. The latest of the Palestinian synagogues of this type seems to be that found at Jericho, which has been dated, on both stylistic and archaeological evidence, to the early eighth century. Thus the synagogues of the later type span a period of about 300 years.

The architectural characteristics of the later synagogues are the basilican plan and the mosaic pavements with figurative representations. The basilican plan follows closely that of the churches; it differs from that of the earlier basilicas with their traverse colonnade, reflected in the plan of the earlier type of synagogue. The later synagogues have two rows of columns or pillars in the longitudinal direction only; the hall was thus divided into a central nave and two aisles. The aisles were apparently lower than the nave and were surmounted by the women's galleries, one on each side of the building; these galleries might also have served for clerestory windows. The only exception to this plan was the late synagogue at Hammath-Gader (el-Hammeh, east of Lake Tiberias) which had at the end of each row of columns L-shaped corners with a traverse colonnade connecting them; the plan of this synagogue, however, presents also other anomalies, such as the entrance at the side, and the almost complete absence of the figurative element in its pavements. The entrance to the later synagogue halls was as a rule by three doors in the wall opposite the apse, which was directed towards Jerusalem. This arrangement brought into one line the entrance of the building and the direction of prayer. The orientation of the later synagogues is uniform: they face south in Galilee, west at Gerasa, Jericho, and Na'aran.

In the wall towards Jerusalem, i.e., in the direction of prayer, was a semi-circular apse (except Gerasa, where as at Priene in Ionia, and in the earlier of the two synagogues at Hammath-Gader, the niche was apparently square); this anomaly again confirms the relatively early date of the Gerasa Synagogue. The pavement of the apse was higher than that of the nave. This rise continuing into the nave to produce a platform with steps is comparable to the *schola cantorum* of the Christian churches. In a parallel development, the raised area was in at least three cases (at Hammath by Tiberias, Ma'on [Nirim], and Hammath-Gader) separated from the nave by a chancel screen with screen posts and

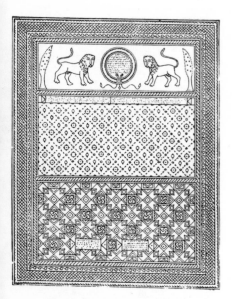

Mosaic floor of Synagogue at el-Hammeh, East of Lake Tiberias (after Rice and Sukenik).

balustrade slabs. The latter were carved with the seven-branched candlesticks. Screens of the same type must have existed in other synagogues where slabs have been found, as at Ashdod, Ascalon, and Gaza, of which no other remains were discovered so far. The raised platform also fulfilled the functions of a reading platform, which thus became superfluous as a free-standing construction. The Torah-shrine, which was still presumably a wooden chest, was placed in the semi-circular apse, and there is some evidence that it was usually separated from the main room by a curtain which rested on attached colonnettes on each side of the apse. Behind the curtain there was place not only for the shrine but for the two candlesticks flanking it. The representation at Beth Alpha suggests that there were in some cases two sculptured lions guarding the shrine.

The synagogues of the later type did not, of course, cease to serve as community centers in addition to their primary function as prayer halls. Thus, besides the narthex, various side-rooms were added to the principal building. The normal basilican type is represented by the synagogues of Gerasa and Beth Alpha, in which the entrance was by way of an open court with a well in the center, as required for ritual ablutions. From the court at Gerasa one entered a prostyle porch. At Beth Alpha and Na'aran there was a closed narthex, but again differing in shape. Whereas at Beth Alpha the narthex corresponds in width to the width of the basilica, at Na'aran it went around the court at least on one side. The court at Na'aran is irregular in shape, with the well in a separate enclosure. From the court (and from the hall) one could enter a side-room, with arches resting on two pillars in the center. We have here most probably the schoolroom attached to the synagogue. At Hammath-Gader the plan is different again; probably owing to the exigencies of space in this busy spa, the narthex and other side-rooms were arranged sideways to the main axis of the hall, instead of lengthwise, the two entrances of the hall being in the side walls, and the main wall facing the apse having no opening.

At Ma'on (Nirim) the narthex combined with the two sides to form one stone-paved ambulatory hall in the center of which the interior hall between two columns of pillars was defined by its own mosaic pavement.

The architectural ornament of the later type of synagogues is very poor compared to the rich and varied ornamentation of the earlier ones. The only parts of the building decorated in relief seem to have been the capitals, which are ordinarily of the Corinthian type, with a seven-branched candlestick replacing the central rosette on the abacus — where the cross was put in the Christian churches of the same period. A good deal more ornament was lavished on the chancel screens: there occurs the *menorah* with its four accompanying *Fig. 59, 60* objects, enclosed within a wreath with sinuous ribbons, also of the same type as found in churches. Other elements are grapes issuing from an amphora, stylized pomegranates, and rosettes of various types.

The principal ornament of the synagogues of the later type were their mosaic pavements, many of which had figured representations. Owing to a fortunate discovery of a variant in the text of the Jerusalem Talmud* we are able to establish the approximate date for the change-over from non-figural to figural pavements, in the first half of the fourth century, after a period of stricter observance. We may perhaps assume that the fairly liberal period in the third century, when the sculptures of the earlier type of synagogue were carved, was succeeded by an iconoclastic movement, and most of the figures of living beings

* See above, preface.

on these buildings were defaced. In the middle of the fourth century, there was again a reaction in favor of a more liberal view, which lasted probably till the seventh century. At that time a cycle of decorations for synagogue pavements was evolved which contained *Fig. 60* three principal elements — the Torah-shrine with flanking candlesticks and lions; the zodiac; and a Biblical scene, probably selected for its expression of hope for redemption: such as Daniel in the Lions' Den (Na'aran), the Sacrifice of Isaac (Beth Alpha), Noah's Ark (Gerasa); at Husifa a symbolic vine seems to have served the same purpose. Other symbols were the lion and bull guarding the entrance to the Beth Alpha Synagogue or the two lions flanking the principal inscription set into the mosaic pavement at Hammath-Gader and Hammath by Tiberias.

The various mosaic representations vary, of course, in their artistic value, but they all show a certain crudity of execution allied with much vigor in draughtsmanship. The *Plates 4, 5 and 6* mosaics at Beth Alpha are contemporary with the pavements in the Christian monastery of the Lady Mary in nearby Beth Shean, or with the funerary chapel at el Hammam, in the vicinity of the same city. In spite of this geographical proximity, the synagogue pavements are entirely different in style, much more Oriental in detail, more primitive and more popular in their conception. They are at the same time somewhat childish and very much alive. Recently, the remains of a mosaic synagogue floor, with representations of *Plate 7* the *menorah*, etc., were found near Tirat Zvi in Galilee, as well as a very beautiful floor with other important remains at Ma'on near Nirim (northwest Negev).

The period of comparative liberalism which brought forth the flourishing figurative art of the later synagogues was cut short by another era in which greater strictness prevailed. Whether this was due to interference by the Moslem rulers of Palestine is a disputed point. In any case, the work of destruction was done by Jewish iconoclasts, as we may see clearly at Na'aran. There the figures themselves were removed, but the inscriptions along them were carefully left in their places. It is noteworthy that the Ma'on pavement (ca. 530 C.E.) still uses animal figures but not those of human beings; the Hammath-Gader pavement has only the representation of two lions, while the late one at Jericho has only the Torah-shrine and the symbolical seven-branched candlestick. In this the synagogue was more liberal than the church; for it allowed representation of a sacred symbol on the floor (earlier generations seem to have walked on Abraham, Isaac, and even the symbolic Divine hand without any scruple). The fact that at Ma'on a number of strictly Jewish symbols were added to the representation of the animals and the amphora, on the side facing Jerusalem, indicates that the Jews regarded the other models as lacking symbolic value.

The list of Palestinian synagogues has been enriched twenty years ago by a Samaritan synagogue, so far the only one of its kind; it was discovered at She'albim (Arab. Salbit) in 1948. This synagogue in its earlier state is a building 15.40 m. x 8.55 m. It is obviously orientated to the north, i.e., towards Mount Gerizim, the sacred mount of the Samaritans. It had a hall and a narthex and there were traces of side-rooms. The mosaic pavements are ornamented with geometric patterns together with the inscription in the Old Hebrew script still used by the Samaritans: "The Lord shall rule for ever and ever." The pavement also contained a Greek inscription and two seven-branched candlesticks. This interesting synagogue is to be dated, in its first stage, to the fourth century C.E. A second Samaritan synagogue may have been discovered at Beth Shean; its apse faces north (!) and it contained an ark with a curtain and candelabra, without any animal figures being

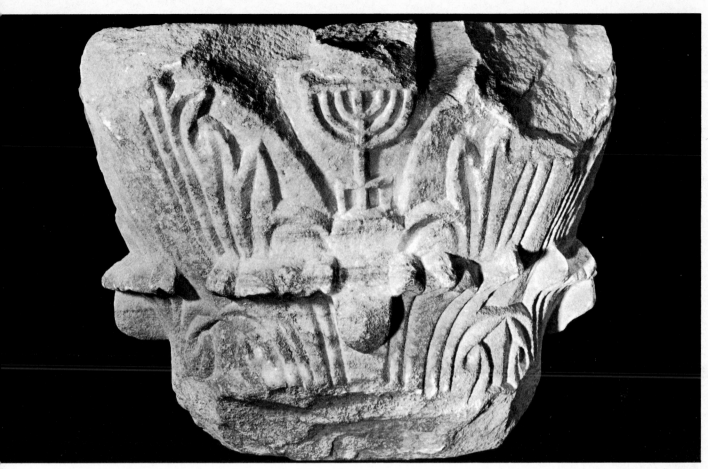

42. Stone capital from the synagogue at Caesarea.
Department of Antiquities and Museums, Jerusalem.

43. Reconstruction of synagogue at Capernaum (after
Kohl and Watzinger).

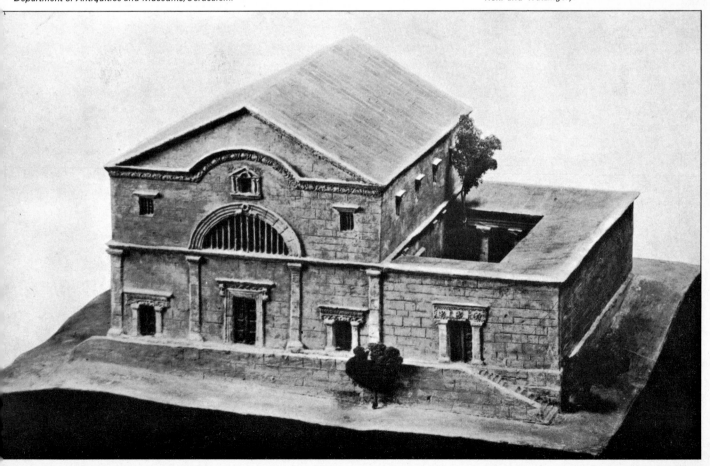

44

45

44. *Ruins of synagogue at Capernaum, interior. Photo by De-*
 partment of Archaeology, Hebrew University of Jerusalem.

45. *Ruins of synagogue at Meron, front view. Photo by Depart-*
 ment of Archaeology, Hebrew University of Jerusalem.

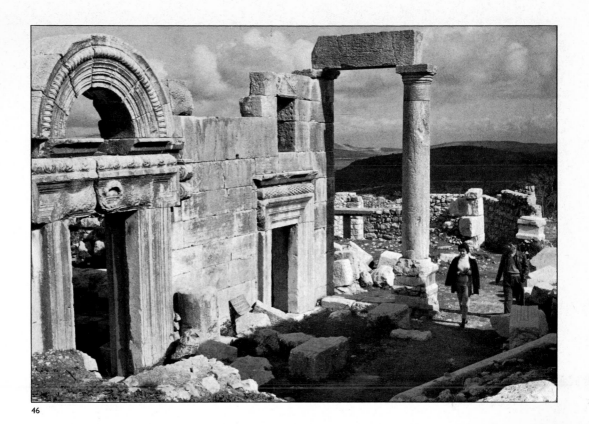

46

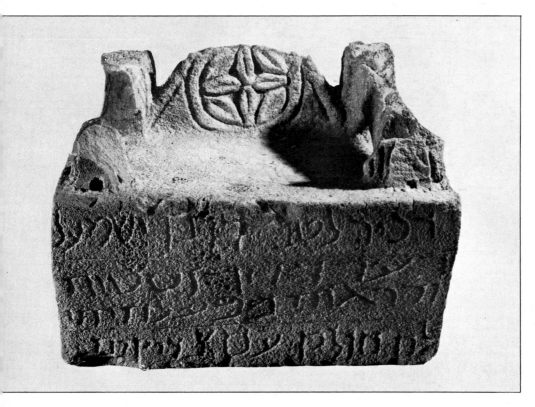

. *Ruins of synagogue at Kfar Bar'am, front view.*

. *"Seat of Moses" from synagogue at Chorazin. Israel Museum.*
 Courtesy of Department of Antiquities and Museums,
 Jerusalem.

48

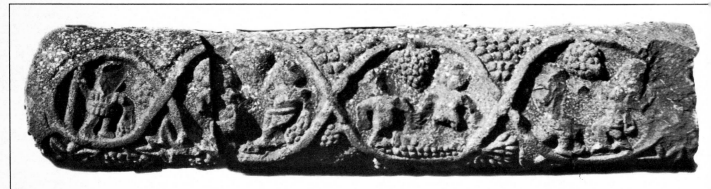

49

50

48. Frieze from synagogue at Capernaum. Costodia di Terra
 Sancta. Photograph by Department of Archaeology, Hebrew
 University of Jerusalem.

49. Frieze from synagogue at Chorazin. Photograph by
 Department of Archaeology, Hebrew University of Jerusalem.

50. Lintel from the portal of the synagogue in Nabratein, Upper
 Galilee. Department of Antiquities and Museums, Jerusalem.

51. Season of Tishrei (Autumn) from the mosaic paveme[nt]
 of the 4th century synagogue at Hamat near Tiberi[as]
 Department of Antiquities and Museums, Jerusalem.

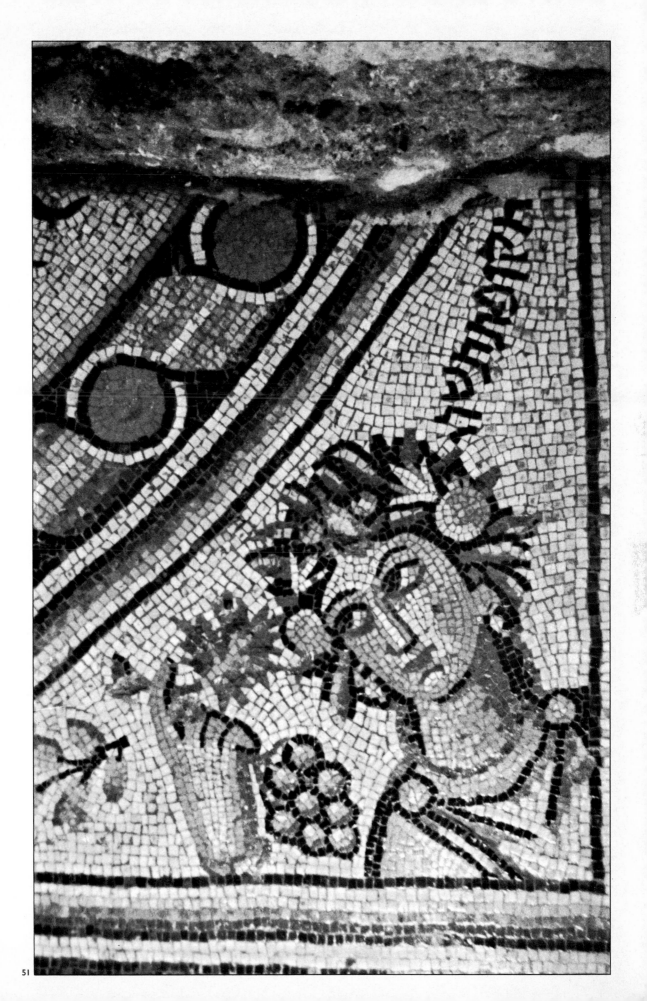

52

53

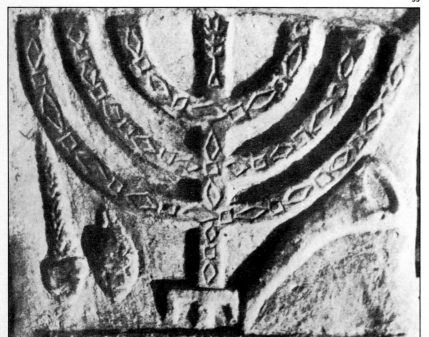

52. Synagogue at Dura-Europos, isometric view (after Pierson).

53. Candlelabrum, palm branch, citrus fruit and shofar. A stone relief from synagogue at Ostia (Italy) after Squarchapino.

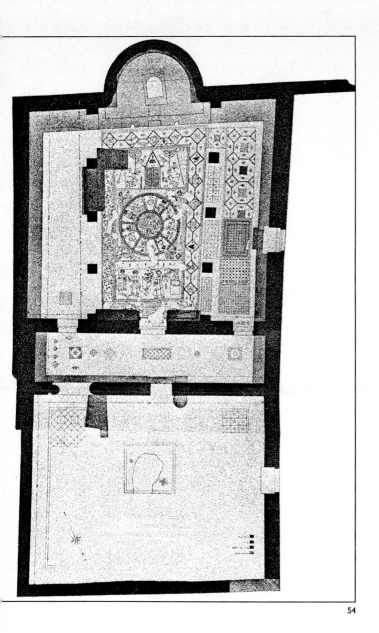

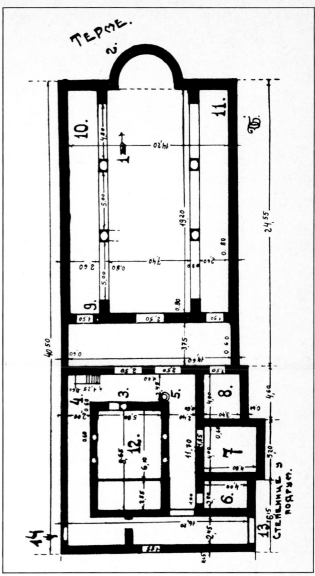

54

55

54. Synagogue at Beth Alpha, ground plan (after Rice and
Sukenik).

55. Synagogue at Stobi (Macedonia) ground plan (after
Petrovic).

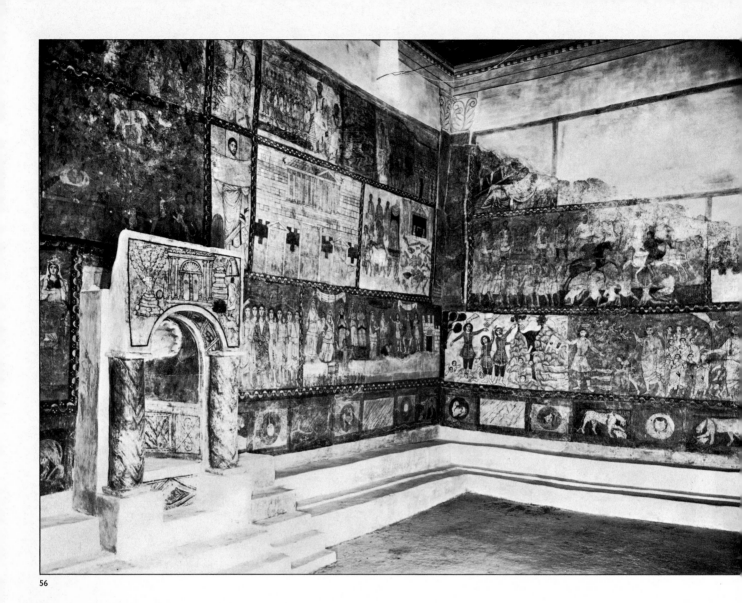

56

56. Synagogue of Dura-Europos, north-west corner, National
Museum, Damascus. Courtesy of Dura-Europos Publications,
Yale University.

represented. It is known that the Samaritans were stricter about a number of prohibitions in the Torah than were the Jews.

In the Diaspora two synagogues of the later type deserve special mention: that at Aegina is identified by a Greek inscription mentioning an archisynagogos and concluding with the formula "Blessing be upon all the donors" which has Aramaic parallels in Palestinian synagogues. If not for this evidence, the building may have been regarded as a church (it is orientated to the east, like all synagogues in Greek lands). The ornament is purely geometrical and the structure with its apse is similar to small chapels. The synagogue at Aegina is a single room, without the dividing rows of columns of a basilica proper.

Another Diaspora synagogue to be assigned to the late period is that of Naro (Hammam Lif) in Tunisia. The plan of this synagogue is peculiar: it had two entrances, a principal one from a court with a porch over the door, followed by another colonnaded court, a narthex, and the main room. The main hall was entered from the north, and the worshiper had to turn at right angles towards the apse in the east wall; a narrow platform stood before the apse. Another entrance to the building was from a corridor in the west; it led to a side-room connected by a door with the main hall; another door at the end of the corridor led directly into the hall. The main inscription of the hall is placed in such a way that it can be read directly by those coming from the west. As the principal benefactress of the synagogue was a woman, Julia, we may assume that the side-room was the women's hall, and that the pavement was so arranged that the women worshipers could see it. The pavement at Naro, in the African style, is most interesting and surprisingly rich. It has a symbolical picture of two peacocks drinking from a kantharos and flanked by two palm trees (symbols perhaps of Paradise and the Land of Israel), with fishes and birds above. The main inscription is flanked by two representations of the *menorah,* one accompanied by a *shofar* and an *ethrog* (?). The rest of the pavement shows beasts and birds, as well as baskets with fruits in an acanthus trellis. The whole style of this synagogue decoration shows a strong non-Jewish influence, and one is rather inclined to believe that when Julia made the pavement "at her own expense" *(de suo proprio tesselavit),* she called upon the local craftsmen who decorated the *"Sancta Sinagoga Naronensis"* as well as they could, avoiding the more obvious Christian symbols.

Fig. 65

VII

In concluding this survey, we may give some thought to the place of the Roman and Byzantine synagogue in the general development of Jewish art, and in the development of art in general. We have here a group of buildings dating from the third to the eighth century C.E.; their homogeneity is assurod owing to the uniform worship they served, and to a large extent also to their geographical proximity.* Also, they form the connecting link between the art of the Period of the Second Temple, with its tomb façades and ossuary decoration, and that of the fully developed medieval synagogue and illuminated manuscript; and in one particularly fortunate instance (at Dura-Europos) they enable us to catch a glimpse of a pictorial cycle illustrating the Bible, which was of immense influence in the development of Christian art.

Fig. 52, 56, 57

* What was formerly considered to be the most westerly synagogue of classical times with archaeological traces (at Elche in Spain) has now been shown pretty conclusively to be a non-Jewish building.

The function of a synagogue as a place of prayer and assembly, of teaching, and occasionally also as a place where the stranger and the needy could pass the night, led the earlier architects to adopt the plan of a Roman basilica, with its traverse transept, combining it with a court surrounded by porches. In the interior, the gallery, used in Roman basilicas as the promenade from which the curious could contemplate the throng below, was adapted to the use of female worshipers. The principal innovations in the interior were closely connected with the peculiar character of the synagogue service, in which prayer, the reading of the Law, and an occasional discourse replaced the incense-burning, libations, and sacrifices of the Temple. This spiritualization of divine worship was the great revolutionary act of Judaism, which was followed by the other monotheistic religions. Thus, in the synagogues, there was no need for an altar, and certainly no place for a statue of the god. In their zeal to differ from their pagan prototypes, the synagogue architects in the earlier phase abolished even the apse of the Roman basilica, which served both as a tribunal and a place for the statue of the god or emperor. No permanent external construction was to mar the simple spirituality of the hall. The light falling from the great window turned towards Jerusalem was a perpetual reminder of the center of Jewish worship; otherwise, the only permanent fixtures were the benches along the walls. In the Roman basilicas the benches were provided only in the apse, where the judges sat; the rest of the hall was given to the merchants and passers-by, rushing in all directions. The more decorous divine service required a place where elderly people could sit throughout; also such benches could be used for instruction. In contrast with this plain interior the facade and approaches of the building were dignified and richly ornamented.

As time went on, this plan was found inconvenient in orientation and in its lack of a permanent focus of prayer. These were provided, first by making a niche in the wall facing the Holy City, and then providing an apse which could serve also as a platform from which the Law could be read and expounded. The evolution of this plan in the Diaspora must have influenced that of the Christian churches when the victorious Church was able to plan its own buildings in the fourth century.

The ornament of the synagogues has a double significance: a Jewish and a general one. As has been seen above, it furnishes palpable evidence that the so-called hostility of the synagogue to figurative art was not a permanent element of Jewish orthodoxy. From the general point of view the synagogues of the classical period are one of the earliest links in the great transformation which turned the classical art of antiquity into medieval Byzantine. The victory of the conceptual over the perspective and of the optical over the plastic principle is reflected in their ornament. Thus, earlier synagogues illustrate the general phenomenon of Jewish art, which is paralleled by that of Jewish linguistics. Owing to its unique history, the Jewish people, whether in its own country or in the Diaspora, was confronted with an external world to which it had to adapt itself. The great victory of the Jewish spirit was its ability to express itself in any foreign medium: whether it had to adopt the Greek or Arabic, German or English languages; or Hellenistic, Byzantine, and Gothic art; keeping throughout the ages its inner integrity, it thus ensured at all times the potential return to its Hebrew origins.

JEWISH PICTORIAL ART IN
THE LATE CLASSICAL PERIOD

by RACHEL WISCHNITZER

There is ample evidence to show that the representational arts were not wholly unknown to the Jews in classical antiquity, even before the fall of Jerusalem. We learn from Josephus (Antiquities XV. ii. 6) that Alexandra, daughter of the High Priest Hyrcanus II (hardly likely, therefore, to be contemptuous of accepted religious conventions), had portraits painted of her two children, which she sent to Mark Antony in the hope of arousing his sympathy. Elsewhere (Wars I xxii. 3) the historian tells us how Herod accused his wife Mariamne of sending her own likeness to Antony with guilty intentions. Whether the allegation was or was not justified does not concern us here; it is the practice of portrait painting among Jews of the upper classes as attested in this story, that is significant. The pious King Agrippa I went as far as to strike coins bearing his likeness — in one case with that of his son, the future Herod Agrippa II, on horseback, on the reverse side. There is some evidence that in the very last days of the Second Temple an ordinance was passed, forbidding all manner of figurative representations of any living creature whatsoever; yet before this, according to the statement of a second-century rabbi "all likenesses were to be found in Jerusalem, except those of human beings,"

The Temple, on the one hand, the royal palace, on the other, were the main centers of artistic activity at this time. A feature of the Temple rebuilt by Herod were the cherubs traditional in sacred Jewish art from time immemorial. After the destruction of Jerusalem by Titus in the year 70, these were set up by the Romans as a trophy on the city gate of Antioch; it would seem, therefore, that they were figure-carvings. The Herodian palace in Tiberias was decorated with animal friezes, which were destroyed by the revolutionaries after the revolt against Rome in the year 66.

Manuscript illumination was known at an early date, and though we have no evidence of actual illuminations in the accepted sense, the possibility of their existence is not to be excluded. A passage of the Jerusalem Talmud (Meg. 71d) refers to a family of scribes living in Jerusalem before 70 who are described as "artists," which seems to imply manuscript illumination. Gold lettering used in a Pentateuch sent by the High Priest is referred to in the Letter of Aristeas; it relates in a legendary fashion the story of the preparation of the Septuagint translation of the Bible for Ptolemy II Philadelphus in Alexandria, in the third century B.C.E. The Talmudic objection to writing the divine names in a sacred scroll in gold letters evidently refers to a current practice. It should be remembered that the rabbinic disapproval applied specifically to scrolls intended for synagogal use; in the case of private codices there may well have been a greater degree of latitude.

That the scope of painting among Jews at this time was not confined to calligraphy is attested by an inscription on a sarcophagus found in a Jewish catacomb on the Via Appia in Rome, dating from the classical period. The deceased, one Eudoxios, is described here as a *zographos,* or painter from life, employing the representation of animals, etc., as well as human beings. Similarly, figure-painting on vessels is mentioned in the Talmud. Rabbinical literature is familiar, too, with frescoes embodying the human likeness, and apparently does not find anything objectionable in this. "The practice of man is, that he draws a figure on a wall, although he cannot instill it with spirit and breath and entrails and organs," a fourth-century moralist observes (T.B. Berakoth 10a: Sabbath 149a).

Scholars differ among themselves as to which originated first — the illustration of scripture scrolls or the decoration with representational motifs of minor objects of general use, such as coins, glass cups, vases and plates, pottery lamps, and textiles (see page 100). Some such transportable articles may have served as channels for the diffusion of Jewish art and have inspired the paintings and carvings of synagogues and tombs. As mentioned elsewhere in this work, a Talmudic source refers to the relaxation in third-century Palestine of the ban on wall-painting, while a fourth-century reference attests to the use of mosaics.

Archaeological finds have now fully confirmed this literary evidence. Jewish monuments of classical antiquity in Palestine and the Diaspora practically cover the whole period of the third to the eighth centuries. Their main feature is homogeneity of content and a strong popular appeal. Originally confined to the circles of the court and the High Priesthood, Jewish art came to be a means of expressing the aspirations of the broad masses.

II

Fig. 52

What we know about the antecedents of Jewish pictorial art, which ermerges in full bloom in the third century C.E. in the wall decoration of the synagogue of Dura-Europos on the Euphrates, on the very soil of the Babylonian Diaspora, would hardly suffice to reconstruct the story of its development. In the course of excavations on this important site, the ruins of a synagogue were found buried under a sloping brick embankment to the north of the main gate, in immediate proximity to the city wall. The strengthening of the fortifications by this means in the face of the menace of invasion in the third century had preserved the buildings in this corner of the city, almost in the same way as those of Pompeii had been preserved by the volcanic eruption. There had been an earlier synagogue on the site, built about the year 200, or shortly before this, its walls decorated with painted ornamentation. This was rebuilt in the year 245, as we are informed by a series of inscriptions in Greek and Aramaic, by Samuel bar Yeda'ya, the *archon,* and his associates. This is the building whose walls were in great part preserved under the embankment, thus saving approximately one-half of the original number of a series of wall paintings illustrating the Bible story, which decorated the interior. To obtain the inclined profile of the embankment, the Roman military engineers cut down the sidewalls of the synagogue hall at an angle to meet the eastern (entrance) wall, which they had virtually razed. Thus, on the entrance wall only one row of pictures has remained, while on the west wall all three rows were left. On the sidewalls the line cuts through all three rows except on the north side where the lower row is fairly intact. In all, thirty panels of the wall decoration have survived.

When the synagogue was excavated, it was found that the paint had flaked off in many spots and the under-painting had come to view. We are thus in a position to compare the wall paintings of the earlier and the later periods, separated by an interval of more than fifty years.

The older decoration occupied only the upper central part of the wall orientated toward Jerusalem (west). On a vine, the branches of which extended over the whole panel, perch two birds. In a grove in the upper middle of the panel is a lioness. Outside the grove, below to the right, two lion cubs are chained one to the other; to the left, a table is set with fruit or loaves. It has been suggested that the two fettered young lions are the last kings of Judah who after their short reign were deported to Egypt and Babylon, respectively. In that case, the lioness in the grove may represent Judah deprived of her children, the birds would symbolize Babylon and Egypt, while the vine is an allegory of the last King of Judah, Zedekiah (cf. Ezekiel chapters XVII and XIX). The table may be "prepared in the presence of my enemies" referred to in Psalm XXIII, 5. The symbolism, however, does not concern us here. We are interested in the artistic values, and these emerge sometimes with startling brilliance on the frescoes of the later synagogue.

Fig. 56

With the extension and partial rebuilding of the Dura Synagogue in 245 C.E., two generations after the original construction, the old decoration appeared to be no longer adequate. Instead of one panel on the wall orientated toward Jerusalem, the prayer-hall now received a decoration running in three rows around all the four walls. Moreover, the allegorical style was abandoned and scenes with human figures were introduced, minutely and graphically illustrating a good part of the Biblical history. Some Biblical heroes, such as Moses, Aaron, David, Joseph, and Jacob, are represented in several scattered scenes, which may have been taken out of complete pictorial cycles. This would imply the existence of illustrated scrolls of at least the books of Genesis, Exodus, Samuel, Kings, Esther, and Ezekiel, as early as the first part of the third-century. Some scholars, moreover, see here indirect evidence of the existence of illustrated Hebrew Bibles which would have influenced early Christian art where Old Testament subjects predominate. On the other hand, it may be observed that in the Christian baptistry in Dura, which was decorated in 212 C.E., there are only two scenes portraying Old Testament subjects, all the others being based on the Gospels.

Plate 3

When the Dura Synagogue paintings were first discovered, and the order in which they were to be read was not known, some scholars maintained that in contrast to early Christian art, where everything is clear and intelligently planned, Jewish art was lacking in ideological content. Only gradually did the conviction grow that the paintings of the synagogue in Dura were conceived as a systematically arranged whole.

The hypothesis that the Dura paintings were derived from illustrated Bible scrolls now lost was strengthened by the fact that, with one exception, the Elijah scenes (which will be spoken of below) form a chronological sequence, faithfully following the text. Stylistic arguments have also been advanced in favor of this thesis. A feature of several of the Dura Synagogue panels is the repeated appearance of the hero within one scene. Such a practice was familiar in illustrated scrolls, deriving from the fact that the reader could not see more than one portion of the scroll at a time, the rest being rolled up. Since wall painting could also be examined only gradually, as the spectator moved along from one portion of the wall to the other, the figures had to be repeated here, too, for the sake of clarity. Thus in the Resurrection panel to be described below, Ezekiel is first seen leading

the ten tribes back from exile and then again announcing the Resurrection. In the Exodus panel Moses appears three times — raising his staff to strike the water, turning back to close the sea, and leading his people to safety. Another interesting point: while the sea with the drowning Egyptians was represented in the Exodus panel, the actual crossing of the Israelites was not. This was regarded as evidence that the wall panel was condensed from a more detailed scroll illustration.

III

On entering the Dura Synagogue through the doorway opposite the Torah-niche, the visitor saw the painted panels running in two series — one to the left of the door, the other to the right — both converging upon the niche on the west. In the lower row, on the left, we have scenes portraying the story of Elijah. We see him fed by the ravens, met by the widow of Zarephat, reviving her son, and bringing his sacrifice. Concluding this series and adjoining the niche, we see the Triumph of Mordecai. Ahasuerus and Esther are seated on separate thrones, that of the former being decorated with lions and eagles. Directly over the scene, in the uppermost row, appears the throne of Solomon, identical in its decoration, for according to Jewish legend, the Persian ruler had come into possession of Solomon's throne. The familiarity with Rabbinic legend and Midrashic stories displayed in the Dura frescoes is in fact very remarkable.

Fig. 57

We move now to the right of the doorway. Here we are met in the lower row by a set of scenes portraying David. He appears as the generous hero who spares Saul's life, in contrast to Joab who has murdered his rivals and is shown receiving the deserved punishment. Later, David is seen raised from the dead along with the tribes of Israel and Judah in the great scene depicting Ezekiel's Vision of the Resurrection of the Dry Bones.

This cycle concludes with the anointing of David, an act which suggests the anointing of the Messiah. What is striking in this sequence is that the scenes do not illustrate one Biblical book or part of it. What we have here is a selection of episodes from different Biblical books, obviously intended to convey some idea. Hence, instead of telling the story of David in a connected narrative, the artist introduced an episode from a chapter of Ezekiel associated in content with the story of David but taken from a different book. He even interrupted the flow of the narrative by inserting before the climax — the scene of the anointing of David — the entirely unconnected episode of the Finding of Moses.

We can only briefly refer to the scenes of the middle row where the theme is the Ark of the Tabernacle, seen first in its glory, and as it was subjected to trials and tribulations.

The upper row, poorly preserved, is a kind of running commentary to the topics of the lower row. Thus we see Saul among the Prophets, where he does not properly belong, directly over the panel which shows Elijah reviving the widow's son — a confirmation, by contrast, of his true prophetic mission. Solomon's throne, set directly over that of Ahasuerus, has already been discussed. The Exodus depicted over the Finding of Moses confirms the child's future leadership.

Noteworthy in the Dura frescoes is the prominence given to the story of Joseph. It appears also in early Christian art, but in Jewish iconography, particularly in a synagogue on old Babylonian soil, the emphasis on the ancestor of the Northern tribes and the Kingdom of Ephraim is significant. To begin with the repainted panel in the upper central part of the west wall, the space on the left, where the table stood in the earlier

fresco, is now occupied by Jacob on his deathbed blessing his twelve sons, while on the right, we see Jacob blessing Joseph's sons, Ephraim and Manasseh. Above the blessing of the twelve tribes, on the left side, appears David playing his lyre. However, in the panel on top of the two blessing scenes, Joseph is seated in the center surrounded by his brothers, his children, and his children's children.

The two central superimposed panels which we have described were framed on both sides by standing figures to emphasize their importance. On the left we have Abraham and on the right a figure holding an open scroll, variously interpreted as Moses, Joshua, Samuel, Josiah, or Ezra. Above these two side figures, Moses is shown twice in the same episode, with the burning bush on the right and on the left, as he receives the miraculous signs for his mission.

The symmetrical arrangement of these panels in the upper middle of the west wall was meant assuredly to emphasize the niche below, in which the Scripture scrolls were placed during the services. The niche itself had an architectural framework, consisting of an arched front on two columns. The front was decorated with the representation of the Temple accompanied by a *menorah, ethrog,* and *lulab*, ritual accessories found in *Fig. 56*
Jewish art of this period. The Temple was represented in much the same form on the reverse of a tetradrachm of the Second Revolt (132–135). Close to the Temple on its *Fig. 68*
right was portrayed the Sacrifice of Isaac, for, according to ancient Jewish tradition, the Temple of Solomon was built on Mount Moriah, on the spot where the sacrifice episode associated with Isaac had taken place.

No other synagogue of antiquity has been found to possess decorations as those we have been considering hitherto. But it may be assumed that they were not unique. The builders of the Dura Synagogue were presumably following the usual, if not universal, conventions of the age. We owe the preservation of these decorations to exceptional circumstances. Normally, not only where walls collapsed, but even where they were left partly standing but exposed to changes in weather (as in the monumental synagogues of Galilee described above), such preservation was out of the question, though indeed traces of colored stucco decoration have been found in the excavation of the synagogue ruins at Beth Shearim. It is not impossible that a cycle of illustrations similar to that of Dura was used in other synagogues as well; for it must be remembered that before modern times the content and form of art were determined by tradition.

What made the discovery of the Dura Synagogue paintings so significant was, besides the evidence of a Jewish pictorial and representational art, the emergence of what is termed Byzantine art at so early a date. The frontality of the figures, their arrangement in rows (as in the scene of the anointing of David) or in symmetrical groups (Moses at the Well), the disregard of perspective and depth are most striking when compared with the illusionistic style of the Pompeian paintings or reliefs such as those of the Arch of Titus in Rome. Some of the features of this new style existed in late Roman historical reliefs as those on the shaft of Trajan's column in Rome. In painting, however, it had no parallels in the West. Moreover, while in Rome it marked the way toward a heavy, coarse variety of folk art, in Dura this style introduced a new ideal of slender proportions, of a spiritualized facial type (e.g., in the standing figure of the prophet with the open scroll). This anticipates the new sense of values, which gave direction to European art, pointing the way to the characteristic developments of medieval painting and sculpture. The resemblance of the Dura figure of the prophet to the conventional delineation of Jesus in

early Christian art is very striking, indeed, and has given rise to much speculation. It would be wrong, however, to imagine that the Dura Synagogue painters were incapable of realistic observation. The dogs and horses in the panel which shows David sparing Saul are admirably drawn. Mordecai's steed is another example of excellent design. Most remarkable is the individualized treatment of clothes. Aaron, the High Priest, wears a long cloak, trousers checkered in green and black, a long belted tunic, and a miter. His sons, the priests, wear trousers and short belted tunics. In the well scene, Moses, who else-where always wears a plain white garment, now has a long draped garment of the same cut, but of a yellow (perhaps for gold) fabric checkered with pink and purple and edged with fringes. The change of mood is spectacularly emphasized in the scene which shows Elijah reviving the widow's son. On the left, the widow holding her dead child wears dark-brown clothes, and is nude from the waist up in sign of mourning. On the right, holding her revived child, she is in white and yellow, while the child, formerly naked, is decked in pink garments falling in elegant folds. We cannot dwell in detail on the various buildings, the furnishings, the couches, the round banquet tables, the chairs, the thrones, the foot-benches, the lamps, and ceremonial utensils.

IV

A special type of art was mosaic painting, which used stone or glass fragments of different colors to compose a design. This old technique, employed for wall as well as for ceiling and floor decoration, was also used by Jews. However, only floor mosaics have been found so far. The passage from the Palestinian Talmud informs us also (according to the full text: the passage was omitted owing to a homoeoteleuton in the standard printed version) that in the days of Rabbi Abun the practice began of depicting designs on mosaics, and this scholar did not prevent it. (It is not quite clear whether the reference is to Rabbi Abun I, who lived in the first half of the fourth century, or to his later namesake, Rabbi Abun II). According to strict interpretation, a specific prohibition was implied in the Pentateuch (Leviticus XXVI, I) to "figured stones" on the floor of the place of worship. Yet a more liberal attitude firmly established itself in due course, as we see from the rendering of this passage in the so-called Jerusalem Targum which modifies the outright prohibition, provided that the intention to worship was absent.*

In fact, figured mosaic floors bearing artistic representations, including human forms, figures of pagan mythology, and Biblical scenes, were usual and conventional in Palestine in the Byzantine period, before the Arab conquest; not merely were they common in great and sophisticated cities, but even in small rural centers such as what is now Beth Alpha—a place so inconspicuous in antiquity that we now have no knowledge even of its original name.

Fig. 54 The sixth-century synagogue of Beth Alpha has a large semicircular apse projecting from the wall orientated toward Jerusalem. The figured mosaic occupies the whole area of the nave. As the worshiper progressed toward the apse, he saw three consecutive panels: *Plate 4, Fig. 58* the Sacrifice of Isaac, the signs of the zodiac, and a ceremonial grouping, this being closest to the apse in which stood the Torah-shrine of the synagogue. The three panels are surrounded by a broad decorative border. A Greek inscription at the entrance gives the name of the mosaicists responsible for the work, Marianos and his son Hanina. Both

* See introduction.

Plate 1. Side of a bronze pedestal from Cyprus, 12th century
B.C.E. British Museum, London.

*Plate 2. Winged sphinx and kneeling figure before the Tree of
Life, carved on an ivory box of the 8th century B.C.E., from
Hazor. Courtesy Archaeological Expedition to Hazor.*

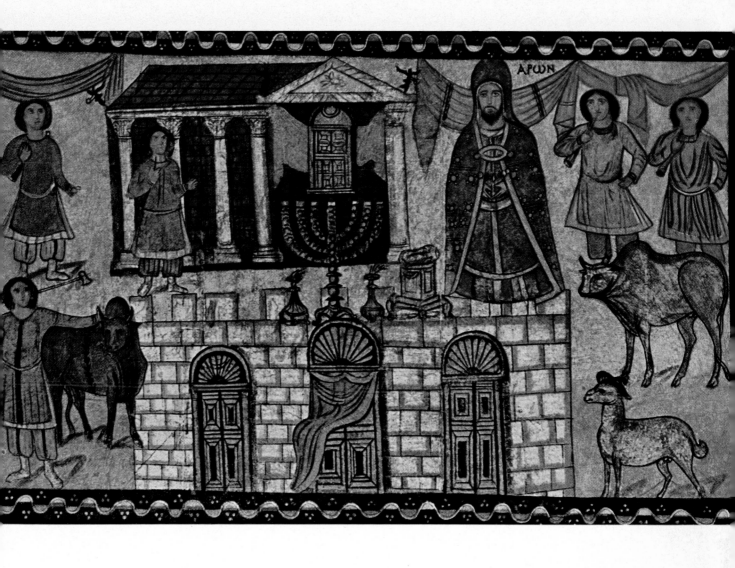

Plate 3. Aaron in the Tabernacle. A painted wall panel from the
3rd century C.E. synagogue of Dura-Europos, a town on the
eastern Syrian frontier of the Roman Empire, where it faced
Parthian territory.

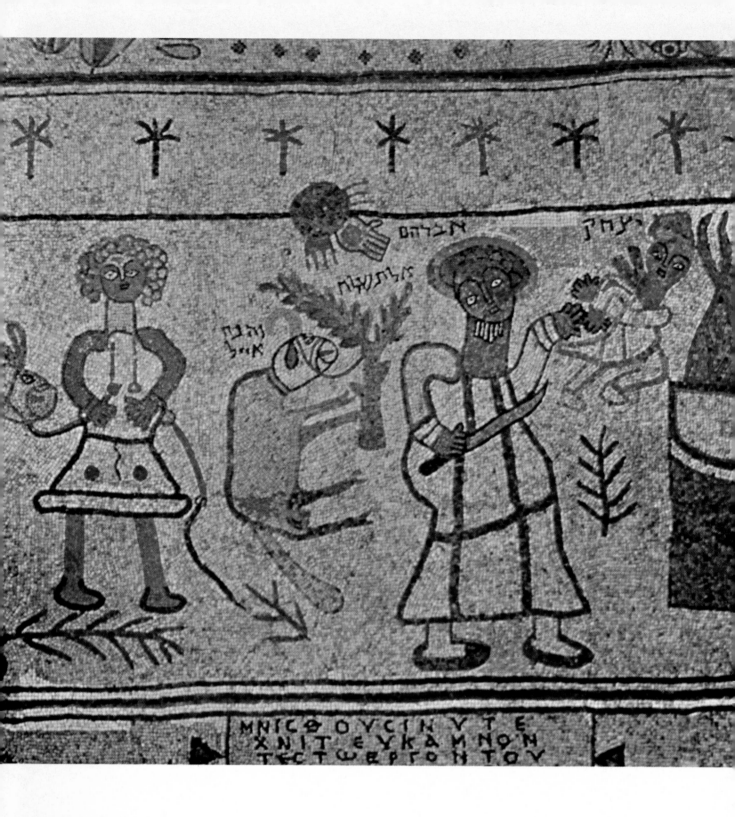

Plate 4. The sacrifice of Isaac. Part of the mosaic pavement of
the Beth Alpha Synagogue from the beginning of the 6th
century C.E.

Plate 5. Aquarius, from the Beth Alpha mosaic, pictured as a man carrying a pail of water, to represent the Hebrew month of Shevat (February).

Plate 6. Sagittarius, pictured as an archer, representing the Hebrew month of Kislev (December), in the Zodiacal circle which forms part of the mosaic floor of the Beth Alpha Synagogue.

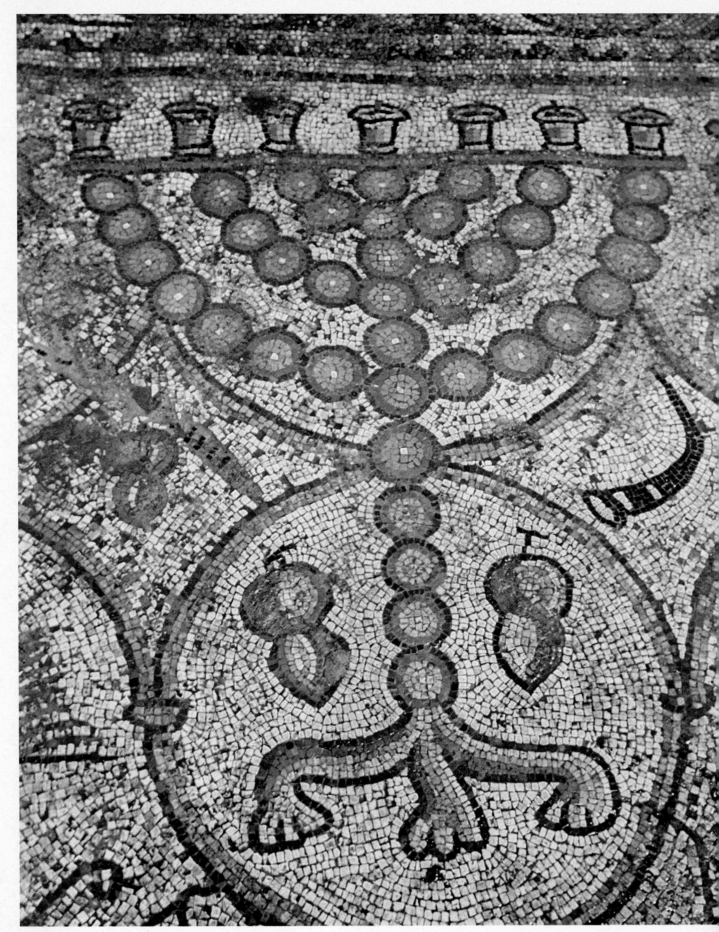

Plate 7. After the destruction of Jerusalem, the seven-branched menorah became one of the most widespread Jewish symbols, acting as an identification mark from the beginning of the 2nd century C.E. onward. This menorah and shofar, or ram's horn, are from a 5th century C.E. synagogue discovered at Nirim in the south of Israel.

Plate 8. With the Jews forbidden by Roman edict to bury their dead on the Mount of Olives near Jerusalem, the fact that Rabbi Judah ha-Nassi was buried at Beth Shearim led to the transformation of the town into a burial place for Jews from all over the world. The tombs were cut in the rock on the slopes of the hill on which Beth Shearim stood.

Plate 9. This magnificent blind façade of three arched doorways, gave into a tomb in the Beth Shearim necropolis in which inscriptions were found referring to Rabbis Gamaliel and Simon, evidently the sons of Rabbi Judah ha-Nassi.

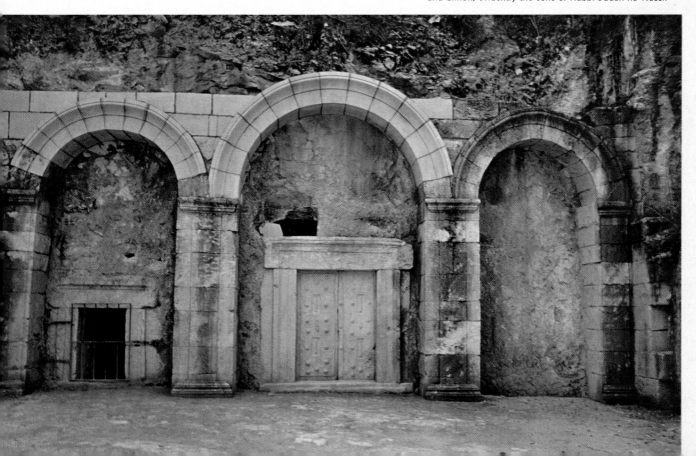

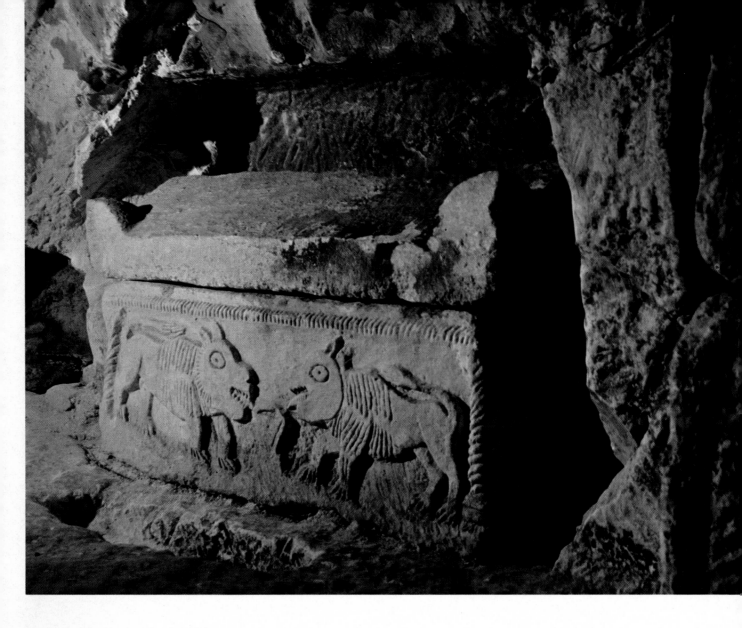

Plate 10. Sarcophagus from Beth Shearim, decorated with
carved lions.

names appear also in the mosaic inscription in the Samaritan synagogue at Beth Shean. It should be noted that whereas the name of the father is Roman, that of the son is in Aramaic, indicative perhaps of a period of heightened nationalism.

The scene of the Sacrifice of Isaac created a great commotion in learned circles when this mosaic was discovered in 1928, for it was the earliest substantial evidence of the existence of Jewish representational art in ancient Palestine. The importance in Jewish theology of this period and later of this episode, the "Akedah" — the dedication of the people of Israel through the willing sacrifice intended by its first ancestor, thereby deserving the Divine mercy for all time — was very great; this explains its prominence both in the wall paintings at Dura and here, as well as in innumerable prayers and hymns, and in medieval ritual art. The execution in the present case is primitive; but it must be borne in mind that Beth Alpha was a poor provincial center, and it may be that the general conception was based on a more ambitious piece of work which the artists had seen elsewhere. To the left are Abraham's two attendants, whom he left behind with the ass when he went up to Mount Moriah. Then comes the ram, entangled in a bush. Abraham stands offering Isaac up towards the altar on the right, the manifestation of God from **heaven** being symbolized by a hand which appears from the clouds: a feature known already in the Exodus and Resurrection panels of the Dura Synagogue, and conceivably to be brought into relation with the sacred hand so common in later Jewish popular religious and folk art.

The Beth Alpha Synagogue mosaic, while poorly executed, is by far the best preserved of those found in Palestine. It thus offers in the most complete form the typical and conventional arrangement. Elsewhere, too, there seems to have been some Scriptural scene, generally of ideological importance, accompanying the decorative or symbolic features. In the fifth-century Synagogue of Jerash in Transjordan, for example, the mosaic floor covering the vestibule depicts the animals of Noah's Ark, this time executed with great competence, though the preservation is fragmentary. At Na'aran ('Ein Duk), there was a representation of Daniel, which would have been unrecognizable now were it not clearly labeled *Daniel, Shalom*. The mosaic in the newly excavated synagogue at *Fig. 51*
Hammat by Tiberias, beautifully executed, resembles that at Beth Alpha in arrangement *Frontispiece*
and the design of the shrine and the zodiac, but has no Biblical scene. A conspicuous incidental feature of the mosaics of the Palestinian synagogues is the *menorah* which sometimes figures as a central motif. In the Jerash Synagogue the *menorah* occupies the center of the inscription panel together with *shofar, lulab,* and so-called "snuff shovel."

These features are to be found also in the beautifully executed synagogue mosaic recently *Plate 7*
found at Nirim in the Negev. The Synagogue of Jericho (7th–8th century) displays in its mosaic pavement a beautifully designed *menorah* in a medallion flanked by a *lulab* and a *shofar,* surmounting a formal Hebrew inscription invoking peace on Israel. A similar one appears at Hulda. On the other hand, we find the ark asserting its central position on *Fig. 59*
the mosaic floors of the synagogues at Beth Guvrin, at Na'aran (5th century), and Beth *Fig. 60*
Alpha (6th century). Much in favor were large circular motifs with radial arrangement of the decoration. In Na'aran, Beth Alpha, and Isfiya it is the zodiacal wheel which is thus represented, in Yafa the few preserved emblems suggest the twelve tribes.

The ceremonial grouping in Beth Alpha is, however, the most complete version of its type. The ark with huge birds perched on its gable is flanked by seven-branched candelabra, lions, and cult-accessories. It is framed with curtains. This may be compared with the

ceremonial images on the gold glasses found in Rome. It has been questioned whether the lions flanking the ark are actually meant to refer to the lion of Judah or whether they represent in fact a feature of contemporary synagogue decoration. In the mosaic of the Synagogue of Hammath-Gader (el-Hammeh, 5th century), the figured decoration is reduced to two lions and two trees which flank a medallion containing an inscription.

In the zodiac panel at Beth Alpha (paralleled closely in the mosaics of the synagogues of Na'aran and Tiberias), we have, in the corners of the square which encloses the zodiac wheel, personifications of the four seasons. One of these, winter, in the upper right corner, has in contrast to the others no attributes of blooming life, no flowers, no fruit, no birds. Nevertheless, the figure which personifies the inclement season is beautiful. Her hair-style, her earrings, her necklace, and embroidered dress are just as perfect as those of the other symbolic female figures. A Torah-scroll is at her side.

The mosaic floor of the Na'aran Synagogue is unfortunately preserved only in part. However, its layout is sufficiently clear. Moving towards the ark, the worshiper saw first a panel depicting beasts and birds, then the wheel of the zodiac, Daniel in the Lion's Den, and finally a ceremonial grouping. The practice of placing the animals rather in the border or entrance area is interesting. Thus in the Jerash mosaic, too, Noah's Ark with the animals is portrayed in the mosaic floor of the vestibule. The zodiac in the Na'aran Synagogue is poorly preserved. The personifications of the seasons in the four corners are much
Fig. 58 damaged. The central circle, however, displays, as at Beth Alpha, the sun-god driving his quadriga. We may wonder how such a frankly pagan image could be used without any attempt at adjustment. One explanation would be that the chariot of the sun had become a conventional calendar figure, and that in the 5th and 6th centuries the outworn pagan symbols were used mechanically. It is, however, conceivable that the idea was transmogrified in Jewish minds to the prophet Elijah mounting to heaven in his fiery chariot. In Christian art of the period, the conventional signs of the zodiac were rarely used. They were replaced by the figures personifying the labors of the twelve months, or by figures of saints, angels, and Christian symbols. The Jewish zodiac designs in Palestinian synagogue mosaics still retained the traditional Roman constellation signs and figures, which became traditional in Jewish art up to the 18th century, now adjusted to the Jewish festivals.

The best designed, though not best preserved, zodiac was the one found in the mosaic pavement in the synagogue of Isfiya. Here the spokes of the wheel are regularly spaced and coincide with the axes of the square (which is not the case in the mosaic zodiacs of Na'aran and Beth Alpha.) Some of the discrepancies of the two latter zodiacs may be accounted for by the desire to avoid the form of the cross.

One of the earliest, most beautiful and most interesting examples of a synagogue mosaic of the classical period extant is that discovered among the ruins of the house of prayer in ancient Naro (Hammam Lif) near Tunis, of the late 4th early 5th century. The well-
Fig. 65 preserved and finely executed pavement here is divided into three panels. The central one fronts the niche. An inscription runs across this central panel, subdividing it into two sections, the one closer to the niche being arranged symmetrically with a double-handled vase in the center, from which a fountain gushes. Peacocks flank and face the vase, while other birds face outward. Two palm trees and small shoots border the scene. Blossoming tendrils fill the background. The inscription is flanked by decorative lozenges, each of which encloses a *menorah*. Above the inscription strip we see fish and ducks wading in

the water. The left part of the scene is unfortunately obliterated. All that is recognizable is blossoming tendrils which suggest dry land. Between the shore and the sea appears a large wheel and above it a form plausibly interpreted as the hand of God. The two fishes were ingeniously identified as the Leviathan and his mate, with reference to the Rabbinic mythology according to which, at the advent of the Messiah, these animals will provide food for the pious. The sun is enclosed in a wheel which may refer to a Jewish legend about the sun "grating against its wheel." If the upper section is interpreted as the Messianic vision, the lower one presumably represents the Garden of Eden. The decorative panels which adjoin the Messianic scene expand it by a vision of the fertility of nature. Local color is added by wading birds of the Nilotic landscape in tendril groves, the African lion, and the ibis, with baskets of fruit and of bread.

Mosaics appear to have been used also in Jewish private homes, depicting secular subjects. In a house of a certain Leontius found in Beth Shean is depicted a Nilotic scene with some Odesian episodes; a stylized candelabrum appears in the middle.

Fig. 64

V

The more modest decorations of the underground cemeteries found in catacombs, in Palestine and the Diaspora, may be regarded as a Jewish folk-art variety of synagogue decoration. There is, for example, an unmistakable link between the art of the Dura Synagogue and the decorations of the catacombs at Beth Shearim. The reliefs, graffiti and dipinti of the walls, as well as those on the stone coffins, found in great numbers in the excavations of 1955, are particularly important for the iconography of Jewish art. We have to keep in mind that catacomb art is usually inferior to the art of the synagogue, both in execution and owing to a lack of a general conceptual decoration scheme. Funeral chambers with family tombs, allowing for a unified comprehensive decoration, are rare. The attempt to achieve such a unified effect was made, however, in one chamber in Beth Shearim which is of considerable interest. Here the walls projecting forward on either side of an arcosolium (a niche sheltering a tomb) are decorated with miniature structures carved in relief. The one on the left is a synagogue ark with the door shut, the one on the right encloses a *menorah*. A lion stands on top of each of the aediculae. The *menorah* is flanked by a *lulab* and a human figure in long draped garments. It is possible that the priest and the *lulab* flanking the *menorah* were meant to suggest an actual liturgical service.

Plates 8, 9, 10

Fig. 63

In the dipinti of the catacomb the ark is shown open with the scrolls visible in the interior, and a lamp suspended from the top. Some specific significance may be assigned to the painted disks which appear in Beth Shearim in various combinations. One *menorah* is seen flanked with disks filled with rosette designs. The larger one, on the left, perhaps represents the sun, the smaller one, on the right, the moon. In another design the two luminaries are apparently set on a vertical axis and connected by a bar. Other motifs in Beth Shearim are a rider, a man leading a horse, a soldier in armor and boats. It has been suggested that the human figures may symbolize, as in medieval Jewish pictorial art, the Messiah mounted on his steed (as described in Zachariah IX, 9) or the Parthian rider of Jewish legend heralding the liberation from Rome. Boats referring to the departure of the deceased, originally an Egyptian and Greek conception, evidently reflect here the belief of the pious in the return to the Holy Land.

Fig. 66, 67

The Jewish catacombs in Italy, particularly in Rome, have important decorations in fresco, as yet inadequately examined — some of them embodying human figures. In two connected chambers of the catacomb on the Via Appia, there appear pagan mythological figures, Victory crowning a young man, Fortune with the horn of plenty, Mercury with the caduceus, peacocks, a ram, and a bag. Here the walls and the ceilings are integrated in a harmonious design. The figures on the vault are enclosed in a central medallion which is surrounded by ornamental framework, scalloped arches filling the

Fig. 61

sides and the corners. The walls, in which doorways and arcosolia are pierced, are divided off by panels in which peacocks are seen perching on branches or walking on the ground. Garlands hanging down from the panel frames add a gay note to the whole. It is possible that these two chambers were only later incorporated into the Jewish catacomb. However this may be, decorative designs such as these appear to have stimulated the imagination of the decorators of the other undoubtedly Jewish catacombs in Rome.

In those of the Vigna Randanini, also in the Via Appia, comprehensive decorative scenes are to be found which are of considerable interest. In one funerary chamber, palm trees are painted in the four corners giving the whole a unified effect. Baskets of flowers and birds decorate the walls. Near this chamber was found the sarcophagus of Eudoxios, the "zographos" mentioned in this chapter.

Fig. 62

In the catacomb of the Villa Torlonia, large decorative compositions appear on the chamber vaults, the sidewalls of the arcosolia, and their soffiti. The central medallion on the vault is usually filled with a *menorah,* while the side and corner compartments display the *ethrog,* the *shofar,* a scroll, and a pomegranate. There also appears a dolphin on a trident. On the rear wall of the arcosolium the center is occupied by the Torah-shrine with its doors open, exhibiting the Scripture scrolls, with other accessories of the synagogue service arranged on either side. Here the Jewish motifs have almost entirely displaced the pagan elements of the decoration.

We may conclude that Jewish figurative art in the classical period faithfully reflected in its selection, its ideology, and its symbolism the atmosphere and the craving of the age.

For the first time in history, Jewish art had created in pictorial language a series of figures inspired by the Bible and forming a conceptual unit, a whole which was based on Jewish living experience. This is what distinguishes Jewish art of the classical period from the Christian interpretation of the "Old Testament" used for polemical purposes. Jewish art had necessarily adopted some of the pictorial vocabulary of its time and place, but infused it with its own meaning. At first tolerated and later obviously guided by the leaders of the synagogue, this art performed a vital function — not only educational, but also inspirational.

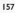

157

57. Synagogue of Dura-Europos, part of west wall. National
Museum, Damascus. Courtesy of Dura-Europos Publications,
Yale University.

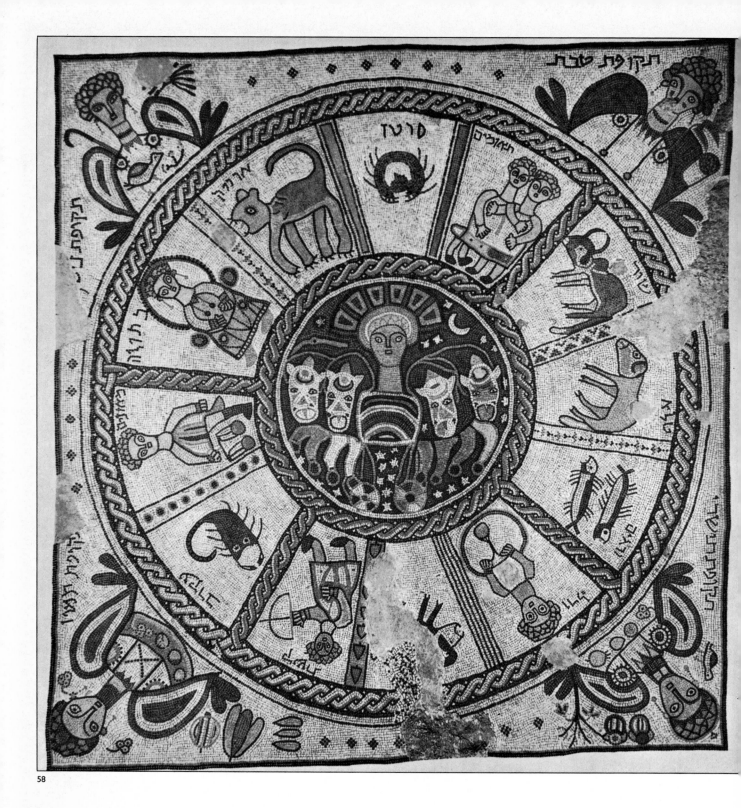

58

58. The constellations and the seasons: central design of floor
 mosaic of Beth-Alpha Synagogue.

59. Jewish Temple symbols. Detail of floor mosaic of synagogue
 at Hulda. Department of Antiquities and Museums, Jerusalem

60. Torah-shrine between two candelabras and other Jewish
 symbols: Detail of floor mosaic of Beth Guvrin synagogue.
 Department of Antiquities and Museums, Jerusalem.

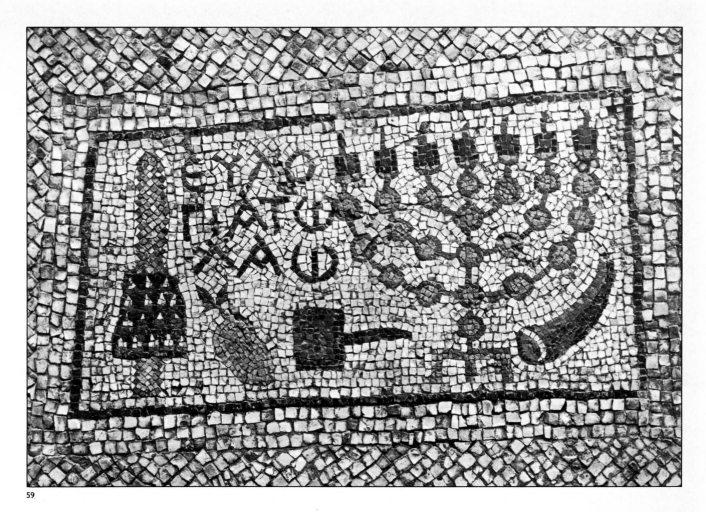

59

60

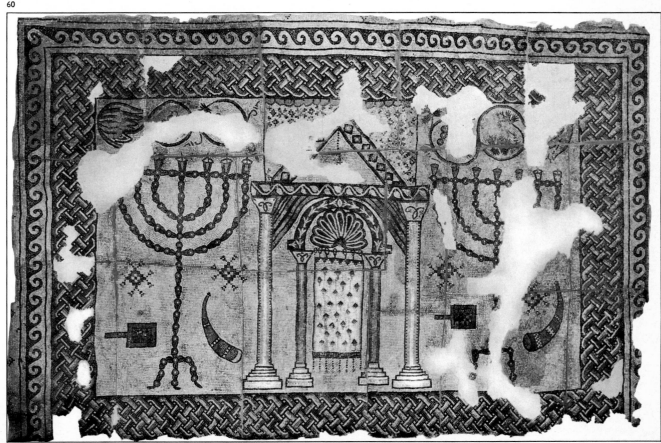

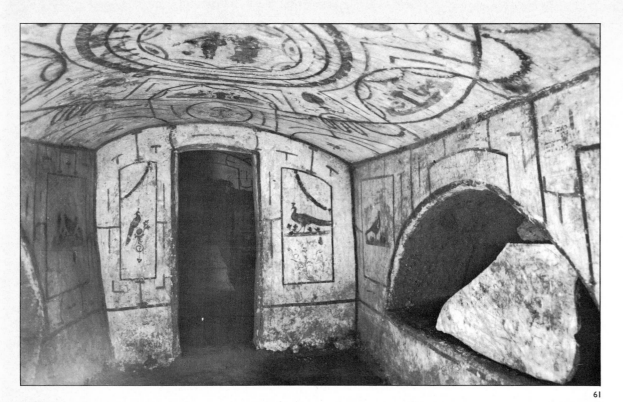

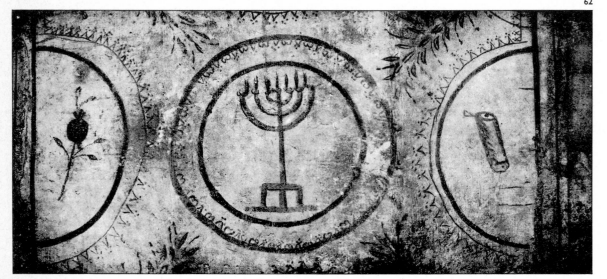

61. Decorated hall of Jewish catacomb in Via Appia, Rome.

62. Candelabrum on a decorated ceiling in catacomb at Villa Torlonia, Rome.

63. Burial chamber at Beth-Shearim

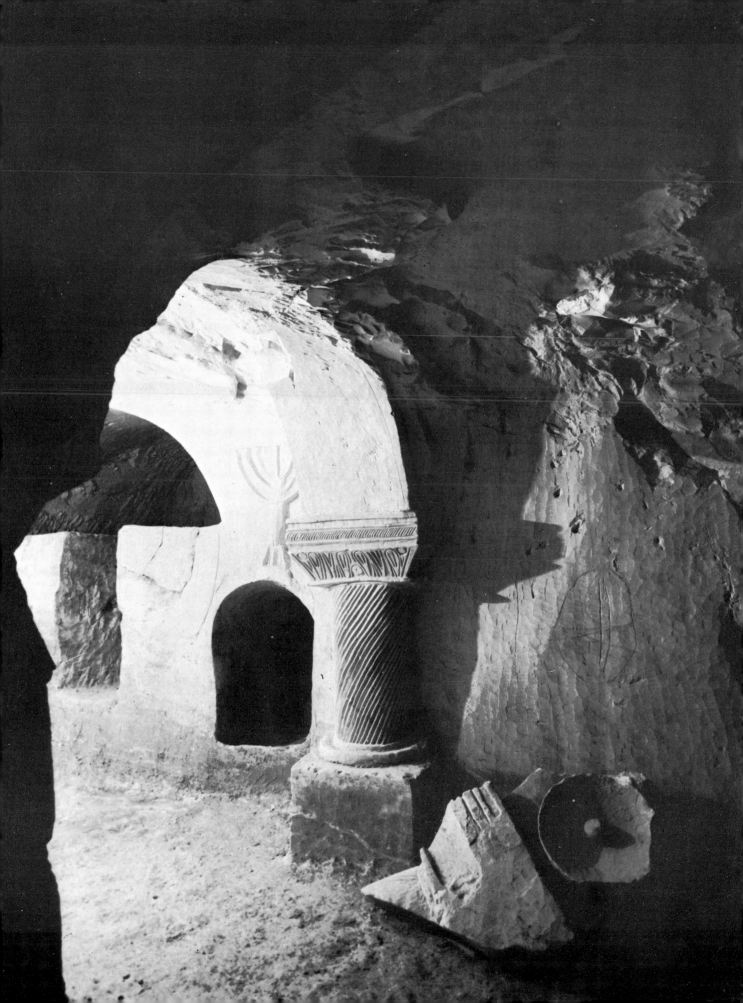

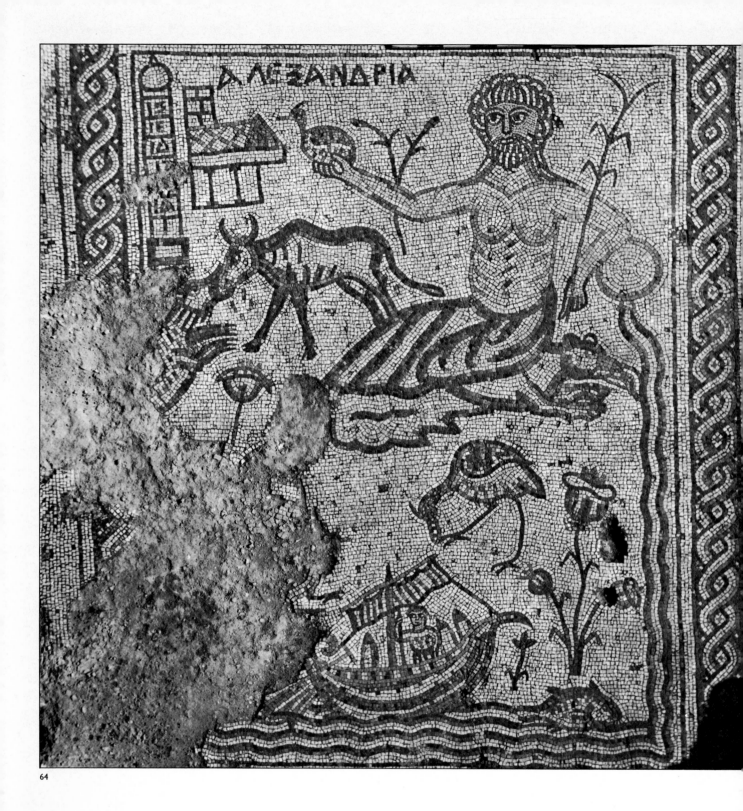

64

64. *Nile River God: Detail of floor mosaic of House of Leontius in Beth Shean Museum. Department of Antiquities and Museums, Jerusalem.*

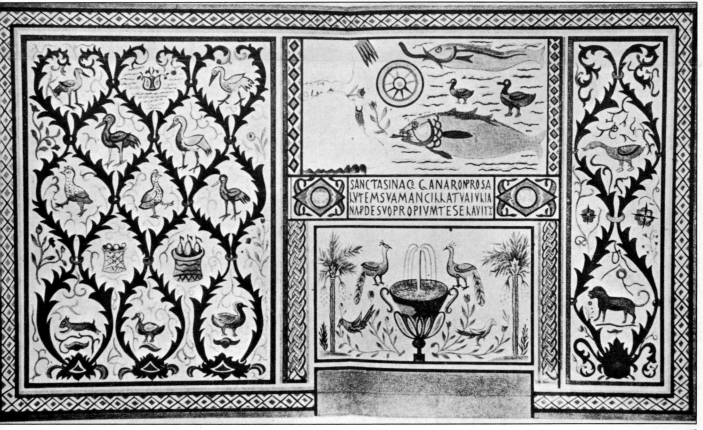

65

65. *A picture of Paradise, detail of floor mosaic of synagogue at Naro, Hammam Lif, Tunis. 5th century. Brooklyn Museum, New-York.*

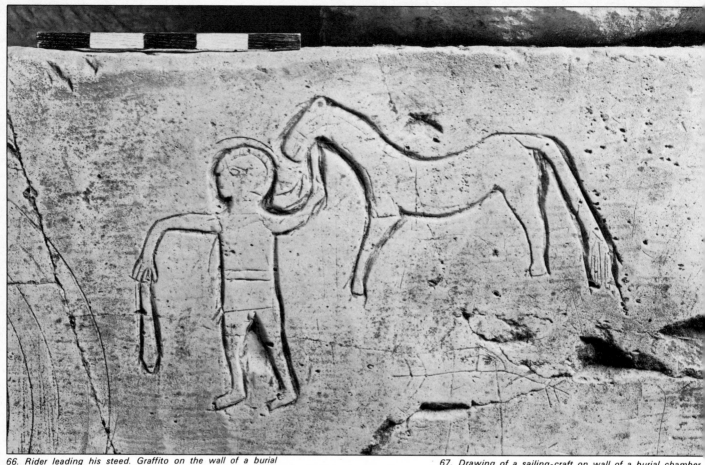

66. *Rider leading his steed. Graffito on the wall of a burial chamber of Beth Shearim. Department of Archaeology, Hebrew University, Jerusalem.*

67. *Drawing of a sailing-craft on wall of a burial chamber Beth Shearim. Department of Archaeology, Hebre University, Jerusalem.*

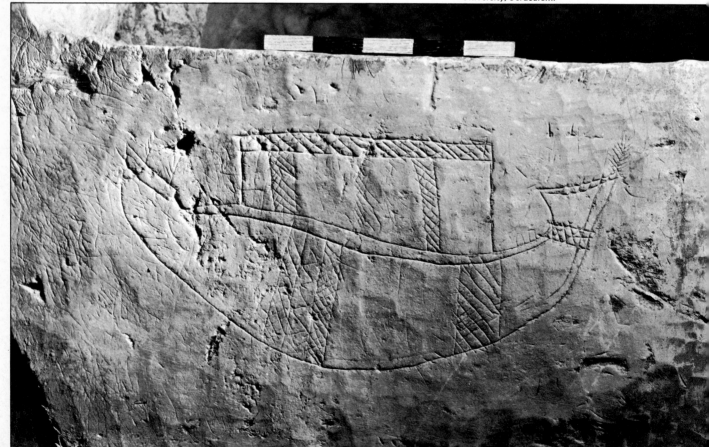

THE MINOR ARTS
OF THE TALMUDIC PERIOD

by SIMON APPELBAUM

The minor Jewish arts of the Talmudic period can be judged as expressions of late Hellenistic or Roman provincial art — although it should be noted that by its very location the art of the Jewish catacombs of Rome cannot be termed "provincial" — or they can be judged on purely subjective criteria. Obviously, all work must be appreciated against the background of its period, but only the personal feelings of the observer can discover in such objects evidence of the direct subjective and observational experience leading to aesthetic achievement. Yet by the definition accepted in this book, a Jewish art-object is one which either bears a Jewish symbol or has been discovered in a Jewish association; it is not, therefore, bound to be of Jewish authorship; but it does reflect Jewish use and Jewish taste.

Great as were the losses of Jewish manpower both in Palestine in the First and Second revolts (of 66–73 and 132–135 C.E., respectively) and in the Diaspora during the furious revolt of 115–117 C.E., which affected Egypt, Cyrenaica, Cyprus, and Mesopotamia, Jewish craftsmen survived in numbers, as the Talmud and other sources evidence. Life in Palestine ultimately returned to normal, the arts and crafts again flourished. No doubt the destruction of the Temple to a certain extent diverted artistic effort to the beautification of the synagogue and a certain change took place in the selection of Jewish decorative symbols: the seven-branched candelabrum *(the menorah),* previously relatively rare, now appears with frequency and occupies a central position in Jewish art, both in the homeland and the Diaspora, in synagogues, on tombs, glass vessels, and clay lamps, accompanied by several other adjuncts connected with the cult. Free-standing tomb monuments and rock-cut tombs with impressive façades, on the other hand, become rarer, as if to avoid the greed and envy of the foes of Judaism, and richly carved ossuaries appear less frequently.

The development and planning of Palestinian synagogues are the subject of another chapter; here we shall only discuss their stone carvings and ornamentations, or the mosaic pavements which they contained.

II

The synagogue differed fundamentally from the pagan temple in that its interior was for the congregation, and was not occupied by statues and offerings; hence it furnished

fewer opportunities for rich inner ornamentation. In effect, the architects of the 2nd and 3rd century synagogues concentrated much of their adornments on the doors, sills, lintels, and windows of the façade and flanks on ground or second-story level, also on the architrave of the gable roof; thus there remained broad wall-surfaces to lend massive dignity and to set off the decorative features.

Fig. 48, 49, 50

The fine arcuated windows were apparently derived from the Syrian school of architecture of the Severan age, as expressed, for instance, at Baalbek; this also was the origin of the richly carved lintels such as are seen in the prayer houses of Chorazin, Kfar Bar'am, and Capernaum. The symbols embodied in the carvings were very numerous, but there recur from synagogue to synagogue the eagle, the lion, birds, the palm tree, and the palm branch, the amphora (from which a vine frequently springs), the ovolo, the ivy wreath, the *menorah,* the vine scroll with leaves, the acanthus, rosettes, the astralagus, medallions, garlands, and conches.

A special problem is presented by the human figures which appear in some synagogues — victories, winged deities, vintners, centaurs, and even female forms. We would remark, however, that these figures rarely dominate the decorative scheme or appear in isolation; generally they only serve to fill the gaps between the other motifs. The execution of these forms is not usually competent (though by no means lacking in spirit), and invariably inferior to that of the formal ornamentation. This difference suggests that the tradition of the craftsmen who executed the formal motifs (plants, and foliage) was much more ancient; this phenomenon cannot be explained by mere provincialism, and is a fair argument for the Jewish origin of the masons who executed these designs. True sculpture in the round was reached by these craftsmen only in the lion-figures that perhaps stood on each side of the Torah-arks in some prayer houses. A figure of this sort from Chorazin

Fig. 82

is full of energy; but a much smaller lion recently found at the same place is far better; it is rearing up and striking with its forepaw, and its face has a fierce snarl, the whole being executed with spirit and imagination.

In most of these structures the builders achieved a satisfying and impressive ensemble. The construction of the doors is skillfully varied to give scope to differing forms of expression; the so-called Torah screen which has been reconstructed at Capernaum has strength and interest. In some of the vine-scroll friezes of the same building one feels not only the artist's delight in a space beautifully filled, but the emotion of the dedicated craftsman who was close to nature and to faith alike.

The opinion of scholars is that while the synagogues were designed by Greco-Roman architects, the decorative details were Jewish work; several features of treatment which are peculiar to the latter, and appear earlier on ossuaries of the Second Temple period, strengthen this view. Not a few of the repertoire of motifs, on the other hand, are derived from the shrines of Syria and Transjordan (particularly notable in this respect are the decorative details of the Nabataean classical temple of Baal Shamin at Sî in southern Syria) which merge Nabataean feeling with Hellenistic technique.

The Palestinian synagogues of "transitional" form between the 3rd century Galilean and the Byzantine buildings are described in another chapter. Stone-carved work is rare here, but attention must be drawn to the fragments of several carved chancel screens which seem to have enclosed the Torah-arks in the later synagogues. Such have been found at Hammath near Tiberias, Hammath-Gader, Ashdod, Ashkelon, and Gaza. The

Fig. 53

forms of *menorah* and their accompanying cult adjuncts (the *shofar, ethrog,* etc.),

sometimes enclosed by wreaths, which one sees on these reliefs, are the competent work of a certain sophistication, but lacking the bold verve of the earlier Galilean carvings. Interesting here is the similarity between the style of these *menorot* and of the ones appearing on some clay lamps of later 3rd century — for example, one discovered at Beth Nattif among the remains of a pagan potter's shop; this would suggest that the reliefs in question were the work of gentile craftsmen, a view that finds some support in the geographical distribution of the finds in cities of pronounced Greek culture. Whatever the case, this style certainly represents the urbanization of the Jewish population of Judea that took place after the destruction of the Second Temple. Among the Jewish architectural carvings of the same period are to be noted the beautiful Corinthian column capitals from the Caesarea synagogue (4th century); their foliage has much originality, and some bear the monograms (in Greek) of the men who contributed them to the building.

Fig. 42

Most of the mosaic pavements of the synagogues of this epoch do not evoke great respect from the artistic point of view. The most aesthetic, perhaps, is that of the Aegina synagogue (Greece), which belongs to the 4th century. This is a "carpet" pavement adorned with formal patterns; its colors are lively and its technique excellent; the general design has balance and restraint. The floor of the Hammam al-Lif Synagogue in Tunisia with its birds and winding wreaths is of good technique, but has a certain coldness which suggests that it may have been pagan work. On the other hand, there is no doubt that the famous Beth Alpha pavement was made by Jewish artists, as inscriptions testify. Despite its low standard judged by "classical" criteria, it is full of primitive vitality, reflecting a popular Oriental *genre* which, originally submerged by the spread of classical art, had vanished completely but had not died, and awakened to new life in the late period. (As a parallel phenomenon at the western end of the Roman Empire may be cited the revival of Celtic art at the end of the 2nd century in Britain and Gaul.) The late mosaic of the synagogue at Nirim in the southern frontier district of the country repeats, with its forty-four panels enclosing symbols and animal figures including elephants, a flamingo and a parrot, a Christian model, and there are Christian parallels in the district; its interest is as much zoological as theological.

Fig. 65

Fig. 58

Plate 7

III

In Palestine, Jewish stone carving was not restricted to synagogues; at Neveh, in Hauran, Jewish stone dwellings of this epoch still survive, with beautifully carved lintels adorned with wreaths set in conches, vine scrolls, grape clusters flanked by *menorot*, and the like. These decorations enjoy a certain stylistic freedom lacking in Galilee; thus, not only synagogues but also secular dwellings possessed decorations of considerable beauty at this period.

Turning now to the Jewish catacombs at Rome we find an art which is, externally at least, almost entirely gentile. Here, in the catacombs of the Vigna Randanini and the Villa Torlonia, the walls and ceilings of the tomb chambers are divided into painted panels filled with plant motifs, birds, deities, fruit, etc., in normal pagan style. In the first three chambers of the Vigna Randanini, Jewish symbols are actually absent, except for a palm tree in the third room (where the general style is rather more impressionist); only in the fourth chamber, whose decoration is decidedly primitive, consisting of denticulated circles painted on the ceiling, does the *menorah* appear. The frescoes at the

Villa Torlonia are also pronouncedly pagan, although in the center of the ceiling of the first chamber the *menorah* and its associated adjuncts are to be seen; the arcosolia, on the other hand, have frescoes of Jewish content — here we see the *shofar*, pomegranate, *Fig. 62* *menorah,* chalice, and similar symbols. Prominent in the fourth arcosolium is a landscape of the Temple flanked by *menorot* over which sail the sun and the moon. These pictures are Jewish by virtue of their content, and whether the painter was a Jew or not, this faced him with a specific compositional problem and with certain decorative opportunities.

The sarcophagi of the Jewish catacombs of Rome are frequently adorned with reliefs representing pagan deities or human beings in a manner quite at variance with the prevalent conception of the prohibitions of normative Judaism. It is clear that most of these sculptures were purchased from gentile masons; this is proved, for instance, by the difference between their technical level and that of the inscriptions on them. The same may be assumed concerning the sarcophagus from the Vigna Randanini, on which are seen erotic carvings in pure pagan style, while the composition contains a medallion later filled by a finely executed *menorah* whose feeling and energy bespeak a Jewish craftsman. As two identical pagan parallels are known, differing only in the absence of the *menorah,* there can be no doubt that this was a gentile sarcophagus purchased from stock and re-adapted for Jewish use. A second sarcophagus from the same catacomb, however, possesses the decorative symbols normal in Jewish Palestinian art (palms, *lulabs,* medallions, rosettes, etc.), and it may be guessed that its author was from the home-country. Very beautiful is the coffin from the Villa Torlonia bearing on its side a *menorah* and *ethrog* in low relief; its execution is so delicate and the handling of spaces so balanced, that one acknowledges an artist of sensibility and feeling.

In one of the catacombs, a Jewish *zographos* is commemorated, that is, a painter of figures. The verb form of the same Greek word is used in a Jewish inscription at Berenice-Benghazi in Cyrenaica, North Africa, in the late 1st century B.C.E., to describe the work of decorating a Jewish building, here called an amphitheater. This building, which probably survived till the great Jewish revolt under Trajan (115–117), may, therefore, have been decorated with frescoes, perhaps even with human figures such as are seen on the walls of the synagogue of Dura-Europos. Thus, this branch of Jewish art, which appears at Dura-Europos in the 3rd century C.E., may have originated in the 1st century B.C.E. or even earlier.

IV

Plate 9 The great treasure house of Jewish sepulchral art in Israel during this period is, of course, Beth Shearim at the western entrance to the Plain of Esdraelon. The brilliant period of this great necropolis began in the second half of the 2nd century C.E., when it became a focus for the burial of Jews not only from Palestine, but also from the whole Middle East, including Palmyra, Babylonia, Syria, and Southern Arabia. The tombs normally resemble the catacombs of Rome insofar as they consist of a series of burial chambers *Plate 8* cut in the soft chalk rock at various levels; sometimes they are entered from the hillside, sometimes through a deep cleft in the hill. The corpses were laid in arcosolia, in galleries, *Fig. 63* in sarcophagi, or in cists cut in the rock floors of the tomb chambers; the bones of the dead were sometimes later collected in wooden ossuaries laid in the arcosolia. The tomb

decorations were not particularly rich or developed; the stone tomb-doors served as special objects of adornment, their faces being generally carved to resemble wooden ones, and divided into panels bearing bosses, medallions, and other decorations. Sometimes the door frame, arch and jambs of the doorway, were also decorated with moldings or an "egg and tongue" border; but the arches of the great façade of Tomb 14 found in 1953 and thought to have been the sepulcher of Rabbi Judah the Prince himself were enriched only with simple moldings.

Plate 9

The square mausoleum, or meeting hall, behind the court of Tomb Series 11 was a monument of striking dignity and beauty, if it has been correctly restored from its remains. Its walls were strengthened by pilasters with molded heads, which supported a fasciated architrave. This was interrupted by the arch of the entrance, but here the frieze and molding were carried over it, and in between were inserted a band of rosettes and a spread eagle flanked by animals. The frieze also bore a rich winding scroll containing flowers in the coils, and the cornice was enriched with a double dentilation and a bead-and-reel decoration. From another mausoleum at Beth Shearim came a remarkable fragment of an animal frieze in high relief representing wolves in combat; the verve and furious energy of this group is so exceptional that it cannot be ascribed to the influence of any classical school; it recalls rather similar animal figures of Celtic and Scythian art, and must be attributed to essentially local Jewish inspiration.

Plate 10

Only recently have intact sarcophagi been discovered at Beth Shearim; their sides are frequently ornamented with bulls' heads, lions, gazelles, and similar figures in relief; sometimes these are picked out in red paint. The work is crude but lusty, and the animals belong to the style of folk art which began to re-express itself in the late Roman Empire. The wall decorations in the tombs are also on the whole rough, and frescoes appear only rarely. In room xii of hall i of series 4, the ceiling is painted in panels defined by red paint and divided by a double stripe and dogtooth pattern in red. The end-wall is covered with a chaotic reticulate pattern in the same color. The other decorations of these tombs consist of rough reliefs and wall-graffiti. Here and there the chalk has been carved into the shape of a pillar, a Torah-ark and shrine are represented, or there appears a human or animal figure. Notable is the relief of a "military saint" bearing a *menorah* on his head. The sculpture is crude in the extreme, but the figure has been placed at a corner with a certain effectiveness that owes much to the soft whiteness of the chalk. To the same type of art belong the conches over the arcosolia, the springing lion, the horseman, and the representation of the front of the Temple. The numerous *menorot* in high relief are a school to themselves, with their massive stems, their oblique spreading branches, and their pronounced expressionism.

If all these are the creations of Jewish folk art, how much more so are the spontaneous and incidental graffiti to be seen on the walls of the burial chambers. Characteristic of these are the club-bearer, a rider leading his steed, the charging horseman, a pair of fighting gladiators, the winged god, and the sketches of ships. Striking talent is exhibited by the drawing of a sailing-craft; it is clear that the draftsman has seen ships and understood them. The twin steering-oars, the curve of the mast stepped into the bottom (a detail which shows that the draftsman had been on board), the features of the sail, yard and rigging, the lines of the hull—all are accurately caught. This craft is under way, and we feel in our faces the breeze that swells her sail; we can even note that she is sailing close to the wind.

Fig. 67

From the arts of building and burial, we pass to the arts of the objects of everyday life —
metalwork, pottery, glass, wood, and textiles.

A fine expression of the ability of Jewish metalworkers is furnished by the coins minted
by the revolutionary Government of Bar Kokhba (132–135 C.E.). The subjects of the issues
are the Temple and its vessels (the façade of the Temple, the amphora, *lulab, ethrog,*
and the rest) and the symbols of the nation as a whole — the palm tree, the bunch of
grapes, and the vine leaf. These symbols have been overstruck on Roman issues in order
to deliver a blow to Roman imperial prestige; most strikingly beautiful are the pieces
representing the lute and the vine leaf.

Prominent among Jewish metal *objets d'art* was the *menorah* (candelabrum) in syna-
gogues; two *menorot* frequently stood on each side of the Torah-ark, sometimes they
were made of stone (like that found at Hammath near Tiberias; the base of another came
from the synagogue at Beth Shearim); but many were of metal and have not survived.
No symbol figures more frequently in Jewish art after the destruction of the Second
Temple. Its representations show that sometimes the branches were linked above by a
crosspiece, the branches themselves being built up in knops or bosses, while the stand
possessed four feet. The stand of the *menorah* portrayed in the apse of the Dura-Europos
synagogue was also formed of superimposed moldings into which the central stem was
inserted. Sometimes the arms took the form of foliage or of leafy branches.

Among the Jewish bronze objects of this period, there has been preserved a bronze
lamp discovered in Syria; it resembles in shape similar lamps of clay, being filled through
a hole in its upper face and possessing a projecting nozzle for the wick. It seems to have
been suspended by a chain attached to a column emerging from the filling aperture.
Worthy of notice here are the representations of the *menorah, lulab, ethrog,* and *shofar*
rising from the lamp's rear rim. Another beautiful example of Jewish metalwork of the
epoch is the fragmentary bronze paten from Naaneh near Ramlah. Its rim is decorated
with an incised winding scroll containing flowers in the swags and also a *menorah* and
Torah-shrine; the center shows four plants with tendrils and palm branches springing
from a vase. The vessel's period is the 4th century. Interesting, also, is a small gold disc
of unknown provenance, belonging to the 3rd or 4th century; its face is decorated in
repoussée with the *menorah* and its associated adjuncts also bearing in Greek the name
of its owner, who was a "pearl-setter."

These metal objects are some faint reminder of the level of Jewish artistic metalworking
in Talmudic days — a craft most of whose products have vanished. We find additional
hints of this art represented on coins — for example, in the chalice which appears on
issues of the First Revolt (66–70 C.E.), in ossuaries, and in synagogue carvings. The
craftsmen of Syria and Egypt exercised a considerable influence on the silverwork of the
later Roman Empire, and their products were distributed over the entire Mediterranean
area. Hence it is hardly surprising to find on late Roman silver vessels (4th century C.E.),
discovered in northwestern Europe, decorative motifs (the Star of David, the whorl rosette,
and the like) drawn from the repertoire of Palestinian Jewish ornamentation.

When we come to discuss clay lamps, we enter a sphere in which the arts meet the
crafts, but their ornamentation was certainly influenced by the art of the period and
reflects popular taste in that sphere. Among Jews a clay oil-lamp was placed on the top
of each branch of the *menorah;* similar lamps are frequently found in Jewish tombs and
sometimes in synagogues in Palestine and abroad. This type of lamp consisted of a round

Fig. 68, 69

Fig. 70, 71, 72, 73

Fig. 74

Fig. 76

body which held the oil, and a nozzle in which the wick was placed. Many examples can be identified as Jewish because they bear Jewish symbols such as the *menorah* and its adjuncts; on the other hand, there are some identical types on which both Jewish and Christian symbols appear, and some Jewish lamps have been encountered in pagan workshops, showing that at certain periods in the age we are discussing, Jews and gentiles did not comprise separate worlds in the artistic sphere; between the two communities there seems to have been a free exchange of products, and one made objects for the other.* After the destruction of the Second Temple, new motifs appear on Jewish lamps, such as the Torah-ark, the amphora, the cluster of grapes, and so on. The variety of motifs is very great, and the identification of lamps as Jewish is often not easy. Research has divided Jewish lamps of the period adorned with the seven-branched candelabrum *Fig. 79* into six principal types, whose respective centers are located in Alexandria, Palestine, Carthage, Asia Minor, and Cyprus. None of these is regarded by archaeologists as earlier than the late 2nd century, but one typologically earlier sample found at Cyrene can hardly be later than the time of Trajan, when the Jewish community of the city ceased to exist, and Cyrene may well have been the first center of the manufacture and diffusion of the type.** There is some reason to believe that the purpose of such lamps was to spread religious propaganda prior to the revolt of 115, and a considerable school of gentile parallels can be cited which served as vehicles of Roman religious propaganda, some actually being manufactured by the state and bearing identical inscriptions with those inscribed on certain coin-issues.

Different were the clay lamps with four or more nozzles, including Hanukkah lamps, *Fig. 75* some of which were circular with the spout broadening to a wide truncated tongue, and some of omphaloid form. Their surfaces offered a wide field for ornamentation (arcades, the Temple, the vine, the amphora, birds, and similar objects), some had Jewish episodes represented on them. Their importance lies in their forming a departure point for the rich Jewish ritual art of Sabbath and Hanukkah lamps which developed during the Middle Ages and continues today.

VI

Tradition ascribes to Jews a participation in the famous Phoenician glass industry, and also the transmission of certain of its industrial processes to Europe; there is no doubt that in the Talmudic period there existed centers of glass manufacture at Tiberias and other places in Palestine; a glass workshop has been found in the ancient town of Beth Shearim. Outstanding among Jewish work are the Jewish "gold-glass" dishes known up and down the Roman Empire from the 3rd century on. They are thought to have originated in Alexandria, where Jewish craftsmen derived the technique of manufacture from the Egyptians in the 1st century C.E., and carried it to Italy. On these bowls, designs were drawn in gold leaf and outlined in black paint, then dusted with a colorless powdered glass which fused at a lower temperature and so formed a protective layer. Over this was gummed a second upper glass. Most of the examples of these dishes have been found in the Jewish and Christian catacombs of Rome, and according to the inscriptions

* For a consideration of the *halakhic* background of this state of affairs, whose results fully bear out the findings of the archaeological data, cf. F. A. Urbach, The Laws of Idolatry in the Light of Historical and Archaeological Facts in the 3rd Century, *Eretz Yisrael*, V, 1958, 189–205.

** *Israel Exploration Journal*, VII, 3, 1957, 154 sqq.

upon them they were gifts to friends and relatives. The Jewish dishes are identifiable by the subjects of their designs, which are usually divided into an upper and lower register

Fig. 77 enclosed by a square or circular frame. The themes include the *menorah* and its adjuncts, the Temple, lions, doves, the palm tree, the amphora, fish, and similar objects. The inscription is either arranged around the rim or along the diametrical division between the registers. Not a few bear pictures of Biblical episodes. A second center of the production of these dishes seems to have been Cologne, and other examples have been recorded from North Africa and Asia Minor.

The technique of glassblowing is thought to have been discovered at the beginning of the present era in Phoenicia, and it was this, together with the technique of molding, that enabled the production of vessels whose walls were decorated with various symbols, Jewish symbols among them. Thus, in Palestine and Syria, we find bottles of various

Fig. 78 forms on whose exteriors appear the *menorah,* the palm tree, the arcade, the grape cluster, and allied objects. Of considerable quality is the flat dish found at Beth Shearim; it possessed a high foot-ring and "kicked" base; it was made of green glass on which motifs were incised around the outer rim. These took the form of a continuous arcade in whose arches were the Jewish symbols — the Torah-ark, chandeliers, lamps, amphorae, the *menorah,* etc.

Fragments of carved bone-work in the form of a ship, a dolphin, and an amphora, found at Beth Shearim, hint at a branch of Jewish craftsmanship which is better evidenced in the Israelite royal period. Although inevitably nothing remains to us of Jewish woodwork

Fig. 80 and wood carving, the tomb-doors already described evidence the existence of that branch, as do the numerous drawings of the Torah-arks seen in graffiti, on clay lamps and elsewhere. Nearly all traces of Jewish textile manufacture have also necessarily disappeared, but the industry is referred to by sources not only in Palestine but also in Egypt and Asia Minor in the Talmudic period; in 4th century Egypt, curtains embroidered with fantastic figures were known as *Iudaica vela.* There is no doubt that such woven stuffs were also used in synagogues for the curtains that were hung before the niches in which the Torah-arks were placed; holes noticed in the walls of the Dura-Europos Synagogue on each side of the niche, and grooves flanking the niche in the Beth Alpha prayer house prove the truth of this supposition.

In summing up our theme, we have to answer the question, Does a genuine "minor" Jewish art reveal itself in our period? We may distinguish two spheres; that of public and that of popular art. The first is manifested in building and in burial, in vessels of metal, clay, and glass. This found its expression first and foremost in classical media, which it adapted to its own spirit. Archaeology proves that there was considerable mutual influence between Jewish and gentile art, and in the 3rd century the synagogue builders of Palestine drew from the repertoire of religious symbolism common to the Syrian and Nabataean cultures. This was a period of rapprochement with the gentiles, when Jewish art entered an era of adventurous exploration into new animal and human

Fig. 82 representations. But Jewish formal decorative motifs show assurance and tradition, and here, if anywhere, we feel the personal observation and the spiritual experience leading to artistic achievement. Although the ability to represent human and animal figures (with one or two striking exceptions) is rudimentary, such representations possess energy and nervous restlessness. Nearly all the graffiti and carvings at Beth Shearim and Beth Alpha possess this quality of movement, which is surely something specifically Jewish.

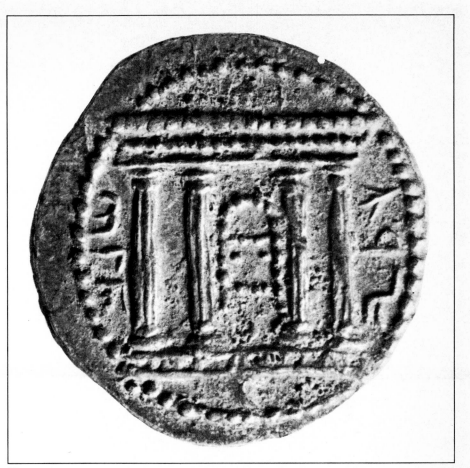

68

69

68, 69. Façade of the Temple, lulav and ethrog; two
sides of a coin of the second revolt under Bar-
Kokhba. Second year, 133 C.E. Numismatic
Museum, Tel Aviv.

70

71

70. *An amphora. Reverse of a coin of the Secon*
 Revolt under Bar-Kokhba. Inscribed: "First year
 Redemption of Israel" — 132 C.E.

71. *A lyre. Obverse of a coin of the Second Revo*
 under Bar-Kokhba. "First year of Redemption
 Israel" 132 C.E.

72

73

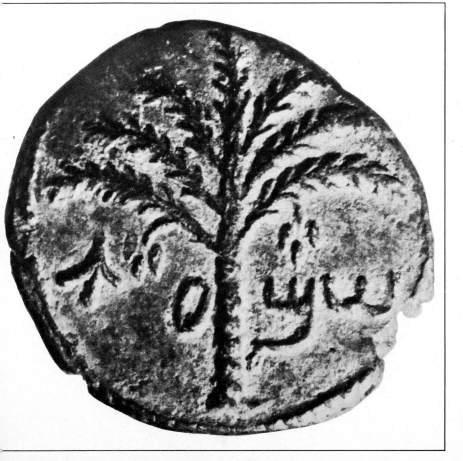

72. Obverse of a coin of the Second Revolt under Bar-Kokhba. First year 132 C.E. inscribed: "Shimon President of Israel" within a wreath.

73. Palm tree. Obverse of a coin of the Second Revolt under Bar-Kokhba. Third year 134 C.E. Inscribed: "Shimon".

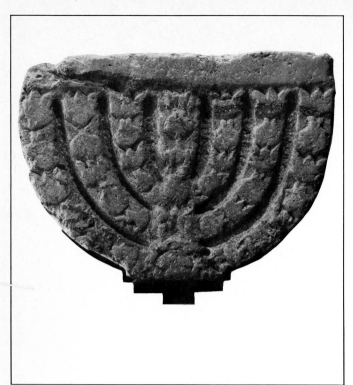

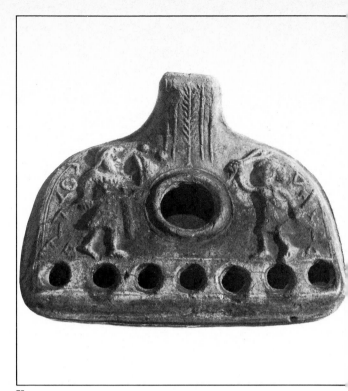

74 75

74. Limestone candelabrum from the synagogue of Hammat near Tiberias, 2nd or 3rd century. Israel Museum, Jerusalem.

75. David and Goliath on a clay lamp from Alexandria. Yale University Art Gallery. Courtesy of Dura-Europos Publications.

76. Bronze lamp from Syria. Miryam Schloessinger Collection, Israel Museum, Jerusalem.

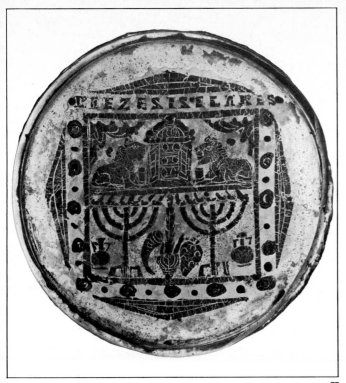

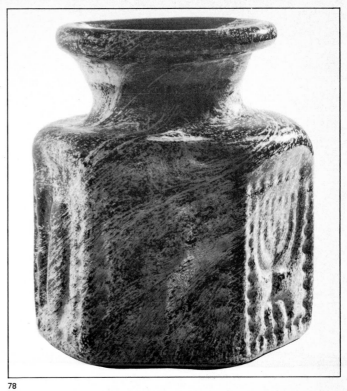

77 78

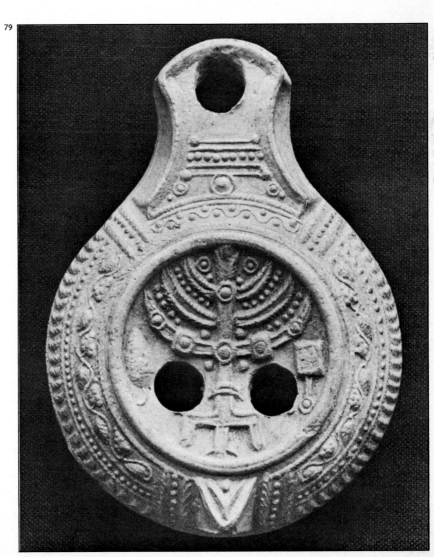

79

77. Holy Ark and Jewish Symbols on a Jewish "gold-glass"
dish from Rome; Israel Museum, Jerusalem.

78. Glass bottle from Palestine; Glass Museum in Haaretz
Museum, Tel-Aviv.

79. Candelabrum on a clay lamp from Palestine; Collection of
the Hebrew University, Jerusalem.

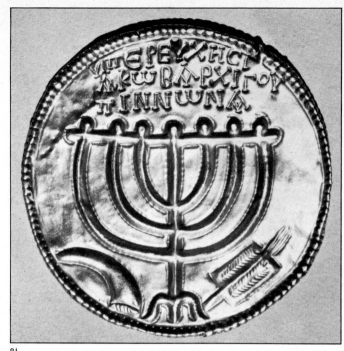

81

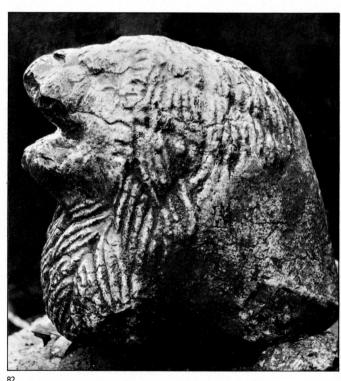

82

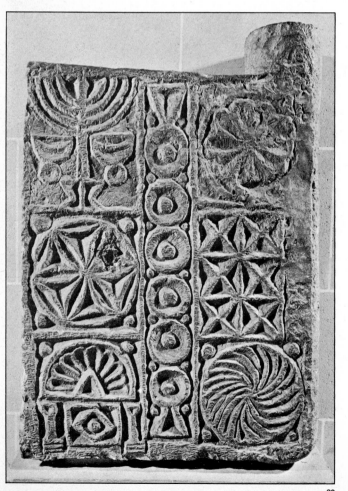

80

80. Stone Tomb door, from, Kfar Yassif. Musée du Louvre, Paris. Courtesy of Musées Nationaux.

81. Byzantine Gold Amulet: Jewish Museum, London.

82. Lion's head, basalt, synagogue at Kfar Bar'am. Courtesy of Department of Archaeology, Hebrew University, Jerusalem.

Perhaps here we may express the opinion that the tendency of the Jewish artist was less to estimate the means of expression than the idea he was seeking to express. Our sketch has shown that throughout the Roman Empire, the Jews in various periods and places accepted the representation of the human form in their art; in Rome, Jews frequently ordered art objects from gentiles. Here the point is, not who was the artist, but that in various instances Jewish symbolism placed the artist before a distinct problem and rendered inevitable a distinctive result. In this sense the art is Jewish, quite irrespective of its technical authorship. In the realm of artistic craftsmanship, there is little doubt that Jews in our epoch attained a high degree of competence, as the "gold glasses," the paten from Naaneh, and the coinage of Bar Kokhba prove. In this respect, the peculiar character of the object is less important than the skill of the technique and aesthetic quality of the result.

Fig. 81

The folk art typified at Beth Alpha and Beth Shearim, on the other hand, seldom reaches distinction. Its importance is as a sociological phenomenon, as a re-emergence from domination by an extraneous medium. The value of Beth Alpha pavements is in their vitality — the craftsmen clearly enjoyed their job.

We may perhaps symbolize Jewish "minor" artistic achievement in the plant scrolls of Capernaum and in the splendid little ship sketch, already discussed, from Beth Shearim. It may be no coincidence that each of these achievements, so different from the other, reflects native familiarity with and love of environment — on the one hand, of the vines and the pomegranates of the Galilean landscapes, on the other, of the sea and its craft. It was at these moments that attachment to the country fused with its loving observation and religious faith produced creative experience.

PART TWO:
JEWISH ART FROM THE
MIDDLE AGES TO
THE EMANCIPATION

SYNAGOGUE ARCHITECTURE OF THE MEDIEVAL AND PRE-EMANCIPATION PERIODS

by AHARON KASHTAN

I. *The Jewish Diaspora's Singular Architectural Achievement*

The architectural history of any normal ethnic or cultural group is determined by its geographical position, its specific climate, and other local conditions. This, however, does not apply to the Jewish people, whose history extends over most continents and countries. A people's normal architectural creativeness embraces every phase of its existence — from dwellings to shrines — and fully expresses its character and way of life. The Jewish people, indeed, did live an organized communal life and frequently erected not only dwellings but also public buildings for their own use in their own quarters. On the other hand, their relatively small numbers and the existence of a rich building tradition among their neighbors precluded the development of a specific Jewish art of building. Only the synagogue, the exclusive architectural heritage of the Jewish people, assumed original significance.

There is a sharp divergency between the history of ancient Israel living its own life in its own environment and the history of the Jewish people in the Diaspora. This led to a lack of continuity in the conception of visual experience and form idiom. The encounter in Europe between the Jewish liturgical tradition and the medieval world of forms, more particularly the contact with Romanesque and Gothic art and techniques, may be said to have produced an architectural response in the basic meaning of the term, insofar as concepts of space were involved.

European art could furnish the instruments, but the needs to which they were put grew out of another soil and a different spiritual climate. We, therefore, find medieval Jewry almost without tradition, so far as language of form was concerned, and devoid of all sources of inspiration or study beyond the creative sphere of its neighbors. Throughout the Middle Ages, Jewry was searching for a means of giving architectural expression to its particular needs. It sifted and selected existing building types for a suitable concept of a synagogue — but it did not find satisfaction or discover an adequate instrument of expression. It was only in Poland of the 16th and 17th centuries, after a prolonged process of adaptation to the cultural environment, that the Jewish community succeeded in creating an independent architectural species. In Italy, too, in the same period, an interior space idiom developed, which constituted an original departure from any known sacral or ecclesiastical architectural idea.

This struggle to create a space principle for the synagogue — a struggle arising from the character and from the religious thinking of Judaism — and the consequence of contact with the flourishing architecture of Europe provide the principal theme for the story of European synagogue-building of medieval and post-medieval times. The theme gains an added interest from the fact that characteristic achievements were restricted to space, the most primary element of architecture.

II. *The evolution of a Program*

It is a basic fact in the history of medieval Jewry that the Jewish communities of the period were generally small. This at once determined the size of the synagogue building and the degree of its architectural importance in relation to its surroundings. The synagogues in small communities were sometimes nothing more than simple rooms set aside for public prayer. Ancient regulations made by Christian ecclesiastical authorities or by secular officials prohibited the building of new synagogues and sometimes even the enlargement of existing buildings. Furthermore, while Jewish law requires synagogues to be higher than the surrounding buildings, ecclesiastical edict prescribed that they should be lower than the local churches. Frequently, such laws were spitefully interpreted. The tradition of placing the level of the synagogue floor below that of the ground outside does not, as is generally held, stem from the first verse of Psalm 130 ("Out of the depths have I cried unto Thee, O Lord") but is also the result of a desire to increase the height of the interior without transgressing the law restricting the external height. Hence, until the 18th century, Jews endeavored to retain a degree of external unpretentiousness in their synagogue buildings, however splendid the interior. This phenomenon could be observed throughout the Jewish Diaspora; the few exceptions known are generally the product of temporary circumstances such as existed, for instance, in 13th century Germany, a period of relative security that was also one of extended building activities. At all events, the intimacy of the Jewish service, based as it is on the constant participation of the individual, invariably necessitated a prayer hall of no great size, the number of the congregation determining the scale of the building — i.e., a functional, not an emotional or architectural consideration.

In describing the architectural essence of the synagogue interior, it is necessary to examine, too, a liturgical development unique to Jewish worship resulting in a permanent architectural problem: the space relationship between the reading platform and the ark. The only legacy connected with form which medieval Jewry inherited from antiquity was the form of liturgy, which determined building design. In ancient times, synagogues already had a fixed "shrine" for the Scrolls of the Law, in the form of a small space or at

Plate 11 least a niche in the east wall. Although the *aron kodesh*, or Ark of the Law, acquires greater importance henceforth as a permanent place for the Scrolls of the Law, orientated to Jerusalem, it does not yet dominate the interior completely, as prayer is not yet the sole activity. The synagogue is still a house of assembly in the literal sense of the term, that is, a place of meeting of the congregation — a secular building. Had prayer been the synagogue's exclusive activity, requiring a pronounced direction, it would have been natural for the ark, being attached to the wall to which the congregation turned, to become the architectural focus, naturally imposing longitudinal axiality similar to that of Christian churches. However, reading of the Law was as important as prayers. Indeed,

the *bimah* — the reading platform — became the synagogue's center of gravity, dominating the entire space from its obvious position in the middle of the audience, thus imposing a pronounced centrality on the building. The rivalry between two focuses, the *aron* situated in the east wall and the *bimah* at the center, and the search for a balance between these two, perennially constituted a disturbing space problem. This pattern, and the reciprocal relationship to the interior space, is the basic idea of the synagogue interior. Only in Italy, as will be explained later, was a harmonious and balanced solution of the above problem found; this solution deviates from the accepted European space concepts based on absolute singularity and axiality. At a later period, the *aron* attained an importance expressed by its increasing size and by the highly artistic level of its execution. This was at a time when Europe was dominated by the late Renaissance and baroque. At this period the prototypes of the *aron,* which survived in European communities until recently, came into being. Many synagogues were now rebuilt and provided with arks in the new idiom. It is characteristic of European Jewry in the epoch concerned that they were conservative in matters of form and frequently subservient to earlier cultural conditions. Thus, at the height of the Renaissance, it preserves for its purposes building forms and space types characteristic of medieval architecture.

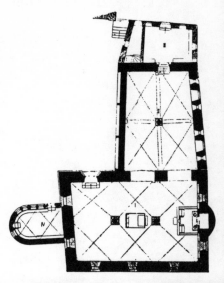

Synagogue at Worms, ground-plan. I. Men's synagogue; II. Women's synagogue; III. Vestibule; IV. Rashi Chapel.

The women's section is an attached but separate portion of the synagogue. The separation of the sexes during prayer, introduced in ancient times, continued in the synagogues of the Middle Ages. In the ancient synagogues a gallery sometimes served this function. It had to be screened off and yet enable the women attending services to hear (not necessarily to see) without being seen. These conditions determined the form of link between the main hall and the women's section. In many cases the place allotted to women was a separate hall on the same level as the main space, as, for example, in the synagogue at Worms. Sometimes the women's accommodation was below the level of the main synagogue or even actually underneath, as, for example, in the 17th century synagogue at Avignon and elsewhere in Provence. When the "El Transito" synagogue was built in Toledo in the 14th century, a gallery was constructed for this purpose above the level of the hall. It was not until the end of the 16th century, when the presence of the woman in the synagogue became an accepted fact, that the women's section acquired importance. In this period synagogues were designed with well-planned accommodation for women. The women's section in the form of a gallery or galleries pitched over a row of columns, a form usual at the end of the period, is a late development, perhaps inspired by the famous Portuguese synagogue in Amsterdam.

Fig. 83

III. *The Impact of Romanesque and Gothic Architecture*

In discussing the synagogues of the Romanesque and Gothic architectural period in Central Europe, we must distinguish two principal types: 1) the double-nave synagogue, and 2) the vaulted chamber, or single-nave, synagogue.

As already mentioned, the synagogue was not regarded by the Jews solely as a sacred building. Had this been so, they might well have chosen the space form current in contemporary churches, i.e., the vaulted medieval basilica. This generally had a nave and two aisles. The plan is pronouncedly longitudinal, with a central axis leading to the High Altar at the eastern end of the building. However, when Jewry was forced to borrow a type of building suitable to its needs, it borrowed not from this example but from the

existing secular types. The choice, therefore, naturally fell on a type of building which was, on the one hand, a reasonable accommodation for a centrally located *bimah* and which, on the other, was as little as possible reminiscent of liturgical arrangements in a church. Town halls and monastic refectories were the nearest models at hand. They were usually vaulted structures consisting either of one undivided chamber or, sometimes, of a double-naved space with a row of pillars or columns along the middle to carry the load of the vaults. The method of construction and structural forms were those prevalent within the geographical domain of the medieval arts: groined or ribbed cross vaults, circular and pointed, plain four- or five-ribbed, and many *lierne* shapes — all varying according to time and place.

IV. *The Medieval Double-Nave Synagogue*

Fig. 82a The oldest building in its early original form before it was destroyed by the Nazis in November, 1938, was the renowned Synagogue of Worms in the Rhineland. Its construction began in 1034, but the structure underwent a fundamental change at the end of the 12th century, a period which saw much building in the city and its surroundings, and marking the transition from early to late Romanesque. The famous Cathedral of Worms was under construction at the same time, and there is a marked affinity between the two buildings in architectural detail. Column capitals and characteristic Romanesque door and window arch carvings are almost identical. The interior space arrangement and structure, which is Romanesque proper, is the earliest known example of a species: the double-naved medieval synagogue of Central Europe. The building is erected on a simple, almost rectangular ground plan. A pair of Romanesque columns with decorated capitals supports along with the walls the six groined cross-vaulted bays. The columns and their capitals, and apparently also the doorway, which shared with the columns details of carving and decoration, were made by a Jewish artist, whose work was commemorated in a Hebrew inscription preserved for nearly 800 years on one of the columns. The resulting double-nave emphasizes the centrality of the *bimah* placed midway between the two columns. (It is on record that the original *bimah* and subsequent replacements were much larger than the one familiar to the last generation of Jews in

Fig. 83 Worms.) The adjacent women's hall attached to the north wall of the main building on the same level is of nearly equal size and was built in 1213, not long after the completion of the second construction phase. This chamber has four vaulting bays with one central column, and is altogether a unique arrangement.

The Worms Synagogue seems to have been the prototype of the double-nave Gothic synagogues all over Central Europe, erected even in places remote from the Rhineland. In Germany itself few traces of this type remain. The interior and structure of the synagogue

Fig. 85 and porch at Ratisbon (Regensburg), destroyed by order of the town council after the expulsion of 1519, are known from two engravings by the 16th century artist Albrecht Altdorfer. The main hall, a double-nave, built at the end of the 13th century in a transitional late Romanesque—early Gothic, had three pillars in a central range, so that the vaulting had four bays in each nave. The entrance porch, built in the 14th century, was Gothic. In its elongated form the Ratisbon Synagogue strongly resembled a monastic refectory. Having three pillars instead of two, the building deviates from the normal formula, since it lacks centrality in the sense of the *bimah* arrangements.

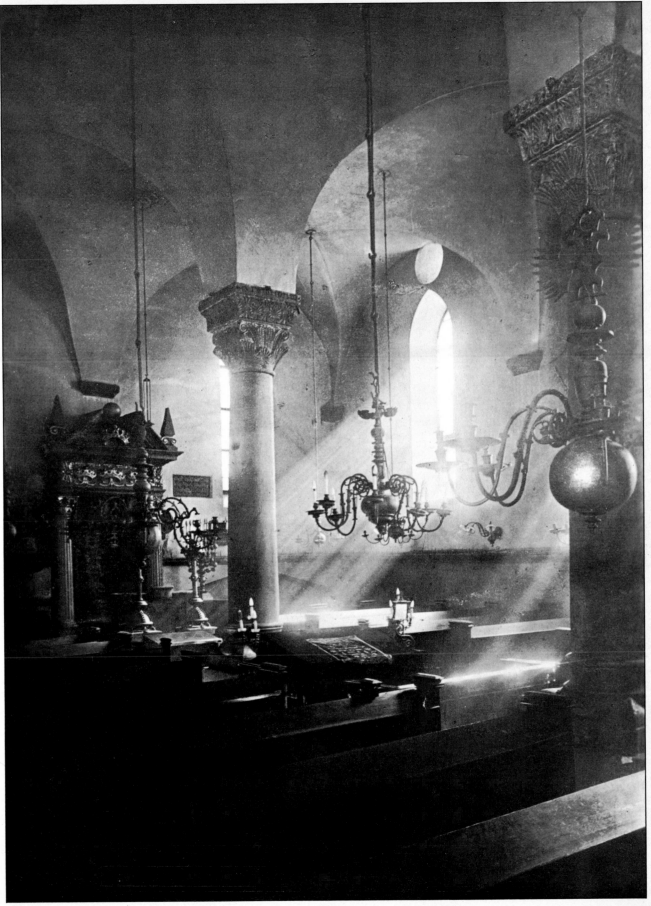

82a. Synagogue at Worms, interior, towards east, before the
Nazi destruction in 1938. Courtesy Kulturinstitut, Worms.

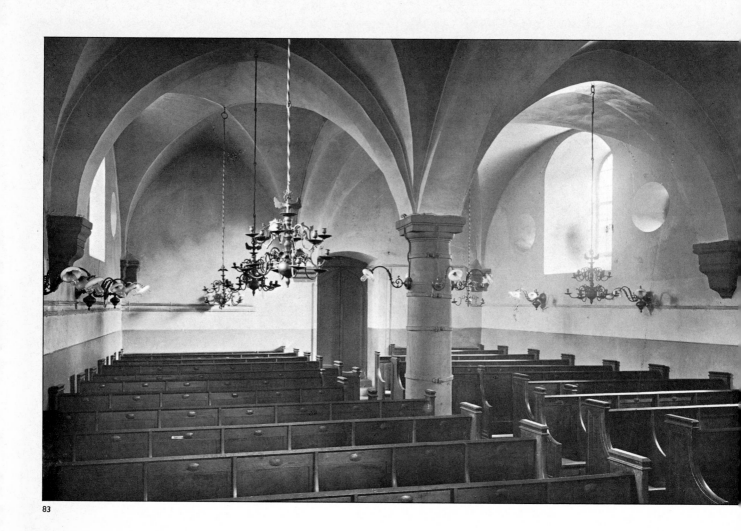

83

83. *Worms Synagogue. Women's section, towards north, after
its reconstruction in 1959. Courtesy Kulturinstitut, Worms.*

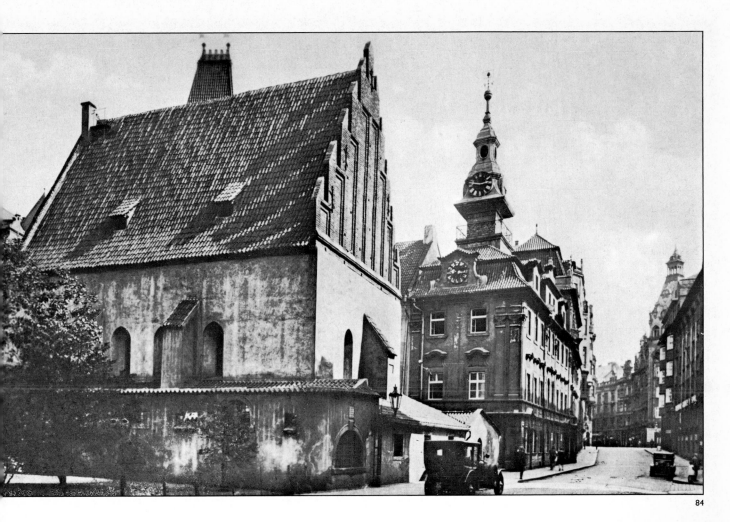

84

84. Altneuschul, Prague, exterior.

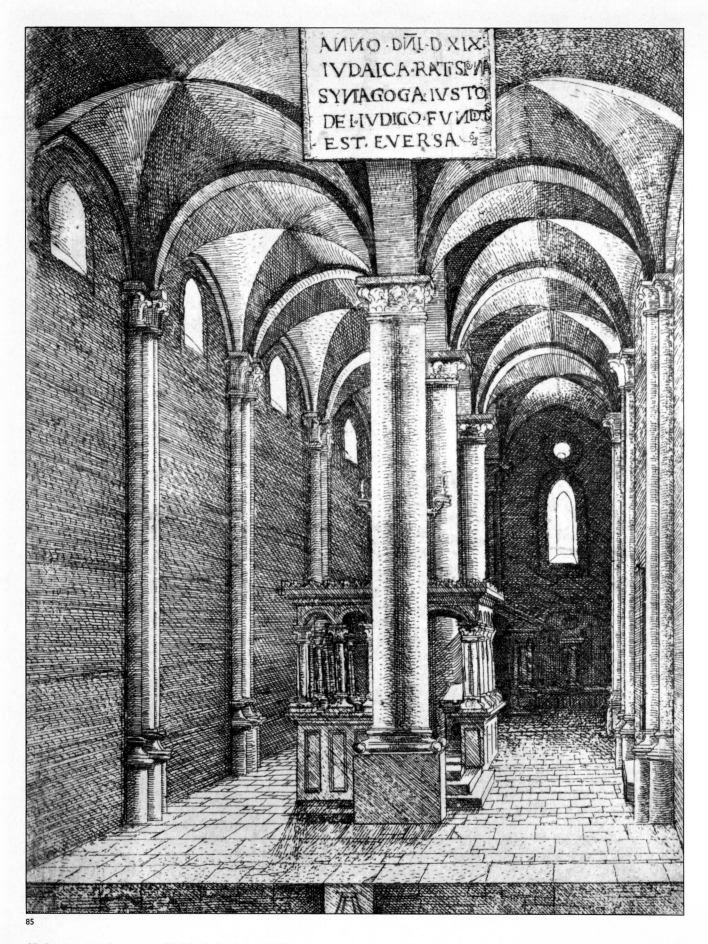

AN NO · DÑI · D · XIX·
IVDAICA · RATISPÑ
SYNAGOGA · IVSTO
DEI · IVDIGO · FVNDℹ
· EST · EVERSA · %

85

85. *Synagogue at Regensburg (Ratisbon), interior; an etching*
 by A. Altdorfer, 1519.

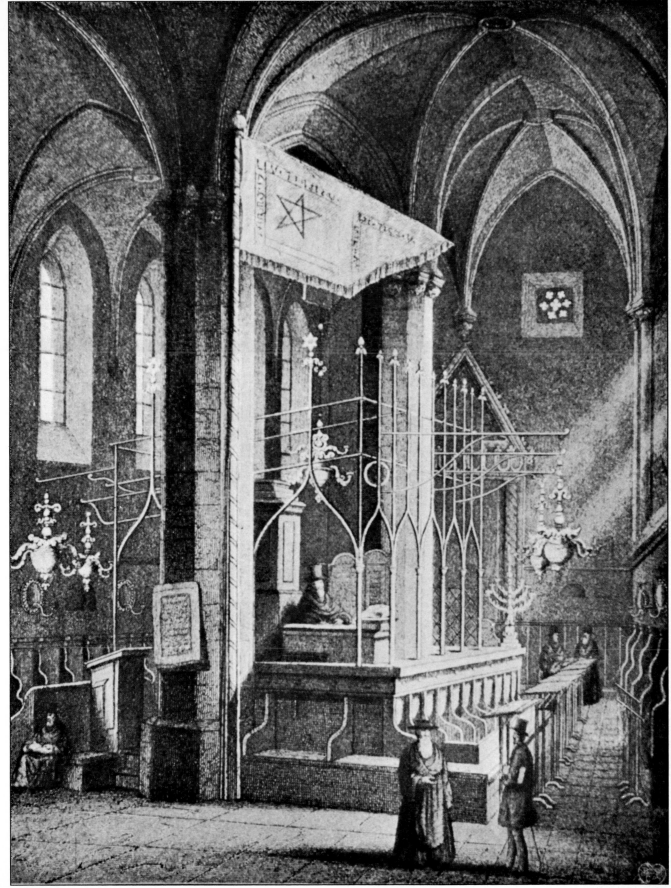

86. *Altneuschul, Prague, interior, east; from an early 19th century engraving.*

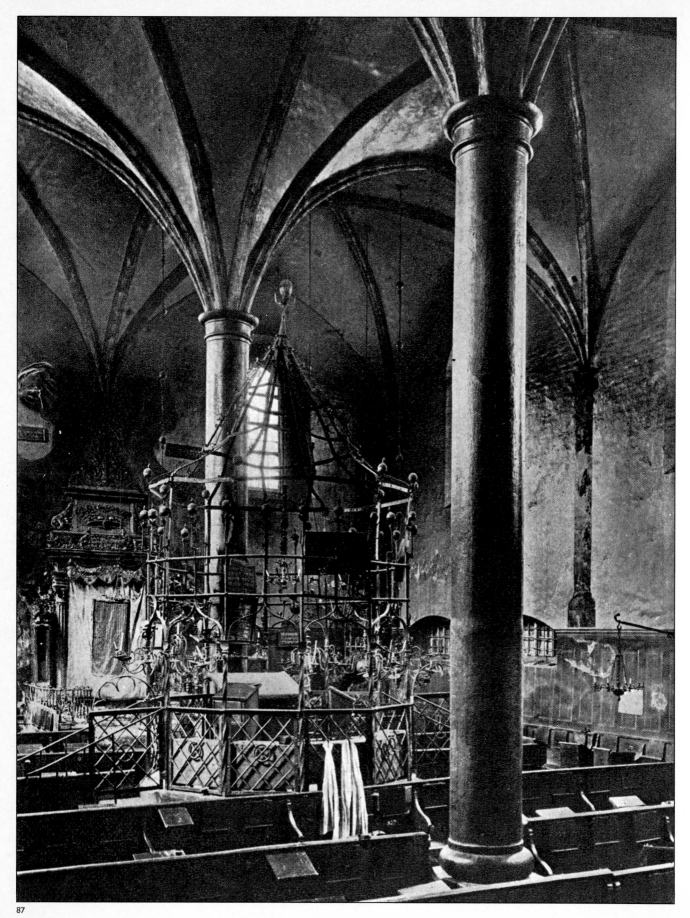

87

87. 'Old' synagogue in Jewish quarter of Kazimierz (Cracow),
 interior, Bimah and Ark. Courtesy Museum of Ethnography
 and Folklore, Tel-Aviv.

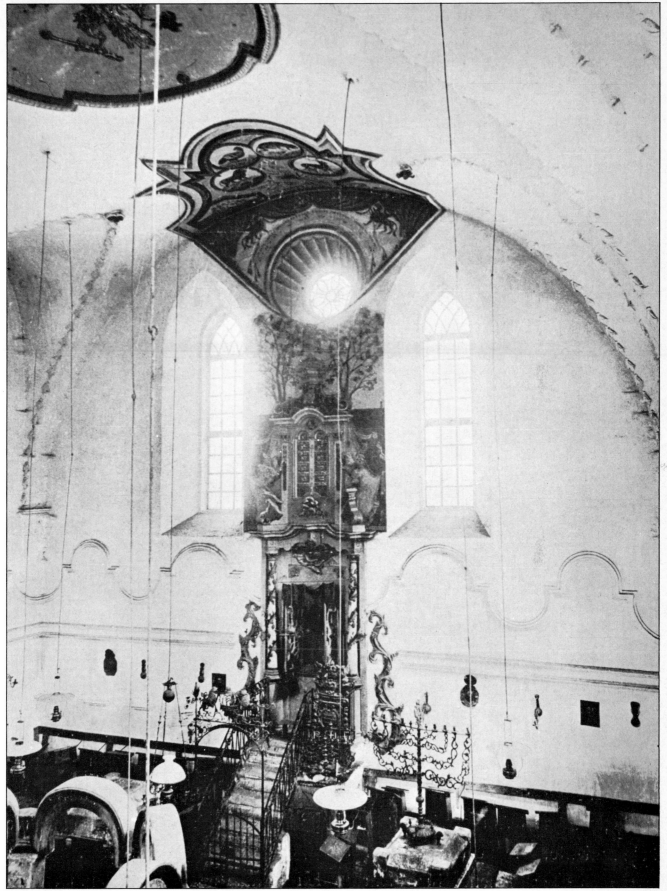

88. Synagogue at Husiatyn, interior, east-wall.

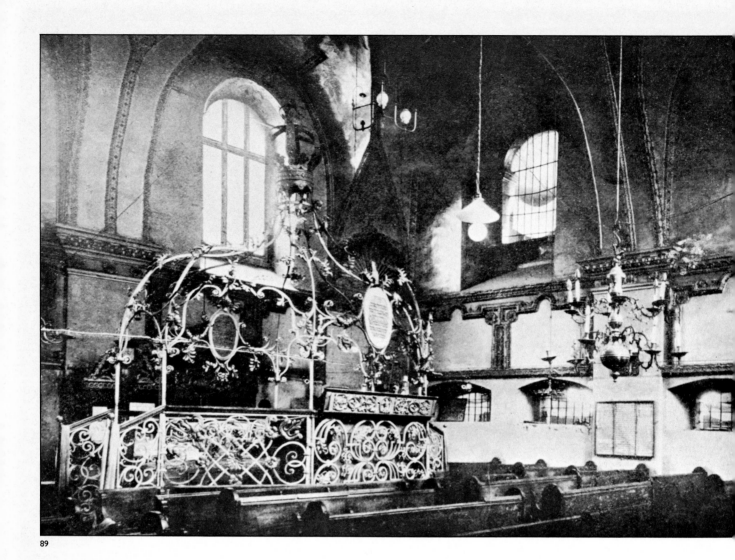

89

89. Synagogue at Zamosc, interior, Bimah

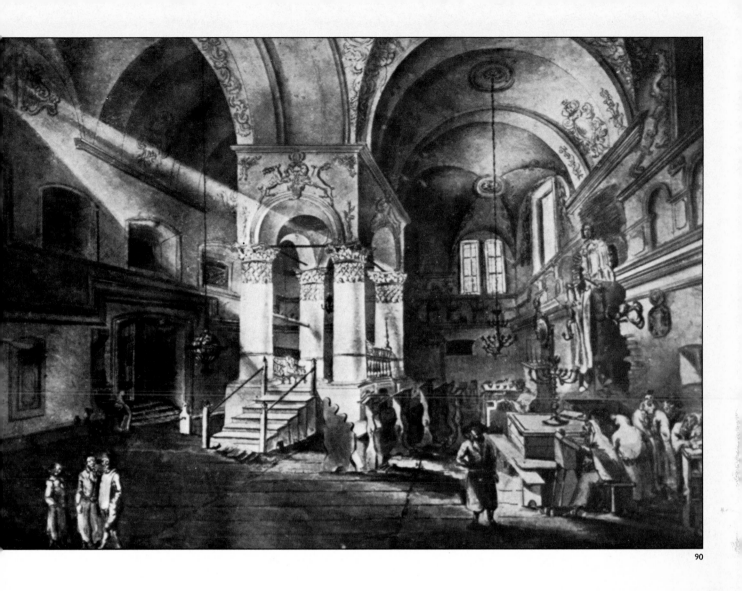

90. Synagogue at Lancut of 17—18th century, interior, central
pillars and Bimah. Water-color by Zygmunt Fogel (1764—
1826). Musée Berson, Warsaw. Courtesy Museum of
Ethnography and Folklore, Tel-Aviv.

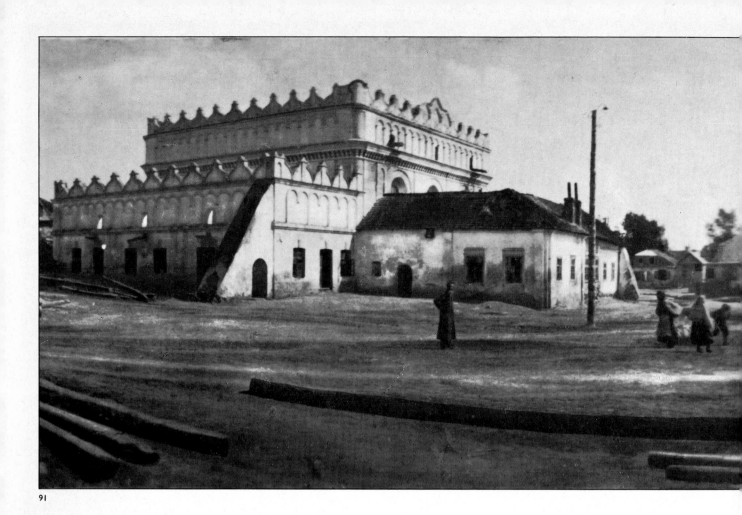

91

91. Synagogue at Luboml, exterior, (D. Davidowitz collection)
Courtesy of Museum of Ethnography and Folklore, Tel-Avi

92. Synagogue at Przemysl, central pillars and Bimah. Courtes
of the Association of Przemysl immigrants in Israel.

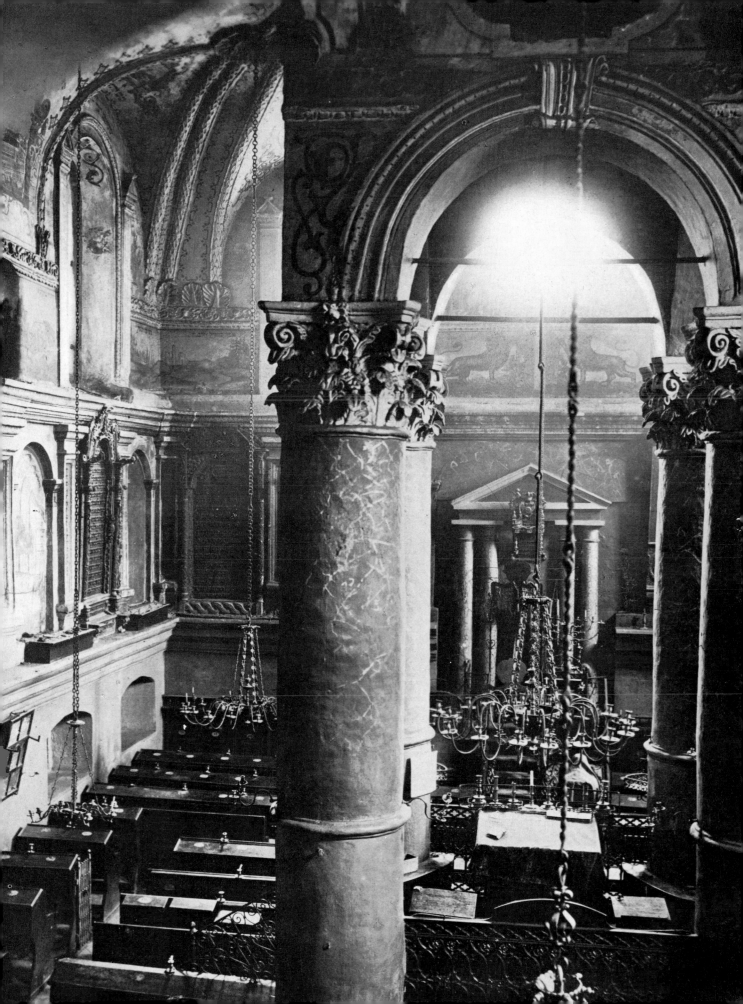

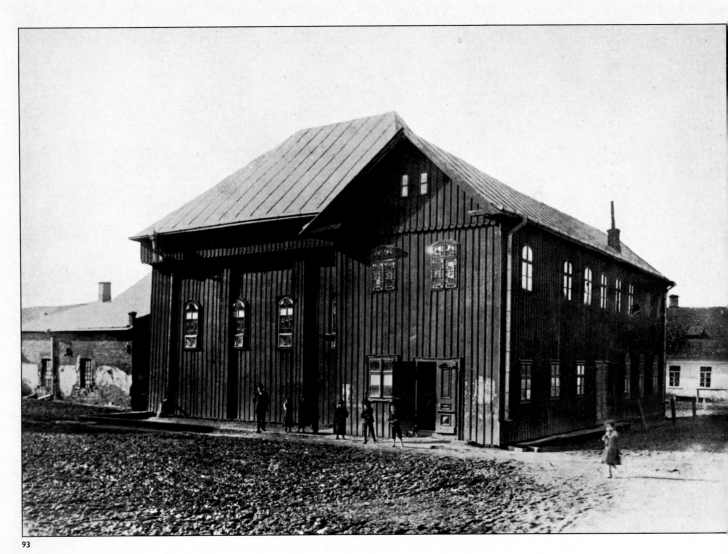

93

93. *Synagogue at Chodorów, exterior, from north-west.*
 Courtesy of the Tel-Aviv Museum.

The most famous of Central European synagogues is the old building in Prague known as the "Altneuschul" (literally: "the Old-New Synagogue"). The gloom that results from the narrow windows gives the interior an atmosphere congenial to the traditional folk stories woven about this building. Most of the "Altneuschul" was built at the end of the 14th century, and is unique in the Middle Ages for its impressive exterior—different from the usual pattern of the period. This can be explained by the fact that it was situated in the heart of a large Jewish quarter, where there was no fear of offending the feelings of a hostile environment. The architectural design is simple and clear: a rectangular double-nave and two-pillared plan of three bays in each nave, identical in principle with the Synagogue of Worms, except that here the building is pronouncedly Gothic in structure and feeling, though restrained in decorative details. The vaults are pointed with pointed-arch ribs, five to each vault. The fifth rib was intended, it would seem, to efface the cross formed by the four diagonal ribs of the usual Gothic vault. Six heavy external buttresses help the thick walls to transfer the lateral thrust where the main arches and ribs push outward. (See plan and section.) Access is through an arched doorway in the south wall in the southwestern bay. The relationship between main entrance and focal points in space is obviously of primary importance in all architectural design—and this seemingly unrelated arrangement demands consideration. Also in other Romanesque and Gothic synagogues the entrance is not in the west wall (opposite the *aron*) nor in the center of the north or south wall (opposite the *bimah*), but in the sector farthest from it (e.g., at Spires, Worms, Fuerth, and elsewhere). Not until the 16th century was a theoretical decision made on the question of the location of the entrance, following Rabbi Joseph Caro's *Shulhan Arukh* of 1567; although for many generations synagogues were still built with doorways not directly related to the interior shrines, a trend was henceforth perceptible to place the main entrance opposite the *aron*. The interior of these later synagogues acquired, accordingly, a longitudinal feeling, and the ark acquired greater architectural importance. The floor of the "Altneu" Synagogue is well below the surface of the street, this difference apparently increasing in the course of years, being probably at first purely symbolical. The building was initially a single, clear architectural mass, expressing its interior volume.

The women's accommodation was added some time afterwards as a low auxiliary structure.

Other extensions, including the porch, were also appended, surrounding the building and visually impairing its exterior. The carving details of the corbeled capitals over the pillars, the wall-corbels, and the keystones of the vaults are restrained, sober, and equal in standard to the best contemporary local work. The tympanum in the pediment over the *aron* is decorated with vine-foliage carvings; the details of the entrance were executed at a later period, evidently on the occasion of one of the reconstructions. The external measurements of the main building are 14x8 meters, somewhat smaller than those of Worms; on the other hand, this Gothic building is higher than its Romanesque predecessor.

The largest of the Romanesque or Gothic synagogues of Central Europe is the "Old" Synagogue built in the Jewish quarter of Kazimierz in Cracow at the end of the 14th century (according to local tradition, in 1364). This synagogue is the last of the series of buildings of the medieval double-nave variety with a pair of pillars. The plan is identical with that of the synagogues at Worms and Prague; the structure is Gothic with a normal

Fig. 84, 86

Altneuschul, Prague, ground-plan
(after Masak).

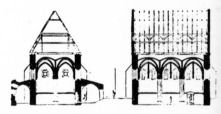

Altneuschul, Prague, cross-section
(after Krautheimer).

Fig. 87

four-ribbed vault to the bay. The reconstruction and external Renaissance alterations carried out in the 16th century have impaired the interior but little. There can be no doubt that the building was constructed under the direct inspiration of the "Altneu" Synagogue, though inferior to it architecturally. Notable is the beautiful *bimah*, of octagonal plan and enclosed by a 16th century wrought-iron cage, sometimes called *keter* (crown). This was a model and inspiration for many crown-shaped *bimot* made in other synagogues, but few attained the same slenderness of late Gothic motifs lightly expressed in metal.

V. *The Gothic Vaulted Single-Nave Synagogue*

The second type of synagogue building in Central Europe in the Middle Ages is the vaulted chamber, a single-cell structure consisting of one nave uninterrupted by supports. There were also, of course, unvaulted synagogues with timber roof-structures such as in Spires and Erfurt. The main construction problem of these stone buildings was always to devise a cover over a medium-sized square or rectangular chamber, mostly in the form of a vault of moderate span. A solution without intermediate supports, of course, assured freedom in respect of functional arrangements, such as the placing of the *bimah* and the *aron*. The single-nave synagogues were built simultaneously with the double-nave ones and present no original architectural contribution. Buildings of this type were built throughout the Jewish Diaspora of Central Europe, some of them well-known for elegant detail and Romanesque or Gothic structure. Among the few that still exist (or existed down to World War II) were those at Bamberg, Miltenberg, Leipnick, as well as the "Pinkas-Schul" built in Prague in the 13th century. Others are known from records and drawings.

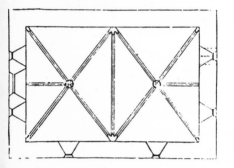

Synagogue at Miltenberg, vault-plan
(after Krautheimer).

The synagogue at Miltenberg-on-Main erected at the end of the 14th century is a relatively small Gothic hall with two bays of vaulting. As in "Altneu" Synagogue, there are five instead of the usual four ribs, the fifth being perpendicular to the gable wall; this stresses the centrality of the rectangular interior by giving equal emphasis to all four walls and by the concentration of the directions of the ribs towards the middle. The other buildings possess a rather longitudinal feeling dependent on the character of the vaulting with its successively repeating bays. An interior photograph of the former Bamberg Synagogue, built in the 13th century, clearly shows the structure of the Gothic ribbed vaulting and conveys a notion of the emphasis of the central longitudinal axis characteristic of structures of this class. The longitudinal axis was later strengthened by the addition of the women's accommodation along the northern or southern wall, the rhythm of whose small windows accompanied the entire length of the interior. Most of the vaulted single-nave synagogues were built at the end of the Middle Ages. The *aron*, at the end of the long interior axis, became visually more important, sometimes leading to the addition of an apse or niche to accommodate the Torah-shrine, thus stressing the longitudinal character. The *bimah* remained in its central position and continued to dominate the space.

VI. *The Renaissance and Baroque Chamber in Bohemia and Galicia*

Before dealing with the original contribution of Polish Jewry, which evolved at the close of the 16th century, a reference should be made to a number of buildings, some of which

are architectural gems even if they do not provide a specific synagogue concept. These were born of the European architecture of the period and thus belong to it in every way, exemplifying a general historical phenomenon. However, apart perhaps from the square-formed synagogues, which were built in Poland and later in Bohemia in the middle of the 18th century, it is difficult to claim that they constitute a specific uniform morphological group.

The Meysel Synagogue in Prague was built in 1592, by a special license granted by the Emperor Rudolph II to the philanthropist and Court Jew after whom the building was named. The building was burnt down completely in 1689 and rebuilt two years later. A wide central nave is flanked on each side by a double-storied aisle. It is covered by a barrel vault intersected by lunettes forming a clerestory. The plaster decorations are in the form of a reticulation of Gothic ribs. The building, in which characteristic early Renaissance elements struggle with the desire to maintain Gothic forms, is a decided deviation from the medieval synagogue type as we have known it till now. The "Klaus" Synagogue (also in Prague), which was built at the end of the 16th century and altered in the 17th, was barrel-vaulted and finished in stucco with plant-scroll and flower ornamentation in the local Renaissance fashion. The stylistic hesitancy of these two examples arises from the peculiar character of Prague, with its persistent Gothic tradition — subsequently shared by an equally strong baroque influence.

In Cracow, also a city of a magnificent medieval and Renaissance architectural tradition, vaulted halls were erected in the said fashion. The oldest of them was built in the suburb of Kazimierz in 1553 by Moses Isserles, while in 1640 the synagogue named after Isaac Jakobowicz was built. It is a prominent example of Renaissance idiom as it was used in small churches and chapels. The architect Francesco Olivieri, the designer of many buildings in the city, was a disciple of the famous Carlo Maderna (who also worked in Cracow in 1594–96). It has a western gallery used for the women's section. The structure is a barrel-vault with a lateral arcade and high lunettes on all sides. Notable is the elegant solution of the division between the women's gallery and the nave by an arcade supported on Tuscan columns. Under the gallery was the entrance lobby, vaulted by small cross vaults. The building is 15 m. high, apparently to make it taller than the adjacent buildings of the Jewish quarter.

The Isaac Nachmanowicz Synagogue at Lwów, built in 1582, is a Polish representative of the square vaulted-chamber type. It is covered by a so-called monastic vault. As with the cross vaulting, here, too, the vault is formed by the intersecting lines of two half-cylinders at right angles, but the enclosure is downward and shaped not unlike an inverted boat, resulting in a square dome. This is sometimes strengthened by arch-ribs which accompany the cylindrical section, so that a six- or eight-partite vaulting is formed — a primarily Gothic construction which was long popular with baroque architects. The chamber, which is almost square and specifically designed with an emphasis on centrality, is covered by a monastic vault of eight parts as described above. High lunettes pierce in pairs each side and lend to the interior of the vault the appearance of a normal cross vault. The *aron* and the remaining detail, the corbels of the vault, the windows, etc., are in Renaissance style. The idea of a square plan for an undivided inner space found its continuation in the Polish synagogues of Zamość, Husiatyn, and *Fig. 88, 89* Szczebrzeszyn.

In the neighboring Bohemia and Moravia direct use was sometimes made at this time of

high altars acquired from churches closed down by Emperor Joseph II. They were adapted to their new use with very slight changes. Here, too, the type of square synagogue with monastic vaulting now gained acceptance, later spreading to Germany. These buildings, more particularly in Bohemia, are built and decorated in the pronounced baroque taste of South Germany and the Austrian countries. In 1757, a fine synagogue of the above description was built in the town of Kuttenplan, situated in the heart of the Jewish "pale" of Western Bohemia. The floor here, too, is below the level of the street, as tradition dictates. A similar synagogue was erected in 1764 at Koenigswart and additional buildings of the same kind were built in many towns and hamlets of that region. The Bohemian towns referred to, lie at the junctions of the main roads leading to Bavaria; hence it is not surprising that similar synagogues were also built there.

VII. *The Four-Pillared Stone Synagogue*

Shortly thereafter, the West, Central, and Eastern Europe, and particularly Poland, experienced historical changes. The beginning of the 16th century sees the last traces of medieval civilization give way to new developments. The isolation of the Jews from their European environment is now more strongly felt. Jewry proceeds to create its own spiritual world in the midst of the Polish cultural *milieu*. Within this Jewish region an independent art emerges, first of a folk character, comprising various arts and crafts. In the course of time a highly indigenous level for expressing one's own world of thought and feeling is achieved.

There was a basic urge to fulfill the provision of a suitable cogent expression for the specific way of worship. It was the Jewish master-builder's dilemma. He faced an intellectual, abstract task — yet, it had to be executed and expressed in material, physical terms. The principal difficulty was the *bimah* and the desire to stress its central position and overriding importance. This problem found an unequivocal solution which rigidly determined the connection of the building's shell with this focal point. The four-pillared synagogue which resulted is an independent architectural invention and native Jewish achievement. It was, of course, possible to build without supports in the center and yet to emphasize the interior's focus by means of a conventional space-relationship, i.e., between a dome and a *bimah* beneath it, as in the case of some well-known later examples or the already mentioned square single-cell synagogue.

A much stronger spatial impact is possible, however, if the structure itself is called upon to take a material part in the sought for space-relationship. The very essence of the physical life of a medieval vaulted stone building is its structural system of carefully balanced forces and counterforces taking the shape of arches, pillars, buttresses, and other load- and thrust-bearing members. If the *bimah* could be visibly integrated as a center into this system, to become its emotional and physical climax, the desire for a truly specific expression would be fulfilled. Such an architectural invention was actually produced. It finally took the shape of a central vault-carrying pile of masonry, split into four pillars to include between them a square *bimah,* a defined space within space. Such was the final conclusion which produced the more extreme type, e.g., the buildings at Rzeszów, Maciejów, Pinsk, Wilno, Nowogródek, Luck, Lancut, and other places. Simultaneously, a less absolute type of building developed, in which the four supporting pillars define a central bay (containing the *bimah*) among nine equal bays, which together

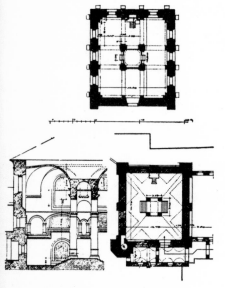

Synagogue at Rzeszów. Above—ground-plan of old synagogue; below—ground-plan and cross-section of new synagogue.

Fig. 90

constitute a square. The synagogues in the suburb of Lwów and at Zótkiew are most characteristic examples of this type of hall with nine equal bays.

Beyond doubt we are here confronted with a fascinating phenomenon in the history of architecture: a space invention following an emotional need. Had the historical conditions of Jewry been different, this type might have continued to exist and develop new forms following fresh methods of construction. There were also some timber synagogues with four pillars surrounding a *bimah* (cf. at Wolpa, or as far as in Rothenburg, Germany, where it was erected by an immigrant Jewish community around 1720) — apparently a superfluous support where timber construction was used, since the latter can bridge relatively large spans. These examples prove the importance of the four-pillared type and illustrate how deeply rooted it had already become in Jewish tradition as a specific expression of monumentality.

The exterior of these buildings possessed characteristics arising both from local conditions and from the influence of the architecture of the period. Many, especially those which stood outside the city walls, were built as fortresses, as clearly expressed in the façades, such as the one at Luboml. The roof was surrounded by a fortified arcaded attic parapet equipped with shooting loopholes and sometimes with crenellated cornices and small towers in the Polish Renaissance manner. These features were adopted, it would seem, by royal order for needs of defense against Cossack or Tartar attacks. In contrast to these were the unfortified synagogues of very simple appearance whose only outstanding characteristic was the roof — generally built in two tiers, one above the other. The structure of the synagogue in the suburb of Lwów is cross-vaulted in all the nine equal vaulting bays and interdivided by 12 arches, with 4 pillars in the corners of the center bay. The plan shows no external buttresses (opposite the arch-piers) as the accepted usage required. The synagogue built in 1632 and an almost identical building at Zótkiew built in 1690 are highly characteristic examples of this form of hall with nine equal bays and four pillars. The interiors of these synagogues usually included a blank decorative arcade (recalling the triforium of a Gothic church), apparently in order to fill in empty wall surface between the floor and the window, which, for reasons of security, began at a considerable height. The other previously described type with the four pillars grouped together appears, for instance, in the "New Synagogue" at Rzeszów (1705) with monastic vaulting. Generally, the vaults of such a synagogue rest on arches springing from the pillars to the walls, which are reinforced outside by buttresses. The four middle pillars join above the *bimah* to form a dome or vault. Beside the synagogues mentioned, many other examples are known to have existed at Lublin, Brody, Mikulow, Ostróg, Przemyśl, and elsewhere — showing that although the home-country of these buildings is Galicia, they spread throughout Poland and even reached eastward to Russia, southwest to Moravia and Slovakia, northward to Lithuania, and westward to Germany.

In Palestine, synagogues of the four-pillar hall type were introduced at an early stage, most of them by Ashkenazi settlers. This type was quickly accepted and was further passed on to other communities which modified it as they understood best, sometimes adding a dome over the central bay. The four-pillar synagogues in Palestine include the Ashkenazi synagogue of the "Ari" and the Sephardi synagogue of Isaac Aboab at Safad, the "Avraham Avinu" Synagogue at Hebron, and the Synagogue of Elijah and the Istanbul Synagogue in the old city of Jerusalem. In the town of Tomar, in Portugal, a medieval structure of the same type, apparently a former synagogue, still exists.

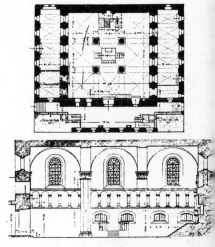

Fig. 91 Synagogue at suburb of Lwów, ground-plan and cross-section of north wall (after Grotte).

Fig. 92

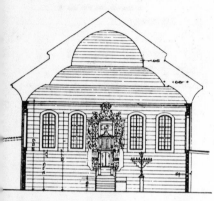

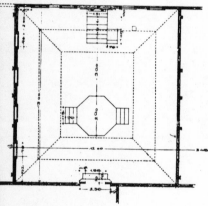

Synagogue at Chodorów, ground-plan
and cross-section (after Grotte).

VIII. The Architectural Vernacular: Timber Synagogues

The Polish timber synagogues are a unique architectural phenomenon. Even the timber churches of North Russia and Scandinavia cannot be regarded as parallels, although the structural influence of a common ancient Slavic pattern is plain. The timber synagogue is the best known expression of a Jewish folk art which developed from the mid-17th century under the influence of the Polish vernacular art and spread over the entire Jewish settlement area of Eastern Europe. Conjectures exist on the origin of timber synagogues, relating them to ancient Slavic temples (the memory and even some remains of which were preserved among the local population) or to the Khazar tradition inherited by Polish Jewry. The truth is that although there were structural links with the ancient Slavic prototype, this development resulted quite naturally through the local wood-working skill preserved among village craftsmen and artisans. Timber was widely used not only for cottages and inns, but also for village churches and even the manor houses of the landed gentry. In spite of these influences, the timber synagogues of Poland constitute a distinct, specific, and unmistakably separate group, associated with Jewish tradition only. It is on record that the timber buildings were designed and executed by Jewish craftsmen-artists.

In the 17th century half of European Jewry was concentrated in Poland; hence it is not surprising that the buildings were numerous*, though now, after the devastations of World War II, scarcely a single one remains. They were relatively high, some of them dominating the surrounding landscape. The characteristics of a distinct group may well have given rise to those particular lines which in some measure recall Far Eastern features. The Poles frequently used the steep double-eaved roof, but the Jewish builder, aware of his special theme, gave the eaves an upward twist and piled roof on roof in an obviously "festive" mood. In a later period the forms become quieter and more restrained, but in the 17th century, the synagogues are generally imaginative combinations, full of movement, and the vividness of their exterior owes much to these additive characteristics. Wall paintings, which also existed in the Polish stone synagogues, constitute a separate topic. In the timber synagogues, these form a characteristic and inseparable part of the interior design. In many cases rich wood carvings and painting integrate and alternate in bright colors. The plan was generally simple. Interior measurements were normally about 15 sq. m. or a little more. The women's section was sometimes an annex and sometimes built-in as an internal gallery. Unique and characteristic was the "winter room," provided as a shelter for very cold weather. It was generally plastered to facilitate heating.

Fig. 93, 94

The oldest known timber building was at Chodorów near Lwów, erected in 1651. While the exterior is quite modest, the interior is elaborate. The roof timbers are internally lined with planks in three molded tiers, the central one forming a barrel-vault. The paintings are the work of Israel ben Mordecai and Isaac ben Judah Leib. The same artists are credited

Fig. 95, 96

with the drawings in the Gwozdziec Synagogue, which carries an octagonal wooden dome over the square center. The transition from square to octagon is provided by triangular squinches at the four corners, but the shape of the rafters suggests the original intention to build a barrel-vault, like that at Chodorów. Most of the Polish wooden

* Some 1800 buildings are said to have been destroyed in East Poland and the Ukraine during the Cossack pogroms in the 17th century. About 100 buildings survived in Poland until 1939.

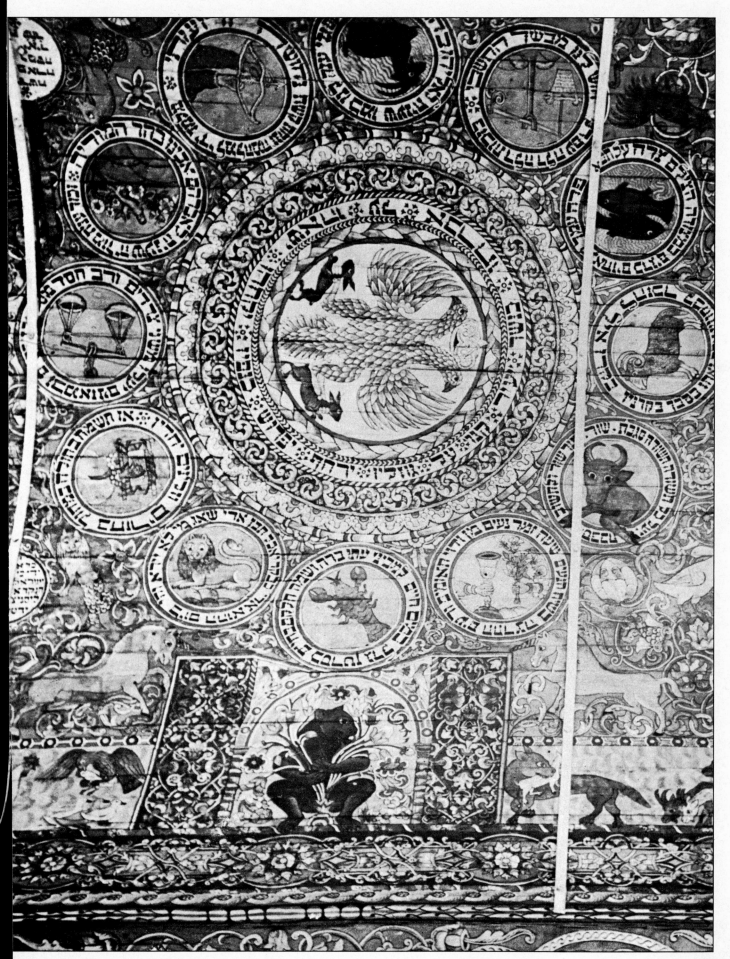

94. *Synagogue at Chodoró*w, *interior of dome. Courtesy of the Tel-Aviv Museum.*

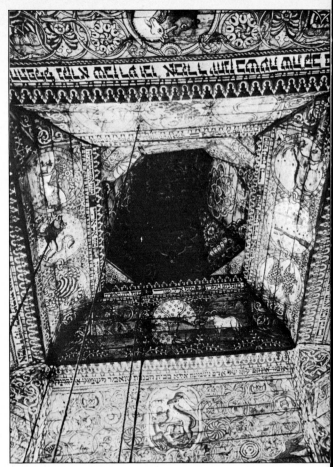

95

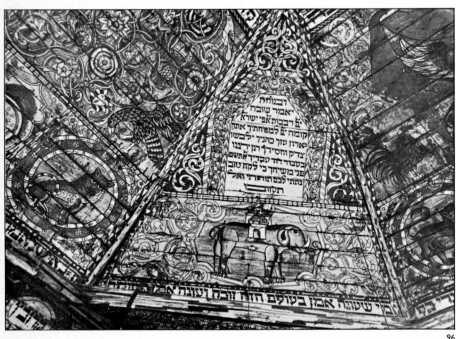

96

95. Synagogue at Gwozdziec, interior of wooden dome.
Courtesy of the Tel-Aviv Museum.

96. Synagogue at Gwozdziec, detail of dome. Courtesy of the
Tel-Aviv Museum.

97

98

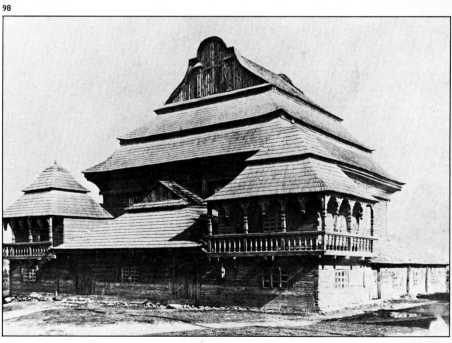

97. *Synagogue at Wolpa, interior of wooden dome. Courtesy of the Tel-Aviv Museum.*

98. *Synagogue at Wolpa, exterior, from south-west. Courtesy of the Tel-Aviv Museum.*

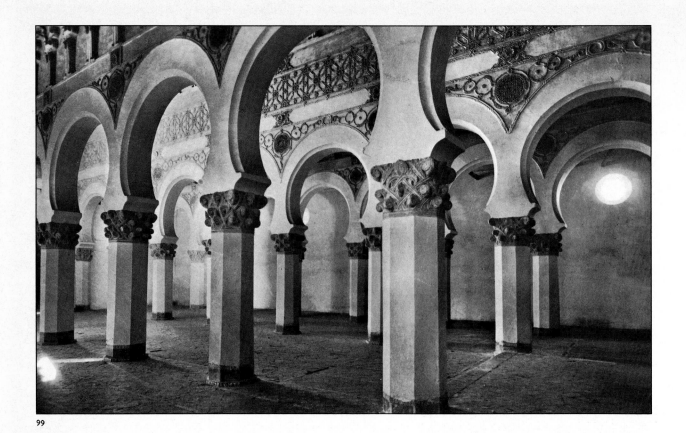

99

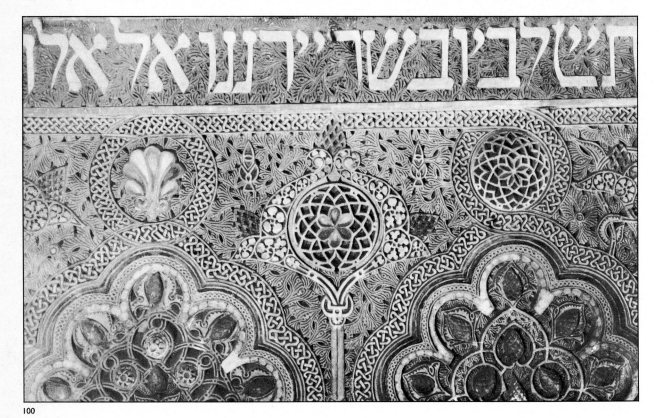

100

99. *Synagogue of Joseph ibn Shushan in Toledo (Santa Maria la Blanca), interior.*

100. *Synagogue of Don Samuel ha-Levi Abulafia in Toledo (El Transito), detail of decoration.*

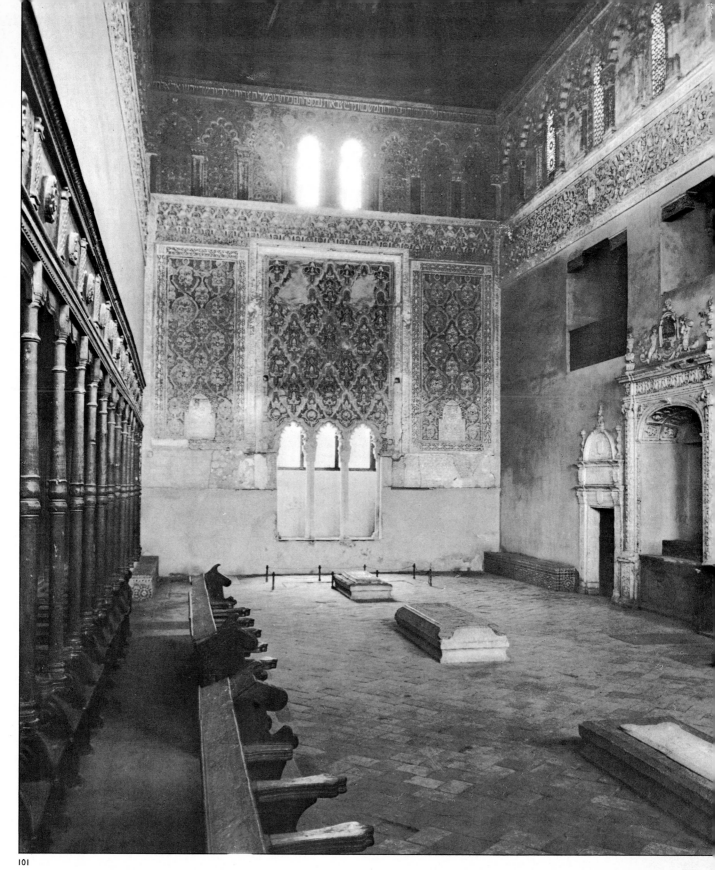

101

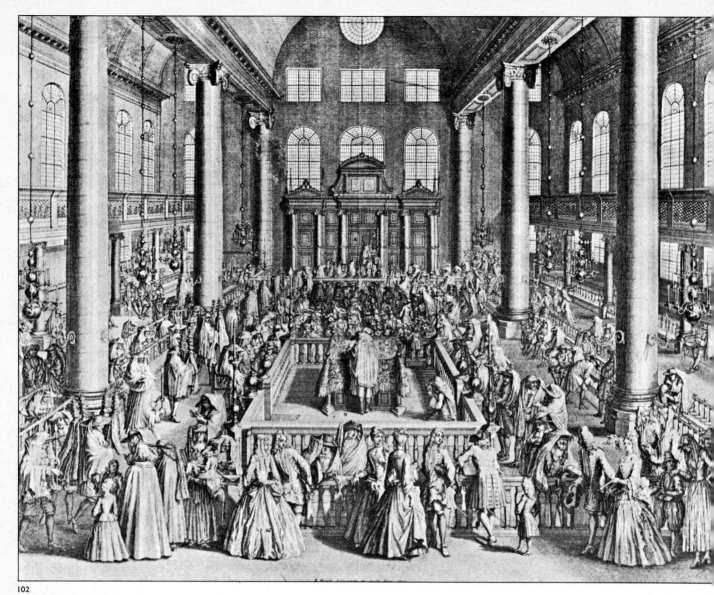

102

102. *The Great Synagogue of the Portuguese community in Amsterdam, 1671–1675, interior, (engraving by B. Picart, 1728).*

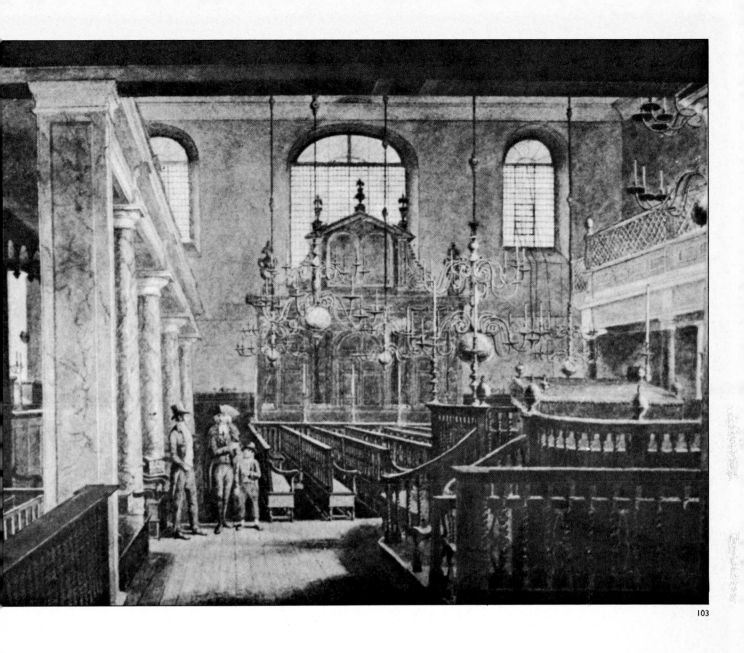

103

103. The Bevis Marks Synagogue, London, 1700—1, interior, east-wall; engraving after a painting by Isaac Mendes Belisario.

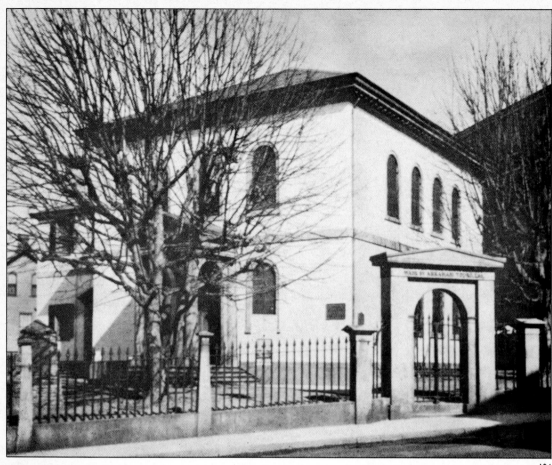

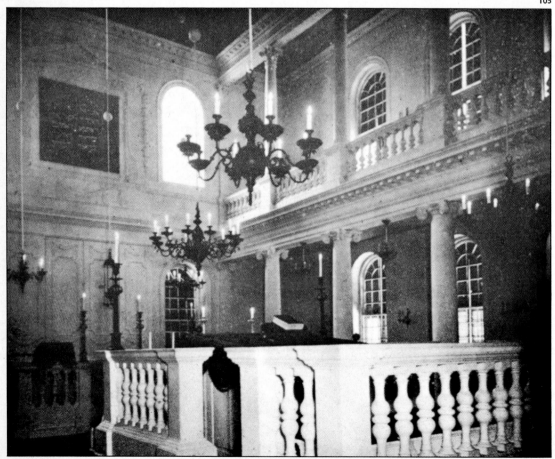

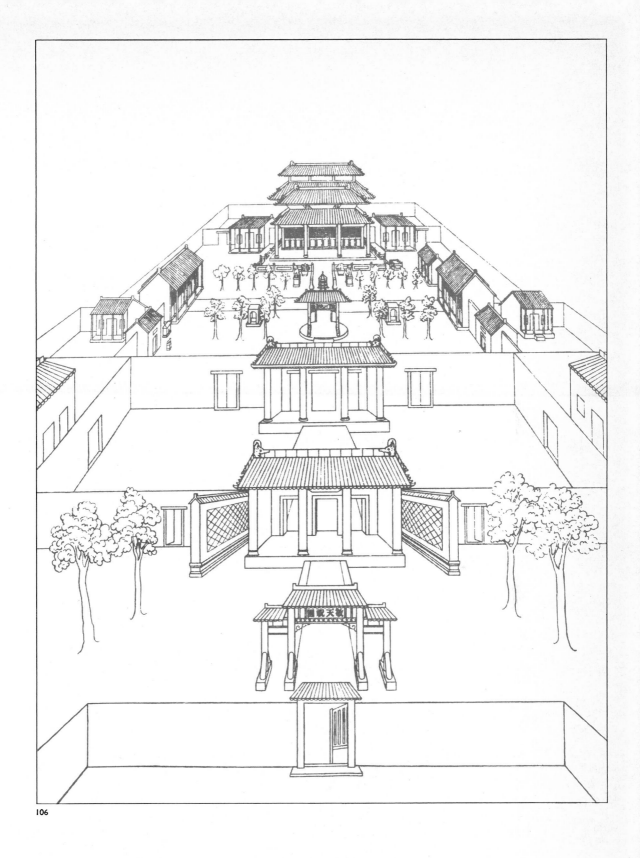

106

104. *Touro Synagogue at Newport, Rhode Island, U.S.A., exterior. Courtesy of Museum of Ethnography and Folklore, Tel-Aviv.*

105. *Touro Synagogue at Newport, Rhode Island, U.S.A., interior. Courtesy of Museum of Ethnography and Folklore, Tel-Aviv.*

106. *Synagogue at Kai-Feng-Fu, China; perspective view facing west (after P. Domenge).*

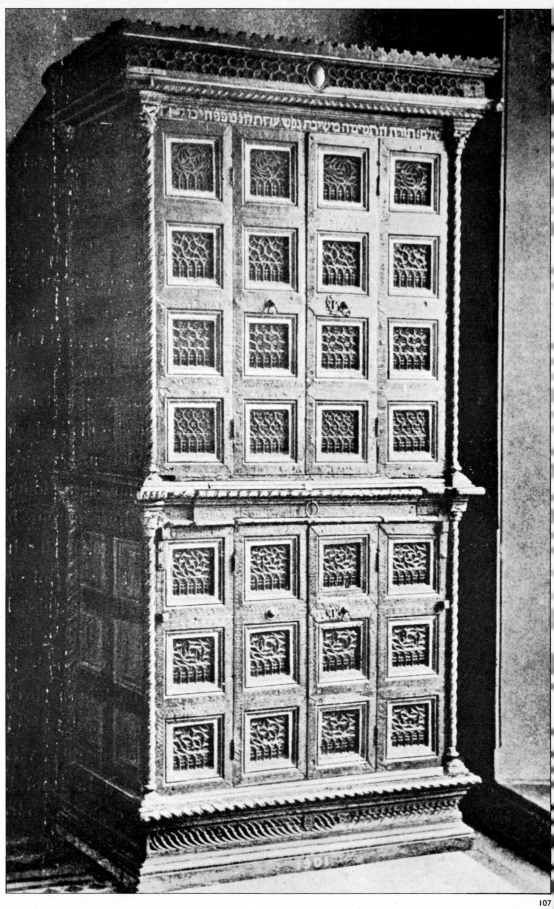

107. *Ark from the Synagogue at Modena of 1505.*
 Musée Cluny, Paris.

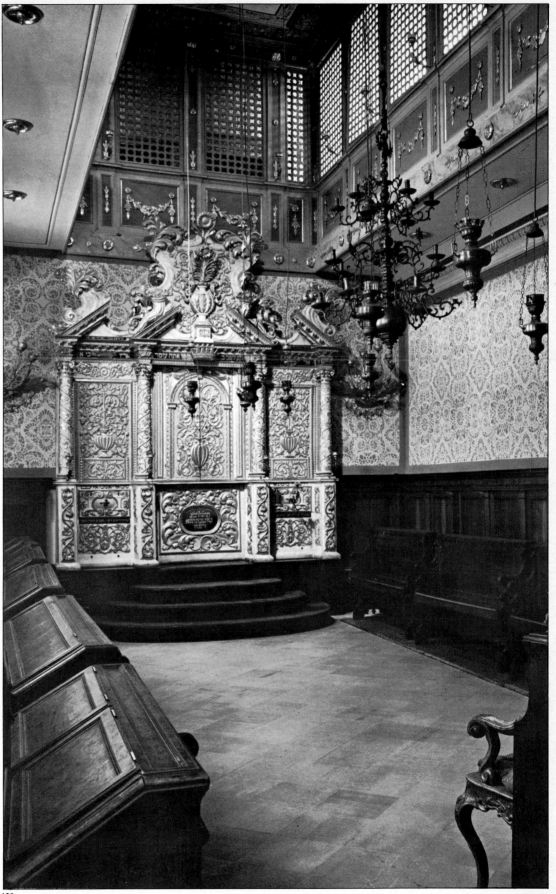

108. Vittorio Veneto Synagogue, main hall towards Ark, (1701),
showing the women's gallery in the second floor. Now in
the Israel Museum, Jerusalem.

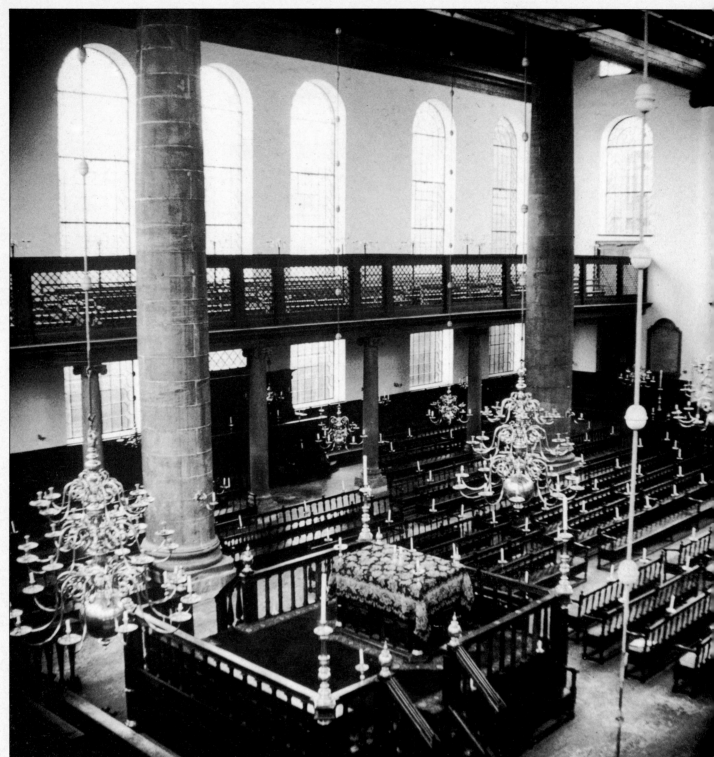

109

109. *Interior of the Great Spanish and Portuguese Synagogue*
 of 1675, Amsterdam.

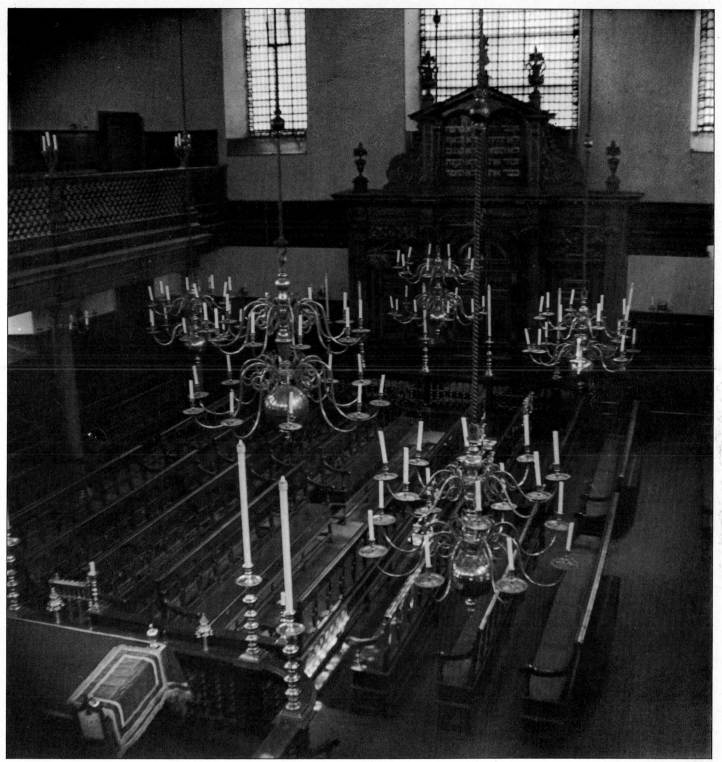

110

110. Interior of the Bevis Marks Synagogue — the great Sephardi
synagogue in London, completed in 1701.

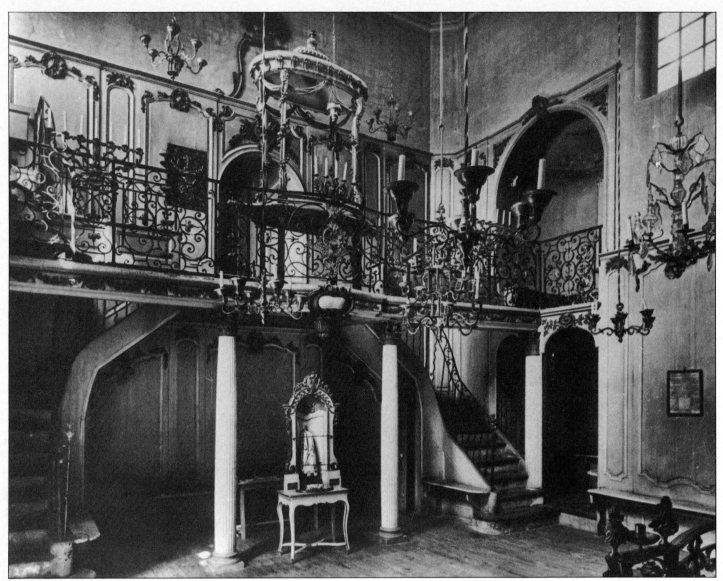

110 a

110a. *The Bimah in the Synagogue at Cavaillon, built by the masons Armelius in 1772–1774 on the site of a 15th century synagogue.*

synagogues were built at the end of the 17th or the beginning of the 18th century. Some of them developed a monumental exterior, like the one in Wolpa, with a modest, but expressive dome. The tradition swiftly spread westward, and in 1767 a timber synagogue was built at Kurnik near Poznań. This synagogue has a quiet and restrained exterior and boasts a pair of timber columns in the classical Tuscan order, such as were common in the neighboring manor houses. Inside was a very interesting dome, slightly reminiscent of stone-vaulting and adorned with paintings and wood carvings. The advent of timber synagogues to Germany has been referred to above, the best known among them being at Bechhofen, Horb, Kirchheim, and Rothenburg.

Fig. 97, 98

IX. The Synagogues of Spain

Jewish life in Eastern and Central Europe engendered specific conditions subsequently manifested in the art of building. The degree of originality of this art was directly contingent on these conditions and especially on the intellectual and religious background. In Southern Europe, independent manifestations of this type occurred among the Jewry of Spain, which had by then developed a tradition of its own.

As a result of local conditions and usages, a type of synagogue came into being among Spanish Jewry which made an ultimate contribution to the problem of balance between the two focal points of the synagogue interior, the *aron* and the *bimah,* or to give them their customary Spanish-Hebrew names—the *hekhal* and the *tevah.* This solution subsequently found its most extreme expression in Italy generations later.

As far as cultural patterns and visual language are concerned, the Jews here belong to the Arab world. The synagogue buildings prove this, for even those built in Christian Spain (the only ones that survived) are constructed in an Islamic or rather Moorish idiom and reveal traces of Western influence in a few details only, in the *mudejar* ornamental manner which combines Islamic with Gothic elements. Thus, for example, in order to adorn the walls of a synagogue, the Spanish Jews employed verses from the Bible written in elegant scribal lettering very much like their Moslem neighbors who embellished the walls of their mosques with verses from the Koran.

The two best known synagogue buildings in Spain are at Toledo. One built in the second half of the 12th century by Joseph Ibn Shushan was confiscated at the beginning of the 15th century and subsequently converted into the church of ''Santa Maria la-Blanca.'' Like most medieval synagogues, this building is modest and unostentatious outside, but splendid within. Its plan and structure are characteristically Moorish and indeed resemble the famous mosque of Cordova. Four long horseshoe arcades which carry a trabeated ceiling divide the interior into five aisles. The columns are octagonal and their capitals are richly carved. The column-bases in the two central colonnades are also adorned with *azulejos.** Small circular windows in the western wall apparently belonged to the women's section which no longer exists. Despite the building's relatively small size (22m. x 28m.), the interior seems spacious, thanks to the rhythm of the arches and columns. The second building in Toledo is the Synagogue of Don Samuel ha-Levi Abulafia, built about the year 1356, later renamed ''El Transito,'' and used as a church. The building was restored to the Jewish community of Madrid and re-inaugurated

Fig. 99

Fig. 100, 101

* Glazed porcelain tiles.

solemnly in the summer of 1966. The plan is that of a longish rectangular hall ($9\frac{1}{2}$m. x 23m.), covered by a flat timber ceiling with carvings. The walls are decorated with carved foliage in the *mudejar* idiom. Lines of verses from the Psalms alternating with decorative patterns adorn all the walls. The lettering belongs to the most beautiful Hebrew specimens.

The walls of the women's gallery, screened off by delicately carved perforated alabaster slabs, are also decorated with ornamental lettering (verses from the Song of Miriam). Most important aesthetically is the eastern wall. The niche was initially made for the Torah-scrolls, and inscriptions on each side of it record the erection of the building and the generosity of the donor. The windows of the hall, which form an upper clerestory, are screened with alabaster grilles admitting a diffused soft light. The synagogue at Cordova is also well-preserved. Several other medieval Spanish synagogues have been only partly preserved, including those at Seville, Segovia, and another one at Toledo, which resembled the one just described in its decorations, inscriptions, and other details.

This description of the synagogues at Toledo has not touched on functional needs. The dominating east wall and the proportions of the hall and the direction of the nave hint at a longitudinal trend. The form of the *tevah*, the Sephardi *bimah*, is known from 13th-century miniatures. At first, it seems to have possessed little importance. Ultimately, the *tevah* found its place near the western end of the hall opposite the *hekhal* (Sephardi term for *aron*). Thus a compromise was obtained between a longitudinal design and the two focuses of the synagogue placed opposite each other along the axis. The expulsion of 1492 put an end to any further evolution in Spain itself—but this concept of balance continued to exist in the Diaspora of the Sephardi exiles.

X. *The Synagogues in the Spanish Diaspora and Oriental Countries*

An account of the characteristic plan of the Italian synagogue, which undoubtedly constitutes a specific Jewish artistic achievement, concludes this survey of the synagogue architecture of the Middle Ages and the pre-emancipation period. But, for the sake of completeness, we must describe briefly the history of the synagogue in the rest of the European Diaspora, more particularly that of the post-expulsion Spanish Jewry in such countries as the south of France, Holland, and England. In those countries there was no evolution of the Spanish model described above.

Fig. 110a Two synagogues survive as monuments of the vanished Jewry of Provence—one at Carpentras, of medieval origin and rebuilt in the 18th century, the other at Cavaillon. In the latter town, a small synagogue erected over the gate of the "Carrière" (the local ghetto) was remodeled in the 18th century in rococo style. It was the Provençal practice to build two niches in the eastern wall on each side of the ark, one for the palm branch on the Feast of Tabernacles, and the other for the "chair of the Prophet Elijah."

Marrano refugees from Spain, founding new communities in Holland and England in the 17th century, introduced novel religious practices. Having severed their connection with their Spanish past, they had to reconstruct their community, and in their synagogue-building the influence of the new environment was strongly felt. The Great Synagogue of

Fig. 102, 109 the Portuguese community in Amsterdam, built in the years 1671–75, was influenced by the architecture of the Dutch churches, just as the famous Spanish and Portuguese

Bevis Marks Synagogue in London, built in 1700–01, resembles the English Protestant meetinghouses of the time. The pattern of a women's gallery set on columns on three sides of the aisle leaving clear only the east end with the ark, later came into general use. Many New World synagogues, e.g., that of the Sephardi community in Curaçao, West Indies, built in 1732, followed these models. On the other hand, the synagogue at Newport, Rhode Island, erected in 1763 after the design of Peter Harrison, owes little if anything to any prototype and is pronouncedly American colonial in style.

Fig. 103, 110

Fig. 104, 105

Synagogue architecture in the Orient and in Moslem countries was shaped by the need of conducting public worship in a traditional form, while adapting architectural solutions of alien origin. The Grand Synagogue of Baghdad is described by the traveler Benjamin of Tudela in the twelfth century as a building which apparently comprised a columned hall opening onto a courtyard not unlike that of a Moslem mosque and magnificently adorned with Hebrew texts like the Spanish synagogues. The famous synagogue at Fostat (Old Cairo) is a former Coptic basilica built in the 9th century. At Damascus there is a vaulted synagogue, the only one in the Orient with a nave and two aisles. Another model for synagogues in this part of the world was provided by the ancient mosques of Cairo, where the court is surrounded by a columned portico; on the side of the *mihrab,* the roofed portion is wider, thus forming a shaded open hall; and a fountain marks the middle of the courtyard. In the conditions of a hot climate, such an arrangement meets all the functional requirements of a synagogue, and at least one was erected in this form — at Aleppo — where the reading-platform occupies the place of the fountain in the center of the courtyard, and the ark supplants the *mihrab,* while shade is provided for the worshipers by the surrounding portico. Farther east, mention may be made of the "White Jews" Synagogue at Cochin, in South India, built in 1564 and extended in 1664, which impressed a visitor shortly after the latter date as being very similar to European syna- gogues. On the other hand, the synagogue at Kai Feng Fu, in China, built by a Jewish mandarin in 1652, and known to us only from the drawing of a Jesuit missionary who visited it a hundred years later, was a characteristic pagoda structure, with a succession of courtyards surrounded by communal offices, with the synagogue proper at the end of the axial line.

Fig. 106

XI. The Synagogues of Italy

In the account of the Spanish synagogues a new arrangement was mentioned, based on a careful balance between the reading-platform and the ark, which developed early in Italy. In Italy this development continued. Jews had lived in Italy from the beginning of the Common Era and had preserved an ancient local tradition. Italy had also absorbed Ashkenazi Jews, and after the expulsion of 1492, a number of refugees from Spain bring- ing their own traditions arrived. It was, therefore, clear that the evolution of synagogue architecture in Italy depended on a variety of factors. The "bipolar" interior plan devised here, whereby the ark and the platform were placed opposite one another in a position of harmonious reciprocity, was an important achievement in the development of synagogue interiors, but it must be emphasized that it was in large measure a concept of interior space rather than of building and structure. In Italy, as in the other medieval Diaspora centers, the synagogues generally lack external distinction, nor was anything novel introduced in the way of structure. The popular methods of construction and covering

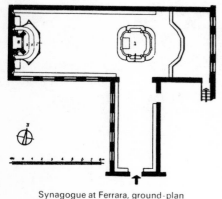

Synagogue at Ferrara, ground-plan
(after Pinkerfeld).

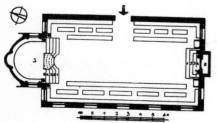

Canton family synagogue at Venice,
ground-plan (after Pinkerfeld).

were the monastic vaults as in the "Scuola Tedesca" (Ashkenazi Synagogue) at Padua, resembling those later used in the Bohemian square-hall synagogues of the 18th century; barrel-vaulting of various types with or without lunettes; coffer ceilings and other forms of construction currently employed in the architecture of the Renaissance and later of the Italian baroque. Decorative treatment drew on forms adopted from the Renaissance, baroque, and rococo building periods, the function of the ornamentation being to cover and to fill wall and ceiling surfaces (without figural representation).

The "bipolar" hall of the Italian synagogues did not take final shape until the 16th and 17th centuries; established types seem to have existed previously, but we know little about them. It was the uniqe contribution of Italian Jewry to synagogue design. There are slight variations in the space arrangements and relationship between *aron* and *bimah*, stemming from regional custom and local building practice. In places such as Pesaro and Ancona, the *bimah* (which is against the western wall) is built on columns almost one story above floor level (in this resembling many local church altars, which are built over a crypt). The "bipolar" arrangement gave full satisfaction and was accepted all over Italy. One of the most beautiful examples of the Italian solution is the Levantine (or Sephardi) synagogue at Ferrara, built in the middle of the 17th century; here the platform is placed in the intersection of the main axis (opposite the ark), with the axis of entrance leading from the vestibule. The reciprocal spatial relations are admirably coordinated and disciplined. But in most of the Italian cities, chiefly in the north, a solution evolved which placed the platform against the western wall and elevated it, though not generally as drastically as in the Pesaro interior, referred to above. Frequently, the placing of the platform against the wall was not satisfactory, and it was introduced into a niche like the ark, e.g., in the "Canton" Synagogue at Venice. The need of stairs which generally ascended in two arms to the lofty reading-platform provided an opportunity for a variety of designs in baroque idiom.

In the "Italian" Synagogue at Padua, for instance, a barrel-vault ceiling connects the reading-platform and the ark. This building belongs to a special type in which the east and west walls are the long ones; in other words, the interior is designed on a lateral axis.

The most important of the North Italian houses of worship is the Sephardi synagogue at Venice. Its erection began in the early years of the 16th century, but it was redesigned and rebuilt not long afterwards by the famous Baldassare Longhena. The building, designed in the typical fashion of the period, has a modest exterior and a splendid interior. Within the rectangular interior the women's section is built as an elliptical gallery surrounding the hall. This brilliant work of Venetian baroque outshines all the other synagogues of the Venetian ghetto: the "Levantine" Synagogue, the "Italian" Synagogue, the "Great Ashkenazi" Synagogue, the "Canton" Synagogue, and the rest. Most of these synagogues were built in the first half of the 17th century, though the last mentioned dates back a hundred years earlier, to the period of the establishment of the Venetian ghetto.

Fig. 107

Apart from the bipolar space concept, the Italian synagogues bequeathed to Jewish art a fine tradition of skilled craftsmanship and furnishing. The adornments and decorations in the baroque manner were of a standard equaling the finest contemporary Italian work. Arks from Italy now grace various museums, while some Italian communities on the verge of dissolution have transferred synagogue furnishings to Israel. Two of the synagogues which were brought to Israel from the Venetian area, both from about 1700,

are now in Jerusalem. The one from Conegliano Veneto is in use as the Synagogue of Roman Rite, and the other, from Vittorio Veneto, was reconstructed in the Israel Museum. They both have magnificent baroque arks and simple *bimot*. The one in the Israel Museum was reconstructed to its original form, with a women's gallery in the second floor, sectioned off by wooden decorated partitions.

Plates 12, 13

Fig. 108

The singular tradition of Italian synagogue interiors persisted even after the advent of the external concomitants of Emancipation had produced a wave of imitations of churches and mosques. This, however, marks the end of a chapter in Jewish architectural history extending over many countries and continents. The special interest of the period described is concerned with the experiments in original architectural expression crowned by the genesis of independent and original architectural inventions. These achievements have retained their sweeping validity down to this day. They were unparalleled in the Emancipation period, with its eclectic buildings, and remain so in the architecture of our own day, both in Israel and the Diaspora, which has not yet found the way to give specific expression to the synagogue and its values.

RITUAL ART

by CECIL ROTH

A characteristic recommendation of the Talmud justifies and proves the antiquity of the ritual art of the Jewish synagogue and home. Rabbis make this comment about the Biblical verse "This is my God, and I will glorify [lit. 'adorn'] him" (Exodus, XV, 2): "Adorn thyself before Him in the performance of the commandments. Make before Him a goodly *succah*, and goodly *lulab*, and a goodly *shofar*, and goodly fringes for your garments, and a goodly *Sepher Torah*... and bind it up with goodly wrappings." Elsewhere, we learn of the adornments hung in the *succah,* and of the gold fillets used to bind up the *lulab,* and more than once of the wrappings for the sacred books. But there is no evidence that at this time any of these appurtenances had any uniformity or were expressly made for a specific purpose. With the exception of a few eight-burner clay lamps presumably intended for use on the feast of Hanukkah, there is barely any evidence of specifically made Jewish ritual adornments, other than those of the Temple, until the close of the first millennium.

It must have been about this period that their manufacture began, for not long after we read of such objects as commonplace. Thus in an inventory of the property of the Palestinian Synagogue in Fostat (Cairo), drawn up in 1186–87, we find scheduled "Two Torah-crowns made out of silver, and three pairs of finials (*rimmonim*) made of silver, and twenty-two Torah-covers made of silk, some of them brocaded with gold," and so on. Presumably, domestic ritual objects began to be made at much the same time. The name of Rabbi Meir of Rothenburg, the great German scholar of the 13th century, figures frequently in connection with our literary evidences, and it may be assumed that by his day Jewish ritual art as we know it now had begun to assume its form.

Little or nothing of this date, however, has been preserved to the present time, our evidence being indirect. The primary reason for this was presumably the vicissitudes of Jewish life. Synagogues everywhere were sacked, burned, and pillaged; communities were driven into exile, expressly forbidden to take with them anything made of precious material: synagogues could sell their sacred treasures in order to ransom prisoners or succor refugees. As a result of all these and similar recurrent crises, as well as normal wear, and the natural tendency (from the antiquary's point of view disastrous) to replace the old by the new, Jewish ritual art of the medieval period has disappeared almost entirely. Hardly more than a hundful of specimens anterior to the sixteenth century are

now traceable. This generalization, to be sure, may perhaps need qualification in due course. If careful and expert inspection could be made of the property of ancient and even modern synagogues, especially in the East, with the same care as has been devoted to the study of ancient manuscripts, it is not improbable that some memorable ritual objects of great antiquity might even now be discovered.

However that may be, the fact remains that the objects of Jewish ritual art which are now extant are virtually all of the post-medieval period. After a trickle of the sixteenth century, there is a great mass of material of the seventeenth and eighteenth, some of it very fine. Perhaps an unduly large proportion is German in origin, reflecting the religious enthusiasm, economic well-being, and good taste of the new groupings in those countries, especially the newly arisen class of Court Jews. It may be remarked that here domestic religious adornments figure in great abundance side by side with those intended for the synagogue. The taste and charm of some of the objects then manufactured in Poland and Eastern Europe belie the general impression of the economic misery and unaesthetic outlook of the Jewish communities in this area.

On the whole, these objects reflect the tastes and fashions of the countries and periods in which they were manufactured. To be sure, in some cases the craftsmen were Jews. Gold and silver smithery was one of the characteristic Jewish occupations in most countries. It is believed that from early times until the modern era, Jews in the Eastern countries were responsible for the manufacture of most of these objects. But in Western Europe, with the growing tendency to exclude the Jews from handicrafts after the period of the Crusades, this was different. Moreover, in remote communities where a Jewish craftsman might not be available, it was necessary to have recourse to the local silversmiths. However that may be, it is certain that much Jewish ritual metalwork is of non-Jewish manufacture; in England, Germany, and Holland it often bears the mark of the gentile manufacturers, sometimes well-known masters of their craft—e.g., the prolific Matthews Wolff (Augsburg, c. 1700), Jeremiah Zobel (Frankfurt am Main, c. 1700), and John Ruslen, Frederick Kandler, Hester Bateman, and William Grundy (London, 18th century). We know of at least two medieval contracts for the manufacture of silver ornaments for the Torah, made between gentile craftsmen and the leaders of the local Jewish communities—one from Arles (1439), the other from Avignon (1477). In the former instance, silversmith Robin Tissard undertook that the commission was to be executed in a room placed at his disposal in the house of one of the local Jews, and that no work should be done on Sabbaths or Jewish holy days.

On the other hand, besides the vast amount of anonymous work of this type which falls into this category, a good deal was carried out by ascertainable Jewish craftsmen of some reputation. We know, for example, of the London silversmith Abraham d'Oliveira (d. 1750), who has been mentioned elsewhere in this work in connection with his work as an artist-engraver, who designed and executed a good deal of ritual silver in London in the first half of the eighteenth century; and of his younger contemporary Myer Myers (1723–94), first President of the Silversmith's Guild of New York, who carried out some distinguished work for synagogues (as well as churches) in America.

Certain decorative features became very common in, and almost characteristic of, the Jewish ritual art of the post-medieval period. In St. Peter's in Rome there is a spirally fluted bronze column, the *colonna santa*, late Classical in origin; it is legendary, said to have been brought from the Temple in Jerusalem, where Jesus leaned against it while

disputing with the rabbis. From the Renaissance period, two twisted columns, apparently copied from the *colonna santa,* and inevitably identified with Yakhin and Boaz of Kings VII, 21, began to figure as a typical feature on the engraved title pages of Hebrew books. It was from there that this feature was copied on various objects of European Jewish ritual art until the end of the eighteenth century.

Plates 23, 25 Other symbols which are commonly found include the lion, representing the Lion of the Tribe of Judah (Genesis XLIX, 9), which as we have seen, was one of the most common *Fig. 77* symbols found in Jewish art from classical antiquity. This illustrated also the Rabbinic *Plate 11* dictum (Ethics of the Fathers, V, 23) that a man should be bold as a lion, light as an eagle, and fleet as a deer to fulfill the will of his Father in Heaven. The eagle and deer also *Fig. 111* figure, though less commonly. The two Tablets of Stone bearing the Ten Commandments, *Plate 13* in the shape which had become conventional in the Middle Ages (among the Christians perhaps earlier than among the Jews), is found very frequently. Sometimes, too, we see other ancient Temple furniture, such as the altar and table of shewbread, perpetuating the tradition already found in medieval manuscripts.

A gift presented by a *Cohen* would often bear a representation of the hands joined in the priestly benediction, of a *Levite* that of the ewer and basin used by members of that tribe in laving the priest's hands. In Italy (and later in the ex-Marrano communities) other family badges and armorial bearings were not unusual. The whole would be commonly surmounted by a crown, symbolizing the traditional Crown of the Law: sometimes by a triple crown, in reference to the Rabbinic dictum (Ethics of the Fathers, IV, 17) that there are three crowns — that of the Torah, of Monarchy, and of Priesthood, "and that of a Good Name surpasses them all."

II

The ritual art of the synagogue naturally centered on the Scroll of the Pentateuch, or *Sepher Torah,* used in the Biblical readings, and wound upon two staves. It is impossible to determine when the practice arose of covering this by an ornament of precious metal. Probably, however, it was relatively late. The Talmud (Baba Bathra 14a) speaks of the Pentateuch deposited by Moses in the Tabernacle as being on silver rollers, but this legendary model does not seem to have been imitated, and in representations in synagogue interiors and on Holy Scrolls in various mediums (gold glasses, etc.) in the classical period there is no trace of anything in the way of ornament. The account of the sack of the Synagogue of Minorca in 438 speaks of the synagogal ornaments and silver, without giving any further details. The same is true of the sacred appurtenances which Pope Gregory the Great ordered to be restored to the Synagogue of Palermo in 599.

Fig. 112 In Oriental communities, the Scroll of the Law was enclosed entirely in a case *(tik),* *Plate 14* which was placed upright on the reading desk and opened out for reading the prescribed portion. This was the general practice in Iraq and the neighboring countries as early as the 10th century, and has remained to our own day. These cases were usually of wood, frequently with inscriptions applied in metal, but were occasionally of silver, finely worked and engraved, and sometimes of gold. In the former metal, a few fine examples *Fig. 113* are extant; none, however, which are anterior to the seventeenth century. Though the *tik* was commonly used only in Eastern communities, cases were made for the scrolls sometimes also in Western countries, especially for well-to-do householders who

wished to have portable Torah-scrolls on their travels. An exquisite pair of such cases in silver, with polygonal sections opening on hinges and spirally fluted handles and finials, was executed in 1766–67 by a gentile master-craftsman for "Dr." Samuel de Falk, the so-called *Baal Shem* of London.

The practice of placing crowns of precious metal on the *Sepher Torah* — at least on such special occasions as the feast of the Rejoicing of the Law — seems also to have been established in Iraq as early as the tenth century (*Shaare Semahot,* p. 117). The Fostat contract of 1186–87 lists among other objects "Two *Sepher*-Crowns made out of silver." This form of ornament was naturally suggested by the Rabbinic dictum cited above which refers to the dignity of learning as "the Crown of the Law" — a phrase inscribed innumerable times on such objects and others connected with the synagogue ritual: These objects, which became known generally as *atarah,* were at the outset especially associated with Southern Europe. Aaron of Lunel tells in his *Sepher haManhig* how in 1203 he persuaded some community which he visited, in Southern France or Spain, to make a silver crown *(atarah)* for the *Sepher Torah* instead of decorating it with miscellaneous female adornments. The contract already referred to of March 12, 1439, between the Avignonese silversmith Robin Tissard and the *baylons* of the Jewish community of Arles was for manufacture, for a total sum of fifty florins, of an *atarah* for the "scroll of the Jews," hexagonal in shape, superimposed on a copper drum with which Tissard was to be provided. There were to be six towers — one at each corner — the top crenellated like a fortress, and the surface to be engraved in imitation of masonry. Chains and columns decorated with lions' heads were also to be part of the design.

Plate 15

The 1477 contract at Avignon was for the manufacture of a crown for the scroll of the law, called *Hatarah,* in accordance with a model with which the gentile silversmith was to be furnished; it was to be adorned with reliefs and with Hebrew lettering. Unfortunately, no such objects of so early a date have been preserved. Later on, the Torah-crowns of the Sephardim tended to be small, shaped like royal coronets, closely superimposed on top of the Torah-scroll.

Among the Ashkenazim, in Eastern Europe particularly, there was a tendency to divorce it more and more from its regal prototype, interior holders being made to fit over the wooden stave-tops and the *keter torah* of very great weight rising sometimes fantastically in tier above tier, each supported by lions, griffins, deer, etc., and the whole sometimes surmounted by an eagle or dove. It is said that in Eastern Europe the former practice was to use the crown on festivals, the simpler finials, or *rimmonim* (see below), on ordinary Sabbaths.

Fig. 114

In the Italian synagogues, crown and finials were used together, the cylindrical *keter* (obviously modeled sometimes on the crowns of the Madonna common in neighboring churches) lying loosely around, and kept in place by the other ornaments. Occasionally two crowns were provided, one surmounting each stave of the scroll, while in one superb example a further crown is placed above these two, symbolizing the proverbial Crowns of Kingship, Priesthood, and Learning.

Plates 15, 16

More usual in Europe than the Torah-crown was the use of finials. The original form in Germany seems to have been a silver plating, later made removable so that it could be placed over the wooden staves: an account of the Rhineland massacres of 1096 speaks of the pillaging of "the silver which was around the winding-staves." Similarly, in the 13th century, Rabbi Meir of Rothenburg (Responsa, ed. Prague, Section 879) referred to

"plating of gold" on the Torah-staves. This presumably explains why to the present day the term *Etz Hayyim* or "Tree of Life" (cf. Prov. III. 18) is applied by the Ashkenazi Jews both to the staves and to their metal ornaments. Ultimately, these became somewhat more elaborate and in due course removable. We can see representations of bulbous Torah-finials quite clearly — apparently at both extremities of the staves — in some medieval manuscripts showing synagogue interiors, e.g., in Vatican MS. Heb. 324 (14th century).

It seems that in Spain these ornaments were generally in the form of apples *(tappuhim)* (cf. *Tur: Hilkhot Sepher Torah,* 282). Solomon Bonfed in his satire on the notables of Saragossa, (c. 1400), sneeringly alleges that they had agreed that "whosoever shall steal the *tappuhim* of the *Sepher Torah* or remove the *atarah*... should have this considered to him as a special glory." In the Orient, however, a slightly more elaborate form modeled on the pomegranate seems to have been introduced at an early date (cf. Maimonides, *Hilkhot Sepher Torah,* X. iv), possibly as a Biblical reminiscence (cf. Ex: 28:34, Jer. 52:22, etc.). Some Oriental finials still preserve this type almost unchanged, while in others it may be discerned under an incrustation of ornament. Moreover, perhaps owing to the great authority of Maimonides and those who followed his phraseology, the term *rimmonim* (now generally used by historians of Jewish art) became usual among the Sephardim for these objects, however drastically their form was subsequently modified.

Plate 17, Fig. 113

We have seen above how the architectural form was adopted for the Torah-crown in Provence as early as the 15th century. Already at this period it was also applied very effectively to the Torah-finials. It is used, in fact, in the oldest examples of these objects known to be extant, of the fourteenth or fifteenth century, now in the Treasury of the Cathedral of Palma (Majorca).* According to an inscription, they belonged originally to the Jewish community of Camarata in Sicily, where we know that the synagogue was pillaged just before the expulsion of 1492. They are fashioned architecturally in the form of square towers, with pointed turrets and twin mauresque embrasures on each side. At each corner, both above and below the turrets, hang small bells. These were to become a feature of the Torah finials (as well as crowns) everywhere, inspiring the name ("bells") generally given to these objects in the English-speaking countries. Their music symbolizes both the joy of the *Torah* and the bells which according to the Bible (Exodus XXVII. 35–5) were to be attached to the robe of the High Priest.

The architectural form of the *rimmonim,* or designs based on it, later became so common as to be characteristic of the type used in Northern and Western Europe. Different countries, and even different towns, developed their own tradition. Thus the Italian type of the 17th and 18th centuries took the form of a three-tiered steeple, with scrolled buttresses and balustrades enclosing the conventional symbols of the Jewish cult (altar, table of shewbread, *menorah,* etc.); in these, as in Italy generally, the bells were usually hung on long chains below the level of the head-piece. A common Nuremberg model was a bulbous shape of silver gilt, with a pierced decoration, topped by a lion rampant which supported a *cartouche* for a dedicatory inscription.

Plates 15, 16

Fig. 115

The type which prevailed in Holland after the settlement of the Jews there in the beginning

* The extreme rarity of older specimens of these and similar objects of Jewish ritual art may be due in part to the order of the Castilian *cortes* of 1480, forbidding the Jews to place silver or gold on their *Torahs*.

of the seventeenth century was in the form of a baroque turret obviously inspired by the local church steeples: sometimes with as many as four tiers, surmounted by a crown. *Fig. 116* This form was subsequently taken to England and is to be found in the earliest London synagogal silver. Early in the eighteenth century the turret form changed here into a composition of bulbous knobs (generally three) pierced with floral compositions, and later into a form composed of an open bowl with a bracketed canopy. In the middle of the century the turret form reappears, to be followed by urn-shaped finials in the neo-Classical style, and culminating in the Regency period with a number of individual compositions of diminishing crowns, obelisks, and a revival of the open-bowl form. This reaction against the architectural form found expression independently in the *rimmonim* produced about 1750–70 by Myer Myers, the first American Jewish silversmith of colonial times.

Some poverty-stricken communities, unable to afford precious metal, made their ritual objects of other materials — the Torah-crowns sometimes of brocade, the *rimmonim* more frequently of painted wood. Some interesting examples of folk-art thus emerged.

In addition to the finials, another adornment for the *Sepher Torah* became popular in Ashkenazi communities beginning in the sixteenth century. Many scrolls were kept in the Torah-shrine, of which sometimes one, sometimes two, sometimes three were used in the prescribed readings. In order to avoid confusion, it became customary to hang around the scroll what was ultimately a highly ornamental plaque containing an inter- *Plate 18* changeable panel which indicated the occasion for the prescribed reading to which the text was adjusted ("New Moon," "Passover," "Hanukkah," and so on). This was known as the *tas* ("plate"), (in English generally and somewhat unfortunately rendered as the *Fig. 117* "breast-plate"). In due course, the container became more and more elaborate, the inscribed panels less and less conspicuous, until in the end they disappeared entirely. Now, the ornamental breast-plate alone remained, without any functional justification. These sometimes attained great splendor in Central Europe of the eighteenth century. A common type, apparently originating in Breslau, embodied the figures of Moses and *Fig. 111* Aaron, supporting the Ten Commandments on the central indicator-panel. Often, in imitation of the priestly breast-plate, the central decoration reproduced the High Priest's *hoshen* (Exodus XXVIII, 15–21), semi-precious stones representing the Twelve Tribes.

Finally, so as to obviate the touching and the possible obliteration of the sacred text by the hand, the *Sepher Torah* was provided with a pointer. In most countries, however, the form ultimately developed of a rod terminating in a hand with outstretched forefinger and it was accordingly, whatever its form, termed *yad*. Generally, this, too, was made of silver, or even gold, sometimes with precious stones (e.g., in a miniature ring). Owing to *Fig. 118* the small bulk of the pointer, it was sometimes possible to devote to its manufacture special pains and indeed expense, and it is hardly possible to describe the innumerable forms it assumed.

III

The use of decorative textile material for wrapping the Holy Books is attested by literary sources already in the Talmudic period (cf. *Sabbath* 133b, Kelim XXVIII, 4). Evidence of the use of fragments goes back possibly to the period of the Hasmoneans, as indicated

123

in the earliest Dead Sea Scrolls in 1947. It was, however, only in the Middle Ages that brocades were specially prepared for these purposes. The accounts of the Rhineland persecutions in 1096, when they speak of the desecration of the *Siphre Torah,* add the detail that the wrappings were pillaged. The earliest *Memorbuch* of Nuremberg records the generosity of a woman (12th century?) who among other things left three "cloaks" to the congregation; but from the context it is possible that the reference is to warm garments for the poor. We learn, however, from the customs of Rabbi Meir of Rothenburg that in his day it was usual for a bridegroom to vow a wrapping *(mappah)* for the Scroll of the Law on the occasion of his marriage. From approximately this period the formulas for benediction in the Italian synagogues called for blessings on those women who made cloaks or wraps for the glory of the *Torah.*

However that may be, at least from the close of the Middle Ages, brocades constituted no small or unimportant part of Jewish ritual art, whether they were the work of pious women or of the expert embroiderers who were common in so many Jewish communities. We are told, for example, how Naphtali Herz Wertheim, a wealthy German banker living in Padua in the early 16th century, made for his domestic synagogue a curtain for the ark and a mantle for the scroll of the Law, both decorated with his crest, at a cost of five hundred ducats.

It was on the curtain for the Torah-shrine — the most prominent feature in the synagogue — that the greatest attention was lavished. This was the case especially among the Ashkenazim: conceivably a remote echo of the ancient Palestinian practice, where as we have seen, in classical antiquity the movable ark was secluded at the east end of the synagogue behind long curtains. This feature was generally known, after the sanctuary curtain of the tabernacle in the wilderness (Exodus XXVI, 31, etc.), as the *parokhet.* The materials used were of the finest: an examination of those manufactured in Moravia and now preserved in the Prague Jewish Museum has revealed fabrics dating back as far as the 14th century and including specimens of the Italian Renaissance, Spanish baroque, and French rococo. Obviously, these were not necessarily of Jewish manufacture and displayed in their patterns no Jewish motifs, the specific quality provided by the lavish use of the superbly decorative Hebrew lettering, either embroidered or applied. Apposite Biblical verses were incorporated, or lengthy inscriptions commemorating the generosity of the donors. To these votive decorations were often added conventional symbols, such as the twisted columns, or the Lion of Judah, or the Crown of Torah, or the Perpetual Lamp symbolizing the light of religion. Sometimes, there were special curtains for special occasions — e.g., for the circumcision ceremony or for the special Sabbaths throughout the year. On the New Year and Day of Atonement it was usual, especially among the Ashkenazim, for the curtain (as well as the other synagogal brocades) to be white and to be embroidered with penitential texts.

Fig. 119

In due course, a stereotyped pattern emerged, in Central Europe especially, for the Torah curtains. Over the top was a valance containing representations in heavy gold thread of the traditional Temple appurtenances — the *menorah,* table of shewbread, altar, and so on. This valance was sometimes known as the *kaporet* or "mercy-seat" (see Exodus, XXV, 17) for no other reason but that the term is so often found in the Pentateuch in conjunction with the *parokhet.* In the ark-curtain itself, most prominent and characteristic were the two twisted columns framing the central panel, generally surmounted by or enclosing a

Fig. 120

dedicatory inscription. The manufacture of these objects reached a high pitch of perfection

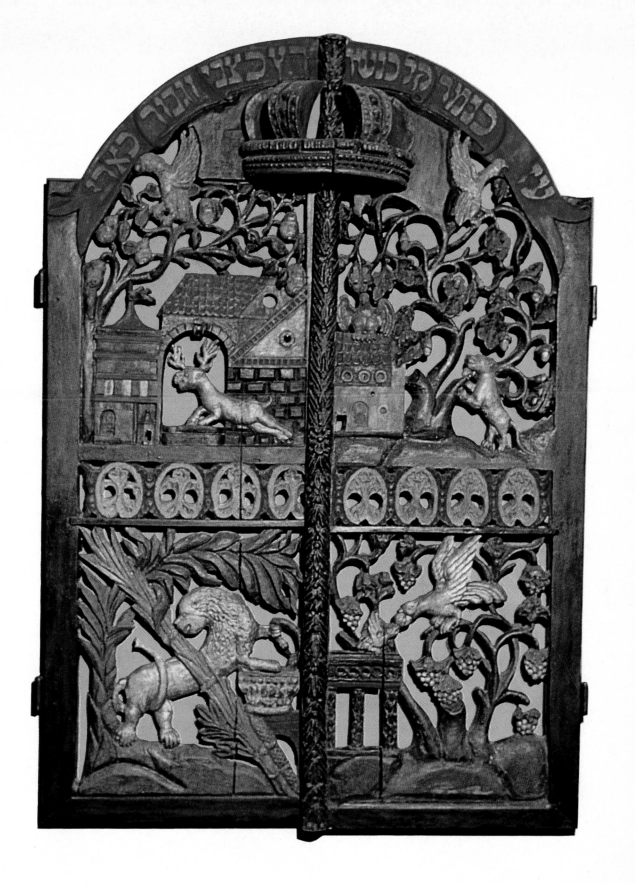

Plate 11. Words from the Ethics of the Fathers served as an important source for synagogue decoration in many Jewish communities in Europe. Usually they were used to adorn the sides and top of the Ark of the Law. In these carved and painted wooden doors from the 18th century synagogue of Cracow, they were used on the doors of the Ark of the Law. Dor Va-Dor Museum of the Chief-Rabbinate, Hekhal Shelomo, Jerusalem.

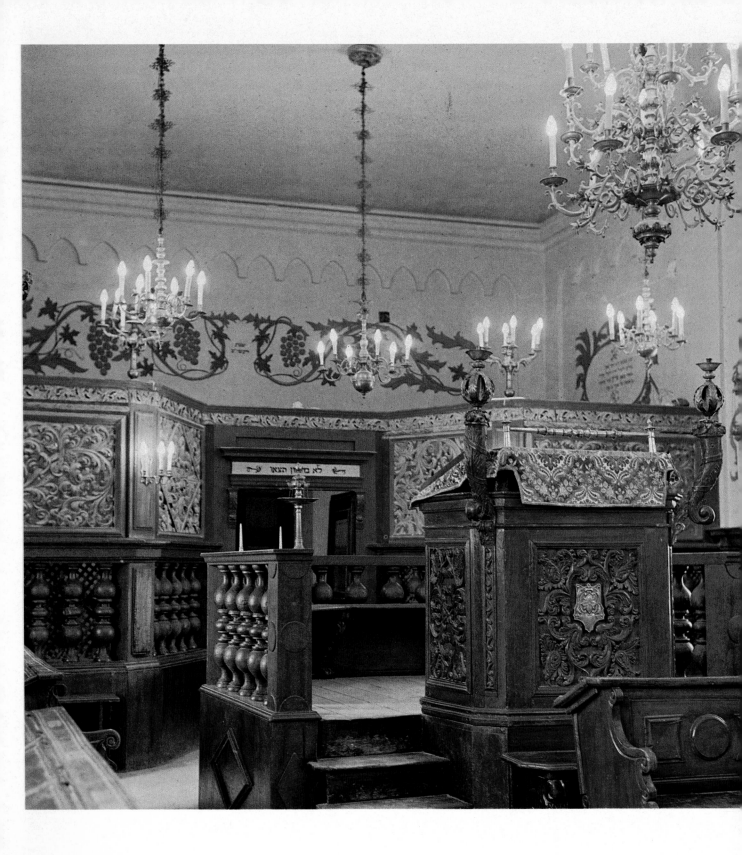

Plate 12. Reconstructed interior of the Conegliano Veneto Synagogue, as it appears in the Roman Synagogue in Jerusalem. The latticework of the women's gallery, which was on the second story of the original building, can be seen on either side of the doorway. The silver candlesticks standing on three sides of the reading desk in the center are set on cornucopias as they were in the original synagogue.

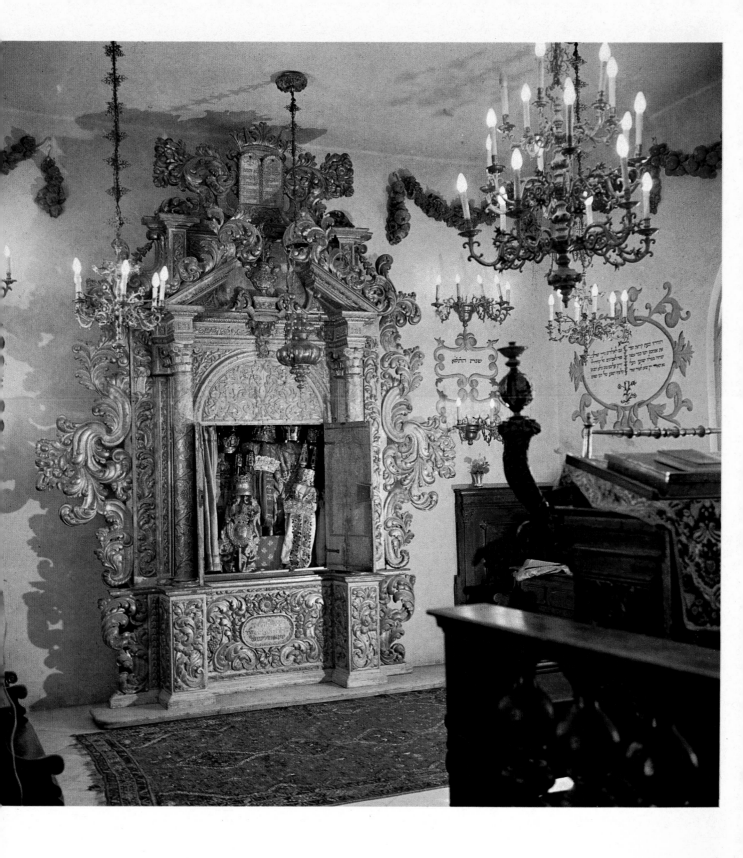

Plate 13. This splendid Ark of the Law, with the Torah scrolls inside, is also from the Conegliano Veneto synagogue, now in the Roman Synagogue, Jerusalem.

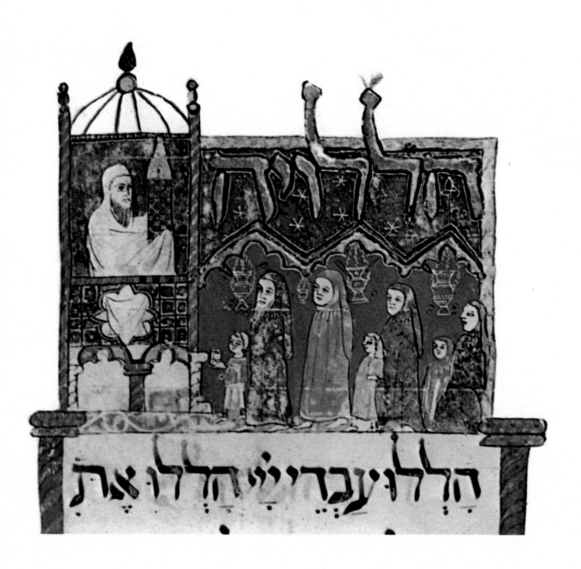

הַלְלוּ עַבְדֵי יְיָ הַלְלוּ אֶת

Plate 14. The cantor, wearing a prayer shawl and standing on
a raised, roofed bimah (platform) is seen raising a Torah
scroll in its case, while four Jews, with their children, stand
in prayer. Illustrated initial-word panel from a manuscript of
a Spanish Passover Haggadah, illuminated in Barcelona in
the 14th century. British Museum, Add. Ms. 14761.

Plate 15. Ornamented Torah scroll in gold-embroidered
surmounted by a partly gilded silver crown, from Italy
1742, and two 18th century silver finials from Italy
Museum, Jerusalem.

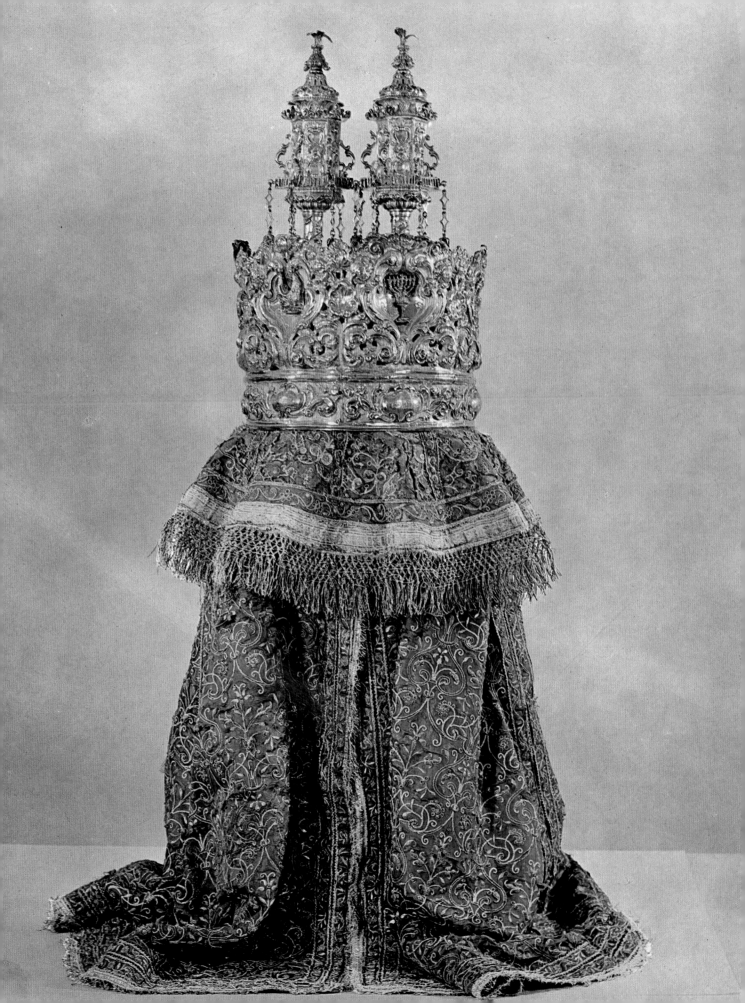

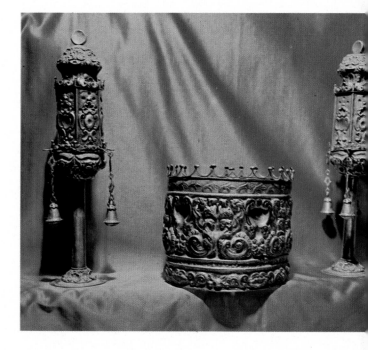

Plate 17. Oriental Torah finials in the shape of pomegranates. Made of painted wood, Tunisia, 19th century. Israel Museum, Jerusalem.

Plate 16. Torah crown from San Daniele del Friuri, between two silver finials, presented to the Synagogue by the poet Isaac Luzzatto. Roman Synagogue Collection, Jerusalem.

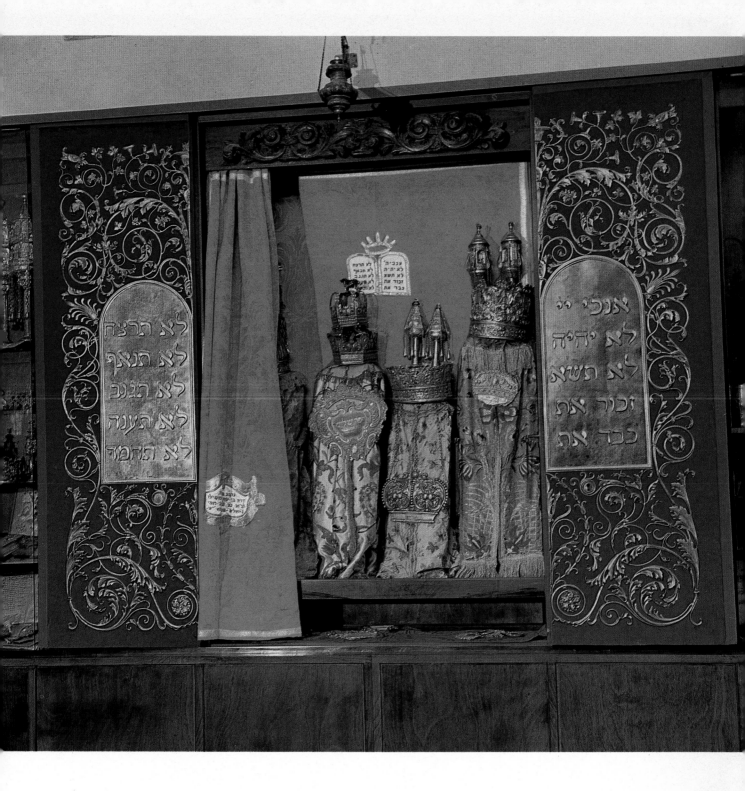

Plate 18. Ark of the Law from the Mantua community, with sliding doors ornamented in silver, bearing two tablets inscribed with the Ten Commandments. Inside are four Torah scrolls wrapped in embroidered mantles, bearing crowns and finials. The breastplate hanging on the second Scroll from the left bears the words "Sefar Shelishi" (Third Torah Scroll), indicating that this was the third scroll to be read on Sabbath. Roman Synagogue Collection, Jerusalem.

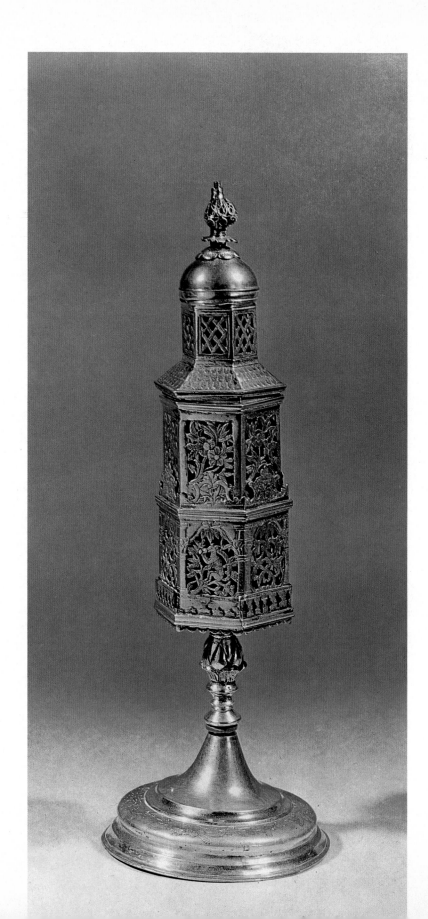

Plate 19. Spiceboxes recall the days of the Second Temple, when it was customary to burn spices on a small incense altar on the evening following the Sabbath, to preserve the fragrance of the holy day. This is apparently the origin of the traditional form of the vessel. The earliest spicebox in the shape of a tower with a pointed roof dates to the 16th century. This one was apparently made in Frankfort, Germany, at the end of the 17th century. Israel Museum, Jerusalem.

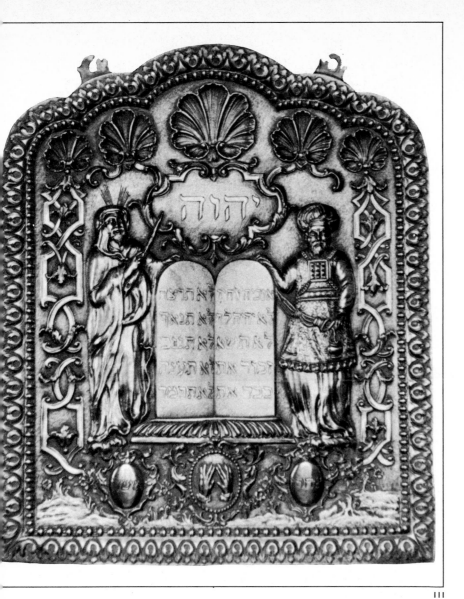

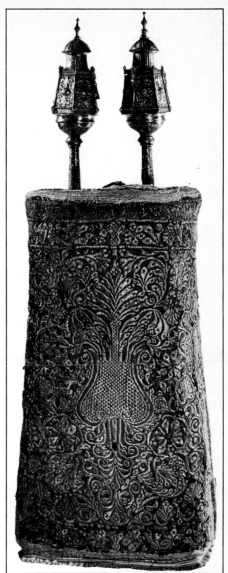

111. *Breastplate for Torah scroll. Silver repoussé, Breslau, 18th century. Jewish Museum, New York.*

112. *Case for Torah scroll, with finials. Velvet mounted on leather with gold and silver thread. Morocco, 19th century. Israel Museum, Jerusalem.*

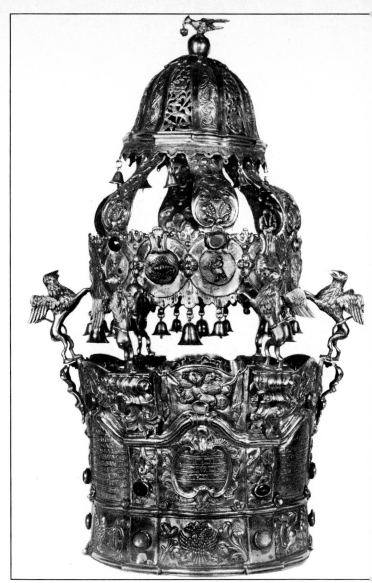

114

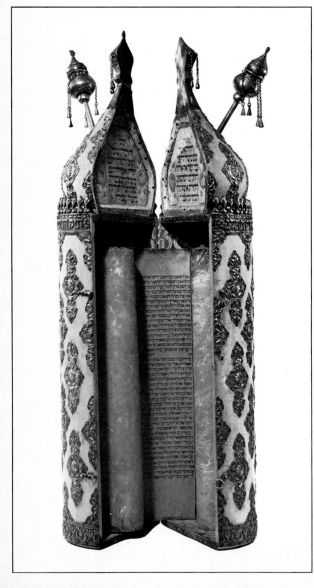

113

113. Case for Torah scroll, with finials. Felt on wood, sil[ver]
decoration. Persia, 19th century. Israel Museum, Jerusale[m]

114. Crown for Torah scroll. Silver parcel-gilt, repoussé a[nd]
cast, with semi-precious stones. Poland, 18th centu[ry].
Jewish Museum, New York.

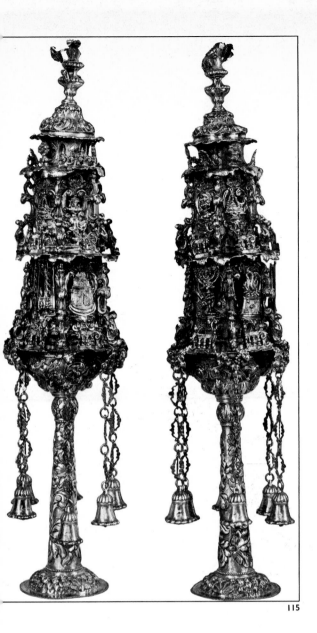

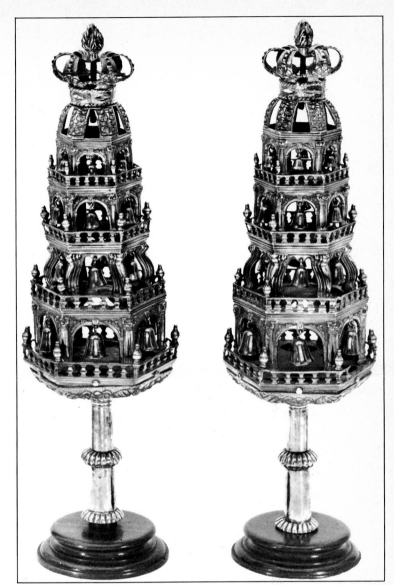

115

116

115. *Finials for Torah scroll. Silver. Venice, 18th century. Tuck Collection of the Jewish Historical Society of England, University College, London.*

116. *Finials for Torah scroll. Silver. Dutch, 18th century. Jewish Historical Museum, Amsterdam.*

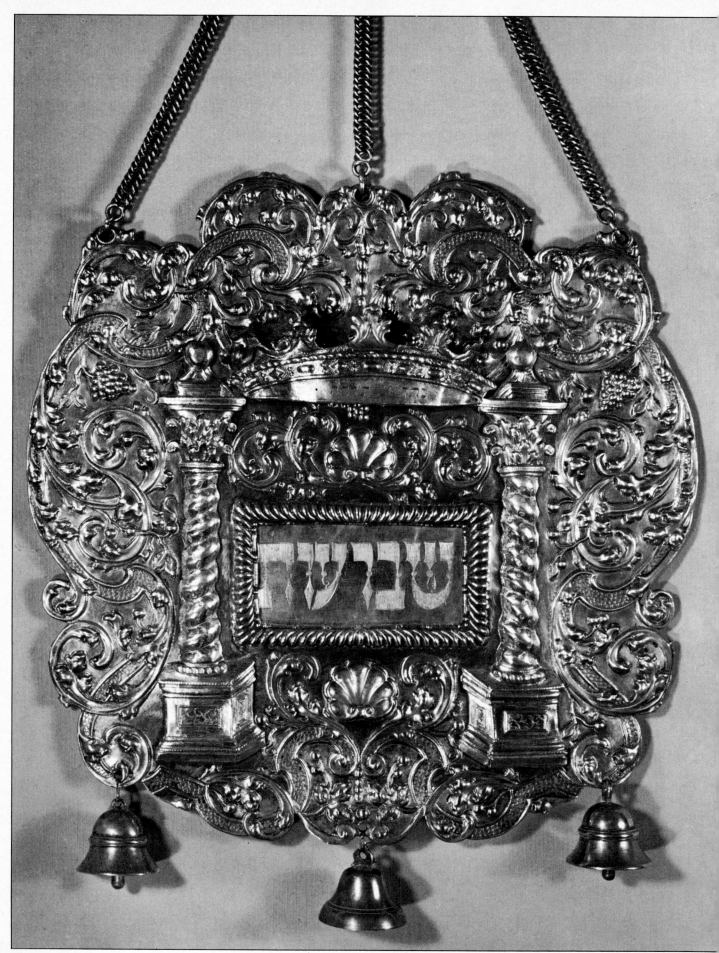

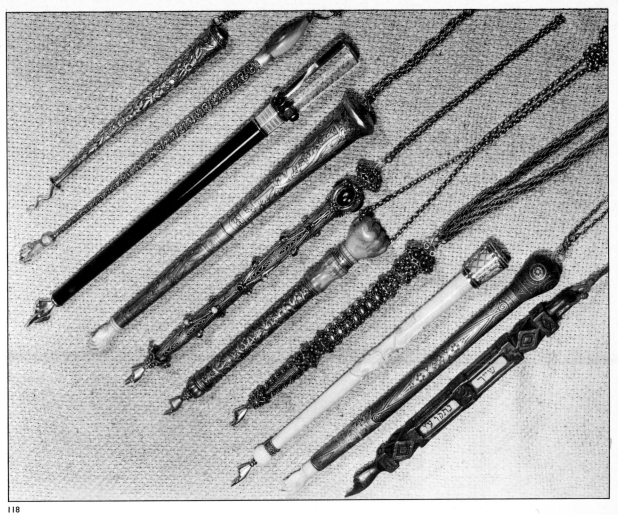

118

119

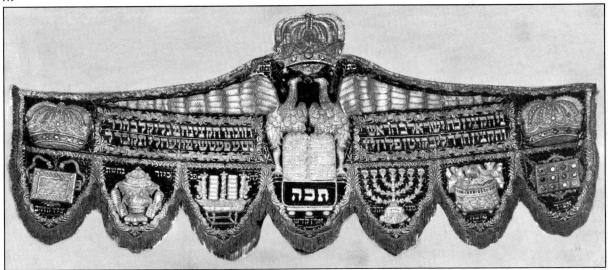

117. Tas, *Breastplate for Torah scroll, with indicator-plaque for Shavu'ot. Silver parcel-gilt. Augsburg, 18th century. Markus (Matthew) Wolff. Jewish Museum, New York.*

118. Yad, *Pointers of Torah scroll. Italy, Germany and other places in Europe, 18th to 19th centuries. Formerly Feinberg Collection, Detroit.*

119. *Valance of ark-curtain: red velvet, with appliqué embroidery. Prague, 1764. Jewish Museum, New York.*

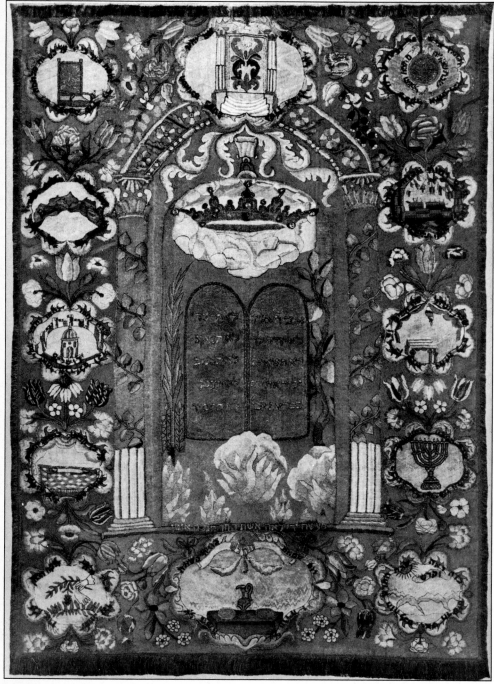

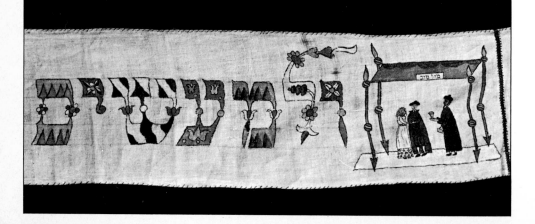

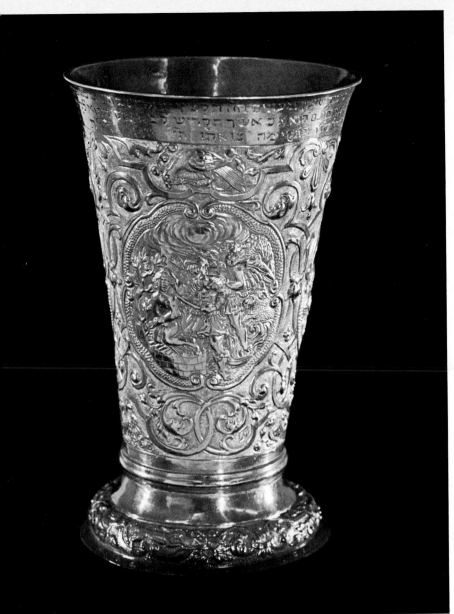

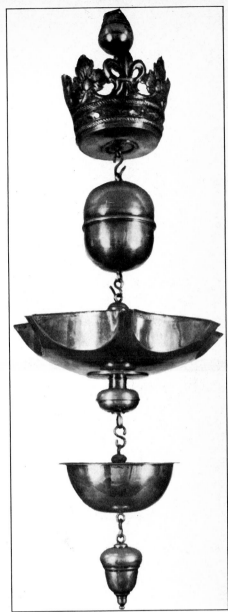

122 123

120. *Ark curtain, with symbols of festivals etc. Needlework on canvas, embroidered with silk, made by Leah Ottolenghi. N. Italy, 1699. Jewish Museum, New York.*

121. *Marriage ceremony. Detail of a binder for Torah-scroll, Germany, 18th century. Israel Museum, Jerusalem.*

122. *Kiddush cup. Silver gilt, decorated with biblical scenes. Nuremberg, 17th century. Donated to a Frankfort synagogue in 1765. Israel Museum, Jerusalem.*

123. *Sabbath lamp, silver. London, 1730. Master: Abraham Lopes d'Oliveira. Jewish Museum, London.*

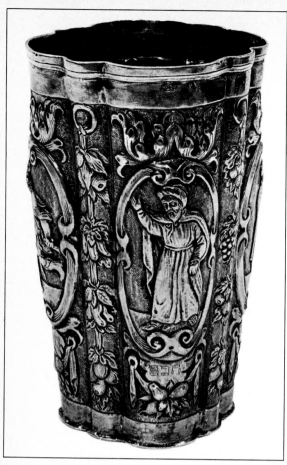

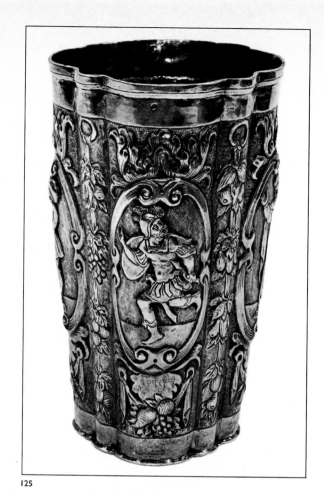

124

125

126

127

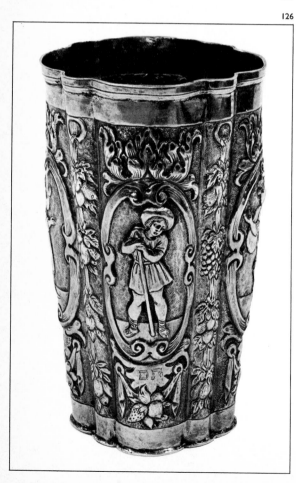

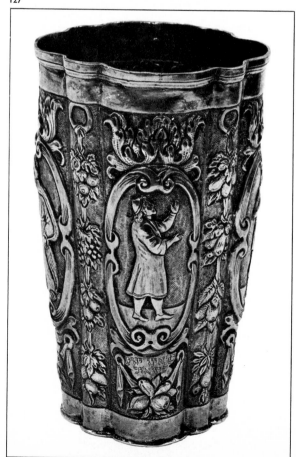

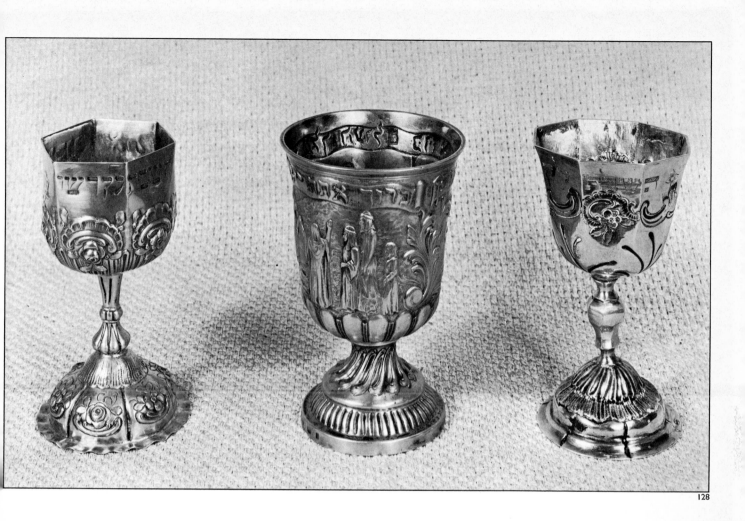

128

The Shalom Ash beaker. Kiddush cup for Passover, silver,
partly gilt. Germany, late 17th century, depicting the
Four Sons of the Haggadah: Israel Museum, Jerusalem
(Permanent loan from Mr. and Mrs. Victor Carter, Los
Angeles. Formerly Shalom Ash Collection):

24. The Wise Son.

25. The Wicked Son.

26. The Simpleton.

27. The Son who does not know how to ask.

128. Kiddush beakers, silver, Central Europe, 18th century.
Formerly Feinberg Collection, Detroit.

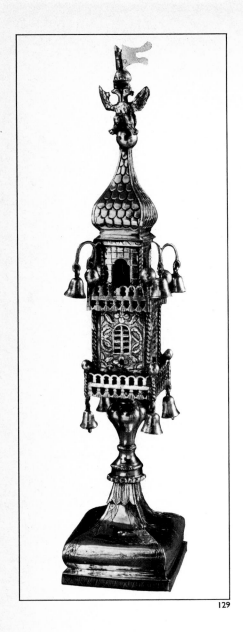 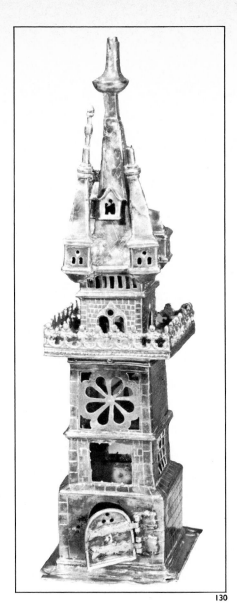 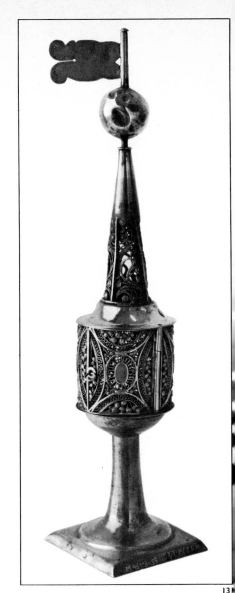

129 · · · · · 130 · · · · · 131

129. *Spice container in the form of a tower. Silver, partly gilt,
 Austria 1817. Israel Museum, Jerusalem.*

130. *Spice container for Havdalah ceremony. Silver, engraved,
 cut-out and cast. Frankfurt am Main, about 1550, restored
 1651. Jewish Museum, New York.*

131. *Spice container. Silver filigree. Poland, 18th century.
 Israel Museum, Jerusalem.*

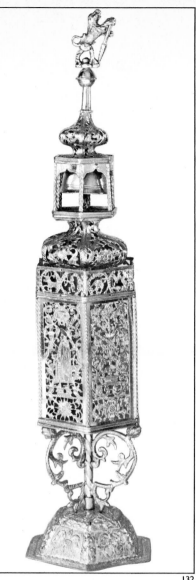

132

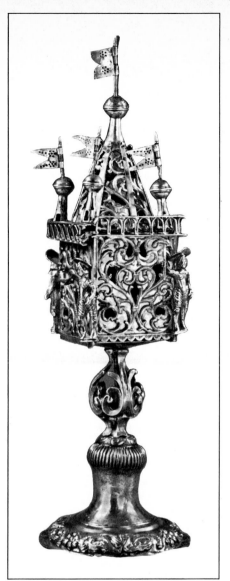

133

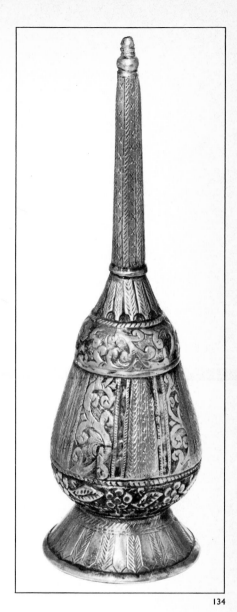

134

132. *Castle-shaped spice container. Germany, 17th century. Israel Museum, Jerusalem.*

133. *Spice container. Eastern Europe, late 18th century. Jewish Museum, New York.*

134. *Container for spices or rose water. Silver repoussé and chased. Middle East, 19th century. Israel Museum, Jerusalem.*

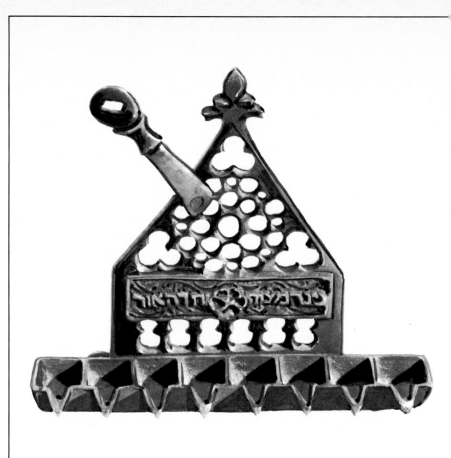

135

136

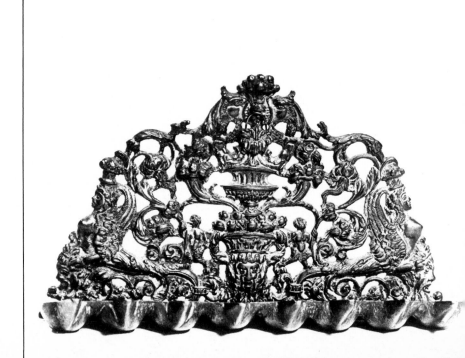

135. Hanukkah lamp, cast bronze, with arm for the
 "shamash" master light. S. French or Italian. 14th
 century. Roth Collection, Jerusalem.

136. Bronze cast Hanukkah lamp, with baroque motifs.
 Italy 16th century. Formerly H. Davidowitz
 Collection, New York.

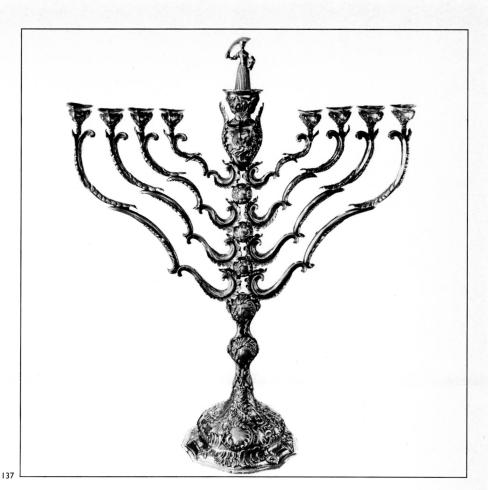

137

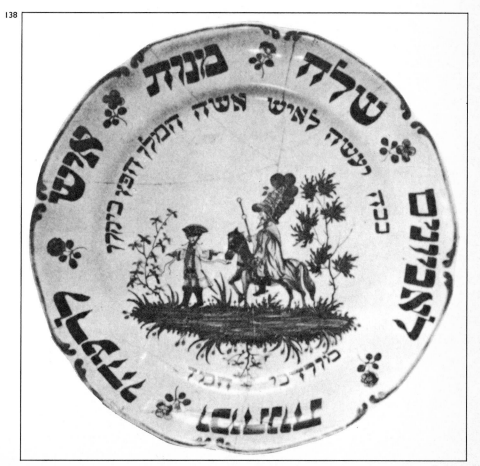

138

137. *Standing Hanukkah lamp, surmounted by Judith holding the head of Holophernes, silver. Augsburg, 1759. Israel Museum, Jerusalem (Gift of Mr. Jacob Michael, New York, in memory of his wife, Erna Michael).*

138. *Purim platter, showing triumph of Mordecai. Porcelain. Strassburg, 18th century. Cluny Museum, Paris.*

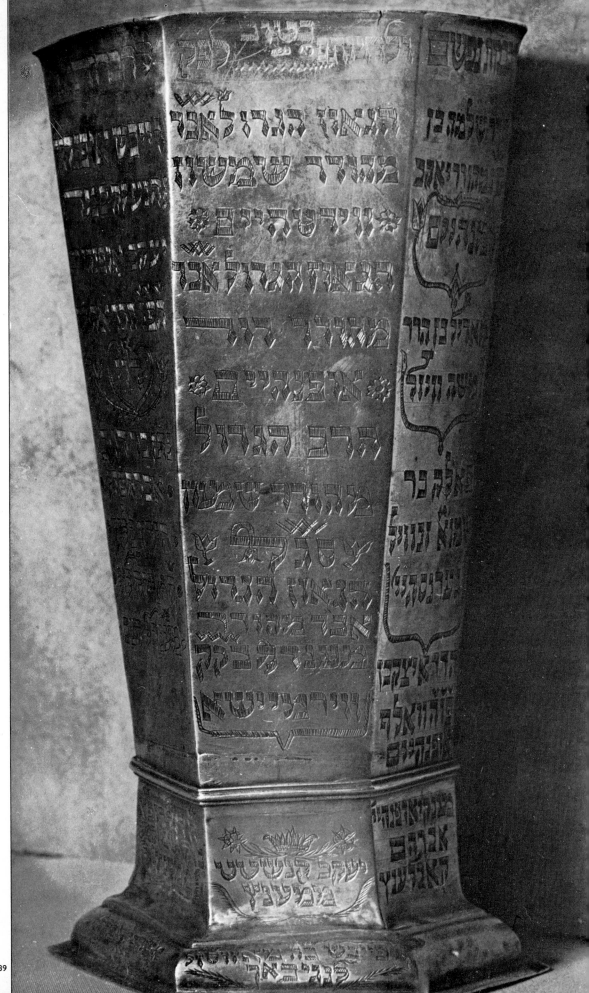

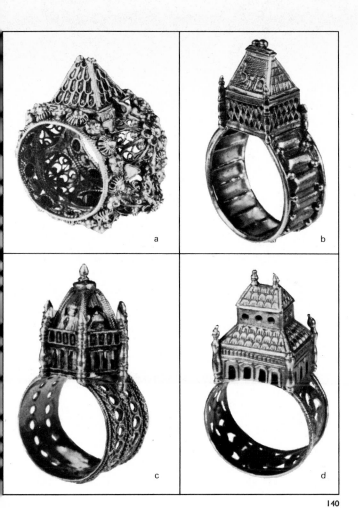

140

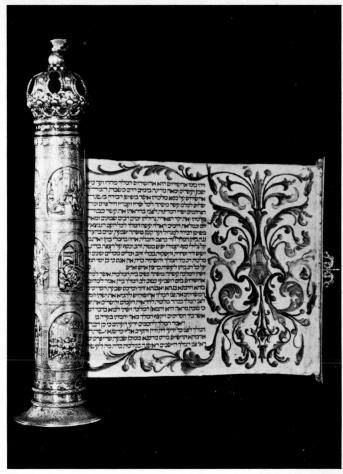

141

139. Beaker of Burial Society of Worms. Silver, chased. Master: Johann Conrad Weiss of Nuremburg 1712. Jewish Museum, New York.

140. Ceremonial marriage rings. Jewish Museum, London.

 (a) Gold filigree with blue and white enamel. Interior inscribed Mazzal-Tov (Good Luck). Italian early XVIIth century.
 (b) Gold. Top engraved Mazzal-Tov. South German, late XVIIth century.
 (c) Gold. Top enamelled Mazzal-Tov. Italian early XVIIth century.
 (d) Gold. Italian early XVIIth century. Jewish Museum, London.

141. Illuminated Scroll of Esther in silver case, embossed with vignettes showing scenes from the story. Germany. 17th century. Jewish Museum, London.

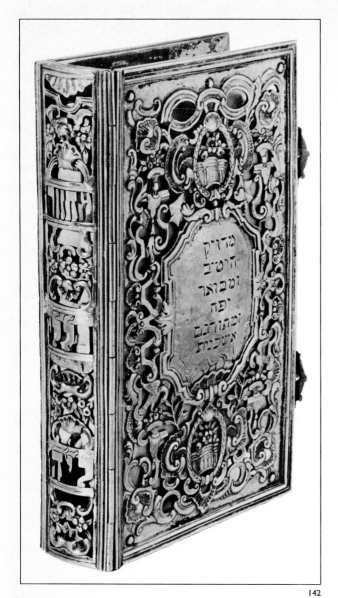
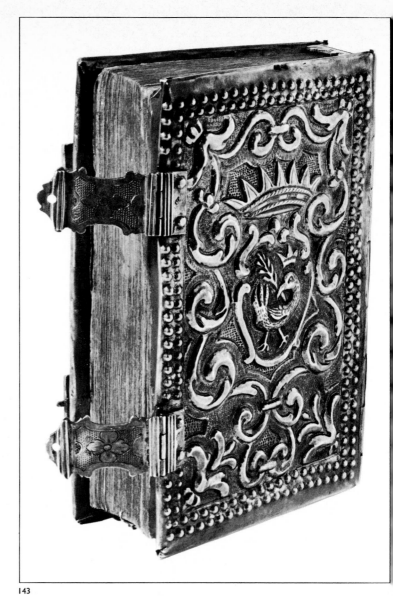

142 143

142. Prayer Bookbinding. France 19th century. Silver repoussé.
Formerly Feinberg Collection (179). Israel Museum,
Jerusalem, (142/52), gift of Mr. Jacob Michael.

143. Prayer Bookbinding. Italy 18th century. Silver repoussé,
with Coat of arms of Da Oliviera family. Formerly Feinberg
Collection (240). Israel Museum, Jerusalem, (142/55),
gift of Mr. Jacob Michael.

in the work of two very gifted artist-embroiderers of the 18th century — Elkanah (Elkone) of Naumberg, whose name is to be found on some memorable work of 1713–24, and Jakob Kopel Gans, of Hochstadt in Bavaria, active from 1726 onward.

There are also extant some impressive mantles for the Torah-scroll made, sometimes *en suite* by these same craftsmen. Among the Sephardim and Italians, these objects, too, tended to be simpler, relying for their aesthetic values mainly on the exquisiteness of the materials, though sometimes embodying a brief inscription. Among the Ashkenazim, on the other hand, they were far more ornate, being encrusted with lettering and symbolism, and sometimes with semi-precious stones. Some of the finest examples extant were made in England in the early years of the eighteenth century for both the Sephardi and the Ashkenazi communities. These have elaborate orphreys in gold and silver thread, sometimes much raised in the manner of what is termed stump-work, which comprise the usual Jewish cult-symbols (including even a miniature Torah-scroll within its shrine), the outcome resembling a plastic model. Some Central European mantles bear the ever-popular figures of Moses and Aaron. The cover for the reading-desk also received much attention, but save for the inscriptions, seldom had a specific design or decoration.

Plate 15
Fig. 112

Before the mantle was placed on the *Sepher Torah,* the scroll was fastened together with a long strip of material, or "binder" *(hitul),* which, being lighter and simpler, was generally of domestic manufacture. These were also often embroidered with verses or the name of the pious donor: in the New York Jewish Museum is one made by an Italian Jewish girl who, as she records, was only six years old at the time. As specimens of needlework, these are sometimes of exquisite quality.

In Germany, an interesting tradition developed. Here the piece of linen used on the occasion of a boy's circumcision was cut up and made by the mother into a binder for the scroll, termed in German "Wimpel," which the child presented to the synagogue on his first visit. This bore a stereotyped formula in large, bold characters, usually embroidered, later sometimes painted: ".....son of, born of good on May the Almighty permit him to grow up to the study of the Law, the marriage-canopy and good deeds." It was customary to decorate the inscription with various conventional symbols; thus above the date of birth was the corresponding sign of the zodiac, at the end, after or above the mention of the word "marriage-canopy" *(huppah)* was a representation of a wedding ceremony, with bride and bridegroom standing under the canopy before the rabbi, a wine-cup in his hand. Many hundreds of such *Wimpeln* were formerly preserved by some German communities such as that of Worms. Occasionally, they attained a high degree of artistic merit.

Fig. 121

IV

Besides the fine specimens of craftsmanship in precious metal intended for use in the synagogue, especially in relation to the Torah-scroll, Jewish ritual demanded the use of a large variety of objects in connection with the home ceremonials.

We may take as an example the hanging Sabbath lamp, which in Germany and other European countries developed a specific star-shaped form. We may trace the development of this type in the domestic scenes depicted in various illuminated *haggadot* of the Middle Ages. The earliest one traceable, going back to the fourteenth century, has six points. Another very old specimen is in the Cathedral Treasury at Erfurt, but though the shaft

probably dates back to the 11th century, the oil vessel (with twelve spouts) may be as much as 500 years younger. More than one Frankfurt silversmith is registered as having manufactured a *Judenstern* (as it was termed in the official register) from the early sixteenth century onwards. Later on the Sephardim of Northern Europe (Amsterdam and London) developed their own variant form, with a deep bowl and blunt spouts. Some superb specimens are extant of both of these types, Sephardi and Ashkenazi, executed in silver: some of the work by the London Sephardi silversmith, Abraham d'Oliveira, in the

Fig. 123

early part of the 18th century. In the seventeenth and eighteenth centuries a number of Ashkenazi Sabbath lamps of very intricate and impressive design, which sometimes embodied figures representing the various Jewish observances, were made in Alsace (Metz, Forbach) and Western Germany (Frankfurt am Main).

In due course, the traditional Sabbath lamp was displaced in most of Europe by candles. Occasionally, candlesticks with symbolic designs were specifically manufactured for Jewish use, though this was not very usual.

The Sabbath, ushered in by the kindling of the lamp, was subsequently "sanctified" over a brimming cup of wine. In Germany, specific hexagonal-shaped silver goblets, engraved with appropriate Biblical verses and scenes, were manufactured in great profusion in the

Fig. 122, 128

17th and 18th centuries in Augsburg, Nuremberg, and elsewhere. Sometimes, special goblets, bearing apparently symbolic representations, were made for the individual festivals, in particular the Passover, or for use in the circumcision ceremony. Special

Fig. 124, 125, 126, 127

goblets were also made to serve as the "Cup of Elijah" for the Seder, and as the ceremonial cup for the circumcision. These were sometimes shaped in the form of barrel-shaped hooped beakers fitting into one another, one being for ordinary use and the other the ceremonial cup. One such beaker is in the Cathedral Treasury of Trent (North Italy) among the property seized from the local Jews at the time of the ritual murder accusation of 1475, when it is said to have been used in the tragic Passover celebration. Of course, the *kiddush* cup could be made of materials other than precious metal. Thus, one of engraved glass, appropriately inscribed, was presented to Solomon Hirschell on his appointment as Chief Rabbi of England in 1802.

As the Sabbath began, so it ended with a picturesque ceremony over the wine, to the light of a taper and to the accompaniment of aromatic herbs, symbolizing the sweetness of the day that had ended. Spices are now used for this purpose in Western countries, but in the Middle Ages, when these were intolerably expensive, a sprig of myrtle (in Hebrew *hadas*) or some other aromatic herb was used, as is still the case in Italy and the Orient. This was replaced by dried leaves, which would naturally be kept in a container. Thus we see the term *hadas* generally applied even now in many parts of Europe to the

Plate 19

"spice-box" used on Saturday night in the ceremony of *havdalah*, or "separation." Rabbi Ephraim ben Isaac of Regensburg (d. 1175) is recorded to have objected to the use of dry myrtle leaves, insisting that only spices were proper for the *mitzvah;* he had a special glass container for them. Later, however, the spice-boxes were made of metal, especially silver.

One of the earliest literary references to these are probably those in the 15th-century ritual compendium *Leket Yosher,* relating the usages of Rabbi Israel Isserlein, of whom his pupil recounts, "I recall that his *hadas* was made of silver in which he had spices." The original type, presumably in architectural form, following the shape of the medieval incense burners, has been preserved in very large numbers of spice-containers for the

havdalah ceremony made in Central and Eastern Europe down to our own day. They are mostly shaped like towers, sometimes very elaborate. In the inventory of the property of the Messianic dreamer, David Reubeni (c. 1530), we read of the "two silver *havdalahs* all of silver, wherein was musk to smell"; we are not told of their form.

Fig. 129

In Germany, towards the end of the Middle Ages, it became very common to make the spice-container in the form of a tower or steeple. A number of references to the manufacture of the "hedes" or "hedisch" are contained in the order-book of the Frankfurt silversmiths' guild from 1532 onwards. In one case this was accompanied by a sketch of the work that had been commissioned from Master Heinrich Heidelberger: it was specified that the object should be made similar to the one which had been owned by the father of the person who ordered it, thus throwing back the history of this type for another generation at least. The original inspiration came possibly from the Christian monstrances in which the Host was exhibited and which often bore a similar architectural form. On one occasion, indeed, in 1550, one of the Frankfurt silversmiths contracted to make a "Juden Monstranz" and it is difficult to imagine what else could have been intended.

This tower-form became immensely popular. Occasionally, it was imitated from a local tower building; often, it would be a veritable church steeple, surmounted by a pennant, and even furnished with a clock-face on which the hour of the conclusion of the Sabbath could be indicated. There is extant one such spice-container made at Frankfurt am Main (c. 1550), now in the Jewish Museum in New York, though it was restored and somewhat altered a hundred years later. The material used was generally silver, sometimes engraved to resemble masonry; later on, especially in Eastern Europe, filigree — coarser and coarser as time went on — was used for the purpose. The tower lent itself to further embellishments: for example, human figures could be placed around it representing the various synagogue officials prepared to begin their work — the rabbi with his sermon, the *shohet* with his knife, the *hazan* holding a beaker of wine, and so on. While the German spice-boxes are usually in the form of a tower with a central spire surrounded by four corner-spires, those from Bohemia often imitate the bulbous bell-towers of the baroque rural churches in that country.

Fig. 130

Fig. 131, 132

Fig. 133

Another form, of spice-box *cum* taper-holder, thus combining the two adjuncts of the *havdalah* ceremony, was evolved in Western Germany in the eighteenth century: in this, the spices were contained in a drawer under the taper, which also was sometimes supported by figures representing the synagogue officials. The shape of Oriental spice-containers was, on its part, influenced by long-necked bottles for rose water, and decorated with Oriental motifs.

Plate 20

Fig. 134

In the ritual art of the Jewish home, perhaps the most important object, after the spice-container, was the eighth (or with the master-light, ninth) oil light for the Hanukkah festival, celebrating the victory of the Maccabees. Later, the practice grew up of making these objects in metal; it is for example recorded that Rabbi Meir of Rothenburg would light the Hanukkah lights only in a metal (not clay) lamp (*Tur Orah Hayim* 673).

The type of lamp that now developed consisted generally of a flat back-plate, to hang against the wall, with the eight oil burners (candles were not yet in use) affixed below it at right angles; the master-light (called *shammash*, or beadle) was generally appended at the top, either in the middle or on the left-hand side. It was on the design of the back that the maker's art centered. The oldest specimen extant is of a Gothic type, believed to be of the fourteenth century: here the back-piece is pierced with a colonnade of arches and a

Fig. 135

circular design almost like the "rose window" of a Gothic church. This type was followed widely at the close of the Middle Ages.

In 16th century Italy, more and more attention began to be paid to the back-piece, which would be cast in copper or bronze or brass, and decorated with cherubs, tritons, cornucopias, urns, masks, and so on in the fullest Renaissance style. Not infrequently, they embody Biblical or apocryphal scenes such as the annunciation of the birth of Isaac, or Judith carrying the head of Holophernes — an episode which in Jewish folklore was also associated with the Hanukkah period. Occasionally, the back has an architectural pattern, obviously deriving in some instances from local buildings; in one case, for example, there is a distinct similarity to the façade of the Church of "Il Redentore" in Venice. The coats of arms of noble patrons also figure on occasion: thus, an entire series of splendid bronze 16th century Hanukkah lamps are adorned with the armorial bearings of cardinals of the Holy Roman Catholic Church, over which *putti* hold their distinctive

Fig. 136

hats whose cords descend decoratively on either side. The baroque style of the 16th century Italian Hanukkah lamp merged into the rococo, which continued to prevail generally there until the end of the ghetto period, with some notable exceptions.

In Holland, the tradition developed of a flat brass back-piece, in which decorations or symbols were engraved or embossed. In the seventeenth and eighteenth centuries this tradition, translated into silver by the eminent craftsmen in Amsterdam and later in London, was to produce some extremely noteworthy examples. In Germany there was a

Plate 21

great multiplicity of styles, some highly complicated, but it is noteworthy that here especially there was little objection to representations of the human figure, as for example in the common scenes of Judith and Holophernes. A delicate new type of standing Hanukkah lamp on a smaller scale began to be produced in the course of the eighteenth century in great numbers, with small variations, at Frankfurt, Augsburg, and elsewhere in Germany. Some splendid examples, many of them imitating these of silver, were made in Northern Europe of pewter at this period. Wrought-brass lamps, with two

Plates 22, 23

master-lights (for use on Sabbath eve), emerged in 18th century Poland. Candelabrum types seem to have been manufactured originally only for synagogue use, a few examples preserved for us from as far back as the Renaissance period. In the last generations, these

Fig. 137

began to be made for the home as well — both as vague reminiscences of the Temple *menorah* and for the utilitarian purpose of lighting the room with candles. The lighting of the Hanukkah lamp remains one of the most popular Jewish domestic observances, and very large numbers of new types, some of considerable artistic merit, continue to be produced, especially in Israel.

V

A further opportunity for Jewish ritual art was given by the domestic *Seder* service on Passover eve, which included a number of symbolic food preparations. These had to be placed in some sort of container, and in Italy towards the close of the Renaissance period it became customary to manufacture special majolica holders for the purpose. Several makers of these platters and similar dishes are recorded, mainly belonging to the families

Plate 24

of Cohen and Azulai, working especially in Pesaro and Ancona in the 17th and early 18th centuries. The Passover dishes are all of the same type. They are approximately 17 in. in diameter, with a wide flange border, relief-decorated, with a floral design in color. Within this are four large oval *cartouches,* those at the top and bottom enclosing

Biblical or festal scenes, those at the side with floral or architectural decorations. These were probably intended for the bitter herbs and other ritual commodities. The larger *cartouches* are divided by smaller panels with figures of the prophets and kings (Moses, Aaron, David, Solomon). The cavetto is inscribed with the text of one of the prayers in the ritual *(Kiddush* or *Ha-lahma),* in some cases supplemented or even substituted by the traditional catchwords giving the order of the service. The manufacturer generally signed the plates on the reverse, adding his distinctive mark. In the last century, these plates were exactly imitated in embossed silver dishes made in Germany.

In Northern Europe, great use was made of *Seder* plates in engraved pewter, often bearing representations of the *Seder* scene or features of the *haggadah,* with the catchwords of the service and personal inscriptions. The oldest of these are of the middle of the 16th century, but the finest specimens date from a later era. Pewter was also used for Purim plates made to carry the traditional gifts, or circumcisional plates usually bearing a representation of the sacrifice of Isaac: the latter are extant also in silver, mostly, however, 19th-century archaistic versions. In Germany, at the end of the 18th century, ingenious three-tiered *Seder* dishes were made to contain the three cakes of unleavened bread, special containers being made for the incidental commodities. For the *haroseth* (a mixture of chopped apple and nuts, symbolic of the mortar which the slaves used in Egypt) there was often made a miniature wheelbarrow, sometimes pushed by a human figure to represent one of the Israelite bondsmen. Porcelain dishes were produced in various countries for Passover as well as for many other purposes — for Purim, for weddings, for the *havdalah* ceremony, or sometimes with a purely ornamental and complimentary object.

Plate 25

Plate 26, Fig. 138

In addition to the *kiddush* cups for the domestic (including the Passover) ritual, wine beakers were sometimes manufactured in Germany, especially for the use of congregational fraternities at their annual banquets or for similar purposes; these were sometimes covered with medallions on which were inscribed the names and family badges of successive wardens or treasurers. Among the most characteristic of these were the beakers or jugs used by the burial societies for their annual banquet. These were made sometimes of glass or porcelain, and were not infrequently decorated with scenes showing the members engaged in their pious work. Sometimes, similar scenes were depicted on porcelain jugs, the lids of which might be surmounted by some detail of the burial-scene in silver.

Fig. 139

Of great importance in Jewish ritual art in the medieval and post-medieval periods were the betrothal rings. These were sometimes of great magnificence, and it is said that they were the property of the Jewish communities, being "given" to the bridegroom in order to perform the ceremony, and were afterwards returned to the synagogue treasury. Their form was completely characteristic, and they are recognizably Jewish, even if they do not bear any inscription. They may be divided roughly into two types. In the one, the band (which in either case is very wide) is flat and decorated, sometimes in enamel, with words of good omen (*mazal tov,* etc.), or in some exceptional but very fine instances with representations such as the High Priest Aaron, the traditional peacemaker between man and wife, or else the story of Eve. Sometimes the band is highly decorated in filigree with raised bosses or rosettes. On the finest and most characteristic, however, there is superimposed a miniature building, presumably intended to represent the Temple in Jerusalem, so as to comply with the Psalmist's injunction (Psalm CXXXVII, 6) to "set Jerusalem above my chiefest joy." The roof of the "Temple" was sometimes hinged and, swinging

Fig. 140

back, revealed the words *mazal tov,* or sometimes the names of bride and bridegroom. In the Renaissance period and throughout the 17th century, these rings, with their superb gold filigree decorated with finest enamel, sometimes attained great magnificence. In the seventeenth-eighteenth centuries, silver rings of a somewhat similar design, but sometimes far more complicated in construction, were used in Central Europe. These very often bear representations of the Sabbath candlesticks accompanied by the appropriate benediction; it is said that they were worn by the brides in later years when they kindled the Sabbath light on Friday evenings.

VI

The foregoing pages have by no means exhausted the categories of ritual art on which the Jews in bygone days lavished their devotion. There were large numbers of other objects connected with the various observances which would receive loving treatment, though the tradition was not perhaps so constant as in the instances which have been described above. In medieval Spain, according to literary sources (Rosh, V.ii) special carpets were made to hang on the synagogue walls, in the Moslem fashion. One specimen dating to the fourteenth century, which bears stylized representations of the Torah-shrine, has been preserved. The handle for the circumcisional knife (and sometimes the blade as well) would be adorned with a circumcisional scene, or a representation of the *Plate 27* sacrifice of Isaac. Most synagogues had special "Chairs of Elijah" for use during the ceremony—double among the Ashkenazim (one seat on which the infant was placed, the other reserved for the invisible Prophet), single in Italy and elsewhere. The cushion for this chair was also sometimes splendidly embroidered. Special ewers and basins were provided, for the use of the priests before they blessed the people.

Occasionally, a householder might commission a miniature ark, perhaps of silver, to hold his domestic Torah-scroll. The Scroll of Esther was not only illuminated, as we shall see later, but was also often placed in an ornate cylindrical container of precious metal, which *Fig. 141* might carry on the decorative motifs of the scroll or depict in *repoussé* work scenes in the story. Among the Ashkenazim in Central and Eastern Europe, the hammer with which the beadle, or *Schulklopfer,* knocked on the street-doors, when he aroused the faithful for early morning worship, was sometimes specially made and finely carved with Hebrew inscriptions. The bread on Sabbath eve would have its cover, a specialty of the women of the household, bearing Hebrew inscriptions and symbols. The *shofar* (horn) sounded on the New Year Feast was normally impressively plain, but sometimes was finely etched with Biblical texts bearing on the observance. In Eastern European synagogues there was placed before the reader's pulpit a tablet artistically inscribed with the Biblical verse: "I have set the Lord always before me" (Psalm XVI, 8) which was sometimes engraved or embossed in silver.

The *mezuzah* for the door-post, containing the prescribed Biblical verses, would be finely fashioned sometimes of wood, silver, or ivory. The case for the citron (*ethrog*) on the Feast of Tabernacles might be of silver — sometimes in the form of the fruit, sometimes as a box ornamented with the ritual symbols. The alms-box at the synagogue door would occasionally be specifically manufactured and bear a Symmetical design. In Italy, especially, beautiful containers with the word *Shaddai* were made for amulets, one very common 17th- and 18th-century type of baroque shape bearing the normal ritual symbols, surmounted by a knight's helm. In the East, on the other hand, the amulet was often finely

engraved on silver at great length: the so-called *avzam* (arm) amulets of Persia are especially common.

The bridal couple often received as a wedding gift a prayer book in an ornamental silver binding, sometimes (especially in Italy) bearing a representation of a Biblical scene relating to his or her name, or the coat of arms of the two families. In Germany the bride-groom wore the bridal belt of silver given him by his bride, the clasp sometimes symbolically fashioned and suitably inscribed. A special silver girdle, dividing the baser from the purer parts of the body was used by householders to fasten their white prayer-robe on the Day of Atonement.

Fig. 142, 143,

The study of Jewish ritual art is, however, in its infancy. Up to a couple of generations ago, little attention was paid to it. Within the last decades, a number of important public collections have been built up. At present, the labor of accumulation is being succeeded by study and investigation. Jewish ritual art has at last begun to take its place in cultural history. It is of particular significance as that branch of art in which Jewish warmth and devotion found in times gone by its most spontaneous and genuine expression, and which is still receiving a memorable development.

JEWISH ART
IN THE MOSLEM WORLD

by LEO ARY MAYER

Modern nationalistic man wants his own nation to produce everything he needs, from atomic research to clothing, from fine arts to food. The true Oriental, on the other hand, never entertained such ideas as cultural self-sufficiency. His society was divided into classes, some devoted to occupations considered honorable and, consequently, privileged and coveted, and others, no matter how important to society as a whole, regarded as castes of slaves or, at best, as second-grade citizens.

The Arab of the Umayyad or Abbasid residences from Cordova to Samarra appreciated art as much as any ancient Greek or medieval European. He devised beautifully built and tastefully appointed houses, and he filled them with tapestries and rugs, which retain their appeal even today, even to people with a very different sense of beauty. He saw to it that—within the limits of his means—his clothes, his arms, his armor, his pen-boxes, his lamps, and braziers were all works of art in their own way. However, like the ancient Greek or the medieval European, he thought little of craftsmen, architects, and painters as members of his own society. It is true that sometimes a Maecenas lavished considerable sums on them, but it was the work of art that mattered, not the maker of a masterpiece. The immediate result of this attitude was that, unlike modern man, the medieval Arab or Persian felt no frustration when his buildings or works of art were created by members of religious or national groups other than his own, or even by foreigners imported for the purpose.

Consequently, for generations (and in certain Moslem states even for long centuries), the artisans of the Moslem world were either professing Jews and Christians or else men of Jewish or Christian outlook. It is, therefore, no wonder if in a given country, say Yemen, where old standards of class differences still prevail, and where a given trade, say that of the smith, is singled out as particularly despicable, the Jews should have had even in modern times a virtual monopoly of all metalwork. If we see a dagger, or a ring, or a silver box or a platter and are sure that it was made in Yemen, we can be equally sure that it was made by a Jew. This was the case a thousand years ago, and it was true until the recent exodus of Jews from Yemen.

In a way, Yemenite art is eternal. Essentially the work of silversmiths, it consists of the most simple geometrical patterns carried out in simple techniques, such as granulation and filigree work. It is the kind of style that has baffled historians of Oriental art faced with jewelry made in such a variety of regions and periods as Byzantine Europe, medieval Egypt, and even modern Timbuktu. Yet the one thing certain about the objects shown

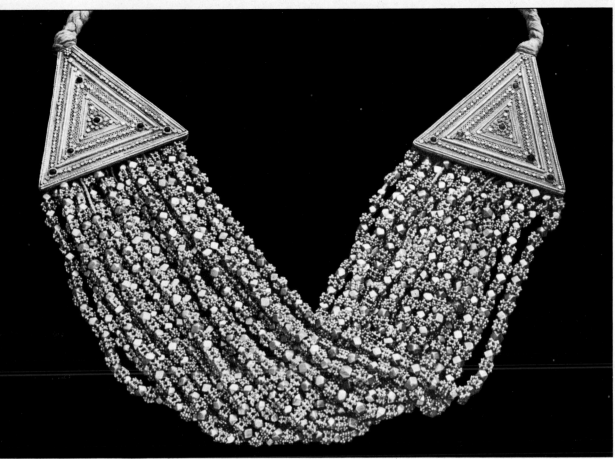

emenite Jewelry. Israel Museum, Jerusalem. 145. "Ma'naqe" — Silver, granulated beads and filigree ornament. San'a.

146. "Labbe Shabk" — for bridal and ceremonial wear. Gilded filigree silver, insets of small turquoises. San'a.

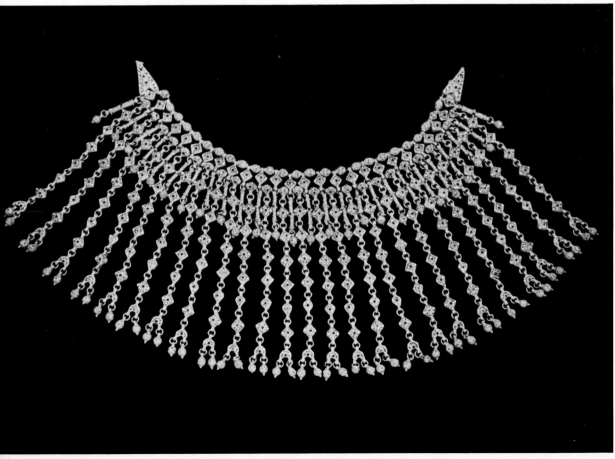

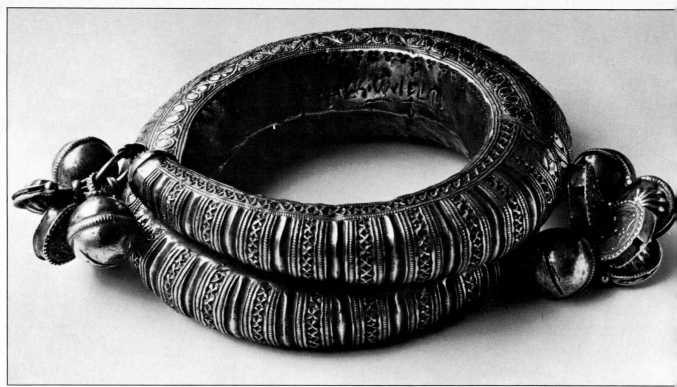

147

148

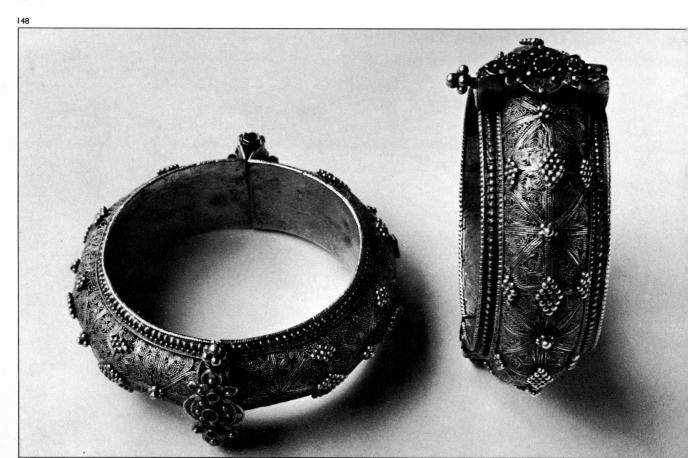

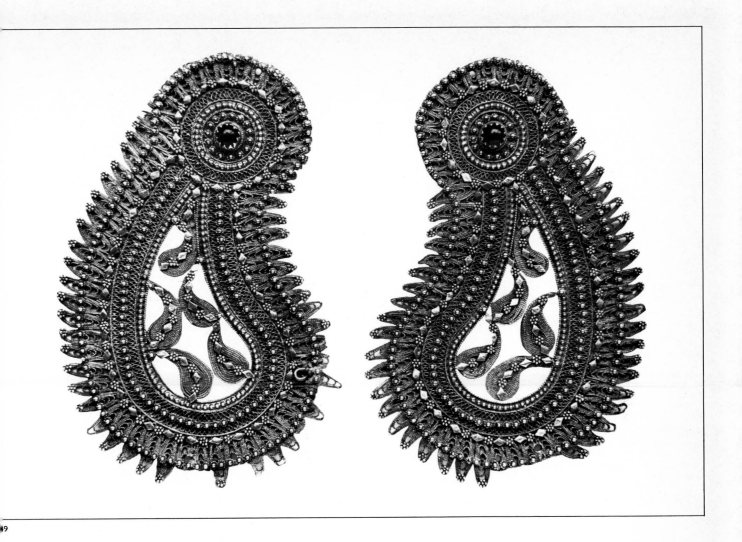

147. Bracelet "Ma'dad" — Silver work; name of artisan engraved in Hebrew Lettering.

148. "Shmeilat" — pair of bracelets (always worn in pairs) for bridal and ceremonial wear. Gilded silver filigree and granulated silver work. San'a.

149. "Gargush" — ornament for woman's hood for bridal and ceremonial wear. Gilded filigree and granulated silver work. Israel Museum, Jerusalem.

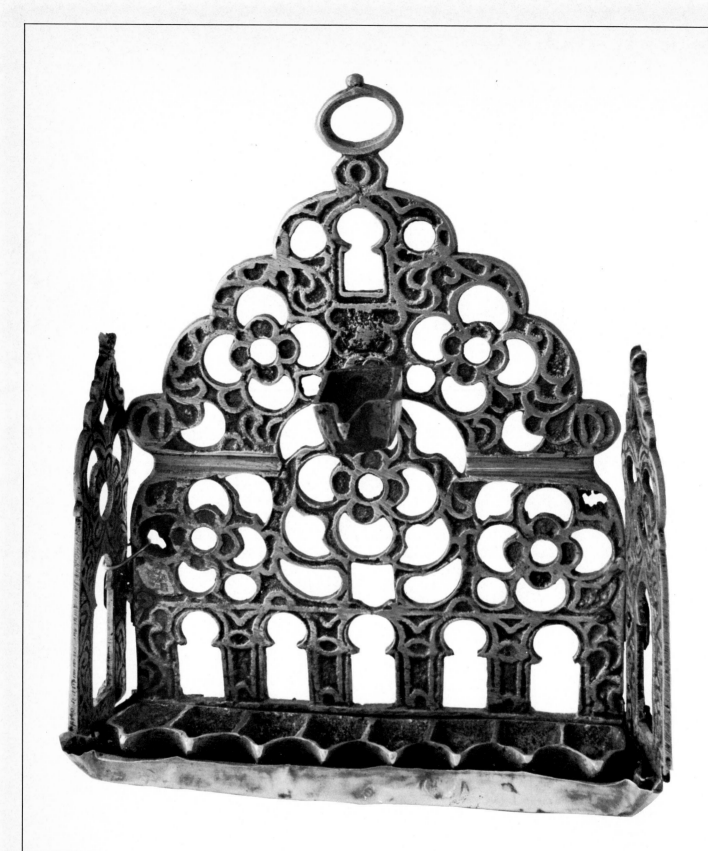

150

151

152

151. *Carved wooden panel with Hebrew inscription. Musée du Louvre. Courtesy of Musées Nationaux, Paris.*

152. *Carved wooden beam, with Hebrew inscription, from Fustat. 13th century. Jewish Museum, New York.*

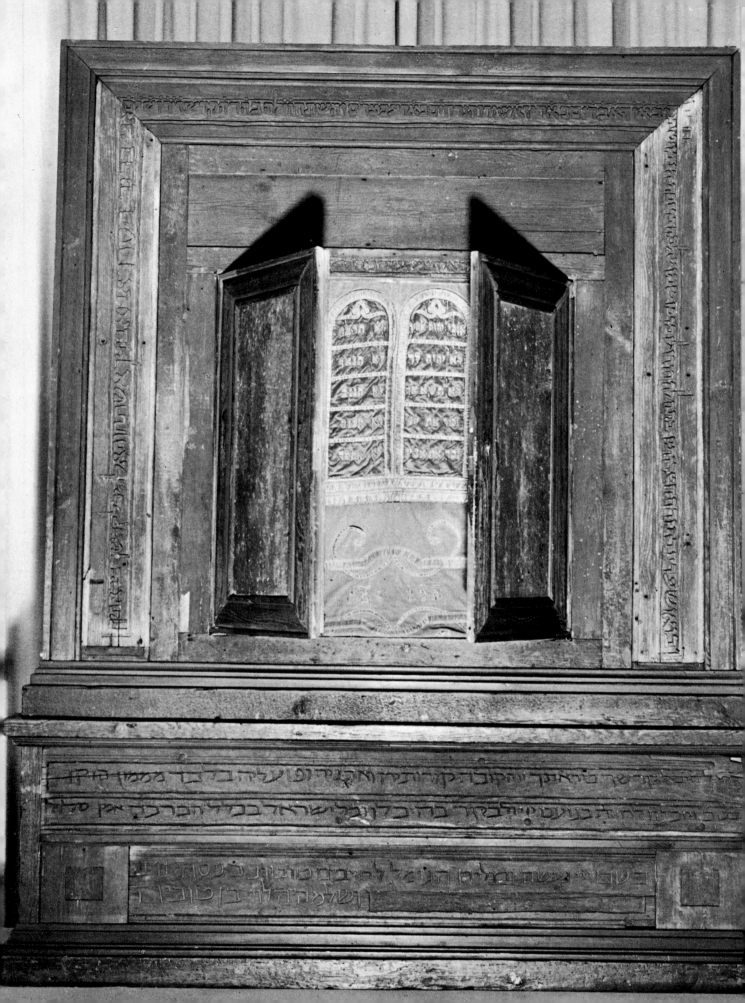

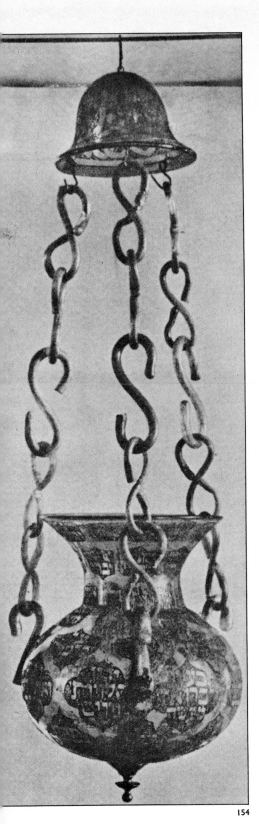

154

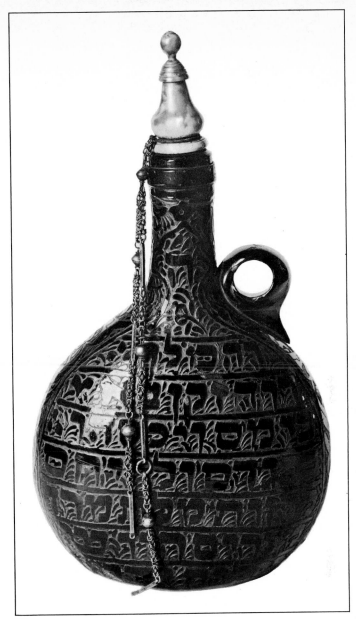

155

153. *Reconstructed Torah-shrine of synagogue at Fustat. 13th century. Jewish Museum, New York.*

154. *Hanging glass lamp with Hebrew inscription. Damascus, 1694. Jewish Museum, London.*

155. *Glass bottle with Hebrew inscription. 18th century. Victoria and Albert Museum, London.*

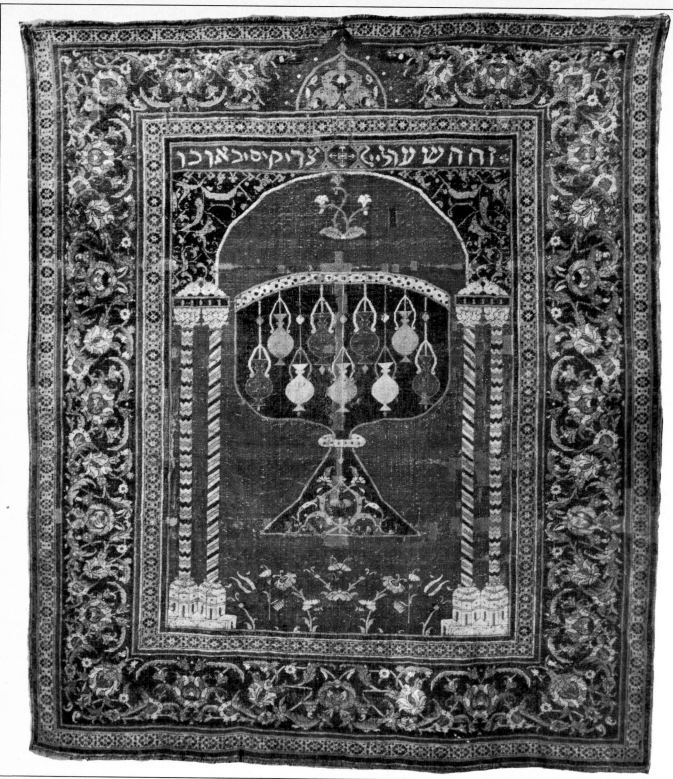

156. Turkish rug, with woven Hebrew inscription, 18th century.
The Textile Museum, Washington, D.C.

157

157. *"The Second Leningrad Bible". Page from decorated MS of the Bible, written at Cairo in 1008 or 1010. State Library, Leningrad. MS. 1 B. 19a, folio 476. (After Günzburg and Stassof).*

159

8. Page from decorated MS. of the Bible, dated 951, perhaps from Jerusalem. State Library, Leningrad, MS. II. 8. (After Günzburg and Stassof).

9. "The First Leningrad Bible". Illuminated page from MS. of Pentateuch, showing the Sanctuary and its vessels, written in Cairo, 929. State Library, Leningrad. MS. 11. 17. (After Günzburg and Stassof).

160. *Decorated page of Bible MS., 11th century. Formerly in*
the Karaite Synagogue, Cairo. State Library, Leningrad,
MS. II. 262. (After Günzburg and Stassof).

161. Page from MS. of Pentateuch from Yemen, with decoration in minuscular writing, dated 1469. British Museum, London, MS. OR. 2348.

163

163. *Page from decorated MS. of Later Prophets from Yemen,*
dated 1475. British Museum, MS. OR. 2211.

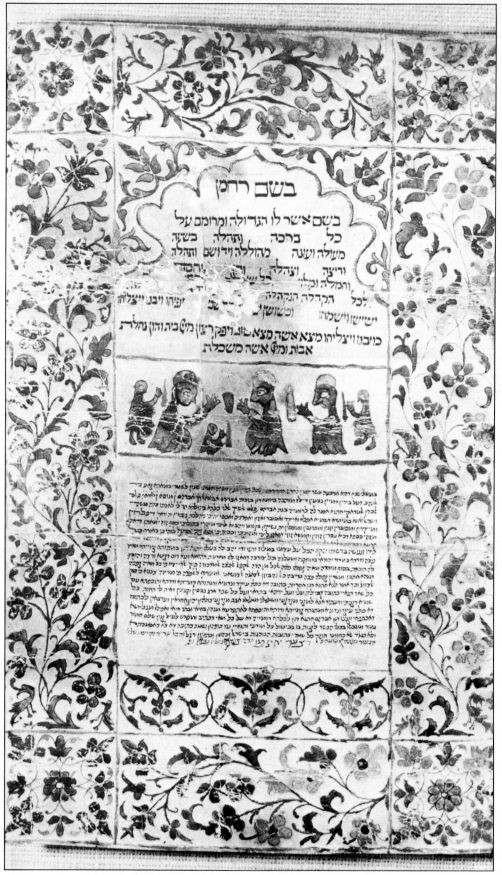

164

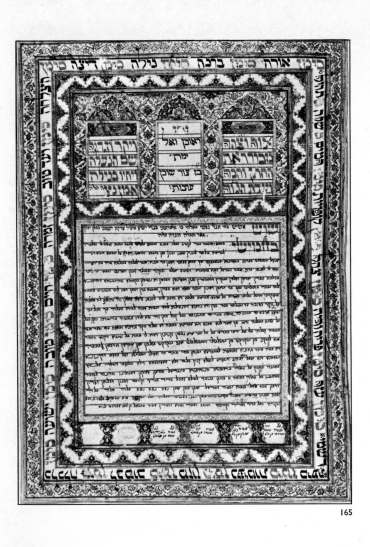

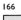

165. Portion of marriage contract, Herat, 1812. Hebrew
University Library, Jerusalem.

166. Oriental Mizrah plate, Persia, 19th century. Israel Museum,
Jerusalem.

here is that they are all Jewish and all made in Yemen. Another region where Jews had a *Fig. 145, 146, 147, 148. 149*
virtual monopoly of metalwork is Northwest Africa. Among the numerous ritual objects
from this area which have survived — mainly modern — a few deserve at least cursory
attention, such as the North-African Hanukkah lamps. *Fig. 150*

There are more examples of definitely Jewish handiwork in wood than in any other
material. Starting with the splendid Fatimid piece, at present in the Louvre, called by *Fig. 151*
Migeon "montant d'une niche de prière," and dated to the 11th–12th century, we find
two hitherto unpublished examples from Egypt, one in the Israel Museum, and the *Fig. 152*
other in the Museum of Islamic Art, Cairo; they are almost contemporary with the one in
the Louvre. The reconstructed ark of a synagogue (now in the Jewish Museum, New *Fig. 153*
York) may date in part from as early as the 13th century. The finest example is a cenotaph
in the traditional mausoleum of Esther and Mordecai in Hamadan; unfortunately it is so
placed that no good photograph can possibly be taken as long as it is *in situ;* while its
removal would be considered sacrilege by Jews and Moslems alike.

II

Apart from metalwork, the most commonly mentioned Jewish craft in the Middle Ages
was the making of glass. We have numerous references to it from Jewish and gentile
sources, yet not a single specimen of medieval glass made in Mohammedan countries
can definitely be called Jewish.

We are on safe ground only centuries later, during the Ottoman period, when a Damascene
master in 1694 produced a lamp (now in the Jewish Museum in London), very much *Fig. 154*
after the fashion of those used in mosques, covered with Hebrew inscriptions, with an
upper bowl decorated with Arabic lettering. Later still and clearly Middle (not Near) *Fig. 155*
Eastern in origin are various bottles, of opaque glass, of which remain several specimens
in public and private collections. Among the most important are those in the Victoria and
Albert Museum, London, and one in the former Feinberg Collection in Detroit.

III

Of Jewish textiles made under Mohammedan rule, almost all the surviving examples are
very late. Most of them belong to the 19th century and are already strongly under
European influence, not falling, therefore, within the orbit of the present treatment. Three
very notable exceptions are an early Moslem turban of fine material now in the Museum
of Islamic Art, Cairo, a Samaritan hanging still in the possession of the Samaritan
community at Nablus, and a Turkish rug in the Textile Museum, Washington, D.C.
The rug is of court manufacture, made either in Istanbul or Brussa, and is obviously *Fig. 156*
of the 18th century. As a whole, it follows the pattern of similar Moslem prayer-
rugs, but it has a few noteworthy peculiarities. The main part looks like a Moslem
prayer-niche, with a big cup in the center on which are displayed nine hanging
lamps of the usual mosque type. This is flanked by two double columns, the bases of
which look like domed mosques — a detail, to the best of our knowledge, unique. The
Hebrew inscription on the upper register of the spandrel of the *mihrab* is a quotation
from Psalm 118:20, to be found over innumerable entrance doors to synagogues all
over the world. The appearance of a Hebrew text on a Turkish carpet is unique. Although
there is nothing to prove that the rug as such was made by Jews — indeed, the clumsy
character of the Hebrew lettering might even suggest the opposite — the rug was

without any doubt woven to Jewish specification and designed in the spirit of Jewish tradition, to serve as a hanging in front of the Torah-shrine, and was a model for later copies.

Of special interest is the Samaritan silk hanging embroidered with silver by Joseph ben Sadaqa in 1509–10, probably in Damascus. It represents the Temple and a variety of objects traditionally connected with the Temple, like the seven-branched candlestick, the incense-burner, and the staff of Aaron. The theme — often to be found in Samaritan, as well as ordinary Hebrew manuscripts and ritual objects almost down to modern times — shows the strong current of Jewish tradition; its execution proves once more how thoroughly the Samaritans, as well as the Rabbinites and Karaites living in the Moslem East, assimilated the language of artistic expression of the nations among whom they lived.

IV

Although Jewish book production excelled at all times and in all countries by its high standard, effort was concentrated on offering a correct text, rather than on turning a manuscript into a work of art. Perhaps this was influenced by the fact that the Torah-scrolls used in the synagogues for reading the weekly lessons were never illuminated. But even the field of the script proper, which — in the sphere of Arabic lettering — is one of the greatest achievements of Moslem artists throughout the ages, was neglected by Jewish scribes in Islamic countries. It may be significant that Abraham ben Joseph, a Jewish Maecenas and bibliophile who prospered during the second half of the 15th century in San'a, had in his library at least two Biblical manuscripts with frontispieces — which *more Islamico* served as an ex-libris as well — framed with bands inscribed in Arabic characters.*

Fig. 157 Jewish illuminated manuscripts from Moslem countries are many, and cover the whole period. The oldest and finest belong to a group acquired in the Near East in the middle of the 19th century by the Karaite scholar, Abraham Firkovitch. He brought them to Russia long before he ruined his reputation by indulging in forgeries and deliberately falsifying genuine objects, in order to prove both the antiquity and the non-Jewishness of the Karaite community in the Crimea. A first skimming from this treasure was published half a century ago, and some of the plates have been reproduced repeatedly ever since. Judged on internal evidence, they are Syro-Egyptian, of the 9th–15th centuries. The subject-matter of these miniatures is Jewish — mainly objects once used in the Temple in Jerusalem, or else to be seen in synagogues or at private religious ceremonies. The ornaments are entirely Moslem, with the one notable exception of some vignettes formed from the Hebrew letter *samekh*.

Fig. 158 It is consequently not surprising to find quite a number of pages depicting the *mihrab*, complete with a pair of flanking columns and a hanging mosque-lamp, side by side with *Fig. 159* Temple objects and vignettes which might have adorned any Arabic Moslem manuscript of that period and region. In a way, the most interesting designs are those reproduced here. They belong to a manuscript, today unfortunately deprived of its colophon, showing geometrical ornaments of the most commonplace sort. Yet its subject can be located and *Fig. 160* dated. The lotus motif in the center of the panel is a well-known Saracenic heraldic

* That the Arabic script does not indicate a Moslem scribe is best proved by the Karaite Biblical manuscripts written in Hebrew, but in Arabic characters, the best known specimens of which are in the British Museum.

emblem and localizes the manuscripts in Syria or Egypt during the early Mameluk period (13th to 14th century); and the very significant panel in the second row shows the Maghribi hand of its master.

In the 15th century an important school of illumination developed in Yemen, which produced many Pentateuchs, decorated in a style similar to the decorative motifs of Yemenite metal work. Persian illumination of the 17th and 18th centuries also produced Hebrew illuminated manuscripts. Among them are prominent Persian paraphrases of the Bible, written in Hebrew characters and decorated with typically Persian miniatures, illustrating Persian epics.

Fig. 161, 163

V

One class of manuscript documents soon became a most popular object for decoration, the *ketubah*, i.e., marriage contract. Although they were never as lavishly illuminated as those of European provenance, they stand out among all other creations of the Jewish communities from one end of the Islamic world to the other. Different as they are, the Yemenite with their strong sense of decorative effect, and those from Herat, with their more vigorous colors, they represent the best that each community could offer in this field. In a class of their own stand the Judeo-Persian marriage contracts, imitating Persian decoration. Close to the marriage contracts are the *mizrah* plates and special plates for Purim. An outstanding example of the latter is to be found in the Israel Museum.

Fig. 164

Fig. 165

Fig. 166

In this short survey, appropriate space ought to have been given to Jewish religious architecture. But it is significant that in lands of Moslem rule it was never properly developed. Even the oldest of the rightly famous Spanish synagogues, Santa Maria la Blanca in Toledo, was erected — according to most conservative dating — already after the Christian reconquest. Most other buildings are either ruled out by their poor appearance, or by their modern date. This applies especially to secular architecture, the best specimens of which are works of the 19th century. As an earlier example we can mention, however, the ceilings of the house of a Jewish patrician in Aleppo, where the Jewish community flourished under the benevolent rule of Mehmed Rejeb Pasha in the first half of the 18th century.

Fig. 99

VI

What then was the standing of Jewish art in Moslem countries? And what was the Jewish contribution to Islamic art? This question, which one may say can be answered easily in the field of science, medicine, or philosophy, must remain open, when applied to the field of art: for the scope of Jewish art under Moslem rule must be established first; and with the very limited means at our disposal, this cannot be done at present. Although there is little difficulty in establishing the date and region where a Jewish work of art was produced in a Moslem country, the sad fact remains that unless it bears a Hebrew inscription, or is of a kind used exclusively for Jewish worship, it cannot be identified as Jewish. Of course, this does not apply to Jews only. It would be just as difficult to apportion the role of Armenians or Copts in secular works of art made in Islamic countries. Unless the signature of a craftsman reveals his ethnical origin, unless an inscription in a non-Arabic script or a religious invocation proves that he is not a member of the Moslem

community, there are no means of knowing whether he belongs to a minority group, and if so, to which.

This is not the only occurrence in the long history of the Jewish people in which the Jewish artist had no idiom of his own. But there is a difference which characterizes the ages. During the Hellenistic period, the Jewish artist was as much a son of his age as any other master. Artistically, he was completely assimilated to his environment. But from time to time, something would shake him — and he would carve a purely Hellenistic Syrian capital, or a sarcophagus as Roman as any in the Empire, or a lintel of his private house, and incorporate in it a seven-branched candlestick, or some other Jewish symbol. It was the inarticulate cry of a mute protesting his identity, powerless to do it in his own language — the idiom of artistic form — but protesting nonetheless.

During the nineteenth and twentieth centuries, too, Jewish painters and sculptors, artistically assimilated to their surroundings, from time to time felt the need to assert their Jewishness. At such moments — and in many cases these were rare and isolated moments — they painted Jewish life: either some scene out of Jewish history or simply a few Jews who happened to be nearby. Up to a point, this was as inefficient and inarticulate a cry as that of their Hellenized forefathers. But it was heard.

We have no means of knowing if the Jewish artist in Moslem countries ever felt this way. His secular work is as Moslem as it can possibly be. Artistically, he left no signature. He was an anonymous donor — and he made sure that his anonymity would not be betrayed to inquisitive historians of Oriental art.

THE ILLUMINATION OF HEBREW MANUSCRIPTS IN THE MIDDLE AGES AND RENAISSANCE

by FRANZ LANDSBERGER

So far as architecture, ceremonial objects, and mural paintings are concerned, medieval Jewish art has to a large extent been lost. That Jewish book-illuminations have been preserved in relatively great numbers is all the more remarkable in view of the many wanderings and sufferings of the Jews during those centuries. It would exceed the space here available even to classify all these illuminated manuscripts. It is only possible to give a general idea of this "art of the book," and to outline its development.

About the beginning of this art, our information is scanty indeed. Nothing is preserved, and the literary sources, too, are sparse. The fictitious "Letter of Aristeas" (written perhaps in the second century B.C.E.) relates that the Egyptian ruler, Ptolemy II Philadelphus (285–247 B.C.E.) wished to incorporate into his library at Alexandria a translation of the Five Books of Moses, and that the special copy brought to him for this purpose from Palestine was written in gold lettering. Elsewhere, too, we read of codices in which the name of God was written in golden script. The Babylonian Talmud (Sabbath 103b), however, comments on this practice unfavorably: "If one writes the names of the Lord in gold, the scrolls thus written must be set aside." Again, we read in the past-Talmudic tractate *Sopherim:* "One does not write a scroll with gold. It once happened that in a scroll of the Alexandrians the names of God were all written in gold. The matter was brought before the sages, who ordered it to be set aside."

The existence of gold script among the Jews then in the classical period is clearly demonstrated: and as it is nowhere mentioned in the pagan literature of the period, the Jews may even have been its inventors. It is true that the practice aroused opposition. But it is not unreasonable to assume that this referred only to the Torah-scrolls for synagogal use, and not to scrolls and codices in private hands, some of which may even have had illustrations of the Bible story similar to those which have been found on the walls and floors of synagogues of late antiquity. Indeed, various attempts have been made to demonstrate in early Christian book-art elements which appear to derive from this earlier Jewish tradition.

II

Yet these illuminated Hebrew codices of the first centuries of the Common Era, if they existed, are lost. Nothing is preserved earlier than the tenth century: and from this period, too, only single pages from Egypt, Palestine, and Yemen have thus far been made available to the student.

Fig. 157, 158

Here, too, gold plays a dominant part. Furthermore, the gold is used not only for letters but also for objects. We have, for instance, in 10th and 11th century Oriental manuscripts a fantastically shaped portal that closes in a semicircle and is supported by a central pillar. This design is composed of minute letters comprising various Biblical quotations. We have here an ancient usage. Already from heathen antiquity we know of *Carmina Figurata,* that is, poems, the letters of which formed an egg, a flute, the wing of a cupid, etc. In Jewish book-illumination, this custom continued throughout the Middle Ages. This micrography was especially popular in the writing of the *Masorah,* the marginal notes which determine the correctness of the traditional text of the Bible. They were written in the form of abstract patterns, but in the later Middle Ages also assumed the shape of

Fig. 167

plants, animals, grotesques, and even human figures.

To return to our oldest preserved codices, there are among them, besides the micrographic figures and marginal decorations, those ceremonial objects which were in the Tabernacle and Temple. The representation, however, is curious. One of the folios in a famous 10th-

Fig. 159

century manuscript, probably Egyptian, shows the Tabernacle not in three dimensions, but completely flat, its five walls lying side by side, like cards. Above the Tabernacle stands the seven-branched candelabrum, also laid flat. Above that is visible a golden strip with two tablets in the middle, two wings at the side. This is presumably the ark with the two tablets of the Law; only these tablets are not inside the ark, as related in the Bible, but placed perpendicular above it to make them visible. The wings denote the cherubs, for apparently there was some hesitation to show the complete figure of such holy creatures. Among the smaller objects we can distinguish two columns, apparently the columns that stood before Solomon's Temple. Here we have then a representation of what the Jew has lost, but for the rebuilding of which he hopes in Messianic times. It is the Messianic hope that made the subject of this folio so popular, and we shall repeatedly come across it in later centuries. There is little advance in the early Middle Ages beyond this representation, probably in obedience to the commandment which prohibited the imitation of natural objects, but not the representation of ceremonial buildings and their implements.

III

In order to follow up the further development of the art of illumination, we must turn to Spain, where the Jews lived, partly under Moorish, partly under Christian domination. Their book-illuminations were influenced now from this side, now from that. Islam had at one time taken over from Judaism the hesitancy to utilize pictures, and now reflected it back on the mother-faith. Christianity, another daughter of Judaism, had early freed itself from the prohibition of pictorial representation, and this departure, too, had its influence on the Jews.*

The former, non-pictorial, tendency is represented significantly and artistically by a series of Bibles, some of them very magnificent, decorated rather than illuminated, there being no correlation between the embellishments and the text, nor any attempt to delineate the human form or scenes out of life. The convention prevailed in these, moreover, of divorcing

* One of the standard Jewish works of reference reproduces a page from an elaborately illuminated MS. (a commentary on the Book of Psalms) purporting to have been executed in 1158 by one Abraham Hispanus(!). If authentic, this would obviously change the entire perspective of the subject. But the MS. (in the Palatine Library, Parma) is clearly not earlier than the 14th century; 1158 is not the date of copying but of the original composition; and Abraham Hispanus is not the scribe or illuminator but the twelfth-century author, the famous Abraham ben Meir ibn Ezra, called Ha-Sephardi (editor's note).

the decoration from the text, some supplementary treatise very lavishly decorated filling the first (or first and last) pages, while the Bible text itself was left plain, or nearly so. In these codices, the only attempt at relating text and decoration was the inclusion, in a number of cases, of a conventional representation of the vessels of the sanctuary which, as we have seen, links up with some of the earliest extant book-illuminations towards the end of the first millennium. A memorable case in point is the so-called Farḥi Bible in the *Fig. 168* Sassoon Collection, achieved in 1366–82 by Elisha ben Abraham Crescas, who was illuminator, as well as scribe. This is decorated from beginning to end in the most profuse style, many of the pages reminding one of the finest Moslem carpets and tapestries, with the lavish decorative use of verses in majuscule letters heightened in gold. The vessels of the sanctuary are here spread over several pages. But more important than these are the illuminations of the preliminary and final pages, in which magnificently indited verses from the Psalms surround an ornamental central panel, a lexicographical treatise figuring in minuscular hand in the margins. The first example shown here is under the influence of Islamic style, with bands that interweave with each other into knots. The area is not filled, and the lines shoot, like lightning, towards the four corners, lending the pattern a strange excitement. Throughout this manuscript the human figure is avoided, even when one would most expect it. Thus where the artist tells of the return of the spies from the Holy Land (Numbers, Chapter XIII) he shows a huge grape-cluster suspended from a wooden frame: there are no spies.

As an example of the other tendency in Spanish-Jewish book-art we may take the 14th century *Haggadah*. The *haggadah*—the ritual for the domestic service on the Eve of Passover—was always a favorite subject for illumination because of its small bulk, its appeal to women and children, its great popularity, and the very fact that it was not taken into the synagogue, where severer standards prevailed. In the more sumptuous Spanish *Haggadahs* the decoration preceding the text consists of many full-page miniatures of Biblical scenes, not, however, exclusively related to the subject-matter of the volume. On the contrary, the artist begins with the creation of the world and only gradually works *Fig. 172* his way up to the story of the Exodus. There follow pictures of the life of the miniaturist's own time. He shows us a synagogue with the Torah-shrine open and the distribution of dough and unleavened bread before the festival.

With regard to content, too, the artist still imposes on himself certain limitations: God is not portrayed. After representing the six days of creation, the artist of the Sarajevo *Haggadah* shows someone in a state of rest. To interpret that figure as a representation of God is incorrect. Here is not God but man, to whom is henceforth assigned the duty of abstaining from work on the seventh day. Where, in the picture of Jacob's dream the artist of the Sarajevo *Haggadah* represents angels, he makes them cover their faces with their wings. But in spite of these limitations, what power of expression there is in these scenes! The passage through the Red Sea is, indeed, pictured somewhat clumsily. But how vivid is the scene below: Miriam beats the timbrel, while the maidens hold their *Fig. 169* hands in dance. The influence of French art is strongly marked in the Spanish *Haggadahs*: the statues of the Wise and Foolish Virgins, in front of Gothic church portals, look similar. The text of the *Haggadah* is usually also illustrated. One *Haggadah* executed in Barcelona in the 14th century, found in the British Museum, has many *genre* scenes. Here we have *Plates 28, 29* not a single occurrence but recurrent events; it is a *genre* picture, but a *genre* picture with religious content. One of the text illustrations represents the father of the house, making

139

Fig. 170 the benediction at the end of the Sabbath and Passover, with his son holding a candle.

Yet another motif recurs in these manuscripts: the inital letters are sometimes distinguished from the others in size and color, which is preferably gold. In this process, these letters are frequently filled with abstract ornaments, floral designs, or even animals, and laid on a specially colored ground which shows patterned traceries. The whole is finally closed by a broad border, which here is crowned with Gothic arches. This enlarged initial is unknown to the Orient. It is the European product which the Christian art of the West had used for centuries, but which seems to have penetrated into Jewish art only in the 13th century, to remain there throughout the Middle Ages, modified in a way that the whole initial word is decorated, rather than the initial letter. The decorated panel is often in conjunction with tendrils or ribbons framing the rest of the text. One should note too the small twigs with tender leaves shooting from them; on some of them tiny birds are perched. This, too, is in accordance with Gothic art which, coming from France, penetrated to Spain, to Jews, as well as to Christians.

We will select one more of the numerous illuminated manuscripts from the Iberian Peninsula, written in 1476. It is generally called, after an 18th-century scholar, the Kennicott Bible, and is today one of the treasures of the Bodleian Library in Oxford. In accordance with the convention mentioned above, this splendid Bible is preceded and followed by a grammatical work, Kimhi's *Sepher Mikhlol.* Here, unencumbered by the sanctity of the Biblical contents, the artist gave free rein to his artistic imagination. The text, written in two columns, is ornamented in the center and at the sides with borders consisting of architectural designs or tendrils but occasionally also incorporating animals, sometimes humorously. At the lower edge of one page, for example, there is a hare feasting on leaves, and, at the top, a monkey swinging in the tendrils. The scribe's colophon, composed of "anthropomorphic" figures ingeniously incorporating human forms, is something of a *tour de force.* This should be compared with the not dissimilar conception, less successful, however, in execution, to be found in the text of a Spanish Bible of a somewhat earlier date. In the Kennicott Bible we again find the abstract ornaments familiar to us from the Farḥi Bible, the beauty of which here consists not only in the always new interplay of the lines, but also in the inexhaustible color combinations, the refinements of which cannot be conveyed in black-and-white. But, whereas the Farḥi Bible illustrates Biblical scenes without the human figure, the artist of the Kennicott Bible now and then overcomes this limitation, and, for instance, shows David as a mighty

Fig. 171 king, a crown upon his head, holding in his right hand a scepter in the shape of a huge club. In this manuscript, then, both tendencies of Spanish-Jewish book-illumination, the abstract and the naturalistic, have been reconciled.

IV

Turning now from Spain to France, it must be emphasized at the outset that culturally, and to some extent socially, the region of Provence in southern France belonged to the Spanish rather than to the French orbit, and the Provençal illuminated Hebrew manuscripts are hardly to be distinguished in scope and style from those of Spain. This region indeed was distinguished for its achievement in this sphere. Abraham ben Nathan haYarḥi at the beginning of the 13th century tells us that Avignon surpassed all other

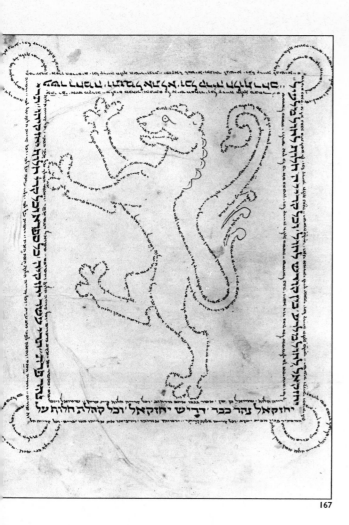

167. Rampant lion shaped in micrography: (Beginning of Masorah to the Book of Ezekiel). Germany 13th century. National Library, Vienna, Cod. hebr. 16, fol. 226.

168. Decorative page of the Farhi Bible by Elisha ben Abraham Crescas. Spain or Provence, 1366–1382. Rabbi S.D. Sassoon Collection, Ashdod, Israel.

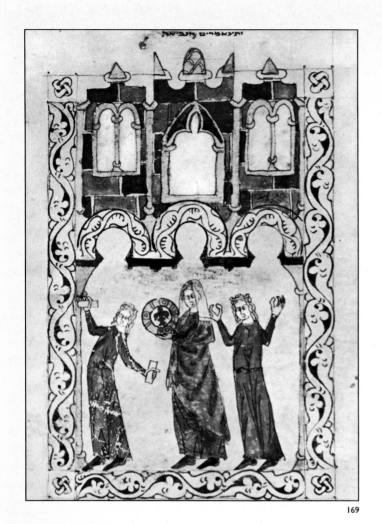

169 170

169. *Miriam and the Israelite women dance while beating the timbrel. Miniature from a Spanish Haggadah of the 14th century. British Museum, London, OR. MS. 2737.*

170. *Benediction at the end of Sabbat and Passover. From the Barcelona Haggadah, Spain. 14th century. British Museum, London, Add. MS. 14762.*

171

172

171. *King David. Marginal illustration to the beginning of the book of Kings in the Kennicott Bible, illustrated by Joseph ibn Hayyim in Corunna (N. Spain), 1476. Bodleian Library, Oxford, Ken. MS. 1.*

172. *The death of the firstborn of the Egyptians. (Exodus 12: 29–30), and the Children of Israel receiving presents from their Egyptian neighbours (Exodus 12:35–36). Miniature from a 14th century illuminated Spanish Haggadah. British Museum, London. OR. MS. 1404.*

173. *Aaron kindles the candelabrum. From a miscellaneous French manuscript of 1278. British Museum, London. Add. MS. 11639.*

174. *The Gates of Mercy. Page from the second volume of the so-called "Worms Mahzor", South Germany, late 13th century. National Library, Jerusalem, MS. Heb. 4. 711/2.*

173

174

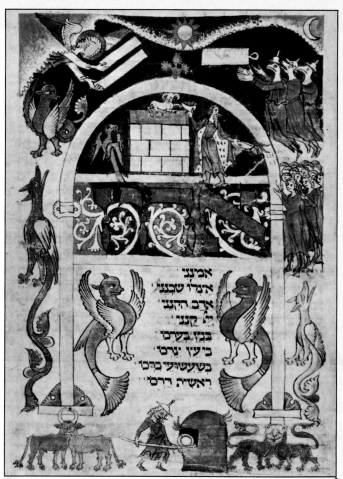

175. The Deer-hunt. From the first volume of the so-called
"Worms Mahzor", South Germany, 1272. National Library,
Jerusalem, MS. Heb. 4. 781/1.

176. The Giving of the Law and the defection of the Israelites.
Page from a 13th century German Mahzor. Bodleian
Library, Oxford, MS. Laud 321.

177

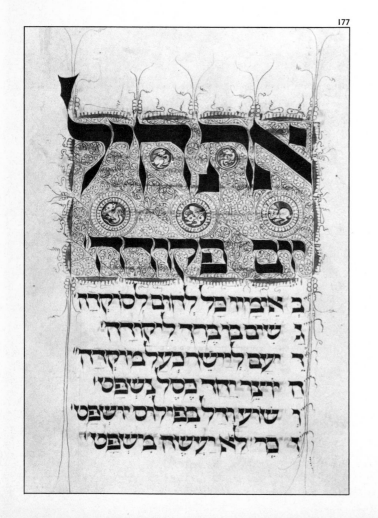

178

177. *Page of a German Mahzor, 1347. National Library, Vienna, Cod. hebr. 163, fol. 69.*

178. *A page from the Yahuda Haggadah. Germany, 15th century, depicting the marriage of Moses and Zipporah. Israel Museum. Jerusalem, MS. 180/50, fol. 17.*

179. *Passover meal. Detail from a Haggadah written by Meir Jaffe. Germany, 15th century. Hebrew Union College, Cincinnati.*

180. *The hare-hunt. Detail from a Haggadah written by Meir Jaffe. Germany, 15th century. Hebrew Union College, Cincinnati.*

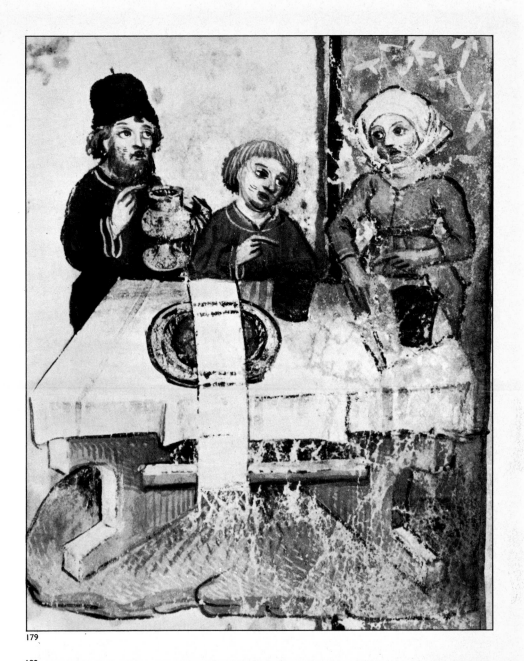

179

180

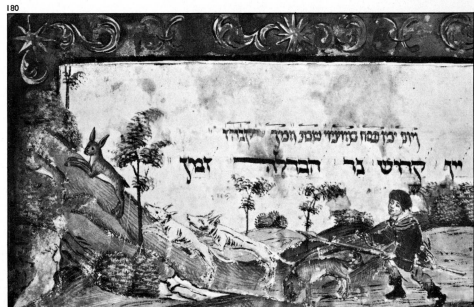

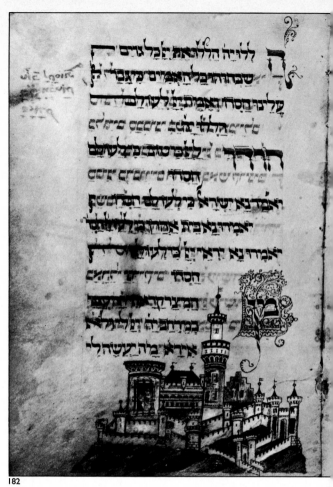

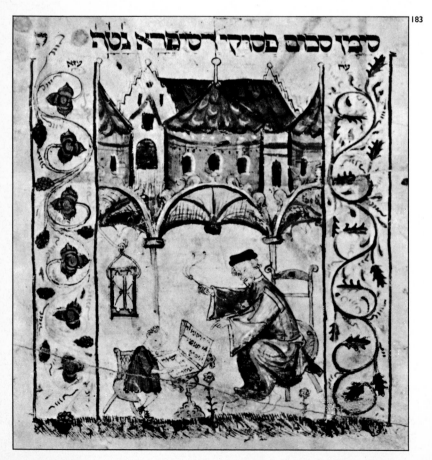

181. The Shepherd. Miniature in the Meshal ha-Kadmoni Isaac ibn Sahula. German manuscript of the 15th century following traditional pattern. National and University Library, Munich, Cod. hebr. 107, fol. 44.

182. Page from Haggadah illuminated by Joel ben Simeon, Italy, 15th century. Library of Congress, Washington, D.

183. Jewish school in the Middle Ages. Miniature from German 14th century manuscript of Pentateuch, Megillot and Haphtaroth. British Museum, London. (Add. M 19776).

184. Introductory page of the Aberdeen Bible, completed 1494 in Italy (probably Naples). University Library Aberdeen.

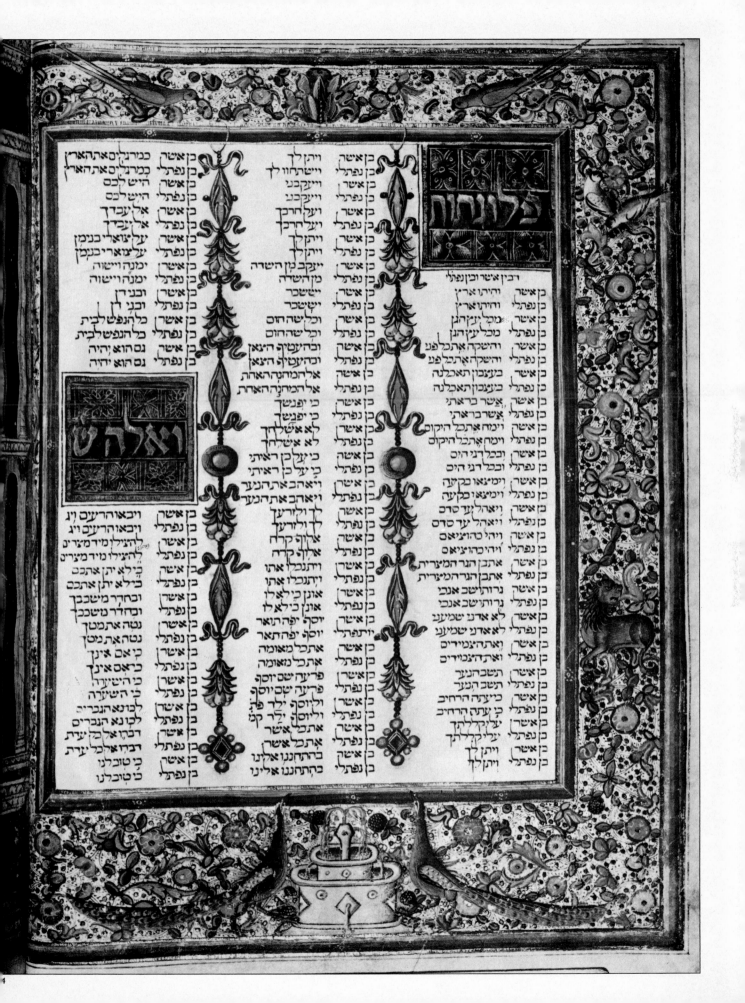

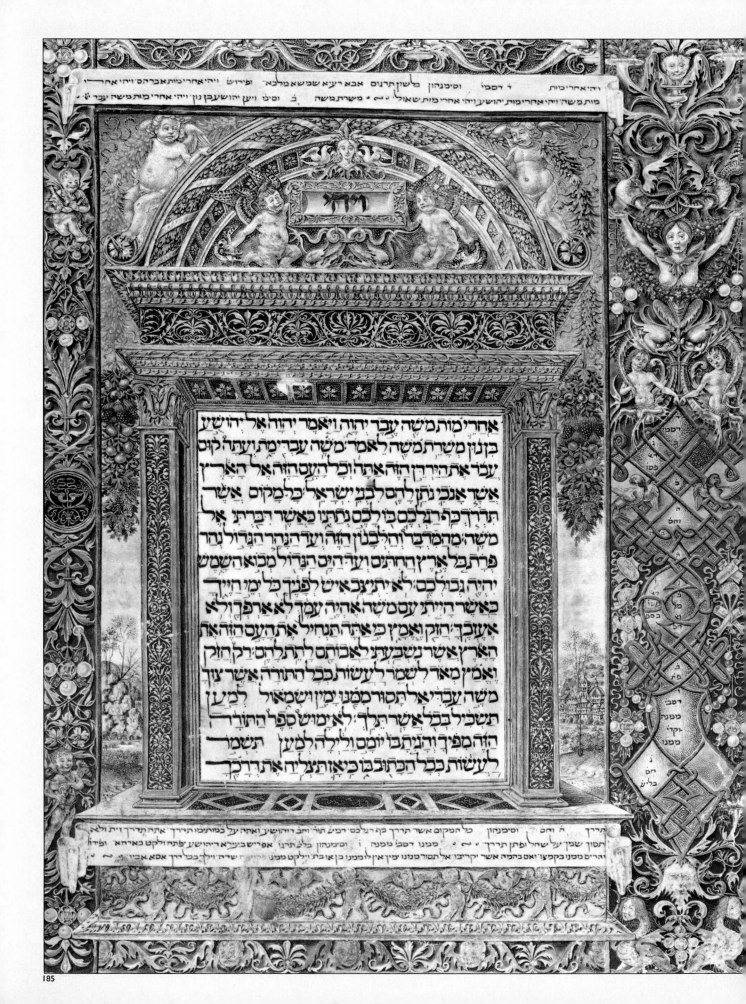

אַחֲרֵי מוֹת מֹשֶׁה עֶבֶד יהוה וַיֹּאמֶר יהוה אֶל יְהוֹשֻׁעַ
בִּן נוּן מְשָׁרֵת מֹשֶׁה לֵאמֹר מֹשֶׁה עַבְדִּי מֵת וְעַתָּה קוּם
עֲבֹר אֶת הַיַּרְדֵּן הַזֶּה אַתָּה וְכָל הָעָם הַזֶּה אֶל הָאָרֶץ
אֲשֶׁר אָנֹכִי נֹתֵן לָהֶם לִבְנֵי יִשְׂרָאֵל כָּל מָקוֹם אֲשֶׁר
תִּדְרֹךְ כַּף רַגְלְכֶם בּוֹ לָכֶם נְתַתִּיו כַּאֲשֶׁר דִּבַּרְתִּי אֶל
מֹשֶׁה מֵהַמִּדְבָּר וְהַלְּבָנוֹן הַזֶּה וְעַד הַנָּהָר הַגָּדוֹל נְהַר
פְּרָת כֹּל אֶרֶץ הַחִתִּים וְעַד הַיָּם הַגָּדוֹל מְבוֹא הַשֶּׁמֶשׁ
יִהְיֶה גְּבוּלְכֶם לֹא יִתְיַצֵּב אִישׁ לְפָנֶיךָ כֹּל יְמֵי חַיֶּיךָ
כַּאֲשֶׁר הָיִיתִי עִם מֹשֶׁה אֶהְיֶה עִמָּךְ לֹא אַרְפְּךָ וְלֹא
אֶעֶזְבֶךָּ חֲזַק וֶאֱמָץ כִּי אַתָּה תַּנְחִיל אֶת הָעָם הַזֶּה אֶת
הָאָרֶץ אֲשֶׁר נִשְׁבַּעְתִּי לַאֲבוֹתָם לָתֵת לָהֶם רַק חֲזַק
וֶאֱמַץ מְאֹד לִשְׁמֹר לַעֲשׂוֹת כְּכָל הַתּוֹרָה אֲשֶׁר צִוְּךָ
מֹשֶׁה עַבְדִּי אַל תָּסוּר מִמֶּנּוּ יָמִין וּשְׂמֹאול לְמַעַן
תַּשְׂכִּיל בְּכֹל אֲשֶׁר תֵּלֵךְ לֹא יָמוּשׁ סֵפֶר הַתּוֹרָה
הַזֶּה מִפִּיךָ וְהָגִיתָ בּוֹ יוֹמָם וָלַיְלָה לְמַעַן תִּשְׁמֹר
לַעֲשׂוֹת כְּכָל הַכָּתוּב בּוֹ כִּי אָז תַּצְלִיחַ אֶת דְּרָכֶךָ

85. *Opening page of the Book of Joshua in an illuminated Bible. Written in Portugal and illuminated in Italy, about 1500. Bibliothèque Narionale, Paris. Cod. hebr. 15, fol. 137.*

86. *King David. Introductory miniature to the Book of Psalms in miscellany volume compiled in N. Italy, late 15th century. Israel Museum, Jerusalem. (Rothschild MS. 24).*

87. *The Passover meal. Page from 16th century Italian Haggadah attributed to Abraham Farrisol. Adler Collection in the Jewish Theological Seminary, New York.*

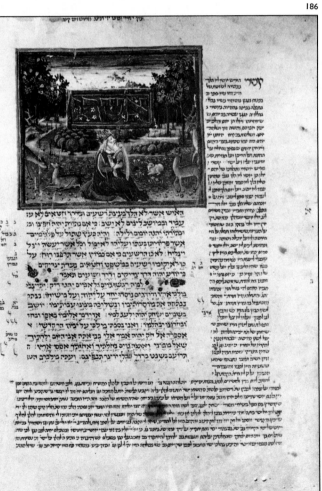

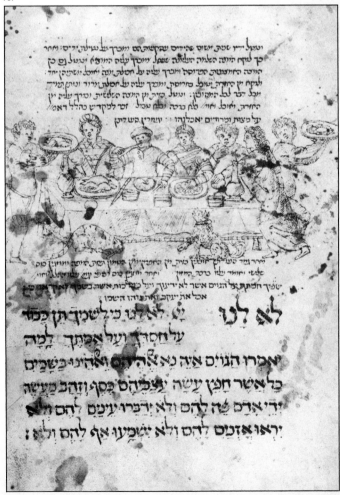

188. The Wayfarer.
Marginal illumi-
nation to Hag-
gadah Meir
Jaffe. Hebrew
Union College,
Cincinnati

Jewish communities in the smoothing out of parchment and its purple dyeing. This cultural influence is discernible particularly as regards Bible manuscripts, where, too, there was the tradition of divorcing the illuminations from the text and incorporating among them the sanctuary vessels, as has been the practice in the Orient and later in Spain. A characteristic example is a manuscript of the Bibliothèque Nationale in Paris, written in 1299 in Perpignan (a similar one, written in 1301, is in the Royal Library in Copenhagen, cod. hebr. 2), where these implements are spread across two pages. The choice of objects is deeply rooted in medieval pictorial tradition. In this case, the elongated proportions should be noted, corresponding to the vertical tendency dominating Gothic art.

It is probable that French Jewry produced some of the finest achievements in the realm of the illuminated Hebrew manuscript of the Middle Ages. Unfortunately, the wholesale burning of Hebrew books here in 1240 and afterwards must have destroyed many memorable specimens of such work, while the expulsions of the Jews in the 14th century ended the tradition at precisely the time when elsewhere it was entering upon its most fecund period. Nevertheless, there have survived a few medieval Franco-Jewish specimens of manuscript illumination which are of rare merit. The most remarkable, probably, is a manuscript of 1277–78, today in the British Museum (Add. MS. 11639). It is a miscellanea, comprising the Pentateuch, the Prophetical Lessons, and other parts of the Bible, together with selected liturgical texts and a number of other writings. Just as varied are the artistic illustrations, above all in the first 800 leaves, almost none of which lacks some artistic treatment, be it a coat of arms, an initial, or an illustration. Forty-one full-page illustrations are devoted to the Bible. Here and there, the same subject occurs twice, suggesting that more than one artist had a hand in this codex. This is the case, for instance, with Aaron kindling the seven-branched candelabrum. It will be recalled *Fig. 173* that the illustrations of the Tabernacle and its implements hitherto considered all lacked the human figure. Now this feature also penetrates into the Jewish field, and here, in the land of origin of Gothic art, the influence of this style becomes apparent in the slender figures which rise upward with a light inclination of the body.

In the 10th-century Egyptian miniature discussed above, only the wings of the cherubs on *Fig. 159* the Ark of the Covenant were visible. In the Sarajevo *Haggadah*, in the scene picturing Jacob's dream, the angels had, indeed, assumed human shape, but their faces were covered with wings. Our French manuscript has overcome all hesitation to represent them. In fact, there is hardly a more graceful representation than that one, where the cherubs guard the Tree of Life. Youthful figures with lifted wings, they hold slender spears in their hands. Here, too, we find this limitation to the flat plane. The cherubs, instead of surrounding the tree in a protective fashion, are placed above one another, the upper ones smaller than those below, as no more space was available.

V

Rich and enduring was the art of the book among Jews in medieval Germany. Here, it is true, Jews were expelled and massacred, but only at specific times and in specific regions, so that in the Middle Ages German territory was never wholly devoid of Jews or of Jewish artistic achievement.

In the literature about Hebrew manuscripts there is sometimes mentioned an illuminated 12th-century commentary to the Pentateuch which was owned by the Synagogue of

Worms: but this is based on a confusion. However, the decoration of Hebrew manuscripts must already have begun at that time. There were at least Masoretic notes in the shape of animals, for already Rabbi Judah the Pious of Regensburg (d. 1217) protests in his *Sepher Ḥasidim* (p. 709) against such levities. We show, as an example of this art, cultivated especially in Germany, a page not from the 12th but from the 13th century. It is from a codex containing the Prophets and Hagiographa. The animal represented here, introducing the book of Ezekiel, is a lion, evidently with reference to the prophet's vision.

Plate 30

Fig. 167

The most interesting work of German-Jewish manuscript art of the 13th century is the two-volume prayer book the first volume of which is of 1272, while the second volume is not dated. They were formerly preserved in the Synagogue of Worms, and now in the library of the Hebrew University of Jerusalem. From the second volume of the so-called Worms *Maḥzor* we illustrate what may be interpreted as the Gates of Mercy, mentioned in the early morning prayer on the Day of Atonement. Their columns rest on wolves, symbolizing the victory of good over evil. Above the round arch appears a multi-colored city, probably of Messianic import — the longed-for Jerusalem.

Fig. 174

In the representation of the human figure there is greater hesitation here than in the above-mentioned French manuscript, no doubt because of a lingering tie with tradition. A hymn for the second day of Pentecost begins with the words "A loving hind," and the artist draws two deer pursued by dogs. Behind them comes the hunter, but he, too, is given the head of a dog. This device of evading the stern prohibition of the Ten Commandments by depicting men with animal or bird heads was fairly common in medieval German-Jewish manuscripts, with results sometimes striking, sometimes merely bizarre. A most curious example is a *Haggadah* manuscript in the Bezalel Museum in Jerusalem. In this, the distorted human faces are very pronounced. In the same tradition as the Worms *Maḥzor*, though les well-executed, is another liturgical manuscript, probably somewhat later in date, in the Bodleian Library, Oxford. Here a portal somewhat similar to that which we have described is surmounted by a delineation of the Giving of the Law at Sinai, in which all the principal characters, though wearing the traditional Jewish pointed hats, are given birds' heads!

Fig. 175

Fig. 176

Whereas in the Worms *Maḥzor* the gate was still rounded at the top, in accordance with the Romanesque style of architecture, those which appear in later German miniatures are topped with a pointed arch, demonstrating the triumph of the Gothic tradition. One of the most beautiful manuscripts in this style is a codex of Maimonides' Code, the *Mishneh Torah,* completed in 1295–96 by Nathan ben Simeon Halevi of Cologne (Academy of Sciences, Budapest; Codex Kaufmann 77). The surfaces of the letters making up the initial words are decorated with ornaments and at the same time set off against a background of stars and little squares. Out of this background — and in this there is a resemblance to the Sarajevo *Haggadah* — flow narrow bands which frame the text. Where these bands again become horizontal, below the text, they increase in thickness. In the example we show they enclose the Sacrifice of Isaac, a basic conception in Jewish symbolism. Abraham has drawn the sacrificial knife, but is stopped by an angel descending from heaven. In spite of the dramatic impulse of the story, there is great delicacy in the slender body of the Patriarch, as is to be expected in a Gothic conception. Like other scenes decorating the manuscript, this one has no relation to the text. It originated from sheer joy in illustration, here even illustration of the naked body.

The graceful style of this manuscript is continued in later books, as for instance in a Pentateuch of about 1300, now in the Schocken Library, Jerusalem. On its first page — the only one illuminated — it has no fewer than forty-six medallions, encircling Biblical scenes from the Creation to the story of Balaam. A *Maḥzor,* written in 1347, now in the National Library, Vienna (cod. hebr. 163), has initial words on a ground consisting of lines, and delicate as spiders' webs.

Fig. 177

Only in the 15th century do initials and runners become broader and heavier, and the figures develop not only in height but in breadth. How short and massive, for instance, are the figures of Moses and his people crossing the Red Sea, as they are shown in a Festival Liturgy (Parma, Bibl. Palatina, cod. Rossi 653) written and illuminated about the middle of the 15th century — probably in northern Italy, but by a German artist.

The most important work in this style is the famous Darmstadt *Haggadah,* preserved in the Landesbibliothek of that place. A complete color reproduction of this codex (Leipzig, 1927) has made it one of the most familiar of Hebrew illuminated manuscripts, and enables all art-lovers to enjoy its remarkable beauty. This lies not so much in the figures of individuals, who do little else but eagerly read the *Haggadah,* but in the entire pages which enchant us with their initials and designs of plants and animals. There is sometimes hardly any room left for the text which is limited to three or four lines. Everything else is filled with borders or decorations encircling the initial word and the text. A comparison with the *Mishneh Torah* just mentioned makes it clear how the Darmstadt *Haggadah* replaces the lightness and elegance of Gothic art by a heavier and more solid style. The manuscript was written and illuminated by a certain Israel ben Meir of Heidelberg, who, to judge from the style of his work, lived in the first half of the 15th century.

Interestingly enough, a manuscript has been preserved by the son of this Israel ben Meir, named Meir Jaffe, who lived in the second half of the 15th century. This is a *Haggadah* now in the Library of the Hebrew Union College, Cincinnati. The son took over from his father the talent for beautiful initials and ornaments; each page here is framed with an ever-varying border. However, his interest in scenes with figures is more strongly developed than is the case with Israel ben Meir. One need only look at his "Seder Meal." Three persons — father, mother, and son — participate; they are possibly the portraits of the patron and his little family. How much depth is there alone in the table with its golden platter, the symbolic dishes on it hidden by a cloth! Elsewhere, the artist shows us a chase recalling the hunting scene of the Worms *Maḥzor.* However, in the Cincinnati *Haggadah* it has another meaning. The sequence of blessings to be recited when the *Seder* night coincides with the termination of the Sabbath forms, with its initial letters, the word "Yaknehaz." With but a slight alteration this was made to form the mnemonic *"Jagt den Has"* ("chase the hare"), and in a large number of manuscripts of German origin (and later in some printed texts) was illustrated with a hare-hunt. The artist of the Cincinnati *Haggadah,* in contrast to the Worms *Maḥzor,* places this chase in a real landscape with bushes and trees. Here, the hunter runs, the hounds jump, the hare tries to escape.

Fig. 188

Fig. 179

Fig. 180
Fig. 175

The approximately contemporary Second Nuremberg *Haggadah* (now in the Schocken Library, Jerusalem) like its sister, the Yahuda *Haggadah* (in the Israel Museum), surpasses the Cincinnati *Haggadah* in its delight of *genre.* After the first pages, illustrating the preparation of unleavened bread from the moment when the grain is brought to the mills up to the baking of the *matzah,* the text is profusely illustrated.

Fig. 178

These lightly sketched illustrations were, at that time, used by German Jews also for secular books. Even if book decorations were principally used for religious writings, there was no dearth of works of a profane nature deemed worthy of illustration. For instance, the animal-fables known as *Meshal ha-Kadmoni* ("Ancient Parable") by the Spaniard Isaac ben Solomon ibn Sahula were, as we are informed, illustrated by the original 13th century author; and his example was not infrequently followed by later copywriters in Germany, as evidenced by copies in Oxford, Milan, and Munich. From the last-mentioned

Fig. 181 a typical pen-drawing is here reproduced. We see a shepherd who, while pasturing his flock, light heartedly plays his flute. All is executed with powerful realism.

This scene, as well as those in the Yahuda *Haggadah,* were doubtless influenced by contemporary German art — especially by the art of engraving, which began to flourish in Germany at that time. It taught, on the one hand, the unhesitating entry of scenes of daily life, like the picture of a Jewish school, on the other hand, the linear treatment of the

Fig. 183 subject placed on the parchment without a background (often at the margin of the page), so that the picture almost appears to have been added casually.

VI

The art of Jewish book-illumination reached its zenith, as is to be anticipated, in Italy. In this country conditions were complicated as far as the art of the book was concerned. Italy was long a land of immigration for persecuted Jews, and in the 14th and 15th centuries especially, many Ashkenazi Jews who fled to that country maintained to a great extent their own traditions. Those German immigrants, who worked as miniaturists, have a mixed kind of style, halfway between German-Jewish and Italian-Jewish art. Among these, to mention only one, was Joël ben Simeon, creator of several *Haggadot*

Fig. 182 including one now in the Library of Congress, Washington. Let us look, for example, at the illustration to a verse from the Psalms, "Out of my straits I called upon the Lord." We see a man praying, with folded hands, in his dungeon in a turret where, as so often in the Middle Ages, prisoners were confined. The city adjoining the tower shows decidedly Italian features — above all, the broad city hall and its tower which does not, as in Germany, surmount the building, but stands adjacent to it as an independent edifice. At the close of the 15th century, a new wave of immigrants swept into Italy from the Iberian Peninsula. This left fewer marks in the field of book-illumination than did the German wave, partly because, at that time, the art of illuminated manuscripts was already declining. Nevertheless, we have some manuscripts, perhaps begun in Spain and completed in Italy, or else executed in collaboration between Italians and Spaniards, the pages of which show partly Spanish and partly Italian influences. A memorable case in point is the Bible Codex in the Library of the University of Aberdeen, completed in

Fig. 184 1494 by a Spanish scribe, probably in Naples. This perpetuates the former Spanish tradition, the Bible text being preceded by a number of sumptuously decorated pages — without, however, any human figures — grouped around an extraneous text. Memorable, too, is a Bible (cod. hebr. 15) in the Bibliothèque Nationale in Paris. Apparently this unfinished manuscript, too, was brought from Spain to Italy in the course of the flight.

Fig. 185 Our example, almost certainly made in Italy, still shows remnants of Moorish art in the intricate pattern of the right-hand border. In the main, the Italian style predominates on this folio. It shows the front of a portal in formal perspective, with those classic decorations which earned for this style the name Renaissance, rebirth of antiquity. In the rounded arch

appears the first word of the Book of Joshua written on a small tablet held by naked cherubs. Other cherubs sit on the arch of the portal bearing garlands. In this manner the whole folio is pervaded by a harmony typical of all Italian art, and also of Italian-Jewish book illuminations.

The native Jewish settlement in Italy was the oldest in Europe, and deeply imbued with Italian culture. How long its tradition of manuscript illumination dates back, it is impossible to determine. The oldest extant examples date no older than to the 14th century, but one may assume that Hebrew codices in Italy were illuminated long before this date. As in northern Europe, there alternately developed the fashion to interpret the Biblical prohibition of pictorial art more liberally — that is to say, to avoid only the representation of God, but to abstain from nothing else; for nature was at that time no longer an object of reverence, least of all in books. Hence, plants, animals, and even people are now pictured with increasing enjoyment.

A supremely charming work, in this respect, is an Italian miscellany of the late 15th early 16th century, in the Bezalel Museum in Jerusalem (formerly owned by the Rothschild Collection ms. 24). It is greatly to be regretted that here only one of its numerous delightful small pictures can be shown. This illustrates the beginning of the Psalms, and we see King David seated on a red cushion playing his harp. He sits in a garden which loses *Fig. 186* itself in woods. Attracted by the sounds of music, deer emerge from the forest and listen without fear. This lovely scene is surrounded by a gilt framework, and this again is wholly characteristic of Italian-Jewish book illumination, its joy in creating a picture-like effect. If, in 15th century Germany, there had been an influence from engravings, with their linear emphasis, in Italy it came from easel pictures with their golden frames, decorated churches, and palaces.

This tendency towards picture-like effect is even more pronounced in a manuscript of Maimonides' *Mishneh Torah,* formerly in Frankfurt-am-Main, but now in private hands in New York. Unfortunately, only the second volume of this valuable manuscript is preserved, but this is enough to prove the eminent artistic abilities of the illuminator. Each book begins with an initial word in burnished gold — a technique with which Jewish book-art is well acquainted. But at the same time, this initial word is placed against a picture illustrating the contents of the tractate. In this, as in many other instances, the initials and pictures arise not only from an artistic need but simultaneously serve a practical purpose: they facilitate the finding of the desired paragraph or section. Our example introduces the section dealing with Temple service. The Temple is here shown as an octagonal structure, obviously an echo of the Mosque of Omar in Jerusalem, a picture of which many a fifteenth-century traveler to Palestine brought back with him as a memento. Two altars flank the Temple; on the right a youth sacrifices an ox, while a priest prepares the burnt-offering on the left. Behind the Temple lies the undulating countryside with hills and trees in the distance. All this is not presented in accurate perspective, but nevertheless achieves an illusion of depth.

Such a degree of technical skill having been mastered, more ambitious achievements were possible. Thus, for example, we have a very successful attempt at representing the interior of a synagogue in a superb manuscript of Jacob ben Asher's ritual code, the *Arba'ah Turim,* copied for a wealthy Jewish banker in Mantua in 1436, and now in the Vatican Library (Codex Rossi 555). The interior of the synagogue is thrown open and permits us to take part in a Jewish religious service as held in 15th century Italy. On the

extreme right is the Torah shrine, a noble piece of Gothic carving. A dignified old man, the draped scroll in his hands, stands in front of it; surrounding him is the congregation devoutly enwrapped in their prayer vestments. Plants and human figures are gracefully intertwined in the surrounding framework.

At the beginning of the three other main sections of this memorable codex there are similar illuminated pages, composed in an identical manner, depicting scenes from contemporary life — a court justice, a butcher's shop, and a delightful representation of a Jewish marriage of the period. The fashionable clothing indicates the prosperity with which the Italian Jews of that day were blessed.

Even more than in Germany, the religious field is abandoned at times in Italy, and secular compositions are frequently illustrated. Avicenna, the great Arab physician of the 11th century, was the author of a comprehensive work ("Canon") on medicine, which had become a standard work in its Hebrew translation. It was, therefore, natural that some wealthy 15th century Italian Jew, probably a physician, commissioned a magnificent copy of this classic; after many vicissitudes, the volume is today in the University Library of Bologna. Here, too, the books are introduced by fully illuminated pages.

About the middle of the 15th century a serious rival began to threaten the hand-written and hand-illuminated book: the art of printing with movable letters, together with illustrations in the form of woodcuts, and later of engravings. Illuminated manuscripts yielded to this rival only gradually. This fact is illustrated by an early 16th century Italian *Haggadah* in the Jewish Theological Seminary in New York, from which we *Fig. 187* reproduce the page depicting the familiar *Seder* meal. Now, the participants wear the ample and splendid costumes of the High Renaissance known to us from the pictures of Titian or Veronese; the table, too, heavy with foods, testifies to the abundance of that time.

Even in the 17th century the art of the written and hand-painted book did not cease, and in the 18th century it had a revival. This will be treated elsewhere in this volume by another author.

VII

We have repeatedly stressed the dependence of Jewish manuscript art on the countries and times in which it originated. This involves the question whether these works, certainly written by Jews, were illustrated by non-Jews? The colophons appended to the text sometimes provide us with conclusive evidence. To be sure, not all manuscripts have colophons, and those which have them usually tell of the work of the scribe, not of the illustrator. Nevertheless, there are exceptions, and these include some manuscripts of high artistic merit. To mention the most important: at the close of the 13th century *Mishneh Torah* written in Germany, Nathan ben Simeon Halevi thanks God that He made him "worthy to write, to complete and to finish with painted pictures the book of Ibn Maimon." The 14th century Farḥi Bible was written and illuminated by Elisha ben Abraham Crescas, and the Kennicott Bible, by Joseph Hayyim. Here we have the interesting situation that the scribe and the illuminator are different persons — the demand for illustrated manuscripts among Jews in Spain was apparently so great that a division of labor was desirable.

We even know a tractate on the art of illumination *(Libro de como se facem as cores)* composed by a Portuguese Jew by the name of Abraham ben Judah ibn Ḥayyim. The tractate deals with the preparation of colors, above all gold. Such information can certainly be based only on personal experience. His work is in Portuguese, but written in Hebrew script, which proves that he is addressing not the general population, but his co-religionists.

This documentary evidence is reinforced by various arguments which would make it likely that many such manuscripts, though they do not mention the fact, were actually illustrated by Jews. The Sarajevo *Haggadah* and the rest of the memorable series of 14th century Spanish *Haggadot* have no colophons. However, we often find here several scenes assembled on one page; for instance, the creation of Eve, the Fall, the expulsion from Paradise, and the first human couple at work. Christian art would picture these happenings from left to right. Here, however, the first scene starts on the right and continues towards the left. This is the direction of Hebrew script, and apparently the artist-scribe naturally set down the sequence of his scenes in this order. Again: the Christian artist of the Middle Ages, illustrating the Old Testament, depended mainly on the text as he found it in the Bible. The Jewish medieval artist, on the other hand, knew a large number of legends which had been woven around the Bible and made ample use of them.

We see, for instance, in *Haggadah* manuscripts how Abraham is locked into the burning oven by Nimrod, but emerges unharmed; Joseph's dead body is cast into the Nile by the Egyptians; Pharaoh bathes in the blood of Israelite children to rid himself of disease; Moses is imprisoned by Jethro but freed by his daughter, Zipporah, whereupon he marries her. This wedding (illustrated in the Second Nuremberg *Haggadah*) faithfully shows other characteristic features drawn from daily life. Thus, bride and bridegroom stand under a *tallit,* the mother being next to the former, and the rabbi, wine cup in hand, next to the latter. A miniature in the Cologne *Mishneh Torah* of 1295/96, already mentioned, reinforces the point. Moses with the Tablets of the Law stands in front of a rock, from which a crowd of men and women look out. This apparently illustrates the well-known Talmudic legend which tells how as the Israelites reached mount Sinai, God turned the mountain over them, saying: "If you accept the Torah, it is well; otherwise, this mountain will be your grave." Completely Jewish in feeling, and therefore presumably painted by Jewish artists, are also the Messianic scenes, the coming of Elijah, or the appearance of the Temple and its implements.

Nor is it only the *Haggadah* that exploits these topics. The French miscellany of the 13th century, now in the British Museum, displays on separate pages three mythical creatures— the Yakhani or Ziz (a gigantic bird, here shaped like an ostrich), the Leviathan (a colossal sea mammal), and the aurochs *(shor ha-bar),* a kind of buffalo with an enormous tail. Messianic hope is legendarily linked with these animals, which were to furnish the food for the righteous in the Messianic Kindgom. Even the festive meal at which these foods are consumed is portrayed in a German Bible of the 13th century, preserved in the Ambrosian Library in Milan (cod. hebr. 30–32).

In spite of the seriousness of these scenes, humor occasionally gains the upper hand. In the Washington *Haggadah,* we see the arrival of Elijah who is riding on a donkey, and on the same mount are also seated no fewer than four children, some on the tail! In the same *Haggadah* the three symbolic dishes are reproduced which are essential to the

observance of the *Seder* service: the paschal lamb, the unleavened bread, and the bitter herbs. The unleavened bread is held aloft by a monkey, while a man holds up the bitter herbs, at the same time pointing with his free hand at his wife! This and similar pleasantries are repeated also in other *Haggadot.*

Jewish book-illuminations, moreover, show, at times, illustrations which are manifestly Jewish by reason of their fidelity to the actual words of the Hebrew text. There is, for *Fig. 188* instance, the sentence occurring in the *Haggadah:* "Go forth and learn what Laban, the Aramaean, designed to do to thy father" (i.e., Jacob). The artist of the Cincinnati *Haggadah* illustrates this by a young wanderer walking across a field, a lance over his shoulder and a book in his hand; thus, he separates the phrase, "Go forth and learn" from the context and illustrates it independently. Similar treatment is found in connection with the "four sons" of the *Haggadah,* who have their different attitudes towards the miraculous happenings of the narrative. As regards the youngest "who knows not how to ask questions," the *Haggadah* advises: "Thou shalt open up for him." Many an illustrator, however, deliberately ignoring the true meaning of the phrase, puts a companion next to this son who opens up his mouth. Such peculiarities could hardly have been painted by non-Jews. From all this, it is manifest that the number of Hebrew manuscripts illustrated by Jewish artists is far greater than the handful thus designated in the colophons.

From the Jewish point of view, there were no objections to calling in non-Jewish assistance in matters of graphic art. Such outside aid can be traced through the whole history of Jewish art, and could also have been utilized for the art of making books. In this field, however—in contrast to, for example, architecture—everything favored the Jew. No matter to what occupations the majority belonged—a Jewish scribe was indispensable to a congregation. The need for Torah-scrolls, prayer books, codices of the Talmud, the works of the great religious sages, marriage contracts, and bills of divorce was sufficient to give him, at least in a larger community, a full-time occupation and at the same time an assured livelihood.

Such writing required great care and, as far as Torah-scrolls were concerned, had to meet not only ritual but also aesthetic requirements. From this it follows that some of these scribes felt impelled to decorate their manuscripts, where it was permissible, with initials, ornaments, and even illustrations. Barred from other artistic achievements through personal inhibitions (by the prohibition of making images) or through outward restrictions (by not being accepted into guilds), they found the art of book-making in many cases the only channel for their artistic urge. For this reason medieval illuminations are of such great significance for Jewish art in general. Among other peoples, the art of illumination is only one aspect, and not even the most important one, of their artistic productivity. For medieval Jews, however, the art of the book is the center of all artistic activity. All talent is directed toward it. Here, the rich storehouse of Jewish thought and imagination, of Jewish solemnity and Jewish humor find pictorial expression. And here, finally, we have the clearest evidence of the fact that the Jews of the Middle Ages enjoyed form and color.

Plate 20. Candlestick for the Havdala ceremony marking the end of the Sabbath, from Frankfort, 1741. Acquired by subscription in memory of the late M. Narkiss, for thirty-five years director of the Bezalel Museum. Israel Museum, Jerusalem.

Plate 21. The Ignatio Bawer Hanukkah lamp from Augsburg, early 18th century, decorated with the two-headed German eagle and the figure of Judith brandishing the sword with which she cut off the head of Holofernes. Israel Museum, Jerusalem.

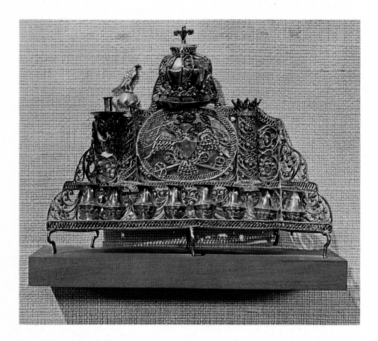

Plate 22. Filigree silver Hanukkah lamp from the Ukraine (18th century). Israel Museum, Jerusalem.

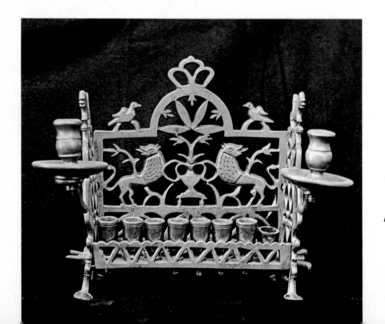

Plate 23. Simple Hanukkah lamps made in Poland of brass alloy, were not inferior in ornamentation to the more magnificent lamps of silver and gold. The symmetrical motif of a pair of animals is one of the traditional characteristics of such lamps. The earliest Hanukkah lamps were apparently of clay or stone; the oldest known metal lamp with a back plate dates from 14th century France.

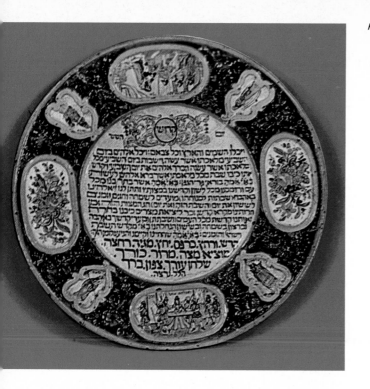

Plate 24. *Majolica Passover dish, apparently made by "Isaac Cohen, the first" of Pesaro, 1614. Special ceramic Passover plates were common in Spain in the 14th century and from there, their use spread to Italy and other countries. The center of this plate contains the benediction for the wine and the catchword reminders of the order of the ceremony. The upper cartouche in the border shows Joseph revealing his identity to his brothers, while the lower one records the custom of celebrating Passover Eve by imitating the Israelites in Egypt, dressed for their journey and walking round the table as they eat the paschal lamb. Jewish Museum, New York.*

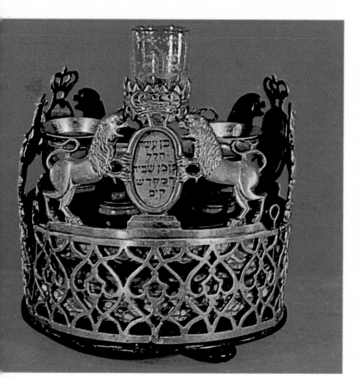

Plate 25. *Magnificent Passover dish from Poland, 18th century. The lower part of the dish, divided into three compartments for each of the ceremonial matzot, is enclosed by an ornamental copper grille which supports six lions, bearing aloft three crowns. The upper part of the dish held containers for the haroset, the bone symbolising the Paschal lamb, an egg to represent the daily Temple sacrifice, and parsley to act as the bitter herb, eaten to recall the bitterness of the bondage in Egypt. Jewish Museum, New York.*

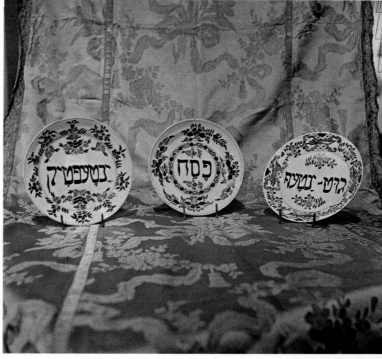

Plate 26. *Delftware for Passover, inscribed in Yiddish; from left to right: "festive", "Passover", "Happy holiday".*

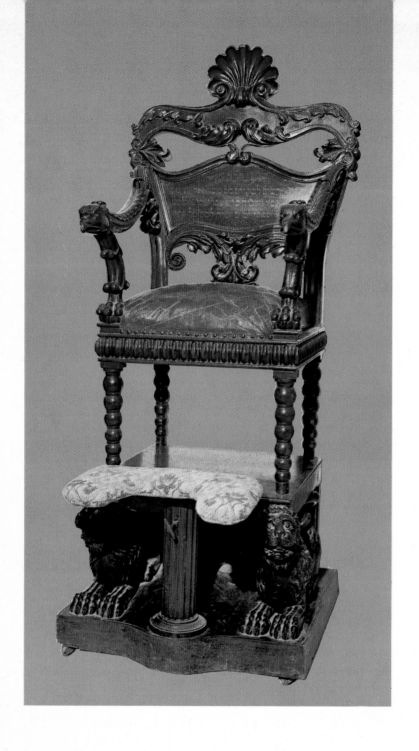

Plate 27. The chair on which the new-born infant was circumcised was called the Chair of Elijah, as he is considered the patron of babies, protecting them zealously, especially after circumcision. Chairs specially fashioned for the ceremony, with a footrest for the godfather holding the infant on his knees, were to be found in Jewish communities in Germany and Italy. This one is from Italy, now in the Roman Synagogue, Jerusalem.

Plate 28. Drinking the first cup of wine and washing the ha Under the table, a dog gnaws a bone. From the century Barcelona Haggadah. British Museum, Lon Add Ms. 14762.

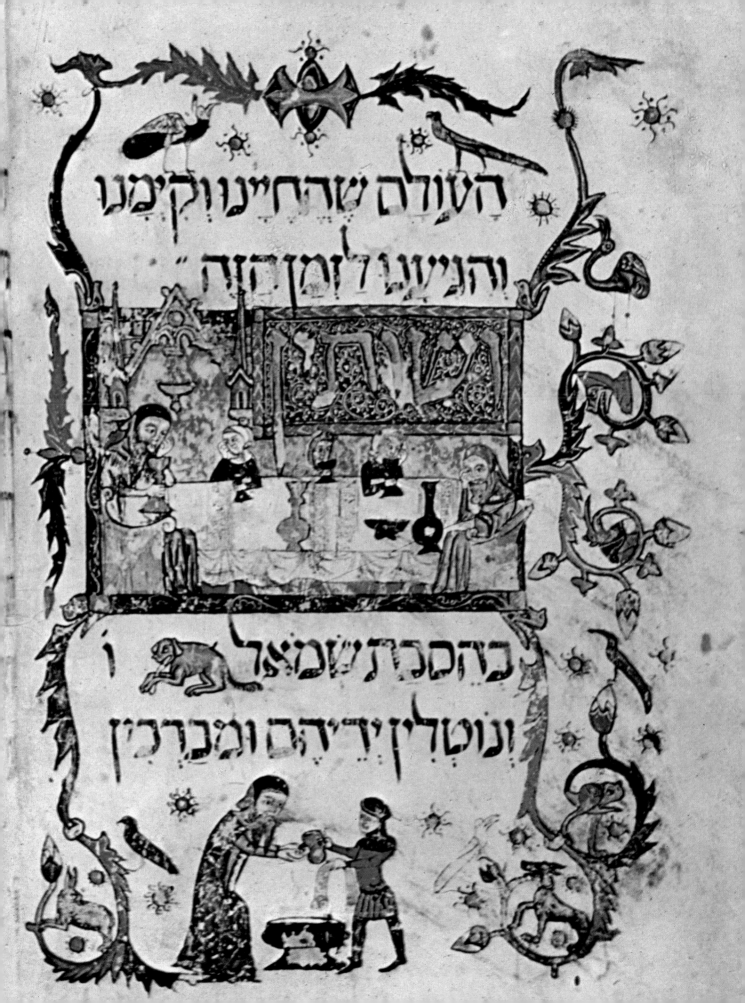

הָעוֹלָם שֶׁהִחְיֵנוּ וְקִיְּמָנוּ

וְהִגִּיעָנוּ לַזְּמַן הַזֶּה ״

כְּהֶסֵבַת הַשְּׂמֹאל וְ

וְנוֹטְלִין יְדֵיהֶם וּמְבָרְכִין

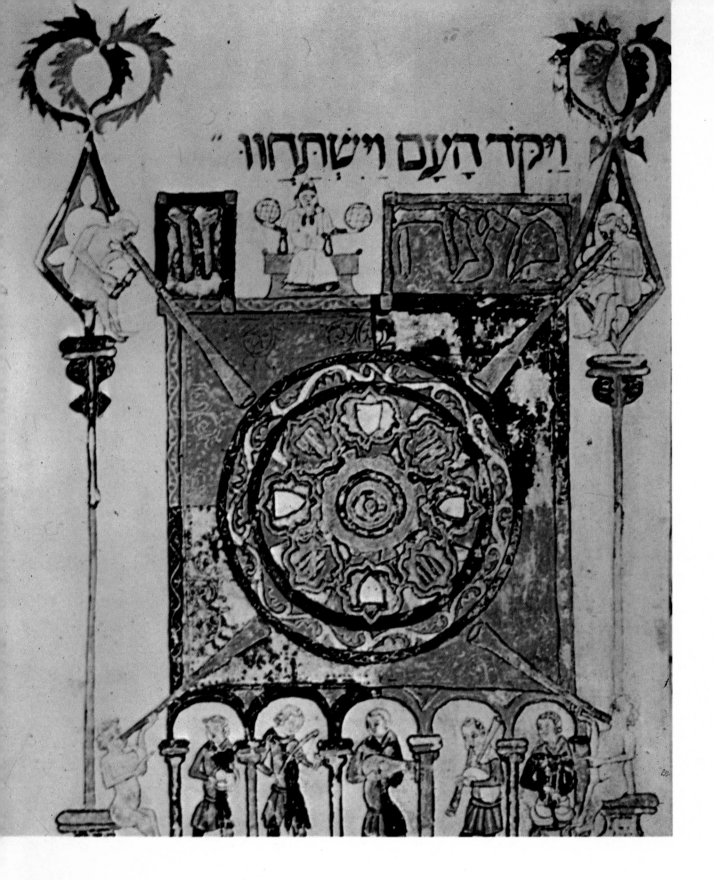

ויקד העם וישתחוו

Plate 29. Illuminated page introducing the text explaining the
significance of the *matza* in the Passover ceremony. The
nude figures blowing trumpets in the four corners represent
the four winds, thus making the round *matza* the symbol of
the whole world, while the five musicians below stand for
the harmony of the world. Another page from the 14th
century Barcelona Haggadah. British Museum, Add. Ms.
14762.

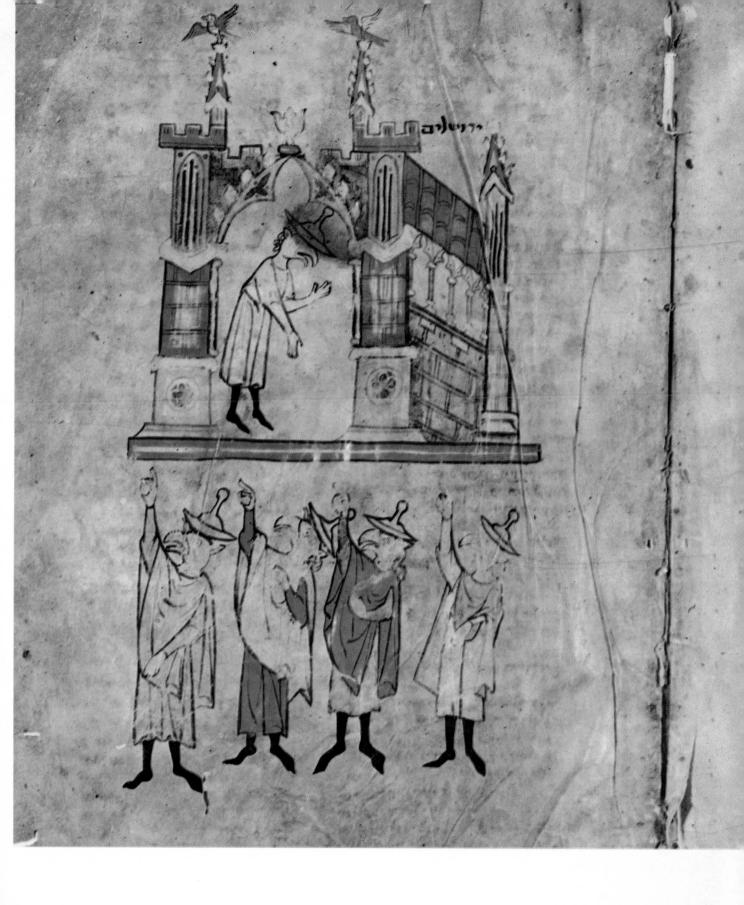

Plate 30. The city of Jerusalem, pictured in accordance with medieval tradition as a splendid Gothic edifice, to which the Jews raise their arms in adoration. The illustration comes from the final page of the "Bird Head Haggadah," written and illuminated in South Germany about 1300. Israel Museum, Jerusalem.

Plate 31. Ketubah (marriage contract) from Krems (Austria), 1391–2. This is one of the earliest European illuminated marriage contracts and only four fragments of it have servived. Here the groom, Shalom ben Menahem, is holding up a large ring while his bride, who wears a crown, extends her arm towards him. The tradition of decorating ketubot is known from Egypt since the 10th century. National Library, Nienna.

THE ILLUMINATION OF HEBREW MANUSCRIPTS AFTER THE INVENTION OF PRINTING

by ERNEST M. NAMENYI

With the invention of printing the role played by miniatures and illuminations in European art came to an end. Calligraphy was to eke out a precarious existence in the chancelleries; its domain would no longer be the book but the manufacture of documents and diplomas, and it, too, would be exposed in its turn to the influence of the printed letter.

From the point of view of art, printing at the outset led to an impoverishment. The miniaturists and illuminators of long tradition had acquired an unusual facility in the art of decorating a page. Rich patrons were accustomed to this magnificence and regarded printed books as the product of a craftsman, not of an artist. Indeed, in order to conceal their plainness, the first incunabula were entrusted to miniaturists in order to be embellished by hand with ornamental letters and designs. This was the case, for example, in various copies of the earliest editions of the Hebrew Bible. But such survivals were exceptional. The ornamentation of printed books took before long a new direction in accordance with the techniques of printing and the ever-increasing number of copies which poured from the press.

Nevertheless, in Jewish book-art, printing did not completely eliminate miniature art, and even as late as the 17th and 18th centuries, Jewish artistic creation found one of its most characteristic expressions in illuminated books. The *sopherim* (or scribes) never disappeared from the scene of Jewish life, because it was their duty to copy Torah-scrolls and certain other religious texts for use in the synagogue. Strict regulations governed this type of work, all artistic fantasy being excluded. The constant desire to give a perfect form to their calligraphy preserved among the *sopherim* an artistic aspiration which they were able to satisfy fully only outside of their principal vocation. Thus, for example, scrolls of the Book of Esther *(megilloth)* were often enhanced with artistic decorations. Another field for the creative work of scribes, in the countries where Sephardic culture predominated, was the preparation of *ketuboth,* or marriage contracts. And finally, in the 18th century there reappear *Haggadoth* and prayer books illustrated with miniatures, as well as communal registers and those of synagogue charities and subsidiary organizations.

The forms of European art applied in all these fields of artistic activity. We will revert to them one by one. Baroque and rococo became a universal language, culminating in the classicism of the end of the 18th century. Nothing contributed more to the dissemination

of these forms of expression than the spread of the art of engraving. Through this means, the *sopherim,* like all craftsmen and artists, became familiar with the works of art of all Europe. They were thus able to draw inspiration from it for decorative motifs and the illustration of books and scrolls.

II

The outward form of the *ketubah,* or marriage contract, is not fixed by any religious prescription; only its contents are determined by rabbinic rules. The custom of illuminating *ketuboth* is proved by documents dating from the 10th century. Thus, one marriage contract discovered in the Cairo *Genizah* has its text encircled by a colored architectural decoration in micrographic writing; while some of the text is in color.

The custom to decorate *ketuboth* seems to have been widespread later on, for the first known medieval specimen after the one referred to above, is of German origin, being dated *Plate 31* 1391, at Krems (Austria). It represents the groom on the right extending a large ring towards his bride. However, few of these works of art prior to the 17th century have survived. The largest number of them (with the exception of some Oriental-style *ketuboth* from North Africa and the Balkans, which seem to preserve an old tradition of exuberant floral decorations) come to us from Italy, which was the essential home of this art. Here, families vied with one another in commissioning richly illuminated *ketuboth* on the occasion of a marriage: indeed, the Sumptuary Laws enacted by the community of Ancona in 1776 forbade its members to spend more than the sum of 40 *poali* in the illumination of the marriage contract.

In the 17th century, the forms of Italian baroque dominated the artistic conception of these documents with many remnants of the soberness of the Renaissance. In the 18th century the forms of baroque remain, but a certain excess of decoration appears. Thus a superb Modena *ketubah* of 1756 (British Museum, MS. Or. 6706) has the text written within a portico of two twisted columns surmounted by cherubs. At the base, two miniatures ornament the work, the whole completely encircled by a cut-out garland of colored flowers. The structural forms of baroque are before long supplanted by the light grace of rococo, also expressing itself in rich floral decoration. Towards the end of the century a more severe classical taste makes its appearance, as for example in one beautiful document decorated in Ferrara in 1775, bearing the majestic figure of Samuel (Hebrew Union College, Cincinnati, Ohio).

The text of the contract is often placed inside an architectural doorway, sometimes in a portico with two openings, recalling the tablets of Moses. In the Balkans and Islamic countries of the old Ottoman Empire, these doorways occasionally take the form of the outline of a window or of a *mihrab* (prayer-niche). Floral decoration is never lacking, inevitably bearing the imprint of the period and the place where the work was done. In cities without artistic tradition, this floral decoration, sometimes with folkloristic overtones, generally encircles the traditional coats of arms of the two families—a very common motif in Italy.

Another element frequently used were the signs of the zodiac, thus creating a link with the engraving in certain printed prayer books, as well as with the floor mosaics of the Galilean synagogues of the Classical period. The signs of the zodiac are complemented by symbols of the four seasons, while the legendary coats of arms of the twelve tribes of Israel are also sometimes included.

In more elaborate miniatures a drawing of the City of Jerusalem in the spirit of Psalm 137 ("That I place Jerusalem at the head of my joy") is quite frequent. On certain *ketuboth* again, we find a series of illustrations of Psalm 128: "Thy wife shall be as a fruitful vine, in the innermost parts of thy house; Thy children like olive plants, round about the table." These are occasionally depicted in contemporary costume.

Illustrations of the Song of Songs and the Book of Esther — especially if one of the bridal couple bears the name of Esther or Mordecai — lend themselves particularly to the marriage contract. Some specimens are surrounded by minuscular writing in ornamental patterns of the Song of Songs or kindred text. *Ketuboth* are frequently illuminated, too, with representations of Adam and Eve, the first married couple, shown under the Tree of Knowledge in the Garden of Eden. Besides such iconographic elements, themes in connection with the individuals about to be married were used to decorate these contracts. Rabbi Abraham de Boton of Salonica (1545–88), in his responsa (15), discusses the inclusion in the *ketubah* of portraits of the married couple, together with the sun and the moon. He does not approve of it, though he hesitates to oppose it outright. Nevertheless, we meet (e.g., on a 1718 Sienna *ketubah* in the Jewish Museum, Budapest) pictures of the couple in their wedding clothes. On an elaborate marriage contract (probably executed in Amsterdam) of two members of the Texeira and the de Mattos families, who were joined in wedlock in Hamburg in 1690, we see not only the portraits of the married couple under a *huppah*, or canopy, held up by angels, but also the entire assemblage, including a rabbi reciting the benedictions, and the *hazan* holding a wine-goblet.

It was a common practice to allude to the names of the married couple by scenes representing Biblical personalities whose names they carried. The duties and the occupations of the young couple were also illustrated. Thus on the Sienna *ketubah*, mentioned above, the virtue of hospitality is represented by a series of miniatures. These portray the husband and his bride receiving distinguished visitors on horseback in front of their house; the husband followed by servants bearing provisions; the housewife drawing wine from a cask and turning the millstone; and finally the guests sitting around the table with their hosts.

The names of the artists who illuminated these marriage contracts are not generally known, nor is it certain that they were always Jews, though a few signed specimens are extant which prove that this was sometimes the case.

The framework of the *ketubah* was sometimes engraved, instead of being painted by hand. In Italy, we find a beautiful and elaborate copper-plate form surmounted by Adam and Eve, nude, under the Tree of Knowledge, with vignettes and bevies of *putti* (cherubs) below: this seems to be of the 16th century and was perhaps executed at Mantua. In Holland, Salom Italia, a painter and engraver of Italian origin, of whom we shall speak *Fig. 190* again in various connections, produced, at about 1648, a copperplate *ketubah* (subsequently colored by hand) showing a number of rural scenes, some of them Biblical. This was later superceded by another, far simpler, in Dutch taste, with plain floral and architectural decorations and the drawing of a young couple. This type, with some modifications (in 1693, for example, the name of the much-loved *Haham* Isaac Aboab was added at the base as a tribute to his memory) was current for many generations, until the Age of Emancipation. A copy executed by H. Burg was in use in London until the middle of the 19th century.

Although the *ketubah* was the most common document to be illuminated, it did not

stand alone. Other opportunities were taken by *sopherim* with artistic talent to enhance the magnificence of their work by the use of miniatures in a similar fashion. Next in order of prominence are the epithalamiums, or marriage-poems, generally in Hebrew. Floral decorations, with allusions to the subject matter of the poem (e.g., a house for the newlywed), were often appended to such documents in Italy and Holland. Other occasions were not lacking. Rabbinical diplomas, for example, could be ornamented with the crown of the Torah and encircled by decorations of acanthus leaves and cherubs. The custom of decorating university diplomas with miniatures (including those of Jews, when they graduated, for example, at Padua at this period) could well serve as a model. There is extant even a license for a member of a wealthy family to act as *shohet,* or ritual slaughterer, in which the decoration includes a man performing this function.

Fig. 189 An example of this type of *ketubah* of 1857 from Rome is at the Israel Museum; on it we see national Italian flags, along with angels blowing trumpets, the sun and the moon, and two fishes. Fish, as a fertility symbol, was a common feature in marriage contacts, *Fig. 191* as can be seen in another *ketubah* at the Israel Museum, of 1880 from Singapore.

We are charmed by the naiveté of the tablets used to mark the Eastern direction *(mizrah),* *Fig. 192, 193* to which one turned in prayer, as decoration for the walls of the *succah* on the Feast of Tabernacles, or as amulets. Thus, for example, mystical parchments bearing the divine name *shaddai* represent the best in the Jewish popular art of Alsace. Other instances are the *omer* calendars, which were common in all countries.

III

The main field of artistic activity maintained by the *sopherim* after the invention of the printing press was the ornamentation of the scrolls of the Book of Esther. For the ceremonial reading by the *hazan* in the synagogue on the feast of Purim, only scrolls written according to ritual prescription could be employed. For private use, however, illuminated *megilloth* were in great fashion. Moreover, while the decoration of the *ketuboth* is limited to Italy, and to a lesser extent the countries of Sephardi tradition, the embellishment of the *megilloth* existed all over Europe from the 17th century onwards. The text continued to be written generally in the traditional fashion, but the scrolls were decorated with miniatures or with a copperplate or etched framework.

How early the tradition of illuminating the *megillah* goes back is impossible to ascertain. A superb unique specimen in sepia in the Library of the Athenaeum, Liverpool, is clearly dated 1453, but obviously belongs to the 17th–18th century; another with the date 1512 in the John Rylands Library, Manchester, displays the style, costume, and general characteristics of a period of at least two generations after this date; while one executed at Castelnuovo near Sienna (c. 1567), now in the library of the Hebrew University, Jerusalem, is decorated rather than illuminated. On the other hand, the illuminations to the Book of Esther in the Alba Bible, executed with Jewish collaboration in Spain in the 15th century, reproduce certain characteristic features of the later *megillah* illumination (e.g., Zeresh's emptying of household refuse on the head of her husband, imagining him to be his Jewish enemy Mordecai); and this makes it conceivable that illuminated *megilloth* were known in the Iberian Peninsula at this period. Extant specimens of the late 16th century both from Central and from Southern Europe plainly indicate a long antecedent tradition. From this period, in any case, the record is continuous.

In Italy, two types of illuminated *megilloth* may be distinguished. One, the most frequent,

is purely ornamental. The columns of the text are framed with ornaments, either linear, formed of entwining ribbons of rich fantasy and coloring, or else acantho-floral; sometimes, animals, too, are used, in imitation of the frames adorning the pages of the Renaissance manuscripts. Occasionally, the beginning of the scroll, which is cut out into a point, contained the coat of arms of the owner's family in the midst of lavish ornamentation. The illustration of the text, however, stands by itself. Thus, for instance, a beautiful *megillah* of the beginning of the 17th century in the Bibliotheca Casanatense in Rome (Cas. 4851) retains the floral and geometrical ornamentation between the columns, but above these displays illustrated miniatures of the various episodes of the Book, taking into account the *midrashic* interpretations, all enclosed within geometric patterns.

In most cases, however, an architectural decoration prevails. The text is framed by the arches of an arcade and surmounted by elaborate tympana. The twisted columns are girdled in accordance with baroque taste with garlands of flowers, and support cornices adorned with vases and allegorical figures. Between the bases of the columns and above the columns of text are vignettes, illustrating the events told in the story and (generally towards the end), the customs associated with Purim — the presentation of gifts, the banquets, the dancing.

The same way competent 18th-century artists produced the splendid *megilloth* preserved by the Jewish community of Padua, the Kaufmann Collection in the Academy of Sciences of Budapest, and in the Jewish Museum in London. In this work stress is laid on the connection between the various parts of the Holy Scriptures and the Book of Esther. The symbolic human figures on top of the balustrade refer to the moral of the story. The medallions between the pedestals of the columns and those above the columns of text illustrate the narrative and the customs of Purim. The whole is completely harmonious and, despite its richness, never loses its vivacity.

A completely different tradition is represented by a series of *megilloth* superbly executed in sepia. Between the columns of text the characters of the story were drawn on a black background. Above, garlands of foliage gush out of vases, while birds flutter around medallions with heads. Below, flowers and lions surrounded the medallions. This beautiful piece, resembling a wood engraving, seems to be of a 16th-century type, as the costumes show too. Of this type of *megillah* several specimens exist, including some late copies (e.g., one executed at Venice in 1748 by a Polish artist, Aryeh Loeb ben Daniel). Probably the finest is the one in the C. Roth Collection, Jerusalem, which was found (together with *Fig. 194* another of the same type) by the present owner in the south of France. There is, thus, good reason to believe that there was an engraved prototype of French origin, probably emanating from the Jewish communities of Avignon and the Comtat Venaissin. It is likely that wood engravings illustrating the Book of Esther existed in certain Jewish communities early in the 16th century. The traditional norms for the writing of the text of the Book prescribed that the names of the condemned sons of Haman should figure, in bold characters, in an otherwise blank column. The fantasy of the miniaturists sometimes filled this up with a representation of a gallows on successive stages of which hangs one of the ten unfortunates!

In other *megilloth* (presumably made in Italy in the 17th and 18th centuries) an elaborate illumination presenting scenes of the stories of Esther is cut out of the parchment, with superb skill, showing the silk lining underneath and forming a laced frame to the text. There are instances in the Jewish Museum in London and in the C. Roth Collection, *Fig. 193a*

153

both unfortunately unsigned, but perhaps from the same hand. Such illuminations found sometimes on *ketuboth* were widely current in Holland during the 17th century and thence made their way on folkloristic *mizraḥs* into Hungary, Poland, Alsace, and North Africa, where they remained in fashion until the middle of the 19th century.

Alongside these illuminated scrolls there appear from the 17th century *megilloth* with copperplate borders. Outstanding among these is one here illustrated, several copies of which are extant. The quietness of the ornamentation is equaled by the beauty of the vignettes. The arcades vaulting the columns are surmounted by a balustrade adorned with flowers and birds. Between the bases of the columns there are twenty vignettes depicting the story of this Biblical novel. The last engraving represents the entrance of the Messiah into Jerusalem, taken from the Venice *Haggadah* of 1609, giving a messianic character to the whole. The technical execution was as follows: the decorative portion of the scroll was printed from one plate; the vignettes, which were inserted later on, from separate small plates, into the open spaces; the text was then filled in by hand.

Two more engraved *megilloth* are extant in a great many copies. In both, the columns of text are separated by decorative pillars. The top of one is adorned with small landscapes having no connection with the contents of the Book, while at the bottom sixteen vignettes follow the story and finish with an illustration of the celebrations of Purim. These vignettes, printed from separate plates, are joined together with vases containing flowers. The page containing the blessings is framed with scenes of the story of Esther. The other *megillah,* probably Italian of the 17th century, is notable for the medallions placed above the written columns; each contains the bust of a character in the story, surrounded by acanthus leaves. The last plate, framing the blessings, has the initial word with ornamented lettering and, as tail-piece, five characters (Haman, Mordecai, Esther, Zeresh, and Harbona) carrying oval signboards — probably characteristic of the décor of contemporary Purim plays. These two variants, of less artistic value than the scroll described previously, had a great influence on the hand-illuminated *megilloth* of the 18th century. The Christian engraver Francesco Grisellini of Venice also produced a beautiful *megillah* in 1748, framing the text with arcades capped by a balustrade with vases of flowers and birds, and illustrating the story of Esther in vignettes set below the text.

In the middle of the 17th century the production of engravings moved from Italy to *Fig. 216, 190* Amsterdam. The *megilloth* and *ketuboth* executed by Salom Italia in Amsterdam are among the finest in Jewish art. We know two of his works in copperplate; the conception *Fig. 190, 219* and execution are both of remarkable artistry. He places the characters on pedestals between the columns of text. The text is framed by a rich architectural design with baroque tympana crowned by flowers and figures of women holding palms. In the larger of these scrolls, made in 1637, vignettes representing the various scenes of the story, as well as charming landscapes, are engraved between the bases of the columns. These engravings are missing in the second scroll, the smaller one of 1660. From the same hand we have also some pen-drawn *megilloth.* They are of the same artistic conception as the engraved scrolls. At the beginning of the scrolls, a medallion borne by two angels carries the artist's signature. A *megillah* of outstanding artistic merit was made in 1687 in Amsterdam by Aaron de Chaves. The text is surrounded by lush floral ornamentation animated by all kinds of creatures. The only illustration is at the beginning of the scroll, a medallion representing Esther before Ahasuerus.

The 17th-century *megilloth* with copperplate ornamentation are either of Italian or of

Dutch origin. From 1700 onwards decorations by engraving appear also in Germany. One such scroll with decorations was executed by the Christian painter-engraver J. J. Frank around 1700. The border of the scroll consists of acanthuses with birds and female torsos and of oval medallions with landscapes. The columns of text are separated by twisted columns topped by vases with flowers and small statuettes. At the beginning of the scroll three small engravings illustrate the story of the Book. In all these *megilloth* with engravings, the text remains written by hand, except for the column showing gallows and the names of the sons of Haman. Two *megilloth*, however, were engraved entirely on copper — one an indifferent piece of the 18th century, the other, executed by Marcus Donath in 1834 at Nyitra (Hungary), a work of candid folklore.

From the 17th century onwards, hand-illuminated *megilloth* were produced in great numbers in Germany. These are only variants of the engraved scrolls; indeed, in some cases the actual copperplate borders are enhanced with watercolor. Some of them, on the other hand, give evidence of fine artistic taste and solid craftsmanship. In the beginning, as was the case generally in southern Germany, Italian influence predominates. There are a great number of folkloristic *megilloth*, which frame the text of the Biblical story with a naïve decoration, not entirely devoid of grace, using flowers and the signs of the zodiac. Among the most interesting of these is a crude Alsatian scroll of the end of the 18th century (Klagsbald Collection, Paris), where Vashti assumes the features of Marie-Antoinette and is beheaded by the guillotine!

Decorated (but not illuminated) scrolls of Esther were found also, though less frequently, in the Orient. One Persian type shows the text within attractive colored borders. Here the hypothetical ancestry of Haman and of Mordecai, for many generations, is elaborately embossed with fine decorative effect. Perhaps the most curious illuminated *megillah* from the East is one (C. Roth Collection) partly decorated in Chinese style of the 19th century. None of the decorations illustrate the text. The beginning of this scroll *Fig. 195* is decorated with the classical Buddhist and Confucian symbols. Towards the end, illuminations in the fullest sense figure, so that we are shown an executioner in Chinese dress, Chinese children making their culinary preparations and (in the usual place, at the foot of the penultimate column) gaily celebrating the feast.

IV

There is a close relationship between the art of engraving and good penmanship. It is only natural that Amsterdam, where for more than a hundred years Hebrew books had been published with ornamental engravings, should also witness the rise of fine penmen whose production transcends the level of craftsmanship. Epithalamiums (i.e., marriage poems) were very fashionable at the time, especially among the Sephardim, and, as has been mentioned, were presented to the bridal couple in an artistic form. Another matter for calligraphers were books of apologetics in Spanish, which, because of their anti-Christian polemic character, were not intended to be printed. A whole line of excellent penmen produced manuscripts which give clear evidence of the high artistic standard of the Dutch metropolis. Prominent among them was Jacob Gadelle, who was an influential teacher of calligraphy in Amsterdam in the middle of the 17th century. The specimens of his hand still extant testify to a rather pedantic taste, perfect skill in the execution of the title pages, as well as of the richly ornamented initials.

Noteworthy copyists, who executed such work, include Benjamin Senior Godines

(c. 1675) whose rich artistic production will engage us elsewhere, Abraham Machoro (c. 1700), Jehudah Machabeu (c. 1664), and Michael Lopez (c. 1719). A small masterpiece, at present in the museum of the Hebrew Union College in Cincinnati, was produced by an excellent scribe in collaboration with a real artist. In Amsterdam in 1756 Yekutiel Sopher wrote a small psalter containing a pen-drawing of David, with a convincing expression of majesty and humble devotion. The rococo title page and decorative vignettes imitate copper engravings in a very ingenious manner. The picture of David is signed, A. Israel. Probably this is a work of Aron Santcroos, who signed the engraved title pages of the famous Amsterdam edition of the Talmud (1752–65) in Hebrew *"al yede Aharon bar Avraham Yisrael."* He also finally illuminated with contemporary scenes a Hebrew epithalamium to celebrate a wedding in an aristocratic family in 1775. From about this time, moreover, a number of competent writing-masters begin to make their appearance in various other centers of Western Europe — e.g., Israel Solomons, who worked in Oxford at about the same time.

Another type of Hebrew illuminated manuscript of this period, which derives from Italy, is of peculiar interest. A precious possession in many households in that country was a roll (sometimes transferred into book-form) in which were briefly recorded the various cities and holy sites of Palestine, including the graves of the "saints" of the Biblical and post-Biblical periods which were the objects of pilgrimage. These brief descriptions were accompanied by naïve drawings, gaily colored, which gave the reader an approximate idea of the appearance of the places in question. Between the various extant manuscripts there is a close family resemblance, and there is, therefore, every reason to believe that they were all based ultimately on an identical prototype executed perhaps by a visitor to or emissary from the Holy Land in the Renaissance period.

V

In the eighteenth century, the Germanic countries witnessed a renewal of the illuminated book. Two circumstances may be said to have contributed especially to this unique artistic, and primarily Jewish, development. One was the continued vitality of the art of the synagogal scribe, the other was the emergence of the new circles of wealthy Court Jews, who endeavored to imbue every circumstance of Jewish religious life with an atmosphere of luxury and beauty.

Thus, a veritable "court art," as it might be termed, came into being around these solid Jewish businessmen. We need not be surprised, therefore, to learn that the most sought-after of these illuminators, Aron Wolf Gewitsch, also executed a psalter for an Austrian archduke. There is, however, a great difference between the court art of the 17th century and that of the 18th, when the latter's solemn quality gives way to a more humane feeling, less stiff, more intimate, coming nearer to the bourgeois taste.

These illuminated books of the eighteenth century are exclusively liturgical. *Haggadoth, megilloth,* Sabbath prayers, domestic formularies, books of blessings, circumcision registers, psalters, and incidental prayers constitute almost the entire artistic production. The art of engraving exerts its influence on the technique as well as on the iconography of the manuscripts of the 18th century. The pen-drawings closely imitate engravings. It is sometimes difficult to perceive the difference between these drawings and copperplate engravings. The imitation of the engraving is coupled with the imitation of the printed letter for the written text. Since the finest printed books then came from Amsterdam,

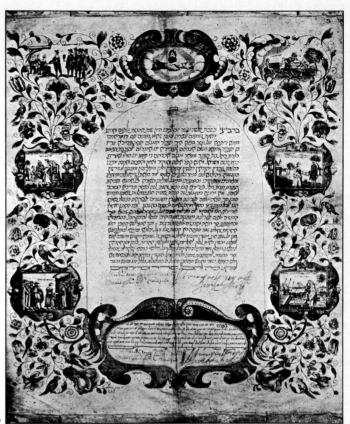

189

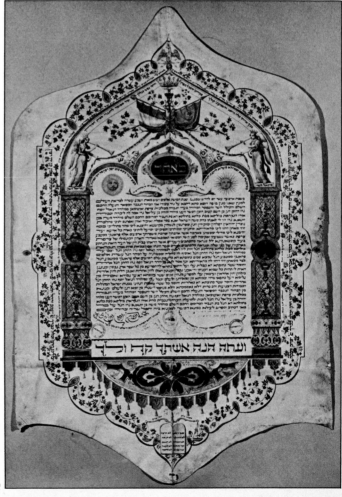

189. *Illuminated marriage-contract (ketubah), Rome 1857. Israel Museum, Jerusalem.*

190. *Illuminated marriage-contract. Rotterdam 1648, copper plate by Salom Italia. Israel Museum, Jerusalem.*

190

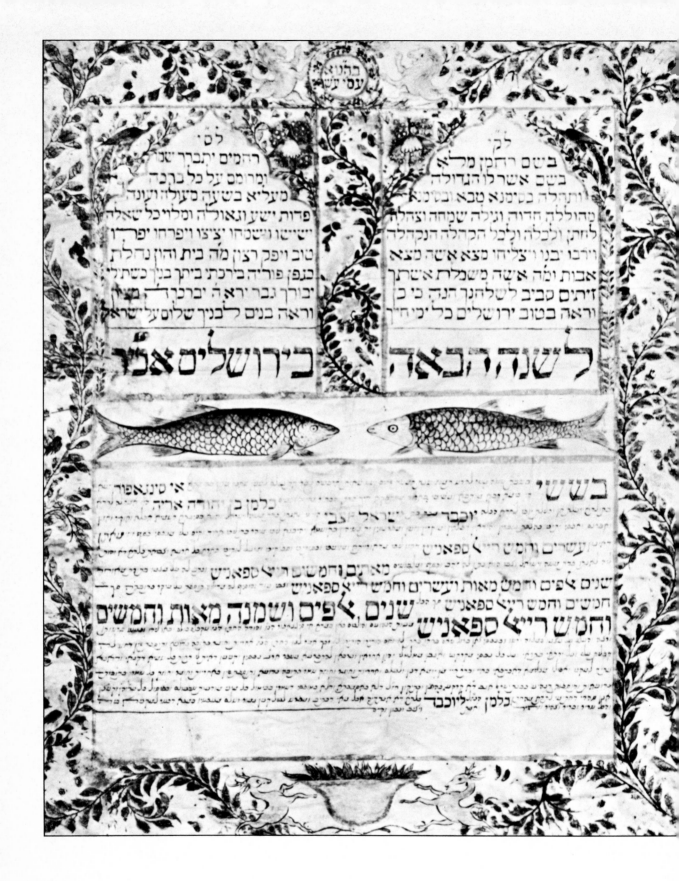

191. Illuminated marriage-contract. Singapore 1880. Israel Museum, Jerusalem.

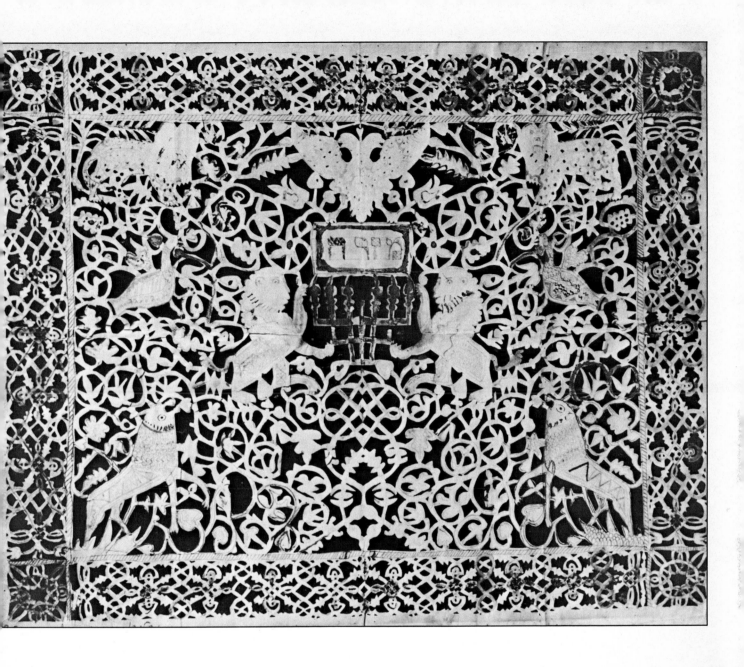

192. Cut-out panel ('Mizrah'). Poland, 1886. Israel Museum, Jerusalem.

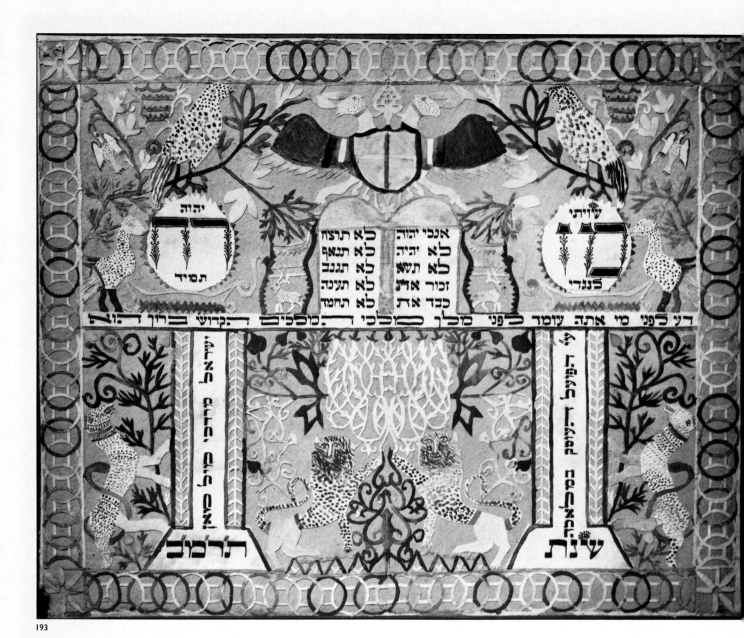

193

193. Cut-out coloured panel ("Mizrah") by Israel Mordechai
Milman, 1882 from Poland. Israel Museum, Jerusalem.

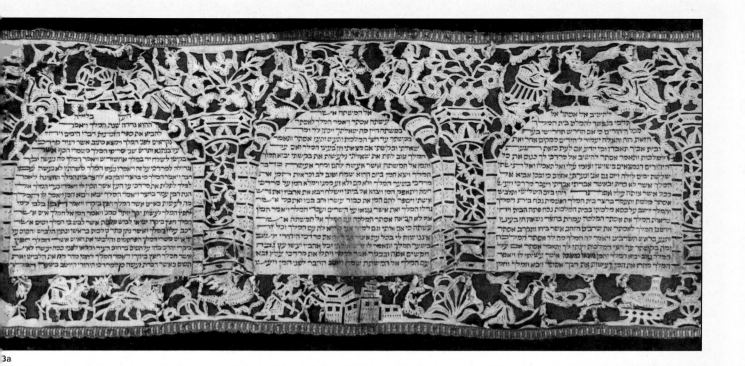

3a

4

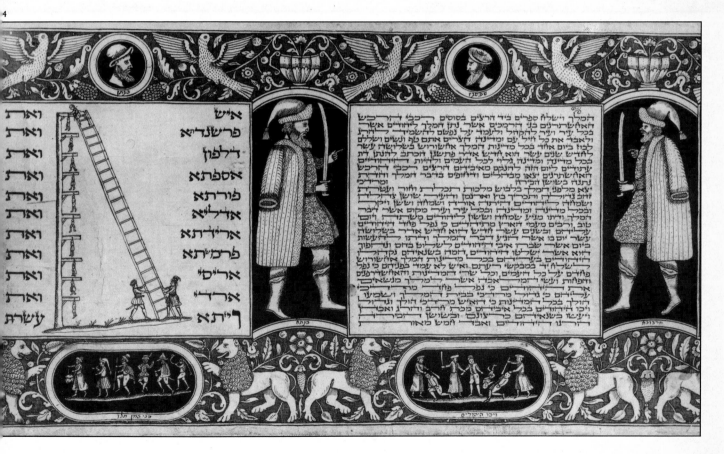

193a. *Scroll of Esther with cut-out borders illustrating the story of the Book, etc. Italy, about 1700. C. Roth Collection, Jerusalem.*

194. *Scroll of Esther, illuminated in sepia. South France, 17th century. C. Roth Collection, Jerusalem.*

195

195. Illuminated Scroll of Esther, partly decorated in 19th century Chinese style. None of the figural decorations illustrate the text, C. Roth Collection, Jerusalem.

196. Joseph Leipnik. The Finding of Moses in Passover Haggadah of 1740. British Museum, London, Sloane MS. 3173, fol. 12.

197. Uri Phoebus Segal. Abraham's sacrifice to God. Page of illuminated Passover Haggadah, 1739. Library of Jewish Community, Copenhagen.

198. Moses Leib Trebitsch. The Passover Meal. Page from a sister to the "van Geldern Haggadah," 1716—17, Hebrew Union College, Cincinnati.

196

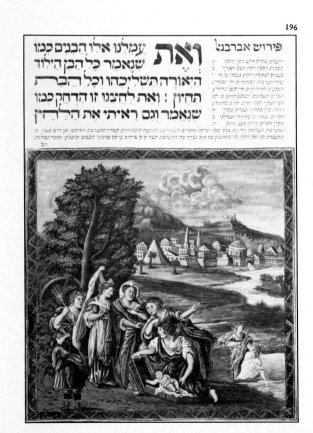

197

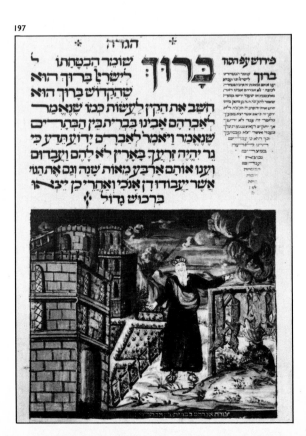

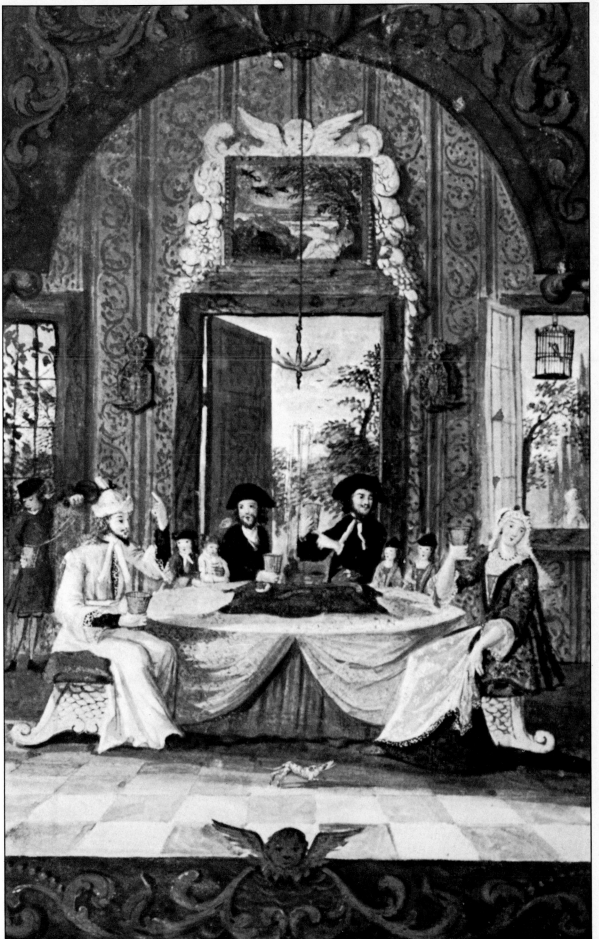

הנאיסארוירהסנבסלאנשאר נרס עד אחד:ובניישראל הלכו

בינשההנתוך היס והמיס להס חמה המימינס ומשמאלס:ויושע

יהוה ביוס ההוא את ישראל מיד מצריס וירא ישראל את מצריס

מת על שפת היס:וירא ישראל את היד הגדלה אשר עשה יהוה

במצריס וייראו העס את יהוה ויאמינו ביהוה ובמשה עבדו:

אז ישיר משה ובני ישראל את השירה הזאת ליהוה ויאמרו

לאמר אשירה ליהוה כי גאה גאה סוס

ורכבו רמה בים: עזי וזמרת יה ויהי לי

לישועה זה אלי ואנוהו אלהי

אבי וארממנהו: יהוה איש מלחמה יהוה

שמו: מרכבת פרעה וחילו ירה בים ומבחר

שלשיו טבעו בים סוף: תהמת יכסימו ירדו במצולת כמו

אבן: ימינך יהוה נאדרי בכח ימינך

יהוה תרעץ אויב: וברב גאונך תהרס

קמיך תשלח חרנך יאכלמו כקש: וברוח

אפיך נערמו מים נצבו כמו נד

נזלים קפאו תהמת בלב ים: אמר

אויב ארדף אשיג אחלק שלל תמלאמו

נפשי אריק חרבי תורישמו ידי: נשפת

ברוחך כסמו ים צללו כעופרת במים

199. A page with the Song of Moses, from a Bible printed in Hijar, Southern Spain, about 1486/9. Border by Alfonso Fernandez de Cordova.

the *sopherim* all over Europe incorporated in their title pages the words "with the characters of Amsterdam." Very many of the manuscript title pages are adorned with the figures of Moses and Aaron, a popular motive of the Amsterdam frontispieces. Meanwhile, the increasing diffusion of reproductions of works of art, through the technique of the copperplate, acquainted the producers of the Jewish illuminated book with the general artistic tendencies of the times. Thus they were able to free themselves from dependence on those models which formerly had been copied so servilely, and gradually began to reveal their inherent artistic abilities.

The best example of this revival is to be found in the illuminated *Haggadoth*. The iconography of the manuscripts was based, almost without exception, on the *Haggadah* published in 1695 and 1712 at Amsterdam, with engravings by the proselyte Abraham *Fig. 210* ben Jacob, copied from the *Icones Biblicae* of Mattheus Merian of Basle. Nevertheless, these engravings of Merian, which did not entirely correspond to the text of the *Haggadah*, were completely transformed by talented miniaturists, who succeeded sometimes in surpassing their model, enriching their manuscripts with small *genre* paintings of real value.

The sages of B'nei-Brak are represented in the Amsterdam *Haggadah* after the engraving of Merian illustrating the banquet of Joseph for his brothers (Genesis XLIII, 32–4), where nine characters sit around a long table under the light of a lamp. The *Haggadah,* however, speaks only of five rabbis, and the scene occurs in the early morning. Aron Wolf Gewitsch, in his *Haggadah* of 1730 (Kaufmann Collection, Academy of Sciences in Budapest, A 423), eliminates the four superfluous figures, sets the rabbis at a round table, removes the lamp, and lets the broad daylight enter through the windows.

The "four sons", of the *Haggadah* were copied by Abraham bar Jacob from various engravings of Merian, which he assembles on one plate, without any connection between them. Judah Pinhas in his *Haggadah* of 1747 (Library of the University of Erlangen, MS 1262) retains these figures, but places them in a small landscape, makes the wicked son stand, instead of running, and turn his face to the wise one, who thus seems to sermonize to him.

Again in the *Haggadah* completed by Joseph ben David Leipnik in the year 1740 (Brit. *Fig. 196* Mus., MS. Sloane 3173), the miniature showing the finding of Moses has nothing in common with the composition of Merian. The whole picture is dominated by the group under the tree dominated by Pharaoh's daughter. The coloring emphasizes the most important characters: the princess and the child-prophet. There is no doubt that, thanks to engravings, our miniaturist knew the works of the great painters of this period, like Poussin and de la Fosse who treated the same subjects.

The three angels who appear before the house of Abraham are represented by Abraham bar Jacob as winged beings wrapped in tunics, while Abraham kneels before them. Uri Phoebus Segal of Altona, on the other hand (*Haggadah* of 1739, Jewish Community of *Fig. 197* Copenhagen) portrays them as three youngsters dressed in the Jewish fashion of the time, sitting at a table under a tree; Abraham serves them the dish prepared for them.

We see, thus, that some of the miniaturists of the 18th century were not mere copyists. Their other works (e.g., blessing formularies), for which they had no model to copy, prove this decisively. Where there was a model, on the other hand, their artistic quality very often surpasses it. They enliven their work with the humane and kindly spirit of the rococo period.

The home of most of these artists was Moravia and Bohemia, whose culture preserved for generations the imprint of the former imperial metropolis. While in Bavaria, the exiles from Vienna after 1670 enhanced the art of ritual embroidery (*Torah*-curtains, etc.); in Moravia they gave a new impulse to the art of pen-and-ink miniature. The oldest of these artists seems to have been Moses Leib ben Wolf of Trebitsch, active after 1713.

Fig. 198 The Cincinnati *Haggadah*, one of his masterpieces, is dated 1716–17. The famous van Geldern *Haggadah*, possibly immortalized by Heinrich Heine in his "Rabbi of Bacharach," is a copy of this type dated 1723. At least a dozen works from his gifted pen are known. His pen-drawings, usually set off by wash, are well-composed little *genre* paintings. Whenever he takes an engraving as a model, he transforms it and recomposes it. But he shows his full mastery in those colored miniatures where, free from any model, he creates real works of art: e.g., the family seated around the table at the *Seder* in the van Geldern *Haggadah* and in that of Cincinnati. The artist expresses himself in quiet lines and harmonious colors; he composes his pages without muddling, places his vignettes and tail-pieces with discrimination, and preserves a just balance between the text and the ornamentation. It seems that Moses Leib continued to reside at his native Trebitsch, since Simon van Geldern, the adventurer-rabbi, passed Trebitsch during his travels through Europe and stayed at his house.

Another artist of Trebitsch also enjoyed a well-established reputation: all the families of the Court Jews were among the clients of Aryeh Judah Leib Cahana of this place, who, however, spent part of his life in Vienna. The first of his works known to us seems to be the prayer book made for the famous Court Jew, Simon Wolf Oppenheimer in 1712.

There is another artist who acquired a privileged position in Vienna, and from whose hand a great number of manuscripts have survived: Aron Wolf of Gewitsch. His oldest extant work is a register of circumcisions, dated Vienna, 1728 (Jewish Museum, Prague). The painted title page of this is richly decorated. As on almost all the title pages of the period, we find the figures of Moses and Aaron, here surrounded by medallions. These represent Elijah rising towards the clouds in a chariot of fire, Abraham receiving the angels, the sacrifice of Isaac. But the principal illustration of the title page is a lovely vignette representing a synagogue — on the right, in front of the *Torah*-shrine, a circumcision scene; on the left a group of women at the entrance to the building. That same year, 1728, Aron Wolf made two *Haggadoth* for the daughters of well-to-do families, and at least six more *Haggadoth* follow each other from 1730 to 1751, in addition to several psalters, etc. The census of Jews at Pressburg in 1735 contains the following entry: "*Aron Schreiber Moravus Gebitsensis Officialis in Bibliotheca Caesarea Viennensi—I Uxor, I famulus, I ancilla.*" This obviously refers to our artist. It is thus possible that he worked with an assistant *(famulus)*. The great number of his works would justify the need for some help, while the unevenness of their quality would confirm it. A small Vienna psalter of 1736, executed for Mayer Michael Simon at Pressburg, is signed "*Schreiber Herlinger,*" for at Pressburg, Aron lives in the same house as Israel Herlinger, "*viennensis cantor judaicus,*" who is possibly his brother. Aron Wolf did not limit himself to the production of Hebrew books. The Austrian National Library in Vienna possesses two pictures in micrographic ornamental handwriting from his pen, made in 1733 and 1738, which contain the Book of Ruth in German, the Song of Songs in Latin, Ecclesiastes and Esther in Hebrew, and Lamentations in French (ser. nov. 1593 and 1594). He was responsible for similar

productions in 1749 and in 1752. Aron Wolf was an excellent penman; all his works have a definite graphic character. His pen-drawings (sometimes set off by coloring) are very neatly executed, with perfect craftsmanship and impeccable taste, but very often drily academic. His talents were eminently graphic and he only painted to enhance his drawings.

Aron Wolf's competitor in Vienna was Meshullam (Zimel) of Polna, Bohemia. Two large calligraphic "prayers for the sovereign" at the Austrian National Library in Vienna (Heb. 223 and 224) were signed by him in Hebrew and in German in the year 1733. It is a calligraphic work, still true of the medieval *massora figurata*. From the 18th century until the middle of the 19th these artificial lettering devices mark the decay of an art, which, among Jews, had reached a very high standard and had given evidence of the artistic fantasy of the Jewish scribes. But Zimel of Polna could do better than that. A book of Sabbath prayers at the British Museum (Add. 1133) testifies to his fine taste and his remarkable skill. Written in Vienna in 1714, it does not reach the high level of craftsmanship displayed by Aron Wolf Gewitsch in some of his works, but contains, nevertheless, some vignettes, like the Sabbath meals, of a naive but attractive artistry. A *Haggadah* of 1735 with 52 vignettes from his hand was formerly at Pressburg. It is very difficult to assign the works made in Vienna during the first half of the 18th century to one or the other of these artists; with their art strongly rooted in calligraphy, it is almost impossible to attribute any anonymous pieces with certainty. At this time, too, the *sopher* Nathan ben Samson of Meseritz illuminated several *Haggadoth* and formularies of blessings with a characteristic breadth of treatment, brightly colored, in sharp contrast to the neat penmanship of the Viennese masters. There are specimens of his work in several collections.

About the middle of the century the production of illuminated books moves into Germany. Vienna's ascendancy is declining. On the other hand, throughout southern Germany, but, above all, at Hamburg, remarkable specimens of the art of illumination now emerge. The most important are of the new school at Hamburg; Joseph ben David Leipnik was of Moravian origin. He, like all those who work at Hamburg, Altona and Wandsbeck, may be recognized by a growing tendency for pictorial expression. They no longer imitate engravings, but adorn their manuscripts with real miniatures. His later *Haggadoth* (Bibliotheca Rosenthaliana, Amsterdam, 1738; Limel Collection, formerly at Frankfurt, 1738; but especially British Museum, MS Sloane 3173, of 1740) are real masterpieces of 18th century Jewish art. Although he follows pretty closely the iconography of the Amsterdam *Haggadah,* he transforms these compositions completely. These miniatures are small pictures, basically independent of their model, and richly colored, though never transgressing the limits of good taste. Leipnik was a talented painter, who obviously knew the works of the great masters from engravings. There is a close relationship between the miniature of his *Haggadah* of 1740, representing Moses saved from the waters, and the paintings of the masters. The illustration of the "four sons" in an interior has nothing to do with similar engravings; while his representation of the various stages of the *Seder* ceremony, and, above all, his illustrations to the final songs, are all *genre* paintings of high merit. It is not surprising that, gifted as he was, he appended to the *Haggadah* he made at Frankfurt in 1731, at the house of Isaac Schwarzschild, a portrait of the daughter or bride of his patron (formerly Zagayski Collection, New York). We may rightly consider him among those Jewish miniaturists who initiated the access of Jewish artists to European art in the 19th century.

Fig. 196

Another scribe of this intermediate type was Judah Pinhas (1727–93), who became court miniaturist at Ansbach in 1775. His famous *Haggadah* of 1747 (Library of the University of Erlangen MS 1262), magnificently written, follows pretty closely the engravings of the Amsterdam edition of 1712, with some very happy modifications. The most interesting page is the one where the artist substituted the engravings illustrating the ten plagues by ten small miniatures in bright colors, each of them a small *genre* painting, where his talent is untrammeled. Judah Pinhas was the son of a *sopher,* and his art had come down to him over many generations: the family record illustrates the manner in which synagogue scribes and miniaturists prepared the way for the 19th century Jewish artists.

Joseph Ben David Leipnik ended his career in the united "three communities" of Hamburg-Altona-Wandsbeck. Their increasing prosperity at this time attracted several scribes whose work differs from that of the Viennese school. Here, the pictorial element dominates. Merian's engravings serve as very remote models, hardly any trace of them remaining. The characters are dressed according to the fashion of Central and East European Jews; for, indeed, some of these artists come from Silesia.

Two pieces executed at Hamburg show the influence exercised by the art of Joseph ben David Leipnik. Their author is Uri Phoebus ben Isaac Segal, who finishes his *Haggadah* (Library of the Jewish Community of Copenhagen) at Altona in 1739 and a circumcision register in 1741 (Hebrew Union College, Cincinnati). In the former he partly follows the iconography of Amsterdam, altering it. The characters, in North European Jewish dress, are set in lovely landscapes or are grouped in small *genre* paintings. A startling realism is wonderfully combined with a poetical conception of the text to be illustrated. Thus, for instance, the three angels appear like "three men" in accordance with the text of Genesis. Flowers, fruit, and heraldic motives blend harmoniously with the calligraphy. The statutory ritual objects of the *Seder* are allegorized by richly dressed figures carrying the unleavened bread and the herbs, and leading the lamb in a lovely landscape. Abraham is represented

Fig. 197 performing the *'Pact between the Portions'* (Genesis, Chapter XV). The patriarch in Oriental dress comes forward towards the sacrifice in a manorial garden. The Temple of Jerusalem appears as a contemporary castle.

VI

We have by no means enumerated all the scribes who decorated their books with more or less interesting miniatures or drawings. Some of them, indeed, produced works of real value, but, on the whole, their achievement does not add anything to the growth of Jewish art.

The stream of Polish Jews entering the other countries of Europe during the 18th century resulted in the introduction of East European folklore themes into Jewish art. In the art of the book, however, this influence did not make itself felt.

To be sure, the fanciful animals and grotesques of the medieval manuscripts which enliven the painted walls of the wooden synagogues of Poland appear also in some illuminated manuscripts from the 17th century onwards. This folkloric art is encountered as far west as London, where the Polish-born Aaron ben Moses Sopher (the first recorded rabbi of the Great Synagogue in London, whose name, therefore, heads the official list of the Chief Rabbis of England) wrote and illuminated a book of miscellaneous prayers in 1714 for the librarian of the Earl of Oxford with decorations and illustrations of touching candor

(British Museum, MS. Harley 5713), as well as similar volumes preserved elsewhere for other patrons. One of the most interesting of the folkloric pieces of Eastern Germany, under Polish influence, is a *Haggadah* by Nathan ben Abraham Speyer, dated Breslau, 1756 (Hebrew Union College, Cincinnati). Everything here is secondary to the coloring; perspective and three-dimensional representation do not disturb him. His only concern is expressiveness and the decorative quality of the painting. If we compare this *Haggadah* with the one made by Uri Phoebus of Hamburg, we notice a common source of inspiration, but the latter has already succeeded in blending the popular elements with the urban art around him.

Still, the East European Jews did not have a monopoly of folkloric art. Wherever the Jews lived scattered among rural populations, the guardians of the treasures of folklore of the peoples, they adopted the artistic language of the country in which they lived. Some memorable works are due to that folkloristic influence, as for instance, the *Haggadoth* made by the scribe Abraham of Eyringen, in Alsace, in the year 1740 (Klagsbald Collection, Paris, 1740; Jewish Museum, London, 1756). His pen-drawings, which merely follow the wood engravings of the *Haggadah* of Venice, are of little importance, but the floral ornamentation, with its lively coloring, tulips, carnations, daisies, crowds all the spaces not required by the text or the illustrations.

In the eastern section of Ashkenazi Jewry we find a folkloristic artist of some talent, in Hayim ben Asher Anshel of Kize (Köpcsény in Hungary), whose *Haggadoth* (extant in various collections) do not contain any illustration of the text, but only floral ornamentation which displays all the grace of the rococo, as well as of the local popular art. The floral ornamentations of these illuminated books add a unique loveliness to these works. The flora of all the countries of Europe where the Jews lived is represented here.

The character of the rich synagogue patrons also changed around the end of the 18th century. The communities of Central Europe now reorganized themselves. Emulating the older communities, the new ones, too, wished to lavish loving attention on their *Memorbuch,* or memorial register; on their *Kuntres* intended for the cantor and containing the special synagogal formularies; and, above all, on their *pinkas*, with their statutes and minutes. The same applies with even more force to the synagogue fraternities and charities *(hebroth).* Sometimes these books belong to the folklore type — e.g., a superb *pinkas* (register) of the Kishinev community — but as a rule they reflect the tendencies of European art. Once in a while, the combination of the two elements produces a work which reaches the acme of the art of Jewish book-illumination.

The finest specimen of this kind, and perhaps the *chef d'oeuvre* of the illuminated book of the 18th century, is the *pinkas* of the Burial Society of Nagykaniza, which was written and illuminated in 1792 by Judah ben Hayim, son of a cantor of Posen (Jewish Museum, Budapest). In addition to its title page and some secondary decorations, such as a figure of Moses in micrographic lettering, it contains the so-called Treatise of Gehenna adorned with seven miniatures of inexhaustible fantasy. In ten more miniatures, in which he shows forceful expression and expert composition, the artist illustrates the ceremonies and the beliefs that follow the moment of death. Seldom has an artist succeeded in rendering with such poignancy a scene in which we see a mourning Jew, seated on the floor, consuming the meal offered to him by the members of the fraternity. These miniatures are among the masterpieces of Jewish art, linking, so to speak, the medieval miniatures with the art of the expressionist painters of our day.

In the 19th century the art of illumination dies out. The Jewish artists find their place in the artistic production of all European countries. The miniaturists of the Jewish book in the Century of Enlightenment are the forerunners of the painters, who in the following century occupy a most honorable place, and less than one hundred years later play a role of first importance in European art. These miniaturists are, in the field of art, what Moses Mendelsohn was in the field of thought: the carriers of a synthesis between European culture and Jewish tradition. They express this tradition with the artistic means of their time. They often fumble, but they prepare the way for future generations, who are able to develop their talent with full mastery of their chosen medium.

THE JEWISH ART OF THE PRINTED BOOK

by ABRAHAM M. HABERMANN

The influence of the manuscript, and implicitly of the illuminated manuscript, was clearly discernible in the earliest productions of the printing press, whether Hebrew or non-Hebrew. On the other hand, printing disclosed numerous new possibilities which never would have occurred to the producers of manuscripts, when the narrow scope of the effort and the fact that it was done once for all, were inherent in the very nature of the work. At that time one writing produced only one book and no more. "Writing with many pens without the work of miracles" (as one of the earliest printers termed his activity) partly referred to the inestimably wider circulation achieved thereby. In the age of manuscripts there were, of course, differences from one place to another and from one period to another in the quality of the work. This applied also to the printed book. The printer, too, endeavored to embellish his work in many ways: by using good paper, effective implements, fine inks, and expert artisans. But his primary concern was to obtain a handsome typeface made by an expert scribe and cut by a practiced engraver; good typesetting improved the layout of the page, which was enhanced by effective lettering, decorations, and borders.

Sometimes the printers made use of scribe-illuminators to adorn the book, and this, too, was a regular practice with many Jewish printers in the 15th century. The first words in several early books, such as Levi ben Gershon's Commentary to Job (Ferrara, 1477) and the Brescia Pentateuch of 1492, were not printed, and the space was left empty for hand-illumination. Several copies are extant in which these vacant spaces have been filled in by a skilled illuminator, exactly as in a manuscript of the period.

The second dated printed book, Jacob ben Asher's *Arbaah Turim* (Piove di Sacco, 1475), exhibits an exemplary page. The typeface is well-cut, the columns are straight and tastefully set, and large woodcut letters mark the beginnings and sections. The arrangement of parts of pages and of the colophons at the end in the form of goblets, triangles, or other shapes, as found in this volume and in other early printed books, was also intended to please the eye. Decorations of this sort already occur in manuscripts; hence, the printers too, were following the example of the best scribes and continuing their traditional manner of work. It is highly probable that some printers in the early period were at first scribes who, perceiving the signs of the times and the potentialities of the printed book, exchanged their craft for that of printing and made a "holy work" of that too. We know this definitely of Meshullam Cuzi and his family (Piove di Sacco) and

of Abraham Conat (Mantua), who were formerly scribes and went over to the printing craft. Conat's typefaces were cut after his own handwriting, in his characteristic Ashkenazi cursive; this is immediately obvious when his typefaces are compared with his manuscript letters.

The first printers sought an aesthetic model in several varieties of the copyist's letters, and generally neither the draftsman's name nor that of type-cutter is mentioned. There are three classes of letters: the Italian, the Ashkenazi (which merged with the first in course of time, although the late Italian typeface also evinces the influence of Spanish characters), and the Spanish-Oriental; each has its own cursive form. In due course, however, the Jewish printers, wishing to embellish their work to the utmost, had recourse to expert craftsmen for cutting their types, not caring whether they were Jews or gentiles. Some of the latter were indeed persons of high reputation, who may be considered artists in their own right. Not infrequently, they were originally silversmiths, and their training is reflected in the exquisiteness of their achievement. Solomon Alkabez, one of the pioneer Spanish printers, for example, commissioned that same "Master Pedro" who did similar work for non-Jewish printers at the same period to cut Hebrew types for his press at Guadalajara, which began to function in 1476.

More significant was the silversmith Alfonso Fernandez de Cordova, who not only designed the types and decorations used in some of the most memorable productions of the non-Jewish printing press in Spain at this period, including the great Valencian Bible of 1477–78, but also in all probability cut the splendid types used in the Hebrew press at Hijar in 1489–92; as we shall see, he also executed the lovely borders, and presumably the finely decorated initial letters used at this press. When we come to Renaissance Italy, our information becomes more precise. Gershom Soncino, who earned immortality as printer, both in Italian (with Latin) and Hebrew, boasted how for both purposes he had secured the services as type-cutter of Master Francesco Griffo, or Francesco of Bologna, inventor of the so-called *italic* lettering, who was one of the most famous craftsmen and engravers of the day. Similarly, the type-artist Guillaume le Bé, who came from Paris to Venice in 1545, cut a very beautiful Hebrew type for the printing press of Marco Antonio Giustiniani, for Meir di Parenzo, and others in Italy. It was he who subsequently cut Hebrew typefaces for various presses in Paris and for Plantin in Antwerp. In Holland in the mid-17th century the artist Christofal Van Dyk prepared successful Hebrew typefaces for the Amsterdam printer Joseph Athias; these are marked by fineness of line and are highly pleasing to the eye, and their influence on Hebrew printing is still perceptible. The single letters of these great craftsmen are sometimes so aesthetically satisfying that they are to be considered works of art in themselves. This applied perhaps with particular force to some of the types used by Sephardi printers in Amsterdam in the 17th century, which reproduce the impressive calligraphy of the medieval Spanish manuscripts and have close analogies with the superbly decorative lettering used in the interior embellishments of the El Transito Synagogue of Toledo.

The climax of the work of these typographical artists, both Jewish and non-Jewish, was in the ornamental letters which were used as headpieces for the pages or to mark the beginning of paragraphs. Already in the work of pioneer productions of the Piove di Sacco press of 1475, Meshullam Cuzi used larger letters at the beginning of the paragraphs and so on for decorative effect, and this practice was not unusual later on. Later on, a special decorative lettering was sometimes designed for this purpose, the letters being of

200. Opening page of Code of Jacob ben Asher, Leiria,
Portugal, 1495. Border by Abraham d'Ortas.

בן תימא אומר הוי עז כנמר וקל כנשר ורץ
כצבי וגבור כארי לעשות רצון אביך שבשמים
פרט ארבע' דברים בעבודת הבורא יתברך
והתחיל בעז כנמה לפי שהוא כלל גדול ב
בעבודת הבוראית לפי שפעמים אדם חפץ
לעשות מצוה ונמנע לעשותה מפני בני אדם
שמלעיגין עליו ועל כן הזהיר שתעיז פניך כ
כנגד דמלעינים ואל תמנע מלעשות המצוה
וכן אמר רבן יוחנן בן זכאי לתלמידיו יהי ר
רצון שתהא מורא שמים עליכם כמורא בשר
ודם וכן הוא אומר לענין הבושה שפעמים
אדם מתכייש מפני האדם ית' ממה שיתכייש
מפני הבוראית' על כן הזהיר שתעיז מצחך
כנגד המלעינים ולא תבוש וכן אמר דוד עה
וארברה בעדותיך נגד מלכים ולא אבו' אף
כי יהיה נרדף וכורדה בין האומות היה מחזיק
בתורתו ולומד אף כי זהו מלעיני עליו ואומר
קל כנשר כנגד ראו' העין מדימה אותו לנשר
כי כאשר הנשר טט באיר כך הוא ראו'העין
לוכר שתעצים עיניך מראות כרע כי הוא
תחילת העביר' שהעין רואה והלב חומד וכלי
המעשה גומרין ואמר נבמר כארי כנגד הלב
כי הגבורה בעבודת הבורא יתברך חזא כלב
שתתחזק לבך בעבודתו ואמר רץ כצבי כנגד
רגלים שרגליך לטוב ירוצו וכן דוד המלך
עה היה מתפלל על שלשתם אלא ששנה
הסדר אמר הדריכני בנתיב מצותיך על ה
רגלים ואמר אחר כך הט לבי ואמר אחר כך
העבר עיני מראו' רע והזכי כלב הטיה וכען

העכרה כי הלב הוא כרשותו לוטאתו בדרך
הטובה או לרעה אף אחר שראה כעש' השוא
על כן התפלל שיעזרינג להטותו לדרך
הטובה אבל ראות השוא אינו כרשותו כי א
איפשר טיפנע בו פתאום לכן ויראבו התפל'
שיעכיר עינו מראו' טוא ולא תמטיא לפני
כלל לכן צדיך האדם להתגבר כארי לעמד
בבקר לעבודת בוראו ואף אם ישיאגו יצדו
בחורף לאבר איך תעמד בבקר כי הקור נ
גדו או ישיאגו בקץ לאב' איך תעמ' מטתך
ועדיין לא שבעת משנתך דתנבר עליו לקום
שתהא אתה מעורר השח' ולא ידא הו מעיר'
כמו שאמר דוד עה עורה כבדי עורה הנבל
וכנור אעירה שחר אני מעיר השחר ואין ה
השחר מעיר אותי וכל שכן אם ישכים קדם
אור הבקר לקו' לדתחנן לפני בוראו מה יפיג
ומה טובו וטוב מ שטקדרים שיכוין לשעות ש
שמשתנות המשמרות שהן בשליש הלילה נ
ולסוף שני שליש הלילה ולסוף הלילה ש
שבאלו הכבו' הקדוש ברוך הוא נזכר הלילה
לחורבן הבית תלות ישראל בין האומות נ
והתפלל שיתפלל אדם באותה שעה על ה
החורבן וחנלו' רציוה וקרובה להתקבל ויפיל
תחנתו לפנ הבקום אחד הטרבה ואחד ה
דבמטע' ובלבד שיכון לבו בתחגונו כי ט
מעט בבמונה מדרבות כהם שלא בבמונה וט'
לוטר פרשת העקדה ופרשת המן ועשרה
הדכרו' ופרשת הקרבנות כגן פרשת העולה
וסנחה ושלמים וחטאת ואשם אבגם פרשת

201. Opening page of Code of Jacob ben Asher with border
originally intented for a non-Hebrew work. Soncino, 1490.

בִּשְׁלֹשִׁים שָׁנָה בָּרְבִיעִי בַּחֲמִשָּׁה לַחֹדֶשׁ וַאֲנִי
בְתוֹךְ הַגּוֹלָה עַל־נְהַר כְּבָר נִפְתְּחוּ הַשָּׁמַיִם וָ
אֶרְאֶה מַרְאוֹת אֱלֹדִים: בַּחֲמִשָּׁה לַחֹדֶשׁ הִיא
הַשָּׁנָה הַחֲמִישִׁית לְגָלוּת הַמֶּלֶךְ יוֹיָכִן: הָיֹה הָ
יָה דְבַר־יְהוָה אֶל־יְחֶזְקֵאל בֶּן־בּוּזִי הַכֹּהֵן בְּ
אֶרֶץ כַּשְׂדִּים עַל־נְהַר־כְּבָר וַתְּהִי עָלָיו שָׁם יַד־
יְהוָה: וָאֵרֶא וְהִנֵּה רוּחַ סְעָרָה בָּאָה מִן־הַצָּ
פוֹן עָנָן גָּדוֹל וְאֵשׁ מִתְלַקַּחַת וְנֹגַהּ לוֹ סָבִיב
וּמִתּוֹכָהּ כְּעֵין הַחַשְׁמַל מִתּוֹךְ הָאֵשׁ: וּמִתּוֹכָהּ
דְּמוּת אַרְבַּע חַיּוֹת וְזֶה מַרְאֵיהֶן דְּמוּת אָדָם לָ
הֵנָּה: וְאַרְבָּעָה פָנִים לְאֶחָת וְאַרְבַּע כְּנָפַיִם לְ
אֶחָת לָהֶם: וְרַגְלֵיהֶם רֶגֶל יְשָׁרָה וְכַף רַגְלֵיהֶם
כְּכַף רֶגֶל עֵגֶל וְנֹצְצִים כְּעֵין נְחֹשֶׁת קָ
לָל: וִידֵי אָדָם מִתַּחַת כַּנְפֵיהֶם עַל אַרְבַּעַת

אֶל אֲשֶׁר יִהְיֶה שָּׁמָּה הָרוּחַ לָלֶכֶת יֵלֵכוּ לֹא יִס
סַבּוּ בְּלֶכְתָּן: וּדְמוּת הַחַיּוֹת מַרְאֵיהֶם כְּגַחֲלֵי
אֵשׁ בֹּעֲרֹת כְּמַרְאֵה הַלַּפִּדִים הִיא מִתְהַלֶּכֶת
בֵּין הַחַיּוֹת וְנֹגַהּ לָאֵשׁ וּמִן הָאֵשׁ יוֹצֵא בָרָק: וְ
וְהַחַיּוֹת רָצוֹא וָשׁוֹב כְּמַרְאֵה הַבָּזָק: וָאֵרֶא הַ
הַחַיּוֹת וְהִנֵּה אוֹפַן אֶחָד בָּאָרֶץ אֵצֶל הַחַיּוֹת לְ
לְאַרְבַּעַת פָּנָיו: מַרְאֵה הָאוֹפַנִּים וּמַעֲשֵׂיהֶם
כְּעֵין תַּרְשִׁישׁ וּדְמוּת אֶחָד לְאַרְבַּעְתָּן וּמַרְאֵיהֶם
וּמַעֲשֵׂיהֶם כַּאֲשֶׁר יִהְיֶה הָאוֹפַן בְּתוֹךְ הָאוֹפָן:
עַל־אַרְבַּעַת רִבְעֵיהֶן בְּלֶכְתָּם יֵלֵכוּ לֹא יִסַּבּוּ
בְּלֶכְתָּן: וְגַבֵּיהֶן וְגֹבַהּ לָהֶם וְיִרְאָה לָהֶם וְגַבֹּתָם
מְלֵאֹת עֵינַיִם סָבִיב לְאַרְבַּעְתָּן: וּבְלֶכֶת הַחַיּוֹת
יֵלְכוּ הָאוֹפַנִּים אֶצְלָם וּבְהִנָּשֵׂא הַחַיּוֹת מֵעַל
הָאָרֶץ יִנָּשְׂאוּ הָאוֹפַנִּים: עַל־אֲשֶׁר יִהְיֶה שָּׁם
הָרוּחַ לָלֶכֶת יֵלֵכוּ שָׁמָּה הָרוּחַ לָלֶכֶת וְהָאוֹ
וְהָאוֹפַנִּים יִנָּשְׂאוּ לְעֻמָּתָם כִּי רוּחַ הַחַיָּה בָּ
בָּאוֹפַנִּים: בְּלֶכְתָּם יֵלֵכוּ וּבְעָמְדָם יַעֲמֹדוּ וּבְהִ
וּבְהִנָּשְׂאָם מֵעַל הָאָרֶץ יִנָּשְׂאוּ הָאוֹפַנִּים לְעֻ
לְעֻמָּתָם כִּי רוּחַ הַחַיָּה בָּאוֹפַנִּים: וּדְמוּת עַל
רָאשֵׁי הַחַיָּה רָקִיעַ כְּעֵין הַקֶּרַח הַנּוֹרָא נָטוּי
עַל־רָאשֵׁיהֶם מִלְמָעְלָה: וְתַחַת הָרָקִיעַ כַּנְפֵי
כַּנְפֵיהֶם יְשָׁרוֹת אִשָּׁה אֶל־אֲחוֹתָהּ לְאִישׁ שְׁתַּיִם

202. First page of the Book of the Prophet Ezekiel, from the
Bible printed by Joshua Solomon Soncino in 1488. This is
the first complete edition of the Hebrew Bible.

*203. Opening page of Bahya's Commentary on the Bible,
Naples, 1492. Border by Moses ben Isaac.*

יהודה

בן תימא אומר הוי עז כנמר וקל כנשר ורץ כצבי וגבור כארי לעשות רצון אביך שבשמים פרט ל'רברי בעבורת הבורא ית'והתחיל בעז כנמר לפי שהוא כלל גדול בעבורת הבורא יתברך לפי שפעמים ארם חפץ לעשו'מצוה ונמנע לעשותה מפני בני ארם שמלעיג' עליו ועל כן הזה'שתעיז פניך כנגר המלעיג' ואל תמנע מלעשות המצוה ובן אמר רבן יוחנן בן זכאי לתלמידיו יהי רצון שתהא מורא שמים עליכם כמו'בשר ורם וכן הוא אומ'לענ'הבושה שפעמי' ארם מתחייש מפני האדם יותר ממה שיחבייש מפני הב' יתברך על כן הזהיר שתעיז מצחך כנגר המליעגים ולא תבוש וכן אמר רוד עה'ואברבה בערותיך נגר מלכים ולא אבוש אף כי היה נרדף ובוזה בין האומוד'היה מחזיק בתורתו ולומר אף כי היו מליעגים עליו ואומר קל כנשר כנגר ראות העין ורימה אותו לנשר כי כאשר הנשר שט באויר כך חוא ראות העין לומר שתעוצם עיניך מראות ברע כי הוא תחילת העבר שהעין רואה והלב הומר וכלי'המעש' נומרין ואמר גבור כארי כנגר הלב כי הגבורה בעבורה הבורא יתברך היא בלב שתהזק לבך בעבורתו ואמר רץ כצבי כנגר הרגלים שרגליך לטוב ידוצו וכן דוד המלך עה' היה מתהלל על שלשחם אלא ששנה הסדר ואמר הדריכני בנת'מצוותיך על הרגלים ואמר אחר כך הט לבי ואמר

ב א או'כ

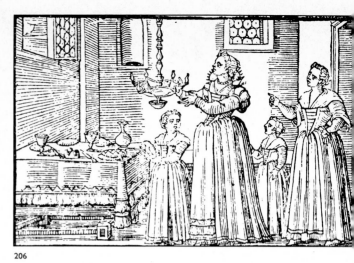

206

207

204

205

204. *Title-page of Meah Berakhot, Amsterdam, 1687, Copper engraving by Benjamin Senior Godines. Shocken Library, Jerusalem.*

205. *Printer's mark of Gershom Soncino. Italy, 1497/8.*

206. *Kindling the Sabbath lamp. From a Book of Minhagim (Customs), Venice, 1601.*

207. *"The Easterner's Parable" by Isaac ibn Sahula. Soncino, Brescia, 1491, woodcut.*

לַחְמָא עַנְיָא רִי אַ
אֲבָלוּ אַבְהֲרָתְנָא בְּ
בְּאַרְעָא דְמִצְרַיִם
בָּל דְכְפִין יֵיתֵי וְיֵבוֹל
בָּל דְיִצְרִיךְ יֵיתֵי יִם
וְיִפְסַח הָשַׁתָּא הָבָא
לְשָׁנָה הַבָּא בְּאַרְעָ

209

208

208. The slaughtering of the Passover sacrifice and the walking
 around the table set for the Passover meal. Wood-block
 engraving. Venice, about 1480.

209. A page from the Prague Haggadah of 1526. Printed by
 Solomon ha-Cohen's sons; woodcut.

210. Title page of Passover Haggadah; Amsterdam, 169
Copper-plates by Abraham ben Jacob. Israel Museum
Jerusalem.

211. The battles of Israel in Canaan, illustration from a Haggada
Venice, 1609; woodcut.

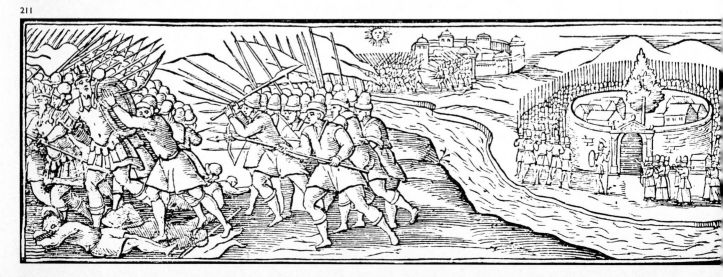

ornamental form, with animal or floral designs introduced inside the thicker strokes, and were set in a decorative engraved background. We find such letters in Spain and Portugal, in the presses at Faro (1487), Lisbon (1489), and above all in Hijar (1489–92). More beautiful still are the initial letters used by the Soncino family in Italy from 1484 onwards, with lavish use of letters printed in white on black, within a decorative framework. This feature could take two forms. Either an entire word might be engraved decoratively as a whole and used as a heading, or else the single letters could be cut separately and combined together as required. The use of these ornamental headings and letters continued to be common in Italy well into the 16th century. Thereafter, it was perpetuated in Germany and Poland, for some generations later, sometimes attaining a fairly high aesthetic level.

II

The most beautiful feature in the early Hebrew printed books, from the aesthetic point of view, were the decorative borders, some of them being superb works of art in themselves. The earliest Hebrew printed books, following the model of manuscripts like all books produced at this time, had no title pages. Instead, sometimes, the first page (and occasionally other outstanding pages further in the book) was—again like manuscripts— enclosed in fine ornamental borders, on which the utmost attention was lavished, and highly capable and sometimes eminent artists being employed to design and engrave them. These are among the most beautiful features that are to be found in early printing, and some used in Hebrew works are fully up to the standard of the finest productions of the period. There are a few specimens in early examples of Spanish-Hebrew printing before the expulsion of 1492. One, of remarkable delicacy, appears around the Song of Moses and elsewhere in the Bible printed by Eliezer ben Abraham Alantansi at Hijar in southern *Fig. 199* Spain, about 1486–89, with beautiful traceries and charming animal figures. This is ascribed, as has been indicated above, to the silversmith and type-cutter Alfonso Fernandez de Cordova, who was very active in printing at this time and at one period produced non-Jewish books in partnership with Alantansi's partner, Solomon Zalmati.

The border to which we have been referring was used by de Cordova in a Latin liturgical work, the Missal, according to the ritual of Saragossa, which appeared at Hijar about the same time. The whole question of the interrelationship is very complicated, and there is no need to go into it here in detail; but it may be said that de Cordova was so closely associated with Jews that he has been suspected of belonging to a Marrano family. The later history of the lovely border which we have been discussing is remarkable. It was apparently taken to Portugal, and was used by Eleazar Toledano in a couple of works produced in Lisbon in 1489. After the expulsion of the Jews from Portugal, it was somehow brought to Constantinople, and there employed in several other works produced between 1505 and 1509, though by now increasingly worn and indistinct. Portions of it were also used in various 16th-century works as decorations between the different sections.

Whereas some mystery is attached to the origins of this decorative feature, another used in a Hebrew production of the Iberian Peninsula of this period is almost certainly of Jewish authorship. This is the heavier and less satisfying border around the opening page of the first part of the Ritual Code ("Tur") of Jacob ben Asher, produced by Samuel *Fig. 200* d'Ortas and his sons at Leiria in Portugal in 1495. The somewhat primitive floral and

animal tracery here has been adapted to serve as it were by way of illustration to the Rabbinical aphorism quoted at the beginning of the text which it encloses: "Be thou old as a leopard, light as an eagle, fleet as a deer, and valorous as a lion, to do the will of thy Father in Heaven." Accordingly, these animals (with some others) are depicted in the border, an escutcheon at the top enclosing the leopard with the legend in Hebrew (often misread): "Bold of Face." This was assuredly then designed and executed by a Jewish artist; and in view of the fact that in colophons to his works Samuel d'Ortas speaks so much of the technical ability of his sons — in particular the eldest(?), Abraham — it seems likely enough that this achievement must be ascribed to him.

Naturally, it was in Italy, the home of superior printing, that the finest and most artistic borders are to be found in Hebrew, as in general typography. The Soncino family, especially, made lavish use of this decorative feature, from 1487 onwards. They had a

Fig. 201 special liking for a type showing lavish contrasts of black and white, with cherubs disporting themselves in the lateral margins and supporting a blank space left at the bottom for the owner's family or personal badge, which was to be filled by hand. Not infrequently, the identical border occurs time after time in works produced by the same printers. Generally speaking, the borders were, it seems, originally designed for non-Jewish works, the blocks being subsequently purchased, after use, by the Hebrew printer; or perhaps he acquired them from a wandering craftsman, before they had been used by non-Jews. When the border was designed for a non-Jewish book, an obvious difficulty presented itself. The normal position for the engraved border at the beginning of a work was around the first page, which would be on the recto side of the leaf, where the title page is in modern books. Obviously, it was desirable for the outer margin to be wider than the inner. But the outer margin in a Hebrew book is on the left, whereas in a Latin or Italian book it is to the right. When a Hebrew printer wished to make use of a border prepared for a Latin book, he was hence faced with a delicate problem of adjustment. This might be solved in various ways. He might simply disregard it and use the border in the conventional position, regardless of the unaesthetic effect created by having the narrower border outside; or he might forego its use at the beginning of the volume and insert it at some convenient place later on — perhaps on the verso of the first page; or, highly conscientious, he might have the entire border recut, at considerable expense, to suit the requirements of the Hebrew books; or, somewhat barbarically, he might cut the border into four pieces and rearrange it with the wide margin outside. All of these expedients were tried at one time or another by the printers of the Soncino family. We can trace, for example, Joshua Solomon Soncino's various experiments with the most memorable of the borders which he used — a superb achievement, which had been cut by some extremely able artist-craftsman and was originally used by the great Neapolitan printer Francesco del Tuppo in his magnificent edition of Aesop (Naples, 1485). In 1487, Soncino used it unaltered in his Rashi edition, on the recto of the first page. Apparently

Fig. 201 disliking the aesthetic effect here, in his *editio princeps* of the Hebrew Bible (1488). he did not use it at all at the beginning of the volume, but inserted it with magnificent effect, on the verso of the page, at the beginning of Joshua. This, of course, involved the inconvenience that the first page of the book, where an ornamentation of this sort was most in place, was left plain and unadorned. Later, therefore, Soncino cut the border into four and interchanged the right- and left-hand margins, as we see in various Talmudic tractates which he produced in 1489–90. In the opening pages of other books of the

Fig. 202 Bible, only a decorated initial word was used, with no borders, i.e. the book of Ezekiel.

From what has just been said, there follows an important corollary, which has an intimate bearing on the problem of Jewish art and artists in the period of the Renaissance. If a border of this type has the wider margin on the left-hand side, there is good reason to believe that it was originally prepared for a Hebrew book, and conceivably by a Jewish artist, even though its symbolism and style seem to be specifically non-Jewish.

There is one exceptionally lovely border of this type, which was used by both Jewish and gentile printers at Naples in 1491–92, and was subsequently taken to Turkey and figures there in various works between 1531 and 1532. Its motifs are distinctly pagan in character. It comprises within a setting of profuse branch-work a fanciful representation of a hunting scene, showing winged cherubs (one of them mounted on a horse, another on a stag, and a third blowing his horn), hounds hunting down deer and hare, and a peacock standing on a hare's back; the bottom panel embodies within a circle a shield which is left blank for a coat of arms. The style has been variously described as Hispano-Mauresque and Neapolitan. There is something of a mystery attached to the origins and authorship of this border and the sequence in which it was used. It figures in the gentile form (i.e., with the wide margin on the right) in the Italian work, *L'Aquila Volante*, produced by Aiolfo de' Cantoni in Naples in the summer of 1492—one of the loveliest productions of the Neapolitan press. But it had already appeared some months earlier in the Jewish form (with the wide margin on the left) in the Bible produced at this same place by Joshua Solomon Soncino. There is, therefore, some reason to imagine that the Jewish form is the earlier. Moreover, it is used in the edition of Bahya's commentary on the Bible, also printed in Naples about this time (Tammuz 8th 5252 = July 3rd 1492). In the colophon of this volume, the printer, Azriel Gunzenhausen, informs us that he was assisted in his work by his brother-in-law, Moses ben Isaac, "a wise and expert artisan, skilled in wood engraving in connection with printing, marvelous in counsel." There is thus some reason to believe that the lovely panel which we have been considering was the work of a Jewish craftsman, obviously of superb ability, being produced by him originally at the commission of a Jewish printer and for a Hebrew publication.

Fig. 203

III

In due course, the use of engraved borders was given up, and their place was superseded by title pages. The Hebrew printed books of the 15th century do not yet possess title pages. As in the manuscript period, in the *incunabula* a blank folio or page heads the volume in order to protect the body of the text. Only the colophon—which does not occur in every book—evidences the work's title, its place of printing, etc. A title page is first found in a Hebrew work in the *Rokeaḥ* printed at Fano in 1505, but generally speaking this was not usual in printing in those days, and even the title page just mentioned is without any adornment. A woodcut in the form of a real title page (*shaar*, or gate in Hebrew, symbolizing as it were the entry of the reader into the book) seems to have been first used by Daniel Bomberg in the Jerusalem Talmud, Venice, 1522–23. Later on, more and more care was lavished on the title pages which became miniature works of art in themselves.

The Italian arched frontispiece has also influenced Hebrew book printing in the south of Germany. An opening page of the *Code Jacob ben Asher*, printed in Augsburg in 1540, has the formal composition of an Italian title page. Its Christian origin is obvious— the presentation of God creating the animals and Eve is observed in the pediment. The

Fig. 203a

two common caryatid figures on the sides come to the fore, with the columns left behind them.

In the second half of the 16th century title pages were often decorated with twisted baroque columns in the form of the pillar in St. Peter's in Rome which, according to ancient tradition, derived from the Temple in Jerusalem. It was probably through the influence of this, which before long was greatly imitated outside Italy, that the symbol of the twisted columns became later on so extremely common in Jewish ritual art of every description in northern Europe.

Fig. 204

Later, it became usual to add to the engraved frontispieces some vignette illustrating the subject-matter, or else an allusion to the life of the Biblical character whose name was borne by the author, the patron, or the printer. The earliest instance recorded is, to be sure, in a Christian anti-Jewish production of the Jewish polemical work, Rabbi Yomtov Lipman's *Sepher ha-Nitzaḥon* (Altdorf, 1644): here the name of the Almighty is seen above, and below it a man kneels; Moses and Aaron appear on each side, and underneath a Christian holding a Bible is debating with a Jew. The motive here was missionary. But later the Jews followed this tradition. For example, delicately executed copper engravings adorn the title page of *Tikkun Sopherim* (Amsterdam, 1666), constituting illustrations to the crowns of the Torah, of Priesthood, of Kingship, and a Good Name, and portraying David and his son Solomon in attitudes appropriate to the crowns concerned. The title page of *Meah Berakhot* (Amsterdam, 1687) has delightful copper engravings of the performance of those commandments requiring benedictions (the sounding of the *shofar*, circumcision, etc.) and of the verse "and Isaac sowed and the Lord blessed him" (Gen. 26:12), in honor of Isaac Aboab da Fonseca, then rabbi of the community. The artist was Benjamin Senior Godines, well-known in his day also as a scribe and copyist. On the other hand, the frame of the title page of the book *Mizbaḥ ha-Zahav* (Basle, 1602) is by Hans Holbein whose name is signed on its upper part. This, however, is not so surprising, since the printer was in this case a non-Jew, although working for the Jewish market. Fine copper engravings for the title page of the Venice Bible of 1746, published by the Bragadin Press, were executed by the Christian artist Francesco Griselini. Biblical drawings also appear on the title page of the Yiddish book *Meilitz Yoisher* (Amsterdam, 1688–89), showing Moses receiving the tablets on Mount Sinai, Miriam on the bank of the Nile, Elijah with the false prophets, his ascent to heaven in the fiery chariot, and other themes. The drawing of the ravens bringing bread to Elijah is signed with the initials "J.V.H." finely engraved on copper, probably but not certainly those of a gentile artist. Highly noteworthy, too, is the engraved (second) title page to the scientific text of the Bible entitled *Minḥat Shai* which appeared in Mantua in 1742/4: this is repeated thrice in the book, before each section of the Bible. It shows scenes from the lives of Moses, Joshua, Solomon, David, Esther, Daniel, and Ezekiel, this last (as has been mentioned already in the introduction to this work) showing the resurrection of the dead bones, with the figure of the Almighty appearing from the clouds. This throws some sidelight on the attitude towards art of pious Jews in some environments at this period, and is therefore among the most memorable productions of the sort extant in Jewish books.

Fig. 203a, 210

Hebrew printers had a particular affection for pictures of Moses and Aaron, who are to be found in innumerable different forms on the title pages of their books, especially in Germany and Holland, from the 17th century. This motif later finds its way onto sacred

vessels and into religious art. Particularly memorable in their way are the frontispieces of a few liturgical and other works produced in Amsterdam at the time of the Messianic ferment in 1666, in some of which Sabbetai Zevi, the pseudo-Messiah, is seen on his throne, surrounded by his adherents.

The services of gentile craftsmen continued to be used sometimes for such work. One may mention as an example the exquisite title page of the Amsterdam Pentateuch of 1726, with vignettes of the lives of Moses, Samuel, and David (in honor of the three patrons of the work who bore those names). This was executed by the eminent French artist Bernard Picart, whose illustrations of Jewish life in Holland at the beginning of the 18th century are among the finest artistic records of Jewish life of former days. It is likely enough that the services of non-Jewish artists were invited for many other productions of this sort, besides those mentioned above, but the vast majority of the work in question is naturally anonymous.

In the early period, the printers often used symbolical badges to represent name, family, or occupation, with the incidental object of adorning and beautifying their books. The motifs are various: the priestly blessings; Biblical personalities (as a sign of belonging to a Levitical family); musical instruments; the seven-branched candelabrum; and so on. The earliest printer's badges known to us are from Spain. The first is of a lion within a shield appearing at the end of the book *Tor Oraḥ Ḥayyim,* Hijar, 1485, the shield being printed in red ink. The same flag is printed on several other occasions within a black shield. Especially interesting is the printer's mark of Gershom Soncino, which appears *Fig. 205* from the years 1497–98, and subsequently with several changes. Here we see a decorative frame containing a wall and tower flanked by guards. There are two birds on the wall, and the name of the printer is written on each side. The variety and interest of these printers' marks in Hebrew books is so great that an entire volume has been devoted to them. Some of them are exquisitely executed and may be counted as miniature masterpieces of Jewish book-art. An astonishing symbol is a figure of a naked woman appearing in books printed by Meir and Asher Prinz (Prinzo), and even in a Pentateuch (Venice, 1580).

IV

The earliest Jewish book containing illustrations, so far as is known (but it must be remembered that many of the early products of the Hebrew press may have been completely lost owing to the ravages of time and of hatred) links up in the most distinct and definite manner with the tradition of the medieval book-illumination. The only medieval Hebrew literary work which had a consistent tradition of illumination was the book of animal-fables and so on entitled "The Easterner's (or Ancient) Parable," of the 13th-century Spanish author, Isaac ibn Sahula. It has been told briefly in another chapter that the author illustrated the original manuscript of the work (to attract the interest of youth, as he tells us), and that almost all the extant medieval manuscripts of the work contain illustrations apparently following on the general lines of his original. When Soncino printed this work at Brescia in 1491 (2nd ed. 1497/8), he therefore included *Fig. 207* in it also more than eighty woodcuts of fairly high quality illustrating the story. Their authorship is unknown. It was at one time believed that they were of non-Jewish origin, being perhaps transferred to this work from an unidentified and untraced non-Jewish source. Now that we know these illustrations followed a well-established tradition, this hypothesis may be discarded. The Christian origin was confirmed as it seemed by the

fact that in one of the illustrations a monk is seen wearing a crucifix — something unimaginable in a Jewish production. It has, however, since been established that this last embellishment was a practical joke played by a Christian scholar on the great Hebrew bibliographer, Moritz Steinschneider, having been added by hand! Later editions of the work also, down to the 18th century, contained illustrations, based on these, as was the case also with some other books of fables (e.g., the Yiddish *Kuh Buch,* Frankfurt am Main, 1687, etc.).

There is a curious link with the oldest Jewish pictorial tradition in one decorative feature which became common in Jewish printed books. In another chapter it has been seen how in classical antiquity — e.g., in the mosaic floors of the Palestinian synagogue of the early centuries of the Common Era — it was usual to embody a representation of the twelve signs of the zodiac. Now, after a thousand years, this tradition reemerges. The first representation is found in a secular work — the licentious "Compositions of Immanuel" by Immanuel of Rome (Brescia, 1492). Later it became customary to include representations of the zodiac in the prayer books of the Ashkenazi rite in the prayers for rain recited on the last day of the Feast of Tabernacles and for Passover, when the hymns included in the service mention this astronomical feature. Another early work which embodied crude illustrations was the Yiddish pseudo-Josephus ("Jossipon") published in Zurich, in 1547, which served as the model for many later editions of that ever-popular composition, the women's compendium of Biblical history, the *Tzenah u'Reenah,* and also in numerous Dutch and German editions of the 17th and 18th centuries. They reveal the obvious influence of the *Fox Fables* illustrations, but they also include drawings of Jewish peddlers and other Jews carrying *lulabs.* It is probable that all these drawings are taken from similar non-Jewish books.

Headless man blessing the moon for *Hoshana Rabbah* from a Book of *Minhagim,* Amsterdam, 1723.

Fig. 206

Fig. 208

The first illustrated printed books of *Minhagim,* or customs, contain pictures like those in the *Haggadoth* (see below) with the addition of new pictures for the months and holidays. In the *Minhagim* in Judeo-German printed in Venice in 1601, we find, beside pictures of Passover, narrative pictures of the giving of the Law, the burning of the Temple, the sounding of the *shofar,* the sermon on the Sabbath of Penitence, the benediction of the new moon, a woman kindling the Sabbath lamp, and so on. The Amsterdam presses inserted further pictures of the Feast of Tabernacles, Purim players, a wedding, a circumcision, etc. The Amsterdam *Minhagim* of 1723 included a picture of a headless man for *Hoshana Rabbah,* illustrating the legend that a man who did not see the shadow of his head on this night would die during the year — a very interesting illustration of Jewish folk-art, traceable as far back as the 13th century, and paralleled, of course, in general folklore.

Especially notable are the illustrated broad-sheets of Jewish content which begin in the 15th century and occur sporadically in the 16th, 17th, and 18th. Only a few have survived, owing to the general fate of loose sheets, which are difficult to preserve. The earliest to have survived are two wood-block engravings on the subject of Passover, attributed to Venice and dated at about 1480, known in a solitary copy. Here are seen first the plague of darkness and the death of the firstborn, and secondly, the slaughtering of the Passover sacrifice, with the table set for the Passover meal, besides which six Jews stand with girded loins and staffs in their hands. There is reason to suppose that there were sheets of this sort for every festival and its relevant topics, and it is probable that the craftsmanship was non-Jewish.

Individual sheets are also known illustrating Jewish holidays: the lighting of the Hanukkah lamp, of the Sabbath candles, and so on, as well as talismans for the protection of the woman in childbirth, marriage contracts, and wedding songs; most of them were printed in Italy and Amsterdam in the 17th and 18th centuries. From such isolated sheets seems to have developed an entire series of drawings which illustrate the books devoted to special occasions, particularly *Minhagim* books. Most of this crudely sketched material, however, can only be placed in the category of folk-art, though its importance for social and cultural history is considerable. On the other hand, it links up in the most direct fashion with the beloved work in which the art of the Hebrew printed book reached its supreme achievement — the ritual for the domestic service on Passover eve.

V

The first printed illustrated *Haggadah* was published, it is believed, in Constantinople about 1515; only two pages of it have survived. These show two woodcuts: a drawing of four people sitting at the Passover *Seder,* and another of Moses and Aaron before Pharaoh. The style of drawing is Oriental-Spanish. Drawings of the sort found subsequently in the Passover *Haggadah* appear also in the first edition of *Birkat ha-Mazon* (Prague, 1514). We see here a table set for Passover and the members of the family eating around it; another illustration shows the hunting of the hare — in German "Jagd der Hasen," giving the initials of the order of benedictions at the outset of the Passover meal, as in medieval German-Jewish manuscripts. What has been mentioned so far was by way of experiment. It was only later that the real tradition began.

We may begin by indicating the nature of the illustrations which recur in almost all of the various illustrated editions of the *Haggadah,* now numbering more than three hundred. Firstly, there are those which may be termed introductory: these illustrate the search for the leaven on the eve of Passover, the various stages in the ritual, and so on. In Ashkenazi editions, down to the 17th century, we find at this stage also the traditional representation of the hare-hunt. The main part of the text is illustrated by the story of the Exodus from Egypt and the events leading up to it, sometimes beginning with the story of the Patriarchs and going on to the Giving of the Law at Sinai. After the meal, when the atmosphere of the service changes and concentrates on prayer rather than on narrative, the illustrations, too, take on a Messianic tinge, and we find in very many cases a representation of the Messiah, sometimes with Elijah as his harbinger, and of the Temple, as known in some medieval manuscripts and early engravings.

The Prague *Haggadah* of 1526 is the prototype of all of the noble series of illustrated *Fig. 209* Passover *Haggadoth* that have appeared all over the world down to our days. This, with its splendid lettering, its ornamental initials, its marginal cuts and decorations, and its superb borders around three of the most important pages, is among the finest productions of the 16th-century printing press in any language. After the sanctification, the usual scene of the hare-hunt follows. In the margins there are cuts, sometimes repeated more than once, showing the householder lifting the cup of benediction or reclining for the service in the manner of freedom, or his servant pouring water for the ceremonial ablutions, or the slaves in Egypt making mortar, or the "four sons," and so on. Larger cuts at the bottom of the pages show Pharaoh in his legendary bath of children's blood, the hurling of the Hebrew infants into the river, or the triumph at the Red Sea. But the greatest glory of the book are the three borders (at the outset of the entire volume, at the beginning of

the actual *Seder* service, and after the Grace). The last is perhaps the most impressive. Here, the border is flanked above with Adam and Eve, with Samson bearing the gates of Gaza below Adam, and Judith with the head of Holophernes below Eve. At the bottom is the coat of arms of the kingdom of Bohemia. Within the framework we see the advent of the Messiah, riding on his ass—once again, a traditional motif. The Hebrew letter *shin* appears on the robe of Moses holding the rod and again on the figure of Moses standing beside the Red Sea. The Bohemian coat of arms is also flanked by this letter which appears once more on the robe of King David three pages later. Some suppose that this alludes to the name of the printer, Hayyim Shahor, one of the partners in the press, who in this case was the artist or engraver; it is perhaps more reasonable to suppose that it merely indicates the name of Solomon Ha-Cohen, the father of the two brothers who were partners in the printing of this *Haggadah.*

In the Prague *Haggadah* of 1590 the illustrations follow those of the first Prague edition, some exactly and some with modifications; but the drawings here are very rough. The typefaces, borders, and illuminated letters in this edition are also different. For the 1606 Prague edition new woodcuts were made, such as the sermon on the Great Sabbath, the blessing of the candles, and so on. The Prague drawings of 1624 are taken from the 1606 issue. In the Prague printing of 1706 appear woodcuts from the previous Prague editions, and even worn cuts deriving from the 1526 issue. In the Augsburg *Haggadah* of 1534, although the influence of the Prague printing is recognizable, and the printer was one of the printers of the Prague *Haggadah,* we see drawings of quite a different character.

The tradition of the Prague *Haggadah* was brought southwards over the Alps to Mantua, a city which always stood in close relations with German and Bohemian Jewry. An illustrated *Haggadah* was produced here in 1550 which, though it shows a definite Italian spirit, at the same time demonstrates clearly the influence of the original Prague edition. The *Haggadah* printed here in 1560 is much influenced in spirit, arrangement, and illustrations by the 1526 Prague edition; even its colophon resembles that of the Prague issue. The borders here, however, are completely different, and the Italian stylistic manner is prominent. In the engraving representing the migration of Abraham into the Promised Land, only one person, instead of two, sits in the boat crossing the river—in this case a gondola—while a second stands behind to steer the craft. The earlier drawings in the book showing the baking of the *matzot,* the Passover meal, etc., are very primitive; the later drawings appear to have been executed by another artist and their artistic standard is distinctly higher. In the Mantua issue of 1568, the printer utilized the engravings of 1560, and this issue closely resembled the former in its arrangement. A *Haggadah* printed at Amsterdam in 1662 is influenced both in its drawings and in the arrangement of the pages by the Mantua editions. However, as the artist and the cutter of the Amsterdam edition copied the Mantua drawings with the utmost precision, the drawings came out in the printing the wrong way around, as in a mirror.

A new tradition, which had a great influence on the cycle of illustrations in successive *Haggadoth* produced in the Sephardi world down to our own day, appears in the edition published in Venice in 1609, "with many pictures regarding all the signs and miracles which were performed for our ancestors in Egypt." This was the ancestor of all the editions which appeared subsequently in Venice, as well as later in Pisa and Leghorn; in these cases the illustrations were newly engraved but did not reach the same high technical and artistic level. In these Venetian *Haggadoth* there figures an entire series of illustrations of

Vignette from a *Haggadah.*
Venice, 1609; woodcut.

the history of the Israelites, from Abraham down to the Exodus, sometimes at the foot of *Fig. 211*
the printed text and sometimes above it. In the Venice edition we find, moreover, for the
first time, two features which later on become almost invariable — a full page towards the
beginning with a series of vignettes, of some importance from the point of view of social
history, showing the various stages of the Passover meal, with the participants naturally
dressed in contemporary costume, and another, further on, depicting the Ten Plagues.
The initial letters comprise drawings of scenes and buildings; while in the historical il-
lustrations the magicians standing before Pharaoh are shown as Negroes *(nigro-
manti)!*

A new style and a new method of artistic engravings are to be found in the Amsterdam
Haggadah of 1695, printed "according to copperplates by the youth Abraham ben Jacob
of the family of our Father Abraham." Abraham ben Jacob was a Christian who came
from the Rhineland to Amsterdam and adopted Judaism about the year 1689. His dealings
with Jews, mainly with printers and compositors, attracted him to the Jewish religion,
which he embraced as a full proselyte. He continued working on portraits and copperplate
title pages until approximately 1738. Of him and of his craftsman's skill it is stated on the
second title page of the *Haggadah:* "Therefore a spirit of knowledge and fear of God in the
exalted person of Abraham son of Jacob our father caused him to draw and cut and en-
grave with tools upon a sheet of copper, when previously the forms were cut in wood,
and there was no beauty. All will now see with their own eyes that the forms engraved in
copper possess the same superiority as light has over darkness in their beauty, and will
rejoice forever over this innovation of craftsmanship by an artist known by his fellows as
one of the highest skill and ability, as a practiced craftsman in the art of drawing and
engraving seals and all plans, models and pictures of everything that is in heaven and
earth." This, then, was the first printed *Haggadah* containing engraved copperplate
illustrations.

The decorative title page contains, beside large pictures of Moses and Aaron, miniatures
of Biblical events such as Adam and Eve, the Tower of Babel, the Flood, the Destruction *Fig. 210*
of Sodom, Abraham and Melchizedek, and Jacob at Bethel. From this edition we know
another remnant, without the miniatures, instead of which there is a drawing of Moses
with his sheep in the desert, watching the burning bush. Fourteen pictures of the Exodus
and the keeping of the Passover, as in the Venice editions, are included in this *Haggadah.*
All of them show a marked Christian influence, most of all in the picture of David kneeling
in prayer to the "Holy Spirit." It has now been established that these copper engravings
were made after the engravings of Mattheus Merian in his *Icones Biblicae* printed at
Basle, 1625–26. At the end of the *Haggadah* is a map of "all the journeys in the desert
down to the sharing of the land among all the tribes of Israel." This was the first map
to be printed with names in Hebrew, and perhaps the first map of Palestine (in the full
sense of the word) to be published by a Jew.

This *Haggadah* became the prototype for those published in the Ashkenazi world, in the
same way as the Venice edition of 1609 was the prototype of those in the Sephardi world,
but to a far greater extent. It was reprinted in Amsterdam in 1712, with many additional
or improved features, some of them taken over from the Venice edition, and now, therefore,
omitting the name of the proselyte illustrator. It was imitated in a large number of
later editions (Frankfurt am Main, 1710; Sulzbach, 1711; Offenbach, 1721 and 1755;
Fürth, 1762, and so on).

In the copper engravings of the *Haggadah* (published in Metz in 1767), a clear attempt was made, however, to eliminate the influence of Christian art from the illustrations: e.g., in the title page where Moses is kneeling in front of a glaring sun; in the drawings of the Giving of the Law and in the picture of King David, whence the Holy Spirit has been eliminated. The illustrations reappeared without change in vast numbers of cheap *Haggadoth,* published in Europe and America in the 19th and 20th centuries. They were copied lavishly on various Passover dishes, such as *Seder* plates and *kiddush* cups. And they served as the model for the illustrations of a whole series of hand-illuminated *Haggadoth* produced by an important school of manuscript artists all over Central Europe in the 18th century.

There were numerous later illustrated editions of the *Haggadah* which could well receive mention here, and fuller treatment in a work specifically devoted to this subject; for example, the Basle edition of 1816, with its twelve illustrations depicting various episodes of Biblical history; or the important Trieste *Haggadah* of 1864, very popular in its day, with its 58 delicate and well-conceived copperplate illustrations by C. Kirchmayr, still showing, however, the influence of the Venice edition of 1609. In the 20th century also, many important *Haggadoth* have appeared, such as those illustrated by Jacob Steinhardt, Joseph Budko, Albert Rutherston, Arthur Szyk, and so on; while in contemporary Israel there have been splendid editions of I. Zim-Zimberknopf, Jacob Wechsler, and others. These artists and their production introduce us, however, to a later stage of the development of Jewish art. Recently, institutions and publishers began publishing in photoprint exemplary illustrated *Haggadoth* of the manuscript period, such as the Kaufman *Haggadah* (Budapest, 1957), the Sarajevo *Haggadah* (Tel Aviv—Jerusalem, 1954), and *The Birds' Head Haggadah* (Jerusalem, 1967).

PART THREE:
JEWISH ART FROM THE
EMANCIPATION TO
MODERN TIMES

JEWISH ART AND ARTISTS BEFORE EMANCIPATION

by CECIL ROTH

In the first centuries of the Middle Ages, two parallel processes tended to drive the cultural activities of the Jews, especially in Europe, into narrower channels than heretofore. One was the growth of Christian religious prejudice, which aimed at the complete exclusion of the Jews from gentile society. The other was the intensification of the sway of the Talmud which, while making the Jewish community more and more a self-contained society, emphasized that the only proper intellectual activity was the study of the Torah; and at the same time stressed the anti-artistic or rather iconoclastic attitudes implicit to some extent in the rabbinic approach. At this time, moreover—and down to the post-Renaissance period—a vast proportion of European art was ecclesiastical, a fact which again restricted Jewish participation. This did not mean that Jewish participation was wholly absent, but it did mean that much of it was anonymous. We thus approach the stage when the existence of Jewish art and artists has to be demonstrated, less from actual objects than from scattered literary allusions.

In previous sections of this work it has been seen that Jewish artists, some specimens of whose production have survived, were known in the Roman Empire, not only in Palestine and its immediate neighborhood, but in the European Diaspora as well. This tradition was strengthened subsequently as the Jews became more and more an urban and, at the beginning, an artisan element. In the late classical and the early medieval periods Jewish craftsmen enjoyed a high reputation—e.g., in glasswork and metalwork. From the 6th cent. onwards, and well on into the Middle Ages, Jews were associated with the royal mints all over Europe and the Mediterranean area. The name of Priscus (later Court Jeweler to the Frankish King Chilperic I, and destined to meet a tragic end) appears together with that of a certain Domnulus—and this, too, was a Jewish name—on a coin issued at Chalon-sur-Saône in about 555. The first coins minted in the Eastern Caliphate in the second half of the 7th century, to replace the Byzantine and Persian coins, which had formerly circulated, were engraved by a Jew named Sumair. Numerous other Jewish minters are known throughout the Middle Ages. Even in England, Biblical names appear with curious frequency in this connection. What is most remarkable is that the coins struck in Poland at the end of the 12th and the beginning of the 13th centuries bear inscriptions in Hebrew characters, giving the names of the rulers for whom they were struck (e.g., "Mechislaw King of Poland"; "Blessing on Mechislaw," etc.) or the names

Fig. 213

Fig. 214 of the Jewish minters (Abraham ben Isaac Nagid, Joseph Kalisch, etc.). There can be little doubt that Jewish craftsmen also carried out the technical work. Throughout Europe, Jews were known at this period as jewelers and goldsmiths, which at this time implied a high degree of technical ability. In Spain and the Mediterranean countries generally, goldsmithery was regarded as one of the characteristic Jewish occupations. This was to a great extent the outcome to the fact that Islam forbade Moslems to engage in such work, which until recent years was left in the countries of North Africa, for example, wholly in Jewish hands; and it is certain that among the anonymous productions of this age, which excite our admiration, some must be of Jewish workmanship.

There was, of course, one factor which inevitably minimized Jewish collaboration in artistic life at this time. It has been mentioned above—that so much of European art was religious and ecclesiastical in intention. For a Jew to manufacture articles of Christian religious use was thus preposterous; and it was through the medium of such work that the artist or craftsman obtained his practice, made his name known, and worked up his clientele. Nevertheless, the fact that it was preposterous does not imply that it was non-existent. In 1415, the anti-Pope Benedict XIII, then resident in Spain, issued a bull in which he forbade the Jews to be employed in the making of ceremonial objects for Christian use, such as chalices or crucifixes. Similarly, in 1480, Queen Isabella of Castile appointed a court painter, one of whose duties was to ensure that "no Jew or Moor paint the figure of our Lord and Redeemer, Jesus Christ, or of Holy Mary the Glorious." Obviously, then, such professional activity was not unknown. Anecdotes are told about Jewish religious artists of this type: how, for example, a miraculous picture of the Madonna long preserved at Barking, just outside London, was the work of a Jewish painter Marlibrun of Billingsgate, "the most skilful painter of the whole world" (c. 1290), who subsequently became converted to Christianity. Whether there is a kernel of truth in this strange tale cannot be determined. But official records in various lands provide us with cases concerning which there can be no doubt. A certain Solomon Barbut manufactured in 1399 a reliquary for the Augustinian Priory of Barcelona; while at Huesca three years later two Jewish goldsmiths contracted to provide a crucifix before the ensuing Christmas. Nor were those who executed such commissions only the ignorant or the religiously indifferent; one official document tells us how a certain Rabbi Samuel of Murcia traveled about Spain in 1378 with a royal safe-conduct in the company of Jaime Sanchez, *sculptor imaginum,* whom, presumably, he assisted in his work. The sources introduce us, moreover, to a number of persons whose scope was secular. When Francis of Assisi was in Spain in 1214, a Jewish sculptor is said to have executed his likeness; and we know how in 1345 a silversmith named Moses Jacob was summoned from Perpignan by the King of Aragon to execute the ornamental work for his clocks. These instances assembled almost at random demonstrate that in certain parts of Europe in the medieval period Jewish artists were familiar, some of whom had no objection to depicting the human form in the round (more objectionable by far from the point of view of strict rabbinical law than mere painting, as we have seen above), or even to the manufacture of Christian religious objects.

That painters, too, were to be found is, therefore, self-evident. One important specimen of Jewish art of this period—though its chief importance was not in the artistic field— is the famous Catalan Atlas (now in the Bibliothèque Nationale in Paris) executed in 1376/7 by Abraham Crescas of Majorca and his son Judah for the King of Aragon, who

pronounced it to be the fairest map that he had ever seen. In this, the geographical details are emphasized and illustrated by drawings of castles, animals, symbolic figures, and so on, executed in color, and sometimes with considerable verve and dramatic effect. Professional painters who are mentioned in contemporary documents include Abraham ben Yomtob de Salinas (1406) with his son Bonastruc; and Moses ibn Forma of Saragossa (1438). Nor can one dismiss the hypothesis that the two brothers Guillen and Juan de Levi, whose productions are beginning to attract the attention of students of the newly revealed 15th century Aragonese school of painting, were of Jewish birth, as their name seems to imply.

Another branch of craftsmanship in the Middle Ages which demanded a high degree of artistic, as well as technical ability was bookbinding; and we find records of Jewish book-binders even in the papal court at Avignon. The bull of the anti-Pope Benedict XIII, which also forbade Jews to bind volumes containing the sacred names of Jesus and the Virgin Mary, shows how closely Jews were associated with this craft. In Germany, they are said to have been expert in the difficult type of leather-work known as *cuir ciselé*, with the use of damped leather as a basis for carved designs. Specimens are extant of the work of Meir Jaffe, known also as a scribe and manuscript-illuminator of merit. In 1468 he was commissioned to bind a copy of the Pentateuch for the City Council of Nuremberg. This *Fig. 212* splendid achievement (now preserved in the State Library at Munich) is decorated with the civic coat of arms supported by a deer which is entwined in thin tendrils. The back cover shows an intricate pattern of thicker boughs, terminating in human heads, and there is a Hebrew inscription giving the craftsman's name. One authority, who terms him "a supreme artist," ascribes to him also a number of other distinguished works of the same type and period.

An earlier chapter of this work dealt with Jewish manuscript-illumination of the Middle Ages. Here a single point only is to be emphasized. While it is certain that some of these illuminations were executed by non-Jewish artists, and while the vast majority are anonymous, so that their authorship is open to doubt, there are a few which are certainly the work of Jews, whose names are preserved. Thus, for example, Meir Jaffe, who has just been mentioned, is known to us as a skilled book-illuminator as well as bookbinder; the Kennicott Bible in Oxford was the achievement of Joseph ibn Hayyim; Nathan ben Simeon executed a superb codex of Maimonides' Code at Cologne in 1295; Joel ben Simeon created a series of illuminated *Haggadoth* in the late 15th century in Germany and northern Italy, and so on. Isaac ibn Sahula, the Spaniard, informs us that he made a point of increasing the attraction of his famous book of parables, the *Meshal ha-Kadmoni* (1281) by including a series of illustrations, which presumably provided the patterns for those that appeared in subsequent manuscript and printed versions. It follows that some anonymous productions—especially in cases where knowledge of Jewish ritual or Jewish tradition is shown—may well have been the work of Jewish craftsmen also. A point to be noted is that most of the persons mentioned are known to us only by a single production. Obviously, they must have been responsible for far more than this, and much of their work must have been destroyed or remains unidentified—or, indeed, is to be sought perhaps in non-Hebrew manuscripts, unobtrusively produced for Christian patrons or placed on the general market.

II

In Italy, in the period of the High Renaissance, Jews participated in almost every form of the cultural activity characteristic of the age. That there were artists among them is certain; but, unfortunately, very little of their recognizable production has survived. Moses de Castelazzo (d. 1527) — son of a German immigrant named Abraham Sachs, and himself the first patron of David Reubeni when he arrived in Italy in 1524 — seems to have been a person of some slight note in his day. He designed a portrait-medal of Ercole I d'Este, Duke of Ferrara; he was on terms of easy friendship with the Cardinal Bembo, for whom he worked; he executed, or began to execute, a series of illustrations to the Pentateuch, which he intended to have engraved on wood by his sons, artists like himself, receiving patents of copyright for this from the Council of Ten in Venice and from the Marquess of Mantua. However, nothing of his production can now be identified. The same is the case with Master Isaac of Bologna, goldsmith to the Court of Naples in 1484, and Graziadio of Bologna, for whom Benvenuto Cellini worked as a boy. There are extant some very beautiful specimens of Jewish ritual art in precious metal — silver and gold — dating from the Renaissance period, but there is hardly any positive evidence that the makers were Jews, and there is a high probability that they were not. Perhaps the only identifiable signed object of Jewish domestic use of this age is an exquisite casket now in the Israel Museum, Jerusalem, bearing representations of Jewish ceremonials, finely executed in niello work, apparently about 1460–80, by a master-craftsman from Ferrara named

Fig. 217 Jeshurun Tovar.

Only one Jewish craftsman of the age is of sufficient eminence to enter into art history in the more specific sense. This is Salamone da Sesso, who in 1487 entered the service of the Duke of Ferrara and shortly after accepted baptism under the name Ercole dei Fedeli. For the next thirty years he is found working for various Italian courts — Mantua, Pesaro, Ferrara, Rome. He was especially noted for the magnificent swords and daggers

Fig. 215 which he produced. These are not vulgar instruments for self-defense but superb articles of adornment, the scabbards being encrusted with pagan (never Biblical) scenes, classical symbols, and nude figures in the spirit of the age. The most famous of his productions, specimens of which are to be found in most of the great collections of Renaissance art, is the sinister, exquisite weapon fashioned for Cesare Borgia, which has been designated the Queen of Swords. Towards the close of the 16th century we find a gifted but unoriginal artist in metal from Verona, named Giuseppe de' Levi, who worked in close collaboration with a certain Angelo de' Rossi — in Italy an almost characteristically Jewish name, corresponding to *Mordecai min Ha-Adumim*. That they were both Jews, notwithstanding the ecclesiastical productions with which they were associated, is likely enough; but it remains unproven.

Painting introduces us into a somewhat different sphere, closely associated with that of manuscript-illumination, which has already engaged our attention. There were certainly Jewish painters in Renaissance Italy; two of them, Angelo (= Mordecai) d'Elia and Giacobbe di Vitale (= Jacob ben Ḥayyim, were even admitted in 1507/8 to membership in the painters' guild at Perugia. Nevertheless, of the known paintings of the period virtually nothing can be ascribed to Jews. Giovanni Battista Levi (c. 1552-post 1605), some competent altarpieces by whom have been preserved, may have belonged to a Jewish family, like the metalworker, Giuseppe de' Levi; but his first name makes it certain

that he was not a professing Jew. A certain case, however, is that of Jonah Ostiglia, of Florence (d. 1675) who is said to have become interested in painting only in his thirty-seventh year, when his imagination was fired by seeing someone copying a painting by Salvatore Rosa. He now obtained access to one of the same master's canvases and tried his hand on it. Soon he showed considerable aptitude and in the end grew into Rosa's style to such an extent that, we are told, their works could hardly be distinguished apart. Perhaps it is for that reason that nothing of his production can be identified today. We know, however, that he decorated the salons of some of the Florentine nobility, and that he did landscapes (like his master, he did not excel at figure-painting) for some fellow-artists such as Bracciolini and Giusti.

It is obvious that both the social and the religious impediment disappeared if a Jew became converted to Christianity, and there were presumably quite a number of baptized Jewish artists, in addition to the hypothetical cases mentioned above. In the 17th century, two of these rose above mediocrity. One of the busiest church-painters in Venice in the 17th century was Francesco Ruschi, son of a converted Roman physician. A pupil of the popular Roman artist Giuseppe Cesari, known as "Il Cavaliere d'Arpino" (whose objectionable mannerism he was able to avoid), he learned the dramatic potentialities of light and shade from Caravaggio and those of space from Pietro da Cortona, whose Venetianism he emphasized. It is said that he breathed a new life into the younger generation of artists in Venice, and may thus be considered the forerunner of the minor Renaissance there in the 18th century. It is noteworthy that he showed a predilection for Old Testament subjects; possibly, his Christian allegiance was not so profound. A very different type of person was his contemporary Pietro Liberi (1614–87), baptized son of a Paduan Jew, who after an adventurous career (he had been in turn soldier, merchant, and slave in Tunis) settled as a painter first in Vienna and then in 1659 in Venice. He was eminently successful, specializing in altar-pieces and church decoration, much of which is still to be seen there. His painting is described as easy and clever, with strong medieval reminiscences. His reputation was such that he was able to build for himself what was subsequently the Palazzo Moro on the Grand Canal, and received the dignity of Count of the Holy Roman Empire. In the history of later Venetian art he played an important role as the founder, and earliest Prior, of the College of Artists.

Engraving, which could be applied also to books printed in Hebrew, was obviously in a separate category. Highly ornamental elements, sometimes presumably emanating from Jewish masters, are to be found in Hebrew books almost from the beginning of printing, and some books were already illustrated from the end of the 15th century. A certain Moses ben Isaac, brother-in-law of the Neapolitan Jewish printer Azriel Gunzenhausen, is specifically stated to have been associated with the woodcuts which figured in a work produced by the latter in Naples in 1492. The only Jewish artist of the period whose work in a non-Jewish publication can be identified with certainty is David de' Lodi, who contributed some competent engravings to a historical work on Cremona, *Cremona nobilissima città*, produced in that city in 1585. He is said to be the earliest known Jewish copper engraver.

Another branch of artistic production in which Italian Jews were engaged in the Renaissance and post-Renaissance periods was ceramic manufacture. We know of a Lazzaro Levi, who was licensed to work at Mantua in 1629, though — once again — none of his work is identifiable. Jewish ritual objects of some merit (Passover plates and the

like) were produced by members of the Cohen and Azulai families who were at work in Faenza, Padua, Pesaro, Ancona from the middle of the 16th down to the middle of the 18th century. It is natural to suppose that their work was entirely confined to Jewish ritual production. Probably, therefore, some unsigned pieces (particularly those bearing Old Testament or Apocryphal scenes, which might have been intended for Jewish clients) are to be ascribed to them.

Another aspect of artistic activity which must be taken into consideration is architecture. A separate section of this work (chapter VII) will deal in detail with the synagogues of the medieval and post-medieval periods. Here, it is necessary only to consider to what extent they were the work of Jewish architects. In some cases, certainly, they were not, and the names of the gentiles responsible for the work are recorded. In some instances it is certain, however, that it was carried out by Jews. Thus, for example, though the former ascription of the Transito Synagogue at Toledo to a fictitious Meir Abdeli cannot be maintained, that of Cordova (1315) was apparently constructed by Isaac Moheb. The Hebrew tablet in the former synagogue of Trani makes it clear that the architect was "a man of understanding, honored member of our body." The synagogue of Monchique (Oporto), the ruins of which are still impressive, was constructed, as we know from similar evidence, under the direction of Don Joseph ibn Aryeh, "the officer who supervised the work." The epitaph of Judah Goldsmied de Herz in the Old Cemetery of Prague states that it was according to his plans that the Pinkas Synagogue and part of the Meisel Synagogue in that city were constructed; though in the view of a contemporary Jewish chronicler, the main responsibility for the latter is to be attributed to Judah and Joseph Wahl. Likewise, some of the Eastern European synagogues have attached to them the names of Jewish architects such as Simha Weiss (Nasielsk), Benjamin Hillel of Lutsk (Lutomiersk), and so on. These names are sufficient to prove that Jewish architects were at work in the Middle Ages and thereafter, before the age of emancipation. Their achievement obviously extended well beyond the handful of buildings which may definitely be ascribed to them. In this case, too, we may assume that their work was not necessarily confined to the religious sphere, nor even to a Jewish clientele.

III

We have been dealing, thus far, with scattered names and random episodes of Jews who managed to elude or break through social prejudice and religious bars, and were thus able to participate in certain aspects of artistic activity in southern Europe in the medieval and Renaissance period. For such participation, though not indeed for art itself, a far more favorable atmosphere emerged in the 17th century in certain Protestant lands of northern Europe. On the one hand, religious prejudices here dwindled, and the new communities which began to emerge in cities such as London and Amsterdam were economically, and to some extent socially, emancipated. On the other hand, art lost its specifically religious connotation, and it now became possible for one who did not belong to the Christian Church to take part in it without straining his conscience. Moreover, the new communities were to a great extent dependent on the Marranos who, as Christians in Spain and Portugal, had followed the same walks of life as their neighbors, and continued to have the same tastes and engage in the same occupations after they arrived at places where they could freely profess their religion. Simultaneously, Ashkenazi practitioners of various forms of art began to emerge in the environment of the semi-emancipated Court Jews in

the various German states, later spreading elsewhere. Thus, from the 17th century, Jewish artists working in a European *milieu* begin to become relatively common.

A point that emerges time after time in connection with the persons with whom we will have to deal is that their artistic activity was at the outset incidental to their main occupation. They did not become artists in order to satisfy an inner urge, but, in the course of earning their livelihood, they found and developed their artistic bent. The journeyman seal-cutter develops some competence in medal-engraving; the pewter-engraver becomes an expert in copperplate; the calligraphist expands into the miniaturist; the painter on porcelain becomes a painter on ivory and thereafter on canvas; the tobacconist even, as the result of producing decorative snuffboxes, ultimately builds up a reputation as a miniaturist. There is not as yet — nor in view of social conditions of the time could there be — any question of the young Jewish enthusiast boldly embarking on art or painting as a career.

We may take as our starting point Salom (Solomon) Italia, a member of the well-known Italian family of printers of that name, who may have learned the art of engraving in the ancestral business in Mantua. Perhaps as the result of the temporary expulsion of the Jews from that city by the German troops in 1629, he came to Amsterdam, where for the next thirty years he was very active. We know only of his work in a definitely Jewish connotation. As will be described below, he produced the engraved borders for two *Fig. 216* noteworthy Scrolls of Esther, as well as for a *ketubah*. In the present connection, more importance is attached to his non-religious production. This included the well-known portrait of Menasseh ben Israel which he engraved in 1642, a dull achievement in the *Fig. 219* spirit of the age: technically well-executed, historically valuable, but not quite alive. It is perhaps unfortunate that this specimen of Italia's work inevitably has to bear comparison with the famous portrait of the same individual which Rembrandt van Rijn painted and etched in 1636, with the brooding, haunting face, and the heavy-lidded eyes, a man six years younger than the scholar of Italia's portrait, but bearing on his shoulders all the weight of the ages. Italia is also believed to have been responsible for the rather clumsy etchings — executed no doubt hastily — to Menasseh ben Israel's *Piedra Gloriosa* of 1655. These replaced in the published edition the famous series originally prepared for the work by Rembrandt, which included a representation of the Godhead, and was presumably rejected for that reason by the author when the plates became worn. Passable in themselves, Italia's etchings are clumsy and amateurish when they are compared with the master's mystical interpretation of Scriptural prophecy. Another well-known portrait by Salom Italia is that of Rabbi Jacob Judah Leon, called Templo (1603–75) — himself a border-line artist, who owed his name to the representations of the Temple which he not only reconstructed in model form, but also painted and subsequently engraved. *Fig. 218*

Among the first of the 17th-century artists was Moses Belmonte (1619–47); he both drew and etched a portrait of his mother, Simha Vaz Belmonte, in her extreme old age, who, with her husband Jacob Israel Belmonte, had been among the founders of the Jewish settlement in Amsterdam. To be sure, drawing and painting were part of the accomplishment of any well-to-do family at this period — of the female members especially — and it is only to be anticipated that the Sephardi magnates of London and Amsterdam dabbled in them like their neighbors. Thus, in the collections of the Henriques da Costa family of Amsterdam, dispersed in 1895, there figured numerous 18th-century drawings and paintings of otherwise unknown members of that and allied clans.

In the course of this generation, it became usual for the rabbis of the Spanish and Portuguese communities of northern Europe (as well as some of their Ashkenazi colleagues) to have their likenesses engraved, so that they could be available to members of their flock. A large number of the artists as well as the engravers were Jews. We may view persons, such as the Danish Jew David Estevens, painter of a dignified likeness of *Ḥaham* David Nieto at his desk — a typical specimen of early 18th-century portraiture — which was engraved by the English engraver McArdell in 1727, or Solomon da Silva, author of a portrait of *Ḥaham* Moses Gomes da Mesquita, of London, engraved by J. Faber, in 1752.

Among the Sephardi group in England there emerges one woman-painter who was not without ability — Catherine da Costa (1679–1756) who is not only the earliest known Anglo-Jewish artist, but also perhaps the first Jewish woman-artist specimens of whose work are preserved. Member of a cultured and wealthy family, and a pupil of the famous drawing-master and mezzotint engraver Bernard Lens, she was responsible for an interesting group of family miniatures and portraits, some of which show a naive charm — e.g., that of her father, Dr. Fernando Mendez, formerly physician to King Charles II, dressed in full 18th-century fashion (1721), and the livelier miniature of her own son, Abraham da Costa, in his tenth year (1714).

Besides these, we find a number of Jewish engravers associated with the title pages of of works printed in London and Amsterdam at this period. A number of expert calligraphers, who generally embodied finely drawn title pages in their productions, are of interest in this connection. These are dealt with in greater detail elsewhere, together with the revival at this period of Jewish manuscript art, which reached an unexpectedly high level (see chapter XII).

Some Jewish engravers of this circle are known to us also by productions in oils, showing a somewhat wider competence. Thus "Ar de Chaves," who engraved the elaborate symbolic portrait-group which figures in Miguel de Barrios' *Imperio de Dios* (Brussels c. 1670–73 or 1700), is presumably identical with Aaron de Chaves (d. 1705), who painted a conventional panel of Moses and Aaron for the Sephardi synagogue in London. He shows a greater competence in a Scroll of Esther which he imaginatively illustrated in 1687.*

Fig. 204 We will encounter also the name of Benjamin Senior Godines, a notable calligraphist and capable engraver, who *inter alia* both edited and engraved the frontispiece for the Hebrew and Spanish *Orden de Benediciones* (Amsterdam, 1687). He had some wider ambitions, and at least on one occasion embarked as a painter in oils. The Jewish Museum in London has a series of morality pictures executed by him in 1679 and 1681 for his friend and patron Isaac di Matatia Aboab of Amsterdam. One (a tribute to the artist's patron) illustrates episodes in the life of the Patriarch Isaac; the second, a symbolic scene of the virtues of justice and charity; and finally, a *memento mori* executed in 1681 showing the dandy (attended by his Negro servant) and the corpse that he is to be, and in the background, the Jewish cemetery of Ouderkerk, after Van Ruysdael's well-known picture. This same subject was used by the artist again in another picture for the same patron in the following year. The series, more Catholic than Jewish in inspiration, is

* A. Rubens, *A Jewish Iconography*, p. 91, doubts the ascription of the de Barrios frontispiece (engraved by Christian Hagen) to Chaves, but it is accepted by J. Meijer, *Encyclopaedia Sephardica Neerlandica*, who illustrates his artistic activity from other sources.

typical of the cultural and spiritual atmosphere of Amsterdam Jewry in the 17th century. The artist shows some ingenuity, but oil painting was clearly not his *forte*. Some other morality paintings of this period are preserved, but the artists are unknown. At the close of the 18th century the Jewish Burial Society at Prague had the room in which it met decorated with a series of paintings representing the pious functions incumbent on its members. These charming *genre* paintings are almost certainly the work of a Jewish artist, to judge from the close acquaintance with Jewish practice that they show.

Environmental influence may be traced also in another incidental aspect of art which received its pale reflection within the Jewish community. A few caricatures are extant from different countries which show that the Jews appreciated and were able to use this characteristic 18th-century weapon of argument. A controversy which raged in London in 1749 regarding the newly established Sephardi Hospital, *Beth Ḥolim*, was the occasion for the publication of a print entitled *The Jerusalem Infirmary*, illustrating a play of the same title. It satirized the behavior and weaknesses of those associated with the management of the institution and emphasized certain alleged abuses in its management; it appeared anonymously, with the authorship distributed among various impossible names (*inve.* Ribi Tarfon; *Pinx.* Ribi Zadok. *Scup.* Ribi Bagbug), and it is not certain (though probable) that the artist was a Jew. In 1777, a scholar from Modena in Italy, Zechariah Padova, after a quarrel with the leaders of his community, caricatured them in an etching, in which he depicted himself seated in his study and his elegantly dressed opponents advancing on him, one of them — his bitterest enemy — having a dog's body. The artist's self-portrait is noteworthy.

Fig. 220

Notwithstanding this unusual achievement, it is curious that Italian Jewry, with its intense aesthetic sense and strong artistic tradition, still produced so little in this field. A rabbi of Zante, Abraham Cohen, was apparently the author of the poor classical portrait prefixed to his *Birkat Avraham* (Venice, 1719). Jacob Carpi (1685–1748) of Verona, who emigrated to Amsterdam at the beginning of the 18th century, besides dealing in works of art, painted there portraits and historical scenes, none at present readily identifiable. Raphael Bachi of Turin (1717–67) settled in Paris as a tobacconist and snuff-merchant, later beginning to decorate and then to paint his snuffboxes. Ultimately, this became his main occupation, and in due course, he developed into a fashionable miniature-painter, his clientele including the families of the Duke of Modena and the Prince de Condé He was often employed by the court for painting portrait-miniatures on the snuffboxes which were presented to foreign potentates and notables, his work being neither better nor worse than that of the average miniature-painter of the day. Clearly, this list could be expanded, but not with any outstanding name; and the fact demonstrates how strangely retrograde Italian Jewry was in this respect.

Above, attention has been drawn from time to time to various artists of Jewish birth who had been converted to Christianity. We must also take into account the opposite phenomenon which emerges at this time — of Christian artists who became converted to Judaism. One of these was of some eminence — the English miniaturist Alexander Cooper (1605–60), brother of the more distinguished Samuel Cooper, who is considered perhaps the most gifted of English miniaturists. Alexander Cooper subsequently appeared in Amsterdam and Stockholm, where he called himself Abraham and was constantly referred to as a Jew; and there can be no doubt that he had become a convert to Judaism. Towards the end of the century, a certain German pastor likewise became converted and

settled in Amsterdam, where he was known by the Jews under the name of Abraham ben Jacob. He seems to have become a professional engraver, among his productions being a map of Palestine with Hebrew lettering, an amulet, and the illustrations to the Amsterdam *Haggadah* of 1695—of some artistic merit—which thereafter set a new

Fig. 210

fashion. There is also ascribed to him the engraving of a portrait of *Ḥaham* Isaac Aboab da Fonseca of Amsterdam, painted by the otherwise unknown Jewish artist (or was it a brother-proselyte?), Joseph ben Abraham.

Except for the one or two early instances that have been mentioned above, we do not know the name of any Jewish sculptor, good or bad, in any land until the 19th century, a fact natural to ascribe to the traditional prejudice which was especially strong against plastic art.* There is, however, one aspect of sculpture with which Jews were closely associated, and in which Jews were probably personally engaged; and it is necessary to devote a few moments to the consideration of this. Jewish tombstones in the Middle Ages were simple, owing any artistic effect they possessed entirely to the inscriptions, which, on the other hand, were sometimes very rudely engraved. From the Renaissance period, more artistic funerary monuments began to emerge, occasionally of artistic merit; sometimes the craftsmen responsible for them were Jews. In Italy, the beauty lay in the form and incidental decoration, though sometimes coats of arms and family badges were added. In Germany and Central Europe (as, for example, in the famous cemetery of Prague), there was a greater elaboration, the heavily carved Hebrew characters being used with magnificent decorative effect and symbolism lavishly added at the summit.**

Among the Sephardi communities of Holland and its dependencies, an important school of funerary sculpture developed in the 17th and 18th centuries. Here the inscriptions on the recumbent marble tombstones were principally in Spanish, Hebrew being used only incidentally. They were decorated in very many cases by reliefs of a remarkably high artistic standard, Italian rather than Dutch in feeling and execution. They generally depict scenes associated with the Biblical prototype of the person commemorated: the death of Rachel, the triumph of Mordecai, the sacrifice of Isaac, and so on. In one case (the calling of Samuel, commemorating Samuel Senior Texeira, 1717) we see even a representation apparently of the Deity himself. In another case (1726), from the Dutch colony of Curaçao in the West Indies, the tombstone depicts the deathbed scene, together with the bust of the deceased in high relief. That the sculptors of these very able works were Jews is unproved. But there is nothing exactly similar in the art of the environment at this time, and there is good reason for imagining that this school of sculpture may have been Jewish in authorship as it was in object and in inspiration.

IV

A wholly different—and in the long run more productive—approach to art from that of the English and Dutch Sephardim was emerging meanwhile in the sphere of the Ashkenazi communities of Central and Eastern Europe. These found their principal patron in the circle of cultured Court Jews, socially assimilated in many respects to the general bourgeois population, who at this time played so prominent a role in German Jewry.

* The only recorded exception to this generalization is Bourig Meyer (1630–1710), said to be a Portuguese Jewish sculptor of Frankfurt who collaborated with a non-Jew in carving a series of busts of Roman emperors in porphyry (cf. Thieme-Becker, *Kuenstler Lexicon*). But the name is obviously not Portuguese, the first name is non-Jewish, and there is no evidence that he was in fact a Jew, though he may have been of Jewish extraction.
* * This work is, of course, mainly anonymous, but it is reported that at Cernauti (Czernowitz) it was carried out by successive generations of the families Picker and Steinmetz, the communal grave-diggers.

One of the characteristic Jewish occupations in this geographical area, going back for many centuries, was seal- and gem-engraving. This was a branch of activity which arose naturally from dealing in precious stones; it normally had no ecclesiastical applications and thus was exempt from theological inhibitions; and it was not subject to guild-control, being largely carried on by itinerant craftsmen. Thus, from the 17th century, this occupation became very widespread in Germany and the neighboring lands. Competence in this exacting occupation naturally became extended to other spheres—for example, to pewter-engraving, thereafter to engraving in its more specific sense, and hence to designing, medal-making and miniature- (or at a later stage portrait-) painting. The art of the calligrapher-scribe, who progressed from the writing of sacred books to the production of decorated and then illuminated codices, ultimately led also in the same direction. It was within this context that the new school of Jewish art and of professional Jewish artists began its slow and hesitating development. Hence, in due course, a wholly unexpected result ensued—a group of artists of some little merit arose earlier among the socially retrograde Ashkenazi Jews than among the culturally advanced Sephardim.

Let us take as an illustration of the emergence at this period of the "modern" Jewish artists the record of one gifted family which excelled in different ways in successive generations. In Ansbach there lived in the mid-18th century a Torah-scribe named Samuel son of Pinhas (Phineas), from Lehrberg, who earned his livelihood by the honored profession of copying Torah-scrolls and codices in the traditional calligraphic style. He brought up his son, Judah Löw Pinhas (1727–93), to the same pious calling, which the latter developed in conventional fashion, copying sacred books and illuminating them by hand in the style common at this time. At the age of thirteen he wrote and decorated a Scroll of Esther and a Passover *Haggadah* so elegantly that the margrave of Ansbach arranged for him to be properly trained. In due course, Leo Pinhas (as the young artist was now called) became his court painter. His production, which includes portraits of the higher aristocracy and of the Prussian royal family, was of considerable merit. He had probably studied with the distinguished Berlin miniaturist Friedrich König, whose style he copied: the style of the two men is in any case so similar that some portraits ascribed to the latter are in all probability the work of his Jewish disciple. Leo Pinhas' son, Salomon Pinhas (1759–1837), was brought up to the same profession and similarly became court painter in Cassel and later to the Prince of Bayreuth, his sitters including the King of Prussia and his family. He also executed, besides some calligraphic work of a purely Jewish nature, numerous portraits for a Jewish clientele, including a series devoted to the members of the Jewish Consistory of the Napoleonic kingdom of Westphalia. In later life, when miniatures began to go out of fashion, he turned to book illustration and to copying Old Masters, in which ungrateful occupation he showed some competence. His son, Hermann Hirsch Pinhas (born 1795), in turn, followed the same profession in a more "modern" fashion and achieved distinction as a copper-engraver, the fourth professional artist in direct line of descent. We see here the straight genealogy from the traditional Hebrew scribe-calligraphist through the 18th-century miniature-painter to the conventional 19th-century artist.*

* Another artist-son of Salomon Pinhas was Jacob Pinhas (1788–1861) who, however, gave up painting and became an influential liberal journalist. The Dutch-Jewish artist G. C. Pinhas, who in 1780 executed a portrait of Rabbi Saul Levy Lowenstam of Amsterdam (later engraved), was apparently not a member of this family.

Another outstanding family of miniature-painters who worked in the same environment, but unlike the Pinhas clan did not remain true to Judaism, was that of Treu. Its originator was one Joel Nathan (son of the affluent Wolf Nathan, Court Jew to the Prince-Bishop of Bamberg), who in his youth fell under Jesuit influence and became baptized under the name of Joseph Marquard Treu (1713–96). He, too, graduated into the art of miniature-painting, like so many other Jews of this generation, and in this capacity became court painter in his native Bamberg. His later work included also still-life compositions, *genre* scenes, and even a number of rather heavy altar-pieces. Six of his children — including his three daughters — also attained some slight note in their day as artists. It is unnecessary, however, to mention here more than two of them — Johann Joseph Christian Treu (1739–99), who succeeded his father as miniature-painter at the small court of Bamberg, and Johann Nicholaus Treu (1734–86), the eldest and most important of the brood — who served in a similar capacity in the sister-court of Würzburg. The last named achieved something of a reputation for his altar paintings, as well as for a portrait of the unfortunate Pope Pius VI, oppressor, in his days of power, of the Jews of Rome. It was only two generations from the days of the Court Jew who had founded the family — but how far removed in atmosphere!

The most distinguished of the Jewish artists of this circle was unquestionably Jeremias David Alexander Fiorino (1797–1847) who, trained as a porcelain-painter, achieved brilliant success and decorated a famous Meissen *service* for the Saxon royal family. In due course he extended his interests, building up a distinguished clientele as a portraitist and being appointed court painter at Dresden. He is considered one of the most brilliant miniaturists of his day, many specimens of his work being preserved in the important German collections. His nephew, Alexander Fiorino, was also a portrait-painter of merit. Another eminent Jewish miniaturist of this period was Lippman Fraenckel (1772–1857) who, born in Mecklenburg of a Polish father, emigrated as a boy to Copenhagen, where he was apprenticed to a goldsmith and at the same time studied at the Academy. From 1797 to 1805 he was at work in Sweden, where he found his *métier* and made portraits of many members of the nobility and gentlemen of the court; afterwards he returned as court miniaturist to Copenhagen. His miniatures, most of them on ivory, are of impeccable workmanship, and show a lively though restrained sense of color. Yet another artist who worked in much the same environment was Moses Samuel Löwe (1756–1831) who, as Michael Johann Friedrich Löwe, built up a fashionable clientele, his portrait of the Empress Catherine II of Russia and miniature of the philosopher Kant being very well-known.

A different approach to the career of the professional artist converted the Jewish pewter- or metal-engraver into a line-engraver and etcher in the period when this type of artistic work was particularly flourishing. In the 18th century, quite a number of Jewish names are attached to engraved portraits produced in various West European countries, as has already been seen in the foregoing pages. A certain Zevi Hirsch Leibowitz is said to have engraved a series of no fewer than 165 portraits of members of the Radziwill family in Poland between 1746 and 1768. Berlin at the close of the 18th century attracted a number of such practitioners and gave them an outlet for their talents. Thus, Benedict Heinrich Bendix (1768–1828), a native Berliner, learned the art of engraving and became very proficient, besides being a fair portrait-painter; his sitters included many of the Jewish intellectual leaders of the time, as well as military and political figures. His solitary mezzo-tint, of Aron Beer, the *Ḥazan* of the Berlin Synagogue (after the portrait by J.C. Frisch)

demonstrates his loyalties as well as his ability. The four brothers Henschel (August, d. 1829; Friedrich, d. 1837; Moritz, d. 1862; Wilhelm, d. 1865) arrived in Berlin from Breslau about 1806, already proficient in their craft, and for a short while seemed to show great promise, but always in collaboration, signing their works "the brothers Henschel." They produced, besides successful pastel portraits and miniatures, a number of engravings that were at one time extremely popular throughout Germany, especially their "Scenes from the Life of Goethe" and their portraits of such celebrities as Fichte and the singer Catalini, patriotic illustrations, theatrical scenes, and even plates of military costume. The Berlin Academy of Arts esteemed the ability of August and Wilhelm highly enough to grant them in 1812 the title of academic artists. But it seems as though August provided most of the force and the genius behind the little family group; for after his death at his own hand in 1829, the three surviving brothers returned to Breslau, where they spent the rest of their days in obscurity.

A process similar to that which developed Jewish metal-decorators into etchers brought about the metamorphosis of Jewish seal-engravers into medallists. As we have seen above, Jewish mint-masters had been known as far back as the Dark Ages in various countries of Europe, but their production was utilitarian rather than aesthetic in intention. A mysterious medal bearing the name of Benjamin son of Elijah Beer the Physician — obviously an Italian production of the Renaissance period (1497 or 1503?) — seems to be of Jewish authorship, to judge from the impressive Hebrew inscription it bears (the significance being conveyed by a long and involved acrostic), but it is impossible to be more precise about it. Hence, the earliest known Jewish medallist in the more exact sense was probably Joel ben Lipman Levi, who carried out a crude portrait-medal in honor of Eleazar ben Samuel Schmelka of Brody when he was appointed Rabbi of *Fig. 222* Amsterdam. It is a poor piece of work, chiefly important because of the heated rabbinical controversy which it aroused (see Responsa of Jacob Emden, n. 170). In Germany and the adjacent areas an entire school of Jewish engravers and medallists emerged, however, in the course of the next generation: Samuel Judin (c. 1730–1800) who struck coins and medals for the court of St. Petersburg, including one in commemoration of the victory of Poltava; Aaron Jacobson, appointed in 1750 engraver at the Danish court; Abraham Aaron (c. 1744–1824) who worked at the courts of Mecklenburg and of Stockholm, and was responsible for some very satisfactory medals in the classical style, fashionable at the time; and several more. Perhaps the most gifted was one of the earliest — Jacob Abraham (1723–1811), who was followed by his son, Abraham Abramson (1754–1811). The former, of Polish birth, emerged to prominence in Berlin under Frederick the Great, for whom he designed several coins and a somewhat florid series of medals to commemorate his victories. The son — the first Jew to become a member of the Prussian Academy of Arts — issued a fine classicistic series of medals in honor of the leaders of German intellectual life, from Kant downwards, and not, of course, forgetting his own co-religionist Moses Mendelssohn. These are certainly as good as any examples of this type produced at this period, the delicacy of execution compensating in part for the absence of imaginative force.

In the early years of the nineteenth century the tradition was carried on by competent craftsmen such as the Dutch Sephardi family of Elion in successive generations; or the Belgian Jean Henri Simon (1752–1834), who had served as an army officer under Napoleon and whose gems in the classical style were so competently carried out that

they were mistaken for antiques; or later on (as we shall see), Jacques Wiener, who, after achieving a reputation as a medallist, engraved the earliest Belgian postage stamps. Thus the old tradition linked up with a typical 19th century form of art.*

V

Meanwhile, with the somewhat ampler opportunities in England, where social prejudices were less than in almost any other European country, the handful of newly immigrated Jews produced quite a noteworthy succession of professional and semi-professional artists, working in a general sphere and for the general market (even though they may have included one or two co-religionists among their clientele). They painted dutiful and dull Hanoverian-style portraits; they exhibited at the Royal Academy and similar institutions, a proof of competence if not of genius; and they were very soon — for the most part, deservedly — forgotten.

It is noteworthy that many of them were active in designing and engraving bookplates, obviously, a direct consequence of their competence as seal-makers or as engravers on pewter, which in turn could naturally lead on to more ambitious work. This, too, ran in families, as was the case on the Continent. Thus, for example, the founder of the Jewish community of Portsmouth in 1747 was Benjamin Levy (d. 1784), originally of Wiesbaden, who, by profession a pewter-engraver, executed some decorative bookplates for both Jewish and non-Jewish clients; these included what is reputed to be the oldest Jewish *ex-libris* known, which he made for the Sephardi magnate Isaac Mendes in 1746. His tastes were inherited and extended by his sons, two of whom were also professional engravers — Elias, who designed a number of bookplates and many local views, and Isaac, who collaborated in bookplate production with another Jew, Moses Mordecai (later of Exeter), twenty of whose products are recorded. At Exeter, too, lived the versatile silversmith, Ezekiel Abraham Ezekiel (1757–1806), who also produced several engraved portraits and *ex libris* and was a successful miniature- and portrait-painter, enjoying in his day a considerable local reputation. Solomon Polack (1757–1839), of Dutch birth (connected perhaps with the portraitist Abraham Isaac Polack, who was responsible for both drawing and engraving in 1764 a mediocre etching of Saul Levi, rabbi at The Hague), exhibited numerous pictures at the Royal Academy from 1790 onwards, engraved the title pages to some Hebrew books printed in London, and published several engraved portraits of uneven value. The adventurer Casanova records how when he visited England in 1763 and wished to have a memento of one of his mistresses, he requested a friend to put him in touch with the best miniaturist in London "and he sent me a Jew" — possibly, Jeremias, who was working here at the time and whose name suggests Jewish origin.

A close link with the Continent was provided by Solomon Yomtob Bennet (1761–1838), who, born in Poland, worked with some success as an engraver in Berlin, signing his works there Benet Solomon, B. Salamo, etc. (his portrait of Frederick William II won him a government prize). In middle life he moved to London, where his artistic activity was obscured by his insatiable appetite for quarrelling with everybody, from the Chief Rabbi

Benjamin Levy of Portsmouth.
Ex-libris for Isaac Mendes, 1746.
(The earliest known Jewish book-plate).

* In Paris, a few Jews are described as "engravers" in the official police-registers at the middle of the century. Among them was Tobia Baer, formerly of Metz, and resident in the capital from about 1759 onwards, whose cameos were famous and of a high quality. Among his works was a portrait of Henry IV. He is believed to have painted miniatures also.

downwards; his literary and exegetical work, too, was of some importance, his treatise on the Temple of Ezekiel (1824) being illustrated by a magnificent and erudite engraving by his own hand.

From the most intimate English synagogal environment emerged at this time Frederick Benjamin Barlin, son of the reader of the Chatham Jewish community, who exhibited at the Royal Academy in 1802 and 1807. His best known work is a heavily impressive oil portrait of the Chief Rabbi Solomon Hirschell, now in the National Gallery, London; while a more elegant likeness, typically English in its courtly posture and background, which he painted of the Sephardi *Haham,* Raphael Meldola, was engraved and published by a Sephardi co-religionist, Joshua Lopez. Contemporary with Barlin was the "little Jew named Burrell," who exhibited in 1801–07 and gave lessons in painting to Sir Walter Scott. In the circle of the 18th century Ashkenazi painters in England there was, too, one woman artist, who achieved some degree of success — Martha Isaacs, a prolific portrait-painter and miniaturist, who exhibited in London from 1771 onwards and subsequently went to practice her art in India, where she married out of the faith into a military family. Among her earlier works were portraits of David Tevele Schiff, Rabbi of the Great Synagogue in London, who, it is interesting to note, apparently did not have any objection to sitting for a woman. (A Sephardi woman-painter, named De Castro, had exhibited a flower-piece at the Royal Academy in 1777, being possibly the first person of Jewish birth to do so.)

A prolific family of Jewish painters which emerged in England at this time was that of Town, or Towne, which hovered, it may be said, on the borderline between fame and notoriety. The father of the clan was Francis Town (1738–1826), presumably of German birth, who was endowed with the same decorative ingenuity as other Jews of this time, boasting that he was "the inventor of the art of painting on velvet." He had three sons, all of whom imitated his example. Benjamin, whose activities were curtailed when he went out of his mind, faithfully followed in his father's steps and achieved somewhat of a reputation for his proficiency in the same "art," which he taught to ladies of the aristocracy. Charles (1781–1854), more gifted, exhibited at the Royal Academy and British Institute from 1806 onwards. He had distinct ability as an animal and landscape painter, with marked affinities to the Norwich school, which was in vogue at this period of British painting. His work shows a deep sympathy with the English country scene — for example, his *Cattle Fair,* depicting the Norwich marketplace. Another son of Francis Town was Edward (1790–1870), who exhibited at the Royal Academy at the early age of sixteen and displayed great promise, but afterwards became an army officer.*

Fig. 221

A highly distinguished name to be mentioned at this point is that of Johann Zoffany (1725–1810) who, born in Frankfurt, ran away from home and after a period of wandering came at about 1761 to England. Here, in due course, he received the royal patronage, was brought into fashion, and was among the foundation members of the Royal Academy in 1769. From 1772 he worked in Tuscany, and from 1783 to 1790 in India, where he executed some of his best work, thereafter returning to England. His portraits and conversation pieces are among the most urbane representations of 18th century English

* It is important not to confuse the members of this family with the highly distinguished English artists Charles Towne (d.c. 1850), the animal painter, and Francis Towne (1740–1816), the landscape painter. The work of the two Charles Town(e)s showed a marked and most confusing affinity of subject and style, though the Jewish painter had a broader touch than his Christian namesake, whose minute handling even in his largest works bordered on miniature.

life. His biographers suggest that his parents were Bohemian Jews, and it is recorded that when he first came to London in penury he lodged in the house of a kindly Jew. Certainly, he had some inclination for Jewish society. Among his portraits is that of Jacob (James) Basevi-Cervetto, the gifted Veronese Jewish musician who introduced the cello into England.

The case of Zoffany is, admittedly, dubious. On the other hand, there was one extremely eminent artist of this period who also worked for a time in England, about whose Jewish origins there is no doubt, though he, too, was not a professing Jew. In him we have a figure whose significance in artistic history of his time was immeasurable. Once again, we are dealing, as so often, with a hereditary tradition and influence. Ishmael Israel Mengs (1688–1746), German by birth, Danish by residence, and originally an enamel-worker, was converted to Christianity — or else informally abandoned Judaism — early in life and became court painter in Saxony; a number of his canvases and miniatures, of fair competence, are preserved. His son, Anton Raphael Mengs (1728–1779) — brought up indeed as a Christian, and probably of mixed birth — was one of the most celebrated and influential figures in European painting of the 18th century. An infant prodigy, he became at the age of twenty-one first painter to the Elector of Saxony, and five years later, Director of the Vatican Academy. Subsequently, he worked in Russia and for a time in England, where he executed a celebrated altarpiece for All Souls' College, Oxford. Charles III of Spain twice summoned him to Madrid, and pensioned seven out of his twenty children when he died in Rome, in poverty, at the age of fifty-one. The reputation which he enjoyed in his day was immense — and far beyond his deserts. He was hailed as the savior of style and Europe's greatest painter. He was an influential writer on the theory of art. He was the first authoritative person to recognize the genius of Goya. Even his more pedantic rules of painting, which he professed to recognize in the Old Masters (e.g., that if one hand in a portrait shows the palm, the other must be turned inwards) were meticulously observed by his followers. He left, moreover, a lasting impression on the history of painting as the founder of the neo-classical school, which was to reach its climax in the generation after his death.

Fig. 223

Enough has been said in the foregoing pages to demonstrate that, contrary to the generally held opinion, Jews were not entirely divorced from the field of aesthetic achievement even in the orbit of the figurative arts in the pre-emancipation period. This account — inevitably sketchy and episodic — is necessary in order to understand the background of the remarkable developments of the 19th and 20th centuries.

JEWISH ARTISTS OF THE AGE OF EMANCIPATION

by ALFRED WERNER

Time is a merciless eliminator. It erases names, once highly regarded, from the honor rolls of human endeavor. Occasionally, revisions are made by a generation which re-evaluates deeds, books, and works of art in a spirit different from that of its parents or grandparents, and such revisions are justifiable and even necessary. On the whole, however, what is forgotten after fifty years is rightly forgotten.

Going through the standard Jewish work of reference published during the first years of this century, the *Jewish Encyclopedia*, one is astonished by the large number of entries about artists born between the French Revolution and the Crimean War (though oddly enough, the greatest of all, Camille Pissarro, is not even mentioned there!). Today, very few of these names are to be found in current handbooks of art, and even fewer samples of the works of these artists remain on exhibition in galleries and museums. Yet during their lives, all of the painters and sculptors mentioned in the *Encyclopedia* received prizes and honors; their paintings and sculptures were acquired by public collectors, and some of these artists were even granted titles of nobility. Nearly all of them were conformists, working—some with admirable skill—in the conventional manner approved by the academies and preferred by the dealers and their customers; many, for court acceptance, changed their Jewish names to more gentile-sounding ones, and quite a few, at the peak of the assimilationist trend, abandoned Judaism for Christianity.

Towards the beginning of the 19th century, a considerable improvement could be observed in most countries of Western and Central Europe in the standard of living of broad sections of the Jewish communities. This soon led to an improvement in their cultural life, too, which began to follow the pattern of that of their gentile neighbors in each nation. Jewish family life had long been restricted within the cultural framework of the earlier era, which had preceded any general movement of emancipation. Now, however, it began to adopt many features of non-Jewish family life, so that, among other novelties, a demand for family portraits soon became fairly widespread in the wealthier classes. It is not surprising that many of the new Jewish art patrons had recourse, at first, to the services of Jewish artists recommended to them by friends or relatives. Jewish artists thus emancipated themselves from their traditional field of miniature-painting in order to include portrait-painting, and later *genre* painting too, within their activities.

Nor did these Jewish portrait-painters limit themselves to reproducing the features of this new class of Jewish patrons. As had happened earlier in the case of the miniature-

painters, a reputation once made in the Jewish community soon attracted gentile patrons, too. Throughout Western and Central Europe, we find few major talents among the new Jewish portrait-painters; but many of these pioneers of Jewish art are still interesting as men of real vision and initiative, in no way inferior as artists to the majority of their non-Jewish colleagues in that age. From portrait-painting these bourgeois artists graduated, as it were, to more ambitious projects, including the historical canvases so popular in the 19th century.

As will be seen, a disproportionately large number of the Jewish artists of the Age of Emancipation were Germans or of German origin, or at all events studied at German academies and pursued their careers in Germany; inevitably so, since this was the country in which at this time Jewish intellectual emancipation made the most startling progress. It is worthwhile to deal at some length with two characteristic figures, who still count prominently in the major works on 19th century German art: Philipp Veit and Eduard Bendemann.

The story of Philipp Veit (1793–1877) and his less successful brother, Johannes, or Jonas (1790–1854), is of great interest to the Jewish historian, as well as to the general art historian. The brothers were the sons of Dorothea, eldest daughter of the philosopher Moses Mendelssohn, and a Berlin Jewish banker, Simon Veit. Intellectually superior to her uncultured husband, and unhappy in her marriage, Dorothea left Veit after meeting the brilliant writer, Friedrich von Schlegel. In order to marry him. she turned Protestant. Six years later, the Schlegels adopted the Roman Catholic faith.

The father tried to educate his sons in the Jewish tradition. But they rebelled against it and finally went to live with their mother, who to the end of her life was to exert a profound and not always healthy influence on them. Deeply attracted by Christianity, Philipp embraced the Roman Catholic faith at the age of seventeen; his brother followed suit. From 1815 to 1830, Philipp lived in Rome, joining a group of ardently Catholic German artists who became known as the Nazarenes—the only German painters between the Renaissance and the Expressionists to contribute a new and original style to European art. The theory of the Nazarenes expressed a rebellion against contemporary classicism. To them art was a religion which had found its purest expression in the works of pious Quattrocento masters, to whom they turned in order to work in the same spirit. Theirs was a very spiritualized, anti-sensual, noble art, expressive of the romantic sentiments of the era; today, much of it looks disappointingly poor, with unctuousness of themes, hardness of contour, and aridness of color. Some of it, however, remains memorable for its perfect composition and delicate workmanship.

The Nazarene movement found a generous patron in the person of Jacob Salomon Bartholdy (1779–1825), one of the earliest of the long line of great Jewish patrons who were to enrich the collections of the Old and the New World. A grandson of Moses Mendelssohn and an uncle of the composer Felix Mendelssohn Bartholdy, he, too, had embraced Protestantism as a young man. He engaged Veit and his friends to adorn his house, the Casa Bartholdy in the Via Sistina in Rome, with frescoes. Veit was the first to revive the long-abandoned technique of painting directly on wet plaster. Significantly, the theme for these frescoes was taken from the Old Testament—the story of Joseph, from his sale down to his recognition by his brethren. Veit painted *Joseph and Potiphar's Wife* and *The Seven Fruitful Years.* When the pictures were unveiled in 1819, a festival of German artists was held in Rome. In 1887 the house was torn down, and the frescoes,

bought by the Prussian government, were then transferred to the National Gallery in Berlin.

After his return to Germany, Veit became director of the Staedel Institute at Frankfurt-am-Main. Of the pictures he painted there, the most important is the large mural for the Institute, *The Introduction of Christianity into Germany by Saint Boniface.* In the center stands the allegorical figure of Religion, one hand placed on the Holy Scriptures borne up by an angel, the other hand holding a palm branch, the symbol of enduring peace. While St. Boniface is proclaiming to the heathen Germans the good tidings of redemption, a young Teuton, hatchet in hand, waits to cut down the pagan god Thor's oak.

Many of Veit's easel paintings can still be found in churches in Rome and Germany and Austria, and he decorated several cathedrals with frescoes. The figures he drew in the anti-naturalistic vein of the Nazarenes often appear somewhat awkward and stiff, and much of his religious art is marred by an overdose of sentimentalism, such as his picture of the Immaculate Conception in the Church of the Trinita dei Monti in Rome. He left some very delicate pencil sketches and many excellent portraits, among them several self-portraits. Of the work of his brother Johannes, who was not very productive and died much younger, little is recorded except an altarpiece for the cathedral at Liege, an *Adoration of the Shepherds* for a Catholic church in Berlin, and several pictures of the Virgin.

In his memoirs, the painter Moritz Daniel Oppenheim, who had contacts with the Nazarenes during his stay in Rome but resisted their influence, tells of his meetings with Philipp Veit when the latter was director of the Staedel Institute. The Jewishly orthodox Oppenheim was sad to notice the strict Catholic spirit in the Veit household, especially in the artist's mother, who lived with the family: "When her grandchildren...came to wish her good night, she gave them her blessing with the sign of the cross; this, coming from the daughter of Moses Mendelssohn, made a painful impression on me." Oppenheim adds: "Ostentatiously pious as was the mother in the expression of her Catholicism, her children, certainly no less pious, remained undemonstrative."

The story of Eduard Julius Friedrich Bendemann, who was born in Berlin in 1811 and died in Düsseldorf in 1880, shows that in 19th-century Germany, once a gifted man had abandoned Judaism, every door was open to him. Bendemann held all the honors, all the distinctions that were available to an artist. He was only twenty-seven when he attained a professorship at the Dresden Academy. Shortly thereafter, he was commissioned to decorate the palace of the King of Saxony. In 1859 he became director of the famous Düsseldorf Academy. He was a knight of the Prussian Order *Pour le Mérite,* and there was hardly an available distinction that was not bestowed upon him, hardly an institution that did not make him an honorary member.

Yet, of his countless works — including *The Arts at the Fountain of Poetry* (a once-famous canvas), the imaginary portrait of Emperor Lothar for the historic Roemersaal in the ancient town hall of Frankfurt, and the numerous life-size portraits of celebrities — not a single one is now remembered. Bendemann's fame rests on two canvases on Biblical themes: *The Mourning Jews in the Babylonian Exile* and *Jeremiah at the Fall of Jerusalem* commissioned by the Crown Prince of Prussia. They were made in 1832 and 1836, the first three years before, the second a year after Bendemann took an important step — conversion to Christianity.

In the first painting, four figures are seated beneath a tree; one of them, a bearded man in

the center holds a harp in his chained right hand. In the second picture, a similar bearded man, flanked by groups to his right and left, is supposed to be the Prophet Jeremiah. In the foreground, there are a few fragments of architecture, while the background contains some of the most romantic and theatrical ruins that ever appeared on a canvas. Everything is carefully arranged as in a tableau. The sorrow displayed by the figures is no more real than the landscape in which they have been placed.

These pictures are typical of the Düsseldorf School which had been founded by Gottfried von Schadow, one of the Nazarenes, after his return from Rome. They have the cold coloring, the smooth monotonous finish characterizing works of this school, and succeed by story-telling rather than by artistic merit. In these two paintings, the "line of beauty" turned the figures into bloodless shadows and washed-out puppets. But the two pictures have a disarming nobility and dignity. When, forty years after *The Mourning Jews,* Bendemann returned to a Biblical theme in the *The Jews Led into Captivity in Babylon,* the technique was still there, perhaps even greater than before. But the quiet passion of the young man had given way to a virtuosity that now made the more mature artist produce a huge canvas with over fifty figures, tumultuous and wild. It is effective, but in the same way as a bad film, catering to the sentiments of a Victorian crowd that never grew up emotionally or aesthetically. The inability to express genuine feeling remained with Bendemann to the end. But his failures must not make us overlook the fact that as a portraitist he ranks among the best German masters of the 19th century

II

Veit and Bendemann were two major figures in their day. But they did not stand alone; and it may be that some of their less known colleagues were as gifted. Eduard Magnus (1799–1872), for example, was a Jewish artist of considerable talent, whose stylistic evolution reflects most of the more significant aspects of German painting of his age. Beginning as a follower of the Nazarene Brotherhood, in whose evolution Philipp Veit had played so important a part, Magnus subsequently developed a kind of Romantic neo-Classicism, influenced to some extent by the French painter Ingres, and finally adopted a more realistic and less idealistic style as he advanced in years. He enjoyed a great reputation as a portrait-painter, and has left us likenesses of Felix Mendelssohn-Bartholdy and of the singer Jenny Lind, as well as some charming *genre* paintings that record the more romantic aspects of his travels in France, Italy, and Spain.

Julius Muhr (1819–65) was another well-known German-Jewish painter; the son of an outstanding champion of Jewish emancipation, he painted, among other subjects, a *Mass in the Sistine Chapel* which attracted considerable attention. Nathaniel Sichel (1843–1907), another Munich graduate, was only twenty when he became famous through his historical composition representing *Philip the Magnanimous at his Wife's Grave*; another picture, *Joseph Explains the Dreams of Pharaoh,* won Sichel the Rome Prize, after which he specialized in historical compositions.

Towards the middle of the 19th century, Hermann Nelke was active as portrait-painter at the court in Hanover. Among his pastels, which reveal considerable sensitivity, a portrait of his mother-in-law shows us a striking example of Jewish womanhood, whose features express both energy and kindness. Hamburg produced Leo Lehmann (1782–

1859), who was known for his portraits. His two sons, Heinrich (1814–82) and Rudolf (1819–1905) followed in their father's footsteps. Henri Lehmann, as he called himself after his early removal to Paris, was one of the most successful pupils of the great Ingres, to whom he was piously devoted. He painted many murals for public buildings in Paris, devotional pictures for churches, and the portraits of such celebrities as Liszt, Chopin, Meyerbeer, and, of course, his master Ingres. Among his pupils were Pissarro and Seurat who, however, revolted against his cold skill.

Julius Jacob (1811–82) studied in Düsseldorf and under the fashionable Romantic master Delaroche in Paris, then returned to Germany between trips throughout Europe, North Africa, and Asia Minor, from which he brought back *genre* scenes of exotic life and romantic landscapes. Gustav Herz (1805–75) has left us an interesting portrait of Leopold Zunz.

In Austria, there was Friedrich Friedlaender (1825–1901), widely known for his historical paintings. One of the co-founders of the Vienna Society of Artists, he was granted a title by the Emperor, and was then known as Ritter von Malheim. In France, Benjamin-Eugène Fichel (1826–95), painted small *genre* compositions after the manner of Meissonnier. In Sweden, Geskel Salomon (1821–1902) was professor at the Stockholm Art Academy, well-known both as a painter and as an art historian; he has left us a few interesting *genre* paintings which illustrate aspects of Jewish religious life in 19th-century Scandinavia. In Italy, Samuel Jesi (1788–1853), of Correggio, had prizes and honors lavished upon him for his works, which attained a wide popularity; a medal was even struck in his honor. He was famous in his day for his engravings after paintings by the Italian masters of the Renaissance, especially Raphael and Fra Bartolomeo.

In this field, in which several Jews had attained prominence even in the 18th century, the Wiener family deserves particular attention here. Born in Venloo, on the Dutch-German frontier, Jacques Wiener (1815–99) studied at first in Aachen, later in Paris, where he specialized in engraving and modeling. In 1839, he settled in Brussels. His first medal was struck in Belgium in 1841. In 1845, he was the author of a famous series of medals representing interior and exterior views of a number of Belgian churches and other historical monuments; these medals are outstanding examples of the kind of art that the Romantic interest in the past was suggesting, in those years, to other Western European artists, too. Between 1850 and 1865, Wiener designed 41 more medals, representing some of the main historical monuments of Europe. He also designed and engraved the Belgian postage stamp which was the first to be issued on the continent of Europe. His two brothers, Leopold (1823–91) and Charles (1832–88), began their careers as his pupils. In 1847 Leopold participated in a competition for the design of the new Belgian five-franc piece; the design that he submitted was so good that the judges questioned his authorship, after which he submitted a second design within a few days; the award was refused him. Between 1850 and 1860, he designed a series of medals on historical themes, as well as more than one hundred and fifty different coins for the Belgian mint. He was also the author of a number of pieces of statuary and some panels in relief: *Moses as a Child, Samson Breaking his Bonds,* and the monumental marble group commemorating the Van Eyck brothers in Maestricht.

Charles Wiener, the youngest of the three brothers, became assistant engraver of the Royal mint in London and, in 1864, chief medal designer at the mint in Lisbon. In 1867, he returned to Brussels, where he devoted all his time to the Belgian mint. The coins which

he then designed can be numbered among the most beautiful of his age. Among his medals are excellent portraits of Sir Moses Montefiore and of the Belgian Chief Rabbis Loeb and Astruc. The activity of the three Wiener brothers illustrates the transitional style which was popular, in this field, between the neo-classical era and the modern.*

III

Jewish artists were meanwhile beginning to discover the contemporary Jewish scene and the artistic potentialities of everyday Jewish life. *Genre* paintings are found on the walls of Egyptian and Etruscan tombs, on Greek and Roman vases, and in the art of Asia. From the Christian Middle Ages to the 18th century, however, this sort of painting was generally held in low esteem by the high-born patrons of art—the aristocrats or church dignitaries, who, apart from portraiture, gave the artist a choice only between religious, allegorical, or historical subjects. Yet, even during the feudal period *genre* painting was practiced, though on a modest scale, by the illustrators of books, religious or otherwise, who adorned manuscripts with miniature harvest scenes, portrayal of burghers in the pursuit of their homely occupations and other unheroic activities. So, as is shown elsewhere in this volume, the Jewish scribes, too, frequently adorned Passover *Haggadoth* and Scrolls of Esther with naive representations of the more pleasant aspects of ghetto life.

But wherever the middle class came to the fore, especially in the Low Countries, *genre* painting also had its patrons. The bourgeois preferred pictures showing himself and his kind in situations and moods that he could understand, pictures that told a story in a didactic, sentimental, romantic, or even satirical vein, but always a simple story. The political and economic maturity achieved by the middle class after the French Revolution created a new class of art patrons—lawyers, businessmen, bourgeois, political and civic leaders. These all needed portrait-painters as well as limners of *genre* pictures. A little later, there was also to be a market for historical canvases to satisfy the new nationalist and patriotic trends. Meanwhile, the Jewish-born artist discovered, to his great delight, that the gentile patrons did not discriminate against him—as they might have done a hundred years earlier—as long as he gave them what they wanted.

Often, his earliest patrons were Jews who had made fortunes, whose tastes were as conventional as those of their Christian competitors. A growing number of middle-class Jews had not yet developed a taste of their own, but did not care to follow the general trend, and were ready to accept works of art with a "Jewish motif." Soon, Jewish artists were available to fill the need.

Moritz Daniel Oppenheim, who was born at Hanau near Frankfurt-am-Main in 1799 or 1801 was the first unbaptized Jew to achieve a more than fleeting success in the field of art. His well-to-do parents not only gave him the traditional training but also sent him to the *gymnasium* and, when he gave evidence of talent, to the local art school. The boy was then taken up by members of the local nobility who invited him to their castles, where he was allowed to make copies of what everyone believed to be genuine works by Raphael, Correggio, Leonardo da Vinci, and other Old Masters.

After studying in Munich and Paris, Oppenheim went to Rome where he was to remain

* It has frequently been claimed, though without conclusive proof, that the outstanding French animal-painter Rosa Bonheur was of Jewish origin.

for four years. There he worked conscientiously at the St. Lucca Academy. When Oppenheim's drawing of *The Return of the Prodigal Son* was about to be granted the prize in a competition, the jury learned that the artist was a German Jew and decided to give the Academy's award to an Italian. The Danish sculptor Thorwaldsen, however, was a member of this jury and resented its decision; although unable to change his colleagues' mind, Thorwaldsen voted in favor of Oppenheim and succeeded in having the prize awarded to no one.

Oppenheim's drawings and oils of Old and New Testament episodes, made during his stay in Italy and shortly after his return to Germany in 1825, were once widely appreciated. Today, one can still admire the excellent composition, with its skillful grouping; but modern taste revolts against the theatricality of the scenes, which exhibit the kind of banal emotionalism that already marred so much 18th-century Italian painting. Oppenheim's talent was better suited to the portrayal of the world and of men and women of his era. Ten drawings for Goethe's idyll, *Hermann und Dorothea,* thus earned Oppenheim the aged poet's extravagant praise.

Six years later, in 1833, the artist began the series which gained him lasting fame. *The Return of a Jewish Volunteer from the Wars of Liberation to his Family*, which made timely appearance at a moment when the enfranchisement of German Jews was being debated, tells a story, and tells it reasonably well. Wounded in battle, and still carrying his right arm in a sling, the young officer obviously has just arrived at his parental home. The pious father, an open Hebrew book before him, regards the decoration on his son's chest with paternal pride, but also with some uneasiness, since it is in the shape of a cross.

Encouraged by the success of this picture, Oppenheim composed in the course of years nineteen other canvases on Jewish motifs in the costume of the late 18th century, going back some fifty years in history. Eventually he was asked to repeat these oils in gray gouache *(grisaille)* in order to facilitate photographic reproduction. The painter undertook this imposing task with brilliant results.

These *Bilder aus dem Altjeudischen Familienleben* ("Pictures of Old-Time Jewish Family Life") went through many editions. A family is shown in several compositions celebrating the various festivals: an old rabbi questions a youngster; an infant is held up to touch the Torah Scroll in synagogue; a Talmud student is invited to the Sabbath dinner. *Fig. 224* These were the kind of pictures the middle-class Jew then understood and enjoyed. They are, unquestionably, superior to many other *genre* paintings of the period, because Oppenheim never permitted a preoccupation with detail to detract from the solidity of form and from the completeness of the overall concept. He died in old age in 1882.

IV

In the first third of the 19th century, a majority of the more gifted and successful Jewish artists of Europe came from those areas in the West where the Jew was already accepted in society and where almost no obstacle impeded his career as an artist. The second third of the century witnessed the appearance of an increasing number of Jewish artists born and trained in the confines of Eastern Europe, at first in Hungary, later in Poland, too.

In Hungary, it was towards the middle of the century that a greater artistic activity began to be noticed, coinciding with other Hungarian manifestations of a will for political and

cultural autonomy. In the first generation of consciously Hungarian painters, a number of Jewish artists achieved real distinction. The most striking figure among them was surely Theodore Alconière, whose real name was Hermann Cohn (1797–1865). After receiving his artistic training in Vienna, he spent several years in Rome, where he acquired the dramatically Romantic style that characterizes the work of a number of other successful painters of his generation. His first major success then came when Alconière was appointed court portraitist to the Duchy of Parma. Towards 1848, he returned to Hungary, where he painted equestrian portraits of Hungarian aristocrats, which are interesting examples of this kind of Romantic painting. He also painted a large number of Romantic or exotic *genre* compositions. After 1850, he was mostly in Vienna, earning a meagre livelihood as the author of humorous lithographs. In utter destitution, he even set about to counterfeit bank notes, but bound himself over to the police before even attempting to circulate the product of his peculiar industry. Two years later, he died in a Vienna hospital.

Willy Beck (1844–86), a pupil of Alconière, was another Jewish-Hungarian painter of talent. Beck began to exhibit *genre* paintings at the Budapest Salon, but soon attracted attention as the author of some striking portraits. After completing his studies abroad, he returned to Pest and was forced, for a while, to earn his living by publishing a humorous periodical in German, the *Zeitgeist,* to which he contributed all the prose and all the cartoons. In 1849, he returned to Vienna, where he edited the *Charivari* until police action suspended its publication and forced him to return to Hungary. There, he continued to paint while also contributing drawings to the Leipzig *Illustrierte Zeitung.*

The life of the third important Hungarian-Jewish painter of this group, Moritz Adler (1826–1902), was less eventful and more successful. It was as a student in Paris that he painted the fine double portrait of two painters (one of them perhaps Adler himself) that now hangs in the Budapest City Museum. In 1848, Adler returned to Hungary, where he exhibited still-life compositions and *genre* paintings that were among the most popular of his age. His *Apotheosis of Baron Joseph Eötvös,* celebrating the champion of the emancipation of Hungary's Jews, was purchased by the National Museum, and the great series of his portraits, slightly academic in their realism, has recorded for us the features of all of Budapest society of that era, whether Jewish or Christian.

Plate 32 In Poland, the emergence of outstanding Jewish artistic talents came later than in Hungary. Maurycy Gottlieb (1856–79) was deeply rooted throughout his brief life in Romantic traditions of an earlier generation, so that it is more suitable to discuss his work here than in the context of his Impressionist and Realist contemporaries. A native of Drohobycz, Galicia, he was raised in the atmosphere of the *Haskalah* movement, and the elder Gottlieb proved his enlightenment by not objecting to his son's receiving instruction in drawing.

The unusually gifted boy was only sixteen when he went to Cracow to study at the Academy under the greatest Polish master, Jan Matejko. The teacher took an ardent interest in his young Jewish pupil, and transfused his own exuberant patriotism into the latter's soul. The memory of the ill-fated Polish 1863 uprising against the hated Russian rule was still fresh, and Gottlieb tasted bitterly the shame and humiliation of proud Poland. He painted scenes from his nation's glorious past (for instance, *Boleslav before the Gates of Kiev),* portrayed himself in the gala dress of a Polish aristocrat, and wrote fervently patriotic poems in German, the language of the Polish-Jewish intelligentsia.

He was only twenty-two when he painted his most famous work, *Jews at Prayer on the Day of Atonement* (1878), now in the Tel Aviv Museum. There was something mawkish and sentimental in Oppenheim's portrayal of Jews, while in Leopold Horowitz' once celebrated presentations of Warsaw Jews there was too much theatricality, too much gesticulation at the expense of inner feelings and of real emotion. In Gottlieb's painting, on the other hand, the figures are not posed, they are real; their expressions, their gestures are convincing. In rich yet restrained colors, he showed the earnest, dignified men in the act of prayer, the Oriental beauty of the Jewish women. Among the men is Gottlieb himself, shadowing his face with his hand.

Fig. 225

The painting caused a sensation in Jewish circles. The Hebrew press hailed it as a genuinely Jewish masterpiece. Indeed, it paved the way for the coming generation of Eastern European Jewish artists, as it showed to them, as well as to their parents and educators, that art and Judaism need not be antagonistic.

Gottlieb was unbelievably prolific, as if he had been driven to work by a presentiment of his early death. His *Jesus Preaching in the Temple* was a revolutionary piece insofar as it no longer shows Jesus as an Italian, a German, a Pole, etc., as had been done by artists before, but as a Jew, preaching to a crowd of interested Hebrews. In *Shylock and Jessica,* the old man embraces his daughter as if he were anticipating her loss, and seems to cry from the depths of his soul: "Jessica, Jessica, my child!" The same innate feelings are expressed in a portrait of his fiancée. Finally, in the composition called *Ahasuerus,* one finds a self-portrait, which unlike the earlier one, where the artist presented himself as an aristocratic Pole, now reveals him as a Jew, dreamy, and with a deep sadness in his eyes.

Fig. 226

Gottlieb died at the age of twenty-three in a Cracow hospital, of tuberculosis of the larynx. Though his art did not reach the degree of completeness and maturity he would have attained had fate been kinder to him, Gottlieb has earned himself a niche of honor in the history of art in general, as well as of Jewish art. Today, we value above all his portraits. Like those of Rembrandt, they are gems of psychological penetration in an era that vied in beautifying and falsifying its sitters. Gottlieb probably never saw the work of Corot. Yet his portraits of girls and elderly women have a delicacy and lightness of touch and a charm of coloring strongly reminiscent of that French master.

V

It was in Holland, at The Hague, that there appeared, towards the middle of the 19th century, the first group of Jewish painters who can truly be said to have constituted a Jewish school or movement in art, though they remained a group of friends with common ties and interests, rather than a school with a consciously formulated doctrine. The most gifted among them was Morits Leon (1838–65), a painter of Sephardic extraction who died too young to give the full measure of his talent. He has left us, in the Municipal Museum in The Hague, a fine synagogue interior, *The Unveiling of the Holy Law,* for which he was posthumously awarded a gold medal in 1865. Some of his rare watercolors reveal a warmth of color and a brilliance of technique that might well have earned him an outstanding place among the Romantic masters of this medium.

The productive nucleus among the Jewish painters of The Hague is to be found in the Verveer family, where three brothers acquired considerable reputation. Salomon Leonardus Verveer (1813–76) is remembered mainly as a painter in oils and watercolor, of

Fig. 227 typically Dutch views, including landscapes, seascapes, and street scenes. Among the latter, his paintings of Amsterdam's Jewish market and of other aspects of the city's old Jewish quarter deserve particular mention, though his views of the Dutch seashore and of fisher-villages are more generally appreciated by his compatriots. He was also the author of some popular lithographs. His young brother Moses Leonardus Verveer (1817–1903) was active in Holland as a pioneer photographer, but also helped Elchanon Leonardus Verveer (1826–1900), the youngest of the three, in painting some landscapes and *genre* scenes. The last named was indeed a very popular painter, leaving us a great number of works of these two categories; in his *genre* scenes, he often selected folkloristic themes, which he treated in a somewhat sentimental manner. His woodcuts were also, at one time, much appreciated.

Moritz Calisch (1819–70) was another painter of this group, who specialized in portraits, as well as in *genre* scenes inspired by his observations of daily life; among the latter are a number of paintings on Jewish themes. He also executed a few historical compositions. *A Mother's Blessing,* now in Amsterdam's Rijksmuseum, is a good example of the somewhat limited scope that Calisch imposed on himself by over-stressing the anecdotic element at the expense of those more artistic qualities which Jozef Israels was later destined to revive in Dutch painting. In his portraits, however, Calisch achieved fame as one of the most objective and dignified Dutch artists of his generation.

The painters David Joseph Bles (1821–99), well-known for his *genre* scenes, and Joseph Bles (1825–73), a pupil of Salomon Leonardus Verveer, have generally been neglected by historians of Jewish art. As a master of Dutch "Biedermeyer" Romanticism, David Joseph Bles is represented, however, in most major museums of Holland. His *genre* scenes, most of which are situated chronologically in the past, have a flavor of 18th-century "bourgeois" sentimentalism. He has also left us some watercolors representing scenes of Jewish religious and family life, all revealing a rather charming quality of

Fig. 228 intimacy that he shares with Moritz Oppenheim. His *Searching the House,* representing a police raid in an 18th century Dutch home, is a fine example of his more anecdotic and documentary manner.

VI

The existence of a small school of Jewish artists in England in the Hanoverian period has only recently been brought to the notice of students.* This school comprised painters, engravers, and miniaturists, none indeed of any great importance in himself, though some of them exhibited time after time at the Royal Academy. In the early Victorian era, however, there emerged in England at least three Jewish artists who were of outstanding ability, though time has blurred their reputation.

The most distinguished in his day was Solomon Alexander Hart (1806–81), the son of a Plymouth silversmith, who moved with his family to London in 1820. First apprenticed to an engraver, Solomon entered the Royal Academy as a student in 1823 and three years later exhibited a miniature portrait of his father. He continued for a time to paint miniatures for a livelihood, but showed his first oil at the British Institution in 1828 and, two years later, *Elevation of the Law,* also called *Interior of a Jewish Synagogue at the Time of the Reading of the Law* (apparently depicting the interior of the former Polish Synagogue

See chapter XIII.

in London), a painting which eventually came into the possession of the Tate Gallery.

Hart became an associate of the Royal Academy as early as 1835, and a full member five years later. From 1854 to 1863, he was professor of painting at the Royal Academy, and subsequently, until his death in London in 1881, he served there as librarian.

Hart's large canvases, crowded with figures and usually illustrating some famous episode of English history (e.g., *Henry I Receiving News of the Shipwreck and Death of his Son; The Execution of Lady Jane Grey; Wolsey and Buckingham*), are done in the formal, dignified "academic" style that matured in the Regency period. However celebrated these paintings were a hundred years ago, they appear to us now stiff and overfinished, with over-posed figures. This is also true of Hart's works on Jewish themes, such as *Hannah, the Mother of Samuel; Isaac of York in the Castle of Front de Boeuf; the Conference between Menasseh ben Israel and Oliver Cromwell;* and *The Expulsion of the Jews from Spain.* The *Elevation of the Law* is, with all the faults of the English academic tradition in which it is rooted, a highly impressive work; a feeling of great dignity emanates from it, as the reader of the Torah unrolls the Scroll on the *bimah*, and bearded old men, most of them with prayer-shawls covering their heads, gather around him. Analogous is his dignified, impressive, and highly romanticized canvas representing the procession of the Scrolls on the occasion of the *Rejoicing of the Law in the Ancient Synagogue at Leghorn.* *Fig. 229*

His younger contemporary, Abraham Solomon (1824–62), was outstanding among a group of Victorian *genre* painters whose works were long neglected in spite of their excellent qualities, mostly because so many bad painters were carelessly classed together with them. Solomon is a typical Victorian artist insofar as he saw the world through rose-tinted spectacles, mirroring in his paintings an age of order and self-control, of material prosperity and external graciousness.

He was the son of a well-to-do London merchant, Michael Solomon, the first Jewish freeman of the city in the 19th century. His mother, Kathe, had also dabbled in painting, and his younger brother Simeon, and his sister, Rebecca, distinguished themselves as artists. Abraham had his first picture accepted at the Royal Academy in 1843. In the 'forties he exhibited "period pieces" inspired by the works of Goldsmith and Molière, but he had his great success in the 'fifties with two pairs of paintings that became famous in thousands of chromolithographs on both sides of the Atlantic. *Waiting for the Verdict* showed a scene in the anteroom of a court, with the prisoner's family anxiously awaiting the result of the trial; the companion picture was *The Acquittal.* The social scene is revealed in the second pair of pictures, showing people in a relatively new conveyance, the railway train. *First Class: The Meeting* shows a young man meeting a pretty girl in a railway compartment. In the original version, which was sharply criticized because of this impropriety, the old gentleman in the corner was seen asleep, a fact which facilitated the young traveler's flirtation. *Third Class: The Departure,* the companion picture, shows the young son of a widowed mother leaving by train to emigrate to Australia. The social implication of the pictures is simple enough: those who are wealthy enough to travel first-class move in an atmosphere of security and make pleasant friends, while the third-class passengers are plagued by economic insecurity and distress.

Familiar with the work of the pre-Raphaelites, a group with which his brother was closely associated, Solomon also resorted to meticulous craftsmanship and close observation

of nature. His pictures, small in scale, careful in detail, and brilliant in color, are so well painted that they are still as glowing and radiant as when they were produced. Abraham Solomon died in his thirty-eighth year, on the very day he was elected Associate of the Royal Academy.

The most gifted of all mid-19th century Anglo-Jewish artists, and certainly the most interesting figure among them, was Abraham Solomon's younger brother, Simeon (1834–1905), whose tragic, restless life followed the self-destructive pattern of his contemporaries Baudelaire, Rimbaud, and Oscar Wilde. Simeon Solomon's work, rarely appreciated by Victorians, who resented the artist's ways and often his choice of subject as well, is now gaining more and more importance in the eyes of connoisseurs.

Solomon, who was mainly self-taught, fell at an early age under the spell of the pre-Raphaelite Brotherhood, which in many respects resembled the group of German Nazarenes founded in Rome thirty years earlier. Here, too, were serious, dedicated young artists who loathed the conventionality of the art sponsored by the academies; here, too, was a re-discovery of early Italian art, the simplicity and purity of which appealed to both groups far more than the sophistication of the Cinquecento.

At Rossetti's studio, Simeon Solomon was a frequent and welcome visitor, while his gifted but equally unstable sister Rebecca, who died in 1886, was employed by Millais to make copies and to paint draperies. Simeon was only seventeen when he first showed a drawing at the Royal Academy. Two years later, in 1860, his picture *The Finding of Moses* was attacked by a critic ("Two ludicrously ugly women looking at a dingy baby don't form a pleasing subject"), but was warmly defended by the novelist Thackeray, who thought it finely drawn and composed. The painter Burne-Jones said that, in his opinion, Solomon was the greatest artist among all the pre-Raphaelites. Oscar Wilde, who had collected many of Solomon's drawings while an undergraduate at Oxford, said towards the end of his life that these were among the treasures the loss of which he most regretted.

Fig. 231 Solomon's work was uneven, but the best of it was unsurpassed in beauty of line and composition, especially in his drawing of faces, whether he drew the sensitive faces of young rabbis or the more sensuous ephebic countenances of Greek youths. The most graphic description of Solomon's drawing is by the poet Swinburne who wrote:

"There is a questioning wonder in their faces, a fine joy and a faint sorrow, a trouble as of water stirred, a delight as of thirst appeased. Always a feast or sacrifice, in chamber or in field, the air and carriage of their beauty has something in it of the strange: hardly a figure but has some touch, though never so delicately slight, either of eagerness or of weariness, some note of expectation or of satiety, some semblance of outlook or inlook: but prospective or introspective, an expression is there which is not pure Greek, a shade or tone of thought or feeling beyond Hellenic contemplation; whether it be oriental or modern in its origin, and derive from national or personal sources. This passionate sentiment of mystery seems at times to 'overinform its tenement' of line and color, and impress itself even to perplexity upon the sense of the spectator."

Solomon's most important work was a canvas, *Habet* (1884), inspired by a contemporary novel, *The Gladiators*. Had the theme been taken by one of the more celebrated Royal Academicians, it would have revealed a pre-occupation with archaeological details, whereas Solomon was more interested in giving expression to the play of emotion and character on the faces of Roman ladies gazing from the gallery into the arena, where a

212. Meir Jaffe. Binding of the Pentateuch
for the Nuremberg City Council. 1468.
Munich State Library. Cod. hebr. 212.

213. Coin struck by the Jews Priscus and
Domnulus, Chalon-sur-Saône, about
555. Paris, Bibliothèque Nationale,
Cabinet des médailles.

214. Polish coins with Hebrew inscription:
"Berakha" — Blessing. 12th century.
British Museum, London.

212

213 214 214

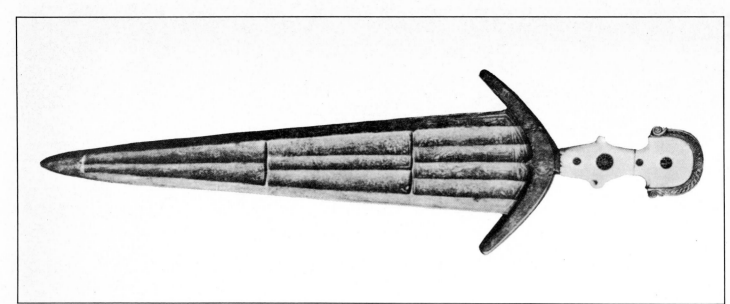

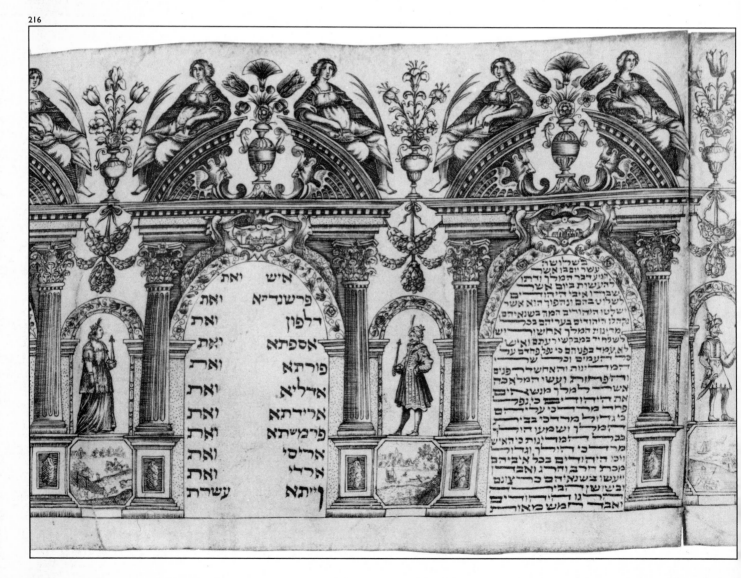

215. Salamone da Sesso (Ercole dei Fedeli). The Sword of the
 Gonzaga Family, Louvre, Paris.

216. Salom Italia. Engraved border for a Scroll of Esther.
 Israel Museum, Jerusalem.

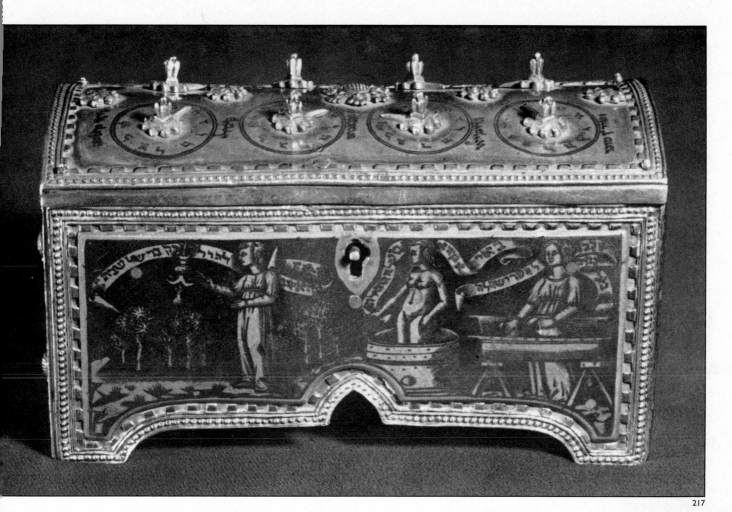

217

218

217. *Jeshurun Tovar (?). Housewife's casket. Italy, about 1460–80, Israel Museum, Jerusalem.*

218. *Jacob Judah Leon (Templo). Reconstructed model of Solomon's Temple, 1670.*

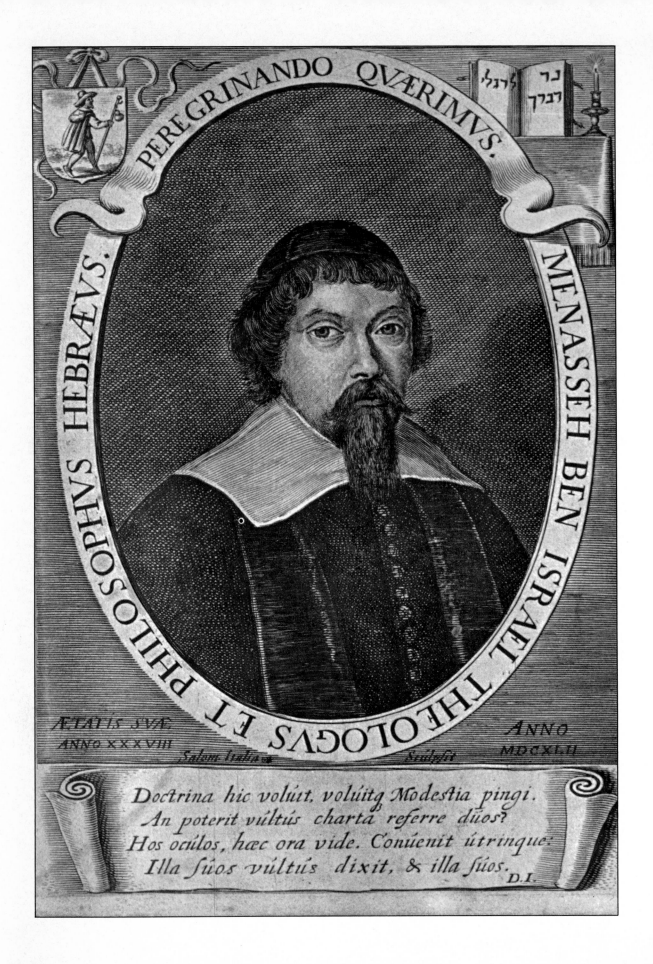

PEREGRINANDO QVÆRIMVS.

MENASSEH BEN ISRAEL

THEOLOGVS ET PHILOSOPHVS HEBRÆVS.

נר לרגלי דבריך

ÆTATIS SVÆ
ANNO XXXVIII

ANNO
MDCXLII

Salom Italia Sculpsit

Doctrina hic voluit, voluitq Modestia pingi.
An poterit vultus chartâ referre duos?
Hos oculos, hæc ora vide. Convenit utrinque:
Illa suos vultus dixit, & illa suos.
D.I.

219. Salom Italia. Portrait of Menasseh ben Israel. 1642.

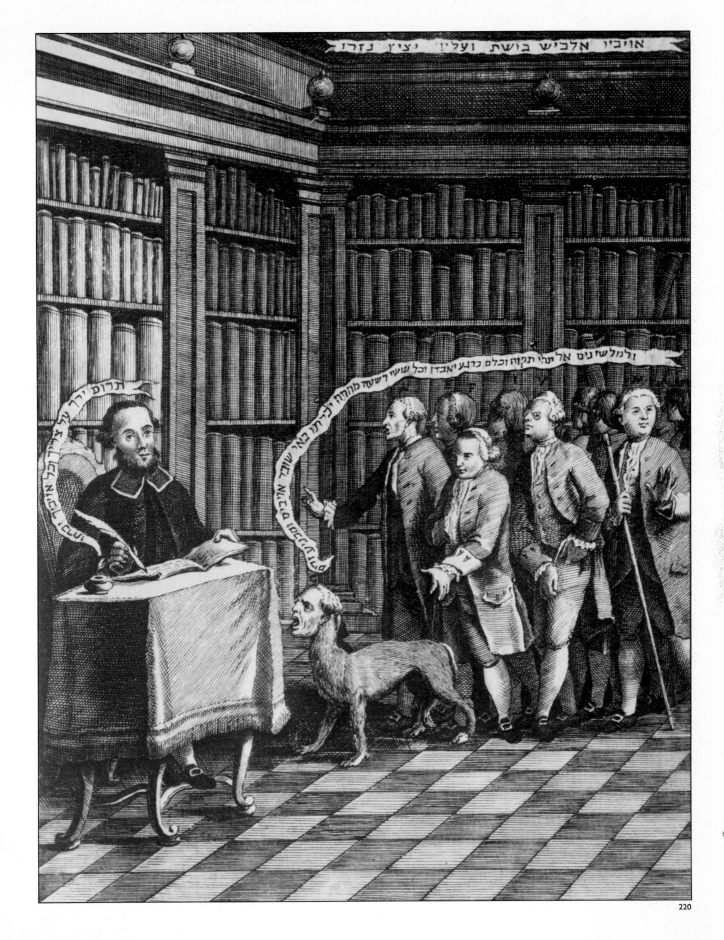

220. *Zechariah Padova. Caricature of his opponents. Modena. Italy, 1777.*

221

222

221. *Charles Town. Cattle Fair. Williamson Art Gallery, Birken-
head, Cheshire.*

222. *Joel ben Lipman Levi. Portrait medal of Eleazar ben
Samuel Schmelka of Brody, Amsterdam, 1735. Obverse
and reverse. The Hague, Koninklijke Penning kabinet, 4653.*

223

222

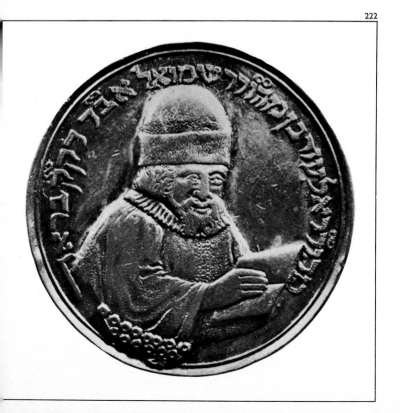

223. Anton Raphael Mengs. The Magician. Israel Museum, Jerusalem.

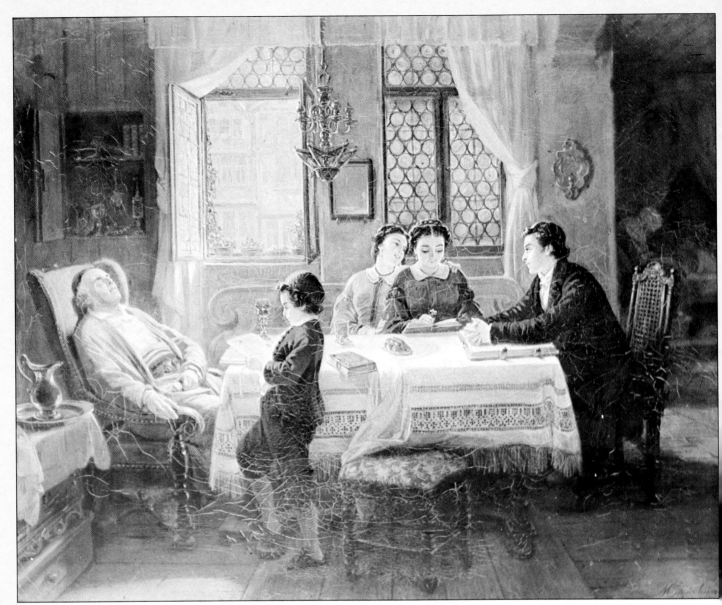

224

224. *Moritz Daniel Oppenheim. Sabbath Afternoon. Israel Museum, Jerusalem.*

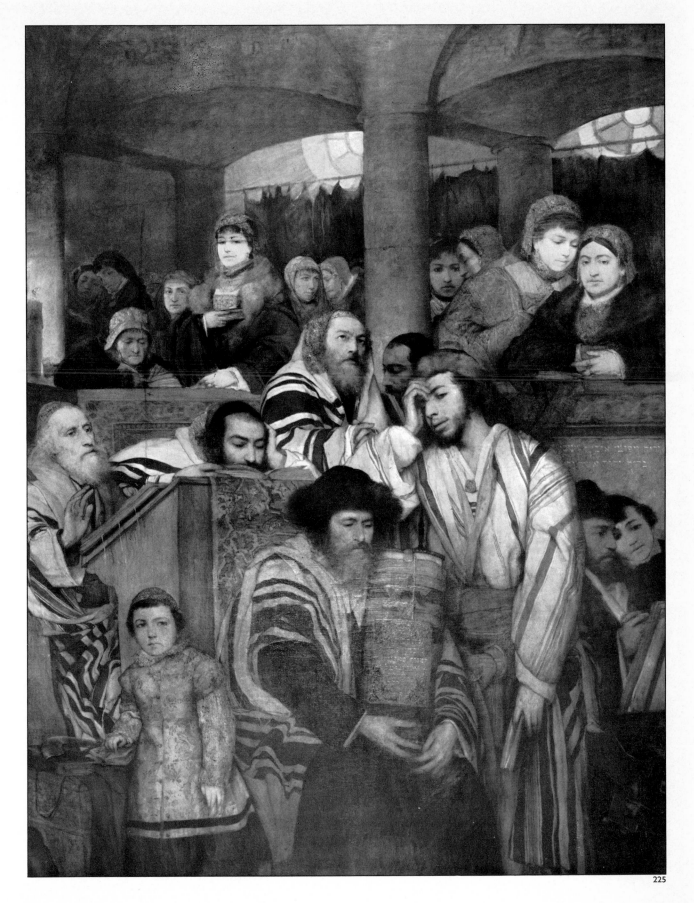

225

225. *Maurycy Gottlieb. Prayer at a synagogue on the Day of Atonement. Tel Aviv Museum.*

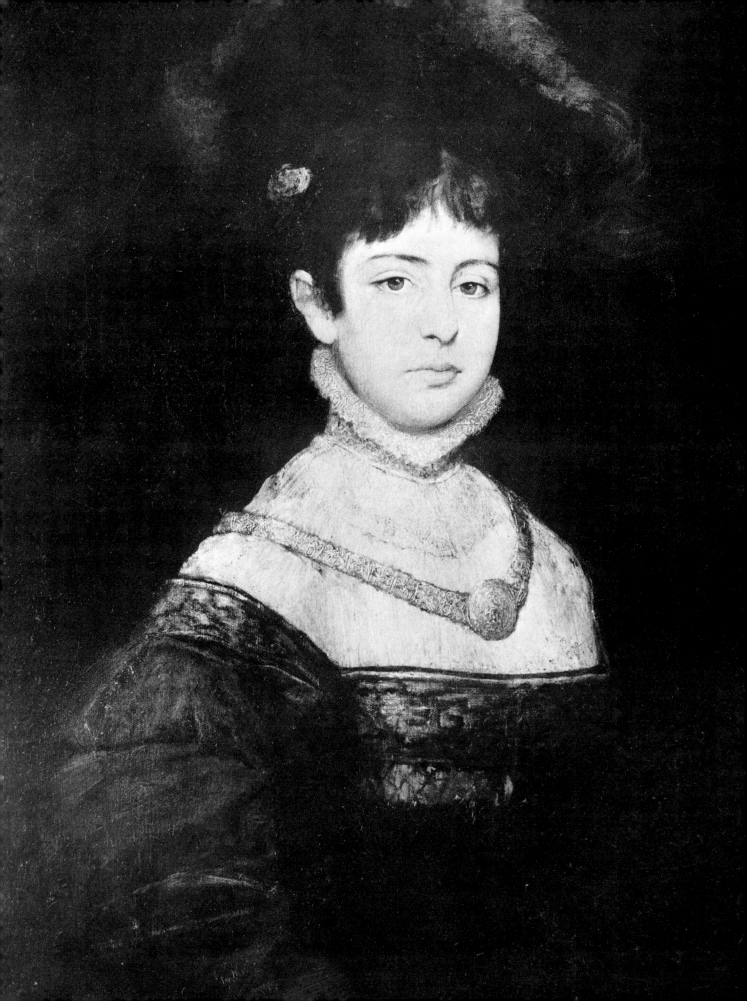

227. Salomon Leonardus Verveer. Landscape of Noordwijk,
1865. Oil on Canvas. Rijksmuseum, Amsterdam.

226. Maurycy Gottlieb. Portrait of his fiancee. Tel-Aviv Museum.

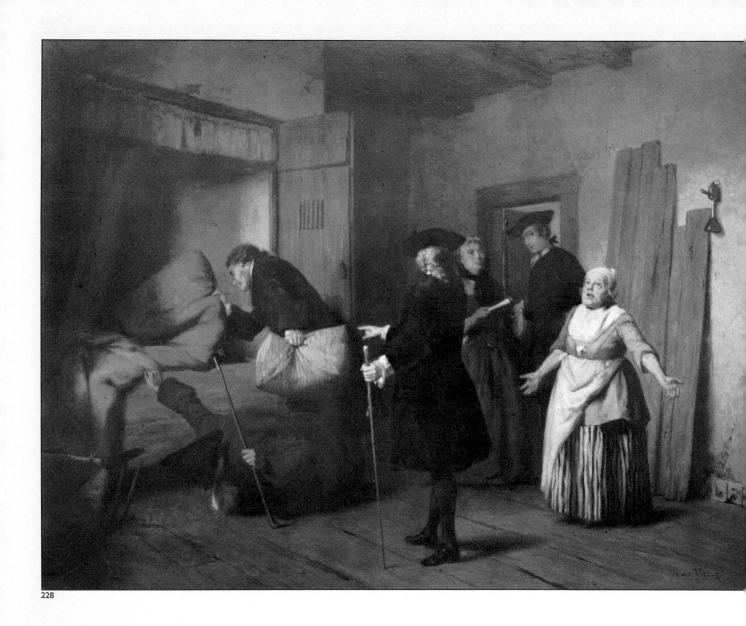

228

228. *David Joseph Bles. The Raid on the Home. Oil on canvas. Municipal Museums of Amsterdam.*

229. *Solomon Alexander Hart. The Rejoicing of the Law in the Ancient Synagogue at Leghorn. Oscar Gruss Collection, New York.*

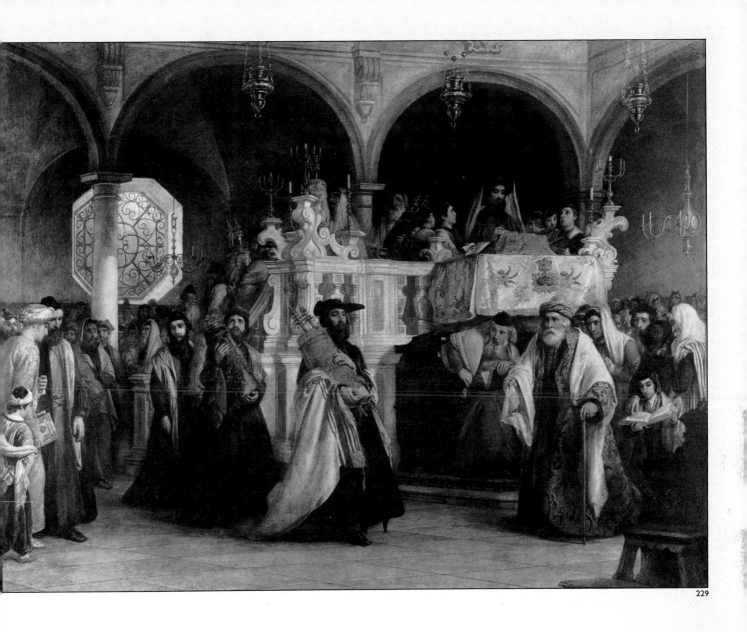

229

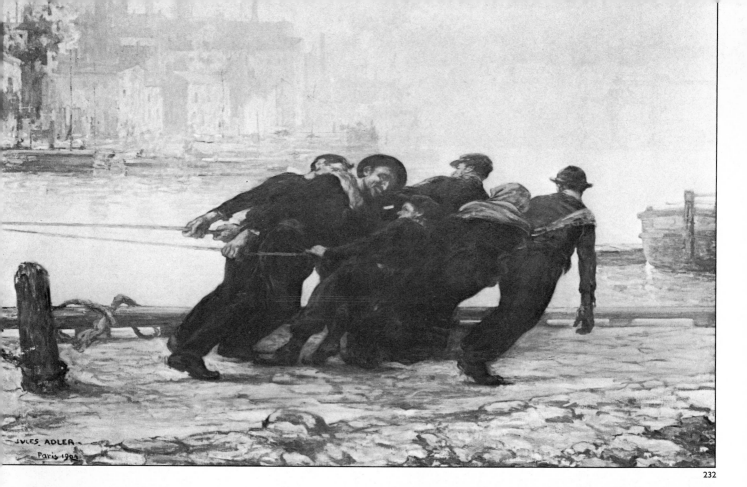

232

233

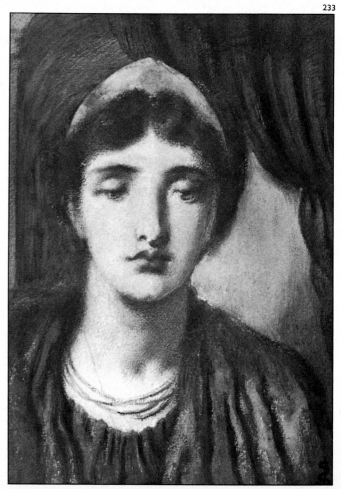

230. Jules Adler. *Towing the Barge, 1904. Museum of Modern Art, Paris.*

231. Simeon Solomon. *Roman Lady, watercolor, 1895. Israel Museum, Jerusalem.*

gladiator, having fallen to his opponent, is about to lose his life, the victim of their merciless whim. Some of Solomon's canvases depict Jewish themes, such as *The Scrolls of the Law* (a young man carrying the Torah) or *Isaac Offered*. He also executed a number of woodcuts depicting scenes of Jewish religious life.

But his best work is to be found in his colored chalk drawings, where he revealed himself in all his tenderness and sorrowfulness, as one who lived in this world and yet was not part of it, especially in his drawings of single heads or of two heads facing one another, e.g., *Jesus and Mary Magdalen* or *The Virgin and the Angel of Annunciation*. Then there are his beautiful pencil drawings, illustrating the *Book of Ruth* and the *Song of Songs*, which have the subtle charm of mystical music.

But for circumstances and a basic weakness of character, Solomon might have accomplished more and won for himself a brilliant name in the annals of art. Swinburne apparently introduced him to homosexual and sadistic practices. The Victorian world was shocked by tales of orgies celebrated by the poet and his friends; handsome and unstable, Solomon participated in the exciting fare of art, sex, drink, and drugs.

For a number of years, nevertheless, Solomon worked adequately, and regularly sent canvases for exhibition at the Royal Academy. At one time, he was almost as popular as Millais, and his black-and-white drawings were widely sought by magazines. But, before he was forty, deterioration set in, and there was an unsavory charge for which he was sent to prison. Released from jail, he then took to drink and drugs. Efforts of friends to save him were of no avail.

He continued to draw, selling his work for a few shillings to cheap dealers. What works of this period have survived show emaciated, brooding faces, which indicate that to his very end the artist retained his astonishing talent. At one time, he worked as a pavement artist and even sold matches in the streets to obtain what he wanted most — drink and drugs. One day, he was found by police on the street, unconscious. He was taken to his "lodgings" in the workhouse where shortly after he died of heart failure. Solomon is now considered one of the more interesting English artists of his era. Some of his paintings of Jewish subjects, dramatic, sensitive, and rich in color, are to be reckoned among the best of what is commonly called Jewish art, notwithstanding the fact that the artist, early in life, had become converted from nominal Jewish orthodoxy to a fervent Catholicism.

VII

In a later chapter of this work, there will be some account of the remarkable outburst of Jewish artistic activity in all media in the United States in the present generation. It is desirable, therefore, to devote a few pages here to its modest beginnings. One or two names — but names only — survive from the late 18th century and the early 19th. It is interesting to note that almost all of the artists in question were associated with Charleston, South Carolina — clearly, the leisured South constituted a more favorable soil for artistic activity than the harsh, commercial North. Among these were Joshua Canterson (Canter), who had studied at Copenhagen and was at work in America in the 'seventeen-eighties; a John Canter (1782–1823), probably a relative, who helped to establish the South Carolina Academy of Fine Arts; Lawrence L. Cohen, who went to Düsseldorf to study and later fought in the Civil War; and perhaps a few more.*

* Of the remarkable landscape-painter Albert Sonntag, one of the masters of the American Hudson River School, not enough is known to make it possible to determine whether or not he was of Jewish origin.

Fortunately we are better informed about two other early painters, Theodore Sydney Moise and Solomon Nunes Carvalho; and enough works by each are extant to allow us to form an opinion of their merits. Moise was born in Charleston, in 1806 and received an elementary knowledge of painting from his aunt, Penina, a poetess and "Sunday painter." We know nothing of his further training, only that he had a studio in New Orleans from 1850 to his death in 1883. He was described by a contemporary as a "fashionable, dashing, and improvident genius, many of whose portraits were executed to cancel debts."

Associating himself with Trevor Fowler, with whom he traveled through the *ante-bellum* South, Moise executed portraits of the rich landowners, their families, their personnel, even their horses and dogs. Occasionally, it is impossible to distinguish Fowler's work from that of Moise, many of whose portraits, some painted in collaboration with Fowler, are still to be found in old Southern mansions. New Orleans has many of his works: an equestrian portrait of General Jackson in the City Hall, a portrait of Governor Herbert in the State Library, while the Court House has *inter alia* an enormous canvas showing sixty-four members of the Volunteer Fire Brigade parading in Canal Street.* Moise was noted for his ability to make spirited likenesses of racers and war-horses.

Competing with a new medium praised for its impartiality, the daguerreotype, Moise fully realized that his sitters wanted records, not interpretations. So did Solomon Nunes Carvalho (1815–94), an equally solid and competent portraitist. A scion of a well-known Sephardic family, he was only twenty-three when he made from memory, for the trustees of the Charleston Synagogue, his well-known painting of the interior of the building which had just been destroyed by fire. In 1852, a silver medal was awarded him by the South Carolina Institute for his painting — now lost — *The Intercession of Moses for Israel,* but no doubt analogous to his still-surviving *Moses Before the Amalekites,* a melodramatic composition in the taste of its time. There is, however, great charm and tenderness in his portraits.

A hundred years ago, as today, it was difficult for an American artist without an enormous reputation to make a living from his art alone. Carvalho was therefore engaged in taking and processing daguerreotypes, and even made some technical contributions to early photography. In 1853, as artist and daguerreotypist, he accompanied Colonel John C. Fremont's hazardous expedition across the United States to the West Coast. His account, which he both wrote and illustrated, *Incidents of Travel and Adventure in the Far West,* was published in 1857 (reprinted 1954). Carvalho's best-known works are Rocky Mountain subjects, deriving from this expedition and typical of the art of the so-called Hudson River School of 19th-century American landscape painting.

Other American Jewish artists of this period may be disposed of here in only a few lines. A slightly younger contemporary of Carvalho was the New York portrait-painter, Jacob H. Lazarus (1822–91), who studied under the American painter Henry Inman, and continued in the tradition of emphasizing likeness rather than character. Max Rosenthal (1833–1918), a native of Russian Poland, remembered today as an inventor rather than an artist, came to the United States in 1849. His introduction of chromolithography to America, and his invention of the sand-blast process of engraving patterns on glass were

* In 1925, it was discovered that a fine 1843 portrait of the statesman Henry Clay, presented to the Metropolitan Museum in New York in 1909, was not, as a new reading of the small signature revealed, by Samuel F. B. Morse, the artist and inventor, but by the forgotten Moise.

his major contributions. During the Civil War he followed the Army of the Potomac as official illustrator for the United States Military Commission. His numerous etched portraits of famous Americans are preserved in the Smithsonian Institution at Washington. Rosenthal's once-celebrated large altar painting *Jesus at Prayer,* made for a Baltimore Protestant church, caused a brief stir when objections were raised to the phylacteries on the head and right arm of Jesus.

Not related to this artist was Toby Edward Rosenthal (1848–1917). Today, Toby Rosenthal, a native of New Haven, Connecticut, is so completely forgotten that it is hard to realize that in the 'seventies and 'eighties he was one of the most celebrated American painters. In Munich, where he became a pupil of Carl von Piloty, he learned to execute huge canvases, filled with large groups of figures, the subjects being taken either from history or from romantic poetry. Rosenthal's *Elaine,* taken from Tennyson's *Idylls of the King,* shows, for example, that embodiment of pure love on her bier, on a richly adorned and garlanded barge.

But neither the excellence of the painting nor their suberb composition could save from oblivion these impersonal oils, which today annoy us with their false pathos.

A little older than Rosenthal was the New Yorker Gustave Henry Mosler (1841–1920), the first American honored by the French Government with the purchase of a painting for the Luxembourg Museum. *The Return of the Prodigal Son* shows the remorseful youth finding his mother on her deathbed. Stricken with grief, he falls on his knees, while a priest looks on in deep commiseration. Though well-painted, this picture is over-elaborate and theatrical. The same can be said of *The Birth of the Flag* (Betsy Ross and her friends stitching together the first American flag), in the Corcoran Gallery in Washington, and of *A Wedding Festival in Brittany,* in the Metropolitan Museum of New York. The figures in both are most unreal, distributed in unreal settings, though the artist, undoubtedly in all sincerity, believed he had caught the situation as realistically and correctly as possible. Mosler's portraits, executed in fresh, vigorous brushwork, are superior to the rest of his work.

It is a curious fact that, whereas in the 20th century many American Jews have been in the vanguard of the progressive movement in the arts, in the preceding century most American-Jewish painters remained conformists, happy to gain a foothold in the realm of academic art. It might be said in their defense that before the end of the century American art amounted on the whole to little. But among the innovators of American painting in the last century, there was not a single Jew.

JEWISH IMPRESSIONISTS

by ERNEST M. NAMENYI

The artistic history of the second half of the 19th century is characterized by the most profound technical revolution that painting has experienced since the Renaissance — Impressionism, which has determined the evolution of the arts of a hundred years in all countries of Europe. In this great movement, Jewish artists have played a leading part. Up to the middle of the 19th century no single Jewish artist and no work of art created by a Jew can be proved to have definitely contributed towards forming the style of any one period. With the birth of Impressionism, however, we find in almost every major artistic center of Europe great Jewish painters, who contributed from the very start to the success of the new school. Everywhere they are in the forefront of the major painters who, in each country, initiated the artistic revolution that now concerns us.

The political revolutions of 1848, though many of them remained abortive, brought a decisive crisis in the social life of Europe. The ideals and achievements of the French Revolution became, in spite of many setbacks, the common heritage of the whole Continent.

Meanwhile, the situation throughout Western and Central Europe was favorable to the Jews as it never had been before. Economic liberalism made it possible for them to pursue very diversified commercial and industrial activities, and even the liberal professions were beginning to admit them freely. In Eastern Europe, too, the restrictions that weighed upon the Jews were, as it then seemed, beginning to be less oppressive. It is not surprising, in the light of this, that Jews of the generation of 1848 were everywhere in the vanguard of the movement which fought for freedom, national liberation, and a more equitable social order. Nevertheless, the revolutions of 1848 were not the fruit of dreams that visited idealists; they were brought about by new conditions experienced by the masses. Economic and social upheavals coincided with the formulating of new ideas that were modern and realistic in their origins, though they may have become idealistic, too, in the heat of the enthusiasms that they engendered. Progress in the sciences also gave these ideas a quality of realism and of positivism, and an almost religious passion for social justice, an ideal that has never been foreign to Jews, added a dynamic power to this whole philosophy.

These ideals were, of course, inevitably destined to find expression in art, and above all in the form of art that was most representative of this period, in painting. The Realist painters of the 19th century indeed viewed nature as part of a universe where man was no onlooker from the outside, but an integral element. Constable and Turner, among the

great English masters; Courbet, Corot, and Millet among the French, saw the universe as a homogeneous whole, and the content of their paintings reflects the ideas of their era. The people, the working class and its life and labors, interested them particularly, among the many elements of a homogeneous universe; and it is this social philosophy that characterizes their attitude. All these great painters agreed to seek ways and means of expressing the life of their age, of creating a living art with lyrical undertones, inspired as they were by an almost innocent sense of the majesty of mere life.

Nevertheless, they managed only to render the contents of life, leaving the expression of its lyrical undertones to those painters who around 1870 began to form a new school. Full of devout humility before the manifestations of nature and of a great admiration for contemporary science, these new painters felt absolutely integrated within their universe, within the shifting life of nature. Imbued with a humility that had never yet expressed itself in painting, these artists approached nature in a spirit that no longer made them want to transform it according to their arbitrary notions; instead, they were content to render their immediate and subjective impressions of nature. In their eyes, light now became the universal element that makes it possible to experience sensations that are authentic. Light was thus their prime concern, enclosing everything and giving something of eternity to the fleeting moments of life. This led the Impressionists to formulate a new conception of the finite. They no longer wanted to represent objects with exactitude, but only to communicate their own impressions of things, so that they considered a picture finished as soon as they felt that they had expressed the sensations which they had experienced.

The composition of their works was merely one of light, not of objects, and refrained from any balanced distribution of images throughout the canvas, as well as from any representation of space in perspective. Light dissolves forms and by means of its vibrations gives a sense of color that earlier painters had neglected. The Impressionists resorted to a lighter range of colors and tried above all to keep the various colors separate and distinct rather than mix them to obtain a brighter coloring.

One of the chief characteristics of the history of 19th-century painting is the absolute supremacy of the French school in this field. It is in France that the Impressionist movement got under way, around 1870; and this occurred, for the first time in centuries, not so much as the result of the efforts of a single genius, as of the concerted efforts of a whole group of painters of genius, among whom the most diligent and the most consecrated craftsmen were Monet, Sisley, Renoir, Cézanne, and one Jew — the most conscious and articulate among the Impressionists — Camille Pissarro (1830–1903).

II

Born on the island of Saint Thomas, in the West Indies, Pissarro was of Sephardi extraction and remoter Marrano origin, though of French nationality. At first, Camille was expected to become, like his father, a dealer in household goods and ironmongery. In 1847, the future painter was sent to Paris, to complete his studies. On his return to Saint Thomas, he worked for a while in the family business, but soon escaped back to France, where, after an unsuccessful attempt to enter the studio of Corot, he became a student in the Ecole des Beaux Arts, at that time under the somewhat despotic management of the great neo-Classical painter Ingres. In 1850, Pissarro exhibited in the annual Paris Salon a landscape painted in the open air in Montmorency in which the influence of Corot

prevailed. In the 1863 Salon of the artists rejected by the official Salon (Salon des Refusés), a critic advised Pissarro to be careful not to imitate Corot. He then withdrew for a time to Louveciennes, where he painted Ile de France landscapes—simple but unpretentious, all masterpieces.

During the Franco-Prussian War, Pissarro fled to London, and the Germans destroyed a large number of his paintings. In 1874, he was back in Paris and exhibited in the first Impressionist show, remaining faithful to the new school throughout its seven subsequent shows. In 1884, he settled in Epernay, and was on close terms with Signac, Seurat, and Van Gogh. For a while, he was a member of Seurat's neo-Impressionist *(Pointilliste)* group, but towards the end of his life settled for good in Paris. Afflicted with an eye complaint, he could no longer leave his room, and painted views of the boulevard from his window. He died on November 13th, 1903.

Fig. 233 Among the major Impressionist masters, Pissarro is the one who was most aware of the revolutionary nature of the movement. At the age of sixty, he had the face of an apostle and was always to be seen carrying a board under either arm, so that they all said of him, at the Nouvelle Athènes café, where the Impressionists had their headquarters: "Here comes Moses bearing the Tablets of the Law."

Pissarro's devotion to nature was equaled only by his faith in his principles and by his absolute respect for the artistic truths which he accepted or had discovered. Art, in his eyes, was something as sacred as the Law, and any compromise, he felt, was sacrilege. For years, he struggled in poverty but never made any concessions to the demands of opportunism; yet he was far from being rigid in his principles. He felt, for instance, that Seurat's *pointilliste* technique was more in keeping with the findings of modern science, and he adopted it in his own painting, abandoning it only after having observed that this technique of dividing light into its spectral components was too slow and thus conflicted with the immediacy of sensation. Enthusiastically, Pissarro acclaimed everything that seemed to him to represent progress. His influence on Cézanne, who influenced him in turn in his quest for simplicity and structure, makes Pissarro perhaps the most important individual source of the style of the School of Paris. Gauguin considered Pissarro his master, in spite of the divergences of opinion that later drove them apart and which can be explained in terms of their different conceptions of the philosophy of art. Pissarro remained, indeed, the living conscience of Impressionism.

Alone among the Impressionists, Pissarro sought the subjects of many of his paintings in the life of peasants. The fields, the earth, nature itself, all these are indissolubly bound to those who till the soil.

Pissarro had not been the first among 19th-century painters to turn in this manner towards the life of peasants. The "Angelus" and other works by Millet had already met with great success; and the Jew Josef Israels, in Holland, had also begun to produce his deeply emotional and somewhat melancholy compositions representing scenes from the life of peasants and of the poor. The subject matter of these three painters may indeed have much in common, but Pissarro's technique, his forms, and his real content reveal that his philosophy was entirely personal.

He does not seek to move us but lives among his models and knows all their tasks. His peasants thus remain prosaic, and the natural scene that he paints is as simple and prosaic as he sees it. Only in the light or in the colors is there any lyrical quality. The vitality of Pissarro's peasants, their strength and beauty, are thus the vitality, strength and beauty

of nature itself, within which they are fully integrated, simple and powerful as the whole scene that surrounds them. Nor are these figures painted to suggest to us any charity, sympathy, or pity; on the contrary, we see them living and working in their true setting.

Pissarro's philosophy remained at all times in complete harmony with the artistic revolution which he initiated and which continues in our own times. He is thus the true father of all the artistic non-conformism that seems to have been a characteristic of most of the great Jewish painters of the past fifty years.

The graphic arts played a considerable part in Pissarro's total production, more important than in that of most other Impressionists. We know close to two hundred different Pissarro prints. Even today, some critics find fault with his sense of color which, they feel, lacks brilliance; but nobody has disputed that his etchings and lithographs are of the highest quality and outstanding in their beauty. The love and perseverance with which Pissarro followed his son Lucien's experiments in book-decoration, the criticism and advice that are contained in the older man's letters, all testify to his constant interest in graphic art.

All of Pissarro's sons became painters. Without rising to the peaks of creative art that their father had reached, they inherited from him a sensitive nature and an artistic integrity that reveal the almost religious significance of art in the whole family's life. Lucien Pissarro (1863–1944) was an outstanding post-Impressionist. He married in England, where he spent most of his productive years and influenced the works of several English painters of his generation. In close cooperation with his father, he also produced woodcuts of great beauty, illustrating the legend of Esther and the various tasks of those who till the soil. Lucien's daughter Orovida is likewise an artist of considerable merit. Influenced by the styles of the Far East, she has distinguished herself in studies of animals, where she renders the rhythm of their movements with great sensitivity. Of Camille Pissarro's other sons, Georges (born 1871), generally known as Manzana Pissarro, is remembered mainly for his beautiful color prints, birds, and flowers; he revived, in some respects, the almost forgotten art of the great Japanese woodcut artists. Félix Pissarro (1874–97) adopted Jean Roch as his pseudonym, but died too young to obtain much recognition; Ludovic-Rodolphe Pissarro (1878–1952) chose to sign his works only with his own given names and is remembered mainly as a fine graphic artist and as the devoted author of the analytical catalogue of his father's works; Paul-Emile Pissarro (born 1884) is known for his sensitive landscapes of the Ile de France and for his fine etchings.

Among other French-Jewish artists of the period we are considering, Jules Adler (1830–1903) deserves particular mention. Without being an Impressionist, he shared with Pissarro a great interest in social problems and is remembered, above all, as a painter of scenes in the life of workers and of the underprivileged. His painting in the Paris Museum of Modern Art "Towing the Barge" is a characteristic example of his art. Jules Adler was deeply moved by human misery, which he depicted with sobriety and pity rather than with imagination or anger. Brought up in the same tradition, his son Jean Adler (1899–1944) followed, like Pissarro's sons, in his father's footsteps; a young painter of promise and remarkable integrity, he was murdered by the Germans before his art had fully matured. Edouard Brandon (1831–97), of an old established Bordeaux Sephardi family, is remembered for his compositions on Biblical and traditional Jewish themes, which he

Fig. 230

209

handled with delicacy and a sense of the problems of light and shadow. Alphonse Levy (1843–1918) is noteworthy as the sentimental and good-natured satyrist of Alsacian-Jewish types and customs.

Henri-Léopold Levy (1840–1904) was a successful painter of historical scenes, many of his works being commissioned to decorate public buildings in Paris; eclectic, opulent, and slightly decadent in his mannered style, he remained primarily a decorative artist.

More important than these, in the generation of the disciples of the great Impressionists, was Lucien Levy-Dhurmer (1865–1943), who was born in Algiers and distinguished himself in Paris as a fashionable portrait-painter of the elegant Parisian *Jugendstil*. His *Fig. 232* fine portraits of the writer Georges Rodenbach, of the novelist Pierre Loti, and of the politician Georges Clémenceau are interesting examples of his period's delight in literary allusions; for the portrait of Rodenbach, for instance, Levy-Dhurmer chose the Flemish city of Bruges as a background. His art thus achieved, with great facility, an interesting synthesis of nature and of contemporary currents in fashion and in the decorative arts. His pastels are, in this respect, fine period-pieces, as are also some of his drawings. In his deeply moving painting representing blind Moslem beggars in Tangier, Levy-Dhurmer revealed a rare quality of human sympathy that distinguishes his work from most other contemporary treatments of exotic North-African themes.

Henri Caro-Delvaille (1876–1928) who, like Brandon, belonged to the old-established Sephardi group of southwest France, was a pupil of the fashionable portrait-painter, Léon Bonnet, and inherited many of his master's characteristics. Always graceful and pleasing, Caro-Delvaille enjoyed great popularity, especially with his somewhat sensual portraits of fashionable women. He decorated the *château* of his friend, the poet Edmond Rostand, in Cambo, near Bayonne, and painted a portrait of Madame Rostand, herself a well-known writer. Caro-Delvaille's best-known painting is an interesting illustration *Fig. 234* of French-Jewish social life in his generations: "My Wife and her Sisters" representing the daughters of the rabbi of the ancient community of Bayonne.

Less dependent on mere fashion than other more recent styles of painting, Impressionism and post-Impressionism have continued to inspire, in our century, a number of outstanding French painters, among whom several Jewish artists have achieved considerable distinction. Simon Levy (born 1886) has sought to develop the style of Cézanne in an idiom of his own. Brilliantly intellectual in his compositions, he sometimes fails to transcend a too systematic illustration of his theories. His landscapes of Provence and his fine interiors, many of which he painted in Belgium between 1905 and 1910, prove, nevertheless, that he is a painter of individuality and talent whose draftsmanship and sense of color reveal unusual refreshment. Edouard Kayser (born 1882) and André Strauss (born 1885) are also to be reckoned among the more original and gifted contemporary disciples of Cézanne; the still-life compositions of Kayser and the landscapes of Strauss achieve an interesting synthesis of post-Impressionist and *Fauvist* trends. Their art is, moreover, typically French in its sense of restraint and balance, its intellectually meditative rather than mystical quality. Léopold Levy (born 1882) is another distinguished artist of the post-Impressionist school. Long a professor in an academy of fine arts in Turkey, where he helped a whole generation of young Turkish painters to integrate themselves in a Western tradition of modern art, he has now returned to France, where his qualities of sobriety and taste are beginning to obtain the recognition that they deserve.

III

Although Camille Pissarro had lived in England as a refugee from the Franco-Prussian War, the influence of the Paris Impressionists was felt there, except in the work of Whistler, only much later. Among Anglo-Jewish painters of this era, Solomon J. Solomon (1860–1921) remains an outstanding personality. Deeply rooted in the Jewish religious tradition, he created a painting "Allegory," which inspired considerable discussion; it illustrates the ultimate worldwide triumph of Jewish idealism through the alliance of Christianity and of the Jewish faith. For London's Royal Exchange and for the House of Lords, he was commissioned to paint important decorative panels. Besides, he was for a long while in great demand as a portrait-painter in Edwardian and early Georgian society; in his portraits of fashionable women and men he revived, with a few elegantly Impres- *Fig. 235* sionist devices, the grand manner of the great 18th-century and early 19th-century English masters. One of his more outstanding portraits is that of Israel Zangwill, painted with an energetic virtuosity which expresses eloquently the complex personality of his model. As one of the founders of the New English Art Club, he contributed, moreover, towards a better understanding of contemporary continental trends. Solomon J. Solomon's sister Lily Delissa Joseph (1863–1940) was also an artist of talent.

Sir William Rothenstein (1872–1945) will always be remembered as one of the characteristic artists of the English Impressionist and post-Impressionist schools. His works are remarkable for the subtlety and discretion of his colors as well as for the delicate and painterly texture of his surfaces, in some of which he occasionally allowed himself heavier *impasto* effects, too. His "Carrying the Law" is a fine example of his earlier manner, in which he frequently painted synagogue interiors and scenes inspired by Jewish religious life. Here he managed to suggest the element of the sublime in the ceremony by stressing the white of the striped prayer-shawls of the pious worshipers who surround the sacred scrolls of the Law, and thus contrast strikingly with the *chiaroscuro* of the rest of the scene. In his landscapes, Rothenstein specialized in communicating the delicate interplay of light and colors that is typical of the English scene; in this respect, he achieved an art that is often analogous to that of the great French post-Impressionists. His younger brother Albert Rutherston (1881–1953) was well-known in England as a graphic artist and an illustrator of fine editions; his *Haggadah* is particularly appreciated by collectors.

Among English cartoonists, Sir Max Beerbohm (1872–1956) was of Jewish origin. A witty but never hostile satirist of the intellectual and artistic fads of his contemporaries, he parodied among other themes the affectations of pre-Raphaelite art. His famous cartoons—such as for example that representing Sir William Rothenstein—exemplify his urbane wit, which stressed the social absurdity of situations rather than their political implications.

Among other Anglo-Jewish artists of this era, the Whitechapel painter Joseph Mordecai (1851–1940) is remembered for his portraits of East End Jewish types; Frank Emanuel (1865–1948) achieved a considerable reputation through his etchings; Arthur Friedenson (born 1872), a well-known landscape painter, was the first Jew to have a canvas bought by the Tate Gallery under the terms of the Chantry bequest for fostering British art; while Joseph ("Tom") Friedenson (1878–1931) is remembered for his delicate etchings. The poet Isaac Rosenberg (1890–1918) also painted some remarkable portraits in an

idiom that sought to emulate the expressive qualities of French post-Impressionism. J.H. Amschewitz (1865–1949) earned considerable popularity with his very carefully painted Jewish *genre* scenes and his graphic work, in which he remained in the tradition of the great masters of the past. The Polish-born painter Leopold Pilichowski (1867–1933) had already exploited with great success, before settling in England, the traditional Rembrandtesque manner which characterizes, with a few Impressionist innovations, his portraits of Jewish types and personalities and his Jewish *genre* scenes, such as the

Fig. 236 Jewish Wedding in Tel Aviv Museum; as a portraitist of several outstanding figures in the early history of Zionism and author of a monumental canvas depicting with a wealth of detail the opening of the Hebrew University at Jerusalem in 1925, Pilichowski will long be remembered. One of the most successful painters of English society portraits throughout the earlier part of the 20th century was the Hungarian artist Philip Alexius de Laszlo (1869–1937), who became, towards the turn of the century, one of Europe's most successful portraitists of royalty and of high society. In 1914, he settled in England, where he distinguished himself as a brilliant and often optimistic analyst of his models, whom he flattered by representing them in a grand manner and in colorful poses.

The history of the Jewish contribution to non-academic American art really begins around 1910, when New York artists and art-lovers first developed an interest in the revolutionary achievements of the School of Paris. Between 1880 and 1910, America's few Impressionist painters, among whom no Jewish artists of importance are recorded, met with no success at all at home and generally preferred to live and work in Europe.

Yet America, in this period, had already been awakened rather rudely from its nostalgic and sometimes visionary dreams of the Romantic past by the efforts of its Realist, or "ash-can," school; the shifting world of realities that it set out to depict was often sordid and had little indeed in common with the stable idealistic traditions of American intellectual and artistic life from the Revolution until the Civil War. It is one of the anomalies of American cultural history that there should have been no outstanding Jewish painters among these Realists and that the visionary painter Louis Eilshemius (1864–1941) should have remained, among his contemporaries, the last important representative of the kind of Romantic landscape painters which, in the works of the so-called Hudson River school, had characterized much of American art of the 19th century.

Born in Arlington, New Jersey, of well-to-do parents from whom he inherited a typically middle-class 19th century European conception of culture and the arts, Eilshemius studied painting for many years in Paris, mainly with masters of the Barbizon school of landscape painting. He departed, however, from the soberly realistic lyrical manner of the Barbizon school by frequently introducing in his almost conventional landscapes allegorical figures, mainly nudes, that are depicted in a style that seems almost shockingly naïve or literal. For years, the eccentric artist was the laughingstock of New York's art world, all of whose galleries refused to show his works. In his desperate longing for recognition and encouragement, Eilshemius had meanwhile become increasingly unbalanced, finally claiming supernatural powers as the Mahatma of Manhattan. Only after his death did he receive some of the recognition that he deserved, both as a naive painter of unusual genius and as the last of America's great landscape painters of the Romantic school.

The New York painter Arnold Friedman (1879–1946) was a literalist or a naïve painter of

an entirely different temper. Friedman had to work for a living all his life as a postal official and was never able, until his retirement, to devote more than Sundays and holidays to art. Instead of assuming, as Eilshemius did, the absolute reality of Romantic fantasies, conventions, and allegories, Friedman set out conversely to paint with all the feeling, care, and skill that were generally lavished by earlier painters on more lofty topics, exactly what his eyes saw in real life. Some of his vistas of New York's industrial suburbs are so realistically reproduced, without any attempt at caricature or comment of any sort, that they suggest an unreality of their own, which a more derisive or more Romantic artist would never have been able to achieve. After his retirement, Friedman was at last able to devote to art all the time and care that his compulsive and somewhat pedantic talent required. In "Sawtooth Falls," he thus sought to reproduce, in the surface and texture of his painting, effects and phenomena which he had observed, without any display of personal imagination and fantasy. In recent years, Friedman has been acclaimed both as a master of American "magic realism" and a precursor of some of the least realistic of recent American art trends.

Among other American-Jewish painters of the era which concern us here, a number of successful but somewhat academic portrait-painters might be mentioned, such as George de Maduro Peixotto (1859–1937) and Ernest Clifford Peixotto (1869–1940), who enjoyed considerable reputations also as creators of large decorative panels for public buildings.

IV

Nowhere in Europe did the ideas of 1848 leave as profound a mark on the minds of men as in Italy; nowhere else did the spirit of revolt against all that seemed to frustrate the achievement of national and social ideals cause as profound an upheaval among the young. In the field of painting, a spirit of revolt against obsolete neo-Classical formulas thus inspired young Italian artists with all the more dissatisfaction because the decadence of Italian art in their age contrasted so strikingly with its glorious past. It was in Florence that this spirit of revolt, quite properly, was first felt, between 1848 and 1850, around the tables of a café in the Via Larga, the Café Michelangelo, where all the more advanced younger artists were accustomed to meet. This revolutionary group (whose theories, to be sure, were far more revolutionary than their works) become known as the *macchiaioli,* from the word *macchia,* meaning a spot or blot.

The most important figure of the group was the Jewish painter Serafino da Tivoli (1826–90). Born in Livorno, he had come to Florence at the age of twelve with the intention of studying literature. But his predilection for painting and the influence of his new surroundings soon made him decide that art was his real vocation. On his return to Florence, after a visit to the International Exhibition in Paris in 1855, Serafino da Tivoli adopted a much more rapid and summary manner in his painting, and his friends decided that it had the effect of producing the *macchie,* or spots, to which the new Italian school of *macchiaioli* henceforth owed its name. He is thus recognized as the father of the movement. The landscapes which he exhibited in Florence reveal an unusual quality of spontaneity, of movement, and of freshness. But critics and the public remained hostile to his art and, in 1860, he left his country to settle in Paris, remaining there until 1890. In Paris, the art of Serafino da Tivoli became more and more unconventional and increasingly realistic. Quite late, he allowed himself to come under the influence of Corot in works such as

"The Seine at Saint Denis" and "The Old Fish-house in Bougival." His landscapes thus remain his most valid works. Still, if one compares them with some of the more luminous works of other painters of the *macchiaioli* school, one feels that Serafino da Tivoli remained too deeply attached to certain principles of 18th-century art as it had survived in the neo-Classicism of the early 19th century. Sincere in his expression and his love of nature, he achieved at times a quality of poetry that is nevertheless very convincing.

But another Jewish painter of the *macchiaioli* school, Vito d'Ancona (1824—84), was endowed with greater artistic gifts. Born in Pesaro, of a wealthy and cultured family, he first showed his talent in historical compositions, e.g., "Savonarola Refusing Absolution to Lorenzo de Medici" and "Dante Meeting Beatrice by the Arno" (1859). But he became an ardent convert to the doctrines of Serafino da Tivoli, assimilating them thoroughly and applying them to the creation of landscape paintings which he conceived according to relatively simple principles of composition and painted with a liveliness that went far

Fig. 237 beyond the virtuosity of the founder of the new school. In his nudes and his portraits, the colors are rich, intense, and luminous, though the forms do not dissolve according to the Impressionist technique. Vito d'Ancona thus remained faithful to the more solid principles of composition which had been those of neo-Classical art. In 1868, he came to Paris, where he was fascinated by the great city's life, but, already weakened by a serious illness, was no longer able to produce many works. After his return to Florence in 1874, when his health no longer allowed to work in the open air, he painted small nudes that are unusually expressive.

A number of other Italian-Jewish painters were influenced by the *macchiaioli* school — e.g., Adolfo Belimbau who, born in 1845 in Egypt, spent most of his life in Tuscany and exerted a considerable influence on many younger artists in Livorno, where many of his works revealed, for a while, his interest in social problems, before he became a mediocre manufacturer of *genre* paintings; Vittorio Corcos (1859—1933) of Livorno, who at an early age studied in Florence and Naples, finally settled in Paris as a successful portraitist of beautiful women; Ulvi Liegi (an anagram for his proper name, Luigi Levi) (1860—1942), also of Livorno, a sensitive colorist, who in the course of his long life reflected in his work the influence of more modern schools, too; and Vittorio Bolaffi (1833—1931), who began his career as a Realist disciple of the *macchiaioli,* but was subsequently influenced by Cézanne, Gauguin, Seurat, above all Modigliani, then even by some Surrealists, becoming after his trip to the Orient, in 1912, increasingly estranged from the Realism of his youth.

Other Italian-Jewish painters of the period were Alberto Issel (born 1848), who belonged to the circle of the Spanish master Villegas in Rome and was a painter of "real life," though deeply rooted in Romantic traditions. The landscapes of Clemente Pugliese Levi (1855—1936) communicate a sense of serenity and reveal the artist's sensitive nature. Arturo Rieti (born 1863) was a vigorous portraitist, not averse to deliberately caricatural touches. Amalia Besso (1856—1929) distinguished herself as the author of delicately feminine landscapes. And, at the other extreme, one of the greatest Italian caricaturists of the Risorgimento period, the modern Cesare Redenti, was likewise of Jewish birth.

V

The contribution of Italian Jews, as of Italy generally, to 19th-century art was so small as to be negligible. On the other hand, in another land of great traditions, Holland, there

emerged in this same period one figure who towers above his contemporaries there, and whose influence on European painting in this period was profound. Few artists, indeed, managed to express the generous humanitarian ideals of the time in terms of pictorial realism more faithfully than Jozef Israels (1824–1911). His beliefs, in this respect, are identical with those of the generation of 1848, though deeply impregnated also with the moral traditions of Judaism and its passion for social justice. Born in Groningen, of a devout family, Jozef Israels was admitted at the age of seventeen to the Amsterdam Academy of Fine Arts, and it seemed, at first, as if he would be but another academic artist. In 1843, however, he went to Paris, where he spent five years, though he continued, on his return to Amsterdam, to paint large historical compositions.

In 1853, Israels returned to France, where he worked for a while in Barbizon. But French Realism soon revealed itself as the true source of his art, becoming fully apparent when he settled for a while in Zandvoort, on the coast near Amsterdam, and shared the life of the fishermen there, learning to understand their problems and preoccupations. Israels was deeply moved by the simple life of these people, and the spirit that he had been able to detect in the works of Courbet and of Millet became part of his own life and art, too, though he also assimilated a more powerful and rich influence through his study of the works of Rembrandt. As he wrote: "I understand Millet's point of view and am in full agreement with him. I too am interested only in the painterly qualities of my subject-matter, but I somehow manage to come closer than he to the people. I share its purpose… and try to orient myself within the world that is peculiar to labor so as to reproduce in my paintings impressions of it that are alive."

The main preoccupation of the artist was to find means of rendering these impressions in pictorial terms, so that his intellectual starting point was the same as that of the Impressionists, though the path that he ultimately found and followed was different. From Rembrandt, for instance, he learned how to express all his feelings and thoughts through light, not the kind of light that makes all colors vibrate, as in the works of the Impressionists, but the kind that forces its path through surrounding gloom in order to stress the emotions and thoughts of the painter. The poor in the paintings of Israels are no longer the peasants of the works of Millet; they have been stripped of the rhetorical appeal that characterizes the great French painter, since Israels no longer intended to arouse pity and *Plate 33* charitable feeling. Instead, he identified himself entirely with his subject and expressed, without adding anything to it, "the atmosphere of the life of plain people and of the under-privileged." In this, he was full of the kind of Jewish humanism that recognizes charity as a social duty which must serve justice.

It was but natural that the influence of Rembrandt should become preponderant in the style of expression that Israels chose. There are thus no contrasts in his paintings, only gradations of light and shade, and it is not so much physical beauty that he seeks or mere prettiness, as reality itself, with its ugly aspects, too. Instead of joy, he likewise seeks to express the reality of those who toil beneath the burden of life that they must bear. He, therefore, chose the subjects of many of his paintings from the life of the poor. The humanism of the artist is always present in these compositions, not only providing light, but warmth, too, mingling and awakening the elements of life, all tremulous with poetry and mystery.

Israels was also concerned with the life of his own people, and his paintings on Jewish themes are, in this respect, the most important documents of Jewish art of his age. "The

Fig. 239

Son of an Ancient People'' thus represents a junk-dealer seated outside his shop, a perfect illustration of a certain decrepitude of Jewish life in the Diaspora. In his representations of Jewish weddings, too, on which theme he painted several pictures, we find, in the highlighted foreground, a bridegroom who is no longer young and a bride who is none too attractive; but this couple still communicates much of the workday life of petty tradespeople. His palette remained poor but was rich in gradations; his art was a constant struggle to express without ambiguity both the spirit of Dutch life and that of Judaism. Nothing in his work was light or easy or due to mere chance, so that all his paintings reveal how he wrestled with the angel, never relinquishing his hold until the ultimate blessing was vouchsafed. Towards the end of his life, he went to Spain and North Africa. From Tangiers, Israels brought back his last great work, "The Torah-Scribe," an old man bent over the parchment that is the source of light in the whole composition and, in itself, offers a magnificent justification of the craft that provides copies of the Eternal Word.

The etchings of Israels are as expressive as his paintings. Here, too, he remains the devoted pupil of Rembrandt, and the peculiar qualities of his craftsmanship are more eloquent and more personal, at times, than in his paintings.

The influence of Israels on artists in his own country and throughout Europe was for a long while very great. It is not difficult to detect this influence, for instance, in early works of Van Gogh. Nor can one truly understand the art of Max Liebermann unless one discerns there the influence of Israels. Throughout the world, Jewish painters turned with admiration towards their great Dutch contemporary. Still, it was on the Jewish painters of his immediate *milieu* in Holland that the influence of Israels can be detected most clearly. As far as their manner of painting is concerned, some of them developed the techniques of their master in terms of a more modern idiom; but the peculiar mystical realism of Dutch-Jewish life that Israels was the first to express has now produced some of the most truly Jewish art of the 19th century. In Amsterdam, a school of artists thus came into being of which one can say that it was the first, in modern times, to have achieved a human and psychological approach in depicting Jewish types and scenes of Jewish life.

Plate 34

The son of Jozef Israels, Isaac Israels (1865–1934), managed to liberate himself at an early age from the immediate influence of his father's style. After living many years in Paris, he assimilated the theories of the great French Impressionists and became the most important representative of this school in Holland. He was nearly forty when, influenced by Zola's novel "Germinal," he went to Charleroi, in Belgium, to study industrial life. From now on he achieved great distinction as a penetrating interpreter of the modern world, especially in his paintings of men or women at work in factories. From 1903 to 1914, he lived in Paris, where he developed a brighter range of colors, more cheerful and

Fig. 238

even witty, and a style that was increasingly spontaneous, concise, and refined. He specialized in scenes that reveal the life of the Paris working girls, the *grisettes* and *midinettes* at the turn of the century. In 1921, he traveled to Java and brought back from this trip a series of paintings that are truly his finest, depicting with great virtuosity the art of Indonesian dancers. By this time, Isaac Israels had developed far from the manner of his father and no longer limited himself to contrasts of light and shadows, but had achieved a style of his own in which bright colors contrast their tonalities.

The influence of Jozef Israels continued, meanwhile, to be more direct on a number of painters who specialized in scenes of the life of Amsterdam's Jewish quarter. Among these artists who formed the first group of Jewish painters to study Jewish life in a modern

artistic idiom, an idealist reaction against the more scientific or realistic aspects of Impressionism soon began to be felt. It took the form, so typically Dutch as well as typically Jewish, of a reaffirmation of the primacy of the idea rather than of painterly technique. Among the painters who followed Gauguin to Pont Aven and founded the group known as the *Nabis,* representing an idealistic secession from the Impressionists, the dwarflike Dutch Jew Meyer de Haan (1852–95) was a striking figure. His technique revealed unusual ability, and he was very much appreciated in his own country, where he earned a good living. Then, one day, he wandered into an exhibition where he saw for the first time some Impressionist paintings. These moved him so deeply that he decided he must get to know the artists. He heard that Pissarro was in London and went there at once. Pissarro then spoke to him of his admiration for Gauguin, and Meyer de Haan set off immediately to find Gauguin with the firm intention of working with him. The Dutch painter thus abandoned everything to submit, like a schoolboy, to Gauguin's teachings. He returned to end his days in Amsterdam, where his paintings of Jews are still popular. Edouard Frankfort was another Amsterdam painter who specialized in scenes of Jewish life. In his representations of religious ceremonies, he avoided the somewhat monotonous browns that characterize the work of several pupils of Jozef Israels and obtained his *chiaroscuro* effects by using a greater range of colors. The Sephardi Baruch Lopes Leao de Laguna (born 1864) was more impressionistic in his art, and has left us some interesting portraits of Jewish types. Martin Monnickendamm (1874–1943), originally a disciple of Jozef Israels in his use of Rembrandtesque technique, spent some time in Paris, where he modified his style so that his more mature work reveals, in the choice of brilliant colors, an influence of Van Gogh. Other Amsterdam painters who belonged to this school include Salomon Meijer, Moritz Calisch, Ezechiel Davidson, Jeftel Salomon, Elchanan Verveer, and David Blanes, the youngest of the group. Mention should be made of the etcher Jozef Teixera de Mattos and another Sephardi, Samuel Jessurun de Mesquita (1868–1944). The last was one of the finest European woodcut artists of his generation, a specialist in color prints in which he achieved a very felicitous synthesis of the styles and techniques of Europe and of the Far East; he was deported by the Germans and murdered in Auschwitz.

VI

Until the end of the 19th century, German art was, with a very few exceptions, dominated by the grandiloquent historical style of the Munich school or the academic sentimentalism of the Düsseldorf school that produced so many Romantic landscapes, *genre* scenes, and pretentious portraits.

The artist who through his activities even more than through his works contributed most towards encouraging a new current in German art was Max Liebermann (1848–1935).[*]
He was a scion of the middle-class German Jewry that, as early as 1848, began to feel entirely identified with the German liberalism then beginning to enjoy its heyday. As a representative of this generation, Max Liebermann illustrated a synthesis of German, Jewish, and European culture.

Plate 36

Ever since his childhood, he had felt drawn to painting and, at the age of fifteen, became

[*] The great German post-Romantic painter Hans von Marées was only a half-Jew and has therefore been excluded from the present discussion.

a pupil of the Berlin painter Karl Steffeck. From him Liebermann inherited a great respect for sheer draftsmanship. In Weimar, he was influenced by the Hungarian painter Munkacsy, a Romantic realist, whom he followed in 1873 to Paris. Here, Liebermann began to assimilate the teachings of the Barbizon painters though not as yet able to feel the essential aspects of their art. At the same time, he had occasion to witness the heroic era of Impressionism, but this, too, left no mark on his art for the time being. The surroundings which liberated in Liebermann a more spontaneous attitude seem to have been those that he subsequently discovered in Holland, where from 1875 he spent his summers regularly. The works that he brought back from Holland remain masterpieces. Here we see the full flowering of his talent, its great complexity, and its robust sensuality.

Among his own contemporaries, he admired the art of Israels and was interested in the subjects which the Dutch master chose to paint, but Liebermann was unable to communicate the same element of sympathy and pathos when he too chose to paint poor and simple people.

Both his brief stay in Paris and his late activities in Munich remained, however, but stages in Liebermann's artistic development. In 1884, he returned to Berlin, where he soon became the most respected personality in the capital's artistic world. More and more deeply influenced by the great Berlin painter Adolf von Menzel—a man of moods and fantasies and a wonderful draftsman—he stripped the latter's art of all its anecdotic elements, retaining only his energetic and exact draftsmanship, his wit, and his range of colors that was rich and realistic if not brilliant.

Liebermann acquired his great historical importance at the turn of the century, when the works of the French Impressionists began to be understood and appreciated in Germany. Liebermann now discovered, in Berlin, the truly revolutionary nature of this kind of painting. He immediately began to study, to understand the world that the Impressionists communicate in their art. With an infallible logic, he formulated for his own art the principles that all this implied. His painting then began to develop in the direction suggested by French painting. But he was no mere imitator. German Impressionism, as it is now called, differs considerably from that of French. A certain Nordic stiffness of composition and harshness of color characterize the art of the Impressionists in Germany. But the confusion that had long reigned in the German art world began to be less great, with the foundation, in 1898, of the Berlin "Sezession," the group of artists who thereby proclaimed their break with the academic pontiffs. Liebermann had been one of the initiators of this movement and, as early as 1899, was elected its president. His activities, both as a public speaker and in his writings, in which he communicated his deep convictions with great objectivity and wit, played a determining part in Germany's artistic evolution. After the first World War, he was elected president of Berlin's Academy of Fine Arts. In 1933, he was forbidden by the Nazis to exhibit and even to paint, while his works were banished from all German museums and public collections. Broken-hearted, he died in 1935, retaining his wit and dignity until the very last.

Liebermann's painting reached its peak of perfection towards the end of the 19th century, revealing him as an equal of many of his most famous contemporaries. Though he had chosen Berlin as his home, he spent most of his summers in Holland. His admiration for Jozef Israels and his great friendship with Isaac Israels can be detected in the choice of his subjects. His famous painting, now in the Munich Museum, the "Woman with a Herd of Goats," for instance, is a moving interpretation of the loneliness and

Plate 32. Maurycy Gottlieb. Portrait of a Young Woman (painted 1877). This deeply romantic painter was born in the city of Drohobycz, one of the centers of Jewish enlightenment in Galicia. Israel Museum, Jerusalem.

Plate 33. Jozef Israels. Self-portrait, painted during the last years of the Dutch painter's life when he was already under the influence of the Impressionists.

Plate 34. Isaac Israels. Portrait of a Young Woman. The son of Jozef Israels, Isaac (1865–1934) was also noted for his Impressionistic portraits. Israel Museum, Jerusalem.

*Plate 35. Lesser Ury. Winter's Day in Berlin, executed about
1925. Israel Museum, Jerusalem.*

36. Max Liebermann. Self-portrait, showing the great contribution of this artist (1847–1935) to the German Impressionist school of the 1920's. Israel Museum, Jerusalem.

Plate 37. Leonid Pasternak. Self-portrait (1937). The style of the father of the writer, Boris Pasternak, was chiefly influenced by German Expressionist painting.

Plate 38. One of the first Jewish artists of the period of the emancipation was Isaac Levitan of Lithuania (1860—1900). Considered the greatest Russian landscape painter of his time, Levitan's works, like this landscape, express the melancholy of the broad Russian horizon. Israel Museum, Jerusalem.

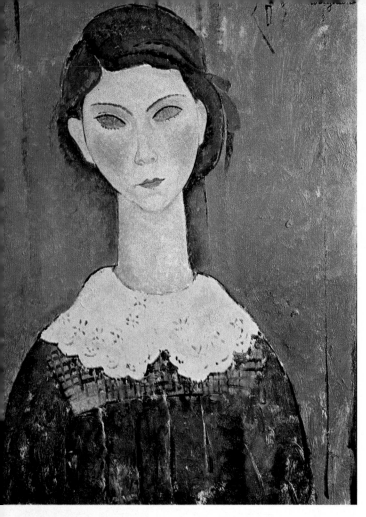

Plate 39. Amedeo Modigliani. Portrait of a girl. After
studying classic academic art in Venice, Modigliani
developed an original style, far removed from
accepted realism and influenced largely by African
sculpture and Cubism. Only some ten years after
his death in 1920 was his genius finally recognized
and he was acclaimed the most human and sensual
artist of the School of Paris. This figure of a girl —
the daughter of his concierge in Paris — was painted
in 1917. Joseph H. Hazen Collection, New York.

Plate 40. Simplicity and monumentalism distinguish
the works of Moise Kisling, one of the artists of the
School of Paris during the first half of this century.
Although Kisling never belonged to any single
artistic faction, his Man with a Pipe (1923) reflects
the influence of Cubism. Israel Museum, Jerusalem.

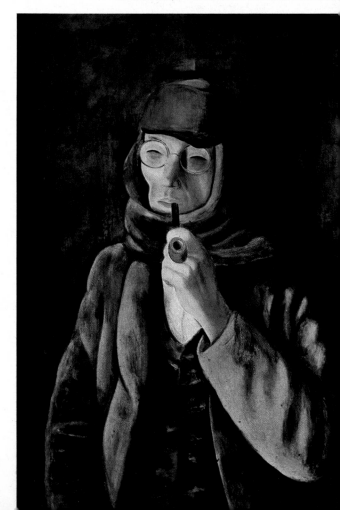

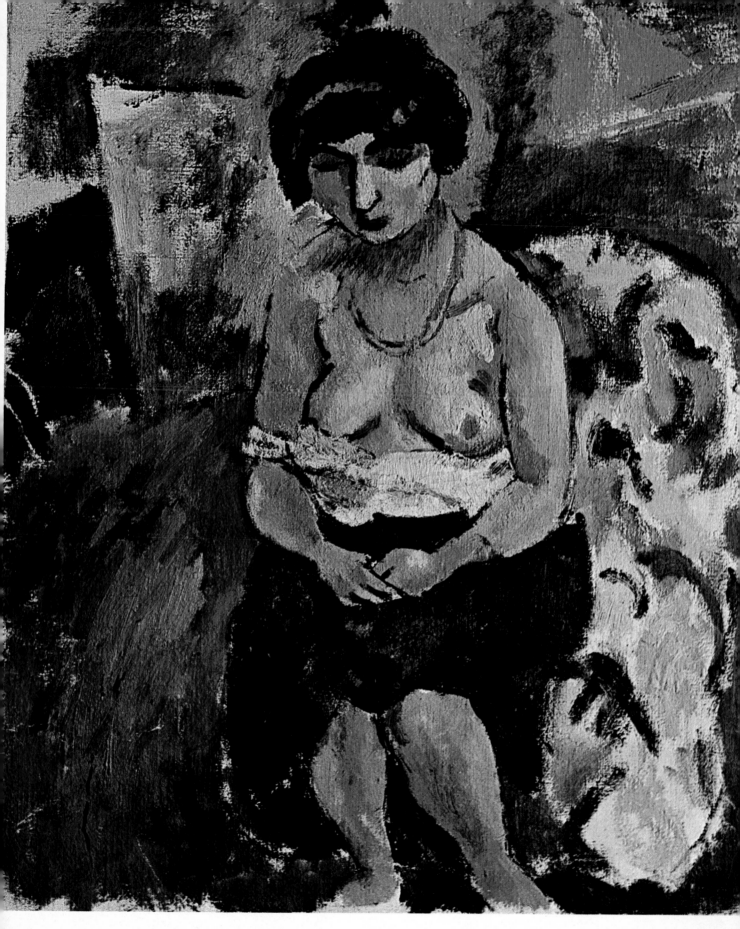

Plate 41. Jules Pascin. Prostitute. Pascin was born in Bulgaria, studied in Munich and travelled through Spain, Belgium, the Netherlands, America and North Africa before finally settling in Paris. In the course of his extensive travels he made numerous sketches which reveal his special interest in exotic events and figures, especially women. Israel Museum, Jerusalem (Gift of the painter's brother, Joseph Pincas, Paris).

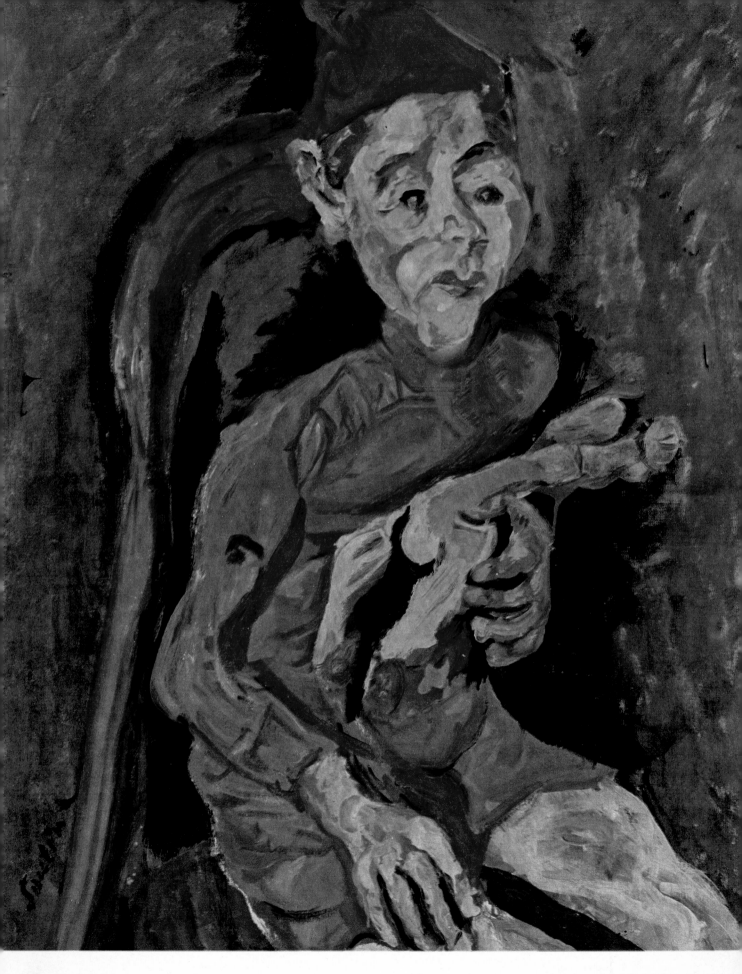

Plate 42. Chaim Soutine. The page boy.

poverty of a landscape of sand-hills, all concentrated in the figure of a poor peasant-woman herding her goats, perhaps her only worldly possession. Liebermann's "Old People's Corner," his "Hospital Garden in Edam," and his "Seamstress" belong to the *Fig. 240* same world as that of Jozef Israel's preoccupations, though without the great compassion that marks all the Dutch master's work on such themes. In his "Children by the Sea" and the various studies of horsemen on the seashore, Liebermann created works that are very close to those of some of the great French Impressionists. His masterpieces remain, however, the *Judengassen* scenes that he painted in Amsterdam at the turn of the century. In reproducing the bustle of these crowded Jewish quarters, he proved both the maturity of his art and his own deep sense of solidarity with Jewish life, a solidarity that he never relinquished.

Portraits also played an important part in the life-work of Liebermann, and he was one *Fig. 241* of the most popular portraitists in Germany in its years of economic expansion. Some of these, in which he has left us the effigy of an outstanding personality, can be counted among the more striking portraits of his age, revealing both the perfection of his art and his great critical insight. In Liebermann's eyes, the interpretation of the character of his model had to go beyond all that is merely individual, so that he has left us portraits of representatives of an intellectual or social class.

Liebermann's graphic work is also of great merit. His drawings, like those of Degas, must be considered in the same light as his paintings; they served as preliminary studies for the latter. Of his numerous etchings, many fail, indeed, to achieve the perfection and sensitivity of those of Camille Pissarro, though some, including the portrait of Hermann Cohen, are works of great vigor which can be classed among the best of his generation.

Whereas Liebermann found much of his inspiration in the life of small towns and villages of Holland, the art of another of Germany's three most outstanding Impressionists,*, Lesser Ury (1861–1931), is almost entirely centered around the life of the German capital. Unlike Liebermann, Ury, born of a family that was poor and disunited, felt the oppressive weight of poverty throughout his youth. Even when success came, somewhat late in his life, he remained a misanthrope and continued to avoid all the artists who might have been his friends. He thus led a life of unhappiness and poverty and died wearing rags, locked up in his studio as a recluse, though a considerable fortune in bonds was found buried beneath the floor.

Born in Birnbaum in German Poland, he ran away from home and set out on his own to become a painter, studying in Düsseldorf, Brussels, and Paris. Lesser Ury's works of these years still betray an academic character and are mainly *genre* pieces. From 1882 to 1884, he withdrew to Volluvet, and the landscapes that he produced in this Belgian village can be found among his best works. He assimilated the influence of the French Impressionists sooner than did Liebermann, and then remained faithful until his death to his convictions as an Impressionist. But Lesser Ury rarely completed his paintings in the open air, in the setting that had inspired them; instead, he generally composed them in his studio after sketches made in the open air.

In 1885, Lesser Ury returned to Berlin, where he remained until his death in 1931. In his

* The third among the major German Impressionists was Louis Corinth, who was not a Jew but married the Jewish writer Charlotte Behrens and who included many Jews among his friends and pupils, so that he, too, was affected by the Nazi ban on Jewish and "judaizing" artists.

Plate 35

most characteristic works, he was, therefore, inspired by the life of the German metropolis, by the characters whom he could observe in its streets and cafés, by the city-scapes of its rainy streets. The rain-swept skies and the passers-by that almost fade into the surrounding mists which rise from the shining sidewalks are features of his favorite topics. Above all, he remains a subtle colorist. Martin Buber wrote of his work: "He belonged among those Promethean natures that always seek a new language, capable of expressing everything... He found this language in his use of color. Form expresses none of the ambiguous relationships between things, their effects on each other... A thing does not exist in itself, but everything exists in everything. Form divides, but color unites."

Like the art of all great French Impressionists, that of Lesser Ury is essentially pantheistic. Though he remains one of the great interpreters of the moods of a great city, Lesser Ury also produced among his lasting works some landscapes that can vie with those of the most reputed Impressionist Paris masters. Pastels offered him a range in which he achieved great technical brilliance. Lesser Ury expressed, in his large visionary compositions on Biblical and Jewish themes, his mystical attachment to the sacred texts and to the chosen people. Here, his figures are reduced to mere objects that are integrated within a vaster vision, the scale of which suggests fresco compositions depicting an allegorical struggle between the individual and the whole of creation. Lesser Ury's "Jeremiah," "Moses," "Paradise Lost," and above all his "Destruction of Jerusalem," are not great art as interpretations of city life; they remain, however, an expression of the spirit of Judaism by an artist of rare value.

In addition to Liebermann and Lesser Ury, a number of other Jewish artists deserve mention as outstanding personalities in the German art world of the era that interests us here. Ernst Oppler (1867–1929), an outstanding and active member of the Berlin "Sezession" group, developed an aristocratic style as a painter of vigorous and lively portraits, and has left us some very felicitous interpretations of the rhythms and colors of the great Russian ballets. His brother, Alexander Oppler (1869–1937) was a sculptor known in Berlin for his portraits.

Fig. 244

Julius Bodenstein, Benno Becker, Lazar Krestin, Georges Mosson, Julie Wolfthorn, Jacob Nussbaum, Ernst Pickard, and Hans Borchardt all achieved distinction as landscape painters, their various styles reflecting to a greater or a lesser extent the influence of the great French Impressionists. Lazar Krestin also painted some thoughtful and sober portraits of Eastern European Jewish types, as well as *genre* scenes where he refrained from being too anecdotic. Among Berlin's more successful portraitists, Joseph Oppenheimer (born 1876) subsequently achieved considerable reputation also in England and in the United States, and Eugen Spiro (born (1874) is now well-known in New York. Julius Rosenbaum (born 1879) has also painted some city-scapes of Berlin that offer interesting analogies with the typically Parisian scenes of Utrillo; his wife Adèle Reifenberg-Rosenbaum (born 1893) has remained faithful to German post-Impressionist and Fauviste idioms in her fine landscapes of Italy.

Germany's Jewish etchers and draftsmen of the latter half of the 19th century and of the early decades of the 20th century also made outstanding contributions to the evolution of the graphic arts. Among them, the most important was Thomas Theodor Heine (1867–1948), one of the founders of the Munich *Simplicissimus,* of which he remained for many years the chief contributor, always active in its battle against political and social ills. A merciless critic of German militarism, he even dared attack the sacrosanct person of

Emperor Wilhelm II and revealed in his drawings all the weaknesses, contradictions, intolerance, and narrow-mindedness of a regime that was already doomed and of the life of the German family and of the German bourgeoisie. The virulence of Heine's satire combined with his brilliant draftsmanship earned him a place among the most outstanding cartoonists of his age.

Thanks to his great knowledge of all the technical aspects of etching, Hermann Struck (1876–1944) has contributed almost more than any other artist to the evolution of this art in Germany in his generation. He has also left some fine prints representing views of Israel and Jewish types observed in various lands. The etchings of Ernst Oppler, mentioned above, represent perhaps his most lasting contribution to German Impressionism; in his sketches of ballet scenes, he managed to capture movement and light, in terms of black and white, with unusual felicity. Emil Orlik (1870–1932) was born in Prague but spent most of his active years in Berlin; in addition to painting some striking portraits, he was an outstanding designer and illustrator of fine books and also designed a number of medals executed by the Berlin mint. Another distinguished graphic artist from Prague, also active in Germany, was Hugo Steiner, (d. 1945), who also played an important part in improving the standards of German (and later American) book illustration; he has left some fine prints of the old Jewish ghetto of his native city.

Fig. 243

Particularly well-known in Jewish circles was Ephraim Moses Lilien (1874–1925) who, born in Galicia, lived mainly in Germany, where he was one of the chief contributors of *Die Jugend,* the periodical that gave its name to the *Jugendstil,* Germany's "modern" style of the turn of the century. Lilien's illustrations, especially those that he did for an edition of the Bible, reveal a taste for decorative effects and were very popular in their day. In the portrait of his own father, a humble woodturner, he has left us a lasting monument to those artisans of Poland who have contributed so much to Jewish folk-art. Struck and Lilien were the masters who inspired a whole school of Jewish graphic artists in Central and Eastern Europe, among whom Joseph Budko (1880–1940), a pupil of Struck, deserves particular mention. After the rise of the Nazis he settled in Jerusalem and until his death was director of the "Bezalel" school of art.

Fig. 242

In most European countries we have seen that Jewish artists of the 19th century tended, on occasion, to seek inspiration in the ceremonies of the Jewish religion and in scenes of Jewish folklore. But it was in Vienna that a group of painters managed to gain recognition by specializing in the treatment of Jewish themes. In the politically conservative empire of the Hapsburgs, the Romantic had refrained from attempting the technical innovations of their Western European colleagues or the extreme spirituality and asceticism of some Germans. The salons of Austrian art were thus dominated by historical compositions, *genre* scenes redolent of local folklore and literary anecdote, and landscapes that expressed all the nostalgia of Viennese *Lieder* for country life.

Three Jewish painters achieved fame here as chroniclers of Jewish life in Galicia and in Eastern Europe in general. Translating into Jewish terms the folkloristic regionalism that characterized much of Austrian Romantic *genre* painting, they created, for the prosperous Jewish middle class of Vienna, a specifically Jewish art that reflected, in terms of Jewish types and customs, the sentimental traditionalism of the Austrian middle class. The first of the trio was Leopold Horowitz (1839–1917), who was born in Hungary but spent most of his life in Vienna. His first success was obtained when he exhibited a painting entitled *Tisha B'av,* a *genre* composition representing a synagogue interior on the fast commemo-

Ephraim Moses Lilien. My Child.

221

rating the destruction of Jerusalem with figures gesticulating in grief in a theatrical manner. A sensation at the Vienna Salon, this painting was immediately reproduced, and thousands of copies of it were sold through the world. Horowitz was best known, however, as the fashionable portraitist of the Polish nobility and of the Austrian Court under the Emperor Franz Joseph.

Fourteen years younger, Isidor Kaufmann (1853–1921) was also born in Hungary, but soon came to Vienna where he spent all his working years and made a great career as the chronicler of Galician Jewish types and customs. His *genre* paintings are actually large miniatures, in which his brilliant sense of color and delicate gradations of tone are often overshadowed by the excessively anecdotic nature of his themes, such as that of "A *Fig. 245* Rabbi" or "The Chess-players." He revealed, however, his very real quality as a painter in a few compositions where he refrained from introducing any human figures. His best compositions such as "The Sabbath," "Friday Evening," and "The Rabbi's Door" reflect the less histrionic influence of French naturalism of the end of the 19th century. Isidor Kaufmann's son, Philip Kaufmann, continued to paint Jewish types and *genre* scenes, at first in Vienna and now in London, in an idiom that has borrowed many devices from the Impressionists, but subsequently greatly extended his interests.

The youngest of these three Viennese chroniclers of Eastern European Jewish life was Jehuda Epstein (1870–1945), who was born in Mogilev, in the Ukraine, but lived in Vienna and died in South Africa. He, too, chose anecdotic subjects, as in his "Chess-player," or Biblical themes, as in his "Job," "Saul and David," and "Maccabees." At first, his painting was somewhat dull and colorless, but he soon began to achieve increasingly rich and colorful effects, developing, especially in his landscapes, a quality of vision and a technique that were more and more impressionistic. The Polish painter Mauricy Trebacz (1863–1943) was a late survivor and a minor representative of this school of *genre* painting that had originated in Vienna. Well-known in Poland for his representations of typical Jewish characters and scenes, he was murdered by the Germans in Warsaw, at the age of eighty.

Among the early works of a number of outstanding Eastern European Jewish painters of the 20th century, examples of this kind of Viennese-Jewish regionalism of *genre* painting can still be found, though generally blended with Rembrandtesque effects inherited from Jozef Israels. Only with the emergence of artists such as Lasar Segall, Marc Chagall, Issachar Ryback, and Jankel Adler, who will be treated of later, did Eastern European Jewry discover themes and forms that are characteristic of its own folklore and spirit.

VIII

In the Decennial Fine Arts Exhibition within the 1900 Paris World Fair the section devoted to Hungarian painting attracted considerable attention. In this, more Jews participated than in any other European nation's exhibit: fifteen Hungarian Jewish painters were indeed represented, exhibiting thirty-one paintings, out of a total of 147. Though the view of Hungarian art that this show gave was still far from complete, it nevertheless illustrated most of the artistic trends that were being felt in the country in the last part of the century. Whereas in 1850, Hungarian painting had still been under the domination of the Viennese Academy, it had subsequently achieved more and more freedom as it began to feel the attraction of Munich, which offered more leeway for the development of individual talent. But the influence of Munich also began to wane in Hungary, as else-

where in Europe, when the primacy of Paris was slowly recognized there, too, as the only determining factor in the evolution of painting. The importance of the Jewish painters also placed them in the front rank among their contemporaries. We have already had occasion to mention Horovitz, Isidor Kaufmann, and Laszlo, all three of whom obtained their major successes beyond the frontiers of their native land, so that their work is discussed in other sections of the present chapter. In Hungary itself, however, a number of outstanding Jewish artists contributed valuable elements to the evolution of modern Hungarian painting.

This evolution occurred, at first, mainly in two artist colonies, the one in Nagybanya in Transylvania, the other in Szolnok, in the great Hungarian plains; both allowing a number of artists to achieve a decisive step forward in coordinating their ideas, thus determining the general trend of Hungarian painting towards the beginning of the present century. Alexander Bihari (1856–1906) was the son of a poor house-painter and studied in Budapest and in Vienna. In 1883, a wealthy patron made it possible for him to travel to Paris, where he perfected his technical knowledge of his art. Bihari's stay in Paris determined his whole artistic development, as he was able to assimilate the Naturalist masters' style fully into his own. For a while, he continued to paint *genre* pictures and was soon Hungary's outstanding artist in this limited field. The element of anecdote in Bihari's painting remained somewhat restrained, however, and never overwhelmed the more painterly aspects of the composition; a quality of Parisian wit seemed to protect him against the temptations of a heavier sentimentality, and he observed nature with so much love that he was prevented from attempting histrionic effects of mere prettiness. On his return from Paris, Bihari settled in Szolnok, an agricultural center in the great Hungarian plains. Here, he studied the monotonous life of the peasants and small-town notables, in the transparent and almost vibrant atmosphere in which the dry air seems to separate figures rather than enclose them in a common medium. He did not glorify his peasant figures in a Romantic spirit; instead, he painted the people as he saw them in their everyday surroundings, thus achieving some veritable masterpieces. With broad strokes of the brush, Bihari grouped and painted his figures in such a manner that they are held together in an organic pattern particularly striking in its details, which he painted with accomplished simplicity and directness. His masterpiece is perhaps his "Sunday Afternoon," in which the Impressionist influence is obvious, the well-fed boredom of this group of minor civil servants, seated around tables and smoking their pipes as they play cards while their women-folk gossip and drink their coffee, representing the last and most glorious stage of a school of *genre* painting that had achieved full mastery of its means.

Fig. 246

The most important individual figure in the Szolnok artists' colony was Adolf Fényes (1867–1945). The son of a rabbi in the rural center of Kecskemet, he began to study law but left the university and devoted himself to painting. After staying a while in Holland, he painted a cycle on themes derived from the life of the poor. These works of Fényes were declared to be socialist art, and severely criticized as such. They reflected, indeed, in their somber composition the deep compassion that the artist felt, in spite of his lofty intellectualism, for workers and for the underprivileged. In 1901, Fényes was invited to participate in the foundation of the Szolnok artists' colony. Here his constant contact with the landscape of the great plains, with their alternating climate of overwhelming mud and dust-storms and their penetrating and crystalline light that never seems to allow any movement, and his acquaintance with the peasants of this area, with their simple life, so

full of human dignity, all achieved a metamorphosis in the palette of the artist. At first, he limited himself to *genre* paintings, full of folkloristic implications, but the figures in them are brought to life by his use of light colors. His careful analysis in his observation of subject-matter was already preparing the way for the future evolution of his art, especially when he began to compose his pictures in terms of color, which made it possible for him to attain true Impressionism without any transition. In his admirable still-life paintings, however, a decorative element already foreshadowed the next step in his artistic evolution. The First World War distracted the artist from his sensitive philosophical optimism concerning world developments. He observed mankind, but turned his gaze away from man's evil actions, thus tending to create a world of his own, a world of the Bible and of wonderful legends and tales. The themes of his paintings of this period are: "The Jews Defeating the Amalekites," "Noah's Ark," "Moses Striking the Rock" — Biblical composition deeply rooted in the purest Jewish tradition, representing not so much the individuals but the event, with the figures entirely integrated within this surrounding landscape so as to be one with it. One of the very last paintings of Fényes, "The Old Artist in a Landscape of Snow," is like a final harmonious chord in this great creator's life. He died in 1945 as a result of his sufferings during the period of Nazi domination.

The artists' colony in Nagybanya had come into being shortly before that of Szolnok and was perhaps more important because of the more excellent teaching of some of its more distinguished residents. Outstanding among them was the Jewish painter Bela Ivanyi-Grunwald (1867–1940). Interested, above all, in problems of light and shadow and in the power of color as a means of expression in itself, he was influenced by Gauguin in decorative effects that he achieved in scenes from the life of Hungarian peasants, where the black outlines of his design stress the colors which bring warmth into his atmosphere. Soon, however, he gave up composition in terms of planes in order to place his figures in a spatial context. His paintings inspired by landscapes of the area around Lake Balaton adopted heavier forms of a more Romantic nature, and his brush-strokes became more energetic, so as to express an artistic sensitivity that was never divorced from a certain robust sensuality.

Among the modern painters of Hungary, none has remained as faithful to the Impressionist formula as Isaac Perlmutter (1866–1932). His views of the area around his home, in a village near the capital, and his interiors of peasant homes, with figures in picturesque Hungarian costumes, strike one as optimistic in their outlook, thanks to his fresh and powerful colors. On the other hand, his vistas of open-air markets achieve unity of composition through thoughtful arrangements of forms and colors.

Fig. 247

IX

The artistic traditions of Swedish, Norwegian, and Danish painting scarcely go back beyond the end of the 18th century. In Sweden, the overwhelming darkness of the long winter months exerted a restraining and depressing influence on most painters. For months on end, they were forced to interrupt their work for lack of light, and true painting qualities yielded to something that called "Stämning," an untranslatable word that designates a certain spiritual atmosphere. The Academy of Stockholm seemed so unsatisfactory to most Swedish painters of real talent that they tended, during the latter half of the century, to emigrate to Paris. Here, their leader was Ernst Josephson (1851–1906), the most important Swedish painter of the 19th century, whose talents rank foremost among

Jewish painters of his age, second only to that of Camille Pissarro and of Jozef Israels. He was a scion of one of the first Jewish families to settle in Sweden, and the atmosphere of his home was unusually favorable to the development of his artistic ambitions. In 1867, he was already a student of the Stockholm Academy, a veritable fortress of conventional historical painting, of which his earliest works are faithful examples. In Paris, however, he discovered Courbet and Manet, Pissarro and Degas. He recognized immediately the true sources of an art that would be contemporary, and his portraits soon expressed all the implications of his newly discovered technique. In these, which can be classed among the best Impressionist portraits painted in any country, the light colors, the broad brush-strokes, and the temperamental painting diffuse a youthful, bright, and frank lighting that contrasts vigorously with all previous 19th century Swedish painting. The characters are integrated in their surroundings, suddenly arrested in the flux of becoming rather than static in being. The artist did not seek to immortalize their features but to capture them in a moment of their life.

Fig. 248

In 1885, when Sweden's artistic opposition that had settled in Montmartre decided to organize itself as a movement, its exhibition of anti-academic art "from the banks of the Seine" was achieved to a great extent thanks to Josephson, who was the most aggressive and enterprising member of the group. When some of its members were ready to accept a compromise, Josephson remained true to his principles, almost alone in the storm of critical and public protest. In the evolution of his art, his trips to Spain, in 1881 and 1882, represent an interesting diversion. His eclecticism was now unable to escape from the influence of Velasquez, and the famous paintings that he brought back from his travels, "The Blacksmith," "The Cigarette-girl," "The Dancer," all reveal this. Their frank and refreshing realism at first shocked the critics in Stockholm. Josephson's most famous painting was his "Undine," inspired by a Nordic legend. This had originally been conceived by the artist in his youth, but he painted a number of variations on its theme, the final version (1884) being purchased by Prince Eugene of Sweden for presentation to the Stockholm Museum. The management refused, however, to accept the gift but, some twenty years later, purchased an earlier version of the same painting.

In France, Josephson continued to paint pictures where the forms, as sheer expression, are increasingly striking. He withdrew to Bréhat, a small island off the Breton coast, where he still painted some masterpieces in which the artist's conception comes close to that of Pissarro's representations of peasants. His portrait of the Bréhat policeman, however, already indicates some symptoms of the mental disease that was soon to transform the nature of his art. His paintings then became increasingly rare and the artist began to produce a series of drawings that are of as fine a quality as his paintings. The draftsmanship of these is of an extraordinary nervousness, and the artist's formal exaggerations stress their quivering expressiveness. When Josephson died in 1906, he had both initiated the modern movement in Swedish art and indicated its tasks for many years to come.

In Denmark, another great painter of Jewish extraction (though not brought up as a Jew), Theodor Philipsen (1840–1920), played an equally important part as the most outstanding innovator in the artistic life of his country. Influenced by Pissarro and other French Impressionists in his lyrical treatment of design and color, Philipsen became the most important interpreter of Denmark's countryside, of its flat landscapes of green fields, and of its cattle-raising farms. An Impressionist in every detail of his brush-work and coloring,

he has left us some striking paintings, many of the best of which now hang in Copenhagen's National Museum of Fine Arts. His "Slaughtered Ox," among others, achieves a particular quality in the treatment of the animal carcass that hangs in the middle of the picture. Only Soutine, in our age, reached this quality in handling this Rembrandtesque theme in the idioms of post-Impressionism or of Expressionism. One of Philipsen's most remarkable disciples was the Danish-Jewish painter Albert Gottschalk (1860–1906), whose tortured and somber skies contrast strikingly with the serenity of his master's more balanced works. Always true to his beliefs as an Impressionist, Gottschalk was doomed, however, to an unhappy life of almost psychopathic anxieties and doubts, which hindered to a great extent his full artistic development.

A Danish-Jewish painter, Mögens Ballin (1872–1914), was active in the "Nabi" group among the French post-Impressionists. Born of a long-established family of Danish Jews. Mögens Ballin came to Paris in 1891 to study art. At a banquet given in honor of Gauguin, he met Jean Verkade (the Dutch painter who was to become a Catholic monk), who introduced him to the "Nabi" group. In 1892, Ballin traveled with him to Italy, became a convert to Catholicism, and was then admitted to the Franciscan Third Order. Two years later, he returned to Copenhagen, where an exhibition of his work met with great success, but shortly afterwards married, and thereafter devoted most of his time to charitable work. In 1943, during the German occupation of Denmark, a retrospective show of Ballin's "strange, grave, rich and fantastic" work was organized by members of the Danish Resistance as an act of defiance.

The liberal ideas of the 19th century met nowhere as much opposition as within the Tsarist empire, where an intolerant autocracy condemned all new ideas imported from Western Europe. Whereas the Realist writers and artists of Western Europe were already expressing their own philosophy of liberalism and of social justice, the Slavophil writers and painters of Russia still sought to convert the masses to nationalist ideas, considering art to be, above all, a medium for political propaganda. Their painting thus became primarily dependent on literary and political ideas, which were illustrated in strikingly rhetorical images, in a style that already foreshadowed the "Socialist realism" of the Stalinist era, a hundred years later. Towards 1890, however, a certain reaction occurred at last against these trends. Painters began to appear among the Russian intelligentsia who turned their gaze towards the West. Their new faith in art for art's sake introduced a refinement of technique and a new quality of composition in their work. Among the most eminent representatives of this trend were the portrait-painter Valentine Serov, who was partly of Jewish extraction; and the Jewish landscape-painter Isaac Ilitch Levithan (1861–1900), son of a Jewish teacher of Wirballen (Verjbolovo), close to the former Prussian frontier. In 1889, with the help of a Moscow patron, Levithan visited the International Exhibition in Paris and thus discovered the work of Corot and the Impressionists. Levithan was thus one of the first Jewish painters to understand the art of the Impressionists and to assimilate their doctrine, which enabled him to become the great poetic interpreter of *Plate 38* the sad and heavy monotony of Russia's vast horizons and of the apparently motionless skies that brood over its steppes. Levithan's pictorial idiom remains, however, that of his French masters, though his own color harmonies are dull and tend to resolve themselves in grays that are perfect as an expression of his personality, where the Jewish sorrow of the Dispersion is so well blended with the staid resignation of an elegiac Slavic mood.

In 1896, his position now established, he was appointed professor of landscape painting

232

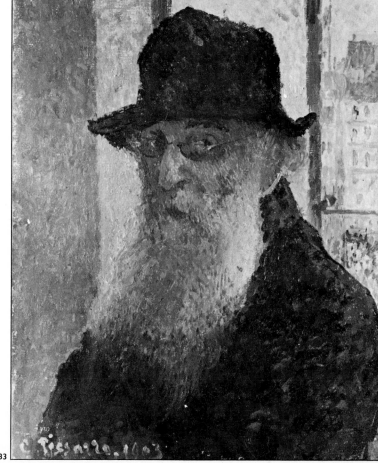

232. *Lucien Levy-Dhurmer. Portrait of Georges Rodenbach.
Museum of Modern Art, Paris. Courtesy of Musées Natio-
naux, Paris.*

233. *Camille Pissarro (1831–1903), self-portrait. London,
Tate Gallery.*

233

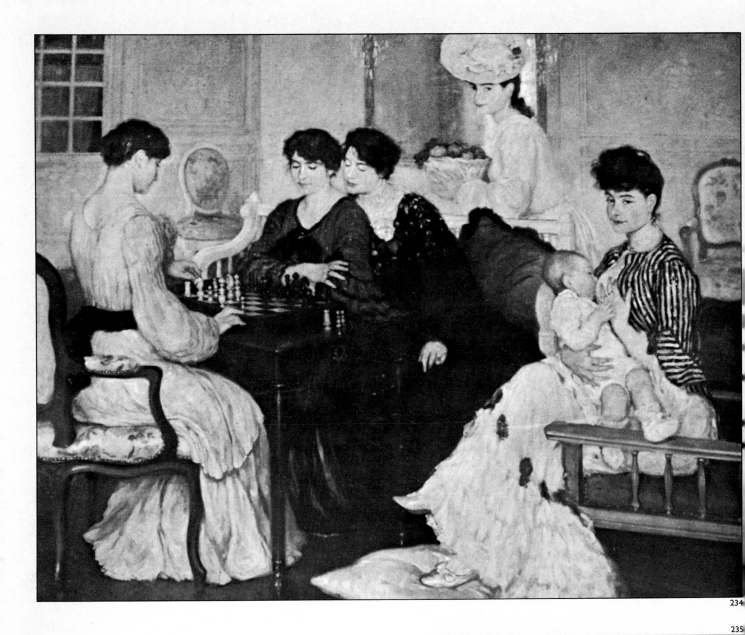

234. Henri Caro-Delvaille. My Wife and her Sisters. Municipal
 Museum of Limoux.

235. Solomon J. Solomon. Portrait. Israel Museum, Jerusalem.

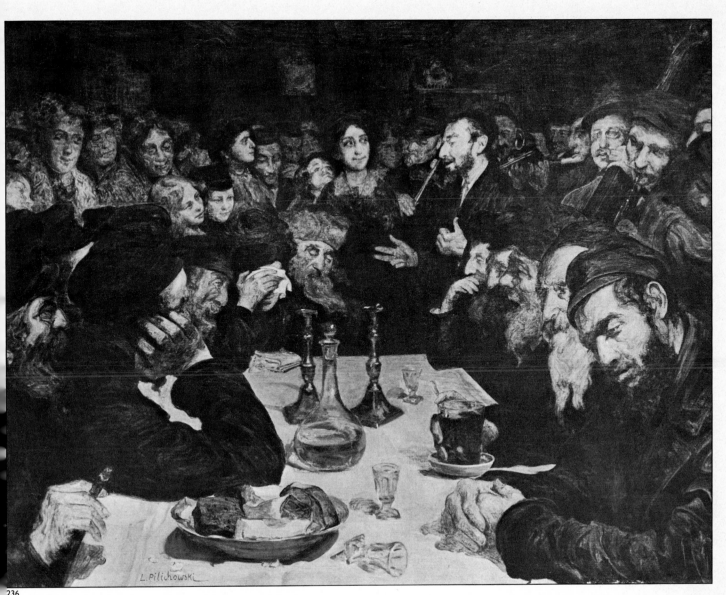

236

237

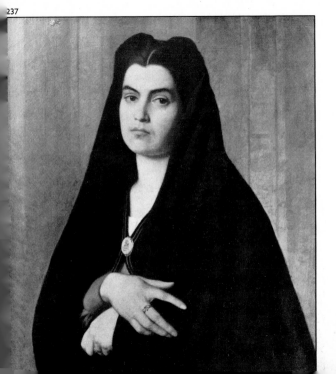

236. Leopold Pilichowski. A Jewish Wedding. Tel-Aviv Museum.

237. Vito d'Ancona. Portrait. Israel Museum, Jerusalem.

238

239

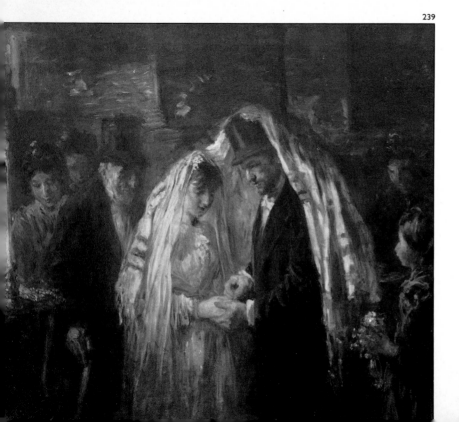

238. Isaac Israels. Behind the scenes. Tel-Aviv Museum.

239. Jozef Israels. A Jewish Wedding. Rijksmuseum, Amsterdam.

240

241

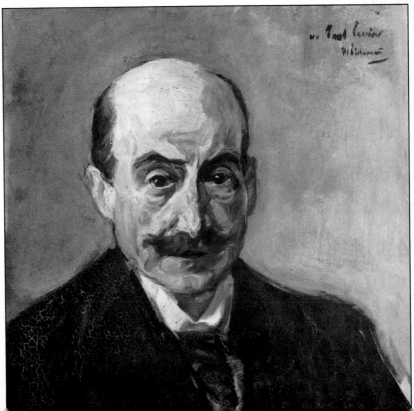

40. *Max Liebermann. Bathers. Tel-Aviv Museum.*

41. *Max Liebermann. Self-Portrait. Tel-Aviv Museum.*

243

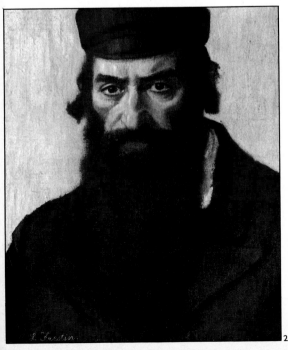

244

242. Joseph Budko. "A man like me will not flee", 1930. Woodcut. Israel Museum, Jerusalem.

243. Hermann Struck. Jerusalem. Etching. Israel Museum, Jerusalem.

244. Lazar Krestin. Portrait of a Kabbalist Jew. Tel-Aviv Museum.

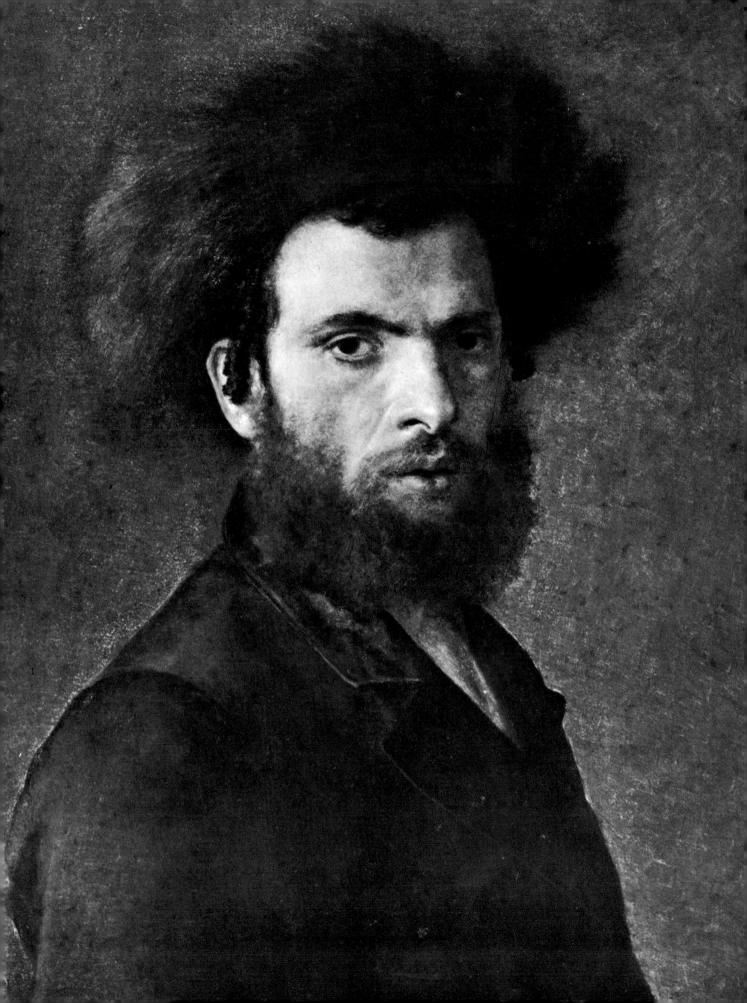

247

247. Isaac Perlmutter. Market-place. Budapest, National
Gallery.

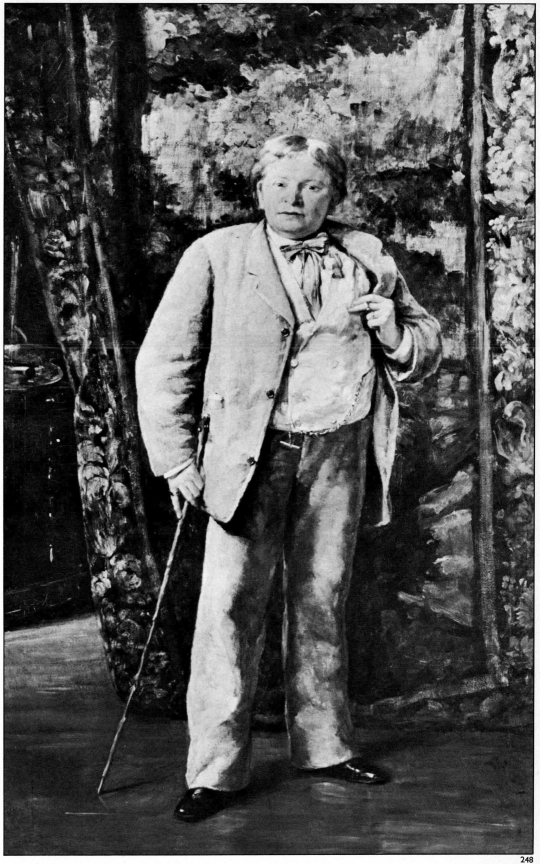

248

248. *Ernst Josephson. Portrait of Carl Scanberg, 1880.*
Göteborg Museum, Sweden.

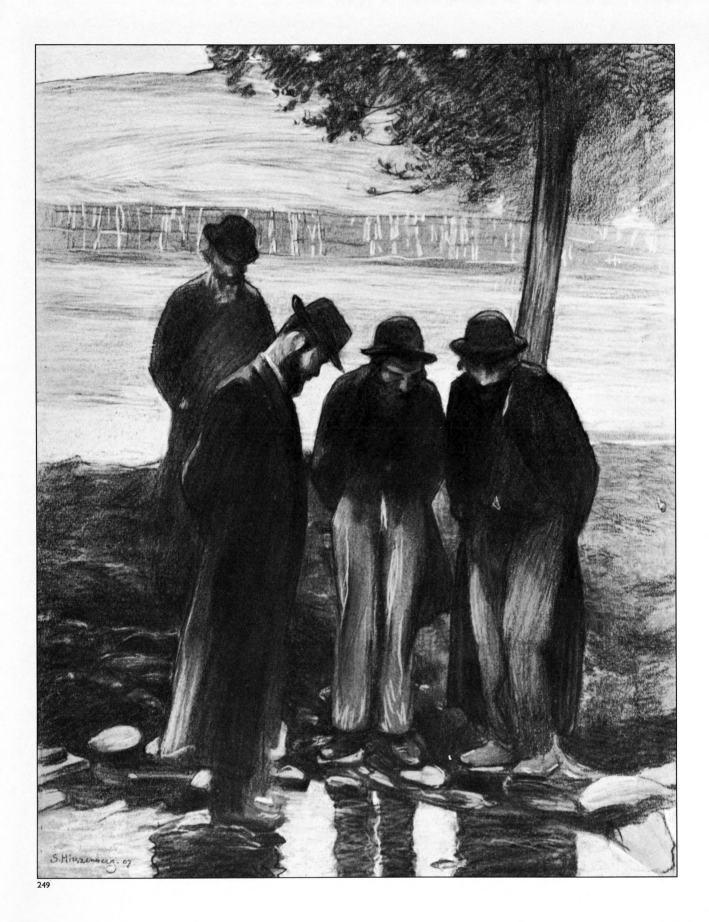

249

249. Samuel Hirszenberg. The "Tashlikh". Tel-Aviv Museum.

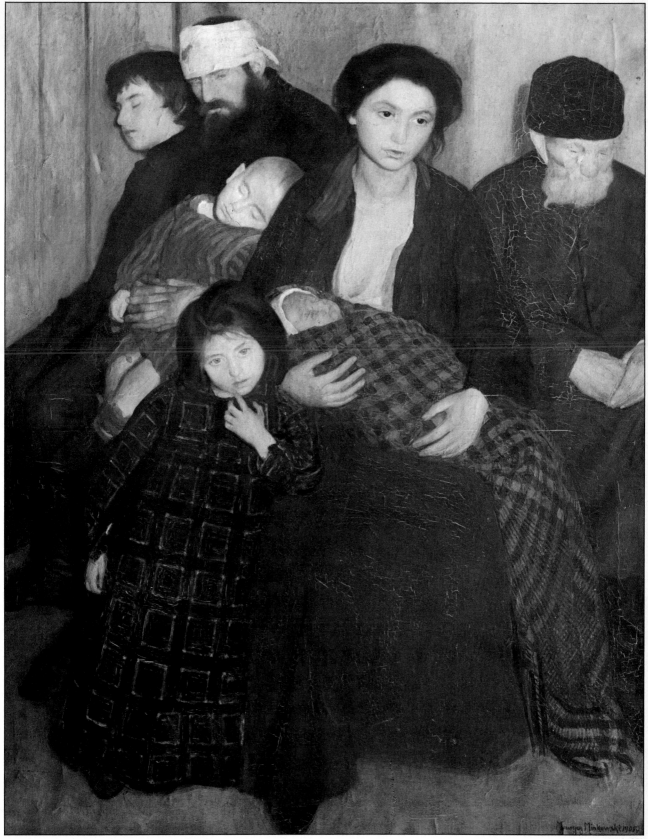

250. Mauricy Minkowski. After the Pogrom. Tel-Aviv Museum.

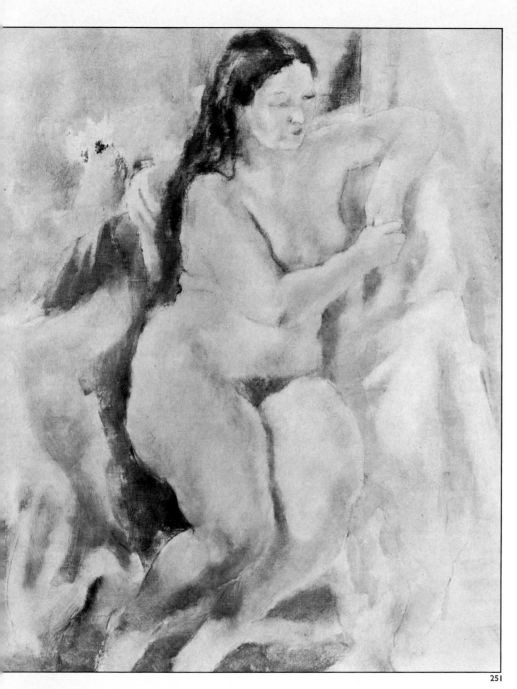

251

252

251. Jules Pascin. Elaine, the red-head. Oil on canvas. Museum
 of Modern Art, Paris. Lucy Krohg Collection.

252. Amadeo Modigliani. Caryatid, Tel-Aviv Museum.

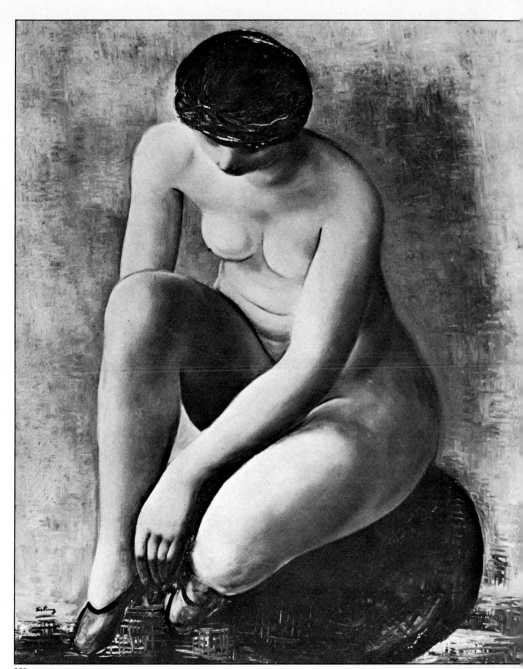

253

253. Moise Kisling. Nude. Oil canvas. Paris, Private Collection.

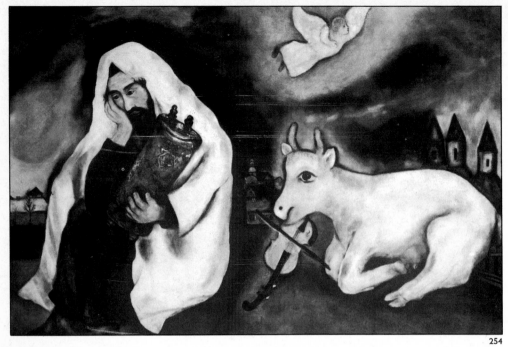

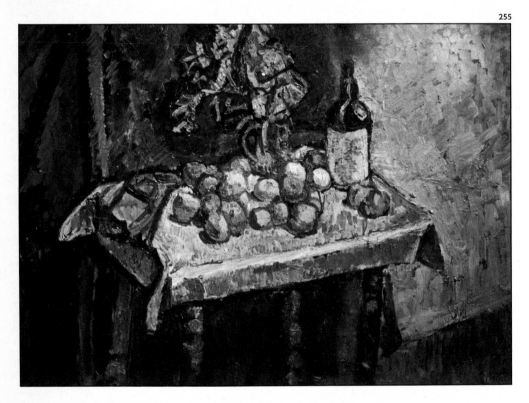

254. *Marc Chagall. Loneliness. Tel-Aviv Museum.*

255. *Pinchas Krémègne. Still Life with Bottle and Apples.*
c. 1920. Oil on Canvas. Paris, Private Collection.

in the Moscow Academy, where he continued to teach until he died of tuberculosis four years later.

When Chekov was at last able to see, in Paris, some of the works of the great French Impressionists, none of these moved his soul, so deeply Russian in its fundamental melancholy, as much as the works of Levithan. "Compared with the landscapes that I saw yesterday," he wrote "those of Levithan proclaim him a true king." Elsewhere, Chekov wrote of Levithan's "vast and novel talent, so original, that of Russia's greatest landscape-painter." When he was forced by circumstances to live in Crimea, Chekov asked his friend to paint him a landscape of the countryside around Moscow and kept this picture framed in the upper part of his desk, always before his eyes as he wrote, "A friend, some haystacks, a forest in the distance, and all this beneath the sovereign light of the moon." It would indeed be difficult to suggest the art of Levithan more faithfully than Chekov has done in his description of the great Jewish painter's "Moonlight over the Village"; "It is already midnight. To the right, one can distinguish the village, with its main street stretching over a distance of some five *versts*. Everything there is caught in a deep and peaceful sleep. No movement, no sound; one would scarcely believe that Nature can be so silent... When one looks at this village street under the moonlight, with its *izbas*, its hay-stacks, its sleepy willows, one feels one's soul appeased. In so restful a place, protected by the night from toil, from care, from sorrow, only the quality of softness, of melancholy, of beauty remains. It looks as if the stars themselves contemplate the village with a tender emotion, as if evil exists no longer in the world and all is now good."

Levithan's art, so deeply impregnated with a melancholy Jewish optimism, profoundly affected the development of Russian art, which henceforth began to follow the path of Western European art and receive its literary expression in the once-famous periodical *Mir Iskousstva* (The World of Art), founded and promoted by Alexandre Benoit and Sergei Diaghilev. This was the circle of innovators whose activities, through the Russian Ballet, soon brought new life to the art of theatrical design, not only in Russia but throughout Western Europe and America. One of the most important figures in this group was Léon Bakst (1868–1924), who was born in Saint Petersburg and died in exile in Paris, was baptized as a child but in his manhood returned to Judaism. In his book illustrations, his incomparably masterly drawings, and especially his designs for the scenery and costumes of *Scheherazade, The Firebird, Petroushka, Le Mariage d'Aurore*, and other famous ballets, Bakst proved himself a craftsman of real genius, in whose art the tradition of the Orient and of the Western world were wonderfully blended. Levithan and Bakst were real fountainheads of modern Russian art which, in the following generations, gave Western Europe and America the many outstanding talents whose humble origins are to be found in the ghettos of Eastern Europe. In the work of Bakst, however, there is little evidence of interest in Jewish traditions; on the contrary, he was one of the originators of a movement in Russian art which sought its inspiration to a great extent in Slavic and Asiatic folk art and in a revival of the long-despised styles and techniques of the painters of Greek Orthodox *ikons*.

Among the disciples of Levithan, there was another Jewish painter of considerable talent who borrowed his artistic views from the major French Impressionists: Alexander Altmann who, born in Odessa, lived many years in Paris, where he died. But whereas Levithan sought his inspiration mainly in the landscapes of his native land, Altmann was a precursor of the many Russian painters of the School of Paris and is remembered today

mainly for his landscapes of the countryside around Paris. His fine compositions of wintry scenes reveal his nostalgia for the snowy landscapes of Russia but express, at the same time, much of the lyrical quality of the French masters who painted in the same regions of France. Leonid Pasternak (1862–1945) was another Odessa-born Jewish painter who,

Plate 37 after studying at the Munich Academy, devoted much of his time to illustrating the works and the philosophy of Leo Tolstoy, including *Resurrection,* and painting more intimate scenes of the interior of Tolstoy's home in Yasnaya-Polyana, as well as portraits that were reproduced and widely circulated. In the Paris Museum of Modern Art, Pasternak's "The Eve of the Examinations" represents a group of male students studying in a lamp-lit room where their white shirts stand out sharply against the surrounding shadows; the anecdotic element of this composition and its facile Impressionism reveal the narrow limits of Pasternak's art. Pasternak was also the author of a number of portraits of celebrities, including Rainer-Maria Rilke and his own son, Boris, later to become more famous than his father.

In Poland, meanwhile, the intellectual and artistic life of the Jewish community was to a great extent influenced by external centers of attraction to which its more outstanding talents were drawn as a consequence of the country's political dependence. We have already seen that artists such as E.M. Lilien and Jehuda Epstein, though born in Poland, were attracted to Germany and Austria where they spent most of their productive years. Other painters, such as Leopold Pilichowski, wandered farther afield, to France, England, or even America. In Poland proper, there continued to be considerable artistic activity, but little of this art ever transcended the limitations of a kind of Jewish provincialism. A few Jewish painters did manage to adapt themselves to the current Polish taste for patriotic and historical painting. One of the celebrities of this school was the Jewish painter Samuel Hirszenberg (1865–1908), a native of Lodz who died in Jerusalem. His "Wandering Jew" gained him an award and considerable fame. Later, he painted a whole series of popular *genre* compositions on Jewish themes such as "The Yeshiva,"

Fig. 249 "Uriel Acosta," "Young Spinoza," "Tashlikh," and "The Jewish Cemetery," which were widely reproduced. His most famous work "Exile," depicting a band of Jews driven out of their houses into the snow, reveals how insufficient were his artistic means to handle a contemporary theme intended to express his deep attachment to the Jewish people.

Mauricy Minkowsk (1881–1930) was considered a prodigy because, in spite of being deaf and dumb, he managed to attain considerable prominence. Minkowski remains one of the most realistic chroniclers of Polish-Jewish life during the last decades of Tsarist

Fig. 250 domination. His compositions depict pogroms and flights, but also the religious life of traditionalist Jewish communities and the day-to-day sufferings of the underprivileged Jewish masses. His gifts of psychological observation often mitigate the excessively dramatic quality of his realism.

A general survey of the part played by Jewish painters in the history of the art of the second half of the 19th century indicates that they were active in every country among the great innovators who stormed the bastions of post-Romantic academism. In France, Camille Pissarro; in Holland, Jozef Israels; in Germany, Max Liebermann and Lesser Ury; in Italy, D'Ancona and Serafino da Tivoli; in Sweden, Ernst Josephson; in England, Sir William Rothenstein; in Russia, Isaac Levithan; in Hungary, Fényes and Ivanyi-Grundwald. All these are names that are always mentioned in any objective history of the evolution of modern art.

THE SCHOOL OF PARIS

by WALDEMAR GEORGE

The sudden appearance of a large number of outstanding Jewish painters in our age was long attributed to the emancipation of a whole people whose faith had for centuries kept it in a marginal relationship to the artistic developments of Europe and of the rest of the world. It is true that the Jewish communities of the Diaspora, subjected as they were to grave limitations imposed upon them both by their own faith and by the instability of their political and economic status, were but rarely able to invent an artistic idiom which could be distinguished from that of their gentile neighbors. But the ghetto, that state within the state, included representatives of almost all the crafts that can contribute towards the establishment of a national style of art. Jewish ritual and folklore art thus reveals if not the key to all the art now produced by Jewish painters since the Age of Emancipation, at least the secret of the genius of so many Jewish artists for self-expression in the mediums of the plastic arts. Immediately after their liberation from the ghetto, Jewish artists indeed began to contribute to the art of their age an element that expresses their own peculiar talent. In France, for instance, we have seen that Camille Pissarro was generally recognized as the lawgiver among the Impressionists. In our own age, both Expressionism and Surrealism, to some extent, have similarly been influenced by the personality of Chagall, while Marcoussis has renovated the idiom of Cubism in order to let it express poetic feelings also. Pascin, on the other hand, remains one of the most hallucinating draftsmen of our century, a true descendant of Hogarth and of Goya, while Soutine revealed his intimate spiritual affinity with Van Gogh, suggesting in his tortured rhythms the advent of an Apocalypse.

But, whereas the images of Chagall seem to have been suggested by ancient Hassidic legends, and the paintings of Soutine are full of a prophetic frenzy, the art of Modigliani manages to bring back to life the lost harmonies, the spiritual subtlety, and the wonderful arabesques of Sandro Botticelli. Bernard Berenson argues in his book, *The Visual Arts,* that Jewish artists, even now that they are emancipated from the ghetto, have never revealed any originality, nor expressed anything that can at all be called Jewish. This statement is obviously arbitrary, and one might well refute it by stating that Jewish painters, though they may fail to create a specifically Jewish style in their art, are nevertheless gifted with a rare quality of universality.

Do we now have to deal with a Jewish art that is homogeneous in its characteristics, or with a number of artists of the Jewish faith or Jewish extraction who, as individuals, play

an important part in the evolution of art in our time? This is our whole problem, though, to be sure, it is similarly posed in the art of nearly every nation. A nationalistic interpretation of art, in this respect, has not only narrowed the intellectual horizon of some of the most illustrious art historians of our day; it has also led them to lose sight of the common aesthetic trends that pervade all of Western art and proclaim its basic unity. If one stresses the distinctive aspects of each national art, whether real or imaginary, one tends to forget what Jean Fouquet has in common with Nuno Gonçalves, Frans Hals with Velásquez, Rouault with James Ensor. The chief characteristic of the art of our age is not the birth of a collective Jewish art — a separate problem — but rather the appearance of a great number of Jewish painters and sculptors who have achieved leadership in the past few decades. Whether they are conscious or not of their racial or religious background, these creative spirits have enriched the common heritage of the civilized world. The great diversity revealed in the work of the Jewish artists of the School of Paris can thus be interpreted in several ways. Some hostile critics have accused these painters of spreading a spirit of eclecticism; we incline rather to hail in their work the birth of a new spirit of universality.

It is too early to write an objective and documented history of the School of Paris. Should it be considered as the ultimate legacy of a whole continent that had reached its decline? Or is it rather to be viewed as anticipating the art of tomorrow? Be that as it may, its heyday began between 1900 and 1914.

With a few exceptions, nearly all the Jewish painters who came from abroad to join the ranks of the School of Paris originated from countries in Eastern Europe and were attracted to Paris by its characteristics as a center both of traditional culture and of artistic invention. Drawn as if by a magnet, they found in the French capital an atmosphere that fostered their own development as individuals. Though they might meet there with a certain lack of understanding or of sympathy in official quarters, they found that their French colleagues were no better understood nor more heartily welcomed. Foreign and French artists shared, in Paris, the same fortunes and misfortunes, exhibited with the same dealers, were attacked or defended by the same critics. Their living and working conditions allowed all to express themselves fully in an atmosphere of freedom that existed nowhere else. As metropolis of European art, Paris offered to foreign painters its museums where the achievement of all lands and ages could be studied. But Paris remains, at the same time, the scene of a series of artistic experiments that constitute our century's major contribution towards the establishment of an entirely novel conception of the arts.

II

We have already seen that a Jewish painter, Camille Pissarro, was one of the main theoreticians of Impressionism and contributed more than almost any other French painter to its technical evolution. When Jewish painters of a later generation, whether sons of well-to-do middle-class parents such as Pascin, Hayden, and Marcoussis, or children of the ghetto like Chagall and Soutine, trod the sidewalks of the French capital for the first time, the Fauvist School had already formulated its doctrines, as had also the Nabi group, which followed in Gauguin's footsteps. The Cubists were, in turn, re-examining all pictorial values in the course of what has been termed "the most important artistic revolution since the Renaissance." Paris was thus the crucible, where the modern

movement in the arts was being created in a series of developments of style and of taste that succeeded one another with unprecedented speed. Whereas Cubism immediately began to exert a powerful influence on a whole group of younger artists, the experiments which Matisse was meanwhile conducting in the field of color continued to attract large numbers of disciples.

How did Jewish painters react to so complex a situation? Many of them, of course, remained merely passive; others, however, absorbed various influences but retained their own specific individuality, using the basic devices of modern art as means towards personal ends of their own. The climate of the School of Paris, then as now, was one of free debate in a spirit of criticism and of research. It is also a climate of genuine culture that can be acquired by direct contact with artists and their works, rather than in academies. Jewish artists who had graduated from the art schools of Central and Eastern Europe often considered themselves self-taught, and quite properly discounted all their earlier training as negligible. As soon as they had developed their own personality, they forgot whatever they had previously been taught and began to formulate their own working principles. Very few of them received any financial help, and their hopes of selling their works was at first very slight. But enthusiasm and genuine friendship compensated for the absence of more material comforts. For a few francs a month, many of them lived in the ramshackle studios of the La Ruche district, without any heating, and worked under open umbrellas to protect themselves against the leaking roofs, with old blankets stuffed into the broken panes of their windows.

To the painters of the Paris School who represented all the various traditions of Jewish culture, every form of expression was allowed, ranging from mysticism to rationalism. Many critics have, therefore, discussed the instability of Jewish painters and their alleged nihilism, or the attraction that revolutionary trends seem to exert on them. It has even been alleged that Jewish painters have made a dogma of iconoclasm and of subversively discrediting the balanced art of classicism. The bankruptcy of anthropomorphic art and of naturalism has frequently been attributed to their influence. If all this were true, every work of art that has revolutionized the artistic world in the past century should be attributed to a Jewish artist. But Van Gogh and Gauguin, Ensor and Eduard Munch, Picasso and Paul Klee, all of whom have contributed basic elements to the revolutionary nature of contemporary art, cannot be accused of having been influenced by subversive theories.

III

Four Jewish painters of the 20th century are universally recognized as major masters of the School of Paris, ranking with Picasso, Braque, or Matisse. These are Amedeo Modigliani, Jules Pascin, Chaim Soutine, and Marc Chagall.

It is inevitable that we should begin with Amedeo Modigliani. The antecedents of this remarkable genius differed fundamentally from that of the majority of those whom we will have to consider in these pages, for he originated, not in one of the teeming ghettos of Eastern Europe, but in the relatively small, multi-cultured, and wholly occidentalized community of Livorno (Leghorn) in Italy, where he was born in 1884 — the youngest of four children. After studying art, at first in Venice, where he received the classical training which he completed by frequenting the museums of Florence, Milan, and Rome, he came to Paris for the first time in 1906. In the various studios where Modigliani lived, he con-

centrated on his work only in fits and starts. He loved life and had many friends, but soon succumbed to a life of poverty, drink, and drugs that helped him forget his bitterness. When he moved from Montmartre to Montparnasse, Modigliani began to associate more particularly with the painters Fernand Léger and Moise Kisling. His dealers were Chéron, Paul Guillaume, above all Zborowski, in whose home he lived for a while. When the first World War was declared, "Deddo" Modigliani, who professed leftist and anti-militarist ideas, refused to fight and began to paint in a kind of feverish haste. Though he spent his days in the cafés of Montparnasse, he was constantly sketching there and often paid for drinks with his drawings. His pockets were always full of such sketches. Once, when a policeman asked him to produce identification papers, he waved a whole bunch of drawings: "Here's my passport!" A life of privation and a sickly constitution, as well as his irregular habits, soon began to tell on his vitality. He died in 1920, aged only thirty-six,

Plate 39 in a Paris hospital ward, murmuring: "Cara, cara Italia!" His last months had been made more bearable by a woman who committed suicide so as not to survive him.

It was in 1915, during the war, that Modigliani's works were first exhibited. In her memoirs, the dealer Berthe Weill writes that a protesting crowd assembled outside her gallery window where she had displayed some nudes as chaste as a medieval master's representations of Eve. But these figures shocked the man in the street, and the police insisted that an exhibition which was causing a public disturbance should be suspended. After his death, he was exhibited more and more frequently and, in 1930, the Venice Biennale devoted a big retrospective show to the greatest Italian painter of the School of Paris.

The chief elements of the art of Modigliani are founded on a basic talent that no teaching could divert from its characteristic development. In his youth, Modigliani had been influenced mainly by Cézanne and the early Cubists, so that his earlier works seem more geometrical and schematic than much of his later productions. His portrait of Kisling belongs to this period, in which the anatomy was generally brought to its simplest form, the body reduced almost to the surging mass of a column, the faces treated like a many-faceted diamond. As if aware that he was destined to die young, Modigliani seemed to waste no time in his rapid evolution. His medievalist period refrained from too didactic a reliance on archaism. Modigliani never excluded an awareness of life and of human values.

His elongated models, like archaic goddesses that haunted the cafés of Montparnasse, reveal the artist's deep sense of pity for all those who were underprivileged. His last painting represents *Motherhood* or a *Virgin with Child:* this painting, with colors that are grave and almost somber, unlike any of his other works, remains full of a sense of humanity. An Italian Jew trained in France summarized in his work the art of the past and indicated

Fig. 252 the path for the art of the future.

A wholly different cultural background was represented by Jules Pascin (Pincas) who was born in 1885 in Vidin in Bulgaria, of well-to-do Spanish-speaking Sephardic parents. Educated in a Viennese boarding school, Pascin began working at an early age in his father's wine business, at that time established in Rumania. But he soon wearied of a settled life and decided to devote all his time to art, which he practiced at first in secret, until he escaped from home, at the age of seventeen, jumping out of the window. He then found his way to Munich, studied in several art schools. Soon his drawings attracted the attention of the editors of satirical periodicals and he became a member of the staff of

Simplicissimus. For a leading Berlin publisher he was also commissioned to illustrate some of the poet Heinrich Heine's works. In spite of his German successes he moved to Paris in 1905, settled in Montmartre, but associated also with the Montparnasse painters, among them the Swedish artist Isaac Grünewald, who painted a remarkable portrait of him.

By nature a wanderer, Pascin traveled in the ensuing years in Spain, Belgium, and Holland. His German publishers continued to ply him with contracts to illustrate books. At the outbreak of the First World War, he thus found himself deprived of his main source of income and set out for the United States, where he was an eloquent propagandist for French art and ideas, but nevertheless became an American citizen. From all his wanderings, which had brought him as far as Cuba, he took back masses of drawings and watercolors. On his return to Paris in 1920, he immediately set feverishly to work and created his most important compositions. After a trip to Tunisia, he returned for a while to New York. In June, 1930, he committed suicide in his Paris studio, leaving somewhat bizarre instructions for burial by a rabbi according to Jewish rites.

No other artist of our age, with the exception of Picasso, has drawn with as much passion and diabolical brilliance. Pascin's objectivity, that of a watchful chronicler and satirist, has left us records of all his travels in Europe, America, and North Africa, especially of low life, which held a special attraction for him. The world that he recorded has the quality of a brisk film montage, with direct views of reality and visions of a bewitched and often burlesque midsummer night's dream. On the balconies of Arab houses, Spanish women exhibited their overripe charms. Cuba, with its motley population of all races — Spanish, Indian, and African — offered to Pascin a particularly rich field, and his numerous sketches of life in Havana are among his best. His early training as a cartoonist had left him an unusual skill at communicating his immediate impressions as an observer. But the exact recording that characterizes much of his early work slowly began to develop into a more purely pictorial art. His draftsmanship became more firm and, at the same time, more cursive. The lines in which he encloses forms seem to vibrate, ever more incisive, expressing the very essence of what he describes. A painter of the contemporary scene, he *Plate 41* does not try to explain away what might seem ugly, but seeks expression rather than harmony. Always he creates beauty, and one cannot remain indifferent to the elegant proportions of his young girls, who are like fallen angels or ambassadresses of sin.

His gift seemed to excel in handling unsavory themes in such a manner as to discover an element of the sublime in them. In spite of their morbidly erotic quality, his drawings thus avoid becoming pornographic. His favorite feminine type is revealed as an almost infantile but sensuously formed figure that remains a kind of *leitmotiv*, under many *Fig. 251* variations, throughout his later work. He was indeed able to vary not only the treatment of his themes, but also his actual subjects. The sketches that he brought back from America or from Tunisia and the satiric drawings that would have delighted Goya thus gave way to fantastic sarabands, rococo ballets, charming Biblical scenes, imaginary Orientalistic fantasies, and allegories peopled with cupids circling like birds in the sky of some never-never-land. For all his fascinating qualities, however, he never achieved, as a painter, the rare quality of his drawings and etchings. His earliest paintings were dark and rather solidly organized, with colors that gave relief to his forms in broad strokes. Later, his palette became lighter, the colors more transparent in their mother-of-pearl fluidity. A real *sfumato* effect composed of colors like those reflected in mist replaces

most of the more strictly localized tones of his composition. Towards the end of his life, Pascin began to dilute his colors in oil of turpentine, and his loveliest nudes, those that have the tones of real Oriental pearls, are of this period.

We may see in Pascin's production, as in Modigliani's, elements which distinguish his work fundamentally from that of a more typical Jewish painter of the Paris School, such as Chaim Soutine. Though many East European ghettos were centers of traditional native art, Soutine's native town — Smilowitchi in Lithuania, where he was born in 1884 — was a modest and obscure community. The atmosphere of almost mystical poetry and of patriarchal tradition that Chagall described in his childhood memories of Vitebsk was not to be detected in the early surroundings of Soutine, the tenth in an indigent family of eleven children. His father, a man without culture, was a tailor and hoped to see Chaim become a cobbler. At the age of seven, the boy already stole a few pennies from his family to buy colored pencils and satisfy his passion to express himself in form and color. He was severely punished, and for two whole days and nights was locked up in a damp basement, in the hope of thus curing him of his vice. But, soon after that, he managed to obtain a box of watercolors and set about painting the portrait of the village idiot. Successful at this ungrateful task, he then asked the venerable rabbi of his community to pose for him. The pious man's son interpreted this request as an insult and gave him a thrashing. Soutine's mother threatened to go to court, but the matter was settled when the rabbi gave her twenty-five roubles to satisfy her claim. But these twenty-five roubles made it possible for Soutine to leave Smilowitchi and study in Minsk, where he enrolled in the School of Fine Arts, moving in 1910 to Vilna. Here a Jewish physician detected Soutine's unusual talent and was generous enough to help him. In 1913, he left for Paris, accompanied by Pinchas Krémègne. He seemed to have achieved his aims, but his difficulties were only beginning.

Plate 42 In Paris, Soutine continued to paint without any hope of a future, without exhibiting, without belonging to any school, without having any patrons. Obsessed with his nightmares, he often sought answers to his questions in the works of the old masters.

Almost no personal correspondence of Soutine's is preserved. The few letters to his friend and dealer Zborowski that have been published give us no real insight into the secret of his character; they are mere business letters, not in any way confessions. He thus remains a mythical figure, interpreted to a great extent in terms of the legend that he himself created. He expressed himself, in general, rather uneasily. Though he spoke French quite fluently after a while, he wrote it with difficulty. His health was always bad, and he followed a severe diet. Money actually scared him, giving him no sense of security.

His perfectionism achieved absurd proportions; he often destroyed his own paintings by burning them or tearing them with his palette-knife.

The main periods of Soutine's earlier production correspond to his sojourns in Cagnes (1918), Céret (1919), Cagnes and Paris (1920–1922). In 1923 and 1924, he obtained some success, at last, when the American collector William Barnes bought several of his pictures and Paul Guillaume published an article about him in *Les Arts à Paris*. In 1926, he experienced his first contact with his public, when Bing exhibited his work without having previously consulted him; Soutine refused to visit the gallery, though the show attracted many visitors.

In 1940, when France was invaded and the persecution of Jews began, Soutine fled from Paris and was invited to come to the United States, but refused to emigrate. In spite

of all the dangers that surrounded him, he continued to paint feverishly. In 1943, he had to return to Paris, to undergo an internal operation, immediately after which he died.

Though Soutine's work can be divided into a number of periods, it retains unity as a whole. While he lived in the artists' colony La Ruche, he painted his flower-pieces, with red gladioli like flaming torches, and his landscapes seem to be shaken by an earthquake; and even the clouds, trees, and hillsides seem to be carried away in a series of wild convulsions. In Cagnes and especially in Céret, after 1920, he painted some two hundred pictures in which his vision achieves a cosmic quality, as the landscapes almost capsize and the outlines of his figures seem to dissolve, contracting and expanding in broken rhythms like those of seizures. Here, he created an apocalyptic world. In his still-life compositions, too, onions, fish, hunks of butcher's meat, vegetables, all seem as living as his portraits; and his self-portraits and the portraits of the models whom he chose at random — choir-boys, girls dressed for their First Communion, hotel bellhops, elevator-boys, and men-servants — achieve a rare quality of almost psychiatric insight.

Soutine's painting relies to a great extent on *impasto* effects which he often achieved on older paintings that he sacrificed to use again as a base. Such an art implies a general knowledge of color that most of his contemporaries lack and that he acquired the hard way, in a constant struggle to transcend the limitations of mere technique. But the puppets of Soutine's world are brought to life by the soul that inhabits them and that the painter discovers as he portrays them, revealing to us the very depths of their hearts. The skull of the boy in his *The Baker's Boy* is revealing, in this respect, as a vivisection. Soutine was not only aware of life, but also of death, and the paintings that he left us after 1935 all reveal, in spite of a kind of relaxation that set in, how true he remained to himself. The epileptic rhythm of his earlier landscapes was slowly replaced by a more ordered scheme of composition. But the artist's newly acquired serenity is only apparent. He had learned to master his own neurosis, but the tension within him increased steadily. In 1942 and 1943, he finally painted *Motherhood* where the stresses and strains of his inner life are revealed at their maximum. The woman whose face seems so ravaged clutches in her arms a child that is asleep or dead.

Soutine's personal background was very similar to that of his slightly junior contemporary, Marc Chagall (born 1887). The latter was the son of a fishmonger's assistant in Vitebsk, an orthodox Jew, in whose devout and profoundly peaceful and united family, the future painter grew up to the accompaniment of recurring religious ceremonies, in a simple but deeply spiritual atmosphere that endowed play and chores alike with symbolical meanings. Chagall's talent revealed itself in his first paintings where he depicts the main stages of a devout Jew's life, his birth, his marriage, and his death, the background of all these scenes being his native Vitebsk.

In Saint Petersburg, Chagall failed when he came up for entrance examination to the Imperial Academy of Fine Arts. Thanks to a monthly subsidy of ten roubles, he was able, nevertheless, to study at the new school of the Society for Advancement in the Arts. The Russian-Jewish lawyer and liberal politician, Maxim Vinaver, became Chagall's patron and encouraged him to emigrate to France. In 1910, Chagall settled in Paris, with other Russian painters, in La Roche. At once he revealed himself as an outstanding personality in the School of Paris. The Berlin critic and promoter, Herwarth Walden arranged a show, Chagall's first, in the Berlin gallery *Der Sturm,* one of the focal points of the modern movement; the introduction to the catalogue, fittingly enough, written by the poet Apollinaire.

235

In 1914, Chagall returned to Russia, where he was obliged to remain throughout the war. In 1918, he was appointed by the revolutionary authorities Cultural Commissar for the Vitebsk area, where he set about reforming the teaching of art, founding local museums, and calling upon well-known artists to cooperate in the establishment of a new social order. In 1919, he was associated, with Issachar Ryback, Nathan Altman, Eliezer Lissitzki, and Isaac Rabinowitsch in the group of artists who sought to formulate in Moscow the principles of a Jewish art, which would be analogous to the arts of the other nationalities of Soviet Russia that were being encouraged to affirm their cultural independence and to develop traditions independent of those of Russian art and literature.

Soon, however, Chagall began to disagree, on matters of art and aesthetic theory, with the young political leaders of the Vitebsk area. In 1924 he, therefore, emigrated again, and after a short period in Berlin, moved on to Paris. Immediately, he was commissioned to illustrate a number of books, including Gogol's *Dead Souls,* the *Fables* of La Fontaine, and the Bible. In 1931, he traveled in the Near East, visited the Holy Land, wandered around Jerusalem in search of local color and types for his illustrations to the Old Testament. In 1941, during the German occupation of France, he emigrated to America. His arrival in wartime New York was somewhat of a triumph. For the Metropolitan Opera, he designed the sets for two ballets, Tchaikovsky's *Aleko* and Stravinsky's *The Firebird.* In 1945, his one-man show at the New York Museum of Modern Art was an almost unprecedented success. Chagall refused, however, to become an American citizen and returned to France after its liberation.

The first influence that helped Chagall develop his extremely personal style was that of Russian-Jewish craftsmen, the naïve painters whose folk art produced the painted signs of the shops in the ghetto. In 1914, Apollinaire already explained that Chagall's art violated all the laws of logic, probability, and physics, refusing to express itself in the pedestrian moods of prose.

But Chagall's style of humor and fantasy had developed slowly, by distinct stages. On his arrival in Paris, he had studied the works of Delacroix, Pissarro, and the Fauvist masters, acquiring at once a brighter harmony of colors, less dependent on almost monochrome effects of grays and browns than some of his earlier Russian works evidence. When he later absorbed the influence of early Cubism, he abandoned for good his Rembrandtesque manner and his reliance on *chiaroscuro,* contrasting instead the bright colors that have characterized his art ever since. But he was never a programmatic Cubist. A painting by Chagall remains anything but a geometrical theorem. Far from wanting to demonstrate laws, to pose and solve problems, Chagall prefers to transcribe legends in terms of style. An inventor of fables that are often based on his own memories, he reintroduced into Cubist art a sense of time, violating its logic, too, as did the artists of the Middle Ages when they depict in one and the same picture several distinct moments of a story. Chagall thus presents, as in much folk art, both the dreamer and his dream, the drunken soldier and his fantasies, the unborn calf within the cow, a cow on a church roof, with the milkmaid *Fig. 254* coming down from the sky to milk it. The air seems indeed to be the element where Chagall is most at home; as in a Yiddish proverb, he depicts the whole village in the air, *Shtetl in der Luft.*

The disasters of war, the German policy of genocide, the destruction of the city where he had been born and had discovered the world of love and color, all contributed to transform Chagall's art, to make him a painter of tragic themes as well as of comic fantasies. In later

years he never recovered all of his prewar peace of mind. His recent fantasies, however popular, are often but pale reflections of those of his earlier years. His greatest work remains, perhaps, the canvas entitled *To My Wife* in the Paris Museum of Modern Art, a kind of synthesis of all his work. In the center of the composition, the bride ascends vertically, wearing her bridal dress with a long train. On the right, the Jewish virgin on her bright crimson bed awaits the companion destined for her by God, her body as luminous as ivory. Through a bunch of flowers, bright like jewels, one can distinguish a view of an old Russian village. A Hanukkah lamp, a turquoise-blue goat, a fiddler on a roof, and a seraph sacrificing a sheep complete this intensely personal parable that yet expresses universal sentiments.

Chagall has brought to modern painting a kind of angelic purity, which he has enriched by allowing it to express again all of man's spiritual aspirations, his dreams, his nostalgia, his legends, his fantasies. Fiction, which is banished from modern art ever since anecdotic and traditional allegories have been condemned as too literary, comes into its own again in the works of the painter from Vitebsk who remains, at heart, a poet, too.

IV

Though Modigliani, Pascin, Soutine, and Chagall are now recognized as the greatest Jewish painters of the School of Paris, several other artists of their generation may yet win recognition as masters. With a few exceptions, all these painters, together with the majority of Jewish artists of the School of Paris between 1910 and 1940, have remained true to a tradition of painting that, stemming originally from the work of Cézanne and the Impressionists, has developed as a continuation of the Fauvist movement, though often assimilating Expressionist influence from Central and Eastern Europe as well as certain Cubist and Realist influences of the School of Paris. Extremely painterly, this tradition has stressed composition, brush-work, a technique of expressing moods in terms of color and texture, rather than subject-matter or formal stylization.

We must now deal with a few of the persons in question one by one, for it is hardly possible to generalize about their work. On the other hand, the life record of the Jewish painters of the School of Paris who were of Eastern European origin is as stereotyped as their production is varied. The Russian or Polish ghetto gave them birth, its warm Jewish life and its keen intellectuality stimulated their genius, Paris brought it to a sudden flame.

Moise Kisling (1891–1952) achieved great fame and popularity as the very type of the painter of Montparnasse in the brilliant Paris bohemia between the two wars. He had come to Paris from Cracow in 1910, volunteered in the French Army in 1914, and after the war became an arbiter of taste in Montparnasse, even imposing on the painters of his generation a style of dress that characterized the marginal social life of the modern artist.

Among the painters of the School of Paris, Kisling was one of the very few to develop an art that relies to a great extent on traditional *chiaroscuro* effects. His technique, in this respect, was always very effective, especially in his judicious use of glazing, which gave his surfaces a smooth and translucent quality, perhaps learned from certain German Renaissance masters. In his design, Kisling allowed himself some freedom to rearrange his forms according to a style that remains his own and that expresses clearly his innate

Plate 40

237

sensuality. His Jewish background never expressed itself in the choice of his subjects, but rather in his interpretation of certain physical types, when he stressed their affinity with the models of Persian miniatures or Byzantine mosaics, thus orientalizing all that he painted. More melancholy and less free in his draftsmanship than Pascin, Kisling tended, towards the end of his life, to repeat himself and to produce too many works that are merely decorative.

Fig. 253

We have already mentioned how Pinchas Krémègne who was born (in 1890) in White Russia and studied for a while in Vilna, came to Paris in 1913 together with Soutine. In the 1913 Salon d'Automne, he made his first public appearance as a sculptor, but soon discovered his real vocation as a painter. His landscapes of Provence, Corsica, Touraine, central France, Sweden, and Palestine all reveal him as a master of the early "heroic" period of the School of Paris. In many of his still-life compositions, one can detect a quality of lyrical sensuality that he has inherited from Renoir. Krémègne's life, whether as an individual or as an artist, offers us a fine example of the dignity, disinterestedness, and the professional integrity that made it possible for the School of Paris to achieve its fame.

Fig. 255

Another close associate of Soutine is Russian-born Michel Kikoine (1892–1968) who shared with Krémègne and other artists of La Ruche the hard times which characterized life there in those years. Modigliani, one of his neighbors, was the first to detect his talent and introduced him to a few patrons. After 1926, Kikoine began to exhibit frequently, in Paris and abroad. Until his death, he claimed to be a disciple of the 19th century French Romantic-Realist master Gustave Courbet and to interpret in his paintings the organic life of nature. But the composition of his mature works reveals a lasting influence of Cézanne as well.

Fig. 260

Georges Kars (1885–1945) is one of the very modern painters who are not yet appreciated as universally as they deserve, and whose work may yet be destined to achieve a great and lasting fame. Born near Prague, he worked in Paris from 1907 onwards, till he fled to Switzerland in 1942. Though he was destined to commit suicide in a moment of acute depression, which came as a reaction after his many anxieties of the war years, Kars remained a painter of a truly optimistic turn of mind, whose lyrical appreciation of life and of human nature strikes one in almost all his paintings. Always faithful to those principles of balanced construction and emotional poise that distinguish the great works of the Italian Renaissance, especially the Florentine masters, Kars has left us a number of compositions that can bear comparison with some of the works of Modigliani and of Picasso's Classical period. The sobriety of his harmonies is relieved by rare touches of brilliant color that he applied with a quality almost akin to wit. The atmosphere that he thus created infuses life into all that he painted, as well as a kind of poetry that he was able to distill from the contemporary scene.

Fig. 256

Plate 43

Future generations may well decide that Abraham Mintchine (1898–1931), too, is to be reckoned among the most gifted representatives of a strictly painterly tradition among the painters of the School of Paris. He began life in Kiev as a goldsmith's apprentice, emigrated from Russia in 1923, and came to Paris in 1926. During the few years of his artistic maturity, Mintchine developed in portraits, strikingly knowing self-portraits, landscapes, still-life compositions, and interiors a rare lyrical quality and a painterly style of his own. Gradually abandoning Cubism and assimilating some of the qualities of German Expressionism, he achieved in a very short while a perfection that many discerning dealers and

collectors soon recognized. His self-portrait, dressed as a harlequin, which hangs in the *Fig. 261*
Tate Gallery, is one of the finest examples of his mature style.

The Jewish background, inconspicuous or absent in the work of so many of his con-
temporaries, can hardly be escaped or avoided in the work of Mané-Katz (1894–1962).
His devout father, *shammash* (synagogue beadle) at Kremenchug in the Ukraine, was
shocked to see his son choose the career of an artist. Nevertheless, at the age of sixteen,
Mané-Katz began to study art in the Academy in Kiev. In 1913, he came to Paris, but in
1914, considered unfit for military service because of his small stature, returned to
Russia. Here he began to treat the Jewish themes and subjects which he saw around him,
elaborating and magnifying them often in poetic terms and on a grandiose scale. In 1921,
in the midst of the Revolution, he decided to return to Paris, where he soon attracted
attention and exhibited regularly. Originally a painter of Biblical scenes and ghetto
types, Mané-Katz has refrained from limiting his art to documentary studies. Like many
other Jewish painters, he has stressed in his works the spiritual aspects of all that he
paints. During the war years, he emigrated to America and, since his return to Paris, has
revealed himself in a new light, as a delicate painter of landscapes, in an entirely new range *Fig. 258*
of colors, bright and cheerful, whereas his earlier work tended to be more somber, relying
more on *chiaroscuro* effects and less on contrasts of color.

We have no option but to pass in review more rapidly here a large number of other artists
perhaps less known, though in many cases certainly no less gifted, than those we have
mentioned, conscious that some of them have not yet reached the fullness of their
genius.

A typical career was that of Isaac Dobrinsky (born 1891) of Makarov in the Ukraine, who
studied in a *yeshiva* before entering an art school, coming to Paris through the generosity
of a patron in 1911. His development as an artist of the School of Paris has been slow but
sure, steady but never spectacular. A realist who delights in the intimate touch, he paints
interiors, children, portraits, views of the French countryside and of picturesque areas of
Paris and its suburbs. Polish-born Maurice Blond (born 1899), primarily a Post-Impres-
sionist, has concentrated on suggesting light, color, and movement mainly by using a
technique of bright streaks of color such as Van Gogh had used, but less violent in their
contrasts and more in keeping with Blond's own gentler temperament. Adolphe Milich
(1884–1964), also Polish by birth and Swiss by nationality, was a painter specializing
in lyrical interpretations of an idyllic world, who has revealed his sensuality and his
optimism in nudes, southern landscapes, still-life paintings, and large compositions of *Fig. 257*
women bathing. In the latter, in particular, the more strictly intellectual influence of the
composition and draftsmanship of Cézanne has been tempered by a return to the
sentiment of Corot's figures of women and to the sensuality of Rubens. In his watercolors,
Milich refrained from any recourse to draftsmanship; blank white spaces bring into relief
his fluid colors that seem to crystallize in solid masses.

Polish by birth, too, is Joseph Pressmane (born 1904) who after three years in Palestine
settled in Paris in 1926. During the war years, he suffered great privations, but soon after
the liberation of France began to attract attention as one of the outstanding younger
painters of the School of Paris. A sense of melancholy distinguishes much of his work.
In his paintings on Jewish themes, especially of brides, he handles his subjects with less
humor and fantasy than Chagall but with a greater seriousness of purpose and a strikingly
lyrical feeling. His landscapes and views of industrial suburbs of Paris reveal a delicate *Fig. 263*

sense of nature and, in spite of occasional touches of realism, a nostalgic awareness of pity for anything that lacks beauty. David Garfinkel (born 1902) of Radom, Poland, has lived in France since 1932 and has specialized in still-life compositions that reveal Expressionist influence in somewhat meditative portraits and in picturesque views of the city. A native of the industrial center Lodz, Jean Markiel (born 1921) studied at the Cracow Academy, then in Paris, where he settled in 1935. Interned during the Second World War as a prisoner in Germany, he resumed work in 1945 and now paints in a kind of studied realistic style that offers some affinity with the work of certain medieval portrait-painters. Although born in Poland, Zygmund Landau (born 1900) is no child of the ghetto. A native of Lodz also, he came in 1919 to France where he developed a more lyrical and tender style of his own, rich in memories of his Jewish and Slavic background. Lodz gave birth also to Zygmund Schreter (born 1896), in Paris since 1934, who is a painter of intimate still-life compositions and interiors and landscapes, and of portraits that express a delicate sense of psychology; he is mainly a colorist, of the school of Bonnard and Vuillard. In his landscapes, he concentrates on expressing the individuality and local color of the scenes which he depicts. Simon Mondzain (born 1890), a native of Chelm who settled in Paris in 1910, has worked in recent years mainly in Algeria. His paintings, among which the *Guitar-player* remains his masterpiece, seek to suggest space without ever having recourse to the trickery of perspective and exclusively by suggesting volume in terms of color, light, and airiness.

Though born in Lithuania and now an American citizen, Max Band (born 1900) was for many years a well-known figure among the painters of the School of Paris. A painter of realistic portraits, of circus scenes, and of clowns and puppets, he has developed a sarcastic style that owes much to Expressionism, but relies on basic draftsmanship, tempered by contrast of color and occasional *impasto* effects derived from the technique of Rembrandt.

Fig. 259

Chwat (born 1888), son of a prosperous banker in Bialystok and a cousin of Simon Segal, was encouraged at an early age by his family to study art in Saint Petersburg and later in Paris, where he assimilated the art of the Impressionist masters. Settling definitely in France immediately after the Russian Revolution, he was for many years prevented by family responsibilities from devoting much time to painting, which remained his hobby until he was able to retire and make it his main occupation. In recent years, he has attracted more and more attention as a legitimate but original heir to the best traditions of Impressionism, tempered by his contacts with some Fauvist masters. A painter of Biblical scenes that seek to express a prophetic or epic mood, he also painted some delicately sensitive still-life compositions, landscapes, and interiors, excelling particularly in twilight and nocturne effects.

David Seifert (born 1896) is a painter whose post-Impressionistic landscapes, still-life compositions, and portraits illustrate clearly how Austrian and German influences in his native Galicia tended to encourage a more Western European kind of art than has generally been produced by artists who came to Paris from territories of the former Russian Empire. An extremely modest artist, he has worked mainly in the tradition of the great Nabi masters, Bonnard and Vuillard. Russian-born Michel Adlen (born 1902), living in Paris since 1923, is one of the organizers of the Federation of Jewish Painters and Sculptors of France. In 1925 he underwent, for a while, a Cubist influence. Later, he developed a more Fauvist style, admirably suited to landscapes of the Ile de France, full of love and

pity for their beauties that seem condemned as the metropolis and its suburbs rapidly encroach on them. Marc Sterling (born c. 1910), also Russian-born, associated at first in Paris with the group of painters of La Ruche. Painting in the general post-Fauvist tradition of Soutine, he has produced some well-organized and dynamic landscapes that express a passionate fervor in vivid colors and expressionistic composition. Kishinev, a city that had no museum, no galleries, only a provincial art school, gave birth to Irisse (born 1903), who studied art there until he was able to emigrate to France. Basically a Fauvist, Irisse has assimilated the teachings of Matisse, and organizes his compositions chiefly in terms of colors that dictate both the textures and the forms.

It was from Bobruisk in Russia that Charles Tcherniawsky (born 1900) came to France in 1913. Here he received his training and began to exhibit. His work has often been included in shows of contemporary French art sponsored by the French Government, and is represented in several French and foreign museums and important private collections. During the German occupation of France, he was active in the Resistance. His very painterly style, that of a post-Fauvist, is admirably suited to landscapes, which he paints with an emotional fervor akin to that of Soutine; his landscapes are generally peopled with figures, thus expressing his conception of the relationship of man to his surroundings. In his portraits, Tcherniawsky reveals unusual psychological insights, similar at times to those of certain Central European Expressionist masters. A Rumanian-Jewish painter of the School of Paris is Robert Helman (born 1910) who has attracted much attention since 1945. Basically an Expressionist, he composes his paintings under the impulse of the moment, with a great and often tortured sense of movement both in his figures and his landscapes. His colors are often violent, revealing a strong influence of the Expressionist schools of Central and Eastern Europe and sometimes lacking certain more delicate painterly qualities that generally distinguish the art of the School of Paris.

Though born in New York, Mottke Weissmann (born c. 1910) has reverted to the Eastern European Jewish folklore of his forebears as a source of inspiration for many of his works. Weissmann came to Paris in 1949, and has specialized in Jewish subjects as well as in views of the city, in portraits, and still-life compositions. He paints in a somewhat tormented manner, resorting frequently to *impasto* effects, and is at his best in his scenes of Jewish family life and in views of French cathedrals. A fellow-townsman of Soutine's is Zarfin, son of a once well-to-do Russian-Jewish industrialist. After studying in Vilna under the same masters as Soutine, he emigrated to Palestine, where he studied in the Bezalel School, but went in 1923 to Berlin, where he was encouraged by Max Liebermann. Since 1924, Zarfin has lived in France, specializing in landscapes and views of harbors. Zarfin's style has matured slowly, his colors gradually acquiring a richness that often suggests the art of the jeweler or the Oriental miniaturist. Palestine, too, contributed to the artistic development of Isaac Antscher (born 1899) who, born in Bessarabia, studied at the Bezalel School from 1921 to 1924, and then moved to Paris. Here he first exhibited, two years later, in various annual salons, besides becoming one of the select group of artists encouraged by the dealer Zborowski. Antscher has distinguished himself as a landscape painter who delights in detail. His views of city scenes, often depicted from above, are remarkable for their soft colors and lyrical feeling, analogous to that of Maurice Utrillo. In his flower-pieces, Antscher's colors are brighter, more rich in contrasts. Similarly, David Murginsky of Suwalki, in Poland, emigrated as a young man to Palestine, studied at the Bezalel School, then was commissioned to execute some of the murals in

the *Hurva* Synagogue in the Old City of Jerusalem. Later, he came to Paris to study in private academies. Since 1947, he has exhibited regularly and has painted murals for the Rashi Synagogue in Paris and for the Great Synagogue in Antwerp, Belgium. His interiors, portraits of children, still-life compositions, and flowers reveal a deep love of nature, expressed in reposeful colors. Born in 1914 in Poland, Yehouda Rasgour likewise emigrated to Palestine in 1934 and studied there under Jacob Steinhardt; in 1948 he moved to Paris and his studiously realistic views of typical Paris streets manage to convey the city's old-world charm. English-born, on the other hand, is Reginald Weston (1908–1967) who emigrated in his youth to Palestine where he studied art and participated in a number of local art movements with other Israeli artists. In 1948, he settled in France, and has now exhibited in various salons as well as in groups. A fine painter of seascapes with ships, of flowers, and still-life arrangements, Weston expresses in his work a typically English delicacy of design and color, revealing his awareness of the great traditions of English watercolor art as well as of Turner and of Whistler's oils. At the same time, he has borrowed some techniques from the abstract painters of recent years, thus conferring on his work a curiously dreamlike and unreal quality.

A number of well-known Hungarian-Jewish painters have lived and worked for many years in the French capital, participating actively in its artistic life. Bela Czobel (born 1883), one of the most outstanding, was born in Nagybanya, a famous Hungarian art-colony. After studying for a while in Munich, he came to Paris, where he immediately became a close associate of Matisse. In 1906, he was already exhibiting at the Salon des Indépendants, among the founders of Fauvism. In the catalogue of Czobel's 1956 Paris exhibition, Picasso published an open letter stressing his importance as one of the initiators of the movement in contemporary art which has brought the School of Paris to the fore through-
Fig. 262 out the world. Czobel is famous in the Hungarian art world as one of the two leaders of the group known as "the Eight," a school of painters, mainly Jewish, who introduced Fauvism to Hungary and has exerted a lasting influence on contemporary Hungarian art. A sensitive innovator in the tradition of Cézanne, Czobel at first relied to a great extent on draftsmanship in his paintings, enclosing the masses of color in his compositions within heavy and dark outlines similar to those that characterize the work of Georges Rouault. Later, Czobel developed a more personal technique of *sfumato* effects which allows him to compose his portraits and still-life arrangements in masses of warm colors, according to principles derived from Cézanne, but without stressing the outlines of their basic draftsmanship. His paintings thus acquire an unusual depth and fluidity, with the colors seeming to melt into each other.

Like Bela Czobel, Robert Berény (1887–1954) was born in Hungary and came to Paris in the early years of this century. Also a leader of "the Eight," he reacted very early against the excessive fluidity of much post-Impressionist painting and in the 1908 Salon des Indépendants attracted attention by developing certain more sculptural qualities of form in a manner analogous to that of the earlier work of the Cubist masters. Maurice Denis wrote, in his *Théories 1890–1910*, that the intentional and somewhat grotesque ugliness of some of Berény's figures remains basically expressive and that his qualities of sheer painting and draftsmanship reveal him as a leader among the Paris Fauvists. An unusually intellectual painter, Berény displays in all his works a profound culture and a great sensitivity. His colors are generally muted, suggesting a somber richness and warmth, often very lyrical. Among his rare but powerful portraits, that of the composer Bela

256

257

256. Georges Kars. "The Stage-box". Oil on Canvas. The painting was lost in Prague, under the German occupation.

257. Adolph Milich. "Venetian dressing-room". Oil on canvas. Paris, Private Collection.

258 259

258. Mane Katz. Torso of a woman. Oil on canvas. Katia Granoff
 Collection.

259. Max Band. Mother and Child. Tel-Aviv Museum.

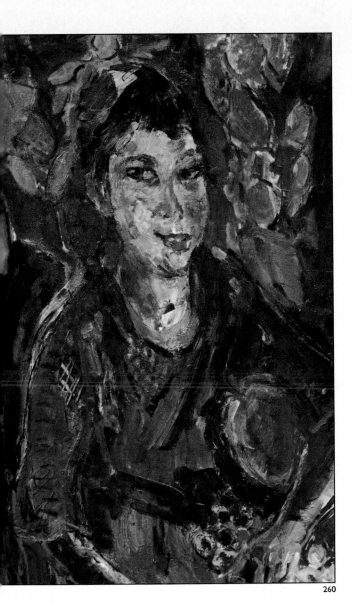

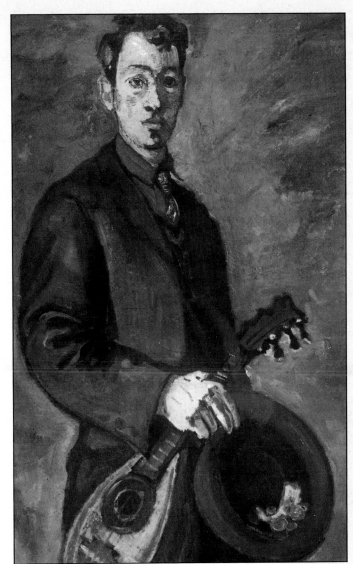

260 261

260. Michel Kikoine. Portrait. Oil on canvas. Paris, Private
 Collection.

261. Abraham Mintchine. Self-portrait. Oil on canvas. Gallery
 Alice Manteau.

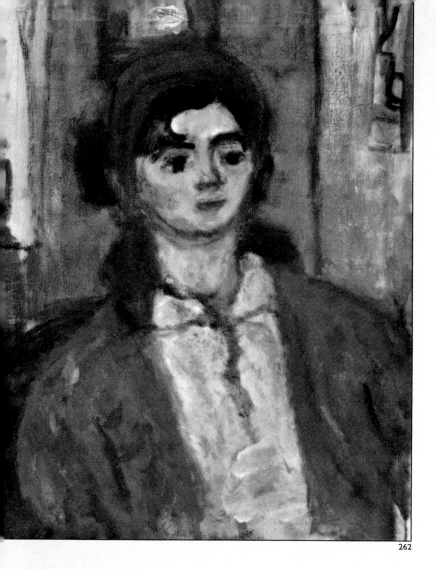

262

263

262. *Bela Czobel. Girl with Green Scarf. Oil on canvas. Paris,
Private Collection.*

263. *J. Pressmane. "Deep blue Sky". Oil on canvas. Paris,
Private Collection.*

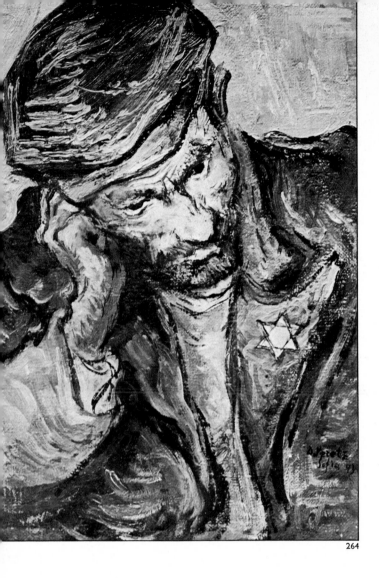

264

265

264. David Peretz. The Jew with the Yellow Star, 1946. Oil on
canvas. Paris, Private Collection.

265. Louis Marcoussis. The Eiffel Tower. Oil on canvas. Paris,
Galerie de Berri.

266

267

266. Otto Freundlich. Composition. 1936. Paris, Atelier d'Art Abstrait.

267. Marcelle Cahn. Composition. Oil on canvas. Paris, Private Collection.

268. Jacques Pailès. Harbor in Brittany. Oil on canvas. Courtesy of M. Kaganovitch.

269. Henri Hayden. The Three Musicians. Museum of Modern Art. Paris. Courtesy Musées Nationaux, Paris.

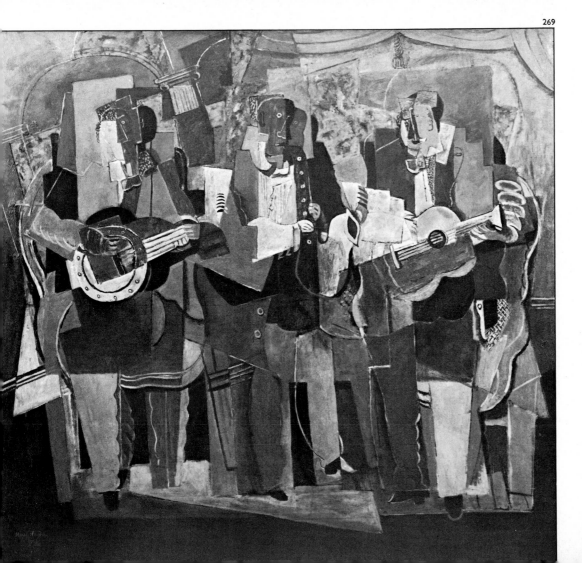

270. *Gabriel Zendel. In Praise of the Craftsman's Tools. Oil on
canvas. Collection of the City of Paris.*

Plate 43. Village on the Rhône (1939), by Georges Kars, the most harmonious of the Jewish painters of the School of Paris, clearly illustrating the painter's lyrical and optimistic attitude to life. Israel Museum, Jerusalem.

Plate 44. Portrait. Benzion Rabinowitz, known by his pseudonym of "Benn". The humanist in the School of Paris. Israel Museum, Jerusalem.

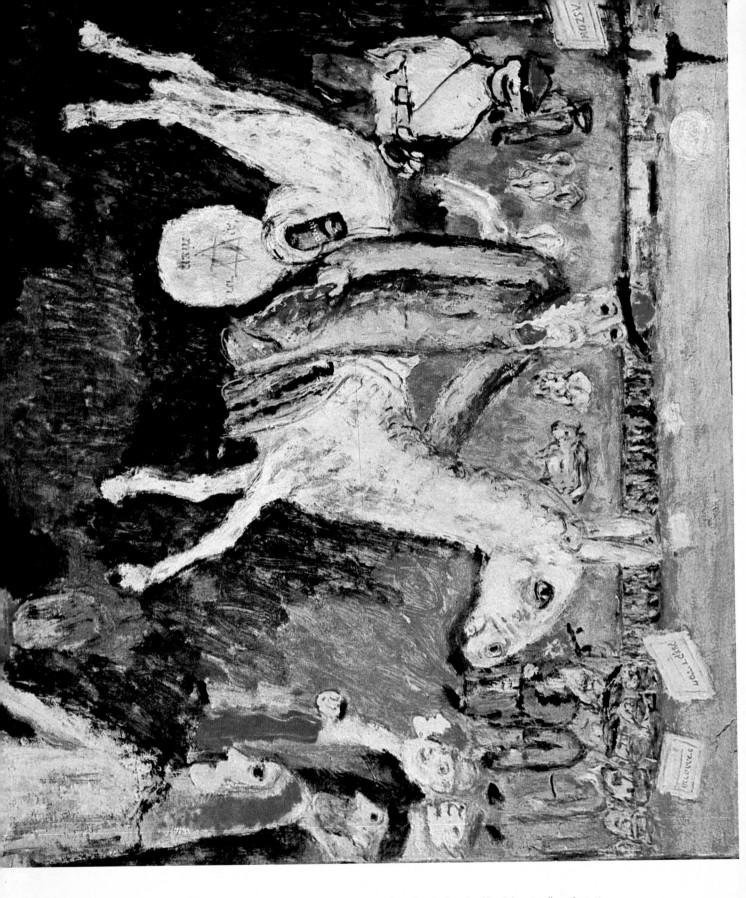

Plate 45. The atmosphere of folk Hasidism in Poland was introduced into Jewish painting of the School of Paris by the caricaturist Ezekiel David Kirszenbaum (1900–1954). Drawing on the figures of his childhood in a Polish town, Kirszenbaum pictured the Messiah as a Hasid, mounted on a white donkey, holding a Phylactery bag in his hand and with the 613 commandments in his saddlebag. As a representative of authority, the Messiah naturally arrives at the railroad station, which is guarded by a non-Jew. His reception committee includes some of the Hasidim of the Rabbi of Kotsk and members of an association for reciting Psalms (Hevra Tehillim), both groups carrying signs to identify themselves. Israel Museum, Jerusalem.

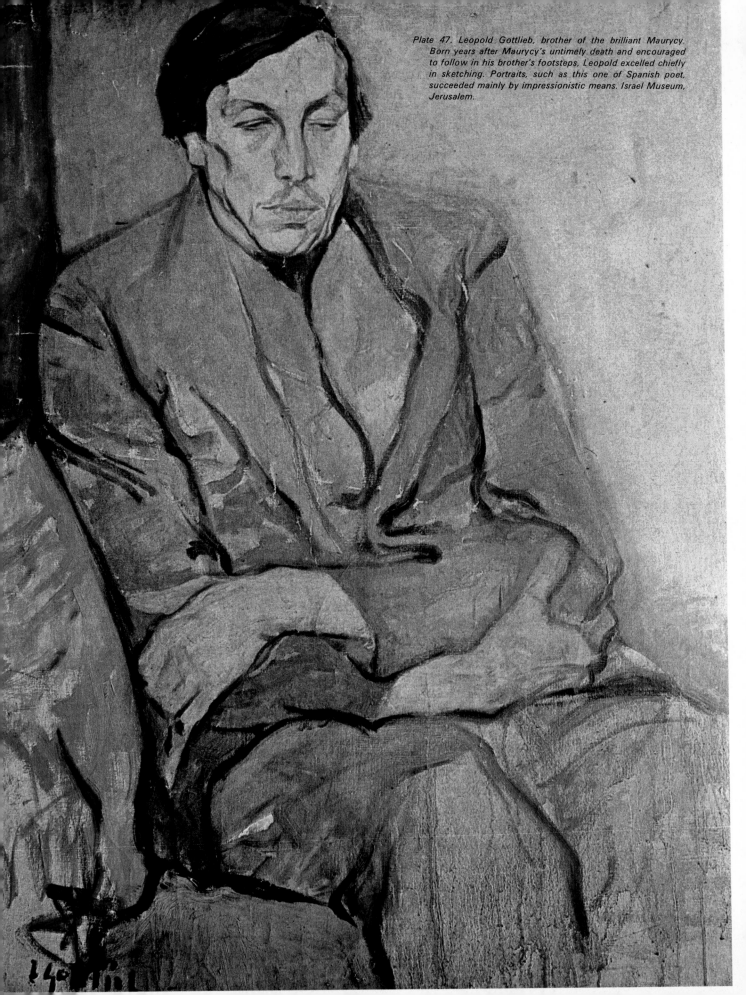

Plate 47. Leopold Gottlieb, brother of the brilliant Maurycy. Born years after Maurycy's untimely death and encouraged to follow in his brother's footsteps, Leopold excelled chiefly in sketching. Portraits, such as this one of Spanish poet, succeeded mainly by impressionistic means. Israel Museum, Jerusalem.

Bartok remains a masterpiece. Profoundly influenced by Cézanne, Dezso Czigany (1883–1937) spent many years in France and distinguished himself particularly in landscapes of Provence as well as in portraits.

Bertalan Por (born 1880) was also in Hungary, but spent many years in France. At first attracting attention as a decorative painter of considerable power, he was commissioned to paint a huge mural for the Popular Opera House in Budapest. After 1919, Bertalan Por became known in Paris mainly as a painter of animals. In 1949 he returned to Hungary. Another Hungarian of the Paris School, Lajos Tihanyi (1885–1942) has also distinguished himself as a disciple of Cézanne. Although a deaf-mute, Tihanyi was well-known between the two world wars in the bohemia of Montparnasse; he died a victim of German extermination policies. Vilmos Perlrott-Csaba (1879–1954) was in his native Hungary a pupil of the Impressionist master Ivanyi-Grünwald before he came to Paris in 1906. A somewhat sober colorist, he reveals strength in his ability to combine color and draftsmanship as compositional elements so as to suggest space in an energetic though ornamental style.

Schwarz-Abryss (born 1905) is a painter whose obsessions and psychological peculiarities often hinder the expression of his perhaps limited but real talent. Born in the Tokay wine country of Hungary, he spent his childhood in utter destitution as one of the twelve children of a seasonally employed laborer. Still illiterate at the age of seventeen, he learned to read and write in six months, when he was sent to a sanatorium to be treated for tuberculosis. In 1930, he emigrated to France as a laborer, to work in steel mills. After a while, he began to try his luck at various other trades until he found congenial work as a house painter. Becoming self employed, he branched out into decoration, finally becoming an artist. In 1939, he exhibited for the first time in the Salon des Indépendants, painting in a style analogous to *Pointillisme,* but with heavier and larger touches of color, a technique which he called *Cloutisme.* Under the German occupation, he lived in hiding in a Paris psychiatric hospital, where he had undergone treatment previously, and developed a great interest in the art of the insane. In his novels, written in French, he has likewise expressed his interest in psychiatric problems, and has published a somewhat confused treatise on relativistic aesthetics. An Expressionist post-Fauvist, Schwarz-Abryss has won many admirers through the rhetorical brilliance of his rather superficial style, which relies on palette-knife effects and striking colors to suggest perspective and relief. He is at his best in landscapes, views of Paris suburbs, flowers, and still-life compositions.

Of the Hungarian painters of the School of Paris, Marcel Vertès (born 1893) is surely the most famous and most popular. After making his début as a cartoonist in Berlin, he settled in Paris, where he is now generally acclaimed as the somewhat commercial but witty and sensitive heir to the great traditions of Toulouse-Lautrec. In many of his drawings and watercolors, Vertès displays a scurrilous sensuality akin to that of Pascin, though generally tempered by a sense of sheer fashion that he has acquired from his vast experience as one of the most successful commercial artists of our age. Of much the same quality as Vertès though his style and his humor remain more essentially Parisian, Paris-born Maurice Van Moppès (born 1904) has come to the fore in recent years as a cartoonist, portrait-painter, and decorator.

Bulgarian like Pascin, David Peretz was born there in a Spanish-speaking Sephardic community. His great admiration for the work of Van Gogh has led him to paint landscapes, flower-pieces, and even self-portraits that are full of echoes in their draftsmanship,

composition, color, tortured fervor, and painterly technique of the great works of his Dutch prototype. In some of his still-life compositions, however, Peretz introduces elements derived from Jewish tradition and family life and is thus at his best when least inspired by Van Gogh. Another of the rare Sephardim among the painters of the School of Paris, S. Sinai (born 1915) was born in Smyrna and has also specialized in realistic descriptions of old-world corners of Paris, especially back-streets of the area of Saint-Germain-des-Prés. Among the more traditionalist Jewish painters of the School of Paris, Marie-André Klein (born 1901) was born in Paris of an old-established French-Jewish family, began studying sculpture, but discovered his real vocation when he met the painter Loutreuil, whose memory he celebrated in a collective portrait, *Hommage à Loutreuil*, that seeks to revive the practice of such works as Fantin Latour's famous *Hommage à Delacroix*. The great mural decoration that Klein painted in 1950 for the Paris Ecole Polytechnique reveals his mature technique as an artist capable of handling elaborate compositions on a very large scale. From his many trips to Spain, Morocco, and Madagascar, he has brought back a number of works that refrain from romantic exoticism but seek to stress the basic humanity of all that he observed. Another French member of the School, Dreyfuss-Stern (born 1890) tends to intellectualize reality in order to re-organize it according to a plastic architecture that relies mainly on patterns of line and color. In his later work, he has developed a greater sensitivity as a colorist. Roger Worms (born 1907) has likewise stressed color in his later work; he has been commissioned, in recent years, to execute murals for a large number of public buildings in France. André-Joseph Hambourg (born 1909) who was born in Paris of mixed Russian and Spanish parentage was one of the Free French Army's war artists during the Second World War and published his impressions of the campaigns in a volume, *From Algiers to Berchtesgaden*. A painter of seascapes, Hambourg has managed to recapture much of the delicacy of the 19th-century masters, especially in his treatments of skies, of water, and of mists.

A number of gifted women have achieved distinction as painters in Paris. Lou Albert-Lazard (born 1894) was born in Metz when this French city was German. After studying in Munich and associating with the *Neue Sezession* group there, she came to Paris and was influenced, at first, by the Cubists. A well-known figure in Montparnasse between the two wars and close friend of the German poet, Rainer-Maria Rilke, she has exhibited portraits of him as well as of Ghandi, Paul Valéry, Einstein, the poet Claudel, and other celebrities. Her lithographs remain perhaps her most distinguished contribution to modern art. In recent years, she has developed a more realistic style, stripped of the earlier influence of Cubism and of German Expressionism.

Marie Chabchay, formerly lecturer on the history of art and librarian in the Russian National Library, has helped establish and organize the Jewish Museum in Paris and has exhibited regularly since 1934 as a painter of almost naïve compositions, treated with a minute care that situates her work on the borderline between Realism and Surrealism. Maxa Nordau, the daughter of the philosopher Max Nordau, was a pupil of the Realist master Jules Adler and has remained faithful to his teachings, excelling in portraits of famous personalities. Ida Mordkin (born 1884) was born in Russia, and studied music in order to be a singer, until she married the painter Abrami, whose pupil she became. After exhibiting with him in Vienna, Prague, and Brussels, she settled in Paris in 1929, and continued to work with him until he was deported and murdered by the Germans.

Fig. 264

Whereas the work of Abrami Mordkin eschewed stylization and, especially in portraits and landscapes, developed a kind of realism that is tempered by Fauvism, the work of his wife has developed a very feminine and almost naïve style that she uses effectively in landscapes, interiors, portraits, and flower-pieces. Sara Voscoboinic is another woman-artist who, though born in Bessarabia and educated in Palestine, has rapidly acquired in Paris a specifically French style since 1951. Her work soon attracted the attention of French critics because of its very feminine and decorative qualities. Originally a somewhat somber expressionist artist, mainly in portraits and figurative compositions, she has developed in France into a painter of delicate and cheerful landscapes and flower-pieces.

V

In spite of the sweeping allegations of certain anti-Semitic or reactionary critics, who consider that this could have been a reproach, the direct participation of Jewish painters in the early activities of Cubism was very slight. The leaders of the movement — Picasso and the rest — were all Spaniards or Frenchmen; before 1930 only a handful of persons attracted attention in Paris as Jewish painters of the Cubist or post-Cubist schools.

Louis Marcoussis (Markus) (1883–1941), came from a well-to-do and somewhat assimilated middle-class Warsaw home and studied art in his native city before coming to Paris in 1907. At first, he underwent the influence of the Impressionist masters, but found his true style of expression after his discovery of Cubism. Between the two wars, *Fig. 265* he achieved a considerable reputation both in Paris and abroad, though his premature death precluded his witnessing the fame that he now enjoys.

Before 1914, Marcoussis had earned a living as an illustrator in Paris comic magazines such as *L'Assiette au Beurre* and *Le Rire.* A decorative style that owes much to the "modern style" of the turn of the century characterizes these early lithographs. Later, he also produced fine etchings that are now prized among the best examples of Cubist graphic art. An exquisite craftsman, Marcoussis enriched the Cubist tradition by bringing to it a quality of taste and of technical refinement that endows all his work with a rare poetic quality. His colors, in particular, are always fresh and youthful, those of a newborn world that renews itself from day to day.

Henri Hayden (1883–1970) was also born in Warsaw, of a prosperous middle-class family. In 1905, he abandoned his **ambitions** as an engineer to concentrate on painting. In 1907, he came to Paris, discovered the new trends in modern art and decided to start afresh. His instructors in Poland had been academic disciples of the German school; in France, he began to study the work of Cézanne. In 1916, he came into contact with the dealer Léonce Rosenberg, who encouraged him throughout the ensuing years. Hayden's *Three Musicians,* painted in 1919 and now in the Paris Museum of Modern Art, remains *Fig. 269* one of the masterpieces of this great period of Cubism. In 1922, Hayden reverted to a more naturalistic style, concentrating mainly on still-life compositions, then on landscapes in which he sought to develop a style as an open-air painter. Until 1949, he continued to experiment in this manner, often somewhat desultorily. During the war years, the Germans looted his Paris studio, so that much of his earlier work is now lost. Since 1949, however, he has returned to his earlier Cubist manner, developing it in a new style of still-life composition in which he excels as an unusually refined and sober artist.

245

One of the most unjustly neglected innovators in modern art is Alfred Reth (born 1884). His early training in Hungary had been strictly academic, but he affirmed his own temperament at an early age by developing a realistic style that eschewed all affectation. In 1904, he came to Paris and soon developed, almost independently, a Cubist style of his own. His early experiments thus coincided with those of Picasso, to whom Reth was never much indebted. Inspired, as Picasso, by Cézanne's later manner, Reth produced, in 1907 and 1908, a number of fine watercolors that reveal a remarkable sense of space; and his nudes and portraits of before 1914 give proof of outstanding maturity. In his recent *Harmonies des Matières,* he has tried to combine in a technique similar to that of collages, a number of unusual materials which he juxtaposes in his paintings: coal-grit, fragments of ceramic, plaster, paper, etc.

After Levy-Dhurmer, Henri Valensi (born 1883) is the first outstanding Jewish painter to hail from French North Africa. Born of a leading Algerian-Jewish family of merchants and professional men of partly Italian extraction, he studied art in Paris, but considers himself, as far as his style is concerned, mainly self-taught. An original theorist in the field of aesthetics, Valensi has lectured and published extensively. After his academic training and a brief Impressionist period, he became, around 1910, one of the pioneers of abstract art, formulating the theories of the Musicalist school as well as the school now known as *Ciné-peinture,* which has sought, somewhat like the Italian Futurists, to develop an art of a dynamic rather than a static nature, suggesting movement rather than poise. Valensi believes that the plastic arts must accept the norms of music, "the most scientific and dynamic of the arts." Abstraction, according to his theories, requires subjecting painting, in its forms and colors, to the laws that govern the rhythms and harmonies of music.

After studying art in Germany, Sonia Delaunay Terk (born 1885) came to Paris as the wife of the German collector and critic Wilhelm Uhde. At first, she was influenced by Gauguin and the Fauvists. After her divorce, she married the Cubist painter Delaunay, founder of Orphism, and became a leading theorist among the experimental abstract artists of the Paris School. In her native Russia, she had already associated with some of the future masters of the ill-starred Russian modernist movement, painting compositions where the spaces of plain color were framed in dark outlines. Her designs for theatrical costumes and sets, her hand-woven fabrics and her tapestries were well-known before; in 1953, she surprised the Paris art world with her first retrospective show, a survey of her entire career as an initiator of experimental movements.

Another neglected innovator among the masters of the School of Paris is Otto Freundlich (1878–1943). Born in Pomerania, he experienced an unhappy childhood and developed early in life a hardness of hearing which contributed towards making him somewhat unsociable and retiring. After first studying art history he felt the urge, at the age of twenty-seven, to become a creative artist. In 1908, he moved to Paris and devoted the rest of his life to a long series of experiments in purely two-dimensional painting, eschewing in almost all his works the "illusionist" devices, such as a perspective and *chiaroscuro,* *Fig. 266* which might give his surfaces the appearance of containing a third dimension.

In 1914, Freundlich returned to Germany. In wartime Berlin, he was active in the *Aktion* and *Sturm* groups, among artists and writers who were mainly pacifists. Many issues of *Die Aktion* and of other wartime publications of the German capital's pacifist and leftist intelligentsia contain illustrations and vignettes by Freundlich. At the same time, he began

to experiment with mosaic and stained glass, having already, as early as 1909, tried sculpture as a medium which, by its very nature, implies a legitimate third dimension. In 1924, Freundlich obtained permission to settle in France again and as an artist specialized in mosaics and stained glass and became active in a number of abstractionist groups and movements. During the German occupation of France, he was arrested and deported to the Lublin-Maidanek extermination camp, where he died. Since 1946, a number of Paris galleries have sought to revive an interest in his work, which is slowly gaining recognition. Haunted from the very start by Platonic consideration of the relationship of truth to beauty and of art to nature, Freundlich painted, except for a few figurative compositions that are mainly allegorical or self-portraits, only constructive two-dimensional arrangements of irregular patterns, broken up in flat patches of bright contrasting colors or of graded shades of the same color, ranging from the palest blues, for instance, to the darkest blue-blacks. One of his early sculptures was reproduced in 1934 as the cover-design of the pamphlet-catalogue for Hitler's traveling exhibit of so-called "perverted art." Valensi and Freundlich deserve to be remembered among the true founders of the abstract tradition in contemporary art.

Marcelle Cahn (born 1895) is another Cubist of the Paris School who received part of her early training in Germany. Born in Strasbourg, she was a pupil, at first, of the great Berlin painter Lovis Corinth, and then in Paris, of the Nabi painters Maurice Denis and Sérusier, and of the Fauvist Orthon Friesz. Only after meeting Léger and the Purist master Amédée Ozenfant did she truly find her style. Her Cubist period thus began as late as 1926, but her art in recent years has remained faithful to the rigorous traditions of Purism, a post-Cubist school that makes a minimum of concessions to non-compositional values.

Fig. 267

Nechama Szmuszkowicz (born 1895), another Purist painter, was born in the Ukraine. After escaping to Poland, in the early years of the Revolution, she worked in the applied arts, especially as a maker of puppets, and exhibited in Berlin in Herwath Walden's *Sturm* gallery. Later, she moved to Paris, where she worked under Léger and Ozenfant. Her Purist compositions have a rare lyrical quality that suggests, in spite of their carefully composed architecture, an almost naïve temperament. In recent years, she has worked steadily on a monumental *Haggadah,* etching the illustrations and even the text as an act of piety inspired by her surviving the Nazi persecutions in occupied France. The Russian Serge Charchoune (born 1888) began to attract attention in Paris as one of the leaders among the Dadaists. Later, he was influenced by Ozenfant's Purist theories and also by Cubism. A strangely modest artist, Charchoune paints works that do not lend themselves easily to photographic reproduction. Painted in white on a white background, some of his works, for instance, suggest the forms of objects by the differentiated texture of his brush-strokes rather than by outlines or contrasts of color. In recent years, he has often sought to interpret, in his paintings, what he experiences when he listens to some of the great musical classics. Recent works of Henri Berlevi (born 1894), so soberly realistic, would never lead one to suspect that he has been, in the past, an active propagandist for some of the most advanced styles of modern art. Born in Warsaw, he studied there and in Antwerp, before completing his studies in Paris. Here he associated with the more modern painters, but then found his way back to Poland, reverted there to a study of the ancient masters, and played an active part in Polish artistic life. After a while, his restless spirit led him to Berlin, where he exhibited some abstract compositions in Walden's *Sturm* Gallery. Returning to Poland in 1924, Berlevi founded there, with a few

friends, the *Blok* group of Polish abstract artists and launched a style known as *Mechano-Faktura* or "mechanical painting." In 1928, again driven by his *Wanderlust,* he moved to Paris where, since 1947, he has painted increasingly realistic still-life compositions of the kind that, in America, are known, because of their *trompe-l'oeil* effects, as "magic realism." Berlevi remains, perhaps as a consequence of his many changes of style, an important and controversial figure in the modern art movement, especially in Poland, rather than a leading painter of the School of Paris.

Though no longer a Cubist, Kiev-born Jacques Païlès (1895) has retained, in the style of his maturity, many elements inherited from his earlier Cubist manner. In still-life paintings, landscapes, portraits, figures, and numberous scenes of circus life, including portraits of clowns and acrobats, he has developed a strong and virile style, relying mainly on solid draftsmanship and composition and on a limited range of carefully selected and *Fig. 268* powerful colors. His original interest in sculpture can still be detected in the almost architectural structure of his compositions, with their horizontal and vertical arrangements of elements of color that suggest depth and relief.

Already as a child, Jacques Chapiro (born 1897), son of a regimental cabinet-maker in the fortress of Dunaburg in Russia, revealed a taste for drawing, so that he ran away from home at the age of ten to study art independently. In Yalta, he worked as a model and a street-sweeper while preparing his sketches for a competition to decorate a Russian Orthodox basilica. He won the competition and, after the Revolution, lived in Moscow and Petrograd. He collaborated with Vachtangov in the production of *The Dybbuk,* remaining deeply influenced by this great director's art and temperament. His style meanwhile developed from Cubism and Constructivism towards a more realistic manner, and he became a member of the "World of Art" group, remaining active for a while among its younger painters. In 1925, however, he settled in Paris. Developing a passionate and discerning taste for French painting, he underwent a gradual but deep transformation of his whole style; it was only in 1949 that he finally revealed himself, in an outstanding *Fig. 271* one-man show, as an important new master of the School of Paris.

Born in Paris of immigrant parents, Gabriel Zendel (born 1906) worked for a while at the Paris Institute of Aesthetics. A post-Cubist with a typical French sense of taste for texture *Fig. 270* as well as for composition and carefully selected color-harmonies, Zendel has developed a personal though somewhat limited style, mainly in still-life compositions and landscapes. A painter's painter, he has been highly praised by discerning critics and already exerts a considerable influence on some younger artists.

Chapoval, whose real name was Chapovalski (1912–53), was brought to France from Kiev in 1919 as a child and studied medicine for a while before deciding that his true vocation was painting. At first a figurative painter who delighted in somewhat surprising and poetic arrangements of unexpected objects, he became increasingly abstract as he matured. At the time of his sudden and early death, he was already considered one of the masters of the post-war School of Paris.

Like Zendel and Chapoval, Georges Arditi (born 1914), though a cousin of the remarkable German writer Elias Canetti, is an unmistakably French painter. Born in Marseilles of Sephardic parents from the Near East, he was sent to Paris, at the age of seventeen, to study at the School of Decorative Arts, where the instruction disappointed him so much that he abandoned it to study painting on his own. An extremely modest and very intellectual painter, Arditi has distinguished himself as a creator of carefully conceived

portraits and still-life arrangements, as well as landscapes, remarkable for their sound *Fig. 272*
composition and clear and balanced color harmonies.

Georges Goldkorn (born 1908) originated in a Hassidic community in Poland and was a Talmudic student until he decided, at the age of eighteen, to become a painter. He left Poland in 1928 and, after studying art in Belgium, fled to France in 1940 and joined the French Resistance. Since the war, he has attracted attention as an interesting innovator in the post-Cubist idiom. In 1955, he began to paint abstract compositions. Goldkorn's monumental figures, posed with a delicate sense of architecture, are painted in clear colors that contrast strikingly with the somewhat heavier outlines that stress his construction. A fine graphic artist, he has etched a series of remarkable plates inspired by the cultural history of the Jews of medieval Spain.

The contribution of Jewish artists to the earlier style of Parisian Dadaism and Surrealism remained very slight. Marcel Janko had indeed been a leader among the original Zürich Dadaists, and Baargeld is mentioned in a number of early surrealist manifestos. Mereth Oppenheim also attracted attention in Paris, around 1930, when she painted the famous picture of the fur-lined cup, which remains one of the commonplaces of Surrealism.

One of the most important Surrealist painters of the Paris School is Rumanian-born Victor Brauner (born 1903). After an earlier period in which he concentrated on depicting his own nightmares in a relatively realistic style, Brauner has developed a broader interest in myths which he interprets as the collective dreams of humanity. His style, as a consequence of his studies of psychology and ethnology, tends now to assimilate, with an eclecticism guided by great technical proficiency and rare taste, a great number of iconographic and decorative elements derived both from the art of primitive peoples and from the painting of children or the insane. All these are integrated, however, by his fine *Fig. 273*
draftsmanship, sound composition, and rare sense of color. His colors, in recent years, have generally been bright, juxtaposed in flat patches without effects of perspective, of shadow, or of relief. In many respects, he thus continues in the tradition of flat Cubism, though a calligraphic element, derived from the art of Aztec manuscript-illuminations and similar primitive arts, often enlivens his paintings with decorative effects that are almost caricatural. A peculiarly wry humor adds an anecdotic element to many of Brauner's compositions which would otherwise be almost abstract as representations of animals and of human figures.

After being very active among the Rumanian Surrealists in Bucharest, Jacques Herold (born 1910) has come to the fore as a Paris Surrealist since the Second World War. Though generally grouped with the Surrealists on account of his interest in the subject-matter of dreams, Herold has developed a technique that reveals his concern for problems of pure painting as well as surrealist topics. By breaking up his forms into patches of bright colors, following a technique analogous to that of *Pointillisme* but using larger units of color, he has formulated a style that achieves effects similar to mosaic, relying in each picture on a very narrow range of colors and often limiting himself to different shades of the same color or of two or three colors.

Among the post-Surrealists is the American painter Dan Harris who signs his work with the pseudonym Zev (born 1914). His fantastic drawings, paintings, and sculptures, the latter sometimes colored as brightly as some of his oils, offer us a derisive parody of the adult world as viewed by children. Gifted with a court jester's sense of caricature, Zev

has developed, in his Paris years, a more painterly technique and a range of colors that is less immediately decorative than in his earlier work exhibited in America.

The work of Esther Carp cannot easily be placed in any of the existing categories of the School of Paris. Born in Poland, she has now lived many years in France, and assimilated certain techniques of Italian Futurism as well as compositional elements derived from French Cubism. In her nearly abstract compositions, by breaking up her colors in patches analagous to those of *Pointillisme,* she achieves an entirely different purpose, actually suggesting movement or even stereoscopy. Her landscapes, still-life compositions, interiors with figures, and street scenes are always the fruit of elaborate preliminary studies and seem to depict a dreamworld that remains very personal.

VI

Most of the painters of the School of Paris have, in the past few decades, been sociable and gregarious, inclined to work in groups that have a style or an ideology in common. Few of them, like Modigliani or Chagall, have created a distinctly personal style or, like Soutine, been legendary recluses. Some artists of the School of Paris can, however, be classified under its various headings only with great difficulty. Russian-born Eugène Zak (1884–1926), for instance, who settled in Paris only in 1922 (four years before his death) remains a somewhat solitary figure, in spite of his affinity with the early Cubists. Almost pre-Raphaelitic in his reverence for Italian painting of the early Renaissance, Zak is yet a modern in his idealized stylization that reflects the influence of musicians, mountebanks, and other dreamlike characters. Zak has systematically idealized everything that *Fig. 274* he painted. Among younger Paris painters, Bella Brisel (born 1930), who was born in Jerusalem, seems to have chosen to depict a similar dreamworld, though her figures, less sculptural in their design, are more reminiscent of the ikons of Russian art. Another Israeli painter of the School of Paris, Sioma Baram (born 1919), has also specialized in depicting a world of legend and of fables, especially of birds and animals, stylized in a very decorative manner.

The poet and painter Max Jacob (1876–1944) was born in Quimper, in Brittany, and distinguished himself, in the group of which Guillaume Apollinaire was the leader, as one of the most disconcertingly witty and imaginative French poets of our century. In 1950, the Paris Museum of Modern Art named one of its rooms after him, exhibiting permanently a number of his gouaches and oils. Converted to Catholicism, Max Jacob generally painted religious scenes; miracles, in particular, seemed to fascinate him. Sometimes naïve, he is yet an accomplished draftsman, and his work is inspired both by a profound faith and a weird sense of humor. Arrested by the Germans during the occupation of France, he was removed from the monastery where he had lived many years in retirement, and died in the Drancy concentration camp near Paris. Devout French intellectuals have said that miracles occurred at his tomb, and there is a movement afoot to obtain his beatification in Rome.

Another curious recluse was the painter and engraver Balgley (1891–1934), who was born in Brest Litovsk and came to Paris before the First World War. For many years, he was one of the poorest, most retiring, and most eccentric of the painters in the art colony of La Ruche. After 1920, he gradually achieved fame through his fine etchings and woodcuts, in which he expressed hauntingly a great sense of pity for the suffering of humanity, especially in his various illustrations of the themes of the *Misfortune of the People,* of

War and Peace, of *The Book of Job,* and of *The Life of Man.* In a big retrospective show held in Paris in 1955, many critics and collectors were surprised by the remarkable quality of many of Balgley's earlier paintings, which reveal a sensitive poetic fantasy analogous to that of Chagall, but haunted by a despair that bears comparison with that of Soutine.

Frenel, known also as Frenkel (born 1898), was perhaps the first Palestinian-born painter of the School of Paris. After studying in Paris he returned to Palestine when it was still a British Mandate, and began to form there, through his own work and his teaching, a truly indigenous school of painting. He was thus the teacher of a number of distinguished Israeli painters, revealing to them the principles of French painting and weaning them away from the more academic influence of Russian schools and of the School of Munich. Returning to Paris after the Second World War, Frenel now exhibits there regularly, offering in his work a remarkable synthesis of Jewish spiritual traditions and of French techniques. His views of Safad and his studies of Jewish religious types reveal his profound attachment to a certain Jewish mysticism.

The work of J.D. Kirszenbaum (1900—54) also defies any attempt at classification under the usual heading of the School of Paris. The son of a rabbinic scholar at Staszow, Poland, he began to paint signboards for local tradesmen at the age of twelve. At the age of seventeen, with a limited training as a craftsman, he emigrated to Germany, working there at first as a laborer, then as an illustrator and cartoonist for a number of Berlin papers, under the pseudonym Duvdivani. In 1933, he came as a refugee to Paris. Kirszenbaum began to work in Paris with a kind of desperation, handling especially Biblical themes, including representations of prophets whose appearance is as ghostly as that of the figures of El Greco. During the German occupation, Kirszenbaum went into hiding; his studio was ransacked and looted, most of his work destroyed, his wife arrested, deported, and murdered. After the liberation of France, Kirszenbaum resumed his work, remaining extremely productive until his unexpected death. It was Kirszenbaum's intimate belief that a writer can be a poet and a prose artist, and that abstract art is the poetry of painting. Though the Eastern European Jewish sources of his inspiration are often *Plate 45* obvious, his style was always that of a disciple of Western European art and of the schools that had undergone the influence of French Impressionism; in addition, he had absorbed the influence of German Expressionism. A true perfectionist, he had thus achieved a remarkable synthesis.

His work, especially after the war, was always haunted by elegiac recollection of things past. Gifted with an unusual pictorial memory, he was able to reconstruct the scenes and settings of his childhood, bringing back to life the villages where he had lived and the men he had known there. Such a memory is like a machine for exploring time, and Kirszenbaum was thus able to resurrect the prophets of the Old Testament, as well as the works and days of an entirely vanished world. The melancholy mood of his reminiscences was enlivened, however, by touches of humor. His trip to Brazil, after the devastating experience of the war years, gave his art a new lease of life, allowing him to rediscover, if only vicariously, something of the original sources of his inspiration. He now seemed to recapture some of the mystery and mysticism of vanished Eastern European Jewry, transforming the monstrous idols and grotesque figures of Rio de Janeiro's carnival into traditional Purim figures, its riotous joy into festivities he had known in his own childhood. *Fig. 275* The paintings that he produced now and on his return to Paris still express the profound

religious nature of his talent, even if the subject-matter of these later works is no longer immediately religious.

Michael Aram, whose real name is Michael S. Gottlieb (born 1908) was born in the Ukraine, achieved success in Germany as a designer of theatrical sets and costumes, and in 1932 emigrated to Palestine, where he continued to work for the theater, mainly for the Ohel Theater company. In 1946, he settled in Paris. Alternately a figurative and an abstract artist, Aram reveals, in some of his works, an almost surrealist quality. His figurative works include some strikingly realistic portraits, both paintings and drawings, as well as some views of Paris rooftops seen from his windows. His more abstract works include some brilliant examples of improvised draftsmanship as well as some extremely free *tachiste* compositions. In his magic-realistic *trompe-l'oeil* compositions, he has also revealed some curious aspects of a truly personal dreamworld.

Though Arthur Kolnik (born 1890) has lived in Paris since 1931 and has exhibited extensively, he is still mentioned but rarely in discussions on Jewish art and certainly deserves to be better known, if only because the quiet and the poise that characterize his traditional types and scenes of Galician Jewry contrast so significantly with the turbulent fantasy of Chagall's Russian Jewry. A faithful chronicler of the now vanished world of the Jews of former Austrian Galicia and Bukovina, Kolnik has recorded its types and atmosphere in paintings, remarkable for their dignified composition and their sober color-harmonies, as well as in his more widely known woodcuts and etchings.

The work of Simon Segal (born 1898) may soon be generally recognized as a contribution to the art of the School of Paris as valuable and original as those of Soutine and Modigliani. Born in Bialystok, Simon Segal is entirely self-taught. Between 1918 and 1924, he was in Berlin and Vienna, where he associated with writers, painters, and circus artists and began to paint his first canvases in a somewhat Expressionist style. In 1923, he came to Paris, worked for a while as a laborer in the Citroen automobile factories, but returned to painting as soon as he could and settled in Toulon. In 1935, Segal painted and exhibited in Paris a series of thirty admirable gouaches entitled *Visions of War;* on the day of the opening of the show, a well-known American collector strolled into the gallery by chance and purchased the entire exhibition. Assured of some financial security, Segal gradually began to develop an increasingly personal style. Segal remains fundamentally a painter

Fig. 276 of rustic types and scenes, of fisher-folk, of the life and surroundings of the simple-hearted and the poor. The men, women, and children whom he portrays are treated in a style that reminds one of the drawings of children or the sculptures of unsophisticated craftsmen. His still-life compositions likewise reveal the utensils that characterize the home-life of poor farmers and workers, such as a very ordinary kitchen-range, and his animals are those that share man's toil and provide him with his sustenance. Segal has thus created a world of his own that no longer bears any trace of the preoccupations of his colleagues in contemporary metropolitan centers. His actual painting, however, is extremely sophisticated in its blending of colors, its brushwork, and texture. The least figurative of abstract Expressionists might indeed learn from Segal, who is most subjective when most objective, most abstract when most figurative.

VII

Around 1930, a reaction began to be felt among certain painters of the School of Paris against the intellectualism and the formalism that characterize much of modern art,

especially since the birth of Cubism, Dada, and Surrealism. It was felt that art was tending to neglect certain human values which characterize the works of the great masters of the past, above all those of the Italian Renaissance, and that the human figure should more frequently constitute the main focus in the subject-matter of a painting. Among the leading painters of this new group, known as Humanist in Paris and neo-Romantic in America, the leaders were Eugène Berman and Victor Tischler, both of them Jews; Léonid Berman, Joseph Floch, Josiah Victor Adès Paul Eliasberg, Benzion Rabinovitch, generally known as Benn. George Merkel and Jacques Zucker are also among its outstanding representatives. The Humanist group can thus be said to have indeed been the school of modern painting which included the largest percentage of Jewish talents. These Jewish painters of the Humanist or neo-Romantic school have distinguished themselves, moreover, by generally being men of outstanding culture and taste, sons of well-to-do parents who encouraged their children to develop an interest in art, music, and literature.

Eugene Berman (born 1899), for instance, was the son of a very prosperous Saint Petersburg banker who played an active part in the cultural life of the Tsarist capital. In 1919, Berman emigrated to Paris, where the family settled in a palatial residence still haunted by the ghosts of Proustian characters who had been frequent guests there. Berman began to study painting in Paris and traveled extensively in Italy; deeply influenced by his memories of Italian landscapes and of the works of the masters of the Seicento, he held his first show with a group that included Bérard, Chelichev, and his own brother Léonid. This was the first public appearance of the Humanist or neo-Romantic school. In 1937, he emigrated to America, where he settled in Hollywood. His influence on younger American artists has been considerable, and his success in America, especially as a designer of theatrical costumes and sets and a creator of extremely distinguished advertising designs has been quite spectacular. A manneristic painter of perspectives and landscapes in the Italian tradition, Berman has returned to a classicist conception of the world as a theater for man's actions, however puzzling these may seem. *Fig. 277*

The painting of Eugéne Berman's brother, Léonid (born 1898) differs from that of Eugene in that he seeks inspiration from the illuminated manuscripts of the late Middle Ages rather than from the Italian masters. Léonid has thus developed a microcosmic quality, in his vision of the universe, that brings out in his art his affinity with that of certain great miniaturists; in his views of the countryside or the seashore, human figures play a less important part than in the landscapes of Eugène. The work of the Viennese Tischler (1890–1950), who moved to Paris in 1928 and became an outstanding master among the young Humanist painters, is that of an aristocratic personality and man of exquisite taste. In his native country, he is beginning to be appreciated as one of the major Austrian painters of the first half of our century. Haunted by the dream of a kind of painting that would be both traditional and novel, he admired Cézanne for the noble proportions of his composition rather than for his innovations. In his own landscapes of French or Italian gardens and his views of cities, Tischler stressed the domesticated aspects of nature as it appears when inhabited and transformed by man. Like Tischler, his fellow-Viennese Joseph Floch (born 1895), who now lives in America, tends to stress the traditional aspects of art, especially his debt to Poussin.

In some respects an heir to the Romantic traditions of the German painters who worked

in Rome in the early decades of the 19th century, Floch seeks to communicate the more noble aspects of the world that he depicts. His figures have a meditative quality that he frequently brings out by depicting them in the act of reading, or else in quiet discussion. His interiors, in this respect, communicate an atmosphere of culture and intellectual refinement. Cairo-born is Josiah Victor (Joe) Adès (born 1893). Gifted with a natural facility as a draftsman, he began to draw as a child, astonishing his family with his ability to observe and to reproduce from memory. Profoundly influenced by the monumental art of ancient Egypt and by its spiritual qualities, he then underwent an Impressionist influence, too. After completing his law studies in Paris, he returned to Egypt to practice law, but in 1922 settled in Paris to devote all his time to painting. His portraits of women often have a visionary quality which they share with those of some painters of the Romantic era.

Plate 44

It is important not to confuse Benzion Rabinovitch (born 1905), who signs his works with the pseudonym Benn, with the American painter Ben Benn. The former, who was born in Bialystok, and studied first in Warsaw, then in Paris, seeks his subject-matter in a world of personal fantasy, in Jewish tradition, and in nature. He insists that a work of art must express some quality of human sentiment and that arbitrary play of colors and lines cannot lead to a valid picture. In his larger compositions, he has developed a curious affinity with the *pittura metafisica* of certain other Italian painters. Like curious pantomimes, these compositions depict scenes enacted by dreamlike figures in an otherwise deserted stage, in a purely imaginary world. Unlike the painters who have directly participated in the Humanist or neo-Romantic movement, Grégoire Michonze (born 1902) has sought inspiration from the Flemish masters, especially Breughel and Bosch, rather than from the Italians. Coming to Paris from Rumania in 1922, he worked for a while in complete solitude and refrained from exhibiting. In 1924, he began to associate with the Surrealist poets and painters, but without subscribing to their doctrines. His somewhat manneristic compositions are like charades imagined to illustrate fables and parables from popular sources, though their actual meaning often remains obscure. Extremely modest, Michonze seems to avoid attracting attention and his work has not yet been fully appreciated.

Fig. 278

Fig. 280

The New York painter Reginald Pollack (born 1924) has lived since 1948 in Paris, where he soon developed a remarkable awareness of the more specifically French aspects of the tradition of the School of Paris. Entirely self-taught, he has acquired a certain calligraphic quality of draftsmanship and composition from the work of Raoul Dufy, a sense of color and spacing from that of Matisse, and a lyrical and intimate quality from the interiors of Bonnard. He tries out many of his compositions as etchings before treating them on a larger scale and in color on canvas. An interior, with a window that opens onto a landscape, is a typical Pollack composition. Married to the Israeli-born painter, Hanna Ben Dov (born 1919), Pollack often chooses the same subjects as his wife; whereas she tends to treat these subjects in muted color harmonies and with *sfumato* effects that soften all her outlines, Pollack uses brighter and more cheerful colors and stresses some of his outlines in a playfully decorative calligraphy.

VIII

A number of different schools of abstract or non-figurative art seem to have exerted an extraordinary appeal, since 1945, on many of the younger Jewish painters of the School

of Paris. Several old painters, too, have abandoned their previous styles in order to express themselves exclusively in the new manner which, in recent years, has been so widely publicized on both sides of the Atlantic. Known as *Tachistes,* Abstract Expressionists, non-formal or non-figurative painters, the artists who belong to these various schools have generally developed great technical skill in their texture and their use of line or of color, so as to compensate for whatever their art may have lost by avoiding any figurative subject-matter. Among the leading theorists of this general trend, particularly significant from the Jewish point of view, is Odessa-born Philippe Hosiasson (born 1898). At first a Cubist and a Parisian disciple of Chirico's *pittura metafisica,* Hosiasson became, after the war, an active promoter of non-formal abstract art, the kind of art that is generally called *Tachiste,* or Abstract Expressionist. Among Jewish painters of the School of Paris, he has distinguished himself by probably being the only one to justify his choice of abstraction in terms of the traditional religious veto on figurative art; his work might thus be interpreted as a kind of regression, after the era of emancipation, from a literal interpretation of the second commandment. In terms of Freudian analysis, this regressive quality is moreover in keeping with the nature of Hosiasson's composition and color-harmonies. Léon Zack (born 1892) is another recent convert to non-formal abstract art, as well as to Catholicism. Born in Nijni Novgorod, he painted in Paris between 1930 and 1939 extremely spiritualized figures, in the general tradition of the Humanist School. Since 1945, he has been strictly non-figurative, but his non-formal compositions have retained a painterly quality that is rare among the younger artists of the new school of which he is a recognized master.

Kolos-Varis is the pseudonym of Hungarian-born Zsigmond Kolozsvari (born 1889). Though he has illustrated a fine *Haggadah* some years ago, Kolos-Varis has generally tended away from his original Expressionism towards Cubism and ever more abstract forms of art. In his recent *Tachiste* paintings, he has distinguished himself from most of his colleagues by the cheerful contrasts achieved in the irregular patches of bright colors of which his compositions consist. Other *Tachistes,* or Abstract Expressionists, of Hungarian origin who have recently achieved a certain reputation in Paris include Paul Kallos, George Feher, and Agathe Vaito. As colorists, however, these Hungarian painters seem to prefer clearer and brighter harmonies and to distinguish themselves as virtuosos of the kind of "pure painting" that relies exclusively on exquisite color and texture.

One of the most outstanding and distinctive abstract painters of the School of Paris is Jean Atlan (born 1913), who was born in the ancient Jewish community of Constantine, in Algeria, and studied philosophy in Paris before the war. Spending the years of the Nazi occupation in hiding in the same Paris psychiatric hospital as Schwarz-Abryss, Atlan developed his interest in painting. Both his calligraphic composition and his colors hark back to the decorative traditions of North African non-figurative art, which he has stripped of its folkloric and craftsmanlike quality and translated into terms of a metropolitan and individualistic culture.

Fig. 279

Marcel Polak was born in Amsterdam in 1902 , lived in hiding but continued to paint during the German occupation, and in 1948 settled in Paris. Primarily a non-formal abstract painter, Marcel Polak suggests in his work the surfaces of stones, the geology of volcanic craters, the structure of clouds. His color-harmonies are extremely subtle; he has specialized in gouache, collages, colored inks, and colored crayons.

Lutka Fink was born in Warsaw (in 1916), where she was encouraged as a child, in

spite of the *Hassidic* traditions of her family, to develop her natural artistic gifts; at the age of seventeen, she exhibited under the sponsorship of the Polish Government. She settled in France in 1936 and absorbed at first various Fauvist influences. Encouraged by Picasso, she began to mature slowly, becoming a non-figurative artist at the time of her two-year visit (1950–1952) to the United States. Her more recent work has a nebulous quality, with rare forms seeming to crystallize out of her iridescent backgrounds.

A young painter who is an utter stranger among the Eastern European or American-Jewish artists of Paris, Albert Avram Bitran was born in Istanbul (in 1931), studied architecture in Paris, and began painting there in 1946. He soon developed a non-figurative style of his own, in which his generally somber patches of color suggest architectural forms. He seems to eschew outlines, however, and concentrates on achieving effects of extreme antiquity in his surfaces that imitate those produced in works salvaged in the course of archaeological excavations.

An important group of younger American abstract or non-figurative painters, mainly of the so-called "drip and drool" school, has attracted considerable attention in Paris in recent years. Many of these young painters are of Jewish origin: Sam Francis, Don Fink, Sam Spanier, Oskar Chelimsky, Norman Blum, John Levee, Allan Zion, among others. John Levee, in particular, has already developed a personal style, though he still owes many of his more strikingly painterly effects to Nicolas de Staël. Oskar Chelimsky, like most of these younger American non-figurative painters of the School of Paris, concentrates almost exclusively on achieving unusual and almost sculptural effects; he has been known to boast that the color on some of his canvases is ten centimeters thick. The effectiveness of the work of many of these younger non-figurative painters is marred by its striking similarity to certain kinds of commercial art, especially to designs for textiles. Because so many of these young American painters justify their style by claiming the Californian painter Mark Tobey as their master, they are frequently referred to as the School of the Pacific Coast. What elements of design appear in their work are supposed to suggest the same aesthetic quality as Chinese writing, but without the ideogrammatic meaning which, in the eyes of a Chinese art-lover, constitutes one of the basic elements of Oriental calligraphy.

IX

Many were the Jewish artists of the School of Paris who were deported and killed by the Germans during the occupation of France between 1940 and 1944. A selection of their work was shown in Paris in an outstanding commemorative exhibition. Though their styles and importance vary considerably, it is perhaps desirable to speak of them together here, in a separate section.

Outstanding among them was Adolphe Feder (1887–1943), now remembered above all as a brilliant colorist. Born in Odessa, where he first studied, he settled before the First World War in Paris. Soon his studio became a meeting place of artists and writers from all over Europe and America. The party which he gave in 1923 in honor of the Soviet poet, Mayakovsky, was long remembered in the annals of Paris bohemia. Feder had been one of the first to collect African sculpture and Ethiopic paintings, and his judgment and taste were famous among dealers and collectors. In 1929, he traveled to Palestine, bringing back a number of works and sketches which attracted much attention. He was deported

and murdered by the Germans during the occupation of France, before his work had yet received the acclaim that it deserves.

Another outstanding artist among the Nazi victims was Henri (Chaim) Epstein (1891–1944), who, born in Lodz, came to Paris after studying in Munich, and soon became a familiar figure in the circle of Modigliani and Soutine. A painter of landscapes, of the peasants at work in their fields, and of still-life compositions that are redolent of nature, he can truly be said to have continued in the great tradition of Camille Pissarro, which he assimilated and tempered with elements of style that he shared with his friends of the Fauvist and Cubist schools.

Other Nazi victims, some of whom had done no more than hint in their work at their potential genius, must be mentioned more briefly. Abrami Mordkin from Yekaterinoslav (1874–1943) has already been mentioned above, as were the Cubist master Otto Freundlich and the painter-poet Max Jacob.

George Ascher, originally of Warsaw (1884–1943) who came to Paris in 1925 after having fought in the Polish campaign of liberation, has left us some delicately composed landscapes. Jacques Gotko (1900–43) emigrated as a child from Russia to France with his family, and became a fine draftsman and water-colorist. Samuel Granovsky, born in Yekaterinoslav (1889–1942) worked at first in Paris as an artist's model while studying art. In 1912, his rather frank self-portrait caused a sensation in the Salon d'Automne. A colorful figure in the bohemian life of Montparnasse cafés and studio-parties between the two wars, Granovsky produced a large number of sculptures, mainly animals, and of paintings, often representing picturesque types such as Paris cab-drivers. He thus developed an uncomplicated and spontaneous style that reveals his jovial nature and his lack of intellectual preoccupations. David Goychmann (1900–42), who emigrated to Palestine from Russia in 1919 as a *halutz*, began to paint there, came later as an art-student to France; his nostalgic portraits and landscapes often suggest his deep attachment to the scenes and the life of his childhood. Tobias Haber (Konstantin, Poland, 1906–43), came to Paris to complete his studies, developed a very personal style as a somewhat lyrical colorist. His finely psychological portraits, occasional still-life paintings and interiors, remarkable for their warmth and sobriety, are represented in a number of museums.

Alice Hoherman of Warsaw (1902–43) painted delicate scenes of family life, and her portraits of young girls reveal her very feminine talent as a colorist with a sense of fashion and a gift for elegant design. David-Michael Krever of Vilna (1904–41) worked in Paris as a painter and sculptor; somewhat decadent at times in his elaborate stylizations, he achieved at his best a mysteriously hieratic quality. Jacob Macznik of Lodz (1905–44) has left us, in addition to a series of interesting gouaches that reproduce faithfully the main features of many of Poland's ancient synagogues, a number of moving landscapes of Paris suburbs.

The portraits and landscapes of Ephraim Mandelbaum of Lublin (1884–1942) manage, within a limited range of color, to express a deep poignancy. Arrested in Poland during the First World War as a spy while he was painting a landscape, he was condemned to death; after his reprieve, he remained subject to acute nervous depressions and a persecution mania. During his internment in a Viennese clinic, Mandelbaum painted a series of interesting portraits of other patients. Alexander Rimer (Lwow, 1889–1942) painted views of public gardens and parks in Paris, with figures of typical strollers which are

redolent of a certain urban "spleen." Léon Weissberg (Przeworsk, Galicia) (1893–1943) excelled as a painter of suburban and industrial landscapes of the Paris area, as well as of hauntingly imaginative Jewish topics. His *Jewish Bride* is a brilliant example of the qualities of painting and of folklore that Eastern European Jewish artists have contributed in recent decades to the style of the School of Paris. Abram Weinbaum (Kamenetz-Podolsk; 1890–1943) came to Paris in 1910 and was extremely productive as a painter of still-life compositions, interiors, and landscapes; he specialized in views of the French capital's more typically old-fashioned neighborhoods, and has also left us a number of interesting studies of Eastern European Jewish types.

There is no possibility in the restricted space at our disposal even to mention the names of more artists of the School of Paris whose life and work were cut short by the Nazis. Enough, however, has been said already to indicate the loss to the art of Europe by the Hitlerian massacre.

To many readers, the history of individual East European Jewish painters of the School of Paris, as briefly listed here, may seem stereotyped. The Russian or Polish ghetto was their place of birth, and one assumes that its warm Jewish life and keen intellectual atmosphere stimulated their genius at an early age, and that the freedom of artistic expression in Paris then allowed its sudden fruition. Yet many of these painters actually spent their childhood in a world of ignorance and sheer destitution rather than of warmth and intellectuality. Others were born of culturally assimilated families in the great urban centers of Eastern Europe. Others again, before reaching Paris, had found their true genius in Vienna or Berlin, among the Expressionists. It is this very variety of cultural and human experiences, concealed in the bare facts of biography, that determined to some extent, within the scope granted to each individual by his personal genius, the wonderful variety of the work of these Jewish painters of the School of Paris.

More Jewish painters have lived and worked in Paris since 1910 than anywhere else in the world at any time in the history of Western art. Attracted to the French capital mainly from Poland and Russia, but also from other lands, they have contributed something very valuable to the traditions and the reputation of the School of Paris, which has thus absorbed the rich heritage of all of Europe, while giving a certain sense of style and of painterly values in return. The contribution of these Jewish artists has been, until recently, mainly of an expressionistic character that suited the peculiar temperament of Eastern European liberals of the beginning of our century, when they sought to break away from the traditions of their community in order to express themselves as individuals. Since 1945, a majority of the younger foreign-born Jewish painters who flock to Paris comes from the United States or from Israel. More intellectual in their theories and less immediately emotional or sensual, these painters are already contributing a taste for abstraction rather than for self-expression as it was practiced by post-Impressionists and Fauvists of the generation of Soutine.

As long as Paris continues to attract such numbers of artists from abroad, the School of Paris can be expected to continue to be universal in its approach to art; and as long as the Jewish element among the foreign painters of Paris continues to be active and important, the universal appeal of the art of Paris can be expected to include some specifically Jewish characteristics, such as those which one can discern in the work of at least some (and by no means the least distinguished) of those whose names have been recorded on these pages.

Fig. 281

a manneristic style that owes much to the fantastic visions of Magnasco. In his more recent works, his color-harmonies have tended to become increasingly dreamlike and somber.

The Sephardi, Corsia (born 1915), on the other hand, reveals in his painting the joyfully sensual character of his native North African background. Born in the Mediterranean seaport of Oran, he spent his childhood in poverty and had to earn his living in a number of manual trades in order to find money for his art studies. A painter by sheer instinct, he reveals in his work his joyful acceptance of reality and of life.

A few other North African Jewish painters can truly be said to have emancipated themselves from their original background and imposed themselves as artists of the School of Paris. Others remain, in spite of their training in French art schools and sometimes in Paris, regionalist rather than metropolitan artists, more attached to their native Algeria or Tunisia than integrated in the art world of the French capital.

Thus Jules Lellouche (born 1903), a native of Monastir in Tunisia, has specialized in depicting scenes and types observed in the course of his visits to little known and primitive Jewish communities. Lellouche has also painted some sensitive Spanish and Italian landscapes, though his style tends to be somewhat academic. Other Tunisian-Jewish artists include Robert Saad, a self-taught artist who lived in his native Djerba and, especially after Mané-Katz visited the island, painted a number of scenes of life in its two Jewish villages. The *Haggadah* illustrations of Edouard Benmussa of Tunis are typical of the somewhat garish and unsophisticated folk-art that still haunts the work of many North African Jewish painters. In Algiers, the painter Assus, basically a post-Impressionist who has absorbed some Fauvist influences, too, has painted a number of colorful scenes of Algerian-Jewish life, especially in some of the more primitive communities of the South.

The significance of these names is that they suggest a hitherto unsuspected reservoir of artistic ability in the isolated and backward Jewish communities of North Africa, and by analogy also of the Levant. It may be that in the next generation there will emerge from these communities, too, artistic genius of the same caliber as has been produced in the last half-century by the teeming Ashkenazi ghettos of Eastern Europe.

272

271. Jaques Chapiro. Figure, 1956. Oil on canvas. Paris, Private
Collection.

272. Georges Arditi, Landscape, 1965. Paris, Artist's Collection.

273

274

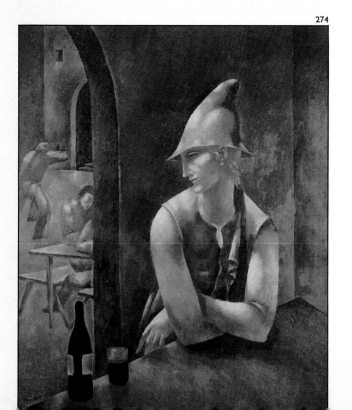

273. Victor Brauner. Man and bull story, 1953. Oil on canv[...]
Paris, Galerie "Rive Gauche".

274. Eugene Zak. Composition, 1919. Oil on canvas. Par[...]
Galerie Zak.

275. J. D. Kirszenbaum. Brazilian Carnival. Oil on canva[...]
Mishkan Leomanut, Museum of Art Ein Harod.

276. Simon Segal. Harbor Scene in Brittany. Gouache on pap[...]
Paris, Galerie Bruno Bassano.

275

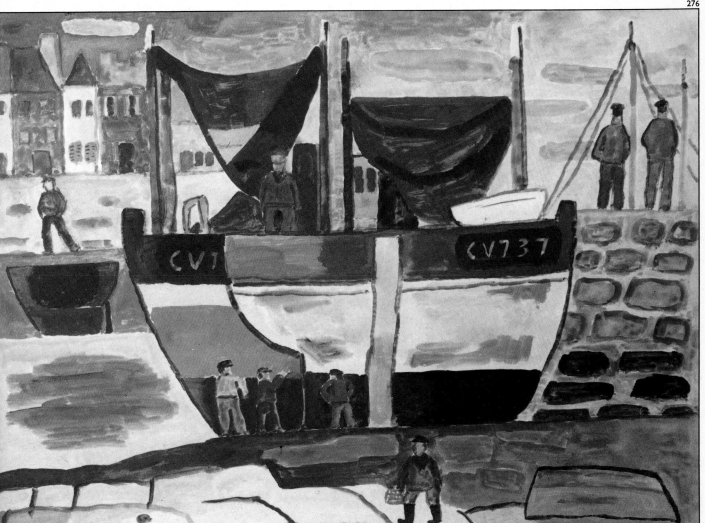

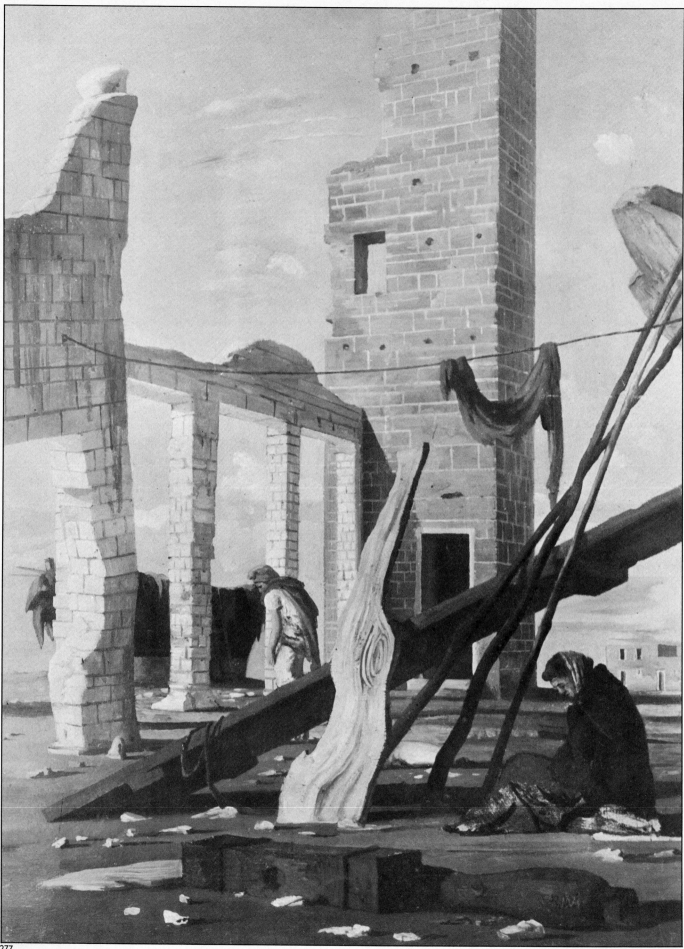

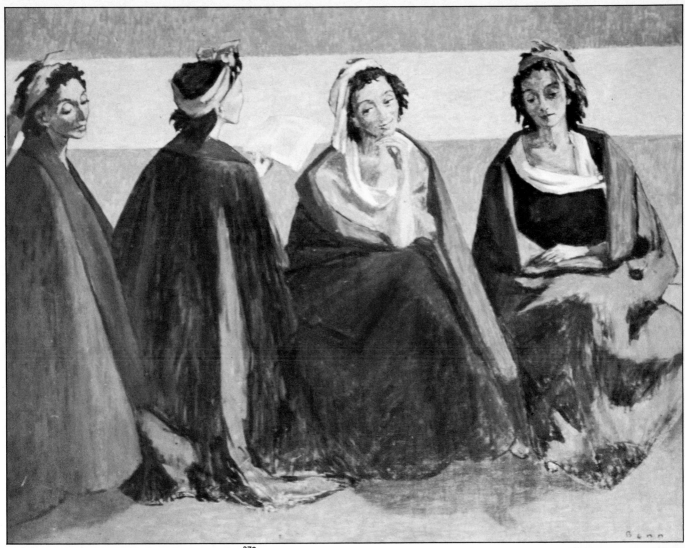

278

279

277. Eugene Berman. Ruins on the Beach. Oil on canvas.
Courtesy Julien Levy Gallery, New York.

278. Benn (Benzion Rabinovitch). A Reading. Oil. Musée du
Petit Palais, Paris.

279. Jean Atlan. Vegetation. Galerie Charpentier, Paris.

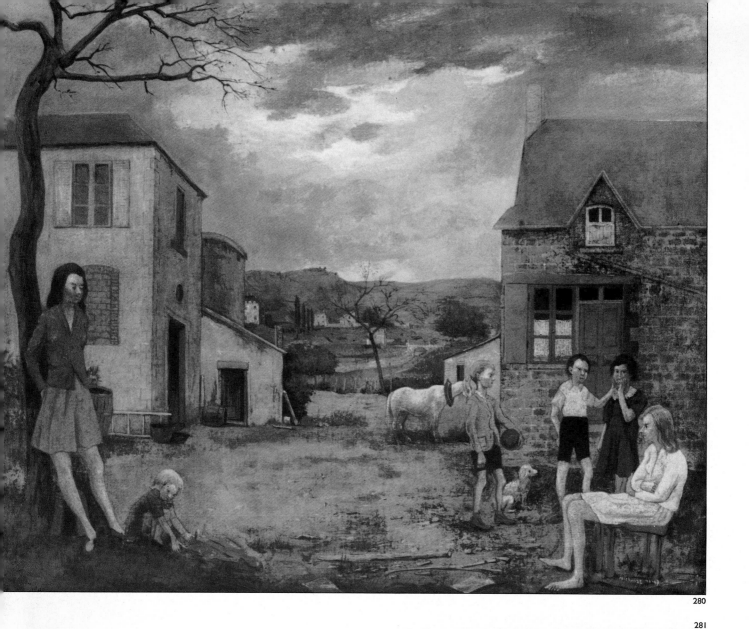

280. Grégoire Michonze. Children at Play, 1946–47. Oil on
canvas. Glasgow Art Gallery and Museum. Courtesy G.
Michonze, Paris.

281. Alfred Aberdam. The Painter's Family, 1936. Oil on canvas.
Paris, Private Collection.

282. Maryan. *Living According to the Law*, 1953. Oil on canvas. Paris, Private Collection.

283. Marek Halter. *The Harbor at Acre*. Oil on canvas. Paris, Private Collection.

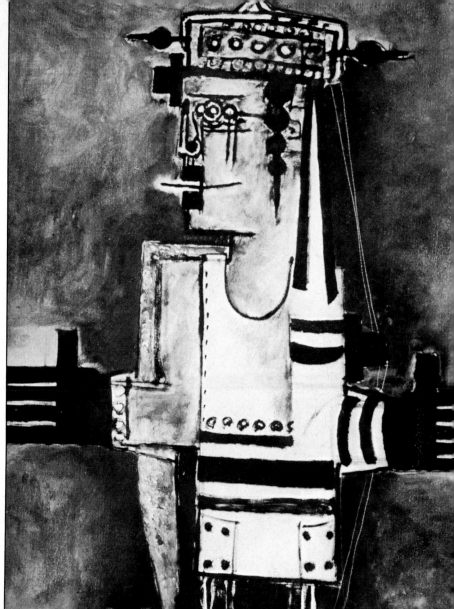

282

283

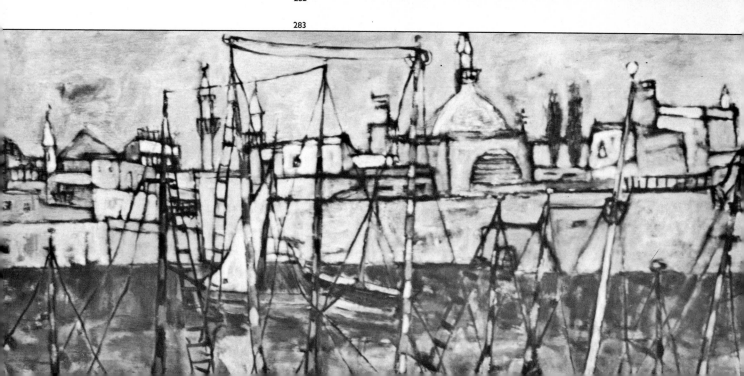

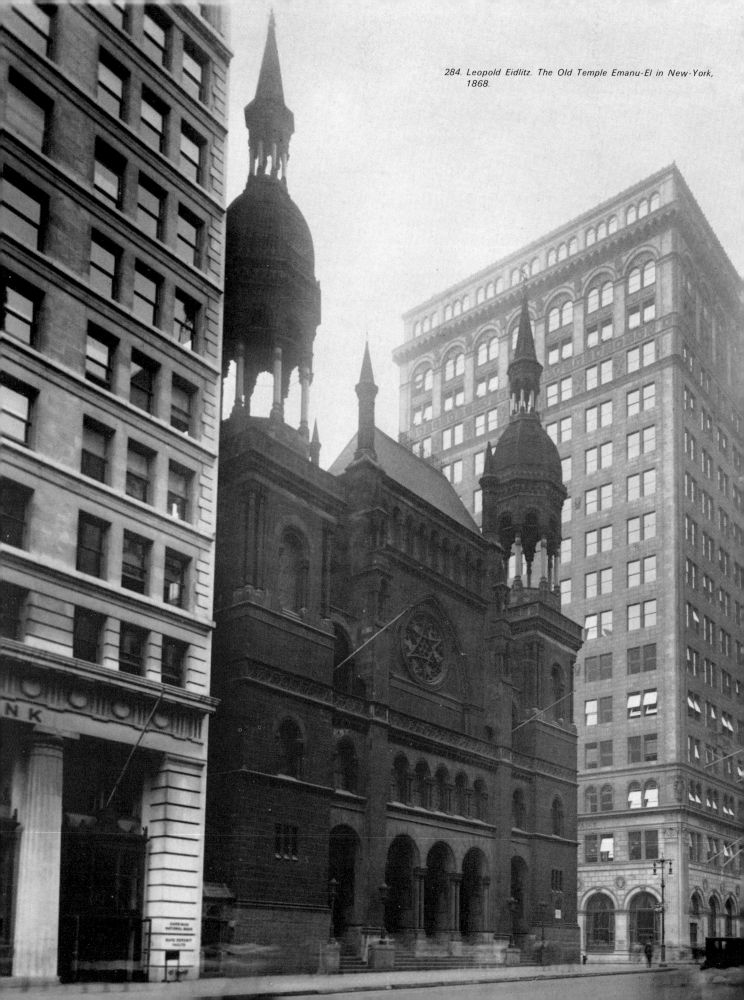

284. Leopold Eidlitz. The Old Temple Emanu-El in New-York, 1868.

JEWS IN ARCHITECTURE

by PERCIVAL GOODMAN

I f we look for a "Jewish architecture," as we might look for a "Jewish literature" with characteristic theme, spirit, and function, we shall not find it; it is not there to be found. It is perhaps only in the most recent decades, in the construction of synagogues and community centers in America and in social-planning in Israel that the question, what could be specifically Jewish in architecture, can even be considered. If, on the other hand, we are looking for Jews practicing architecture, then after a tardy beginning in the 19th century, there is now suddenly a bewilderingly vast representation of Jews in every form and function of building.

The name "architecture" means several different things. It is the provision of shelter and a framework for carrying on various functions; it is the entire man-made physical environment; it is the monuments of significant form that have both an inside and an outside. Likewise, there are several different avenues and motivations that lead to architecture. The concurrence of several different causes operating in modern history has produced the present situation of the Jews in architecture. Modern architecture, like all architecture, is rooted in its community and tied to its site; but its crafts, conditions, functions, forms, and spirit are different from what they were, and are such that now they not only do not exclude the Jews, but in some respects are congenial to abilities and needs developed in the Jews by their historical chances. We are not at this point making a judgment as to the worth of the modern condition of architecture — in our opinion some aspects of it are good and promising, other aspects are disastrous; we are insisting merely that to explain the role of the Jews in the architecture of the 20th century, we must speak both of the Jews and of the architecture.

We have said that several avenues and motivations lead to architecture. Let us mention some of these and the changes in them through the 19th and 20th centuries, so far as they bear on our subject.

(1) It is an art of "masons, carpenters, smiths, plumbers, and glaziers." Throughout the Middle Ages, and indeed from antiquity, it is from these craftsmen and their customary techniques that we must derive both structure and decoration, all of architecture except the plan. Now Jews were excluded, and would necessarily have to exclude themselves, from the "conviviality" and religious and often mystical rites of the corporations of craftsmen. And more generally, as we come into modern times, there is no Jewish building. Even when there are well-defined Jewish communities, as in Poland, the method of building, e.g., the Polish wooden synagogues, belongs to the majority host-people.

Likewise, there are nearly no Jewish plastic decorations. (There are, to be sure, some exceptions to these generalizations: other sections of this work will have assembled the evidence. But by and large, the statement holds.) One could say that this people was visually starved; the views of the old ghettos show no attempt at beauty or order. It was not to be expected then that with the Enlightenment and the Emancipation there could spring up Jewish architects and painters from the crafts below. Hence in the 19th century the Jews made little mark. Only in the 20th century did conditions prevail in the crafts below, where a Jew of talent can learn about buildings and develop ultimately into an architect. In Israel, of course, the conditions and balance are now completely normal in every respect.

In Germany, it was another story. Right up to 1933 the Jews had still not gained entry into the building or technical crafts; the feudal conditions still obtained. So throughout our period there were a couple of hundred Jewish architects who through religious, family, and art connections built synagogues, theaters, department stores, and banks, but did not have the multifarious practice that belongs to and supports builders. (In the Austrian Republic, by contrast, there were many more Jewish architects among a much smaller population, because of the preceding history of the polyglot empire).

In Russia, finally, we see both extremes, which we can roughly characterize as the north and the south. In the north the Jews were excluded; they had no artisans to compete with the gentiles. But in the Ukraine and along the Black Sea, where the gentiles were mainly peasants, the Jews were small townsmen and artisans, and all building contractors were said to be Jews. And since the Revolution, of course, it is from this matrix of trained intelligence in a very backward population that the Jews have occupied (not without arousing resentment) so great a place in Soviet technical and intellectual activity, as in architecture.

(2) Let us now take the contrary tack and consider the status of the architect at the top. During the Middle Ages the master-builder emerged from the artisans; in the Renaissance he became an artist with a full-blown special ideology; and since the Renaissance and especially in the 19th century (less so nowadays), architecture has been a gentleman's profession. Among the fine arts it is the most respectable, the least bohemian.

This gentlemanly status and its correlated schooling have been an avenue of entry to rich, well-connected Jews in the 19th century. (Conversion was, of course, common). What is important is that a man of talent accepted on this gentlemanly level tended to be fully accepted, at least professionally. If we consider the Jewish architects of the 19th century, we find that they are given, apparently without discrimination, civic, monumental, or ecclesiastical commissions; and they are granted the highest honors by their professional compeers.

The attempt will be made here to dwell on the generalizations made in the text by a series of illustrated examples, expanded by personal and critical notes. Naturally, in a limited space, there is an embarrassment to decide what to choose and what to omit. There are perhaps a couple of hundred artists worth exemplifying, because of their excellence or influence or quality of output. Some that others would have chosen have been omitted deliberately and others because adequate illustrative material has not been available (e.g., the French architects Aldrophe and Hirsch, or the contemporary Italian Bruno Zevi). Otherwise, we have taken into account as far as possible geographical distribution,

excellence, typicality, and influence. In some cases, illustrations of the work of out-standing Jewish architects may be found in the next chapter, on synagogue architecture. We may take as an instance the eminent English architect George Basevi (1794–1845), a cousin of Benjamin Disraeli and like him a convert to Christianity, who was killed, as it happens, as the result of a fall from the spire of Ely Cathedral.

The Conservative Club in London (built in 1843), which he designed together with Sydney Smirke, is exactly what a Conservative Club should be: sober and dignified and having a certain scholarly refinement. It is more solid and stonelike than the previous work of the Brothers Adam, aiming towards the much later, somewhat similar style of Stanford White. This work is such an elegant piece of Italian reconstruction that it gives away its Englishness with striking and almost amusing clarity. Notice the large bay window on the building's right — the longing for more light in a cloudy climate. In general, the proportion of the windows to the stone is larger than in the strong, dark-looking, sun-drenched Italian palaces. There is a complete treatment of the moldings, but they will never cast sharp shadows and are, therefore, not sculptural but applied. And how to integrate the chimneys in a manner never made for fireplaces?

Reference may be made here to an independent, and rather surprising production of Basevi's — St. Mary's Church, at Greenwich (near London), which he designed in 1823 as a young man of twenty-nine. It is a fresh and youthful work, perfectly English and highborn, as befits a young man educated in Dr. Burney's school and by Sir John Sloane. But the Georgian style is lightened and made sunnier by a kind of Greek influence, — the young man has profited by his recent travels in Italy. The whole is at the same time native and more knowing than native, and both simple and studied.

Belonging to the same element in Anglo-Jewry as Basevi, but faithful to his Jewish heritage, was David Mocatta (1806–82). He was, as it happens, closely related to Sir Moses Montefiore, to whose influence as a railway director he doubtless owed some of his commissions: for he was responsible for a series of stations which had a considerable influence on railway-station design in England in the early days. They are planned on the basis of repeatable units to make smaller or larger buildings. The "style" is applied *ad libitum:* one station in Tuscan, another Puginesque, neo-Gothic, and so forth. Although Horley Station (c. 1840) is a small building, it is more "modern" in idea than the same architect's larger works. Mocatta traveled and made studies in Italy, was vice-president of the R.I.B.A., and was otherwise typical of the gentleman-architect. He early ceased practice on succeeding to the family fortune, but, being Chairman of the Council of the Reform Congregation in London, designed its first permanent synagogue in 1851.

In the same gentlemanly tradition was Georg Itzig (Hitzig), who was connected with the famous Berlin banking-family. Among his works, so characteristic of the period, were the princely Palazzo Revotella in Trieste and the Deutsche Reichsbank in Berlin (built in 1840). Here once again we have the work of a well-born and cultivated Jew: the total effect is lighter and more refined, in this case more French, than the corresponding German work of the period. The plan and the interior are more interesting than the exterior. The plan is clear and elegant, based on a structural module of groined vaulting. The whole is orderly and controlled, not falsely picturesque. There is an interior staircase that strongly suggests Charles Garnier's Paris Opera, though it is not so good. Notice the Empire touches, like the winged beasts, contrasting with the typically German patterned brick work.

Fig. 285

263

In much the same sphere as Itzig, though somewhat later and as faithless to Judaism as Basevi, was Alfred Messel (1853–1909) — professor, *Geheimrat,* and member of the Prussian Academy of Art. He built, among other notable works, many banks, the Pergamon Museum, and the villa of the Jewish millionaire Eduard Simon (the mere list brings to life a whole social *milieu*). The Wertheim Department Store which he built in Berlin (1904) has been called "one of the important pioneer works of modern architecture"; it is a remarkable combination of stone, steel, and glass. The interior is modeled after the French stores of the period, a big, open, bright-lit space. It is the verticals of the exterior that are most important. Messel considered himself as starting a "neo-Gothic revival," but obviously this is not a stone vertical style at all, but a reinforced concrete vertical style. The confusion between the two shows up especially in the interior, which seems unable to make up its mind how it means to look. (The mansard of the exterior is an unfortunate bow to convention). Now purified of its Gothic flirtation, this kind of vertical style has had an illustrious progeny.

Perhaps a more interesting architect was Leopold Eidlitz (1823–1908), called by the *Architectural Record* "the dean of our guild." On the one hand Eidlitz built a number of churches, including one (Christ Church Cathedral in St. Louis, 1867) which the novelist Charles Kingsley called "the most churchly church in America"; on the other hand, he was the architect of the old Temple Emanu-El (1868) that was certainly one of the most *Fig. 284* notable buildings in old New York.

This astonishing achievement is shown here as it originally loomed on an important corner in the town. At a quick glance it appears to be Bohemian, out of Prague, like its immigrant architect harking back to the strength of his youth. Yet the plan is Gothic — Eidlitz was important in the neo-Gothic movement in America; much of the feeling is Romanesque; and the main decorative intention was "Moorish" that, since the preceding generation in Europe, was considered appropriate to synagogues. The Gothic spires are made into minarets, the corbel-arches are almost horseshoe, and the decorative detail is Arabesque. The pierced balustrade is Gothic, like the rose-window with its Star of David. Yet there are the high-pitched Praguish roofs with iron cresting for effect against a gray sky. It requires very little to turn the domes into onion-domes. And everywhere, especially in the interior, there is a variegated pattern of dark and light colors that belongs to Middle European peasants. Out of this mixture the whole somehow achieves a strong vitality and a kind of Jewishness, in the meaning of an immigrant who has built careful Christian churches, is saddled with a pointless Moorish mannerism in order to be different from the Christians, but who allows expression to an Old Country community feeling. The chief fault in this building was its misproportion. The nave is too small for the pretentious front; the effect is squat. They did not need so big a statement for so small a building. And the towers and minarets are meaningless show when there are neither bells nor *muezzins* calling to prayer.

In contrast to the architecture that sprang from craftsmen, this post-Renaissance and 19th century architecture of the gentleman-artist had a different style and feeling. It was as if a façade that was the "architecture" overlay on the structure made by the builders. The "style," in place of the indigenous styles, became an eclectic combination of the older styles refined and studied as art history. In such an eclectic mode, learning, travel, good taste were the most valuable things; and of these an architect like Basevi had as much as Stanford White. So in his teaching the French Jew of Italian stock, Emanuel

Pontrémoli (born 1865), who was elected a member of the Institut de France in 1922 and was director of the Ecole des Beaux-Arts from 1932 to 1937, laid all stress on good taste. His building for the *Institut de Paléontologie Humaine* in Paris (1913) is the work of a sensitive, learned, and elegant man. Yet this is not "academic" architecture; it is much more old-fashioned and sober, early Renaissance, as if attempting to express himself in a new way by going backwards. One feels power and control in the basic proportions; there is scale; the detail tries to be meaningfully original (notice the frieze of subject-matter at the reading level); there is an attempt to be rough-hewn in the stone-work, and the effect is refined. He has gifts, he cannot find his way, he goes backwards. Pontrémoli has a great fondness for the Greek grandeur and for Salomon Reinach, for whom he designed a house. If Proust's Swann had been an architect, this is the kind of building he might have built.

The historical problem seems to us to be this: up to modern times there was almost no plastic art among the Jews, no sculpture, little painting, hardly any architecture. A Jewish museum of plastic objects has pitifully little to show other than ritual art. In modern times, however, there has been a small number, perhaps proportionately adequate, of Jewish masters in painting, sculpture, and architecture. For modern plastic art, the practice of the modern masters, including a few Jews, has been for the past century an *avant-garde* art; and *avant-garde* is always the rejection of conventions that have become stifling and academic, and the attempt to find a new vitality in what is nearer to primary perception and more spontaneous in expression. *Avant-garde* belongs neither to gentile nor Jew, but is the plight of everybody who must rebel in order to breathe again, and in that number there are numerous Jews. In the *avant-garde* in architecture during the century, whether we consider "L'Art Nouveau" or "De Stijl" or "Expressionism" or the "International Style" or the school of Wright or Urbanism or the Bauhaus, there are many Jews among the disciples and a few among the leaders.

Erich Mendelsohn (1887–1953) is known as the expressionist master, conveying a psychological and depth-psychological content. For his work as a whole it is also profitable to regard him as the architect who is a sculptor by disposition, rather than a constructor or a planner. But, of course, like any master, he is strong in the structure and plan as well, just as a master-musician is strong in melody, harmony, and orchestration, though his peculiar genius may be in one or another of these.

His Einstein Tower, in Potsdam (1921), designed to make certain astronomic observations and experiments to test the relativity theory, was Expressionist sculpture. The sketch is a *Fig. 287* sculptor's sketch. But the sculptural mass with its punched holes seems also like a kind of breathing animal from another planet. It is perhaps brutal and frightening, as if the aspect of this new science that gripped the artist was not its humane mathematics and philosophy but its dark alchemy and atomic power.

Everywhere in Mendelsohn there are curves, asymmetrical curves; not that he distorts the plan, but he seizes the opportunities in it to create his Baroque sculptural shapes. The curves are not mathematical curves.

The Schocken store at Chemnitz (1928) can be regarded as a middle resting-point in the *Fig. 286* sculptural-architectural tug-of-war. Half close your eyes and you at once see the sculptor's sketch, white bars and black spaces. Yet he faces without compromise the architectural issue of the curtain-wall: by maintaining an absolute flatness he achieves as if a thin skin over a cantilevered armature. These flat bands have been often imitated. The

265

whole has a fine elegance and surprising lightness, not French after Le Corbusier but perhaps more like Albers: the detail is artfully arranged: the irregular points of white at the top, the stair-tower border of more delicate horizontals; and for a change the setbacks, probably required by law, are really studied.

The Weizmann House in Rehovot showed the same powers in decline. It is merely "architectural" in a French style he cannot make move. The symmetrical and centered effect is meant to be monumental, but it is frigid. It is doubtful that the patio of the interior is really conditioned to the climate; more likely we have a German misunderstanding of the Moorish plan. The building seems out of place on its stony site; the artist is uprooted. The expected curve appears at the bay window, but it is isolated and its pilasters are too weak even to be pretentious.

After his interlude in Israel (where he designed also some important public buildings, such as the previous Hadassah Hospital on Mont Scopus) Mendelsohn spent his last years in the United States. Among his productions here were some monumental synagogues and temples.

Let us revert to the underlying mass community. Architecture and theater are the community arts *par excellence*. If we consider the plan as extending into the streets, the squares, the neighborhood, we may say that architecture is the overall external behavior. Now in the medieval and Renaissance periods, when the community was organically religious and its political structure closely cemented with indigenous family ties, this approach to architecture was precisely closed to the alien people. Jews could hardly be expected to make the community-buildings whose integral use they did not or were not supposed to understand. The church contained arcane symbols not without their magical force. Even if they knew how, Jews could not make fortifications when they were not bound to be soldiers. They could not lay out the squares when they lived in the ghettos.

During the 19th century, the time of individual enterprise and when architecture came to be largely the application of good taste in the choice of styles, it could be said that the community meaning of building lapsed; it was then not strange for anyone indiscriminately to build anything.

In our own time, however, there is again a resurgence of the community idea in building, and correspondingly a vast literature of city-planning. But the idea of community has changed, under the impact of the many political, economic, and technological changes. In its present form, the community spirit is not only open to Jews but is even peculiarly congenial to them. It is the spirit of social reform-clearance, garden-cities, clinics, settlement-houses; the architecture of the general welfare regarded as the responsibility of the society. The Jews, whose history has made them an intellectual and critical minority, with a strong sense of messianism and steeped in public law, have been leaders in reform and radical politics, in trade-unionism, social work, philanthropy, public medicine, psychiatry, progressive education, and the social sciences. All of these channels feed into the architecture of community and urbanism. In Israel, which has developed from its Zionist beginnings in this sociological atmosphere, we would expect the forms and functions of the corresponding architecture to be pervasive. And if we look elsewhere at similar phenomena, it is not surprising to find the Jews very prominent. Some of the best workers' housing was achieved as early as 1911 by Michel de Klerk
Fig. 289 (1884–1923) in Amsterdam. His plan for housing on Hembrugstraat here is warm and

poetic. To appreciate it, we must compare it with the concrete housing of another Dutchman, Oud; or more extreme, with the *machine-a-vivre* of Le Corbusier or the Seidlungen of the school of Gropius, whose chief concern seems to be correct solar orientation. The feeling here is quiet, quietly controlled space, like Vermeer; and flat like the Lowlands, with sudden vertical accents. The housing fits its street. And what a richness of texture he gets from the virtuoso brickwork! Notice the arbitrary and difficult brick projections, drawing on indigenous skills. Also, there is the clean contrast of the red brick and the white framing. To be sure, this Vermeer-like poetry is not something that can be taught, can be found in a school; but de Klerk was a master.

Jews have been responsible for other notable town-planning achievements. Most famous among them was perhaps the famous Karl Marx Hof in Vienna, designed by Frank and Wlach. We may, take as a less ostentatious instance the pioneer Garden City of Radburn (N.J.) laid out by Clarence S. Stein in collaboration with Henry Wright—a highly interesting American attempt to reform the social pattern in the commercial framework. A disciple of Howard and an associate of Parker and Unwin, Stein has attempted to incorporate the principles of the Garden City also in more urban concentrations. Sunnyside, designed on the outskirts of the metropolis, now provides more possible neighborhood blocks in the middle of a crowded city: Stein kept to the gridiron street-plan, only breaking the lot-lines; more recent neighborhood projects break through the gridiron; on the other hand, Stein achieved a very low coverage, 70 acres for 1,200 families (the Garden City norm is 12 families to the acre). The unified neighborhood planning allows for more urban aesthetics, rather than the usual chaos; and by pooling the yards, makes them of some use. Sunnyside has been endlessly imitated in various "garden apartments." Radburn started out as a Garden City proper, on the "Letchworth" principle of an integrated living-working community; but it has turned out as a dormitory-village serving the metropolitan center. The essence of the plan is to solve by *cul-de-sacs* the typically American problem of the automobiles—a car to a family; as yet no better solution has been offered. Notice the large amount of public land, playground space, held in common. This has been a very influential plan in suburban development in the United States.

The most earnest designer of hospitals in the New World is Isadore Rosenfield (born 1893), whose work has extended as far as Puerto Rico: he designed the Tuberculosis Hospital at Rio Piedras (1949). Rosenfield is probably the purest example of a functionalist, completely dedicated to the physical and psychological welfare of the patients, and it is interesting to see, then, how simply and easily such a building as this sits in its environment. Meticulous planning of every detail from inside out must turn out handsomely. A crucial proof of Rosenfield's dedicated functionalism is his way of correcting and even altogether rejecting his client's program, when he can show that it fails to make ultimate sense; and again his insistence on a comprehensive, long-range program, so that every building is part of the present and the future health of the community.

Like all dedicated functionalists, Rosenfield is fanatic on some particular subject, in his case "horizontality," which he can always prove to be the only rational solution. Whatever the soundness of his "proofs," his buildings look well, and two considerations he adduces tell a good deal about his own style: he prefers the horizontal because it plays down monumentality, and it allows for flexible expansion.

Very active in town-planning in America, in which sphere he executed pioneering work in Baltimore, Rochester, Albany, and Denver, was Arnold W. Brunner (1857–1925).

Fig. 288

Clarence S. Stein. Plan for the Garden City of Radburn.

One of the most respected architects of his time in America, he made many monumental classical reconstructions and was especially busy on civic work. The civic center for Cleveland, for instance (on which he was associated with Burnham, who designed the Chicago park system, and Carrère, who designed the New York Public Library), has been called "the most carefully studied and realistic of all the civic centers proposed in the early 20th century."

Fig. 290

Then it is somewhat ironic that his most famous building is the one we show here: the Lewisohn Stadium in New York, for obviously he spent little time or care on it. Designed as an athletic stadium for City College, it has never been adequate for that purpose. But the Stadium has become the background for the Philharmonic summer concerts; in the new function the Tuscan colonnade and naive proportions have become less pointless than they were; the building is in fact a community center familiar to all and popularly admired; and the acoustics are terrible. Brauner's most effective building was probably the new Temple Beth-El on Fifth Avenue in New York, an impressive gray-stone building with a large arched entrance at the top of steep steps.

The situation in Israel is, of course, especially interesting, since here there is the bold concept of a master-plan for the country as a whole, for economic, social, and defense purposes. In Israel, for well-known historical reasons, there is practically every kind of socio-economic arrangement, from absolute community through cooperatives, and individual enterprise to state-authority. And perhaps the chief problem facing the Israel master-planner must be to elicit the best out of this social cultural pluralism, rather than simply to annihilate embarrassing elements in the interests of "efficiency" or even "necessity." (The formal problem of Israel architecture is perhaps a related one: how to integrate the wealth of incoming cultures with the heritage of this site and history.) The father of the huge task of construction of the last thirty years in Israel was Richard

Fig. 291

(Yitzhak) Kaufmann (1887–1958), a pupil of de Klerk. We illustrate his famous and symbolic plan in the agricultural settlement of Nahalal (1921).

What a schematic, courageous, and somewhat pathetic picture! This is an island in an alien land, centered in its own community; and yet there is nothing in the very center, although there is a monumental layout of trees on the axis. These are rational and principled pioneers: everything is laid out and made from scratch, unembarrassed by the site and previous history, yet naturally, there is little help and inspiration from below; and yet, still again, there is a desperate effort to get in touch with the soil in those radiating farms and stands of planted trees.

Also, one cannot escape the sense of a wagon-circle fortress against a potential attack, retreating to the center. What is most problematic about this bold scheme is the lack of urban feeling. Once given the frame, there is nothing but a scattered small town. This is the problem posed to all communalists; once the fight is over and success is won, what is it for? Unless there is something provided better than the old high urban culture, the effect of achieving stability will be that the next generation drifts away. (And so we see on the plan, that the through-road goes right through the middle, crossing the empty monumental axis.)

Thirty years later we find a master-plan for the country as a whole being proposed. (*Physical Planning in Israel,* by Arieh Sharon—"at the completion of stage one of the master-plan for Israel...the population is envisaged at 2,650,000".) The tendency is to regard the whole as the community, rather than the ideal of the earlier communalism.

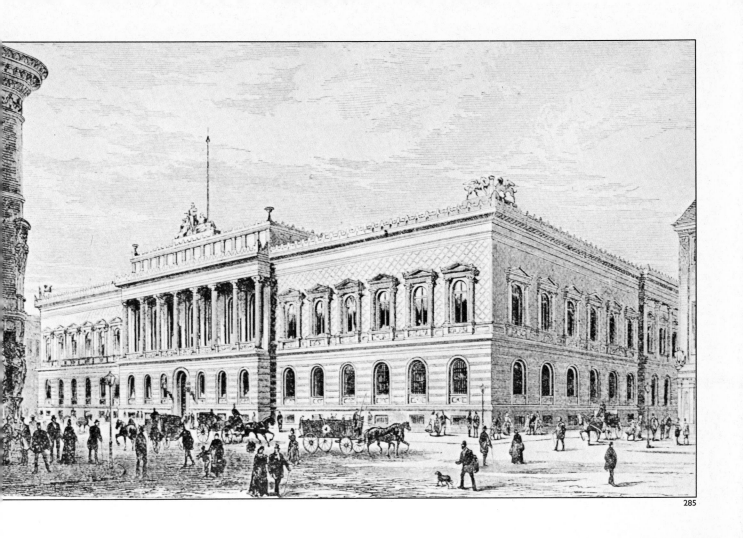

285

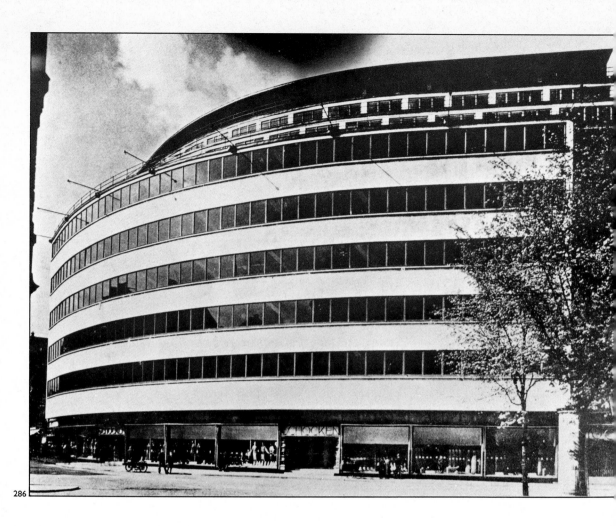

286

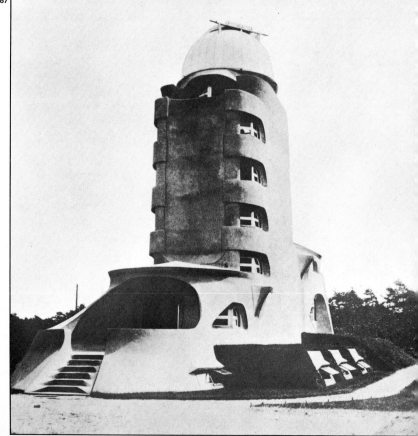

287

286. *Erich Mendelsohn. The Schocken Store in Chemnitz, 1930.*

287. *Erich Mendelsohn. Einstein Tower near Potsdam, c. 1930. Height 14 m. Courtesy Bildarchiv (Handke), Staatsbibliothek, Berlin.*

288. *Frank and Wlach. The Karl Marx Hof in Vienna. 1930. Courtesy Bildarchiv der Osterreicher Nationalbibliothek.*

289. *Michel de Klerk. Housing project on Spaarndammerplantsoen, at Hembrugstraat in the western part of Amsterdam.*

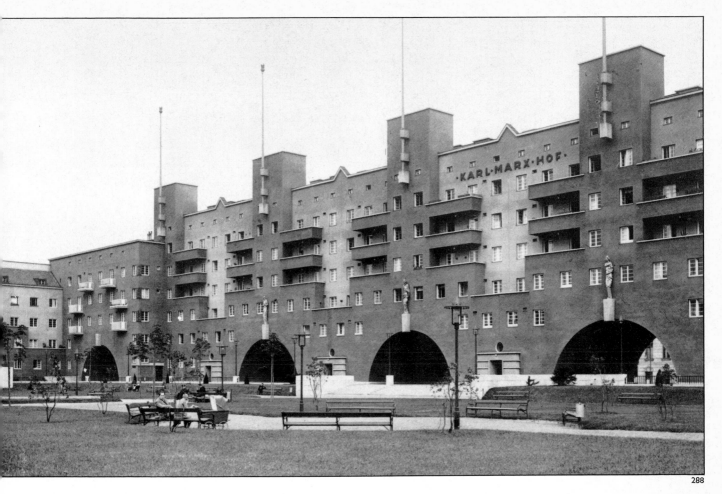

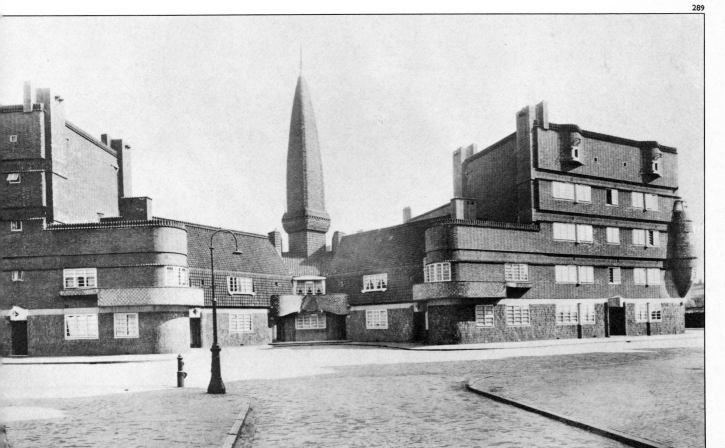

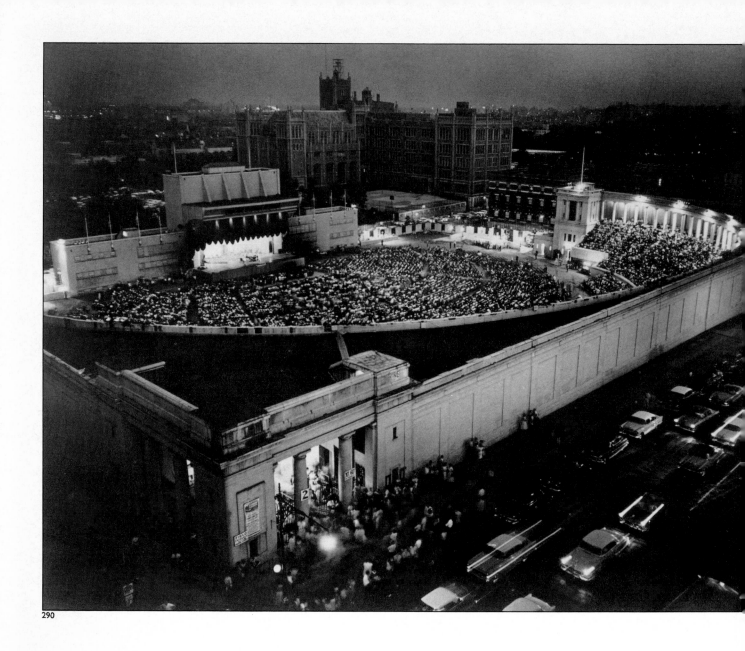

290

290. Arnold W. Brunner. *The Lewisohn Stadium, City College of New York.*

291. Richard Kaufmann. *Nahalal settlement.*

292. Yohanan Ratner. *The Jewish Agency Building in Jerusalem.*

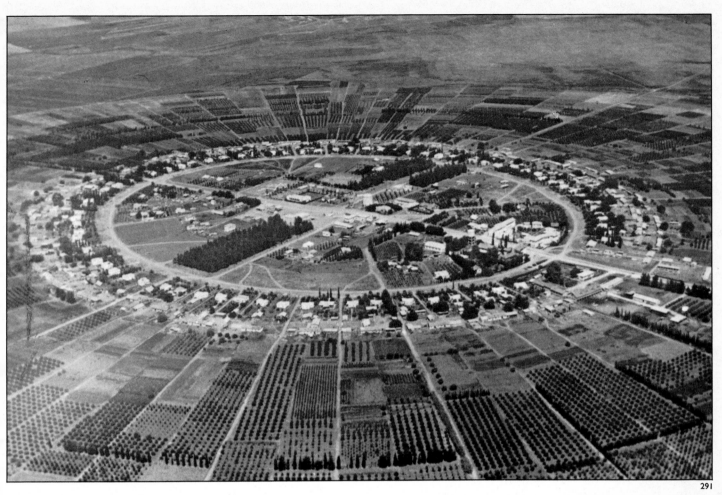

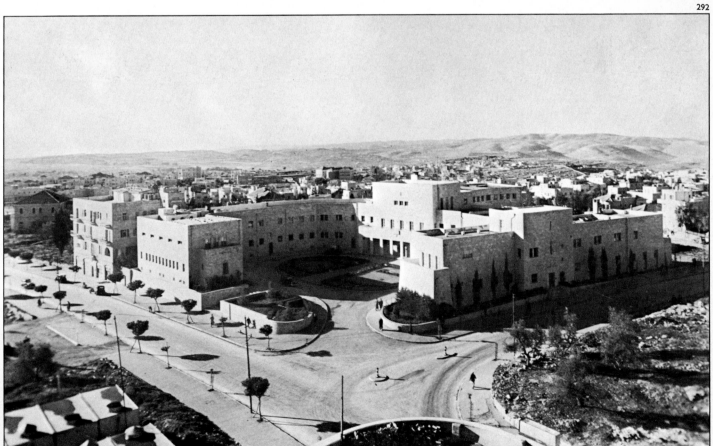

293

293. Dov Karmi. Office building of the Histadrut in Tel-Aviv.
1954.

294. Oskar Kaufmann. The Stadttheater in Bremerhaven, 1909.
Courtesy Magistrat der Stadt Bremerhaven, Stadtbildstelle.

295. Dankmar Adler. The Auditorium Hotel Building in Chicago,
1887. As in 1890–92. Courtesy Chicago Historical Society.

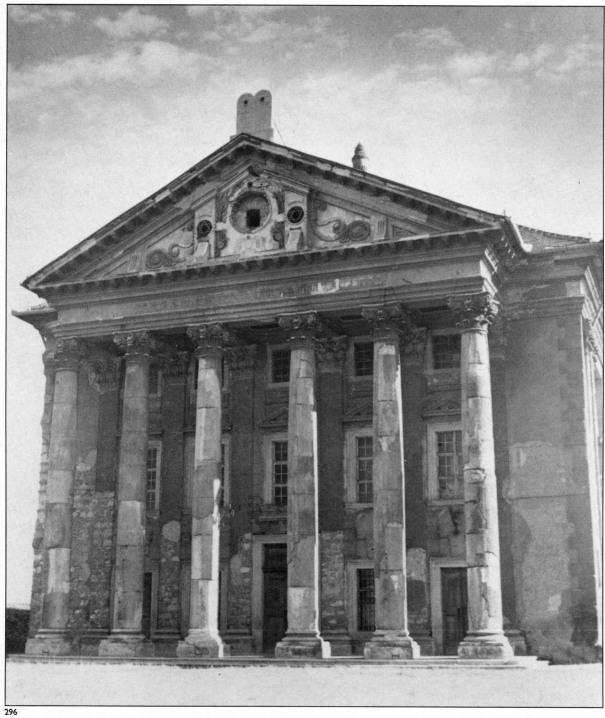

296

296. The Obuda Synagogue, Budapest, 1820/1, by Andras
 Landherr. As in 1968.

Space will not permit the inclusion here of details or illustrations of more than one or two characteristic works of contemporary Israel architects (other than the synagogues to be spoken of in the next chapter).

First, the Jewish Agency building in Jerusalem by Yohanan Ratner, onetime Dean of the *Fig. 292* School of Architecture at the Haifa Technion. We have chosen an early example of his work to show the Jerusalem style, given by the regulation that all buildings must be stone-faced. The rule is perhaps arbitrary but not anti-creative, for the stone is local and the city has an ancient, stony unity; also it is a fortress city with fortress buildings. An artistic difficulty occurs, however, because rough, hand-hewn stone does not express the concrete forms underneath. In Ratner's building, the small apertures, which give a more stony expression, are functional for the excessively brilliant sunlight. In such a style the older Arabic look is perhaps the norm; Ratner's building suggests this and yet is more modern than the rather famous Y.M.C.A. building in the same city that seems to us falsely regional. One wishes, however, that Ratner would have dared to be richer in moldings and shadows, as were the Greeks who also had that sun.

In the offices of the Histadrut (General Federation of Labor) at Tel Aviv by Dov Karmi, *Fig. 293* we see the influence of the French version of the International Style (Le Corbusier) taking precedence over the German (Bauhaus) version that first struck Israel. It may be compared, too, with the Brazilian Internationalists, e.g., the sun-screen and the elaborate louvers, to meet a somewhat similar functional need.

We must now consider a contrary extreme, architecture as a business for private profits, as an adjunct of real estate. Many varieties of architecture, office buildings, and "tax-payers" apartment houses and suburban developments, and every kind of continual renovation depend directly in function, structure, and form on speculative considerations. These are the bread-and-butter of the vast tribe of architects, especially in urban centers, and in the tribe, as in the real estate business itself, the Jews are vastly represented.

Commerce and community-spirit combine in a curious way in the fields of entertainment and merchandising. And these avenues into architecture the Jews have taken in large numbers. Whether we consider theater-builders in the grand style or the innumerable host of movie-playhouses everywhere in the world, we shall find Jewish designers. Or whether we consider huge department stores or little shops, Jews have been extremely apt at creating the setting for fashionable visual display. (Let us mention, in America, the French-born Raymond Loewy and Henry Dreyfus.)

It is always interesting to realize that the fantastic mannerisms that we see everywhere in cafeterias and movie-theaters were once first thought up by some inventive artist. So at the beginning of the century, Oskar Kaufmann (born 1873) with Strand thought up our theaters. This style has the same relation to theater architecture as Reinhardt's staging has to drama: it is the stage-designer's idea of a building. Previously—e.g., the Paris Opera or La Scala in Milan—the theater was monumental, institutional; but in Kaufmann's works—notably the Stadttheater in Bremerhaven (1909) and the Komödie Theater in *Fig. 294* Berlin (1914), we have the theatricality of a monument, the scenery externalized.

In the 1909 building, there is still some relation to the structure; we are reminded of the neo-Gothic of Messel, softly pictorialized, the stone turning to soap. This manner was to climax in the Paris Exposition of Decorative Arts, 1925, and so become worldwide. It is not good, but it is an earnest attempt to develop a modern style; it is not eclectic. The

wings have a solidity like Wright's of the same period in America. There is a struggle to be original, but this originality has not yet been crystallized.

By 1914, there is no longer architecture, but a glamorous front. This theater is, in principle, the Ziegfeld Theater in New York a generation later. The curves and the flood lighting have no relation to the structure and plan, they are for show and they look like plasterboard. This is a kind of baroque turning into psychological effects.

For the sake of completeness we must mention also the approach to architecture form of structural engineering, though this does not bear on our subject.

As with all other parts of architecture, engineering has undergone a revolution in the past hundred years; with the coming of steel and reinforced concrete we may be said to be in a new architectural period altogether, the first such fundamental change since the flowering of the Gothic in the 12th century. But here the participation of the Jews as a group is more difficult to assess. The case is not as with community or commercial building crafts; there seem to be, rather, isolated individuals.

There have been, again in America, individuals whose contribution has been truly outstanding. Louis Sullivan's partner and engineer was Dankmar Adler (1844–1900), and the firm of Adler and Sullivan is imperishably linked with the invention of the skyscraper and the modern concept of functional style.

Fig. 295 The Auditorium Hotel Building in Chicago (1887) is a characteristic work by these founders of modern architecture. Adler was more the "engineer," Sullivan the "artist" of the partnership. As Adler put it, "the pre-eminence in the artistic field of Mr. Sullivan has relieved the senior partner of that branch of professional work, and left him free to devote himself to the engineering problems involved in the modern office building." As Sullivan put it, "Adler was essentially a technician, an engineer, a conscientious administrator..." Between the two there existed a fine confidence, and the handling of the work was divided and adjusted on a temperamental basis — each to have final authority in his own field, without a sharp, arbitrary line being drawn. It was in that office that Frank Lloyd Wright was trained.

The office building here shown is historically important. It is a first celebration of the steel skeleton framework, the posts in their shell. The decorative artist, Sullivan, is obviously embarrassed as to what to do with this new thing — he is having an "Egyptian period," the bay windows seem to be Tudor, some of the decoration an upside-down Gothic. It is only more than ten years later, in the Carson-Pirie-Scott building, that Sullivan will handle this steel and glass with sureness. Obviously here, in spite of the strange appearance, the main aesthetic statement is constructivist, springing from the engineering. These early skyscrapers of Adler and Sullivan, with their forthright horizontals and verticals, caught right off the fundamental expression of this *genre*, that other architects could not improve on for two generations.

The Auditorium is a masonry building, and what is admirable is how delicate and thin the whole is made. To attenuate the construction to this degree and yet support the massive weight above required the calculation of the Gothic master. The base has the fine Romanesque solidity that Sullivan did so well, but in the total effect, to a professional Romanesque again, pales away into the constructivist expression. This is a famous building whose real achievement is not visible from any exterior view. There were serious problems of the foundation, triumphantly solved with great originality, and Adler's

acoustics of the auditorium itself were so advanced that they were used as the standard for the Chicago Opera House forty years later.

Synagogue *Anshe Maariv* in Chicago (1890), also by Adler and Sullivan, somewhat similar to that of the Auditorium but later and therefore richer, is spoken of in the next chapter.

There seems to be no especial link of the Jews in the West to engineering, and they have suffered a certain amount of exclusion from it in certain countries. Yet, where they are accepted, they have sometimes excelled. Thus, Albert Kahn (1869–1942) was without question the most influential industrial architect of modern times. With Henry Ford (for whom he built the great automobile factory at Baton Rouge and almost we might say the City of Detroit) he was the artisan of the single-story factory for the continuous-flow assembly-line. He built not only for Ford, but also for Packard, Cadillac, etc.; and he has been the builder for the aircraft industry — Willow Run, Pratt-Whitney, Curtiss, Glenn Martin, etc. Also, in the spirit of the jobs he has worked at, Kahn, more than any other man, has introduced, for better and worse, assembly-line production methods into the professions of architecture and engineering themselves. The Ohio Steel Foundry Company Building (1940) is engineering functionalism at its best. The whole huge structure depends on the curiously shaped metal bents, that only a man who knows all about steel and the possibilities of working it would have ventured. The glass curtains of the wings hang from the cantilevers.

The work of contemporary Russian-Jewish architects may be instanced from a small and heterogeneous group that may be placed together, despite differences in style and the spread of nearly twenty years; for considered together chronologically, these few pictures make up a poignant historical and ideological drama.

J.G. Gewürtz is from the pre-Revolutionary time and was in the *avant-garde*. In the twenties, when the advanced was the ideal norm, he won great esteem and became Dean of the School of Architecture of the Academy. His project for a fire-station for Leningrad (early 1920's) was a project not very distinguished in the realm of international style planning and embarrassed by an academism unable to make up its mind; but it won its competition. On the other hand, the Botkin Memorial Hospital for Infectious Diseases by A.I. Gegello (born 1891) is quite interesting. At first inspection the model looks like a rather good suburban housing project. As a hospital, it turns against centralization and an inhuman and generally quite unnecessary "efficiency." (No doubt the decentralized plan springs also from the need for isolation of the various diseases.) The suggestion of a *dacha* style in the individual buildings goes in the same direction. In detail the design is fairly clumsy, unable to achieve the pleasant effect of lightness that is sought; this is unquestionably due in part to the lack of skills in this style on the part of the craftsmen; for instance, even the renowned Centrosoyus of Le Corbusier in Moscow was ruined by the lack of craft skills and material of the necessary Western refinement. Gegello was well-known for his House of Culture in Leningrad, that is reported to have the best acoustics of any theater in Russia.

H.A. Trotskii's glass factory at Belyi Bychek, designed in the nineteen-twenties, is more masterly. It has the easy sprawl of an American factory but is more artistic than similar American buildings of the period. Notice the way the diverse elements are bound by the big cantilevered horizontal. In the rear (not shown here) is a bold triangular shed made of

concrete bents, quite advanced for the time. The whole seems to sit very quietly in its woods. This building is typical of Trotskii's work of the period in other *genre.* When we see this same Trotskii again, in his project for the Palace of the Soviets at Leningrad (1937), he has become a "traditionalist" or "neo-Classicist." The project is lifeless, frigid, an imitation of an imitation. There has intervened the official ban against "constructivism," "functionalism," "formalism"; the works we have been so far discussing fall in these considerably overlapping categories. The ideological leader of the pure "functionalists" was Ginsburg, another Jewish architect; and among the "formalists" and "constructivists," "international stylists," were the Jews Langbard, Greenberg, Levenson and Turkus.

The crisis came to a head with the competition for the Palace of the Soviets in Moscow, 1932. The first prize decision ended in dissension among various styles. (One of the winners was Hector Hamilton, an American, with a quite ordinary American business skyscraper-style building, which apparently represented power and elegance in Russia during that year.) A second competition, now confined only to Russians, was won by the "traditionalists," imitative version of Peter the Great's imitation of Versailles and the Renaissance. A third competition finally hit on the ideal of "socialist realism," grandiose, sentimentalized naturalism with a national message. This meant, in architecture, that the Palace would be a pedestal for a statue of Lenin: this was Iofan's idea and he was granted the commission, but work was stopped by the war. Later, he became the principal architect for the rebuilding of Stalingrad.

Let us summarize. To explain how it is that from nothing the Jews have come in a little more than one hundred years to occupy a foremost position in modern architecture, it is not sufficient to say that they have become "naturalized, though hyphenated" to the gentile lines of inquiry. It is not in the nature of creative excellence to spring from conformism and secondary adjustment. Rather, it is necessary to show that there have been changes in the field of architecture itself that have made it receptive to the entry of people historically conditioned like the Jews. This had been the case in the building trades, in the status of the architect, in the idea of community, in real estate, and in modern aesthetics (though not particularly in engineering). The absence of a native plastic art among the Jews explains their slow start in the 19th century, compared to their rapid strides in, for example, science, law, literature, and music. The condition of the art in which they have now succeeded is not "alien" to them but is a human condition, both good and bad, shared by modern people everywhere. The question remains whether on the basis of this modern art the Jews will go on to develop a characteristic style of their own. If so, we would expect it to occur in either America or Israel or both; it would spring from the peculiar needs and functions of relatively stable communities. It is unthinkable that such a style could develop otherwise than from the matrix of the universal modern style.

THE ARCHITECTURE OF THE CONTEMPORARY SYNAGOGUE

by EDWARD JAMILLY

While the 19th century was distinguished by advances in political thought and in sciences and industry, these were accompanied by a marked decline in architectural standards. From civilized peaks of the Renaissance, the art of building sank into a morass of revivals. It was not until the eclectic and aimless styles of the late 19th century had been discarded during the early decades of the 20th that architects came to terms with the realities of life and devised a sure foundation on which to base further development.

The fact that Jewish emancipation occurred during this period, leading to the permeation of Jewry into all spheres of activity and into new geographical areas, had the incidental result that a vast number of new synagogues were now built to architectural standards that were low indeed. Few groups could have been as unfortunate to embark on their greatest building program coincident with a bad period of architecture. Accordingly, there are to be found in the majority of 19th and early 20th century synagogues expense and labor in profusion, and some interesting developments in plan form; but architectural quality is rare.

Architecturally few synagogues of the 19th century compared in quality of design with contemporary buildings of other religions. This may be attributed partly to the fact that no Jewish architects of any note had yet emerged. The Jewish community was, therefore, reliant on designers and builders of other faiths to interpret its ancient ceremonies and provide them with fitting surroundings. Often this produced the inevitable result that the non-Jew built a religious building which accorded with his own ideas, merely modifying the furnishings to suit ceremonial objects; occasionally, the architect, finding himself faced with a new and strange problem, produced a bizarre answer, simply to differ from his own tenets. Furthermore, the design of a synagogue, considered purely as an architectural problem, could receive sympathetic treatment in the hands of a capable and sincere architect of another faith; but poor or small communities, particularly in provincial towns, could rarely afford to employ the best men, and the quality of their buildings is correspondingly debased.

II

Despite the foregoing remarks, the first half of the 19th century provides a number of buildings of interest and a few of quality. This was a period of transition in European architecture. Renaissance, in its national variations, was still the predominant style. Methods of construction and of vaulting and enclosing space were still those of past

centuries; the impact of the new materials that were to revolutionize construction and design in the latter half of the century had scarcely yet been felt.

The Roman basilican plan commonly adopted by synagogues since the dispersal was still predominantly in use, but two experiments, at least in plan form, occur. The first of these was the oval synagogue in Seitenstetten, Vienna (1825–26), by Joseph Kornhäusel; it is hardly surprising that it should have occurred in the Austro-Hungarian Empire, where rounded forms were favored elements of the richly ornamented classic style prevailing. Apart from its plan form, this was a characteristic Empire design, with giant Ionic columns carrying the gallery at mid-height and running upwards to support the roof, very similar in proportion to those used by James Spiller in the Great Synagogue, London (1790); a domed ceiling over the central space terminated in a lantern. At Avignon, a circular synagogue in the Roman manner was built by the local architect Joffroy in 1846–48; recalling the many monuments of that great civilization that remain in Provence, it is not wholly unexpected to find a synagogue adopting a shape that has been popular in the Latin world since the Temple of Vesta was built in Rome. Perhaps the choice of plan form at Avignon may also have been influenced by the precedent set when Freiherr von Erdmannsdorff, at the time he was laying out his castle and grounds, built the circular synagogue at Wörlitz (near Dessau) in 1790. There are considerable differences in detail between these two buildings; the interior of Avignon was lined by superimposed columns and lit through the roof, whereas Wörlitz had a lower ceiling and plain walls pierced by bulls-eye windows.

The New Synagogue, London (1838), by John Davies, is more typical of this period. Here was the traditional basilican layout with the reading desk centrally placed, the ark in the apse facing it, and a processional space between the two. Women's galleries are provided on either side of a rigid symmetrical plan. The interior has grandeur and richness, the style is as formal and correct as the dress of the congregants depicted in the contemporary print.

Paris provided another orthodox basilican example, in the Rue Notre Dame de Nazareth (by Sandrié, 1819–20), although here the side aisles were somewhat squashed by the narrowness of the site. The front elevation, of simple and good classic proportions, opened to an Empire interior with columns of the Doric order supporting the galleries, upon which were set Ionic columns to carry the flat arched and coffered ceiling. There were two slightly unusual features of this design — the synagogue was lit entirely through its ceiling owing to site restrictions; and the women's galleries were screened to their full height by diagonal trellis work. The latter feature was, of course, usual in synagogues of the Middle Ages, but full screening was beginning to be discarded by this date in Western European buildings. This Paris synagogue was rebuilt in 1850–51 by Thierry, but in its original form was supposed to have been modeled on that of Bordeaux (1812, by Corcelle). Bayonne (1837) is yet another example of a basilican plan treated in the Renaissance manner; a strong Roman influence is evident here, in the bold Tuscan columns, medallions, and clear-cut arch over the ark. The ark, as usual in French Sephardi synagogues, is set in an apse and veiled off by great curtains, which are partly raised during the service.

Fig. 296 The Obuda Synagogue at Budapest (by András Landherr 1820–21) possesses a bold Renaissance front with a portico of six Corinthian columns. In Munich, the Frenchman J. Métivier, who was much in demand by the court, undertook two ecclesiastical commissions — a Protestant church and a synagogue. The latter, completed in 1826, was a

notable building of the classical school, and was followed a few years later by the fine synagogue at Copenhagen (1832) by G. Hetsch, architect for university and other public buildings in the Danish capital.

The first settlers in the New World had followed the meetinghouse traditions of their European contemporaries; and the early American synagogues of the 18th century, in New York and Newport, R.I., contained little suggestion in their domestic exteriors of the use to which the interior was put. At the end of the 18th century, however, American synagogues began to take on a new character, as yet undeveloped in the Old World. In this virgin country, where the Jewish settler was on a parity with all other immigrants, the synagogue began to assume similar external expression to that of churches, and the former simplicity and lack of ornamentation of the exterior gave way to monumentality and attempts at glorification of the religious building. The Beth Elohim Synagogue of Charleston, S.C. (1794), though its interior was arranged in accordance with the established Sephardi tradition, even raised a tower and steeple above its Georgian Colonial facade.

III

In 1841, three years after the loss by fire of its first building, the congregation of Charleston opened its second synagogue designed by Cyrus L. Warner and built by a Jew, David Lopez. Behind the heavy Doric portico — a very correct rendering of a Greek hexastyle temple (probably modeled on the Theséion at Athens) — lies a gracious white interior with a shallow curving plastered ceiling and classically molded woodwork. This lays claim to be the best of the Greek revival synagogues.

Fig. 297

More curious than the Greek were a few Egyptian revival synagogues. Egyptian motifs in architecture had a limited span of popularity as reports came back to Europe and then America from archaeologists who followed in the train of Napoleon's Egyptian campaign. Private houses, places of assembly, libraries, and churches were built in the manner of the pharaohs. It was no more inconsistent for synagogues to adopt the dress of their ancient persecutors than that of the Greek; both were derived from pagan buildings, but the former was a little closer to the home of Israel. So, in the days when any style would do, as long as it was the fashionable one, the Mikveh Israel congregation of Philadelphia commissioned William Strickland to design their new synagogue (1822–25). He produced a design basically Georgian in form but with Egyptian details. Strickland was a well-known architect, but of his buildings only this synagogue and a Presbyterian church at Nashville (1848–51) are in the Egyptian revival style; perhaps the synagogue was a small experiment which led the architect to his later and more ambitious design. The Mikveh Israel Synagogue had another distinguishing feature: the semicircular interior was contained within rectangular walls and lit through a domed ceiling by means of a central lantern. Another Philadelphia congregation, the Beth Israel, built a synagogue in 1847–49 in the Egyptian style: its architect was Thomas U. Walter, a pupil of Strickland and the man who gave the U.S. Capitol in Washington its great dome and completed the building of the Congress. In England, free use was made of Egyptian motifs in the tiny Canterbury Synagogue (1848), while three years later, Australia produced another building in this style, the first Adelaide Synagogue (1851).

The Greek and Egyptian revival had this in common — both endowed a building with an appearance of massive construction, of solidity and permanence. The use of these styles

is an indication of self-assurance, eloquent proof of the rapidity with which the timorous exteriors of the 18th century were developing towards the almost aggressive synagogue architecture of the late 19th century.

IV

Until now, synagogues had followed the prevalent styles of their time in the countries of their birth. When churches began to forsake classical architecture for the Gothic styles of the Middle Ages, synagogues (with few exceptions) did not follow suit, partly because Gothic was thought to be identified too closely with Christianity.

Perhaps the revival of interest in the Jews of medieval Spain was responsible for a return to the architectural style of their synagogues. In a spirit of romantic escapism, the Jewish bourgeois of the industrial age evoked the splendor of the palaces and gardens of the Alhambra. Reports of the synagogues of Toledo, now used as churches, began to percolate. Perhaps there was also the thought that the Jews derived from the Middle East, and in Islamic countries had enjoyed a greater continuity of residence and respect than in the West; their architectural association with Saracenic detail would therefore have been of longer duration than other styles.

As early as 1838–40, Gottfried Semper built a squarish synagogue in Dresden of Byzantine form with a simple exterior, a timber dome 69 feet in diameter, and having two stub towers crowned with cupolas flanking the entrance; the internal detail was Moorish. This modest building seated 500, but was followed by more ambitious examples. At mid-century, the interior of the Cologne Synagogue (designed by E.F. Zwirner of Berlin, a church architect fond of florid Gothic and at that time charged with the restoration of Cologne Cathedral) shows how much more elaborate the Moorish decoration had become since Semper's comparatively restrained interior at Dresden. The synagogue in the Tempelgasse in Vienna (1853–58) contained 2,000 seats and was carried out in fullblooded Arabic detail by the well-known Viennese architect and city planner Ludwig von Förster, in conjunction with Theophil von Hansen.

Förster was also responsible for the synagogues in Vienna (Leopoldstadt), at Miskolcz, Hungary, and at Pesht (1860)—the latter banded externally with colored bricks, its façade interspersed with stone and terracotta, decorated with angle towers and cupolas. The architectural historian, Fergusson, writing about Budapest in 1891, describes this synagogue as "the most striking building in that city"; truly it was one of the richest in Europe. Yet despite the romantic ornament with which it was covered, the Budapest synagogue, like the Houses of Parliament in London, remains in plan form and mass essentially a classical building. The old Temple Emanu-El, New York (1868, by Eidlitz, *Fig. 284* an important church architect), reconciled a Gothic plan and details with Moorish decoration, yet for all its pretentiousness, retained a middle-European peasant feeling. In Philadelphia, Frank Furness and George Hewitt built the Rodef Shalom Synagogue (1869–70) in their own particular brand of ugliness with a bulbous dome—"a study," according to a local historian, "from the Arabic, particularly the style of the Calif's Tombs outside Cairo!"

By 1866, elaborate angle towers which characterized this design, were an accepted feature of the Moorish style; they were adopted in many countries, crowned with balloon-like cupolas or onion-shaped and bulbous domes. They flank synagogues of varying sizes at Liverpool, London, and New York (Lexington Avenue). Elsewhere the

same motifs are repeated in more fanciful form. The new Florence Synagogue of 1880, designed by a committee of architects and engineers headed by Falcini, represents the "ultima Thule" of Moorish decoration: within a Byzantine building directly inspired by "Santa Sophia," Constantinople, lies one of the most elaborate interiors achieved during this period. Although excessively ornamented and somewhat restless to modern eyes, one cannot but admire the consistency with which decoration has been applied, the craftsmanship and spaciousness of this interior, while the dome dominates the sector of the city in which it was placed.

Fig. 298

But there were voices raised in protest against the prevalent style. A Jew, Albert Rosengarten (who built synagogues in Cassel and Hamburg in the Romanesque style), wrote a popular handbook in 1874 on architectural styles, in which he found "not the slightest historical justification for the adoption of the Moorish style as normal for Jewish synagogues; it has been merely a question of partiality and perverted taste, and a vague and unauthorized notion of imparting an Oriental aspect to the buildings; the Moorish style is as inconsistent with the purpose of the building on religious grounds as it is on historical."

During the whole time when the Moorish style of ornamentation was fashionable, isolated examples of synagogues in the former Classic or Renaissance manners were still being built. Often a single architect would turn his hand to several styles; H.H. Collins, a Jewish architect who built a number of London synagogues, could design a Sephardi synagogue in a Saracenic manner, and follow it with two others for Ashkenazi congregations in the same city a few years later, using a Doric order, coffered ceiling, and florid Italian Renaissance detail. Karl König, who built many noble mansions in Vienna, could still design a Renaissance synagogue (Vienna, Turnergasse, 1871–72) with Förster's Oriental examples before him. Rome and Warsaw were two capital cities which refused to be swayed by the Moorish; while the latter adopted the Renaissance style, an Italian influence was natural in the Synagogue of Rome, occupying a prominent position on the bank of the Tiber on the site of the former ghetto.

Fig. 299

V

Enough has been said of the almost universal Moorish detail of the mid-19th century to show that it was applied largely to Byzantine designs. Where a large square building was desired of cathedral dimensions, the Byzantine dome over a Greek cross plan was an obvious choice. The synagogue in the Oranienburgerstrasse, Berlin (1859–66, by J. Knoblauch and others), demonstrated the enormous capacity of this form; it seated 3,000, and vestibule and lobbies were enlarged proportionately to receive the congregation. The Byzantine dome was flanked either with barreled or gabled transepts, occasionally endowed with corner towers and cupolas or miniature domes. Florence has already been mentioned as the striking example, but there were others at Sofia, the capital of Bulgaria — geographically close to the prototype for them all — and as far west as the Great Lakes of North America, e.g., the Plum Street Temple of Cincinnati (Ohio), with its thirteen domes and two minarets!

But there was another definite type of architectural style in use — the Romanesque. The synagogues of Breslau and Strasbourg (now destroyed) were surprisingly pure copies of Romanesque churches, favoring the German style with its picturesque turrets. Often the traditional basilican synagogue plan found expression in the manner of the early churches

of Northern Italy; typical of these was the end elevation, consisting of a gable terminating the nave, and lean-to aisles arcading beneath the eaves, and a rose window centrally placed over the entrance. Mannheim Synagogue (1855) is a fairly obvious derivative; so in general form are the elevations of Karlsruhe (1875) and Stuttgart (1861) — although the former is distressingly complicated by too many borrowings from other styles, and the latter a hybrid example of Romanesque detail foisted on a Byzantine domed interior.

Fig. 300

Fig. 284

The synagogues of Paris — Rue de la Victoire, by Aldrophe (1874), Rue des Tournelles by Varcollier (1879) — and Brussels (1880) are Romanesque in style: while the supreme example was the Temple Emanu-El in New York.

There is hardly a synagogue of the period, which does not fall into one or the other of these groups, or into Oriental "mish-mash" grafted onto a Renaissance form. Moorish, Arabic, Saracenic, and Turkish detail was applied freely to all groups, but the use of horseshoe arches, of graffiti-work, of inlayed materials, and internal richness of ornament are more characteristic of Byzantine designs. Often details reminiscent of the Middle Ages in Europe were intermingled — crenellations and machicolations to roof lines, towers and gables, rose windows, stilted arches, octagonal corner turrets, and arcading; particularly were these associated with the Romanesque. Yet it was by no means unusual to find, in the same synagogue building, forms and details drawn from half a dozen historical styles of architecture and mixed together with remarkable lack of taste and consistency.

Materials varied widely: often all were used on the same building. Instead of the serenity, beauty, and repose to be found in a building of good proportions using simple materials well, these synagogues threw restraint to the winds, clamored for attention, and by piling extravagance upon artifice exposed their vulgarity and ostentation from the prominent city sites they now occupied. In fairness let it be said that errors of taste were by no means confined to Jewish places of worship; under the respectable cloak of the Gothic revival, cardinal offences were often committed by church architects, while secular architecture gave unbridled rein to the forces of architectural disruption.

VI

As has been pointed out, although medieval synagogues adopted the contemporary style, synagogues of the 19th century shied away from Gothic. Nevertheless, a certain amount of Gothic detail can be detected, mixed in with the dominant Romanesque, Byzantine, and Oriental styles — sometimes in the tracery of windows or in forms of vaulting, in the use of clustered columns attached to piers, occasionally in the introduction of a pointed arch.

It is a pleasant surprise to discover in the little Beth Jacob Synagogue of Plymouth, Massachusetts, a simple arched entrance and pointed windows flanking it, a rose window piercing the gable end. The building is otherwise Georgian in detail and has a New England clapboard exterior. At Archshofen, in Württemberg, the synagogue (built 1865) was rescued from banality by the insertion of long pointed windows with an upward quirk at the center.

But these were merely tinges of detail in basically un-Gothic structures. For a full-blooded example of a Gothic synagogue, we must go to Savannah, Georgia, where the ancient congregation Mikveh Israel, having commissioned a church architect,* was

* He is popularly believed to have used, on a reduced scale, designs already made for a church.

given such a building in 1877, consistent even to the design of such internal details as the memorial tablets. Perhaps Vienna had more Gothic synagogues than other towns, due to the beliefs of one man, Max Fleischer. Working in a city of Classic and Baroque architecture, he steered firmly away from styles which he considered profane and pagan for religious buildings and designed three Gothic synagogues, in the Schmaltzhofgasse (1883–84) with a flat ceiling decorated with pendants, the Müllnergasse (1888–89) complete with towers, and the Neudeggergasse (1903), in Early English manner. In his choice of style, Fleischer was supposed to have been inspired by the ancient synagogue of Prague. These synagogues were built towards the end of the 19th century, when the Moorish craze had passed its first flush of novelty and excitement. They were accompanied by a few others in the Gothic style, usually in provincial towns (e.g., Sheffield and Leeds in England), where church architects were employed. The exceptions, however, prove the rule, and it is true that no great or notable synagogue in any capital town chose the Gothic.

Fig. 301

Let us pause and consider one or two interesting sidelights in the history of 19th-century synagogues. We have been following general patterns and trends in planning and design, but there are two buildings sufficiently unusual to deserve comment. The Stockholm Synagogue of 1878, designed by F.W. Scholander was described in a contemporary journal as "one of the most noticeable edifices of the Swedish capital." Although it has a simple rectangular plan with galleries, nothing quite like it in external appearance occurred elsewhere. There is a machicolated parapet with a top-heavy appearance, slightly projecting stub towers at each corner and dominant end walls. Perhaps due to its remoteness from the battle-ground of popular styles, the Stockholm Synagogue evolved a peculiar detail of its own — triangular heads to long windows and hexagonal frames to circular.

Fig. 302

A second building to which attention must be drawn is the "Mole Antonelliana," designed as a synagogue in Turin by Alessandro Antonelli of Novara in 1863, and not completed until 15 years later. The architect, after whom it was named, was apparently inspired by the dome of Florence Cathedral to attempt this structural *tour de force* and raised upon a columnated building of two stories, a square base and cupola of heroic proportions bearing a steeple; the spire reached the fantastic height of 250 feet. This building arose out of the desire of the Jewish community of Turin to express its gratitude for its recent emancipation by means of a structure which would be an architectural ornament to the city. Unfortunately, the project turned out to be far too ambitious; funds ran out; there were delays and long drawn-out battles over the cupola. Ultimately, the municipality relieved the Jewish community of the burden, taking over the unfinished building and completing it as a civic monument. It is now used as the Museum of the Risorgimento.

Fig. 304

The last century also provided a number of examples of churches converted to synagogues, thus reversing a trend which since Roman times had been a common occurrence in countries where Jews had been oppressed. Jewish use of churches in the 19th century was not the result of strife and unhappy persecution; rather it was significant of the succession of immigrants, the inability of modest communities to afford to build for themselves, and of friendly relations between communities. As a result of the affinity between the congregational worship of Jews and Nonconformists, their buildings were often similar in architectural character; and chapels acquired by Jews were often converted satisfactorily into synagogues.

VII

We have so far considered synagogues mainly from the aspect of style in outward appearance. But the 19th century brought about important changes in plan arrangement, which were intimately connected with the increasing popularity of Byzantine forms. When, in 1818, the Reformed synagogue or "temple" was founded in Hamburg, a movement was started which was to have far-reaching effects on synagogue design. The basilican plan which had been used for so many centuries because Jewish liturgical furnishings and ceremonial fitted it so well was immediately questioned as soon as the form of service underwent revision. Coupled with the simplified form of service introduced in Reform congregations, came a greater emphasis on the rabbi's position. Greater importance was placed on the sermon. The rabbi became a preacher, choir and organ were introduced, and the form of service came by degrees to resemble in many respects that of Christian worship.

The effect on synagogue planning was revolutionary, and was not confined to Reform synagogues. From his traditional position in the center of the congregation, the minister was elevated to a pulpit. The central reading desk merged into the platform before the ark, and all activity became concentrated at one end of the building. Once this change had occurred, it became desirable to provide good sight lines for the congregation, and the desire to hear the sermon distinctly from all seats led to a reshaping of the basic plan. Form follows functions; first the basilica became shorter, then square, with fixed seating stepped up on the sides from the center. As congregations grew in the larger towns, a Greek cross plan with domed central space gradually became the accepted solution because it brought large numbers of seats as close as possible to the ark platform, and as a structural form was capable of bridging greater areas than the nave roof of the basilica. Largely for the latter reason, the square (and later octagonal) domed plan came into use by Orthodox as well as Reformed congregations, which had to meet the problem of maximum capacity. The combination of *bimah* and ark-platform and the introduction of a choir gallery over the Ark was adopted quite commonly by Orthodox as well as Reformed congregations on the Continent and in the U.S.A. On the other hand, it did not become popular quickly in England, and was resisted by Sephardi communities. Indeed, in strongly Orthodox communities, Reform innovations led to elevation of the traditional layout into a point of principle.

Finally, for a form of service in which the congregations sank to the level of an audience and the minister took the position of leading actor, theater plans became an obvious solution, and in Reformed synagogues of this century are to be found fan-shaped auditorium plans with raked floors; these are minutely studied for good vision and acoustics and have almost theatrical concentration of lines of the ark and pulpit, with materials and lighting cleverly used to create an emotional effect. As the result of the abolition of segregation between the sexes, such plans (except where capacity determines shape) usually lack galleries.

These striking changes, which came about within a century, upset a plan form which had been traditional for more than sixteen centuries. After the full effect of the Reform movement had been felt, the emphasis had changed from a congregational worship, in which the minister* was a leader in the center of his flock, to a staged performance with the

* The word "minister" is used here in a general sense. Traditionally Judaism had a *hazan* who prayed with the congregation and a rabbi who was essentially a teacher.

minister pontificating before an audience. Curiously enough, in discarding Orthodox ritual observances and adopting forms and customs apparently very much simpler and more liberal, Reform synagogues achieved an atmosphere more overpowering than had ever previously obtained; this was done by the staging of services, timing of musical interludes, the significance given to a few special prayers recited in Hebrew, and the emotional character of the architecture.

As the Reform service grew close to that of Christian worship, it is not surprising to find the synagogue, particularly in America, coming to be regarded as a Jewish church and assuming external forms as demonstrative as those of churches. Stylistically, as we have seen, the synagogue—or temple, as the Reformed synagogue had now chosen to call itself—sought an external expression which would differentiate it from churches. For a while, it chose almost unanimously the dome of Byzantine origin, which came to be regarded as a symbol of universality and happened to fit the square plan now adopted to suit the new form of service. The rise of wealthy communities and the full citizenship now enjoyed by Jews, gave opportunities for architectural display and artistic adornment, for which the Byzantine style gave great scope. A general relaxation of Talmudic ordinances opened (or rather reopened) the door to representational art* , hitherto confined to half a dozen symbolic devices. Rules governing the orientation of synagogues were also relaxed; while plausible religious reasons were advanced for a departure from convention, it was admittedly convenient on a valuable or restricted urban site to be able to discard this restriction** .

Before passing to the achievements of the present generation, it may be noted that towards the end of the 19th century, as the Oriental style passed its zenith, there came a further spate of stylistic borrowings. Having exhausted their sources of ornament, architects turned to a final flurry of revivals. In Germany particularly, a curious bastard style which has been called the "Rundbogenstil" emerged; it reached England with the building of the Reform Synagogue in London (1870) and was characterized by a florid ornamentation of Italian Renaissance.

Classic, Renaissance, Georgian, Colonial, Empire, Baroque came back in swift succession—now grafted onto steel skeletons and sometimes handled more skillfully than their riotous predecessors. The Synagogue on the Lindenstrasse, Berlin (1890–91 by Cremer and Wolffenstein) seated nearly 2,000 within its pseudo-Renaissance interior—"Hanoverian" or "Wilhelmian" was the new name for it. In the U.S.A., the Byzantine dome was made of reinforced concrete and clothed with a Spanish mission flavor on the West coast; in Chicago and Cincinnati, the Greek temple came back; Atlanta, Georgia, revived the Colonial style. Shearith Israel, New York, was rebuilt in 1897 in U.S. Government Classical. The enormously impressive Temple Emanu-El (1929) was constructed on one of the most fashionable streets of New York on the lines of a Gothic cathedral, with Romanesque detail.

Synagogue architects were no more adventurous than the body of their profession.

* Perhaps the most remarkable examples are to be found in the Wilshire Boulevard Temple of Los Angeles, U.S.A. (1929), where the characters and events of Jewish history are portrayed in a series of murals within the synagogue. For representational art in the synagogue in former ages, see chapters V and VII.

** Synagogues, like churches (which obviously reflected in this the former synagogal convention) traditionally faced towards the Holy Land: in Europe or North America towards the East (*mizrah*) or South-east. To effect this on sites where main entry in the normal direction would have meant an incorrect orientation, some synagogues were planned for entry at the sides or at the rear of the ark.

They evolved no fresh approach to problems of design; they substituted the new materials now available only where these had economic or structural advantages. A classic architect such as David Mocatta (whose work has been spoken of in the previous chapter) used cast iron columns and brackets to support the galleries of the earlier London Reform Synagogue in 1851, but clothed them with irrelevant stone moldings executed in plaster. In the latter half of the century, the use of cast iron assumed larger proportions as architects appreciated the relative ease by which spaces could be bridged with the material. If only the casting was suitably molded to represent something entirely different — an acanthus leaf, for example — it was sometimes allowed to show. The Central Synagogue, London (1870), made considerable use of cast iron in this way, while the synagogue in the Rue des Tournelles, Paris (1879), expended one-quarter of its budget on ironwork supplied by Eiffel & Co. The American preference for domed synagogues (a symbol of universality) gave early employment to reinforced concrete construction; the most modern technique was wedded to architectural forms of the Roman Empire in the East. Gradually, the new materials became absorbed into buildings, until they became the mainstay. Only during the present century did synagogues begin to shed their eclectic garments and superfluous ornament.

Following the various revivals and the final welter of heterogeneous styles which marked the end of the 19th century, and after the engineering exploits and the introduction of new materials into building, a new idiom began to appear. It showed itself, first of all, in a simplification of design. The façades and the interiors of too many synagogues had been exuberant and restless, hardly conducive to a sense of dignity, repose, and solemnity. To strip the ornament was the first step to take. Once this had been done and the form and material of the building were revealed, the architect began to take greater interest in the general massing and modeling of his design and to explore the natural textures and contrasts inherent in the materials available to him.

Fig. 305 Among the first to break away from eclectic style was the Kehilath Anshe Maariv Synagogue of Chicago (1890–91) designed by the Jewish architect Dankmar Adler and his partner Louis Sullivan, who exerted so profound an influence on American architecture. The interior of this place of worship is similar to though richer than that of the Auditorium Building in the same city, designed somewhat earlier by the same architects. It was followed by Körner in 1913 at Essen — a domed building, reached like the Oranienburgerstrasse Synagogue of Berlin through a series of vestibules. Yet it was fresh in its lack of derivative detail, and made bold and effective use of coursed rubble stone. Zurich also, with a synagogue built in 1923–24 (by Henauer and Witschi), following a competition in 1918, shows the return to sanity after the Byzantine dream.

The German architect Peter Behrens, another great name in the Modern movement, designed in 1928 for Zilina (Czechoslovakia) a domed synagogue which, by comparison with its predecessors and many of its contemporaries, was altogether admirable. It possessed a fine sense of simple dignity, proclaimed its purpose, and was composed well in all its parts; the shape and design of the dome owed nothing to Constantinople, but developed uniquely and naturally from the reinforced concrete system used. During *Fig. 303* the nineteen-twenties, a brick synagogue built at Amsterdam-Zuid (by Harry van Elte) was simpler even than Behrens' building and exemplified the new interest in effects to be obtained by using local materials. This was also a time when architecture came under the influence of Cubism and in consequence buildings followed strict geometric lines.

German Modernism produced a Liberal synagogue at Hamburg in 1931 (Ascher and Friedmann), which was perhaps as ascetic as any; here perfectly plain stone walling, as in the recent Temple of the Sinai Congregation, Chicago (by Friedman, Alschuler & Sincere, 1952), was used entirely unrelieved by any ornament. The reaction from the bastard Moorish synagogue architecture had gone to the other extreme. This building had a well-planned interior, and although the elevations appear stark to our eyes, it was necessary at the time to try and clear away the cobwebs of inherited irrelevancies in order to provide the basis for a new style to develop.

Germany produced other notable synagogues at Plauen and Berlin (by H. Rosenthal and Nathan). In England, during the 1930's, a famous engineer, Sir Owen Williams, designed the synagogue at Dollis Hill, a suburb of London, using poured concrete walls throughout with an unplastered interior. Other London synagogues were built of brick and relied purely on that material, coupled with window proportions for decorative effect; their slit-shaped openings and angular forms produce a curiously Slavic effect in these buildings (Willesden and N.W. Reform both by Landauer, Wills, and Kaula). In Budapest, the Memorial Temple, built before 1935 (Vágo and Farago), relies on the pure forms of square and circle, rectangular base and superimposed dome for its effect; on the plain white wall and triple arched portico, with its shadows, for contrast. The sole concession to romanticism is a battlemented motif running around the building and along its flanking arcade. The effect, though simple, is one of richness. Denmark provided a simple little building at Aalborg (1934). The competition designs for the new Amsterdam synagogue of 1938 show how far architects had come in two decades; the winning design by A. Elzas owed much to J.J.P. Oud, the leading Dutch architect, and had an admirable purity about it.

Fig. 305a

The way of the pioneer is hard; these and similar buildings of the 1920's and 1930's now seem immature and lacking in refinement, too bald and constructively rather experimental. Their value lay in the complete break which they made with the Oriental style. The effect of the few buildings mentioned upon the large number of synagogues built between the two world wars was salutary in that the majority were swung away from the blind alley of eclecticism and became timid and non-commital, occasionally introducing a little reminiscent detail, but for the most part being inoffensive. The ground had been prepared for new ideas.

VIII

The new architecture started by stripping buildings of all irrelevancies and exposing their naked forms. Excess of ornament was replaced by an entire lack of adornment: such is the nature of reaction. The pioneer synagogues of Europe between the two world wars had a sound functional basis and, though lacking human touches, were honest in their external expression and not without a gaunt internal solemnity. But men have rarely been satisfied by integrity alone, and a natural desire for greater artistic content in synagogues gave free rein to the imagination of contemporary architects during the last decade. The work of the pioneers had pointed the way; in the building program immediately following the Second World War, synagogue designs were to reach the next stage of development — a richer and more lyrical style emerged.

The important work of this period lies in the U.S.A. The large and prospering body of American Jews, living in cities that were intensely concentrated and of recent growth,

had a greater need for buildings than any other country of the world. The automobile, and the acceptance of its use by Reform Judaism, made distance of little importance, and many city and suburban congregations acquired with equanimity semi-rural sites for their synagogue centers, often possessing considerable natural prominence and beauty. Parallel with the change in synagogue planning came ancillaries to be attached to the main building. The reversion to the ancient conception of the three-fold function of the synagogue as house of prayer, house of study, and meeting place was given full scope in the ambitious community groupings developed in recent years. The large American temple now consists of a social hall and stage, a temple for prayer — the two often interconnected for greater flexibility — classrooms, a library, kitchen, club-rooms, and administrative offices; occasionally a small chapel is included for weekday services; the whole group is given natural surroundings where possible.

Foremost among the architects commissioned for the larger projects was Erich Mendelsohn, after he settled in America. Quick to seize the opportunities inherent in the new temple programs, he planned a succession of notable Jewish centers, all of which are highly imaginative and emotional and monumental in design. Mendelsohn's liking for curved forms had been displayed previously, not only on many secular buildings, but on the chapel which he built for the Hebrew University Medical Center on Mount Scopus in 1937; and a sketch dated 1936 for a synagogue in the Judean hills shows the very plastic and expressionist nature of his design. His American projects include the Park Synagogue *Fig. 306* of Cleveland, Ohio (1945) — a great domed temple springing from a cluster of flat roofs sited on a ridge; the B'nai Amoona Synagogue, St. Louis, Missouri (1945), with a dramatic parabolic roof; the Jewish Centers of Baltimore, Maryland (1948), and Grand Rapids, Michigan (1948), using a triple barrel vault and butterfly roof respectively. Finally, shortly before his death, he built the centers at St. Paul, Minnesota (1949), and Dallas, Texas (1951), in which he became interested in conical forms of the main temple and demonstrated clearly how the modern style could rise to great occasions and, in his own words, "lift the heart of man."

Mendelsohn built for the large and rich communities. Many smaller synagogues have also been built, and these in many ways approach nearer to the Jewish tradition of congregational worship, shorn of irrelevancies, economically planned, and pleasant; the brick temples at Tyler (Beth-El) and Dallas (Tifereth Israel), both in Texas and both designed by Howard Meyer, were modest examples. Among the many notable post-war buildings may be cited the sophisticated Jewish centers at Champaign, Ill. (Frankel Memorial), *Fig. 307* and Evanston, Ill. (Hillel Foundation), planned around courtyards and with circular temples, by Harrison and Abramovitz; the unusual diamond-shaped plan and cleverly handled roofs of the big Temple Emanu-El, Houston, Texas (Gabert, Mackie, and Kamrath); Loebl, Schlossman, and Bennett's temples at South Bend, Ind. (Beth-El), and River Forest, Ill. (West Suburban Temple Isaiah), both boldly sculptured. Quite the most *Fig. 308, 309, 310* interesting and prolific designer is Percival Goodman, whose synagogues*, though rarely large, embrace all the arts associated with architecture in a fresh and exhilarating manner.

The smaller buildings make play with materials and textures to create pleasing effects and are distinguished for their re-examination of ancient symbols and creation of fresh design forms for them. The arts of sculpture and painting, weaving and glasswork are

* In Baltimore, Denver, Lebanon, Lima, Miami Beach, Millburn, New London, Providence, and Springfield.

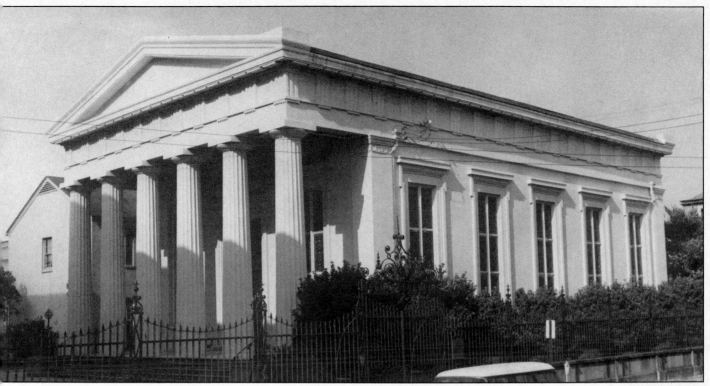

97. The Beth-Elohim Synagogue, Charleston S. C., 1841, designed by Cyrus L. Warner, built by David Lopez.

98. The Florence Synagogue, 1880, interior looking East. Designed by a committee of architects and engineers headed by Falcini, Micheli and Trenes.

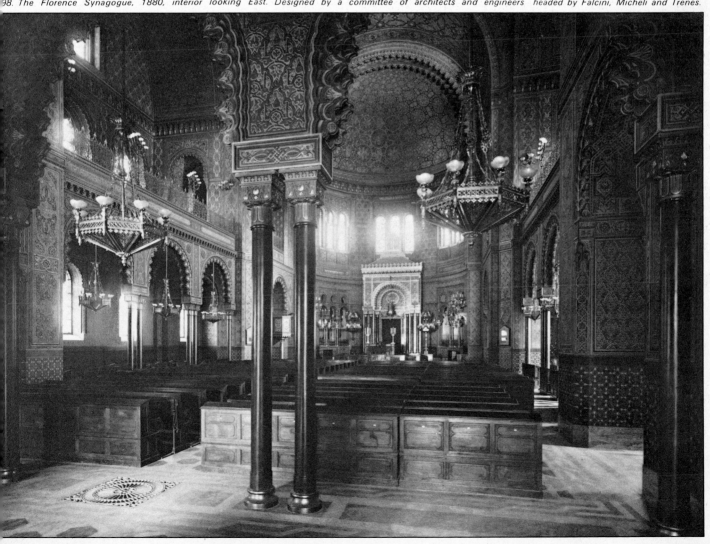

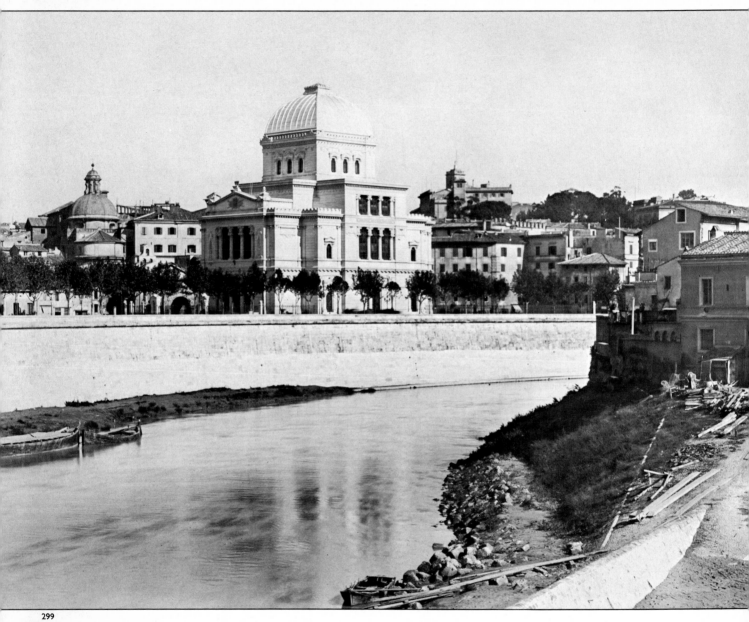

299

*299. The Rome Synagogue on the bank of the Tiber, from the
south-west. Designed by Armanni and Costa.*

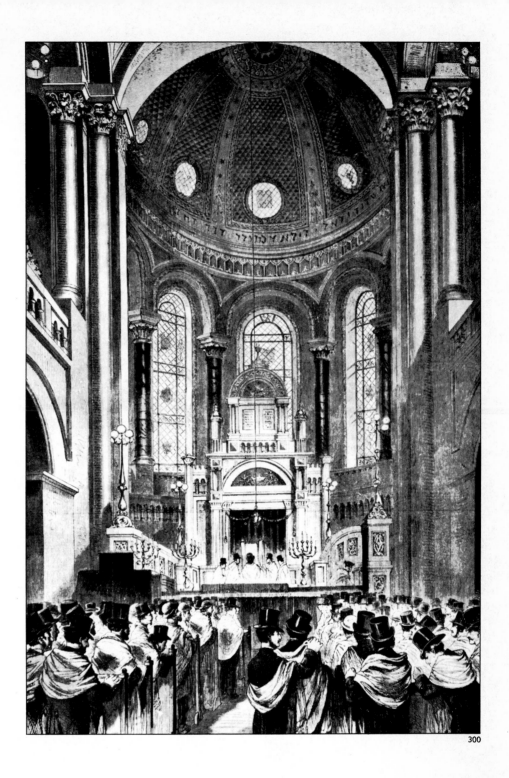

300

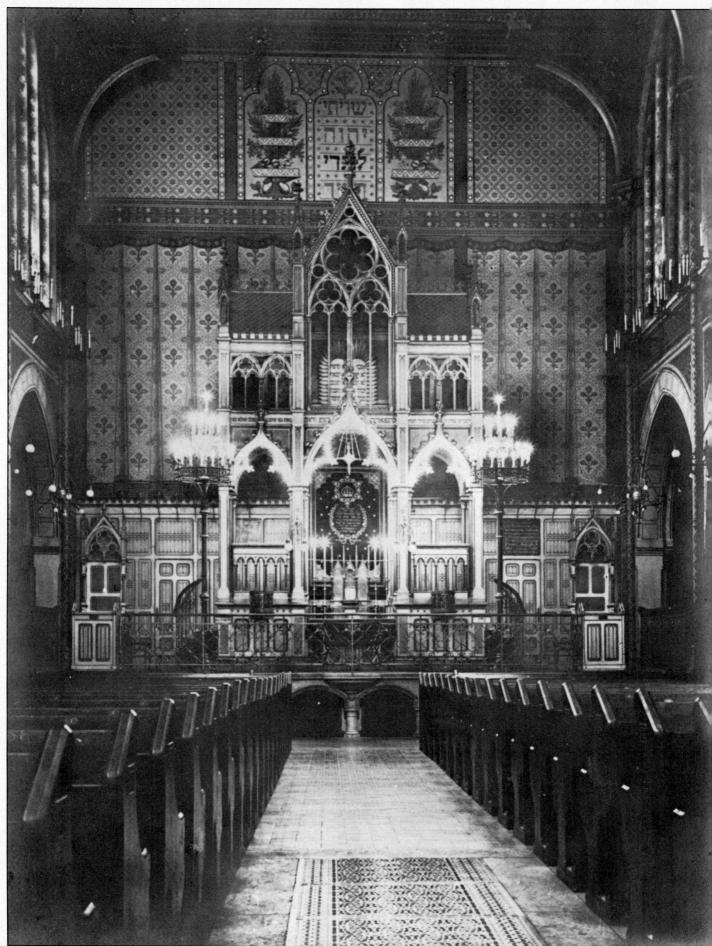

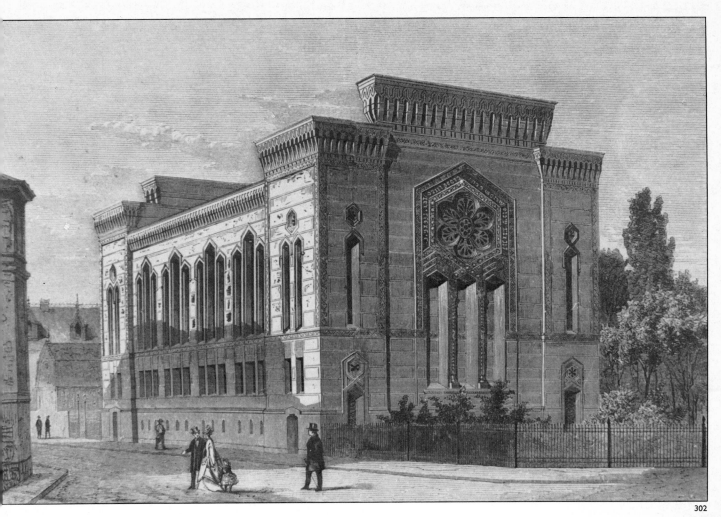

302

301. Max Fleischer. Synagogue at Schmaltzhofgasse, Vienna
(1883/4), interior. Courtesy of Museum of Ethnography
and Folklore, Tel-Aviv.

302. The Stockholm Synagogue, 1878, by F. W. Scholander.

303

303. *Synagogue in Lekstraat, Amsterdam-Zuid 1938, by Harry*
van Elte.

304

305

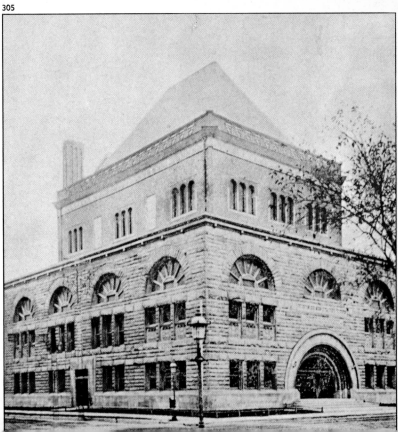

304. "Mole Antonelliana" in Turin, 1863, by Alessandro Antonelli.

305. Kehilath Anshe Maariv Synagogue of Chicago (1890/1),
by Dankmar Adler and Louis Sullivan.

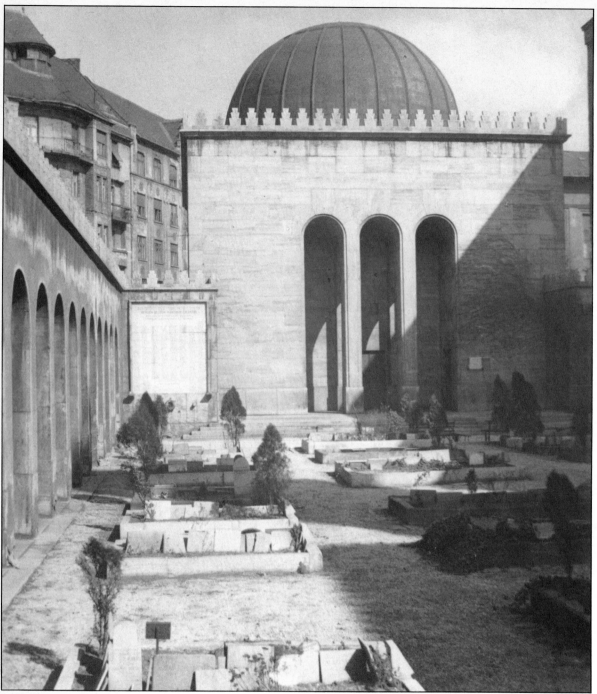

305a.

10580

305a. The Memorial Temple, Budapest, 1935, by Vago and
Farago.

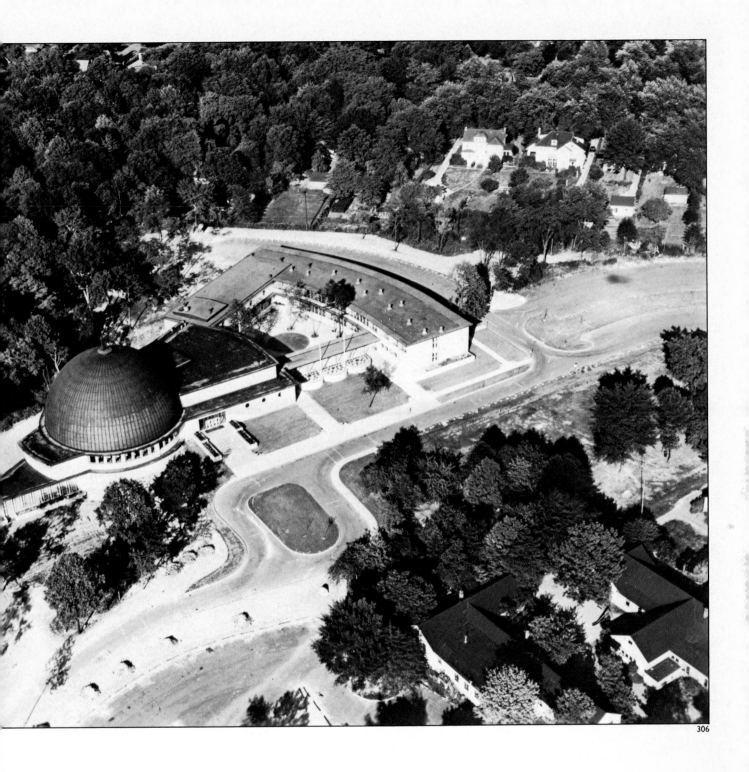

306

306. Park Synagogue of Cleveland, Ohio, 1945, by Erich
Mendelsohn. Aerial view.

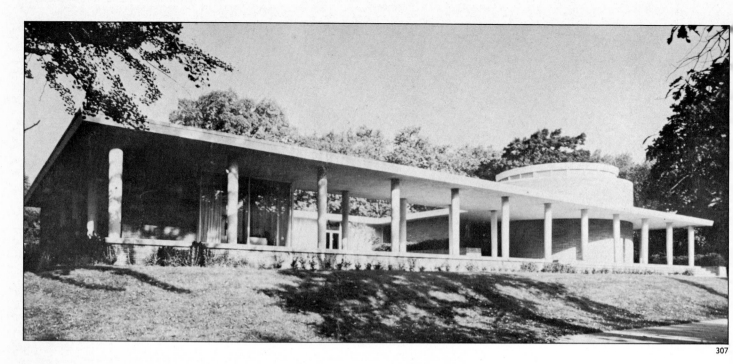

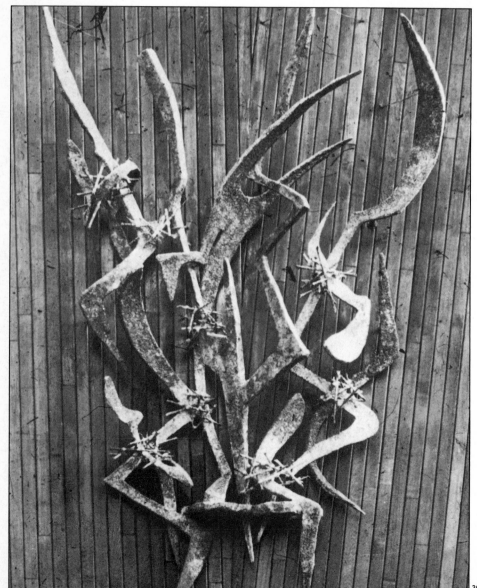

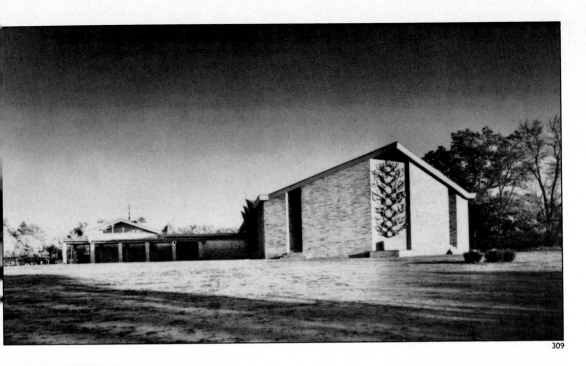

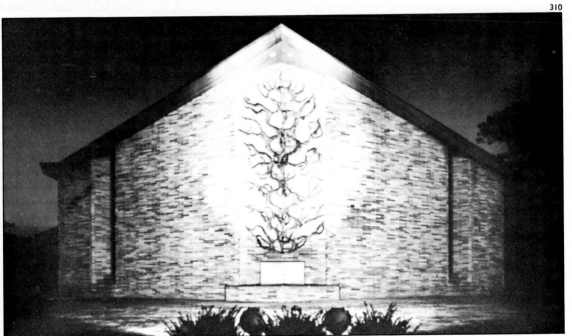

307. *Hillel Foundation, Evanston Ill., by Harrison and Abra-movitz.*

308. *Burning Bush by H. Farber on front of B'nai Israel Temple, Milburn, N. J. Architect — Percival Goodman.*

309. *Beth-El Temple, Springfield, Mass. Architect — Percival Goodman.*

310. *Burning Bush by Abram Lassaw on Beth-El Temple, Springfield, Mass.*

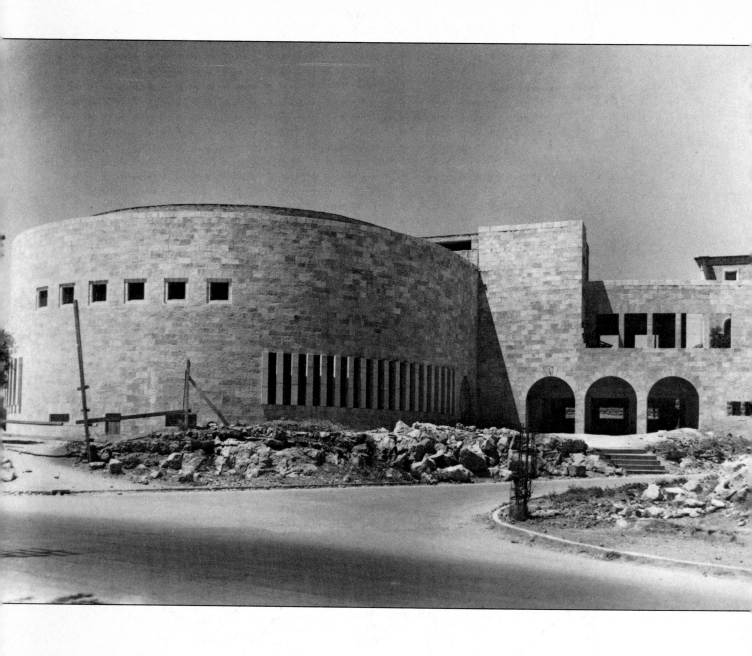

311. *Yeshurun Synagogue, Jerusalem, 1934/5, by E. Stolzer,*
M. Rubin, R. Freidmann.

brought into the synagogue with success. A simple and friendly pattern is emerging in synagogue design by the use of basic materials and the honest and imaginative approach of younger architects collaborating with artists in allied fields.

While the United States provides the vast majority of examples, interesting modern synagogues have also been built in Winnipeg, Canada (Shaare Zedek Synagogue by Green, Blankstein, and Russell, 1951), and Milan, Italy (Manfredo d'Urbino and E. Gentili, both Jews; 1954) — the latter containing an entire reconstruction of the old synagogue destroyed in the War, behind its existing façade.

After the wholesale destruction of German synagogues in the War, they were rebuilt even in tiny residuary communities. One of the first, the West End Synagogue, Frankfurt, was internally rebuilt in 1951 (Kemper, Hadebrand, and Leistikow); unfortunately the Byzantine plan of Franz Roeckle's bombastic building of 1908 remains, but in the reconstruction has been clarified and simplified, with modern stained glass and mosaic work added. A small synagogue recently completed at Woodford, near London (Weinrach), with its simple lines acting as a foil to the treed garden in which it is placed, can perhaps be taken as a sign of awakening in England.

In contrast to the 19th century, when universal styles were artificially imposed, a regional character is now beginning to appear in synagogue design. Apart from the effect of indigenous materials on design, the modern architect studies climatic requirements in a more scientific way than was previously possible. It hardly seems credible today that the beginning of this century could see synagogues in Paris and in French North Africa so similarly designed as to give no indication in their appearance of the variation in climate between their sites. The modern Yeshurun Synagogue in Jerusalem (E. Stolzer, M. Rubin, R. Friedmann, 1934–35), with its window openings reduced to suit the strong sunlight of the Middle East, and the recent synagogue at Herzliya (Mohilever and Canaan, 1950), protected by large perforated sunscreens, appropriately molded to the form of the Shield of David, illustrate the effect which climate can produce on design. The impressive synagogue at Hadera (1935) would be memorable if only for the fact that it was designed by a woman, Judith Stolzer (wife of one of the group responsible for Yeshurun in Jerusalem). Built before the State of Israel came into being, in an area where Arab attacks were frequent, it revived to some extent the conception of the old fortress synagogues in Poland. The courtyard was to have provided shelter in case of emergency for 2,000 persons, while from the tower it would be possible to survey the surrounding countryside for marauders. Israel is young, and due to the many demands on building resources, chief among them housing and the resettlement of immigrants, has so far been unable to provide many urgently needed civic buildings, and yielded few synagogues of any note.

Fig. 311

The synagogue project now inspires the major names of the Modern movement. Sullivan's pupil, Frank Lloyd Wright, published in 1954 a design for a glass-towered pyramidal temple in his favorite atmospheric manner. He has been followed by other non-Jewish architects, fired with the possibilities inherent in synagogue design; Pietro Belluschi and Carl Koch collaborated at Swampscott, Mass. (1954), on the design of the novel and interesting hexagonal Temple Israel, while Philip Johnson's vaulted design for Temple Knesseth Tifereth Israel at Portchester, New York (1954), is both simple and lyrical. The program is spurring to the imagination; the materials and the vocabulary are on hand. There need be no fear of this new style; in the hands of the right men it has all the possibilities of creating fine buildings.

285

THE JEWISH ARTIST IN THE MODERN WORLD

by EDOUARD RODITI

The troubled history, the mass emigration, and the halting emancipation of the Jews of Russia during the past two or three generations has given the Western world — especially France and America — a surprising number of Jewish artists throughout the first half of the 20th century. It is natural, therefore, to begin the survey of the contemporary Jewish artists with some account of those who were more deeply rooted in the life of the country of their birth and whose main productions were bound up with it.

Of the art of Soviet Russia, and of the part played by Jewish painters in its evolution since 1920, the Western world has only a few somewhat vague notions. We know, for instance, that the early years of the Revolution witnessed a great number of artistic experiments and that many Jewish artists participated in these attempts to renovate the pattern of Russian art. Marc Chagall and Jacques Chapiro, among painters who later achieved prominence in the School of Paris, were already well-known as innovators in Soviet Russia. Under the tyranny of Stalin, however, the dictatorship of a single style, called "Socialist Realism," ruthlessly eliminated, by a series of brutal purges, all those artists who were accused of formalism or of bourgeois decadence — in fact, all those who dissented from the party definition of art of the moment.

Though there have been, among the masters of Socialist Realism, a few well-known Jewish painters, their work remains as impersonal and undistinguished as that of their non-Jewish colleagues.

Among Russian artists of the early years of the Revolution and the decade that preceded it, there had been, nevertheless, a number of truly distinguished Jewish painters. Léon Bakst (1866–1924) is remembered everywhere as a master of theatrical costume and stage-designing. His gorgeous inventions indeed revolutionized our entire conception of theatrical art when Serge de Diaghilev introduced his work to the Western world in such ballets as *Cleopatra* (1909), *The Fire Bird* (1910), and *Schéhérezade* (1910). A belated Romantic who had been influenced by the penmanship and the decadent exoticism of Aubrey Beardsley and the artists of the "Fin de Siècle," Bakst reveals himself, in most of his work, as the creator of a kind of Russian *Jugendstil*, distinct both from that of Vienna, Munich, and Berlin and from that of Paris. Bakst reverted, for his forms and his colors, to Russian folk-art and to the Persian and Turkish art of the Caucasus. While representing the Western European trends which sought to renovate the idiom of art,

286

Bakst accomplished this by reverting, in many of his conceptions, to the forms and styles that had existed before 19th-century academic Realism had threatened to stifle all of Russian art. Bakst thus achieved a synthesis of the two spiritual traditions of 19th-century Russian art, the Slavophil and the Western. When he emigrated to Paris with the Diaghilev ballet, Bakst began to exert, especially between 1912 and 1920, a lasting influence on French, German, and English conceptions of theatrical *décor,* too. He remains one of the few truly great Russian artists of the early years of the modern movement in painting. The Polish-Jewish miniaturist and cartoonist Arthur Szyk should be mentioned here as an imitator and popularizer of the Oriental and medievalist styles and techniques of Bakst.

II

The most important development in Russian-Jewish art, however, was the emergence, during the early years of the Revolution, of a small group of Jewish painters who consciously sought to formulate a national Jewish style of art, analogous to the particularist styles which other nationalities of the vast Soviet Empire were being officially encouraged to develop. Centered around the *Habimah* and the Moscow Jewish Art Theater, for which this group designed sets and costumes, the Jewish Art Movement of the early years of the Revolution reverted to the folk-art of the ghetto and to Jewish popular traditions and humor, much as Bakst had already reverted to Russian folk-art and folklore. Prominent among the artists of the Jewish Art Movement were Nathan Altman, Issachar Ryback, Marc Chagall, Eliezer Lissitzki, and the stage-designer Isaac Rabinowitsch.

Nathan Altman (1889–) studied art first in Odessa, under Alexander Exter, and then for a year in Paris, after which he worked in Saint Petersburg. At first, like most of Exter's pupils, a latter-day Impressionist, Altman became, during his brief stay in Paris, a convert to Cézanne's theories of draftsmanship and composition and from 1913 to 1917 practiced a mild and somewhat rationalistic style of Cubism.

Altman's own *Self-portrait* of 1912, his *Old Jew* of 1913, his portraits of the Russian poetess Anna Akhmatova and of Chaim Nachman Bialik, all reveal him as one of the most outstanding among the many painters who throughout the world had taken to heart, in those years, the teaching of Cézanne. In the early 'twenties, Altman enjoyed in Russia great freedom as one of the officially recognized masters of contemporary Russian art.

Fig. 314

In the revolutionary years, from 1918 to 1922, he modified his style, incorporating some elements derived from Italian Futurism, from the *Rayonnisme* of Larionov, and from the *Suprematism* of Malievitsch, so as to develop new and basically architectural art, especially fruitful in poster-work, which is generally known as Constructivism. After 1920, this style exerted a strong influence in Germany, too, especially among the German Dadaists, in the *Neue Sachlichkeit* School and among the designers grouped around the famous Weimar Bauhaus.

Eliezer or El Lissitzki (1891–1941) is another outstanding Russian-Jewish modern master who was a victim of Stalinist persecutions and purges, and is even reported to have died in a Soviet concentration camp. Born in Smolensk, Lissitzki had studied engineering in Germany, but returned to Russia at the time of the Revolution and distinguished himself there, at first, as a disciple of the Jewish Art Movement. As a Constructivist, Lissitzki

joined Tatlin and Rodchenko in a series of experiments in abstract and Constructivist art which soon led him to invent the word *proun* to describe his own style and efforts.

Fig. 312 Lissitzki's *proun* experiments are real triumphs of architectural draftsmanship; adapting all his skills as an engineer to the requirements of a basically two-dimensional and non-utilitarian art, he produced apparently realistic constructions, full of surprises and of illusionist tricks.

Lissitzki is mainly remembered as the man who brought Russian Constructivism to Western Europe. Lissitzki's collages, in which he combined details cut out of photographs and mounted within his own designs of imaginary constructions, revealed to German artists a new field of illusionist art. He collaborated also with the Dadaist Jean Arp in the publication of a book, *Isms in the Arts* (Zurich, 1925). In Hannover, he organized for the *Landesmuseum* the display of a famous collection of abstract art that was subsequently dispersed by the Nazis. In 1928, Lissitzki returned to Russia. For many years, there was no news of him until his death was laconically announced as having occurred in 1941.

Among Lissitzki's friends and associates, the Jewish artists Antoine Pevsner (1888–) and his brother Naum Gabo (1890–), both well-known today as sculptors, deserve mention here as painters, too. At the time of the Revolution, they happened to be in Norway, and decided to return together to Russia. Gabo had studied physics, chemistry, mathematics, and engineering in Germany; Pevsner had studied art in Russia and in Paris. Pevsner's almost abstract paintings and Gabo's sculptures in celluloid, three-dimensional portraits that achieved effects very similar to certain Cubist or Constructivist paintings by Nathan Altman, represent a valuable and distinctive contribution to the history of Russia's ill-starred modern movement. In revolutionary Moscow, Pevsner and Gabo worked for a while in the group founded by the Constructivist master Tatlin, but soon quarreled with him and in 1920 published their famous *Realist Manifesto*, re-affirming a conception in art of the principles of space and of time, as opposed to the imaginary time and imaginary space of the pure Constructists. But the Realism of Pevsner and Gabo was still far from being that of the Socialist Realists, being founded on a "dynamic" notion of space and of time. After 1920, they were both forced to emigrate, under political pressures which made them feel that they were considered undesirable in Russia. Gabo was active, until the Nazis came to power, in Germany, then in Paris and in London, while Pevsner achieved considerable celebrity as a sculptor and innovator in Paris, and later, with his brother, in America.

The most important contributor to the Jewish Art Movement in Russia was Issachar Ryback (1897–1935), who may yet be generally recognized as an artist whose genius, in this field, bears comparison only with that of Marc Chagall. Born in the Ukrainian city of Elisavetgrad (now Kirovo), Ryback died in Paris, on the eve of a one-man show, planned by the big dealer Wildenstein, which was expected to consecrate the painter's international reputation. It was in Elisavetgrad that a ghastly wave of pogroms had started at Easter 1881, rapidly spreading to some hundred and fifty other towns and villages within the area of Jewish settlement known in Tsarist Russia as "the Pale." Though Ryback's own childhood, in this typical Jewish community of Tsarist Russia was happy, it remained haunted, even in its most idyllic moments, by an awareness of the horrors that had been perpetrated there within living memory, under the very eyes of the military and of the officials. From this constant knowledge of the dreadful fate that might at any moment break loose upon the community to which he was so devoted, Ryback acquired

a sense of the precariousness of his way of life and of the sheer fragility of the mere present.

In the new wave of pogroms that swept over the Ukraine in the wake of revolution and counter-revolution, while Ryback was away from home, his father was murdered by Cossack bands which looted and destroyed his birthplace. In 1919 and 1920, Ryback was practically starving in Moscow, though this was also the period of his first enthusiastic association with the artistic *avant-garde* of Soviet Russia. It was now that Ryback began to develop his style as a Cubist, interested in structural experiments mainly as rhetorical devices, means to express intense emotions, and also his taste for folklore. In 1921, he managed to travel to Berlin. Here, his peculiarly expressive style of Cubism soon attracted the attention of critics and collectors. It was in Berlin that Ryback completed his immortal series of lithographs depicting scenes of Jewish life in this imaginary *shtetl*. Together with his watercolors on the theme of the pogroms, these remain Ryback's most important and personal contributions to a consciously Jewish tradition in modern art. They seem to express, with the vividness of compulsive feelings of guilt or grief, the artist's intense filial devotion, discovered too late, for the world he had once abandoned and that had been destroyed while he was away, no longer present to defend it or to perish with it.

Fig. 313, 315

In 1925, Ryback was invited to return to Soviet Russia to design sets and costumes for the Moscow Theater, but in 1926, a changed man, he finally settled in Paris. From now on, Ryback's art became increasingly romantic and nostalgic, even elegiac, whereas he had previously expressed his tragic sense of liberation from the horrors, which he had witnessed or barely escaped, in Cubist or Expressionist structural distortions. These were intended to communicate, in plastic terms, his own ambivalent attitudes, both his love and his horror of the world which he had abandoned against his father's will and which he still felt compelled to celebrate in his art. A series of drypoints which he executed in Paris illustrates some of the felicitous aspects of the artist's spiritual change. His tender feelings for the lost world of his childhood, now that he is no longer obsessed by its tragic fate, easily become maudlin; all that he had once felt and communicated so urgently as a testimony only barely avoids degenerating into the sentimental or humorous anecdotes of *genre* painting. The *shtetl* no longer haunted Ryback's conscience, and his art ceased to be obsessed with his desire to identify himself with the Jewish masses of the small-town ghettos within the "Pale." Ryback also designed a very delicately decorative series of figurines representing various ghetto types.

In 1935, Issachar Ryback died, still relatively unknown to the Western world, yet he remains one of the great masters of a movement, in contemporary Jewish art, which expressed, throughout the first half of our century, traditions and an attitude towards life that one of the greatest tragedies in human history have meanwhile eradicated. The "Jewish painting" of Ryback, like that of Chagall, expressed the same aspirations towards autonomy in the Diaspora as the Yiddish literary movement. Wherever this art and this literature have briefly flourished, they now seem to have been doomed to an early and often a tragic death.

III

The flow of emigration of Jewish artists, even after the Revolution, and especially between 1920 and 1930, indicates that Soviet Russia was still far from offering their talents the kind

of scope that they found more readily in France or in America. Many of these Russian-Jewish painters have now obtained recognition as masters of the School of Paris. Others, like the ill-starred Simon Glatzer (d. 1953), are unjustly forgotten. A native of the province of Minsk, Glatzer was a close friend of Soutine, but developed in Paris a far more naturalistic and less tortured style. His scenes of Russian peasant life transpose, in terms of Slavic folklore, much of the humor of Breughel's scenes of Flemish peasant-life. In his handling of Jewish subjects, too, Glatzer tended to be less melancholy than most other painters of Eastern European Jewish life. During the war years, Glatzer had to simulate insanity in a Paris psychiatric hospital in order to escape from Nazi persecutions, and his reason seems to have been permanently affected by the constant strain of avoiding what might have been considered normal and sound behavior. In some of his later paintings, he thus continued to achieve, without simulation, the same macabre effects as in those painted while he was pretending to be insane.

From Poland, too, the flow of emigration continued to bring to Paris, Berlin, London, and New York considerable numbers of Jewish painters. Marcin Katz, however, was one of the more assimilated and successful Jewish painters in Poland between the two wars. Translating themes borrowed from the life of the Jewish people in terms of a modern idiom that owed its massive and almost sculptural qualities of design and composition to Cézanne and to the Paris Fauvists, Katz has given us, in such works as his *Old Cobbler,* proof of his very artistic feeling for the more stolid and healthy aspects of the life of the craftsmen and manual workers of the Polish ghetto. Almost unknown outside of Poland, Katz deserves to be remembered as a sound artist who might, in Paris, in New York, or in Israel have gained a much more lasting fame.

Roman Kramsztyck (1885–1943) was generally recognized in Paris as one of the most representative Polish painters of his generation. Between the two wars, he acquired in Warsaw a considerable reputation as a portraitist; his tender and somewhat lyrical studies of young women are particularly eloquent. He was killed by the Germans in Warsaw.

Zygmunt Menkes (1896–) was well-known in Poland before he moved to Paris, between the two wars, and later to New York. A painter of brilliantly sensual feminine nudes, of appetizing still-life arrangements, and of joyful allegorical compositions, Menkes has developed a style, that of a Slavic Rubens or Renoir, which distinguishes itself by its warm sense of color and its extremely decorative design. The world that he depicts is an elegiac representation of the artist's own memories of an almost pastoral past, rich and sensual, elegant and innocent.

Fig. 316

One of the most painterly Jewish artists of our century, Leopold Gottlieb (1883–1934), is generally listed as an outstanding figure in the history of contemporary Polish art, though he was also well-known in France as a distinguished painter of the School of Paris. A younger brother of the great Polish-Jewish painter Maurycy Gottlieb, Leopold Gottlieb was born four years after the latter's premature death, and was the youngest child of a family of thirteen brothers and sisters. The parents encouraged their youngest son to follow in his famous brother's footsteps, hoping sincerely that he would inherit the genius of their older son who had died before giving the world the full measure of his talent. Leopold Gottlieb's career indeed reflects the great changes that the artistic world of Eastern Europe had witnessed in recent decades. Though he received, like his older brother, his first instruction in the Cracow Academy, later, in Munich, he was immediately influenced by the Paris Impressionists and decided to study in Paris. During the First

World War, Gottlieb fought in the Polish Legion for the liberation of his fatherland; his sketches of action on the Russian front are preserved in the Museum of Cracow. In 1926, he left Poland, where he had been granted official recognition as a great patriot and as a master of contemporary Polish art, and settled again in Paris, where he died in 1934. Whereas Maurycy Gottlieb had never had occasion to assimilate the influence of French Impressionism, Leopold Gottlieb had rapidly acquired, from his contacts with the art of Western Europe, an extremely delicate and sophisticated awareness of contemporary trends and, after 1918, had proven himself an active contributor to the experimental work of the School of Paris. He never became a member of any specific school, and seems to have avoided committing himself exclusively to any style. On the contrary, he remained an eclectic, trusting only his own taste and his own immediate experiments as an artist. He thus sought, by constantly renovating his style and his means of expression, to communicate, with a sense of immediacy and a vision that never ceases to be fresh, the lyrical feeling with which he handled all themes that presented themselves to his human and artistic sensibility. Leopold Gottlieb's admirably composed portraits testify to his very personal interpretation of the structural philosophy of Cubism, which he had assimilated without ever sacrificing his great gifts for interpreting the natural appearance of his models. In his gouaches, with their clear and diaphanous colors, their delicately elongated figures, Gottlieb has perhaps given us the purest expressions of his art.

Fig. 317

Plate 47

His drawings are classical in their avoidance of all unnecessary detail and extremely sensitive in their draftsmanship, revealing the almost anxious quality of a Jewish sensitivity disciplined by the artist's awareness of the virtues of an art that remains laconic while his etchings, especially his series entitled *The Clowns,* are masterpieces of contemporary drypoint art.

IV

The art of Hungary illustrates, since the middle of the 19th century, an interesting anomaly in that it has always revealed as close an affinity with that of Paris as with the art of neighboring Austria and Germany.

Another close associate of Soutine is Russian-born Michel Kikoine (1892–1968) who in the *Sturm* exhibitions in Berlin around 1920. Though more decorative than the Paris Cubists, Kadar has, in some of his earlier work, a lyrical quality, derived from the folk-art of his native land, that offers analogies with some of the work of Léon Bakst or of Marc Chagell. Imre Szobotka (1890–) is another Hungarian-Jewish Cubist; in spite of an element of naturalism, his style distinguishes itself by its solid construction and its tender and harmonious color arrangements. Szobotka represents, in contemporary Hungarian art, the Western or Parisian tradition, as opposed to Kadar's more native or Eastern European Cubism.

Of the many Hungarian-Jewish artists who died as victims of Germany's criminal persecutions, two of the most outstanding were Istvan Farkas (1887–1944) and Imre Amos (1907–45). Well-known in Paris as one of the most remarkable foreign disciples of the French Fauvists, Farkas expressed his powerful personality in rich and somber color-harmonies that generally suggest a tragic sense of doom. Browns, deep and translucid blues, and greens characterize his paintings, and his landscapes acquire thereby an esoteric quality, mysterious settings for his almost ghost-like figures. In some of his sketches, watercolors, and gouaches, Farkas developed a brilliant graphic style of the

same general character as that of the great Fauvist master Raoul Dufy. Though the French poet and critic André Salmon has written enthusiastically about the art of Farkas, it yet remains, except in Hungary and Israel, but little-known. Almost more than any other Central European painter of the decades between the two wars, Istvan Farkas deserves to be more generously represented in collections of modern painting that are founded on objective appreciation rather than on the dictates of fashions and fads.

Imre Amos was born in Nagykállo, a center of Hungarian *Hassidism* revealing close affinities with Magyar rather than with Slavic folklore. The most truly Jewish of Hungary's contemporary painters, Amos expressed his deep awareness of Jewish religious traditions in his paintings and linocuts, a series of fourteen of the latter being symbolic representations of the main Jewish religious holidays. In many of his paintings, Amos has represented sleeping figures; as in the works of Chagall, their dreams are represented, too, but in a color range that contrasts with the reality of the world from which the sleeper has escaped. These compositions, where almost incandescent pinks, greens, and whites contrast with the darker tones of the real world, deserve to be classed among the most remarkable achievements of contemporary Jewish painting.

Hungarian book-illustrations between the two wars attained a truly remarkable perfection. Many of these outstanding printers, type-designers, book-illustrators, woodcut artists, and etchers of Budapest were Jews. Two only need be mentioned here. Lajos Kosma (1884–1949), a distinguished architect and decorator, has illustrated many Hungarian books with woodcuts and book-ornaments inspired, to a great extent, by Hungarian folk-art. After 1930, his art became much less decorative and liberated itself completely from its folkloristic memories. Sandor Kolozsvari (1896–1945), a brother of the painter Kolos-Vari, was well-known in Hungary as one of his country's finest contemporary book-illustrators; his greatest work is a series of beautiful woodcut illustrations for a very finely printed *Haggadah,* with text in Hungarian and Hebrew. Kolozsvari also died in Hungary as a victim of Nazi terror.

From an international point of view, the most important Hungarian-Jewish artist of our time may well be the abstract sculptor, painter, and photographer, Laszlo Moholy-Nagy (1895–1946). He was closely associated for many years with the German Dada movement, then with the abstract art movement that developed, under the influence of Eli Lissitzki's Constructivism, in the Weimar *Bauhaus* School between the two wars, finally with the *Bauhaus*-in-exile in Chicago.

V

The contribution of Jewish painters to the evolution of contemporary German and Austrian art is still difficult to assess. Nazi propaganda at one time overestimated the influence of Jews in the German art world between 1920 and 1930, and Hitler's anti-modernist cultural purges lumped together, as Jewish or corrupted by Jews, all styles of art that failed to conform to his own very mediocre and conventional tastes. In the great exhibitions of "degenerate art" that he sponsored after purging the German museums, a majority of painters whom he had banned happened to be non-Jews. In the minds of the general public, however, they were often remembered as Jews, and many non-Jewish German artists of talent were forced to seek refuge abroad or, for twelve whole years, were forbidden to paint or to exhibit in their native land.

Anti-Nazi propaganda, on the other hand, especially in the Jewish press in England and

America, tended likewise, though for different reasons, to overestimate the importance of Jews in the modern art movement in Germany. It was thus suggested, at times, that contemporary German art, if purged of its Jewish talents, would remain very poor indeed. Both arguments should now be dismissed. The Jewish contribution to contemporary German art, especially after 1910, remained honorable but, on the whole, rather modest. With the exception of Otto Freundlich, no single German-Jewish painter can be listed today among the major innovators of our age, and Freundlich actually belongs among painters of the School of Paris rather than in a survey of German art. It has often been claimed, without sufficient proof, that Franz Marc was partly of Jewish extraction; Lyonel Feininger, too, in spite of his Jewish wife, his half-Jewish children, and his many Jewish friends, was not a Jew as is so often said. Among the major Expressionist painters of the group known as *Die Brücke*, not a single Jewish artist can be found, though all works produced by this group were banned by the Nazis as Jewish or corrupt art.

To be sure, the Jewish critic and lecturer Herwarth Walden (1878–1941), born in Berlin as Georg Lewin, exerted a profound influence on German art. After studying music, Walden founded in 1904, in Berlin, the *Verein für Kunst*, which promoted public readings of the works of young and unconventional writers. After a few unsuccessful theatrical ventures, he founded, in 1910, the famous Expressionist periodical *Der Sturm* and, in a number of galleries in Berlin and elsewhere, promoted during the following two decades innumerable exhibitions of modern art, both German and foreign. By 1917, however, Walden's taste began to show signs of becoming erratic; in many of his writings, his passionate rejection of all forms of Italian or French Classicism and of Impressionism, together with his praise of the more Gothic and "Germanic" characteristics of Expressionist art, now sound almost nationalistic. In 1929, Walden suddenly emigrated to Soviet Russia, somewhat embittered by his waning success in Germany; after teaching in a foreign languages institute in Moscow, he was arrested as a "formalist" and a "counter-revolutionary" and died in a Soviet concentration camp.

Other Jews who were pioneers of the modern art movement in Germany include Gustav Wolf (1887–1947), Rudolf Levy, Jacob Steinhardt, and Ludwig Meidner. A pupil of Matisse, in Paris, Rudolf Levy introduced Fauvism to Germany as early as 1908. An artist of exquisite taste, more French in his affinities than German, Levy has only recently begun to earn the critical praise that he had for many years deserved. During World War II, Levy was arrested by the Gestapo in Italy and died subsequently in a Nazi concentration camp. More painterly in his style than some other German modernists, Levy always avoided the somewhat crude effects of color and texture that characterize so much German art of his generation.

A truly graphic artist and book-illustrator, Gustav Wolf has left us in *Confessio* (1908) some of the earliest examples of abstract art. His illustrations to the *Book of Genesis* (1913), to the *Book of Job* (1944), and to the *Psalms* (1947) reveal a visionary quality that Wolf shares with William Blake. After his emigration to America in 1937, Wolf's *Vision of Manhattan* (1944) expressed the apocalyptic quality of the New York skyline.

It was in 1910 that Silesian-born Ludwig Meidner (1884–1966) began to attract attention in Berlin. His almost prophetic visions of mechanized warfare and of metropolitan disasters revealed in pictorial terms the same apocalyptic pessimism as the poetry of the leaders of German literary Expressionism. By the nineteen-twenties, Meidner had already ceased to be a pioneer of Expressionist art. His self-portraits reveal most clearly his somewhat

Fig. 318

tortured style of caricature, closely allied, at its best, to Soutine's in its masochistic delight in sheer ugliness. In his black-and-white work, his etchings and lithographs, Meidner remains an artist of outstanding talent, his sense of line and of composition having always been more sound than his taste in colors.

With Ludwig Meidner, Jacob Steinhardt (1887–1969) had founded in 1913 the Berlin Expressionist group known as *Die Pathetiker,* which distinguished itself mainly in the graphic arts, stressing at all times the emotional significance and content of both subject-matter and forms. In his somewhat neo-Gothic or Biblical style, Steinhardt became like Gustav Wolf, one of the finest woodcut artists of our age. Steinhardt's very personal technique of engraving his blocks and his use of color in his prints give these unusually large compositions a kind of painterly quality, especially in the treatment of skies; his work avoids having the dead empty spaces which characterize so much woodcut art. During World War I, Steinhardt had served in the German Army on the Eastern Front, where his contacts with Jewish life in Lithuania awakened in him an awareness of the poetic and plastic values of Jewish traditions. After a first trip to Palestine in 1925, Steinhardt settled there in 1933, and has revealed himself a great teacher.

Among the many Expressionist painters who attracted attention in Germany between the two wars, a number of other Jewish painters deserve to be remembered. Gert Wollheim (1894—) was at first a pupil of Lovis Corinth, then exhibited regularly in Walden's *Sturm* exhibitions. In Düsseldorf, Wollheim taught art in the same school as Jankel Adler and exerted a considerable influence on younger painters of the Rhineland. His somewhat tortured and emotional post-Impressionist style is very typical of the German art of his generation, which tended to distort and to suggest pathos or anguish by stressing the more grotesque or shocking aspects of reality. In exile in France and later in America, Wollheim failed to obtain much recognition. Anita Rée (1885–1933) remains a tragic figure among Jewish artists of her generation. Basically an escapist, she sought refuge from the intolerable monotony of her middle-class Hamburg background in an exotic and somewhat stylized dreamworld that reminds one, at times, of Gauguin's South-Sea paradise. Her hauntingly sad self-portraits seem to foreshadow her suicide, which occurred years later, when she heard that Nazi cultural policies had led to the destruction of a large mural she had recently completed for a Hamburg school.

In addition to Lasar Segall, Jankel Adler, and El Lissitzki, all three of whom profoundly influenced certain aspects of contemporary German art, two other foreign-born Jewish painters who were never well-known outside of Germany lived there for many years and exerted a considerable influence. Born in Jassy in Rumania, the Cubist painter Artur Segal (1875–1957) was at first an Impressionist, but gradually developed, after 1905, a very distinctive style of prismatic Cubism. Segal's trick of dividing many of his pictures in four equal fields tends, however, to be somewhat schematic and monotonous, though his qualities of design and construction remain at all times striking. In 1910, Segal became one of the leaders of the Berlin *Neue Sezession,* which grouped the younger artists who were already revolting against the Impressionist artists of the existing *Sezession,* founded by Max Liebermann—and was influential as a teacher until he emigrated in 1933, first to Spain and then to England.

Fig. 320

Issai Kulviansky (1892–1971) was born in Lithuania. At fifteen, he came to Vilna, where he was a pupil of L.M. Antokolsky. In 1918, after an interlude in Paris, he settled in Berlin and was active in a number of post-war *avant-garde* groups, including the

Bauhaus School when it was still in Dessau, the *Novembergruppe,* and the *Neue Sach-lichkeit* movement. Kulviansky's paintings *Death of the Carpenter, The Jewish Carpenter,* and *My Parents* are fine tributes to the sturdy qualities of the Eastern European Jewish artisan class. In 1933, Kulviansky emigrated to Palestine, and since 1950 has been living in France. As a pioneer of abstract painting and sculpture, too, Kulviansky now produces figurative work only occasionally. The circumstances of his unsettled life and of his many emigrations have prevented Kulviansky from acquiring, through continuity in his exhibitions, the kind of international reputation that he certainly deserves.

Most of the Jewish painters of Switzerland have achieved, with few exceptions, only local prominence. There are, however, one or two exceptions. Willy Guggenheim (1900—), known to the art world as Varlin, is a Zurich painter who lived at one time in Paris. A friend of Soutine and the dealer Zborowsky, Varlin has remained faithful to an Expressionist and very emotional conception of painting that often disdains the more painterly techniques of composition and execution. In his interiors of hospitals and of restaurants, he communicates a sense of sheer alienation that overcomes certain sensitive individuals who feel utterly lost in a setting intended for everybody but adapted to the needs and tastes of nobody in particular. Mainly inspired by horror and disgust, Varlin's art borders at time on caricatures; more negative even than that of Soutine, it expresses but rarely the latter's secret sensuality. Obsessed by his fear of void, Varlin imprisons his figures in a truly haunting emptiness that he never seeks to furnish with decorative detail. On a lower plane of genius, he remains a painter of the same kind of morbid temperament as Van Gogh and Soutine.

The village of Lengnau, in the canton of Aarau in Allemanic Switzerland, harbored for generations a small community of Jews among whom the Guggenheim family was prominent. To these belongs the naive painter Alis Guggenheim (1896—) who began her artistic career at the age of twenty-six, and remains entirely self-taught, though she had tried sculpture and ceramic art before finally concentrating on painting. Her work consists mainly of naturalistic landscapes, naive in their technique and their unconscious stylizations and deeply romantic in their sentiment; or else of curious *genre* scenes of Jewish life in a rural Swiss ghetto, remembered from her childhood. She paints almost exclusively from memory; scenes such as *The Centenarian Janne Washes his Handkerchief in the Lengnau Village Fountain* or *The Synagogue in Lengnau,* full of an elegiac charm. In Paris before 1940 and later in New York, the Basel painter Kurt Seligmann has achieved considerable prominence, at first in the Paris *Abstraction-Création* group, later among Surrealists and post-Surrealists. An outstanding graphic artist, he sought much of his best inspiration from the almost sadistic violence that characterizes Swiss art of the Renaissance, especially the famous Basel *Dance of Death.* Seligmann has also revived with brilliant success the painting on glass of Swiss, Bavarian, and Austrian craftsmen, raising it to unprecedented virtuosity in his brilliant Surrealistic compositions. There is thus, in much of Seligmann's art, a curiously Germanic affinity with the painters and sculptors of the Renaissance.

VI

S.J. Mak van Waag's *Lexicon* of Dutch painters of 1870 to 1940 was published during the Nazi occupation of Holland and, though admirably objective, was forced to brand, by adding a J in brackets after the artist's name, all those artists who happen to be of Jewish

extraction. Many commercial artists and book-illustrators are listed there as Jews, but few are Dutch-Jewish artists of outstanding talent who would deserve our attention. It is indeed surprising to see how few Dutch Jews, after the great contribution of Dutch Jewry to the art of the Netherlands in the 19th century, have been active in our age. Only Paul Roelof Citroen (1896—), a friend and associate of the German Expressionist masters and a close collaborator of the artists of the *Bauhaus* movement, has achieved distinction in Holland as a modern artist. Similarly, of the Scandinavian countries, only Sweden has, in recent decades, had Jewish painters of importance. Isaac Grünewald (1889–1946), above all, was for many years one of the most active promoters of modern ideas and styles in Sweden and throughout Scandinavia.

After studying in Paris with Matisse before the First World War, Grünewald settled in Stockholm, where his great successes slowly transformed him from a brilliantly inventive Fauviste revolutionary into an almost conventional but still outstanding modern painter of society portraits and of typically Swedish landscapes. Isaac Grünewald painted, until about 1920, very brightly colored landscapes and portraits, applying his colors without mixing them and in flat patches, much as did certain Paris Fauvists. Grünewald's city-scapes of cranes and warehouses in the port of Stockholm or of Göteborg also adapted certain techniques of Cubist perspective, with several vanishing points, as they had been developed by Delaunay, the founder of Orphism, in his views of the Eiffel Tower. In some of his less realistic compositions, such as *The Singing Tree,* Grünewald resorted to a calligraphic and almost caricatural kind of composition that in his generation was used

Fig. 319 only by very few painters. His self-portrait and his portrait of the painter Pascin are masterpieces of the kind of humorously Bohemian Fauvism that borders, at times, on German Expressionism. In his designs for costumes and sets for the stage, especially for the operas *Oberon* and *Samson and Delilah,* Isaac Grünewald is among the outstanding creative artists of his generation.

Among the few refugees from Nazi terror who found their way to Sweden, Ernst Benedikt (1882–), former editor of the Vienna daily *Neue Freie Presse* and son of the famous Viennese editor and newspaper publisher Moritz Benedikt, has made the most of his enforced idleness to develop, in exile in Sweden, a talent as a painter, too. Beginning at the age of sixty, he has now exhibited extensively under a pseudonym, Ernst Martin. His style, an Expressionist Primitivism which he calls Intensivism, is always figurative, with a dreamlike quality in which color predominates. As fantasies, his paintings suggest imaginary explorations of a submarine world, or the wonderful skylines of fantastic cities, with weird domes and towers. Martin's tendency to escape in his paintings into imaginary worlds that are situated either above or below our level of reality suggests an analogy between his art and the autistic thinking of certain "directed day-dreaming" techniques in contemporary psychotherapy. A firm believer in the integrity of the child's objective vision of the outside world as well as of the child's own subjective fantasies, Martin has sought a return, in much of his work, to the sources that inspire the paintings of children; in other works, he has also allowed his conceptions of music, whether as a melody or as thematic development, to suggest themes which he develops in plastic terms.

VII

It has been the misfortune of Italian Jewry to come of age in the field of painting in one of the less brilliant periods of Italian art, and to have lost its greatest creative genius, Amedeo

Modigliani, to the School of Paris. In the two major schools of contemporary Italian painting, among the Futurists who were contemporaries of the so-called *Pittura meta-fisica,* no Jewish painters were prominent. Only later, in a second generation of Italian post-Impressionists or Fauvists, did the painter and writer Carlo Levi (1902—) emerge as an important personality.

Carlo Levi's painting has much in common with his writing, which is very often more typical of a painter's sketchbooks, with all the freshness of immediate perception that this implies, than of a professional novelist's considered narrative. Much as his writing is impressionistic and personal, relying on the vivid techniques of reportage, his painting, too, from the very start, has remained true to immediate perception, which he conveys by means of a number of Fauvist devices that are now almost traditional.

Fig. 322

Lucania still haunts much of Levi's painting and writing. In his enforced communion with a landscape that was utterly alien to his own childhood memories of Northern Italy, he seems to have discovered himself and to have become deeply attached to the barrenness and poverty of Southern Italy, which remains, in his mind and heart, symbolic of man's fate, of injustices that may indeed be corrected, and, at the same time, of the sheer tragedy of a destiny that allows no escape.

The eclecticism and diversity of Levi's painting seems to be one of the weaknesses of contemporary Italian art, that of a land whose artistic traditions are so deeply rooted and widely diffused that the individual artist can easily acquire skills and assimilate styles without this development necessarily corresponding to an equivalent spiritual or intellectual ripening. Similar tendencies can be detected in the work of two other leading Italian-Jewish painters, Corrado Cagli and Enrico Donati (1909—).

Cagli was born in the ancient Jewish harbor community of Ancona, on the Adriatic coast. After studying art under a number of Italian masters, he exhibited for the first time in Rome in 1932. The next year, he tried to promote, with a group of other Italian artists, a "School of Rome" which would distinguish itself from the School of Paris by reaffirming those conceptions of art and of man which are supposed to have inspired classical antiquity and the Renaissance and which happened to coincide with Mussolini's notions of Italy's cultural mission in the modern world. Until 1938, Cagli thus received considerable official encouragement from the Fascist régime, which seemed to appreciate the monumental or heroic qualities of some of his work and especially his rhetorical ability to praise all that he painted. He was thus commissioned to execute a number of mosaics and murals for official buildings. Nevertheless, in 1939 Cagli came to France and later to America as a refugee.

In spite of the mannerism that can always be detected, whatever his current style, in all of Cagli's work, he has managed to infuse real intensity into some of his attempts to record the horrors that he witnessed at the time of the liberation of the starved inmates of the Buchenwald concentration camp. Since the war, Cagli has lived most of the time in Italy and has undergone both a neo-Realistic phase and a non-Figurative one in which he has sought to paraphrase some of the discoveries of modern physics. In most of these various experiments, Cagli has unfortunately failed to transcend a kind of programmatic illustration of whatever new theory of art happened, for the time being, to have engaged his eclectic attention. He has revealed, however, an astounding technical virtuosity and a rhetorical brilliance that immediately claims one's attention, though much of his work remains but strikingly decorative.

A second generation Surrealist, Enrico Donati was born in Milan of an ancient North Italian Jewish family. After 1934, he made a successful career in Paris and New York as a commercial artist before attracting attention as a painter of Surrealist and Abstract Expressionist compositions too. Donati can be said to have imposed himself as one of the leaders among the second generation Surrealists whose art has now lost much of the anxiety and the compulsive emotional content which characterized the earlier Paris Surrealists. Surrealism now seems indeed to have entered upon a manneristic phase.

The son of the sculptor Henryk Glicenstein, Emmanuel Romano (1905—) was born in Rome and studied at first under his father's guidance. At the age of twelve, he held his first one-man show in the Munich *Kunstverein*, then exhibited extensively in Italy and Switzerland before emigrating in 1928 to the United States. A skilled draftsman and painter, Romano has matured slowly, producing much of his best work in recent years in the course of his various visits to Israel. Inspired to a great extent by the fresco-work and the mosaics of classical antiquity, he has developed a pastoral style that harks back to a legendary Golden Age of humanity of which he finds surviving elements in the patriarchal

Fig. 321 simplicity of the life of shepherds in Judea or in the hilly regions of contemporary Italy.

The art of the Triestine painter Arturo Nathan (1891–1944) contrasts strangely with the more sophisticated production of the painters just mentioned. Entirely self-taught, Nathan painted imaginary scenes, dreamlike landscapes of the kind that Claude Lorrain, Poussin, and Turner painted in the past. Nathan's unreal seascapes with abandoned wrecks and desolate lighthouses, his landscapes with Gothic ruins and fragments of classical architecture, remain intensely personal, in spite of the many literary memories that they suggest. The scenes that he depicted nearly always included, in the foreground, a single human figure, the painter himself, one presumes, turning his back to us and testifying, by his presence within the picture, to the reality of the dreamlike scene that he faces or to its intimate relationship to himself as sole witness. This device, which creates two levels of reality within the picture, is inherited, perhaps unconsciously, from the aesthetics of 16th-century mannerism.

On the whole, the art of Italian-Jewish painters expresses an unusual serenity, a feeling of adjustment to their social and cultural backgrounds, that are rare in the work of Jewish painters in many other countries; on the other hand, few Italian-Jewish painters have yet transcended the eclecticism, the virtuosity, and the provincialism which seem to be the bane of much contemporary Italian painting.

VIII

It is significant that the first truly creative innovators among the Jewish artists of England came neither from the old-established trader communities of provincial towns, nor from the prosperous upper middle-class of the metropolis or of the newly developed industrial centers. Instead, they were the Warsaw-born painter Alfred A. Wolmark (1876–1961) and the New York sculptor Sir Jacob Epstein (1880–1960).

In the Whitechapel Art Exhibition of 1906, where William Rothenstein had timidly shown a couple of interiors of synagogues because the great portraitist John Sargent had urged him to try his hand at Jewish subjects, Alfred Wolmark's forceful personality at once attracted the attention of London's few perceptive critics. Wolmark's earlier work had included some *genre* paintings, portraits of venerable rabbis or talmudic students. These

he depicted in a Rembrandtesque manner that had been revived by Jozef Israels and Isidor Kaufmann. But Wolmark soon tired of the limitations of so conformist a manner. In Edwardian England, Wolmark thus became, among his more sober British colleagues, the eloquent apostle of sheer color. At a Grafton Gallery show of the International Society of Artists no other English painter dared hang his own work close to Wolmark's, for fear of seeming overpowered by the proximity of such chromatic brilliance. Finally, Wolmark's work was placed next to that of Van Gogh.

In 1916, Wolmark published an article to propose the brightening up of Britain's drab towns, hospitals, and homes. He maintained that color, like music, has a healing power, and that bright harmonies can produce the same psychological phenomena as richly orchestrated music. In this respect, Wolmark was thirty years ahead of the movement which, since the end of World War II, has contributed so much towards making England's daily life less colorless than the industrial revolution and Victorian prudery left it.

Birmingham-born David Bomberg (1890—) remains the first outstandingly creative painter of native-born English Jewry. His earlier Cubist or Vorticist work included some Jewish scenes, which he depicted in a stylized manner. In portraying, for instance, an audience in London's East End Yiddish Theatre, Bomberg relied mainly on architectural or sculptural effects; in his use of color, he restricted himself to the sober range that characterizes the life of most of London's slums. Later, in his more Fauvist landscapes of Petra and Spain, and especially in his flower-compositions, Bomberg developed a brilliantly expressionist freedom of design and a somber richness of color.

During the Second World War, Bomberg abstained for several years from practicing his art as a gesture of atonement and mourning for the tragedy of contemporary mankind and especially of European Jewry. Since he has returned to painting, his work sometimes reveals a rare humanity and maturity.

Of England's Whitechapel painters, Mark Gertler (1892–1939) is the most notable. At first a member of the same small group of East End artists and writers as the poet-painter Isaac Rosenberg, Gertler soon abandoned their somewhat crude Expressionist Subjectivism to develop a very personal and sculptural objectivity, a kind of lower middle-class Classicism that is best illustrated in some of his portraits of his mother. His *Jewish Family,* which now hangs in the Tate Gallery, is a fine example of Gertler's earlier near-Cubist period, when he had much in common with Bomberg and Jacob Kramer. Inspired by the realities of the contemporary scene in London's Jewish East End, these three painters tried to develop, for a while, a modern Anglo-Jewish style that would reflect the whole movement of Jewish emancipation which culminated in other countries in the Socialist *Bund,* in politics, and in literature and the theater in the campaign to raise Yiddish to the level of a literary language. These works of Gertler, Bomberg, and Kramer are English attempts to formulate a Jewish style of art, in much the same spirit as Chagall, Ryback, and others sought to emulate the achievements of Yiddish literature in Eastern Europe. Gertler and his British associates eschewed, however, the bright colors and the fantastic humor that characterize the work of Chagall. Instead, their sobriety of composition and coloring suggest a matter-of-fact quality of understatement that are peculiarly English.

Jacob Kramer (1892—), who was born in the Ukraine, also revealed, in his earlier work, an interesting awareness of the compositional preoccupations of the Paris Cubists, and of the possibilities that such a style offered for the treatment of Jewish themes. In his

Day of Atonement, for instance, Kramer has expressed, by simplifying his forms as in a romanesque sculptural frieze, a rare hieratic quality. In recent years, Kramer has become increasingly reticent as a painter, almost obsessed with the fear of not achieving perfection.

The painting of a majority of England's Jewish artists distinguishes itself by its qualities of restraint and sobriety from the richness of color or texture and the fantasy and originality of conception that characterize much Eastern European Jewish painting, as well as from the extreme individualism of the stylistic evolution of most Jewish painters in Paris and America. It reflects, in their work, some of the staid, if not demure, quality of middle-class English life which, even in the capital, often remains curiously provincial.

The Ukrainian-born painter Bernard Meninsky (1891–1950) distinguished himself particularly as a chronicler of the First World War, scenes of which he depicted in a lyrical style that is less manneristic than some of his later paintings, and with an objectivity that remained as free of Kiplingesque heroics as the war poems of his contemporary Isaac Rosenberg. A Manchester artist, Emmanuel Levy (1900—) has exhibited some moody and almost Expressionist portraits of somewhat meditative and almost neurotic types. Edmond Kapp's (1890—) mordant style of draftsmanship has failed, in recent years, to find adequate subject-matter; one is often left with the feeling that he might, had he been an artist of the School of Paris, have developed a less laconic manner.

Claude Rogers, around 1937, was one of the founders of the Euston Road School of London painters which sought to reaffirm the values of Sickert and the English post-Impressionist masters who, in those years of enthusiasm for the more modern painters of the School of Paris, were sorely neglected. Rogers thus remains one of the most delicately sensitive English painters of landscapes, especially of crowded beach scenes.

By 1934, the modern movement in English art had settled down, on the whole, to a steady routine of imitating new Parisian trends rather than of inventing novel and specifically English styles. In its over-cautious avoidance of extremes one could often detect an element of what Bernard Berenson has defined as provincialism. Much of English art thus lacked the sheer inventiveness and elegance which distinguish the work of a metropolis where styles and tastes are created and then imposed on peripheral areas. There was also, in the work of many English modernists, too obvious a concern with popularizing, in the media of applied art, the more abstruse or extreme styles and devices of Paris. In the work of a number of England's Jewish artists, these trends towards provincialism and commercialization can be detected quite distinctly. In designs for theatrical sets and costumes, for instance, the more creative ideas of continental artists such as Léon Bakst were skilfully adapted to the tastes of London's West End stage by Oliver Messel, a gifted artist of Jewish extraction. In the applied arts, too, Barnett Freedman, who designed the King George V Jubilee postage stamp, and Abraham Games (1914 —) have popularized, with great skill and taste, forms and styles that had originally been considered abstruse or highbrow.

With the advent of Hitler in Germany, a steady stream of refugee artists began to bring new life to English art. During the war years, London and some provincial centers to which Londoners had been evacuated thus became veritable crucibles where an unusual variety of personalities and traditions interacted on each other to produce a renaissance of British art and of the Jewish contribution to this art in particular. Among the many refugee painters who contributed to the establishment of what has been aptly called ''The Conti-

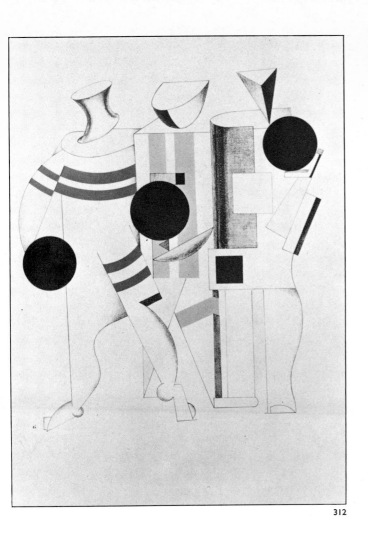

312

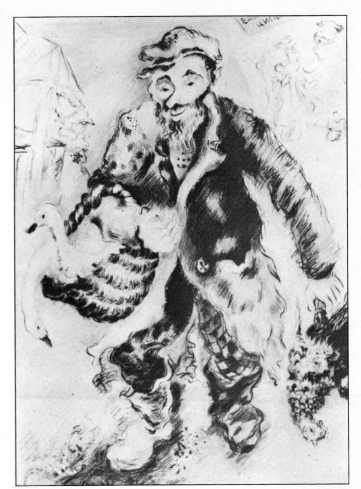

313

314

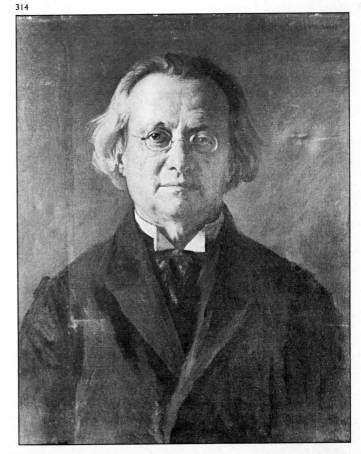

312. *Eliezer Lissitzki. From the Portfolio: "Die Plastische Gestaltung der Electromechanischen Schau. Sieg uber die Sonne". Lithograph. Israel Museum, Jerusalem.*

313. *Issachar Ryback. Jew carrying ducks in a basket. Etching. Israel Museum, Jerusalem.*

314. *Nathan Altman. Portrait. Israel Museum, Jerusalem.*

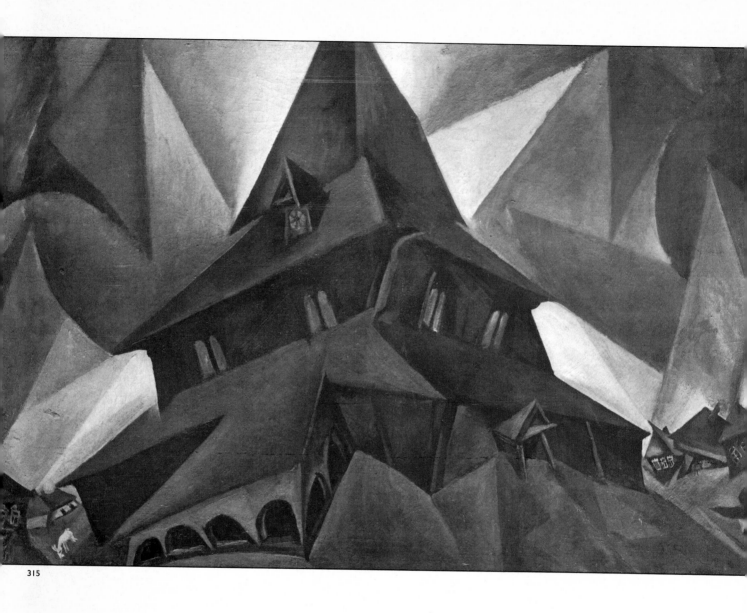

315

315. *Issachar Ryback. The Old Synagogue, 1917. Tel-Aviv Museum.*

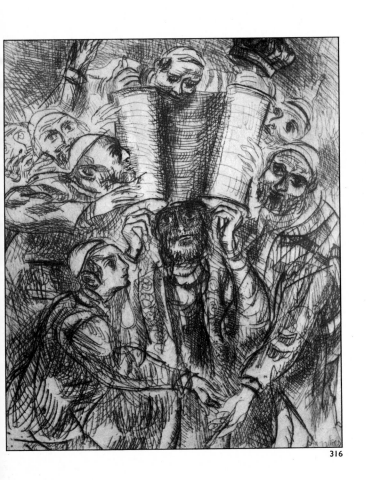

316

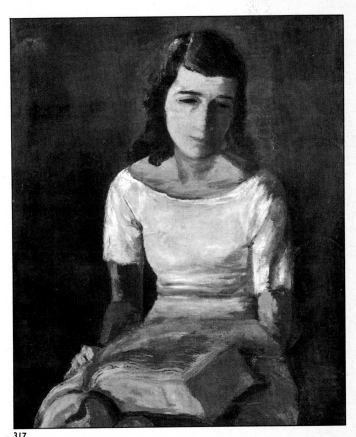

317

316. Zygmunt Menkes. The Rejoicing of the Law. Ink. Study for
an oil painting in the Jewish Museum, New York.

317. Leopold Gottlieb. Portrait of his daughter. Tel-Aviv
Museum.

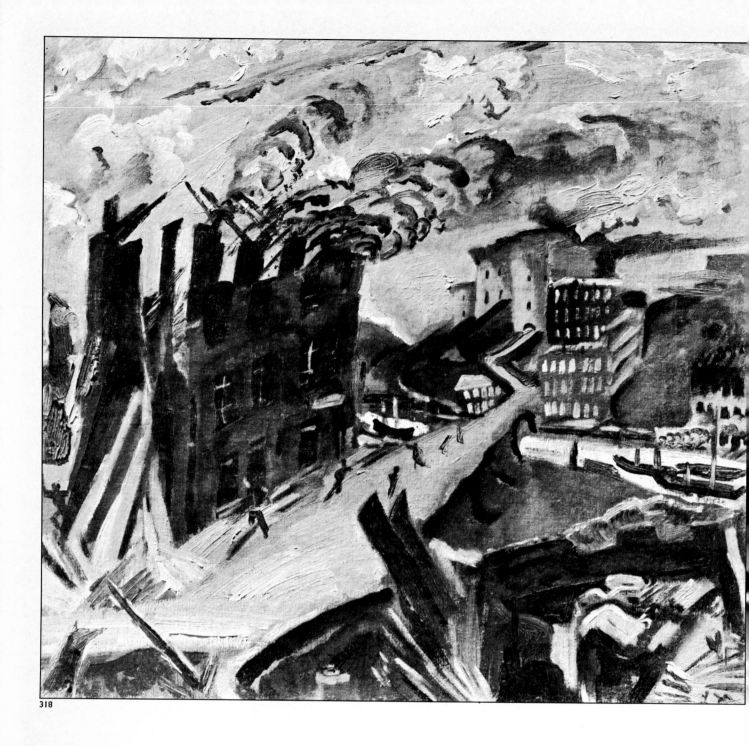

318

318. Ludwig Meidner. Landscape. Tel-Aviv Museum.

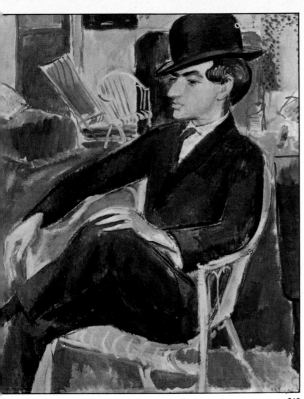

319

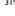 319. Isaac Grunewald, Portrait of the Painter Pascin, 1921.
Oil on canvas. Goteborgs Kunstmuseum.

320. Artur Segal. Fishing Boats in Bornholm Harbor. Collection
Dr. Adolf Behne, Berlin.

320

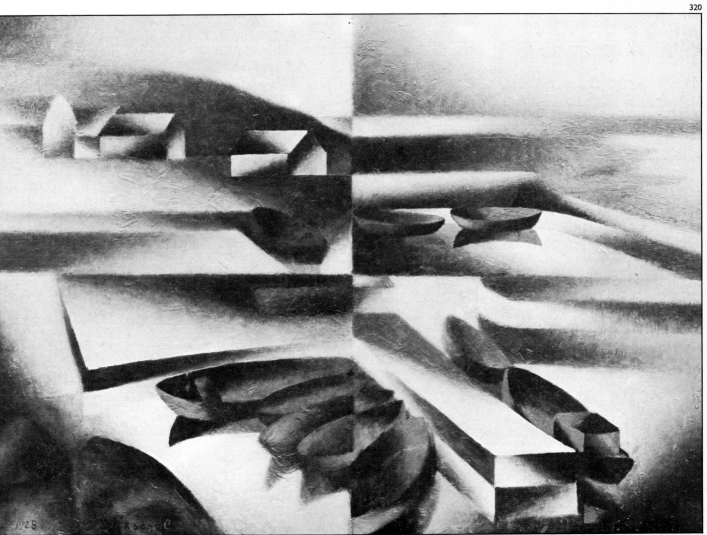

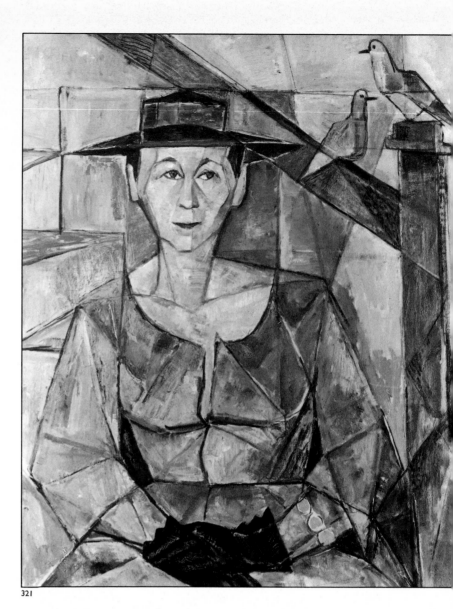

321

322

321. *Emmanuel Romano. Portrait. 1945. Oil on canvas. Israel,*
 Private Collection.

322. *Carlo Levi. Landscape. Courtesy of the 24th International*
 Art Exhibition. Venice, 1948.

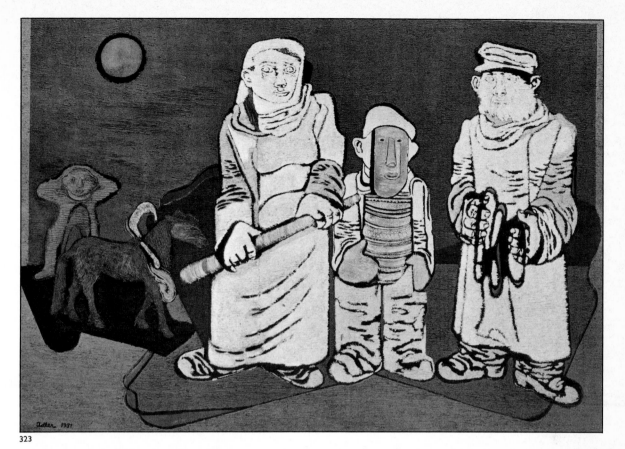

323

324

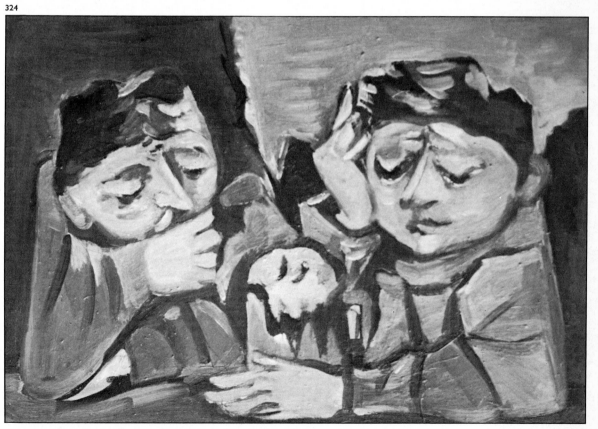

323. Jankel Adler. Purim Spiel. Tel-Aviv Museum.

324. Jacob Bornfriend. The Beer-Drinkers, 1952. London, Private Collection.

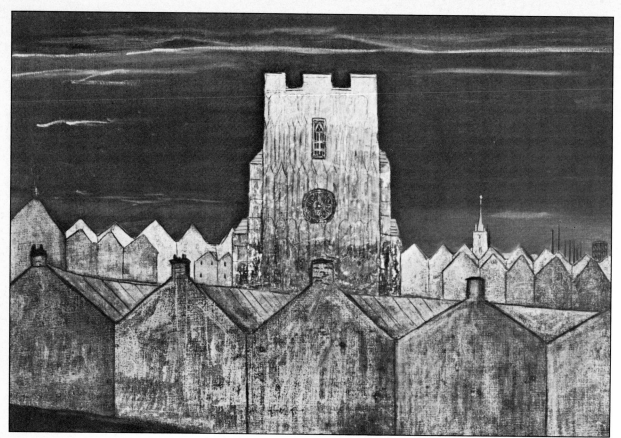

325

326

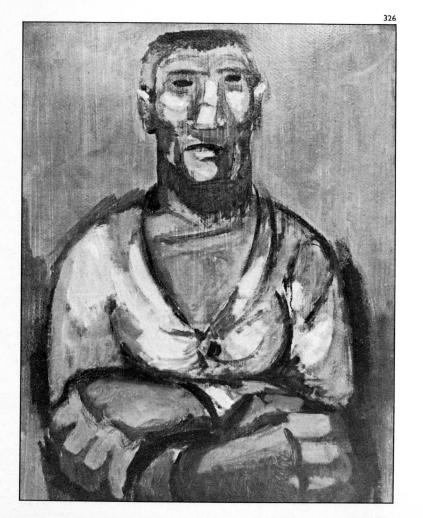

325. Fred Uhlman. English nocturne. Manchester, Private Collection.

326. Joseph Herman. Welsh Miner, 1949. Oil on canvas. London, Private Collection.

327. Hans Feibush. The Prodigal Son, 1950. London, Private Collection.

328. Lasar Segall. Figure from the series "Wanderers", 1949. Rio de Janeiro, Private Collection.

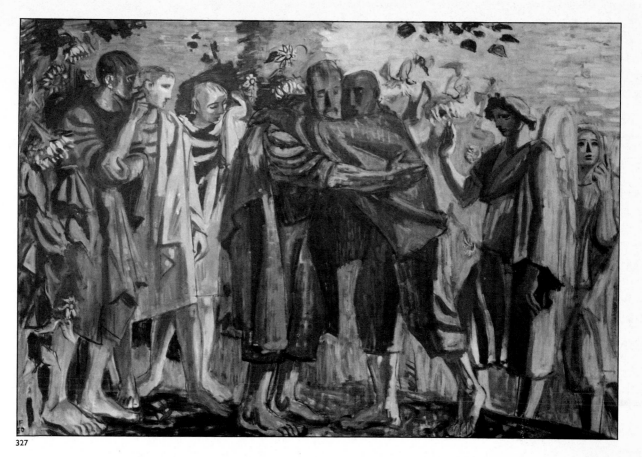

327

328

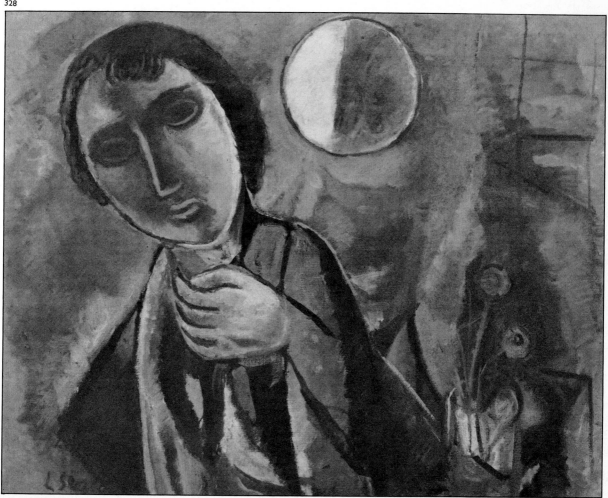

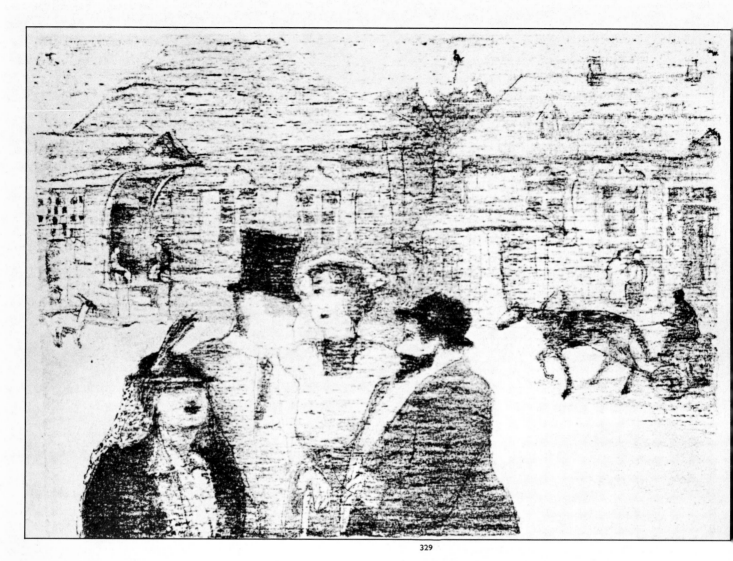

329

330

329. *Anatoli Kaplan. In Boiberik. A lithograph from "Tuvia the Milkman", 1957–61. Courtesy Israel Museum.*

330. *Max Weber. Rabbi. Lithograph. Gift of the artist. Israel Museum, Jerusalem.*

331. *Abraham Walkowitz. Small port. Lithograph. Courtesy Israel Museum, Jerusalem.*

332. *Abraham Walkowitz. The Dancers. Watercolour. Jewish Museum, New York.*

331

332

333. *Louis Lozowick. Changing Shifts. New York, Private Collection.*

334. *Morris Hirschfeld. Nude with cupids. Oil on canvas. Courtesy Sidney Janis Gallery, New York.*

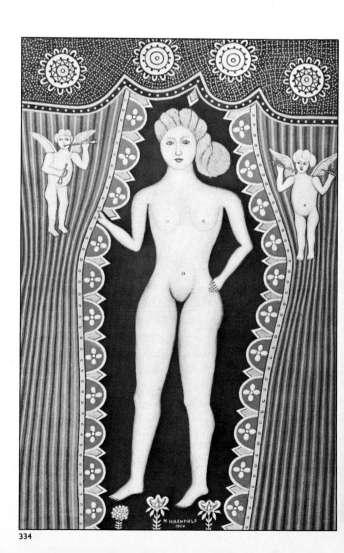

333

334

335. Raphael Soyer. A youth. Tel-Aviv Museum.

336. Moses Soyer. A woman drying herself. Tel-Aviv Museum.

335

336

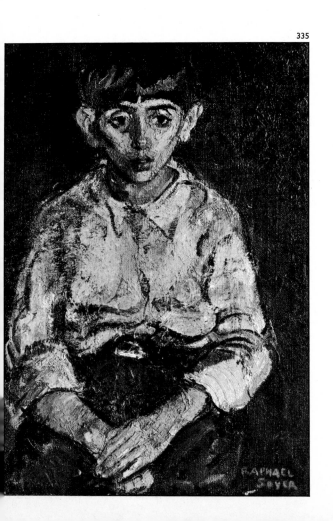

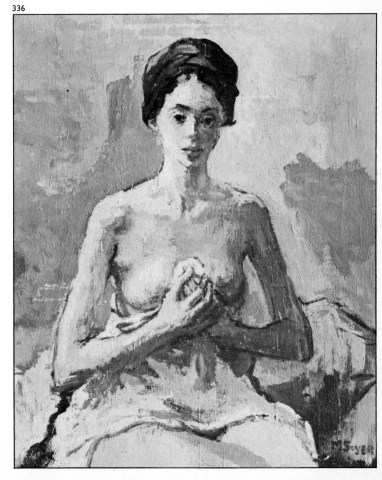

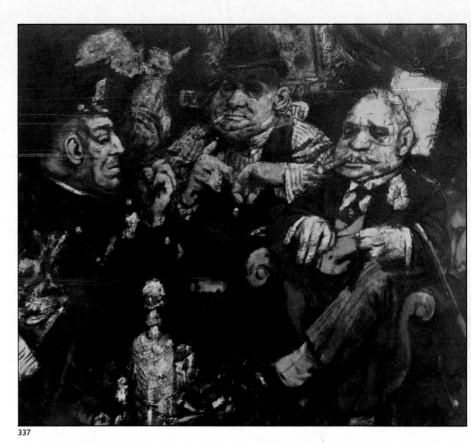

337

338

337. Jack Levine. The Feast of Pure Reason, 1937. Museum of
 Modern Art, New-York.

338. Ben Shahn. Lute and Molecules. Silkscreen. Israel Museum,
 Jerusalem. Gift of Mrs. E. G. Halpert.

nental School of London'' Jankel Adler and Joseph Herman have achieved particular prominence.

The artistic career of Jankel Adler (1895–1949) is typical, in many respects, of the lack of continuity that so many Jewish artists and intellectuals have experienced in our century. Born in Lodz, the seventh of a Jewish miller's ten children, he was apprenticed at the age of eleven to an engraver. After many wanderings, he found his way to Düsseldorf, where he began to enjoy considerable success both as an artist and as a teacher. Here he painted most of the important works of his earlier period; here, too, he had occasion to meet Paul Klee.

In 1933, Adler was invited by the New York College Art Association to exhibit there in an international show, as a member of the German section. This inspired the Nazi *Völkischer Beobachter* to conduct so violent a campaign against him that Adler realized that he could no longer hope to make a living in Germany. Emigrating at first to Paris, he found that he had suffered so serious a nervous shock that he could no longer concentrate on his work. At the outbreak of the Second World War, he volunteered for the Polish Army and began training in France. In 1940, he was evacuated to Scotland, where he was soon demobilized, for reasons of health, and where he remained until 1943. He spent his last years of life in the London area.

In the early twenties, the work of Adler's first period had found ready acceptance in Germany. Always haunted by the problem of formulating a Jewish style of art, Adler had tried to solve it, unlike Chagall and Ryback, by avoiding the anecdotic aspects of Jewish folklore and humor so as to concentrate on those formal or architectonic elements which might be identified and defined as specially Jewish. His style, based to a great extent on his detailed studies of traditional Jewish craftsmanship, can thus be said to be Jewish in that it is intended to transpose, in pictorial terms, the characteristic qualities of Hebrew calligraphy. His monumental figures, stripped of the individuality of his original models, are reduced to their basic character as symbols or types. In some of his earliest paintings, *Fig. 323* one can even observe a striking similarity between the style of draftsmanship of the whole composition and the style of some Hebrew lettering that is but a detail of the whole, an inscription on a dish in a still life, for instance, or the title on a book-binding.

As a refugee in Paris, after 1933, Adler faced a whole new series of personal and artistic problems. An unusually imaginative craftsman, Adler had acquired or invented a wide variety of techniques, so that the texture of his work became increasingly varied and rich, while his subject-matter relied less and less on anecdote. In Paris, and especially as a consequence of his association with Picasso, he devoted most of his time to a systematic re-examination of all the techniques and values acquired in the course of his German years. But it was after 1940, in wartime Scotland, that he attained full maturity. Increasingly personal and creative in his philosophy, he now managed to fuse subject-matter, composition, draftsmanship, texture, and color-harmonies in a single artistic phenomenon that fully expresses his unique personality. Like ideograms, Adler's figures no longer represent individuals or tell an anecdote, but signify basic human types. During the war years and after 1945, Adler thus began to exert on younger English painters, gentiles and Jews alike, a rare spiritual and artistic influence.

In his paintings completed since 1945, Jacob Bornfriend (1904—) has provided interesting illustrations of how a younger man of talent and discrimination can assimilate the influence of both Adler and Picasso and transmute them into a style that is already

personal. Born in a village of Slovakia, Bornfriend spent his childhood on his parents' farm, where he worked until the age of nineteen when he went to Bratislava to study art. A few years later he moved to Prague. It was here that he discarded many of the more decorative elements of Slavic folklore and folk-art that had been suggested to him by the culture of the peasants of his native province. Instead, he was now exposed to the major international currents of modern art and underwent at first the influence of French post-Impressionism and Fauvism. In 1933, Bornfriend turned, however, to Cubism, to which he remained faithful until 1937, when he experienced a brief Surrealist phase. From his earlier training, he had retained, nevertheless, a warmth of color and of texture that is rare among younger disciples of the Cubist masters.

Bornfriend escaped to England in 1939, worked throughout the war in factories, and was again able to concentrate on his art only after 1945. His progress since then has been rapid, proving how much his slow schooling and his experiences of exile and of war have enriched him both as a human being and as an artist. In *The Young Widow* (1952) and *The Beer-Drinkers* (1952), his formal concerns do not preclude a deep feeling for the pathos of human situations, but prevent him, at the same time, from lapsing into the anecdotic. His art, like that of Max Weber or of Jankel Adler, thus illustrates a peculiarly Jewish talent, it seems, for synthesizing Expressionism and Cubism so as to instill new life in a strictly formal art.

Fig. 324

The painter Martin Bloch (1883–1954) had never been granted much recognition in Germany, where he led, until 1934, a sheltered existence. Only in 1955, a year after his death, did his work receive some of the acclaim that his first important one-man show deserved. Originally a disciple of Matisse and the Paris Fauvists, Bloch had also learned much from Cézanne in his style of composition. From the German Expressionists of *Die Brücke,* he had also acquired an ability to reduce whatever he painted to its most dramatic elements, whether it be a landscape or a portrait. Still, his mature style became fully integrated only after his emigration to England, where his work gradually began to discard the German element of over-dramatic distortion which mars so much of the Expressionist art of the 'twenties. Bloch's colors also acquired in England a more harmonious and personal quality, a subtlety that had been lacking in some of his earlier work. After his death, a London critic observed that Bloch had taken to the English landscape "for its own sake and not just because he happened to be here." Exile, in his case, had been an enriching experience, liberating the individual from routines and restrictions which, in his native milieu, had still cramped his style.

X

Of the Jewish painters of post-war England, Josef Herman (1911—) is the one whose work has been the most widely discussed. Born in Warsaw, the son of a poor cobbler who was at times embarrassed to find himself afflicted with so brilliant a child, the future painter felt impelled, after finishing his elementary schooling, to contine his studies for several years in night classes while he worked all day to earn his own living and help his family. At the age of eighteen, he understood that he wanted, above all, to be a painter rather than to study literature or medicine, both of which had also attracted him. In 1936, with the older painter Bobowski, Herman organized in Warsaw a group of artists, predominantly Expressionists, who set out to depict scenes from everyday life, avoiding all forms of Romantic idealism or of escapism.

Herman emigrated to Belgium in 1938. Here the Realist tradition of Flemish art revealed to him a conception of socialism that is void of all notions of class hatred or of revenge.

In 1940, he escaped to England. In wartime Britain, Herman expressed at first his anguish as an exile by seeking refuge in memories of his own childhood and in daydreams of Yiddish folklore. He thus tried to recapture, in a naive and elegiac world reminiscent of that of Chagall, something of his past that now seemed irretrievably doomed. But this inner world of dreams and memories failed to satisfy Herman's longing for an art which would express his ethical aspirations, too, and he thus found himself obliged to impose on himself a new period of self-examination. In 1944, he chanced to discover a Welsh *Fig. 326* mining village, Ystradgynlair, which has now become his spiritual home. The uprooted Jewish painter, whose native background had been ruthlessly destroyed, found here, at last, in a world that might well have seemed utterly alien to him, a new sense of communion with all his neighbors and a home where he has struck roots as a painter of the monumental dignity of man's toil, whether in the fields, on the sea, or in the shafts of a mine. These figures of British toilers show that Herman has transcended the limitations of Jewish particularism as an artist of truly universal character.

Different temperaments react differently to the spiritual experience of exile, which also assumes, in each individual case, a different material and psychological aspect. Fred Uhlman (1901—), for instance, originally a lawyer, took up painting as a hobby only after he had come to Paris as a refugee from Nazism. By 1936, however, he had already acquired sufficient skill to hold his first one-man show there. After this he moved to England. In his earlier work, Uhlman viewed French life, especially in his representations of Paris cemeteries with macabre widows wandering in a maze of fantastic monuments, with an alien's tolerant amusement and a naïve wonder that suggested an affinity with Maurice Utrillo and with some so-called Sunday-painters. In his more recent compositions, however, Uhlman has acquired a linear quality of composition, with his perspectives disposed in a series of receding planes, that is clearly more sophisticated; he seems to be particularly successful in his handling of typical aspects of the English provincial scene, as in his highly stylized but very personal views of cathedral towns, with a huge Anglo-Norman church, small houses clustered around it, almost like a hen surrounded by *Fig. 325* a brood. Fred Uhlman's career is unusual in that, unlike most other naïve painters, he has been privileged to be able to devote more than his Sundays to his art and to discover his vocation as an artist in the prime of his life. He has thus been able to achieve, as an artist, the kind of maturity that naïve painting generally excludes.

Among other foreign-born Jewish artists who have found refuge in England, the Hungarian painter Kalman Kemeny, a disciple of the Paris post-Impressionists and Fauvists, had already won recognition in his native country. His delicately post-Impressionist views of London squares are particularly pleasing, and many of his portraits reveal rare psychological insight. A native of Frankfurt-am-Main, Hans Feibush (1898—) has distinguished himself in England as a painter of religious murals, several of which have been commissioned for some of England's noblest churches, including even the ancient Cathedral of Chichester. His *Crucifixion,* in the Church of Saint John in Waterloo Bridge Road in London, is a good example of his somewhat sculptural and discretely decorative style. Feibush has also worked in the field of color lithography and, in recent years, has produced some sculptures in which his concern as a painter with the problem of sug- *Fig. 327* gesting rounded forms on a flat surface now finds a fruitful field of expression.

A virtuoso of sheer draftsmanship and also of color, the Polish-born painter Feliks Topolski (1907—) has enjoyed ever since he arrived in London during the war years considerable popularity. Enormously prolific, he seems to sketch alamost all that he sees, and a veritable history of our times might well be compiled out of this record of historical scenes that he has witnessed, important men whom he has met, and typical aspects of his extensive travels. A disconcertingly versatile artist, Alva, also from Poland, has tried his luck with several different styles, including a series of somewhat rhetorical but remarkably well-drawn compositions on Biblical and traditional Eastern European Jewish themes. Walter Trier (1890—), a native of Prague, had already acquired in Berlin, before emigrating to England, a mordant quality of metropolitan sarcasm in his sketches and cartoons. After an earlier period as a painter in which he revealed himself as a kind of Expressionist Daumier with a nostalgia for romantically idealized underworld types, Trier soon developed a very individual style as a cartoonist, often imitating with great wit the styles of various Old Masters.

A number of other contemporary English cartoonists are also Jews — Joss, of the London *Star*; Ross, of the Israeli Press; Sallon, of the London *Daily Mirror*; Vicky, of the London *News Chronicle*; Victoria, of the London *Picture Post*; and Mark Wayner. Vicky in particular became increasingly popular in his later years as a brilliantly incisive cartoonist of London's literary and artistic personalities.

XI

It is in Brazil, a former colonial area rapidly developing cosmopolitan cultural characteristics, that one of the major Jewish painters of the past fifty years had been living and was contributing towards developing a national school of painting in which he was already acclaimed as a master. Born in Vilna, Lasar Segall (1891–1957) left home in 1906 and studied art at first in Berlin, where he was forced to undergo an extremely academic training. After a while, however, contacts with Liebermann, Corinth, and the painters of the *Sezession* encouraged him to seek self-expression in less alien styles. In 1913, Segall went on his first trip to Brazil, where he was immediately acclaimed as an ambassador of European art.

In his earlier work, Segall had practiced the kind of Rembrandtesque portrayal of Jewish types and scenes that had been popularized throughout Eastern Europe by Isidor Kaufmann. Segall developed, after his first contacts with Western European modernism in Berlin, a style of angular Cubism, highlighted by bright and almost exotic colors, in which he handled scenes of typically Russian peasant life. On his return to Europe, Segall's work became increasingly somber, if not morbid. In 1916, he visited his family in German-occupied Vilna, a city of starvation, unemployment, and fear. *My Memories of Vilna*, an album of etchings, recorded his impressions of this visit. After his refusal, on cultural-political grounds, to become a permanent member of the Berlin *Freie Sezession*, Segall began to play an increasingly important part as a non-conformist in the artistic and political life of wartime and post-war Germany. Together with Otto Dix, he also founded the Dresden *Sezession* which, especially after the First World War, was an outstanding center of experimental art. All of Segall's works of his German period express deep pathos and a devastating mood of horror or of mourning; his works on Jewish themes in particular, such as his *Kaddish*, are unusually powerful representations of sheer desolation and despair.

In 1923, Segall returned to Brazil, where he lived until his death. Here his style underwent a significant change. Except for a brief period in 1942 when he painted a series of large compositions on such themes as *The Emigrant Ship, War, The Pogrom,* and *The Concentration Camp,* Segall became much less somber, more hopeful. In a series of pastoral landscapes he depicted, for instance, bucolic aspects of Brazilian life in a manner that reveals his profound attachment to his new home. His portraits of women were full of a Latin sensuality that was alien to much of his earlier work. In a series of paintings inspired by low life in the prostitute's quarter of old Rio de Janeiro, Segall returned indeed to some of the themes that had once inspired him in Europe, but he treated them now without any of the violent protest that characterized his interpretations of destitution and of vice in German-occupied Vilna.

Fig. 328

Other Jewish artists who have attracted attention in Latin America include the Argentinian, Mauricio Lasansky (1914—), now a resident of the United States, who has acquired an international reputation as an unusually fine graphic artist. Lasansky's graphic style combines the brilliant colors that characterize the work of Clavé and other Spanish masters with an unusually free sensitivity of design, inherited from Picasso, and a monumental quality in his figures that offers similarities with the work of Jankel Adler.

XII

A comprehensive and objective survey of the Jewish contribution to the contemporary art in the United States of America would require far more space than the whole of the present volume could provide. Never in the history of Jewry have there been so many Jewish painters at work as there are now in New York alone. And never has there been in the whole history of Western art as great a diversity of styles and techniques, indeed as extremely individualistic an approach to painting, as in the highly competitive art world of America.

The history of the Jewish contribution to modern American painting begins around 1910, when reports of the revolutionary achievements of the School of Paris began to reach New York. Between 1880 and 1910, American art as a whole had already been awakened rather rudely from its visionary post-Romantic dreams to face a shifting world of realities which were often sordid or had little in common with the more stable idealistic traditions that had dominated American intellectual and artistic life until the Civil War. Resentful journalists nicknamed the new Realist painters of New York "the ash-can school" of art. It is one of the anomalies of American cultural history that there should have been no Jews among these few early Realists.

As early as 1905, however, Alfred Stieglitz (1864–1945), had begun, in New York, to champion everything that was new and daring in the world of art. Himself one of the first great photographic artists of our century, Stieglitz fostered and encouraged more talents among New York's early modernists than many of Manhattan's more commercially successful dealers and more wealthy art patrons. Among the first American painters whom Stieglitz exhibited, Max Weber (1881–1961) is now generally acclaimed as one of the true pioneers of the art that has developed in the United States since the era of the Impressionists and the Realists.

Born in Russia, Max Weber was brought to America as a boy of ten and grew up in Brooklyn before going to Paris, where he associated with the early Cubist masters. Though he underwent a phase of Classical Cubism that is well exemplified in his *Two Musicians,*

Weber was never satisfied with the limitations imposed upon him by so strictly decorative or architectonic a conception of art. There thus remains, even in his most formal works, a very personal poignancy, a sense of pathos, a deeply human rather than a religious sense of pity, qualities that Weber shares with other Eastern European Jewish masters. Such emotional preoccupations alone might explain the evolution of Weber's style from the *Fig. 330* formal Cubism of his earlier work towards the far more sensitive Expressionism that became his mature style.

Though his work has occasionally reflected some of the dominant trends that seem to haunt almost all American art, Weber has affirmed, in a remarkable diversity of styles, certain permanent preoccupations that reflect his true personality. His elegiac reconstructions of a vanishing Jewish world, for instance, are humorous in spite of the anxiety and nostalgia that they express. Weber's helpless and melancholy female nudes, with their heavily Semitic features, are no odalisques from an exotic Orient like those of Matisse or Pascin, but fugitives from Lower East Side sweatshops. His elderly bearded men, too, so urban in their habits and complex in their reasoning, so carefully dressed but physically unattractive, seem to illustrate an almost incredible and slightly guilty prosperity between a past pogrom and a future that they have not yet learned to trust wholeheartedly. Weber's universe has metaphysical implications, too, and is always conscious of its own nostalgia and anguish, of its inherent absurdity, its fleeting nature. A sense of structure, an element of sheer design and reconstruction, resurrects all that Weber paints, with the magic of memory rather than with the kind of immediate hedonism that seeks to praise and perpetuate, arrested in its course towards death, all that it sees. In a timeless world of emotion and style, Weber recreates a permanent society of his own.

But his style has constantly changed. In *The Trio,* for instance, the heads of the three musicians represented reflect some of the distortions that characterized Picasso's work of those years. In *Geranium,* however, Weber seems to be more truly himself, a master of a new kind of New York Expressionism which sought to transcend the limitations that Picasso and the formalists of the School of Paris had imposed on much of modern art. In such works, Weber has indeed managed to lead contemporary painting back from Cubism towards human emotions and problems that we all experience in our daily lives.

The work of Abraham Walkowitz (1880–1965) has been sorely neglected in recent years. French influences have been numerous and varied in this Siberian-born artist's work, ever since his luminous post-Impressionist studies of Venice, painted as early as 1907. Later, *Fig. 331* Walkowitz exhibited city-scapes of Manhattan that brought to American art a manneristic style of imaginative composition that borrows architectural elements from the contemporary scene in order to rearrange them in patterns that are both more formal and more fantastic than those of reality. Walkowitz was thus one of the first of 20th-century America's city-scape painters to understand the peculiar aesthetic quality of the Manhattan skyline as a phenomenon in itself, something organized and exuberant as a Gothic cathedral and majestic as an Alpine landscape. In his studies of dancers, too, Walkowitz *Fig. 332* has revealed an unusual sense of the dynamics of movement.

Louis Lozowick (1892—) is another distinguished Russian-born painter among America's pioneer Cubists. Never a very complex colorist, Lozowick is often at his best in black-and-white work. Similarly inspired by the city-scapes of industry, he rearranges, in many of his *Fig. 333* paintings, elements of factory architecture much as Delaunay, in Paris, invented formal

variations on the theme of the Eiffel Tower. The severity of some of Lozowick's composi-tions comes, in this respect, closer to the classical Cubism of Paris than any other American painter except Stefan Hirsch (1899—).

This German-born artist came to the United States at an early age and soon distinguished himself as an intellectual and dispassionate painter of landscapes and still-life composi-tions which are systematically stylized and owe much of their sense of volumes and of planes to the Paris Cubists. Later, Hirsch became interested in less individualistic con-ceptions of the social functions of art; much of his work of the past two decades has thus striven to express his aspirations in an emotional style that is sometimes frankly rhe-torical.

It is only since her death in 1944 that Florine Stettheimer has begun to enjoy the fame that she had long deserved as a pioneer of modern American painting. Known for many years to New York's more exclusive intellectual and artistic elite as one of the three charming and witty unmarried daughters of a wealthy family of Wall Street's Jewish aristocracy, she had refrained, all through her life, from exhibiting or selling any of her works. Her carefully preserved naiveté, that of a precocious child who refuses, however sophisticated, ever to be quite ''grown up,'' sometimes emulates the style of certain modern primitives. In a slightly *art nouveau* manner that derived some of its draftsmanship from the drawings of Aubrey Beardsley, Florine Stettheimer has left us fascinating comments on New York life in the age of prohibition.

Among the painters of New York's Greenwich Village who might be compared to the Montparnasse Fauvists of Paris, there were many Jewish artists of outstanding talent. Bernard Karfiol (1886–1952) might thus be defined as a Derain of the School of New York. Born in Hungary, Karfiol soon attracted attention in America as a lyrical painter of nudes, which he endowed with a mellow and meditative quality, achieved as a result of his concentrating all talent, throughout his life, on a limited number of familiar themes to which he remained faithful. As the years went by, Karfiol handled his almost impersonal art-school subjects with an increasingly personal sensitivity. The women whose bodies he portrayed, generally professional models well-known to most New York artists, thus became intensely individualized and almost mysterious.

Maurice Sterne (1878–1957) came to America from his native Latvia in 1890, and studied art in New York and in Europe. His powerful and harmonious style of draftsmanship and composition often suggest the artistic temperament of a sculptor such as Aristide Maillol. In his colors, Sterne is always restrained, never rhetorical or emotional. Though he has spent many years traveling abroad, often in exotic surroundings, he has generally avoided the kind of primitivism or exoticism in which less balanced artists seek in vain to emulate the work of Paul Gauguin. Among the many Jewish painters who have come from Eastern Europe to the West, Sterne is one of the most naturally Classicist.

The work of Ben Benn (1884–) offers affinities both with certain Paris Fauvists and with some of the German Expressionists of *Die Brücke*. Russian-born, Ben Benn came to America as a boy and was one of the handful of Jewish painters who were pioneers in establishing an American tradition of experimental painting in New York before 1914. Since 1940, this tradition has earned recognition as the School of New York, as distinctive and as productive as the School of Paris. Though influenced at first by the Paris Cubists and Fauvists, Benn soon developed qualities of design that are almost akin to those of a cartoonist or of a Far Eastern brush-work draftsman. Far from ridiculing what he describes,

Benn simplifies, on the contrary, in order to stress the tragic quality of his subjects. In much of his work, Benn has allowed his Expressionism to serve the cause of a social philosophy and thus earned considerable popularity in the Roosevelt era, which compromised him later in the eyes of the politically conformist critics of the fifties.

Though the importance of his contribution to the art of the School of New York is often neglected, Ben Kopman (1899—) had developed, as a relatively young artist, a fine style of his own, founded on his discerning appreciation of the aims and means of Matisse, Rouault, and the French Fauvists. Born like Chagall in Vitebsk, Kopman has developed, in his more mature works, an increasingly monumental boldness of design, avoiding the mere subjectivism of much Expressionist art and refusing to express any social or political aspirations that are not intrinsically implied in the topic of each painting. Kopman believes that a work of art should never seek to compete with a book or a speech. His composition *The Lynching* is particularly significant: instead of offering us a kind of pictorial pamphlet on race-hatred, Kopman shows a vast and brooding landscape, with a small and confused crowd in the center, the actual victim remaining difficult to locate.

One of the most unassuming and sensitive among the Russian-born American painters who were pioneers in revealing to New York the heritage of French Impressionism and Fauvism was Samuel Halpert (1885–1930), whose beautifully balanced landscapes and interiors deserve a place in any truly representative collection of American art of the 20th century.

William Meyerowitz (1892—) remains one of the most subtle draftsmen among the American disciples of Cézanne and of the Paris post-Impressionists and Fauvists. Born in Russia, he has painted some deeply moving compositions on traditional Jewish religious and folklore themes as well as landscapes of a rare compositional complexity; his etchings, besides, deserve to be listed among the finest that have been produced in America in the early decades of the modern movement. His wife, Theresa Bernstein, is also a painter of taste and skill; her decorative portraits, especially of children, her flower-pieces, landscapes, and still-life compositions are deservedly popular.

Long before Salvador Dali and the Surrealists imposed themselves on the attention of New York in the 'thirties, the kind of visionary fantasy that distinguishes the art of such European-Jewish painters as Chagall and Balgley was already to be found in the work of a few American painters, too. Morris Kantor (1896—) came to the United States from Russia in 1911. Less folkloristic and more metropolitan in his fantasy and humor than Chagall, Kantor deliberately confuses the subjective and the objective worlds, what one actually sees with what one imagines at the same time. In one of his paintings, Kantor thus gives us a somewhat stylized but relatively realistic view of New York's Union Square, much as Maurice Utrillo might have painted it from a twentieth floor window, but with three huge imaginary red roses floating in mid-air in the foreground, painted just as realistically as the rest. Born in Ukraine, Ben Zion (1899—) had originally planned to be a rabbi, then sought expression as a writer, mainly in Hebrew, and turned to painting relatively late in life. Extremely literary in his choice of subject-matter, mainly Biblical, and in his consciously archaic style, Ben Zion has an almost caricatural way of stressing the more unpleasantly Semitic features of his figures. In his drawings and paintings, he seems to seek effects of a sculptural nature. The sculptor Chaim Gross (1904—), after witnessing in his childhood and youth the horrors of war and the bestialities of Russian anti-Semitism, now expresses in his paintings and drawings, as well as in his sculptures, a truly remark-

able faith in the humane joys of sheer living. His sensitive style as a painter owes much to his sculptural awareness of line and of volume.

The New York critic and dealer Sidney Janis made a hobby, some years ago, of discovering American primitives and "Sunday painters." Among the artists whom he thus discovered and collected, several Jewish painters have now obtained wide recognition as truly remarkable talents, and are now represented in leading American collections and museums. The most gifted and famous of these self-taught Jewish "Sunday painters," Morris Hirschfeld (1890–1956), was born in Poland and gave proof of his artistic talent in his childhood, when he already carved in wood a "noisemaker" for the traditional Purim celebrations of his community. This piece of typical Eastern European Jewish folk-art and some wood-carvings that he made later as a boy for his local synagogue caused a sensation among his compatriots and were still proudly shown to visitors long after his emigration to America. In New York, Hirschfeld worked hard for many years as a maker of elegant slippers for women. Only after his retirement did he take up painting. The "boudoir shoes" that had been his livelihood for many years continued to haunt his pictures, which are remarkable for the strangely idealized eroticism of his presentation of female nudes and the almost compulsively delicate treatment of their tiny feet. In his *Fig. 334* paintings of cats, lions, and tigers, Hirschfeld followed closely the primitive style of much Eastern European synagogue art that still imitates unconsciously, in reproducing exotic beasts, traditional Byzantine or Persian models.

Israel Litwak (1868—) was also a native of Eastern Europe and worked in New York as a cabinetmaker until he, too, after his retirement, took up painting as a hobby. His view of *Fifth Avenue* is typical of the childlike treatment of perspective and of human figures that one finds in all his work. As in the vision of Ezekiel, a wheel-like sun revolves in the sky of many of his landscapes. Only the facades of his houses are rendered with more sophistication and a greater exactitude of detail than anything else in the picture.

XIII

Though the Realism advocated by New York's "ash-can school" towards the turn of the century suffered an eclipse in the years that followed the great Armory Show exhibition and the gradual acclimatization of Cubism, of Fauvism, and of Dada in the American art world, a Realist undercurrent had continued to be felt throughout these years, and, strengthened by political intentions, came to the surface again in the years of depression, after 1929, as a school of protest and of "social significance." The Jewish painters Moses and Raphael Soyer, born as twins in Russia in 1899, provide a link between the earlier "ash-can" school and the more political painters of the Roosevelt era.

The artistic development of the Soyer brothers has been unusually harmonious, encouraged from the start by parents, Russian-Jewish liberal intellectuals, to whom, as Raphael Soyer has said, "Rembrandt and da Vinci were household words." For all their professed Realism, the Soyers have remained profoundly romantic in their ideals, inspired by liberal and humane considerations that give to their work a meditative and mellow quality. Raphael Soyer's *A Youth* and Moses Soyer's *A Woman Drying Herself* *Fig. 335, 336* are fine examples of a style that seeks to perpetuate the tradition of Realism inherited from Frans Hals, Chardin, and Dégas.

William Gropper (1897—) remains the most militant representative of a consciously Marxist school of American Realism. Inspired to a great extent by the art of social protest

of Daumier and of George Grosz, Gropper developed a mordant style as a cartoonist in *The Rebel Worker,* the *New Masses,* and other Leftist or Communist publications. Born on New York's Lower East Side, he had begun to work in a sweatshop at the age of fourteen, for a dollar a day. Under Roosevelt's WPA, Gropper painted some striking murals; his paintings remain, however, basically political cartoons, of which *The Isola-tionist* representing a proto-fascist American senator, is an outstanding example. Jack Levine (1915—) was born in the immigrant slums of Boston and, profoundly influenced by Rouault, Soutine, and George Grosz, developed as a WPA artist a macabre style of moral comment in which he expresses a less unequivocally Marxist awareness of social injustices. The Philadelphia painter Joseph Hirsch (1910—) is a representative of a similar style of caricatural Realism, but expressed in simpler and almost sculptural forms. It lacks the great wealth of detail that gives to Jack Levine's paintings, especially his *Feast of Pure Reason,* now in New York's Museum of Modern Art, the compulsive quality of a brilliantly recorded hallucination.

Fig. 337

The new Realism in literature and the arts, like the earlier Populism of the 19th century, soon struck deep roots in the American Middle West, especially in Chicago, where a number of Jewish painters practiced it with success. The work of Todros Geller (1889–1949) fitted neatly into the general pattern of Middle Western particularism or regionalism. From his birthplace in the Ukraine, Geller had first gone to a private art school in Odessa. After the 1905 wave of pogroms, he emigrated in 1906 to Canada and in 1918 finally settled in Chicago, where he studied under the great "ash-can" Realist George Bellows. Generally acclaimed as the dean of the Middle West's Jewish artists, he designed stained-glass windows and ceremonial objects for synagogues in Chicago and elsewhere. From his early association with Jewish Socialists of the *Bund* in Russia, Geller had acquired a lasting faith in Jewish cultural traditions as a rich mine of themes and inspiration for a Jewish art that would be as popular in its appeal, as the regional art of any other national group.

David Bekker (1897—), born in Vilna, was brought as a child to Palestine, where for a time he was a pupil of Boris Schatz. Shortly before the First World War, he set out for Paris, but remained stranded in Rumania, where he managed to obtain an appointment as engraver. After the war, he completed his studies in Paris and emigrated to the U.S., settling in Chicago. Bekker's paintings have a quality of line and volume that reveals his experience as a sculptor and designer of medals; his styles vary from the "Jewish popu-lism" of his native Vilna to a kind of Palestinian Hassidic art, analogous to that of Frenel and similarly inspired by visits to Safed. In addition, Bekker has assimilated in the tradi-tional Romantic style a certain liberating influence of the major Jewish painters of Paris and the basic Realism of the Chicago school. His faith in his own mission as spokesman for the artistic aspirations of traditional Jewry at large has helped him integrate these con-flicting influences in works such as his *Rabbi Elimelech,* which interpret traditional folk-lore in as personal a manner as Chagall or Ryback.

Whereas Geller and Bekker remained attached, in their Realism, too, to traditional Eastern European Jewish themes, the Russian-born painter William S. Schwartz (1896—) has constantly affirmed his assimilation as an artist of the American Middle West. After coming to America from Vilna in 1913, Schwartz earned his living for many years as a concert entertainer and an opera singer, devoting all his spare time to further training as a painter. His *Upper Michigan Avenue* remains a fine and moving example of the art of the Middle

West, a man-made landscape of Chicago's skyline as distinctive as a Walkowitz view of Manhattan. His *River Boat and Bridge* is a delicately formal rendering of a typical land-scape of the upper Mississippi and Missouri basins, though his *Christian Science Church* is perhaps too decorative a stylization of a small-town Illinois scene. In his portraits of American farmers and workers, Schwartz expresses his intensely Romantic or Populist love of all that is humanly valid in American democracy. Nor has Schwartz limited himself to studies of Middle Western types and scenes. In *A street in Asheville, North Carolina,* and his *Homecoming* that shows the fishing fleet returning to a village harbor on America's New England coast, he has proven his broad and intimate understanding of the American scene.

Ben Shahn (1898–1969) was a painter whose originality has been vastly overestimated. Born in Russia, he first earned his living as an industrial lithographer. In the 'twenties, he studied in Paris, but revolted against all that he might have learned there, rejecting it as mere aestheticism. His series of Populist and somewhat journalistic illustrations to the Sacco and Vanzetti case then attracted the attention of Diego Rivera, who employed him as his assistant on the Rockefeller Center murals that were subsequently condemned as politically objectionable. An *artiste engagé* in the Paris Communist terminology, Shahn also produced a series of illustrations to the life story of Tom Mooney, the martyr of the American Labor Movement.

Fig. 338

The work of Hyman Bloom (1913—) illustrates the limitations of an art that was largely inspired, in its early stages, by the careful study of reproductions rather than of originals. Born in Russia, Bloom studied in Boston, where he developed an ardent admiration for the work of Rouault and of Soutine, which he studied mainly from reproductions. A disciple of their eloquently emotional formal distortions rather than of their delicate painterly techniques, Bloom tends to stress the macabre element in everything that he paints. In his synagogue interiors, his still-life arrangements with amputated human limbs, and his Jewish types, he seems to delight in sheer ugliness and corruption. Bloom's shimmering compositions representing synagogue chandeliers, perhaps tawdry and dusty junk in real life, are among his least macabre compositions; endowed with the brilliance of a Gothic cathedral's rose-window, they enchant with the magic of a Christmas tree remembered from one's dazzled childhood. Profoundly distrustful of all that does not obsess him with the urgency of a hallucination, Bloom concentrates on a limited number of themes that affect him intensely, frequently painting several versions of the same picture, with minute variations that are in themselves deeply significant.

XIV

In the years that followed the Roosevelt era, a majority of American artists withdrew more or less voluntarily from the expression of any political or social opinion into a realm of sheer abstraction. The decade of abstraction saw in America the triumph of an unusually large number of Jewish artists, many of whom had practiced a more figurative art for many years without enjoying much success. When the *Fifty Years of American Art* show raised among Paris and New York critics such a storm of controversy, the critic of the *New York Herald Tribune* protested against the exclusion, among other figurative painters, of Abraham Rattner (1893 —). Born in Poughkeepsie, a small town north of New York City, Rattner lived in France from 1920 to 1940, and obtained recognition as a member of the Minotaure group. In New York, however, he remained almost unknown, exhibiting only

occasionally after 1935 and until his return to America in 1940. His training as an architect reveals itself in the massive structure and the monumental quality of his compositions. Inspired to a great extent by the formalism of Romanesque rather than of Gothic stained-glass windows, of Byzantine mosaics, and of Greek-orthodox ikons, Rattner's art is rigorously modern in its technical devices and its use of color. Never tempted to seek easy successes, he has refrained from courting the gregarious and highly competitive New York art world. The figures of his compositions seem to be molded in bas-relief against a flat background, with their faces, like those of mosaics, stylized according to the laws of a three-dimensional art so as to contrast with the two-dimensional quality of the rest of the picture. Generally avoiding Jewish themes, he has preferred, on several occasions, un-equivocally Christian religious subjects. In his works of recent years, Rattner seems to be experiencing a crisis; he has abandoned his earlier architectural or sculptural conceptions in favor of a kind of abstract-expressionist Tachisme that is not always felicitous and, in spite of his superior painterly technique, often remains nebulous and unconvincing. Three Jewish artists can, in conclusion, be said to have influenced American life in our century, almost more profoundly than any others, whether Jews or gentiles. By ridiculing the machine and presenting it always as something absurdly familiar, made up of odds and ends such as nobody need fear, the cartoonist Rube Goldberg (1883—) exorcized the small man's distrust of contemporary America's increasing mechanization. The French-born industrial designer Raymond Loewy taught America that "ugliness does not pay" and imposed on the vast industrial system of his adopted home the more dynamic aesthetics of "streamlined" forms and of "packaging" that is in harmony with the more rational styles of modern art; he thus achieved, though without reverting to the styles and tastes of a bygone age of handicrafts, the kind of revolution in taste that had been Ruskin's aim in 19th-century England. Finally, the Rumanian-born cartoonist Saul Steinberg (1914—) has made urban America aware of its own foibles and follies, thus helping the individual to become reconciled with the necessity of living in a crowd.

XV

In the final analysis, it can truly be said that the problem of a Jewish style of art is solving itself in our age. Jewish styles of painting, it seems, are originally a product of an acute conflict in the consciousness of individual artists between the cultural traditions of the Western world and the familiar background of orthodox Judaism from which they are breaking away, if only as a consequence of their choice of a career in the figurative arts, a choice that still seems to inspire occasional feelings of guilt. Whether in 19th-century Holland, in the age of Jozef Israels, in Vienna in the age of Isidor Kaufmann, in Russia in the generation of Altman, Ryback, Chagall, and Lissitzki, in the Poland of Jankel Adler and Marcin Katz, among Berlin's "Pathetiker" Expressionists Steinhardt and Meidner, in the group of the London painters Gertler, Bomberg, and Kramer, in various groups of the School of Paris, in Max Weber's New York or in the Chicago of Todros Geller, a Jewish style of painting imposes itself only as a synthesis in this conflict, never as something inherent in the Jewish cultural tradition alone. As soon as the Jewish tradition ceases to assert itself as imperiously in the individual artist's consciousness or to conflict so acutely with other cultural traditions, the urge to formulate a specifically Jewish style evaporates. The evolution of Issachar Rybak from his earlier Jewish style to his later Romanticism is symptomatic, in this respect, of the evolution of Jewish painting in our age.

JEWISH SCULPTORS

by KARL SCHWARZ

Of all the creative arts, sculpture has been most alien to the Jew. Religious prohibitions forbade him the plastic arts, so that he had no opportunity to develop the tectonic qualities of his nature. A grasp of configurations and forms had not entered into the scope of his pictorial application. His spiritual outlook was more concerned with a rhythmic conception of things than with their physical form. Obviously, though, this did not arise from a lack of symmetry or sense of proportion, since he possessed a strong predilection for the ornamental and the descriptive.

Apart from religious prohibitions against the plastic arts, the closely circumscribed existence of the Jew gave him no opportunity for creative activity in the field of sculpture. The Jews and Jewish communities had no monuments, no statues of heroes, nor any other public manifestations of the decorative urge, except the reliefs with which in many regions gravestones were adorned. Even the practice of having portraits made, which became accepted in enlightened circles in the second half of the 18th century, was still remote from sculptural expression. For the human features to be represented in relief on a medal was regarded as legitimate somewhat earlier, because the picture on the medal could be likened to a miniature. Moreover, the form as such had only to be suggested, and physiognomatic detail confronted the artist with none of the problems of form which confront the true plastic artist. In addition, the urge for ornamentation also played a role here. The use of reliefs for ornamental purposes had been common for centuries; first of all, on tombstones, and secondly, in exploiting the rhythms inherent in the forms of the Hebrew script. Later on, symbolic and pictorial representations were introduced which eventually gave rise to a highly developed craftsmanship. Sometimes, the flat relief was drawn in color, thus conveying the impression of a painting more than of a work of sculpture.

Coins and medals, with special regard to the graphic and the decorative aspects, became objects of the Jewish creative urge partly because of the intimacy implied in the attention devoted to minute detail. We find in the 18th century some distinguished Jewish medallists such as the Abrahams family whose work has been discussed in a former chapter. Work of this type links 19th and 20th century Jewish sculptors to the masters of previous generations.

The relief tells a story; the plastic arts represent and reproduce. On another level, the three-dimensional with its definite relation to space, outline, and rhythm was unknown to the Jew until the last century. He lacked the direct experience essential for free expression in

plastic media. Nevertheless, in this field, so long barred to him, he quickly produced in the 19th and 20th centuries a considerable number of sculptors in whom the Jewish latent artistic talents came to the fore. He hewed a way for himself with astonishing perceptive faculties and achieved results no other artists of his time had accomplished. The Jewish artist achieved in a short time a leading position in this new world, until then uncharted and unknown to him.

II

The historical record of Jewish sculpture virtually begins with Mark Antokolski (1842–1902), perhaps the first Jewish artist of ability who dared to take the decisive step towards the free plastic arts. Historically, his importance was such that it is necessary to speak of him at somewhat disproportionate length: moreover, his reputation was at one time enormous — and not undeservedly so.

Though Antokolski was to move to Berlin and later to Paris, where he resided during the second half of his life, his first impressions and experiences set the tone for the rest of his life. Unlike Rodin, he saw no beauty in the nude body. In the rare instances when he modeled a nude, as in the *Mephistopheles,* he remained awkward. Women did not inspire him; they seemed to him physically and intellectually unattractive. Whereas Rodin was all sensuality to the point of suggesting lust, Antokolski was all intellect and philosophy. Yet whatever his faults, Antokolski was one of the more powerful artistic personalities of the last century, one who struggled against greater odds than any sculptor before him. For he was born in the ghetto of Vilna and chose his career against the wishes of his orthodox parents. After attending *heder,* the elementary Jewish school, he began working in modeling and woodcarving. In St. Petersburg, he won prizes with a number of *genre* reliefs on Jewish themes executed in wood and ivory, and ended his studies with a scholarship which enabled him to go to Berlin.

After a while, he returned to St. Petersburg and plunged himself into study of the history of Russia. His *Ivan the Terrible* made the twenty-eight-year-old artist famous overnight, and to this date has remained his most celebrated work. With it, he showed his defiance of the conventional neo-Classical style that had been transplanted to Russia from early 19th-century France, by his courage to deal realistically with a dangerous subject — a mad Tsar. The bloodthirsty Ivan, an incarnation of the might and barbarity of old Russia, is represented in the later years of his life, clad in a monk's garment, with the Bible on his knees, and at his side the notorious steel-pointed staff with which he had killed his own son. Tormented by his conscience, he seeks consolation in the Holy Scriptures.

This work reveals Antokolski's merits as well as his faults. The head is excellent, the facial expressions convincing, the overall composition good. But the excessive preoccupation with extraneous detail — the garment, the cushion, the chair — diverted the artist, and diverts the beholder, from the aesthetic aims of sculpture. The result is a work which represents neither a monumental figure nor the terrible tsar the Russians portray.

It is unfortunate that in Antokolski's work the artist was often overshadowed by the thinker, the historian, or the archaeologist, especially in his later years, when he no longer searched sufficiently for purely plastic revelations. On the other hand, his breadth of soul and seriousness of approach, which tolerated no frivolity, revealed themselves to great advantage in the fine heads of his life-size statues of thinkers such as *Socrates* and *Spinoza,* which he considered his best work, and also in his fine portrait busts. Also worth

Fig. 339

remembering is his *Christ before Pilate:* with bowed head and bare feet, Jesus, a kind of Jewish peasant, stands before his unseen judge.

Antokolski's letters to the critic Stassov, in whose eyes he was "the greatest sculptor of our age," and to other friends, reveal how earnestly the artist strove to achieve the best, though doing so, alas, through spiritual rather than aesthetic analysis. "In art there is something more important than form. In all my work, everywhere I was a faithful slave to meaning," and finally, "What a relief to feel the ground under your feet, to know that you were not mistaken in finding your goal, to realize that Beauty is akin to Truth, and to understand what Beauty is."

Today, few people would agree with Antokolski's concept of beauty, and it was not he but Rodin who led sculpture to new and unexpected heights of expression. Antokolski's pupil, Ilya Ginzburg (1859–1939), is of little interest to us now, though at one time he enjoyed success with pleasant and skillfully rendered children's busts. He earned, however, a special place in the history of Jewish art because in 1919 he founded in Leningrad the Jewish Society of Creative Jewish Art.

Another outstanding pupil of Antokolski's was that imaginative pioneer, Boris Schatz (1866–1932), who was later to make a great name for himself through the establishment of the Bezalel School in Jerusalem, in which he hoped to realize his dream of a national and folkloristic Jewish art. A statue of *Mattathias the Hasmonean,* which he executed in a dramatic pose, attracted such notice that King Ferdinand of Bulgaria invited him to Sofia to found an academy of arts. For the next ten years, he modeled Bulgarian farmers and Jewish *genre* types. His work is characterized by symbolic meaning and spirituality: like other Jewish artists, he was concerned more with content than with external form. On the other hand, his point of departure was painting and he could not free himself from the two-dimensional concept. His most successful works are his portrait plasters of Karl Marx, Rubinstein, and of his beloved teacher, Mark Antokolski. The fact that his Mattathias was regarded as an old Hebrew ballad, and that his sentimental and worthy *genre* scenes were praised as the Jewish art, illustrate the outlook of the period on academic, eclectic art.

Fig. 340

Enjoying a reputation almost equal to that of Antokolski in his day, though now utterly forgotten except in very restricted circles, was Moses Jacob Ezekiel (1844–1917)—memorable as being, perhaps, the first American plastic artist to enjoy worldwide fame. Ezekiel, born in Richmond, Virginia, studied at the Virginia Military Institute and fought in the Civil War on the Confederate side. In 1869, he went to study in Germany where a few years later he was to win, with a bas-relief *Israel* the coveted Rome (Michael Beer) Prize, never before awarded to a foreigner. He then went to Rome and was never to leave this city, except for occasional brief visits to the United States. His studio in the Baths of Diocletian was, for several decades, a center of artistic and social activities in Rome. Among Ezekiel's best-known creations is a monument which B'nai B'rith commissioned him to execute for the Centennial Exhibition in 1876. The work represents Liberty as a woman of majestic appearance, wearing the cap of freedom. In one hand, she holds a wreath of laurel; the other hand is outstretched in benediction. At her side stands a handsome young boy with a flaming lamp, personifying Faith; at her feet, an eagle overcomes a serpent.

It might be said of all Ezekiel's work, a little less would have achieved a great deal more. Design is mercilessly sacrificed to accurate representation, photographic truth is given

priority over rhythm. While there is a mystifying feeling of unfinished about most of the works of Ezekiel, as in the *Confederate Soldiers' Monument* in the Arlington National Cemetery and in the Thomas Jefferson Monument at Charlottesville, both in Virginia, there is an over-finish, an excess of technical skill that enables the beholder to encompass the work in one glance, but then stops him from giving it a second glance. Whereas Antokolski's work gains our interest through a vigor occasionally bordering on barbarous strength, Ezekiel's work is too refined, too cultured, too neat for a generation nourished on the more violent styles of Picasso or Epstein. Like many of the idealistic artists of the period, Ezekiel was, however, a good portrait sculptor, giving excellent likenesses of his sitters without much concern for psychological depths.

III

Unfortunately, only these two 19th-century Jewish sculptors, Antokolski and Ezekiel, are still remembered to any extent, but others who were certainly not devoid of talent are entirely forgotten. For example, the Hungarian Jacob Guttmann (1815–52) remains an interesting and pathetic figure. Apprenticed to a gunsmith at the age of thirteen, he wanted to become an artist as a child, having shown ability in carving toys. At eighteen, he trekked to Vienna, where he learned engraving. No less a patron than the Austrian Chancellor Prince Metternich obtained for him a scholarship enabling him to study. Another patron, Baron Solomon de Rothschild, paid for a trip to Italy. But Guttmann's short life was full of drama. He was constantly on the go. In London, he was shocked by the cold reception accorded him. In Paris, he fell hopelessly in love with the celebrated actress Rachel, herself a Jewess, and became despondent. Ultimately, he lost his mind. In his funerary monument for Rabbi Aaron Chodin, who had heralded the Reform movement in Hungary, Guttmann did a fine portrait bust of the rabbi, probably the first such portrait to appear on a rabbi's tomb. He died in Vienna in his thirty-eighth year. His other works include busts of Metternich and of Pope Pius IX. The original of the last-named was acquired by the Hungarian Museum of Fine Arts, and thousands of reproductions of it were distributed all over Italy. A *Peasant at his Plough* is considered one of Guttmann's finest creations.

More fortunate was a fellow-Hungarian József Engel (1815–1901), who was originally destined for the rabbinate and sent to the *yeshivah* of the famous Rabbi Moses Sofer in Pressburg. While studying, he persisted in trying his hand at sculpture, and his father applied to the rabbi for a "decision" (whether or not this was permissible according to Jewish religious law). The answer was unfavorable, for the master obliged his pupil to disfigure all the human faces of his sculptures. As soon as his father died, however, he moved to Vienna, later establishing a celebrated studio in Rome. Final recognition came to him in England, where his group *Amazons Fighting* and his busts of Queen Victoria and of the Prince Consort were acquired by the latter. By the time of the competition for the monument to Szechenyi, in 1865, his international reputation was so great that he was granted the award. He was forced, however, to modify six times the main figure in the group and the four allegorical figures; as a result, the monument which now stands in one of Budapest's finest squares lacks spontaneity.

Another once famous figure was Samuel Friedrich Beer (born in Brno, Moravia, in 1846, died in Florence, Italy, 1912). He is more widely remembered for his association with Theodor Herzl and the Zionist movement than for his work as a sculptor. But during his life, most of which was spent in Paris and Florence, he was very successful. Berlin's

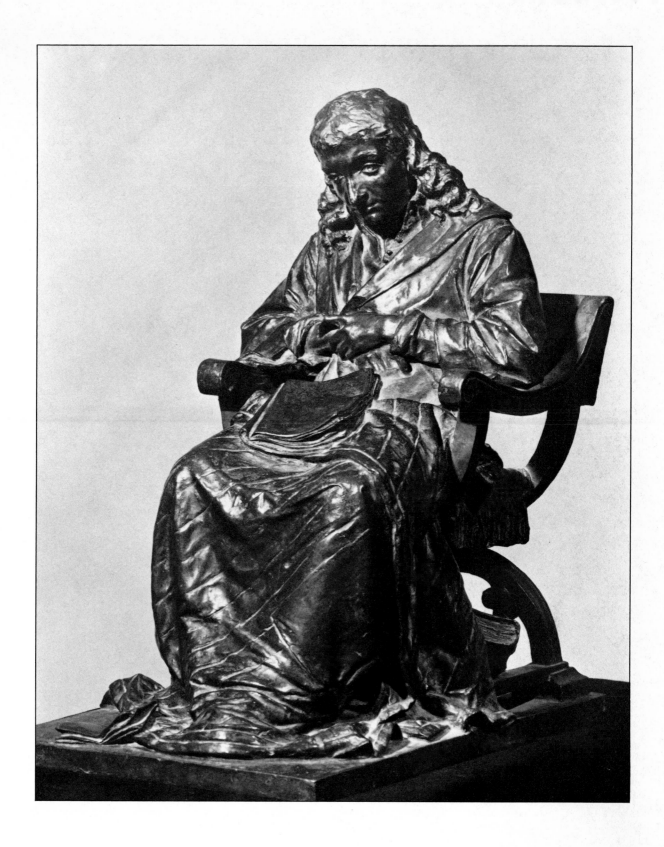

339. *Mark Antokolski. Spinoza, 1882. Bronze copy, Tel-Aviv Museum.*

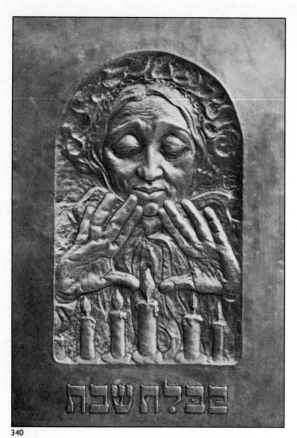

340

341

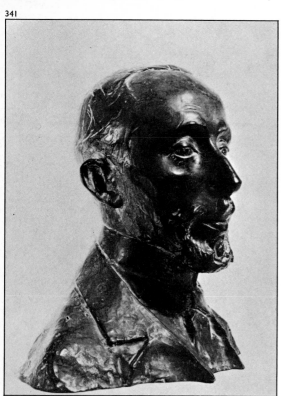

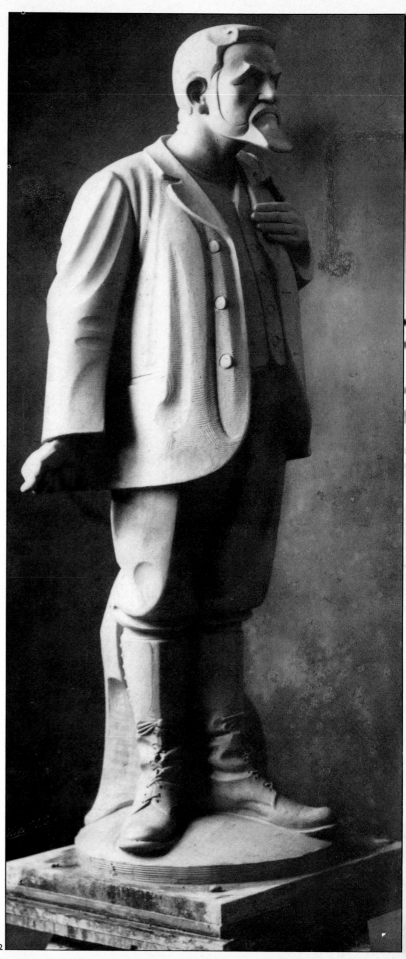

340. Boris Schatz. Blessing over the Sabbath candles. Copper relief. Israel Museum.

341. Enrico Glicenstein. Portrait. Bronze. Israel Museum, Jerusalem.

342. Joseph Mendes da Costa. Monument of General De Wet. Amsterdam. Courtesy Lichtbeelden Instituut, Amsterdam.

342

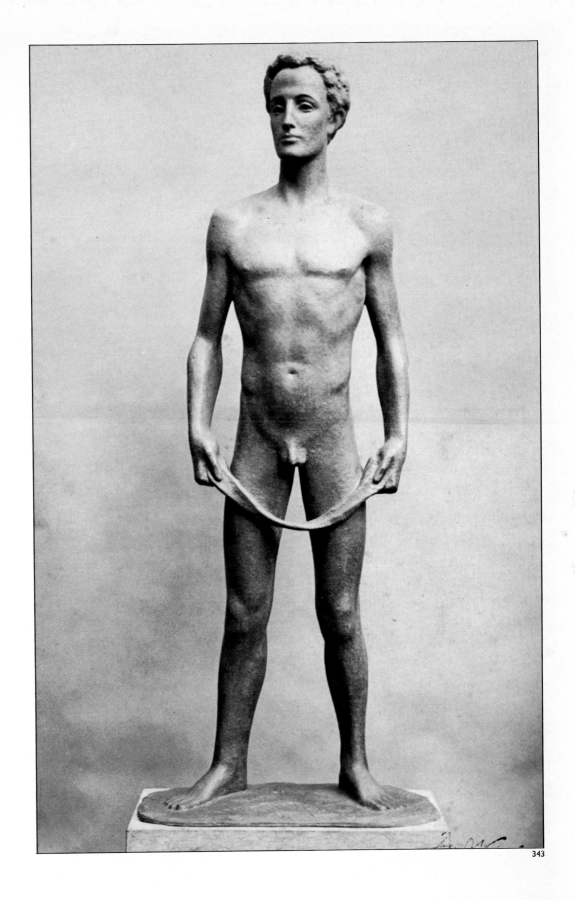

343

343. Arnold Zadikow. "David". Bronze. Tel-Aviv Museum.

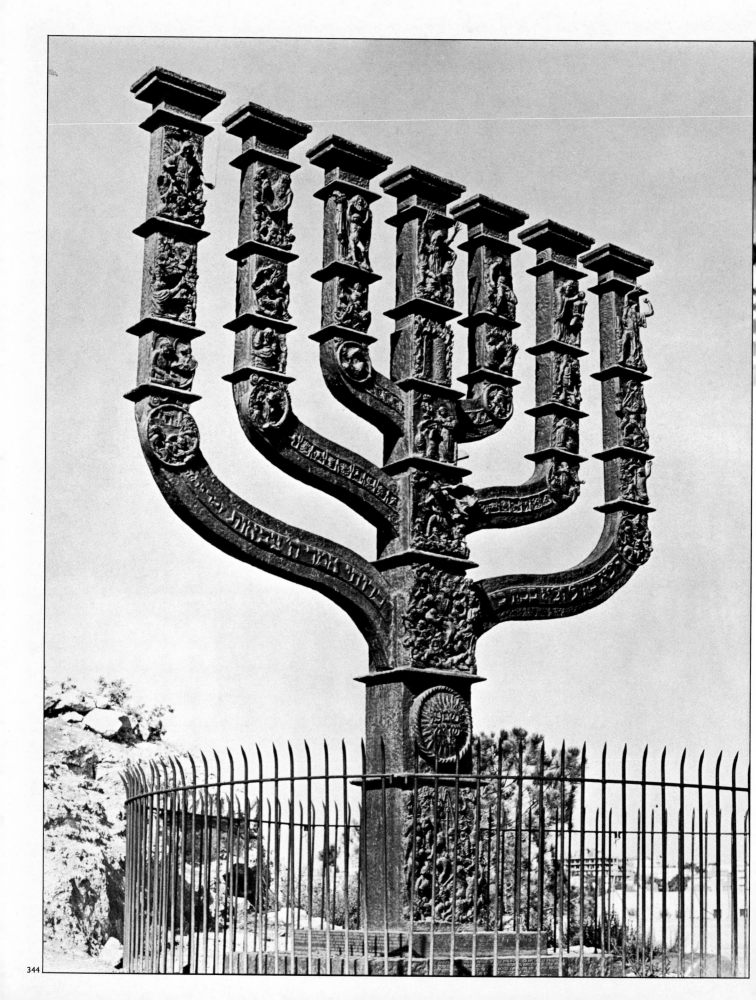

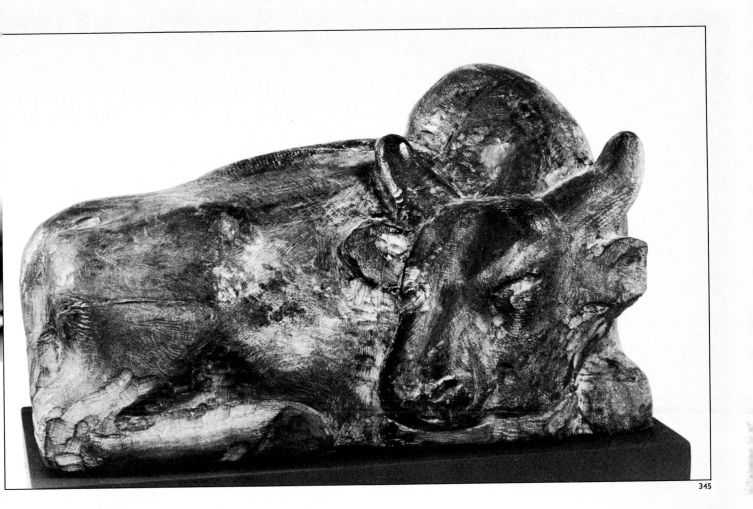

345

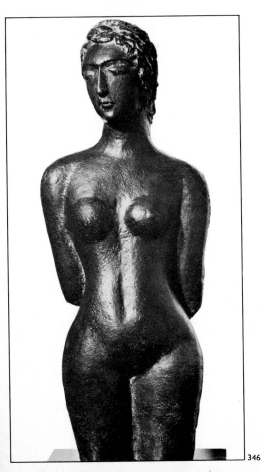

346

344. Benno Elkan. Menorah. Opposite the entrance to Knesset, Jerusalem.

345. Joseph Constant. Cow. Wood. Tel-Aviv Museum.

346. Moyse Kogan. A young woman. Tel-Aviv Museum.

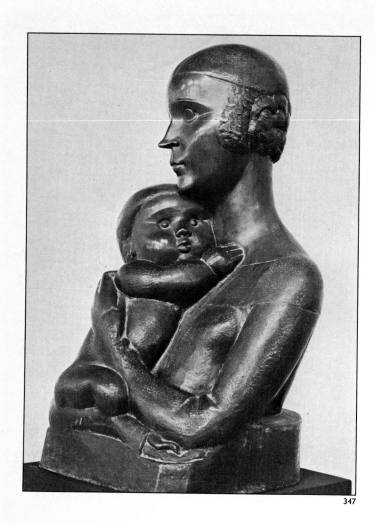

347

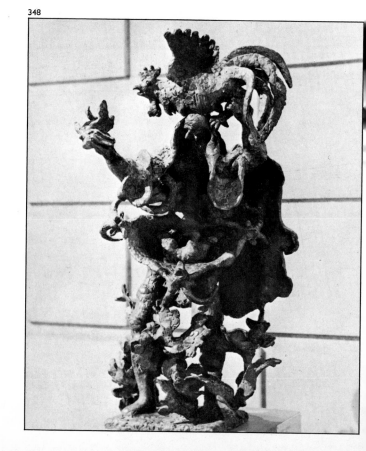

348

347. Hanna Orloff. Mother and Child. Tel-Aviv Museum.

348. Jacques Lipchitz. The Kapparot Sacrifice. Bronze, Ingersol Collection, Philadelphia.

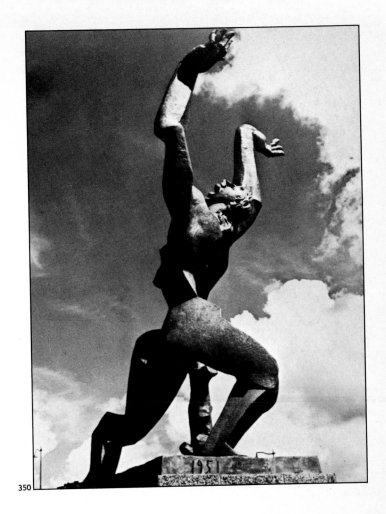

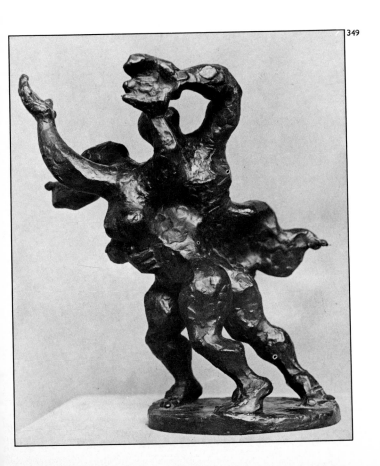

349. Jacques Lipchitz. "La Fuite", 1940. Bronze. Paris, Private Collection.

350. Ossip Zadkin. "May 1940", The Destroyed City. Monument in Rotterdam, 1951. Bronze.

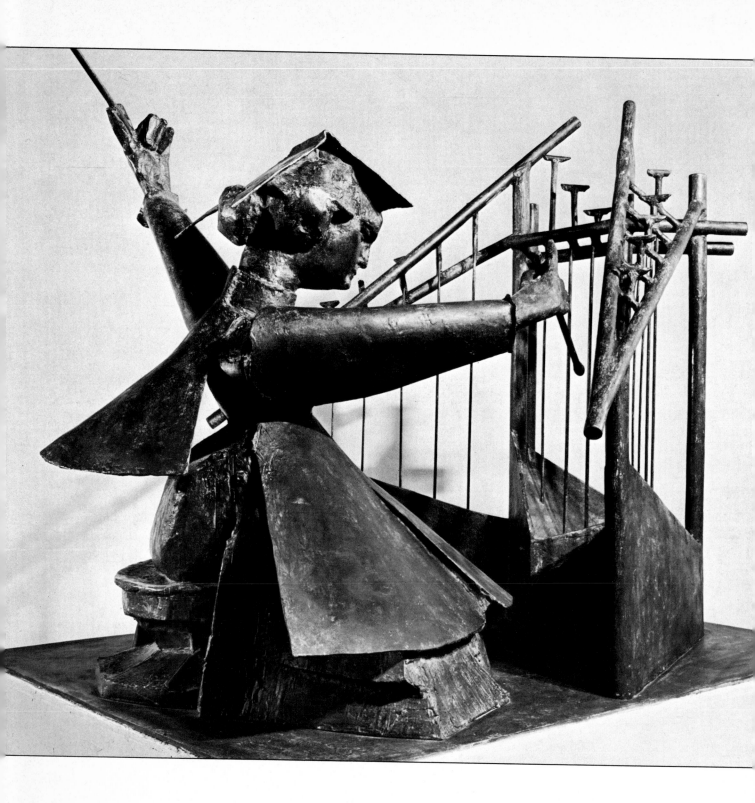

351. Bernard Reder. The Harp Player. Tel-Aviv Museum.

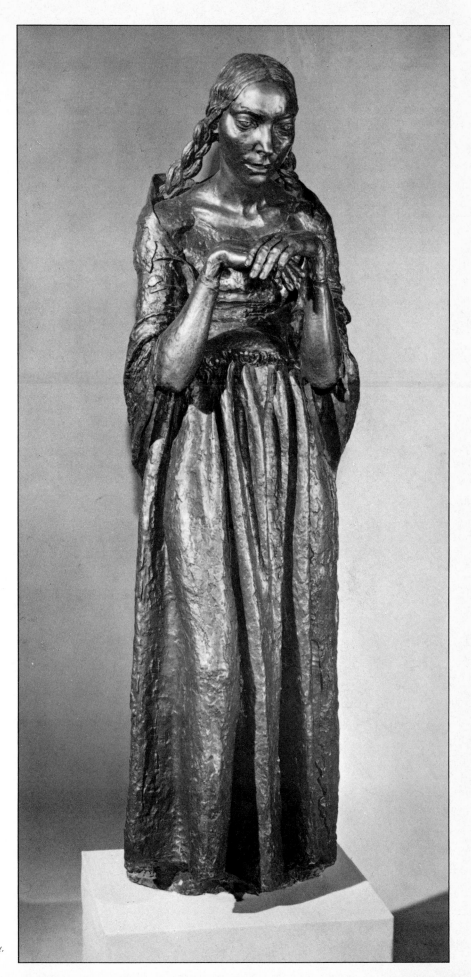

52. *Jacob Epstein. The Annunciation. Bronze. Tate Gallery, London.*

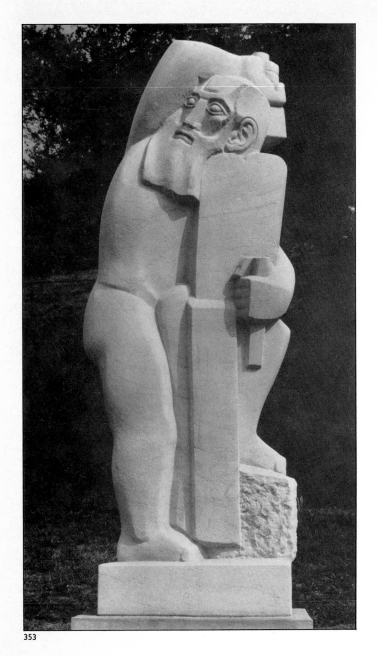

353

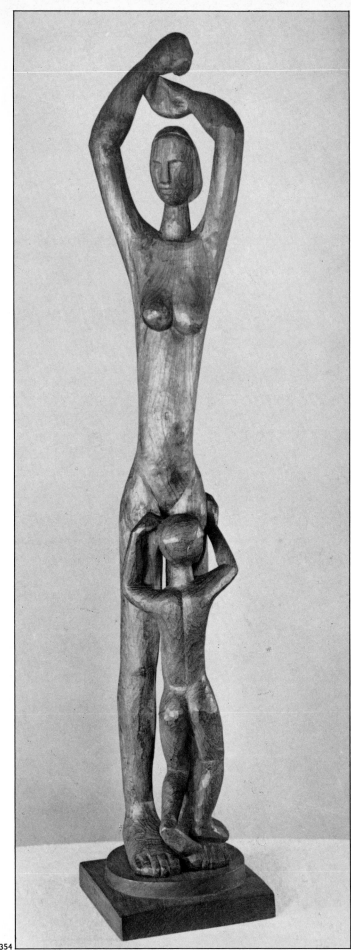

353. Benno Schotz. Moses Hammering out the Ten Commandments. Limestone. Artist's Collection.

354. Lippy Lipschitz. The Tree of Life. Wood. South African National Gallery, Cape Town.

354

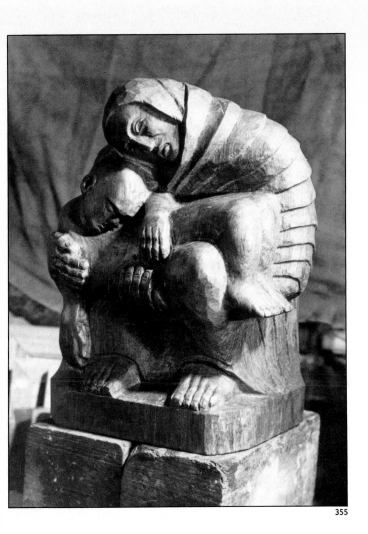

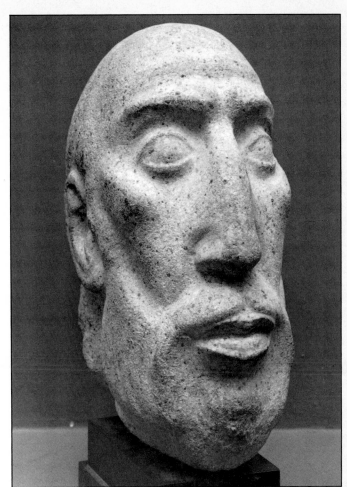

355

356

355. René Shapshak. The Mother. Wood. Bidel Collection, Johannesburg.

356. William Zorach. "The Man of Judah". Granite. New York, Private Collection.

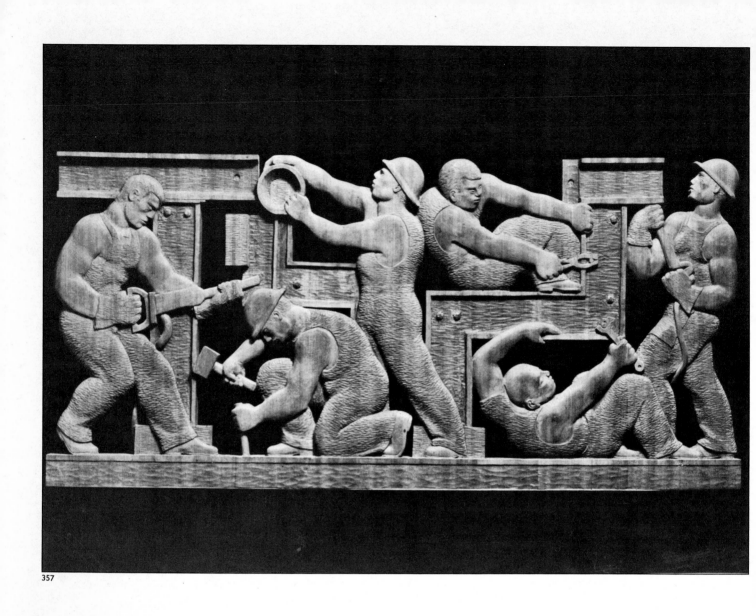

357

357. Maurice Glickman. "Construction". Mahogany. United
 States Section of Fine Arts.

358. Chaim Gross. Head of a Woman. Wood. Tel-Aviv Museum.

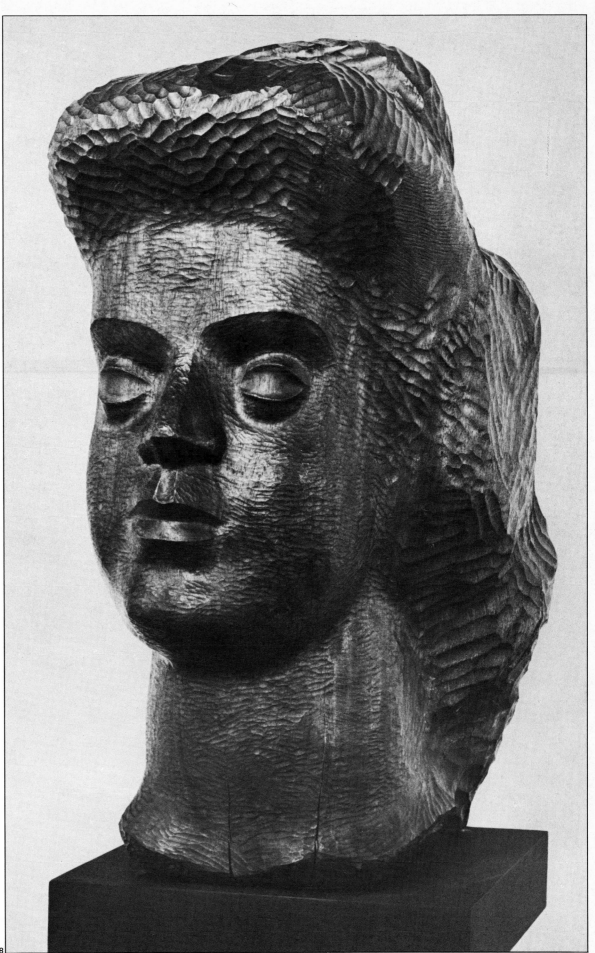

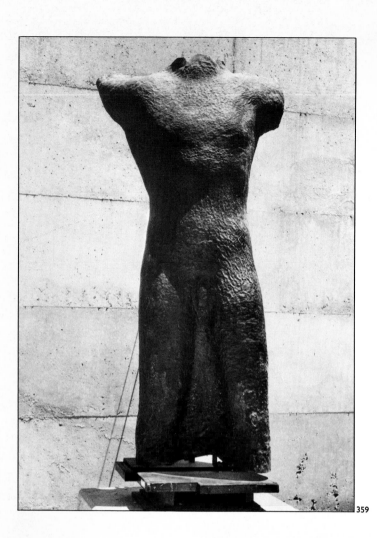

359. Saul Baizerman. "Titan". Hammered copper. Billy Rose Art Garden. Israel Museum, Jerusalem.

360. Dorothy Greenbaum. The Snob. Limestone. 1944.

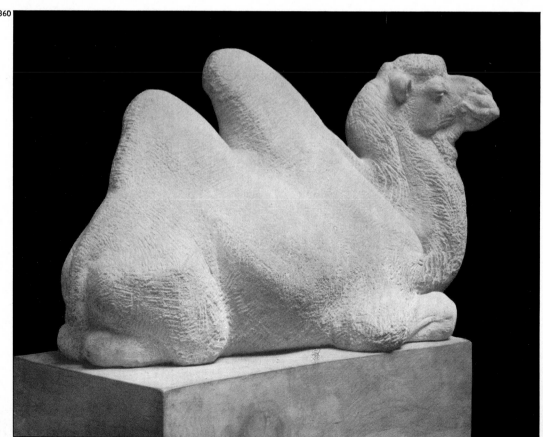

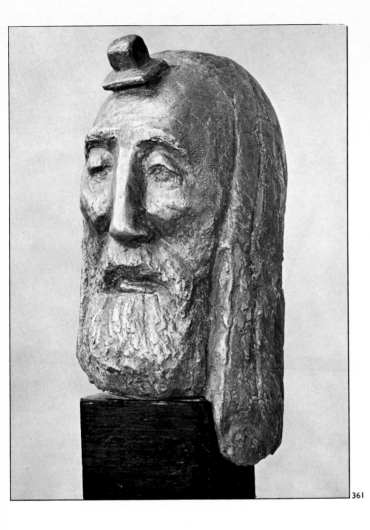

361

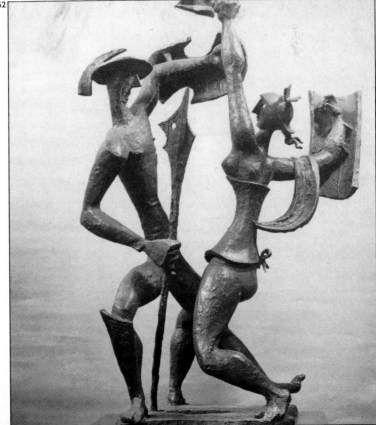

362

361. Minna Harkavy. Last Prayer. Bronze. 1949. Whitney Museum of American Art, New York.

362. Milton Hebald. Battle of the Amazons. Bronze. Metropolitan Museum, New-York.

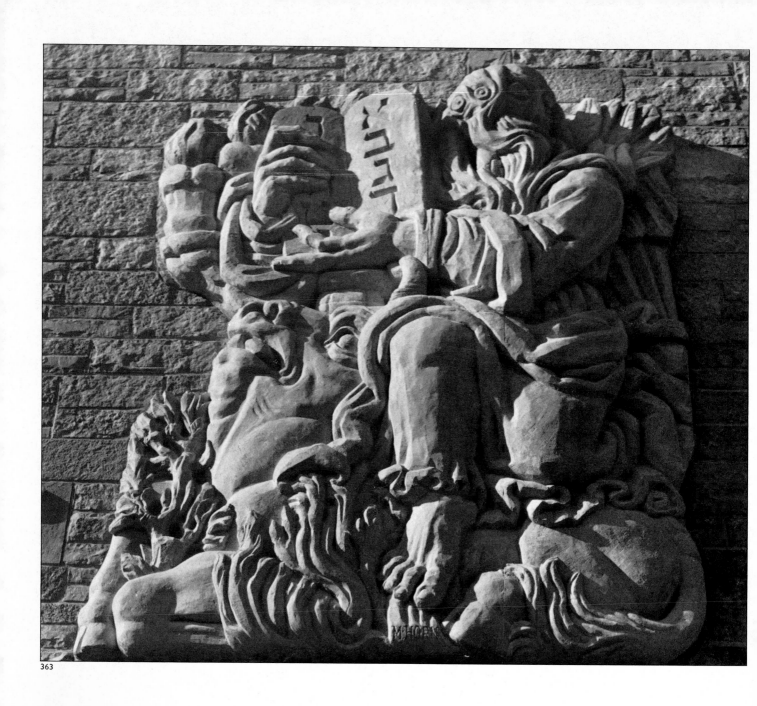

363

363. Milton Horn. "Not by Might, nor by Power but by My Spirit". The Temple in River Forest, near Chicago, Illinois.

National Gallery acquired *Albrecht Duerer as a Boy* and *Luther with Book in Hand Begging for Bread,* while other works are in the Metropolitan Museum of New York and the Museum of Fine Art in Budapest. Under the influence of Herzl, he produced works on a Jewish theme, such as the groups *Shma Yisrael, In the Sweat of thy Brow,* and *Promise.* It was Beer who designed the medal for the First Zionist Congress at Basel (1897).

From certain points of view, the most important Jewish artist of this period, who went beyond the rudimentary limits of the prevailing academic atmosphere, was Henryk (Enrico) Glicenstein (1870–1942). Coming from the same environment as Boris Schatz, he spent his youth in the *heder* and the *yeshivah.* He studied in Munich, and having won the Rome Prize, went to Italy where, living in Rome for the next 25 years, he developed a many-sided artistic activity. His last days were spent in New York. His first works were of a naturalistic bent stressing lyricism and pathos in a *genre*-like fashion. Characteristic of this period is a marble statue called *The Song of Paris* portraying a dancing girl with a ram. His concentration of powers and a feeling for the concept of form arising from the nature of the material begin to reveal themselves in a number of works in wood, such as a torso of archaic size. In a great many of his works, one can trace his development towards an ever-growing realism. However, he reached the height of his singular ability only in his American creations. In 1928, he executed two seated terra-cotta figures, a number of busts in bronze and wood, which are outstanding for their mobile expressiveness.

Fig. 341

Also noteworthy are the marble bust of *Rabbi David Einhorn* and *Lincoln*—the latter in the Lincoln Museum in Springfield. His inner dynamic strength came to the fore chiefly in his wood-working. No contemporary artist made comparable strides—from the naturalistic excitement and untrammeled wilderness and the sometimes weak feeling for style of his early period to the security, clarity, and greatness of an expressionism born of deep experience which the works of his last creative period showed him to possess. In 1940, he created a monumental figure, more than two meters high, of the *Ecce Homo* in which human suffering is compressed to an almost unearthly dignified quiet as if congealed into stone. The finale of his life's work is a powerful monument *La Défense Nationale.* His terra-cotta figure of a woman pioneer in Palestine illustrates his intense Jewish feeling.

Joseph Mendes da Costa (1863–1939) may be termed the founder of modern Dutch sculpture. His artistic efforts revealed themselves in three aspects: as a strongly stylized decorative art in the sculptural ornamentation of buildings; expressionistic busts always in pure, clear forms; and small works of great charm, among which are highly original figures of animals, such as his *Sad Monkey* in which primitive human feelings find their expression. A similar phenomenon is Siegfried Wagner (1874–1952), who became influenced by Oriental forms of still-life after trips to Egypt and Spain following his studies at the Copenhagen Academy. His monumental figure of the *Lurenblaeser* of the Copenhagen Municipality and many gravestones and busts bear his characteristic stamp. In addition, he also executed many utilitarian objects. Kurt Kroner (1885–1929) was for a long time a student of Rodin's.

Fig. 342

Among the great Jewish artists whose lives were brought to a tragic end by the Nazis was the gifted German sculptor Arnold Zadikow (1884–1943), whose first independent works consisted of a lovely ten-cm.-high figure in silver, a number of chiseled silver plaques, and some terra-cotta figures. World War I interrupted his work for five years. This, however, was followed by a rich activity distinguished by a large number of war

Fig. 343

memorials and tombstones on which the traditional form and ornamental application of the Hebrew script are examples of the best modern work of this kind. He made many castings of medals, busts, and a large cast figure of *David* in bronze. His subsequent figure of *Motherhood* in stone, to which he then turned, is his matriculation certificate as a great sculptor. The quiet and softly flowing forms, the gliding together of the planes, the constructive balancing of the structures, and the completeness of the total silhouette present a unity and a timelessness growing out of the stone. Many of his sculptured works in marble were done in Rome. *Il Gioninello,* the statue of a youth and of a female half-figure are works of classic beauty. In 1932 he moved to Paris where he executed many large works and studied the old techniques of glass- and crystal-carving, engraving with diamonds, and glass polishing. By the time of his tragic death in a Nazi concentration camp, he had developed an unusual imagination in the formation and use of stylized decoration pieces as well as crystal bowls of elegantly sweeping rhythms and extremely thin glass. Among the other victims of the Nazis was the gifted 77-year-old Leopold Bernstein Sinaieff, who was well-known for his busts and statues and especially for his *Grieving Ezra,* executed in the style of Dalou and Rodin.

Benno Elkan (1877–1960), born in Dortmund, and living in London from 1933, had a versatility similar to Zadikow's. While studying painting in Paris, he associated with Albert Bartholomé from whom he learned to combine simple architectural form with sculptured decorativeness in bronze, which he applied to tombstones in Germany. Elkan's portraits on medals established his reputation as one of the great artists of his generation. His bust of Walter Rathenau and a life-size marble figure in semi-precious stones called *Persephone* are outstanding. To celebrate the evacuation of Mainz by the Allied Forces after the occupation following World War I, he executed a statue of a kneeling woman in granite for the city of Mainz. In Frankfurt, he executed the granite monument of a grief-stricken woman which he called *To the Fallen.* But these public works of his were destroyed by the Nazis.

He achieved great prominence by renewing a long-forgotten form of art recalling the medieval German craftsman Peter Vischer. These are bronze chandeliers in the form of a tree with each branch a separate lamp enclosing a group of figures. He executed large lamps of this kind, each with many Biblical figures, which were placed in Westminster Abbey and other ecclesiastical buildings in England, and finally his great masterpiece

Fig. 344

a Menorah for the Knesset (the Israel Parliament) building in Jerusalem.

IV

With changing conceptions of art which appeared on the threshold of the 20th century, a new Paris school grew up within which a Jewish enclave left its own stamp. During the course of the years, various personalities who became leaders and trailblazers of modern art emerged. Until this period, Jewish artists had stepped into the limelight as individuals. These, however, were exceptions. From the point of view of numbers, Jewish artists were unimportant. In the new century, this number began growing rapidly. By comparison with the great multitude of artists living in Paris, they were relatively few. However, it is worthy of note that this minority soon came to play an important role. The reason for this is that the Jew, always concerned with the inner world of the individual, quickly identified himself with the new approach to art which substituted a portrayal of the world of effects for a photographic reproduction.

In sculpture, too, Jews were pioneers in presenting this new approach. Amadeo Modigliani, for example, was not only a great painter but also a master of line and form, a sculptor of exceptional originality. Because of the dust produced by working in stone, he was able to devote only short periods to sculpture. In addition, his unstable temperament kept him from completing work that he began. He worked pitifully at pieces he happened to pick up, only to destroy many of them when he was drunk. His sculpture shows Negro and other primitive influences, whose artistic value he was quick to recognize and appreciate as a folk-art. Among the most interesting women's heads are his works in the Philadelphia Museum and the Victoria and Albert Museum in London, while a sandstone statue of a kneeling caryatid in the Museum of Modern Art in New York displays classic rhythm. His early death put an end to his half-revealed talent in this field.

Elie Nadelmann (1884–1946), who began his Paris career with a statue of a woman in motion in the Hellenistic style (1904), later created heads in the style of Rodin whom he greatly admired. From that point on, his art took a definite direction, since he had come to the conclusion that all form consists of geometric elements. From the beginning of World War I he lived in New York — although his art was always anchored in Paris. He never forsook the technique he had acquired of striving to simplify curved forms — e.g., in his *Man Outdoors* (1915), *Couple Dancing a Tango* (1918), many women dancers, and circus figures in strange motion poses. He attained considerable wealth through the execution of commissions from high society. The sculptured heads of his female clients were delicately fashioned in marble. After losing everything in the 1929 crash, he withdrew to a modest studio where, poor and forgotten, he continued to create small plaster-of-paris figures full of capricious movement.

Paris reached its peak as a center of artists during the first decade of the 20th century. As a magnet attracting an ever-increasing number of artists from all over the world, it drew Modigliani from Livorno, Italy; Cracow-born Nadelmann; Kogan whose origins were in Russia, whence Loutschansky also came; Jaffa-born Joseph Constant; and Hanna Orloff, born in the Ukraine who came to Paris via Palestine. Jacques Lipchitz, born in Poland, lived in Paris for 31 years; Zadkin spent many years there. From America, among many others, came Zorach and Epstein in order to enrich their knowledge.

Moyse Kogan (1879–1942) was a master of small art forms *par excellence*. His forte was the rhythm of the human figure in motion. His beings are completely timeless. The figurines *Fig. 346* he produced remind one of Tenagre: they are of the simplest forms, avoiding all detail.

Jacques Loutschansky, who after 47 years in Paris moved to Israel at the age of 75, has always striven for simple forms without tying himself to one particular style. His busts of young girls and women are often lyrical. His children's heads are tender. His portrayals of men — strong and powerful.

Joseph Constant (Constantinovsky) was the most important animal sculptor of our time. All his creations were conceived out of the material he chose to handle. His mediums were marble, wood, bronze, and ceramic ware. Although his treatment of the animals is completely unreal, they affect us as living things which we know. His statues possess a *Fig. 345* quiet beauty and harmony.

Living in Paris, where she came in contact with the modern schools of art, Hanna Orloff had always had a unique style of her own, distinguished for its utmost simplicity of form which she adapted to Cubism. Her favorite medium was wood, whose smooth rounded *Fig. 347* surfaces glide into one another. She was no less a master in marble and bronze which she

often gilded. One sometimes finds something cruelly ironic and glaringly frank in her busts. In her portrayals of women, she knows how to unfold a tender lyricism and in her child studies, the naiveté of the child-world. Her statues of animals are masterpieces of plastic forms. Never verging on the sentimental, dramatic, or pathetic, Hanna Orloff displays a sense of humor, and is, at the same time, original, realistic, and always expressive.

Marek Szwarc's art formerly followed an old Jewish tradition in every way. He drew, almost exclusively, themes from the Bible and the life of the Polish Jews, which he executed in copper relief *(repoussé)* in the manner of objects made by Jewish craftsmen. After conversion to Catholicism, however, he occupied himself chiefly with church decorations.

The first artist to have the courage to translate concepts of abstract painting into sculpture, to carry over the line rhythm of painting into the construction of form, and to remold color into the motion of light was Jacques Lipchitz. His artistic creations are not bound by any one particular formula. Once he became interested in a theme, it occupied him for years until it reached the ultimate in clarity. Thus, in the course of fifteen years, taking the theme of a man with a musical instrument, he formulated it in a variety of works, beginning with a cubistic structure through ever-new variations until he reached the purely abstract form. Out of the man with the musical instrument, a melody-song itself finally emerged. The tumult of the 'thirties made him seek new themes as embodied in the struggle of Jacob with the angel, Prometheus killing the monster, a mother wringing her upraised arms in despair, a prayer rising to heaven, and the *Kapparot Sacrifice*. These are now his themes. *The Miracle* gives expression to the newly risen State of Israel. The rebirth of the Jews in their ancient homeland began to interest him when he was forced to flee France. Living in New York, he has come to play a dominant role in artistic life today.

Fig. 348 349

Ossip Zadkin is no less a painter than a sculptor. His work consists of abstract, cubistic forms brought to life, and achieves supple movement elicited by the play of light. Influenced by the art of primitive peoples, he created a number of longitudinally formed heads in stone similar to those of Modigliani and some compositions in wood with strong cubistic overtones. Lately, he has turned to the use of plaster of paris in order to create a more elastic form and give more sweep to the construction. The effects of light are what bring his work to life. His feeling for space stems from its conception of light. His memorial statue called *The Destroyed City* stands in Rotterdam. It depicts a female figure screaming with terror as she lifts her hands to heaven to ward off the horrors of aerial warfare.

Fig. 350

Bernard Reder, who started his career as a gravestone cutter and did not have his first exhibition until the age of 38, has come a long way from his early coarse, massive bodies with powerful muscles and broad thighs which aroused such horrified astonishment. The influence of Maillol in Paris soon tamed his unbridled primitive strength. He gained conscious control of rhythmic expression without becoming untrue to his own imaginative powers. Works such as *The Squatting Woman, The Woman Bathing,* and *Two Women Standing* reflect the artistic atmosphere of Paris. In New York since 1943, Reder's art has acquired new driving power from the dynamic rhythms of the city's life. His powerful statue in stone *Wounded Woman* was the sensation of the Philadelphia Exposition in 1949. Reder seeks to express his keenly passionate imagination in a dynamic language, as in *The Harp Player*. In his stone as well as in his bronze compositions, he tends more and more to give up realism for exalted rhythms. His *Centaur's Head* and *The Fantastic*

Fig. 351

Bird, both in stone, as well as his bronze groups *Women in Battle with a Bull* and *Women in Battle with an Attacking Eagle* are the high points of his extraordinary power and his fighting spirit, ever seeking new expression.

Jo Davidson (1883–1952), born in Russia and brought to New York as a child, was considered a member of the European school, since it was only after his arrival in Paris at the age of twenty-four that he matured as an artist. He always remained true to the tradition he discovered there. At a very early age, he could already model busts with juggler-like proficiency. The greatest part of his unusually prolific life's work consisted of the busts of nearly all the prominent personalities of his time. In addition, he executed several statues such as a *David, a Russian Woman Dancer,* and later — in 1940 — a large, bronze statue of *Walt Whitman* at which he worked for 14 years. He knew how to bring out the true essence of the beings he reproduced. He had enormous technical skill and a steady, discerning eye. He followed Rodin's impressionistic method and used the play of light and shadow with powerful effect.

Without a doubt, the outstanding sculptor of our time was Sir Jacob Epstein (1880–1959), perhaps the greatest master in casting bronze and working directly on stone. Born in the United States, he acquired his true artistic background in Paris and moved to London where he subsequently lived: thus he belongs to the European school rather than the American. The appearance of each of his early works aroused violent controversy. Epstein *Fig. 352* was perhaps the most radical and uncompromising realist of them all. The idea for his creation always emerged from the medium — in this lay his genius as a sculptor: he did not believe that sculpture should resemble reproduction in wax. Lately, he executed many specifically Christian figures and carried out many commissions for churches. Epstein paid tribute to his people with a completely new concept of *Lazarus Bound.* The works he has executed with a chisel are effective because of their almost primitive simplicity. By primitives here, we mean the way in which he fashioned living power out of dead matter. Epstein was neither bound to any particular medium nor any particular style. His busts of Joseph Conrad and George Bernard Shaw rank especially high. He possessed the rare talent of being able to occupy himself with children. Above all, he used his own daughter as a model, almost from the moment she was born, in variations without number. No other artist has succeeded in creating children's figures with such convincing spontaneity.

Through Epstein's creativeness, many present-day artists have received new inspiration. Among his followers is Benno Schotz, Director of the Glasgow School of Art since 1938, and Scotland's leading artist today. His busts distinguish themselves in that they reflect the individual characteristics of their subjects. He has also executed some charming children's heads. Worthy of mention are his bronze bust of Lord Boyd Orr, brought to life by the play of light and shadows, and his 1952 sculpture of an unusually impressive head of that notable Scottish friend of the Jews, Malcolm Hay. The styles he used are impressionistic for busts and cubistic in monuments, as in his *Moses Hammering out the* *Fig. 353* *Ten Commandments.* Lately, he has gone over to the semi-abstract style, as in his *Adam and Eve.* Schotz's mediums include soft clay, sandstone blocks, and reinforced concrete.

By far the most important of South Africa's sculptors is Lithuanian-born Lippy Lipschitz. His work reflects the characteristically strong rhythm of African Negro art which he joins to the language of form and to the dynamism that he brought back from Paris, where he had

Fig. 354

studied with Bourdelle. The expressiveness of his *Jacob Contending with the Angel* in ebony woods is due to its cubistic form. A teak tree is the inspiration for his group *The Tree of Life* consisting of an exaggerated slim figure of a woman with arms raised over her head and a child cleaving to her.

Together with all other South African artists, Lipschitz' art is completely determined by the natural objects of his environment. He makes use of the countless varied assortment of stone as he does of the trees around him. His mediums give final shape to the idea which impells him to create. A grained piece of stone in his hands becomes a body with smoothly flowing muscles, with the veins expressing motion. Lipschitz has executed two works called *The Sea Nymph.* The first, according to the nature of the stone from which it was created, is compact; whereas the second one, made from a stone found on the seashore which had been deeply hollowed out by the waves, has more open contours and greater inner motion.

In contrast to Lipschitz' symbolic abstract art born out of reality, René Shapshak follows a more stylized classicism in the sense of the modern concept of form. He, too, was trained in Paris and is a master of wood, stone, and glass. His decorative ornaments of cut glass in which light is the main factor creating rhythm, actually belong more in the field of craftsmanship than pure art. There is a most pronounced influence of the primitive African folk-art in his wood sculptures. He frequently uses the swinging movements of tree branches for bold compositions such as in his *Jeremiah's Journey to Heaven.* Others are chiseled out of massive blocks of wood such as his powerful figure of a mother in the

Fig. 355

form of an African peasant woman shrunken with exhaustion, and his large Negro heads.

The artist who has penetrated most deeply into the African soul is Moses Cottler. His figural compositions of native types, although done in wood, give the impression of having been cast in bronze, so smoothly and subtly have they been executed. The emphasis is mostly on psychological expression. Herman Wald, the son of a Hungarian rabbi, is best characterized as the expressionist among the sculptors living in Africa. *Hassidic* emotion and love of music permeate his works which, however, leave much to be desired from the point of view of the laws of plastic form. His *Three Jews* are more an expression of poetry than of sculpture. *The Refugees* pictures a woman petrified with horror holding her child in a tight embrace to save it from its pursuers. The large symbolic figure of a woman, *Kria* (Reading for the Dead), is a memorial to the suffering of the Jewish people, at the same time expressing the hope for a better future.

V

Jews are conspicuous adherents of the *avant-garde* movements in the sphere of American arts. Among American artists, a disproportionately great number are Jewish. They are, it may be said, predestined by the fate of the Jewish people to concern themselves with problematical themes stemming from the stresses and strains of the 20th century. Since most of them come from the lower social strata and have known more of the needs and sorrows of the times than of their blessings, they energetically throw themselves into the struggle for existence. Many of them or their parents have escaped the catastrophe of European Jewry which still echoes in their ears and fills their imagination. This has been their unique contribution to American art. But it would be misleading to recognize only the tragic in their work. They are also capable of striking a happier note. Typical is the work

of William Zorach whose stone figures are the epitome of utter simplicity saturated with a deep, sometimes mystic, expression.

At the age of four, Zorach came to Cleveland from Lithuania, with memories of the small town of Eastern Europe and its persecutions strongly imbedded in his personality. He studied painting in New York and Paris, and was greatly taken by Van Gogh and Gauguin. As a painter in New York, he was a failure. A chance experience in cutting out a flat relief from an old crate brought him to sculpture. Since the age of 36, he has completely devoted himself to the plastic arts. He was the first to bring to modern American art the technique of working directly with stone and wood. He is considered the greatest master of these techniques. Zorach is also a pioneer in the use of structural instead of anatomic forms in art. His early important works include a more than life-size statue of his daughter in marble, a composition in walnut *Pegasus*, a marble bust of his wife, a powerful head of a prophet in black granite, and *The Lovers*. He is much concerned with the theme of mother *Fig. 356* and child. A granite group executed in 1945 is his finest achievement on a variation of this theme. It strikes one as a universal expression of mother love devoid of any romanticism or frivolity.

One of his outstanding pupils is Chaim Gross, who has achieved prominence in the field of wood sculpture. He studied painting in Budapest and New York, but did not find his true calling as an artist until the forests of the New World brought back a childhood fascination for the woods and the wood carving acquired from watching the peasants in his native town of Kolomea in Carpatho-Russia. He knows how to exploit to the utmost the native structure of the wood he works with. He simplifies forms in the abstract manner. He has discovered the rhythmic melody in wood, often repeating the theme of dancing figures in groups. Gross sees this theme in the natural form of the wood, transforming it *Fig. 358* into human bodies, merging and flowing into one another. Like Zorach, he works directly on his media, preferring hard wood. His love for hard material and his joy in working with it has led him to stone sculpture. Thus, he has executed a number of works in marble and onyx. He has a flare, uncommon in sculptors, for the humorous and the light.

Nat Werner, also a pupil of Zorach's, prefers wood as a medium. He is more dramatic in expression and stricter in form than Gross. Sometimes, nonetheless, he prefers a lighter rhythm. Thus he gives expression to his joy at the downfall of the Nazis in the dance-group of a couple with lyre and tambourine in mahogany. Inspiration for this composition came from the Book of Samuel where David is described returning from a victory over the Philistines and being met by people rejoicing, dancing to the music of drums and cymbals. The rhythm of the dance is conveyed in the treatment of the mahogany. Werner's well-known *String Quartet* in elm is a highly successful cubist experiment, while other carvings such as *The Talmud Scholar* are expressionistic.

Another of William Zorach's pupils is Maurice Glickman who came to sculpture via painting. His strictly constructed bronze group of a Negro mother with her child shows the influence of the classic masters of England, France, and Italy where he studied. A further step led him to closed contours as in the beautiful marble group *Destitute*. In his realistically constructed free reliefs in wood he effectively brings out the rhythm of human movement through the use of architectonic parts. He finally achieves a stronger dynamism *Fig. 357* and freer flow of lines and reduces forms to their cubistic content. In the statue of *A Woman Sunk in Grief*, the full force of her sorrow is imparted by the expression of her hands. Glickman executed a group in motion called *Pearl Divers*, cast in aluminum, in

which the play of light on the metal effectively portrays the bodies throwing themselves into the depths with outstretched legs.

A many-sided artist, well versed in all techniques, who has devoted himself mostly to sculpture in connection with architecture, is Louis Slobodkin. Among his noteworthy works are the *Tunnel Men* and *The Mohawks*, cast stone, in which he adheres to a strong tectonic construction. He remains true to the naturalistic impression of bound forms in his three-and-a-half-meter bronze of the young Lincoln. His small terra-cotta *The Old King David* is an interesting motif of motion.

By way of contrast, the leading artists of the past generation representing the Classic Antique style in American sculpture were Maurice Sterne and Saul Baizerman. The former's extended study of art in Greece made its effect felt on the sculptures and paintings he has done over a number of years. As early as 1909, he created the head of a bombardier in Classic style. It is today in the Metropolitan Museum of Art. Other works of his are the stone reliefs for the Roger Kennedy Memorial in Worcester and the marble statue of a seated woman in which his handling of the soft stone is masterly. Saul Baizerman has for a quarter of a century achieved extraordinary effects with his technique of working with copper plates; he hammers concave as well as convex forms directly out of the metal. This method endows his production with expressiveness of light and form. Among his most effective works are the reliefs *Exuberance*, in which the women's bodies appear nearly dematerialized, and *The March of the Innocents*. When looking at these, one almost has the feeling that the media have come to life.

Fig. 359

The classical preoccupation of Jewish artists with the life and suffering of the working proletariat is clearly reflected in the work of Max Kalisch, which is almost exclusively devoted to the theme of the industrial workers. He made realistic reproductions of the working-man as a symbol of his era. His workers are not showpieces, but hard-living figures with muscles flexed. His Riveter, for example, is a strong, realistic work with the body seeming to vibrate with the rattle of the tool his powerful hands are handling. Aaron J. Goodleman is also concerned with proletarian subjects, but these are only one side of his artistic personality. His art is neither thematic nor formally bound. As he varies his mediums from stone to wood or clay, his possibilities of expression move from the quiet static (*Meditation* from a block of granite) to the ecstatic expressionistic *(Together)*, and to deeply symbolic naturalism (*Men and Machines* in bronze). Some of his best creations are highly expressionistic, having Eastern European Jews as subjects.

It is symptomatic of conditions in the New World that a particularly high proportion of women figure prominently among American-Jewish sculptors of eminence and genius, though a century or even half a century ago such a thing could not be imagined. Space permits the mention of only a very few of these. Outstanding, perhaps, is Berta Margoulies who was born in Poland and spent her youth in Belgium and England before coming to America, where she went through the school of William Zorach before proceeding to France and Italy. She is capable of expressing a wide range of human emotions in a large variety of media. The happiness of childhood speaks out of the bronze head of her little son; while the posture and faces of her two refugee children with empty eyes and drawn mouths express shy timidity. There is mute resignation in the cubistic statue of mine-workers' wives crowding behind a fence waiting for news from the scene of a mine accident. The head of an old Jew with its serene dignity and air of deep meditation symbolizes spiritual greatness.

Another woman artist to be influenced by Zorach is Minna Harkavy who also studied with Bourdelle in Paris. Her creations are realistic, large in form, and rich in feeling. Among them are the bust of Henri Barbousse, her tremendously expressive study of a Negro head, and her *Two Men* in rigid forms. Her quiet, exalted head of a bearded old Jew with a phylactery on his forehead, entitled the *Last Prayer* is especially impressive.

Fig. 361

Dorothy Greenbaum, on the other hand, belongs to the masters of the bound form. Self-trained, she works mostly in stone, seeking to preserve the natural form of the block as much as possible. Leaving the natural contours untouched, she has fashioned the quiet, dreamlike head of a girl from an egg-shaped stone. She has shaped a block of sandstone into a naturalistic camel imparting to it symbolic meaning intimated by its title *The Snob*.

Fig. 360

Her hammered lead statue of a woman in motion expresses fine feeling for form, the play of light in its fluctuating rise and fall endowing it with life. Yet another American-Jewish sculptress of exceptional ability is Anita Wechsler, whose art has, in the course of the years, gone through a number of phases from the naturalistic to the realistic and finally to the abstract. She has a strong imagination and a genuine feel for the mediums, and can bestow upon her plastic compositions adequate rhythmic expression. She has learned to work in stone and wood from William Zorach, but has developed her own very personal style. In 1937, she began a series of anti-war sculptures entitled *War Music*. She fashions groups strongly cubistic in form out of cement, wood, and bronze. A strongly stylized decorative mahogany work called *The War* is especially worth mentioning. Her experiment to fuse natural stones rhythmically is interesting. Her abstract constructions of copper and brass bars are, for the time being, experimental attempts.

The American environment is favorable to the appreciation as well as to the evolution of new forms of art; and it is only natural that Jews, with their iconoclastic bent possibly even combined with an atavistic resentment of representational sculpture, should be foremost among those who have embarked on new experiments in this sphere, not always with outstanding success, though sometimes achieving brilliant results. Thus, for example, Milton Hebald has developed his own expressionistic rhythm which he knows how to vary according to the mood of his statute. Seymour Lipton, strongly influenced by Lipchitz, shows a dynamically stronger expressionism than Hebald in the cubic forms of his lead cuts.

Fig. 362

Sal Swarz has moved from a modified expressionism to an abstract decorative style. The former is illustrated by his *Seated Woman Dancer,* in which he makes use of the play of light on the bronze casting to enliven the body's rhythmic forms. The latter style can be observed in his *Recollections of a Mummified Cat,* in which he uses small pieces of glass decoratively, framing them in steel. Jason Seley's dancers are only hinted at summarily since they are stripped of everything physical and melted down to a complex of motion and curves which can be grasped only abstractly and decoratively.

Bernard Rosenthal, together with Alexander Calder, is the discoverer of the so-called free-swinging plastic (mobile). This consists of bent wires attached to little steel plates which move in the wind and produce interesting shadow pictures. He achieves the same effect with relief-like constructions of steel in linear form of animals and plants whose silhouettes are reflected against a stone wall. The movement in sculpture known as Constructivism is the result of the activity of the brothers Naum Gabo and Antoine Pevsner. Naum Gabo, who studied the natural sciences while attending lectures on the concepts of art, began his practical work in 1914 with the execution of a woman's head in cubistic form out of

celluloid and metal. **The** first practical application of Constructivism were his sets for the ballet "La Chatte" performed with great success in Paris, London, and Berlin in 1927. Since then, Constructivism has led to innovations in various industrial fields — for example, the shape of automobiles, radios, etc.

Under the influence of Gabo, his brother Antoine Pevsner came to the conviction that painting was not the only means of expression for his artistic talents. His conic and cylindrical shapes adapted from machine forms consist of brass, bronze, and sometimes oxidized tin plate connected with fine little screens. These creations stress, in contrast to the dynamic-static, volume as an element of space.

A wholly new feature in American Jewish life is the utilization of Jewish artistic genius not only in painting, but even in sculpture, in the service of the synagogue. Many American-Jewish sculptors have found an outlet for their ability in the great temples that are now being erected throughout the land. It is precisely because of the surviving opposition to representational art in the service of Judaism that abstract and non-representational sculpture has found an opportunity.

The first significant attempt to create new Jewish symbolism in abstract form has been made by Herbert Ferber. His aim is the presentation of open-space forms through compositions which are built completely on linear motion. For this purpose he employs rods of bronze and heavy lead, as in the *Metamorphosis* or *Aggressive Act* which are based completely on movement. He also uses sheared metal plates. In the *Stabbing Vectors,* which looks like a cactus plant, one no longer has the impression of a piece of sculpture created of solid matter. Yet constructions like this as symbolic representations

Fig. 308 are capable of evoking emotional sensations. Proof of this are his *Burning Bush* and façade of the synagogue in Milburn. This work elicits the impression of small, crackling flames through copper and lead streamers soldered and corrugated together in pointed and spiral forms.

Nathaniel Katz can be called the rhapsodist among sculptors because his bodies are shaped from single, almost independent individual forms; yet, as a totality, they harmonize like a melody. He drives the distortion of his figures to the utmost and breaks their forms apart. His bronze figure of *Cyrano* in the Whitney Museum is a drastic symbolization of the vain duellist. The grimace-like figure *Victory of the Thumb,* a delightful caricature, and the statue called *Rhapsody,* depicting a woman accompanying herself on a lute, fully absorbed, are full of humor and irony. The sculptor is also a master of dynamic expressionism as seen in the alabaster sandstone relief of *Three Patriarchal Figures* which he recently executed together with A. Raymond Katz for the Vine St. Temple in Nashville.

The art of Milton Horn, on the other hand, is expressionistic through and through. He is a master of rhythmic construction, ecstatic expression, as well as of large, decorative forms. Among his works is the statue of kneeling Jove, six stone reliefs depicting the history of medicine for the University of Pennsylvania's School of Medicine, a wood relief in black walnut depicting Isaiah's visions, and a sculpture for one outer wall of the new temple

Fig. 363 in River Forest near Chicago based on the Biblical verse "not by might, nor by power but by my spirit."

The abstract decorations for Temple Bethel in Springfield, Mass., were executed by Ibram Lassaw, whose constructions consist mostly of copper rods rhythmically reaching the utmost in dematerialization.

* * *

It is to be imagined that very memorable work of this type, expressing the Jewish spiritual genius, will in due course come to the fore in Israel. Here, during the past half century, there has indeed emerged a school of sculptors — harking back to the fecund activity of Boris Schatz, some of whom have gained international reputation. This subject must, however, be treated in the general account of the resurgence of art among the people of Israel — its present scope and ambitions.